DATE DUE

Filed Flat Schwartz, Gary,
ND 1940-
653
R4S3813 Rembrandt
1985

RIVERSIDE CITY COLLEGE
LIBRARY
Riverside, California

AG '87

GENCO

Rembrandt | his life, his paintings

VIKING

Gary Schwartz

Rembrandt

his life, his paintings

A new biography with all accessible paintings
illustrated in colour

VIKING

Text copyright © Gary
 Schwartz, 1985
Illustrations copyright ©
 VBI-Koninklijke Smeets
 Offset, 1985

Designed by Ton Ellemers
 GVN
Edited by James Evans
Production co-ordinated by
 Viviane Hendrick and
 Vera Pokorny
Filmsetting: Zet en Zet bv,
 Helmond
Lithography: Koninklijke
 Smeets Offset bv, Weert,
 and Regrafo GmbH,
 Kempen, West Germany
Printing and binding:
 Koninklijke Smeets Offset
 bv, Weert
Paper: Koninklijke
 Nederlandse
 Papierfabrieken,
 Maastricht
Binding material supplied by
 Rivertex bv, Erichem,
 Belgium

Produced in the Netherlands

ISBN 0-670-80876-8
British Library Cataloguing in
 Publication Data available
Library of Congress Catalog
 Card Number: 85-40546
 (CIP Data available)

VIKING
Penguin Books Ltd,
 Harmondsworth,
 Middlesex, England
Viking Penguin Inc., 40 West
 23rd Street, New York,
 New York 10010, U.S.A.
Penguin Books Australia Ltd,
 Ringwood, Victoria,
 Australia
Penguin Books Canada Ltd,
 2801 John Street,
 Markham, Ontario,
 Canada L3R 1B4
Penguin Books (N.Z.) Ltd,
 182-190 Wairau Road,
 Auckland 10, New Zealand

First published in Dutch
 under the title *Rembrandt,
 zijn leven, zijn schilderijen:
 een nieuwe biografie, met
 alle beschikbare schilderijen
 in kleur afgebeeld,* 1984
Published by Viking 1985

All rights reserved. Without
 limiting the rights under
 copyright reserved above,
 no part of this publication
 may be reproduced, stored
 in or introduced into a
 retrieval system, or
 transmitted, in any form or
 by any means (electronic,
 mechanical, photocopying,
 recording or otherwise),
 without the prior written
 permission of both the
 copyright owner and the
 above publisher of this book

With all my love, for Loekie

You challenged me to write this book, then made it
possible for me to get it done, with just the right kind
of encouragement to push ahead and just the right
kind of criticism to keep me from running away with
myself. Your loving attention, idea by idea and word
by word, was more reward than anyone can hope to
reap from his work.

'ALL' OF REMBRANDT'S PAINTINGS

Here an attempt is made for the first time to illustrate in colour all of Rembrandt's paintings. The undertaking is beset with some basic difficulties. First, there is the well-known disagreement among scholars concerning the authenticity of many paintings under Rembrandt's name. And there is the circumstance that quite a few paintings thought to be by Rembrandt have fallen into the hands of owners who keep them hidden away.

The 348 paintings by Rembrandt illustrated here can justifiably be called 'all accessible paintings.' Among them are all of the works from 1625–1631 regarded by the Rembrandt Research Project as unquestionably or conceivably authentic. For the later paintings, concerning which the Rembrandt Research Project, at the time of writing, has not yet published its findings, I have followed the lead of Horst Gerson's revised Rembrandt corpus of 1968 and 1969. Two paintings of this period which Gerson rejected have been included:

Bellona (fig. 117) and, with reservations, *Saul and David* (fig. 369).

Sixty-two of the paintings included by Gerson are not illustrated or discussed here. Among them are twenty-three that Gerson himself doubted in his notes and two that have since been rejected as Rembrandts by the museums which own them. Most of the remaining group are unavailable for study or photography. Nearly all of them are heads or half-lengths, not very different from paintings that *are* included. Two are landscapes, and only one a history painting.

On p. 380, the reader will find a concordance in which all the paintings accepted by Gerson in 1968 are listed. The works which have been omitted here and those doubted by the present author are identified in a separate column.

DUTCH NAMES AND TERMS

NAMES | Most Dutchmen, in the seventeenth century, called themselves by first name and patronymic. The suffix of the patronymic was usually abbreviated in writing and in speech: *sz.* for men and *dr.* for women. Claes Pietersz., for example, was Claes (short for the more formal Nicolaes), the son of Pieter, or Pieterszoon, spelled Pietersz. This individual also had a surname, which he probably took from the name of his father's house, In de Tulp (In the Tulip). He was therefore also known by the more modern-sounding name Nicolaes Tulp. Patronymics never stood alone. One could call Tulp Dr. Claes Pietersz., but not Dr. Pietersz.

Women had patronymics ending *dr.* for *dochter* (daughter). If a Dutchwoman used a surname, it was that of her father, even if she was married. In the southern Netherlands women used their husbands' surnames.

The extremely varied spellings of names in old sources and documents have been standardized throughout the book.

TITLES | The title *stadhouder* or stadholder, held by the highest official in the Dutch Republic, derives from an office in the former Burgundian Empire. Originally, the stadholder was the monarch's lieutenant, exercising power in his name. With the birth of the Republic, the title was maintained, although the monarchy behind it was no more.

The Amsterdam town government consisted of four *burgemeesters* (burgomasters), eight *schepenen* (aldermen) and thirty-six *vroedschappen* (councilmen). Council seats were held for life, while burgomasters and aldermen were elected for terms of one year.

Above the official posts, there was a dignity known as the *magnificat*, the holder of which exercised arbitrary power over all the members of the city government, particularly those in his own clan. During Rembrandt's period of residence in Amsterdam, the *magnificat* changed hands only twice.

For simplicity's sake, I have used the English 'alderman' for Dutch *schepen*, although the latter office is more like a magistracy. That term had to be avoided because of its indiscriminate application, in Dutch, to offices of all kinds.

The word *regent* I have used unchanged for the families of persons who served as burgomaster, alderman or councilman in a town government. The regents were the most powerful, and in general the wealthiest, members of the patrician class.

CURRENCY | The guilder was divided into twenty *stuivers*, and the *stuiver* into eight *duiten*. For larger transactions, the Flemish pound, worth six guilders, was often employed. One guilder was about a day's wage for an unskilled worker. Skilled workers and shopowners earned between five hundred and one thousand guilders a year, which was also the range of price for a modest house.

TYPES OF PAINTINGS | For the common Dutch designation *tronie*, I have used the word 'face-painting.' In general, this refers to a painting of head or head-and-shoulders format portraying a studio model rather than a paying sitter.

A frequently used term that may be unfamiliar to the reader is 'history painting.' This refers to all paintings of Biblical and mythological as well as historical and allegorical subjects, a specialty which was considered the most demanding and praiseworthy branch of art in Rembrandt's time.

Contents

Preface

'Needless to say, the final objective is a reconstruction and synthesis of the ideas behind the work of art. But without the foundation of historical facts and the framework of social environment, everything remains up in the clouds, and we will never succeed in integrating the work of art and the artist into real life as Rembrandt and his contemporaries knew it.'

J.G. van Gelder, 1970

In view of the vastness of the literature on Rembrandt, the above motto should surprise the reader. With so much attention lavished on every small aspect of his life and work, with so many books on 'Rembrandt and his world' on the library shelves, could the late J.G. van Gelder have been correct in characterizing Rembrandt scholarship as 'up in the clouds'? When I re-read his words after many years, as this book was nearing completion, I agreed with him nonetheless. The final, vital link between Rembrandt's work and the people for whom it had been made was still missing. The other connections between Rembrandt and Dutch society as a whole are certainly important, but his niche within that society had not yet been closely defined. It came as a pleasant shock to realize that my work in progress came close to fitting van Gelder's bill.

I can think of a number of reasons why no earlier attempt had been made to identify the exact milieu for which Rembrandt created his works. Most historians of Dutch art see as their essential task the direct confrontation with the work of art itself. The study of historical or social circumstances may sometimes be of aid to them in that task, or may be so compelling as to be unavoidable. But to set out to integrate art into daily life would be seen as a dilution of the central value of art history as a discipline.

With regard to Rembrandt in particular, there are good reasons for sticking strictly to this attitude. Whereas the biographer of Rubens, for example, can write with pleasure of his hero's successes, his place and that of his works in the courts of Europe, the Rembrandt scholar who attempts to integrate art and life faces a series of historical embarrassments. In 1961, R.W. Scheller summed up the history of the question thus:

'The general judgment on Rembrandt in the Age of Reason is that of a libertine, an outcast, whose great promises remained in the end unfulfilled by his steady refusal to come to terms with the precepts of an academic culture, and by his uncivilized character.

'This opinion is thoroughly revised in the Age of Romanticism, mainly under the influence of the cult of genius. Many anecdotes are re-evaluated in a positive sense. Rembrandt is hailed as a revolutionary, as a champion of Protestantism and of the bourgeoisie. He appears as the opposite of the Catholic courtier Rubens. In Holland he is whitewashed of all his faults in order to elevate him to be a national hero. The result of this movement is the erection of a statue to Rembrandt in Amsterdam in 1852...

'The anecdotes die a hard death; many of them are still preserved in later biographies. But art history does no need them any more; in 1854 Kolloff publishes an article on Rembrandt where he states explicitly an axiom of the later art history; for the knowledge of an artist the main source must not be the stories of his life, but the works of his hand.'

Kolloff's dictum, which is indeed still an axiom of art history, saves the Rembrandt scholar from having to take those two ghosts seriously: Rembrandt the misfit and Rembrandt the revolutionary. As a result, neither of the ghosts has been laid, and we still encounter them in schoolbooks, tourist literature and the Great Soviet Encyclopedia. In recent writing on Rembrandt, we are presented with a dry, impersonal figure whose foremost characteristics are negative: he was not the child of a poor family, not a spendthrift, not the

misunderstood genius. The *Nightwatch* was not rejected, and the artist did not die a pauper.

Another reason why art history has segregated Rembrandt's art from his life is that the documentary materials seem so uninteresting. The Amsterdam archives have turned up a unique wealth of documents on Rembrandt, but of a kind that seems disappointing to the art historian. No memoirs or diaries of artists or art-lovers, no minutes of academies, barely any correspondence between patrons and painters. Instead, there are inventories of art collections mentioning unidentifiable paintings by Rembrandt and notarial statements concerning his financial and legal affairs. Their disappointment in the quality of this material has led art historians to neglect the contribution of the archivists. The same handful of long-known documents concerning known works, or those with important biographical information, are always cited, while the hundreds of others are left unused in the pages of antiquarian journals.

If one wishes to discuss Rembrandt's life and art as a whole, the first thing to do is close the rift between the documents and the works. That has been part of my aim in this book. Rather than picking daintily at the Rembrandt documents, I have attempted to extract the maximum amount of information from them, even if that information does not seem at first sight to add to our knowledge of Rembrandt's art.

The most surprising results, initially, concerned not the direct ties between Rembrandt and those around him, but the links between third parties. The frustrating formlessness of Rembrandt's world began to be dispelled as the common family, religious and political ties between his patrons came to light. The unsuspected revelations the documents contain concern not the aesthetic ideas of Rembrandt's world, but its social dynamics.

The importance of this kind of information is not acknowledged by all art historians, even those interested in the place of art in society. According to the generally accepted view, the vast majority of Dutch seventeenth-century paintings, apart from portraits, was made for the open market. This implies that the early ownership of a painting can only be of secondary importance, conveying information concerning the customers who happened to be attracted to a particular artist, but not about the genesis of the works themselves.

In the case of Rembrandt, there is, however, little reason to suppose that most of his history paintings were made for stock. Those he did keep, or sold to dealers for the open market, tended to have easy-to-sell subjects like the Virgin and Child or the Passion of Christ. The majority of Rembrandt's history paintings depict far more specialized subjects, the potential market for which was quite limited. The first known owners of paintings of this kind were, virtually without exception, Dutch or German princes or Amsterdam patricians. The assumption that the paintings were made on commission has more to be said for it than the traditional view. What makes it possible to study this phenomenon even without documented commissions is that Rembrandt's patrons acted less as individuals than as members of a group. Few of them were devotees of the arts, and even those who were, were mainly concerned with establishing and extending the power and wealth of themselves and their families. All were enmeshed in large clan groupings known as *maagschappen*, and their fates were tied to those of their relatives, near and far. Few aspects of their lives did not reflect clan politics in one way or another, and there is no reason to suppose that their patronage of the arts was an exception.

The notion that Dutch painting of the seventeenth century was produced by small independent specialists has been so pervasive for so long, that there is no secondary literature on the subject of patronage. And in the field of history, kinship politics has been ignored for eighty years. This put me at a disadvantage in trying to reconstruct Rembrandt's career as I now saw it. On the other hand, the very lack of scholarship on the subject increased the sense of adventure. The shift in my point of view opened up possibilities for describing Rembrandt's life, from beginning to end, in much more concrete terms than before. It also created new opportunities to judge the significance and function of many of his paintings. Searching for interpretations of Rembrandt's many paintings of unknown subjects, I found myself looking, not at iconographical tradition, but at the interests of Rembrandt's patrons of a particular period. I developed different expectations of what type of evidence was relevant, what kind of conclusions plausible. And underlying them was a different conception of Rembrandt as an artist. I began to see him less as the independent author of artistic and spiritual creations which he offered for sale to those customers who responded to them, but more as an artistic interpreter of the literary, cultural and religious ideas of a fairly fixed group of patrons.

This is not a small issue. It implies that the scope available to Rembrandt for the exercise of his artistic imagination was much smaller than has been assumed. It also reduces the possibilities open to the scholar seeking to understand Rembrandt's works. Finally, if this approach proves fruitful for

Rembrandt, it may be so for other artists as well.

Assigning to 'the stories of Rembrandt's life' as much importance as to 'the works of his hand' brings another welcome benefit. It helps us to sidestep the conceptual chaos of Rembrandt connoisseurship. The reader is no doubt aware that there is barely a drawing or painting in existence the attribution of which to Rembrandt has never been questioned, and that even today many hundreds of works are disputed. Rembrandt studies are bedevilled by a cruel paradox. Whereas Rembrandt himself is considered as unique an artist as ever lived, his individual works are so lacking in uniqueness that they are constantly being assigned to other hands. My own conviction is that this paradox follows directly from Rembrandt's ways of painting, teaching, collaborating and selling his works, and that it is, therefore, an inextricable aspect of his personality. In my view, it is of much greater historical importance to know whether – and for whom – Rembrandt painted or inspired the painting of a particular composition at a particular moment in his career, than to know whether this or that existing canvas is by the master's own hand.

This attitude is at odds with the prevailing one. Rembrandt studies have been dominated for a century by the search for authenticity. The most ambitious campaign of study ever devoted to Rembrandt is the one launched in 1968 by the Rembrandt Research Project of Amsterdam, whose doings are the object of worried scrutiny in the art world. The main effort of the five-man team is to judge the current attributions and interpretations more critically and systematically than their predecessors, in the conviction that this will enable them to arrive at a reasonably unequivocal corpus of the paintings. So far, they have published one volume, covering the works of the years 1625-1631. In it, they apply such refined attribution criteria that the difference between an authentic Rembrandt and a non-Rembrandt is often reduced to infinitesimal subtleties. They leave one wondering what exactly is being measured, and what significance can be attached to their findings.

Volume I of their *Corpus* has strengthened my belief that a head-on attack on the authenticity and iconography of Rembrandt's paintings, one by one, distorts the historical problems presented by Rembrandt and his circle.

With the 'works of his hand' being such a slippery article, a rich admixture of history and society can only be of benefit to Rembrandt studies. For all the well-known impossibility of true objectiveness, the art historian who studies Rembrandt's paintings in their social context, I believe, has a better chance of understanding them than he who treats them as isolated problems in connoisseurship and iconography.

How successful I have been in reconstructing that context, and in placing Rembrandt's paintings in it, will have to be judged by others. My fondest hope is that my attempt, whatever its shortcomings, would have pleased van Gelder.

ACKNOWLEDGMENTS | In the text and notes I have acknowledged many specific borrowings from other writers. A debt that needs more emphatic acknowledgment is owed to two associates of the Amsterdam municipal archives whose work over the years has furnished much of the material: Dr. I.H. van Eeghen and S.A.C. Dudok van Heel. Miss van Eeghen has published hundreds of finds concerning the early ownership of works by Rembrandt and facts concerning him, his patrons and particularly his portrait sitters. Mr. Dudok van Heel has cast his net wider, and has reconstructed some of the specific milieus in which the artist worked: the Amsterdam Mennonites, the circle around Joannes Wtenbogaert, the patronage of the Hinlopens and de Graeffs. He has demonstrated an enviable talent for putting his finger on essential but neglected figures in Rembrandt's world. Insofar as I have been able to write a continuous account of Rembrandt's career, it is largely thanks to the local connections he and Miss van Eeghen have been finding in the past decades. I owe him, in addition, my warm thanks for his unfailing interest in my work and his guidance through the labyrinth of the Amsterdam archives.

The approach I have taken was inspired in part by discussions on completely different subjects than Rembrandt with three scholars whose works I have been privileged to publish: Henk van Os, Ed Taverne and Wim Vroom.

J. Bruyn provided me with help and encouragement at the frightening moment when the first chapters were in draft. Apart from him and Dudok van Heel, others who read the first few chapters in manuscript and from whose advice I benefited are Rudi Ekkart, Bob Haak and Jonathan Israel. P. Tuynman of the Instituut voor Neolatijn of the University of Amsterdam was invariably generous with his time and criticism in matters concerning Scriverius and Huygens. The need to meet a tight deadline kept me from submitting more of the book for their scrutiny, and I can only hope that the mistakes from which they would have saved me will not turn out to be too serious.

Yet I cannot resent that deadline. Not only was it a necessity for completing a project such as this, in

this case it was also dictated by compelling circumstances. The first Dutch edition was honoured to be chosen as the main selection of the book club Nederlandse Lezerskring Boek en Plaat, which, of course, entailed a firm delivery date set long in advance. The opportunity to offer the book to the reader in this beautiful form for such a reasonable price was made possible by the large financial commitments by Boek en Plaat and Koninklijke Smeets Offset, the publisher as well as printer. Govert Eggink, Francis Mildner, Hans van Hattum and Hans van den Broek shared with me the belief that the unprecedented number of colour illustrations and the mass of details and new viewpoints in this book would be appreciated by a large readership.

The acquisition of the illustrations and the rights, a painstaking and frustrating job, was accomplished in masterly fashion by Viviane Hendrick. In her name as well, I wish to thank the owners of paintings made available in the form of colour transparencies and photographs.

Editing, lithography and printing were monitored with great ability by Vera Pokorny, acting as publisher within the Smeets organisation. To them and their colleagues at the printing works in Weert, I wish to express my gratitude for their exceptional dedication to the book, and admiration for the quality of their work.

The handsome and clear design of this volume, in which so much had to be fitted into so few pages, was the work of Ton Ellemers.

Mr. J.M. de Baar of the Leiden municipal archives contributed the genealogical charts of Rembrandt's family, and filled in the spots in the map of Leiden which are of interest in Rembrandt's early history.

My greatest thanks are reserved for Loekie Schwartz, to whom this book is dedicated. Her translation of my English manuscript into Dutch gave rise to discussions that added immeasurably to the form and content of the text. An original contribution of her own are the translations from the Latin, especially the notoriously difficult Latin of Huygens.

Others whose interest and help I can acknowledge here only be mentioning their names with heartfelt gratitude are Jeremy Bangs, Thom Beek, Egbert Haverkamp Begemann, Albert Blankert, Beatrijs Brenninkmeyer-de Rooij, Ben Broos, Christopher Brown, Robert Cahn, A.T. van Deursen, Henk Dijkstra, Frits Duparc, Jan Piet Filedt Kok, David Freedberg, Marlies Groen, Koert van der Horst, Eddy de Jongh, J.F. Korthals Altes, Mary Lewis, Walter Liedtke, George Möller, Alje Olthof, Jules Rotteveel Mansveld, Simon Schama, Nicolette Sluijter-Seijffert, Wim Smit, H. von Sonnenburg, Astrid and Christian Tümpel, J.A.G. and E.T. van der Veer, Karel Waterman, Ernst van de Wetering, Arthur Wheelock, B. Woelderink, M.L. Wurfbain, the staffs of the Gemeentearchief Amsterdam, the Rijksarchief Utrecht, the Gemeentearchief Leiden, the Algemeen Rijksarchief, The Hague, the Archives Municipal, Avignon, the university libraries of Utrecht, Amsterdam and Leiden, the Kunsthistorisch Instituut Utrecht, the Rijksbureau voor Kunsthistorische Documentatie, Teylers Museum and the Rijksprentenkabinet Amsterdam.

The research and writing of this book have brought back piercing memories of friends made through Rembrandt who died too soon – Horst Gerson, J.G. van Gelder, Jan Emmens, Willem Bloemena, Keith Roberts and Heinz Norden – and of Anne.

Maarssen, July 1984

The Preface, though not the Acknowledgments, was re-written for the English edition, which contains numerous other, minor changes from the first, Dutch, printing. The English version benefitted greatly from the critical editorial work of James Evans.

Maarssen, July 1985

The Netherlands in the early seventeenth century

The country of Rembrandt's birth was the Republic of the United Netherlands. The name is less self-explanatory than it seems. Even to call it a 'country' is to suggest to the modern reader that it was more self-aware and independent than it actually was. When Rembrandt was born in 1606, its status and borders were both disputed, and it balanced on the edge of violent internal conflict.

Political history is not of great importance in the life of every man, certainly not of every artist. But Rembrandt, to a greater degree than is generally realised, was deeply influenced by the history *and* the politics of his country. In order to understand Rembrandt's path from private patronage in Leiden to the court in The Hague and then to the patricians in Amsterdam, it helps to know something about his political surroundings. What were the Netherlands, what was the Union, and what the Republic?

THE NETHERLANDS | What was understood by 'The Netherlands' in 1600 was something completely different from today's Kingdom of the Netherlands, with its homogeneous population of Dutch speakers, its constitutional monarchy and its uniform landscape. The Netherlands of 1600 was far bigger and more varied, extending from German East Frisia through all of present-day Holland, Belgium and Luxembourg to a large piece of north-east France. To Shakespeare, 'the lowlands' was synonymous with 'Burgundy.' These territories may never have been one country, but in the fifteenth and sixteenth centuries they had all belonged to the same person – first the dukes of Burgundy, then the Hapsburg emperors, Maximilian and Charles V, then Charles's son Philip II, king of Spain, duke of Brabant and count of Holland.

In England and France, the old fiefdoms such as those that made up Burgundy were gradually amalgamated into national states. The same process began to take place in the Netherlands, centred around the French-speaking court of Brabant in Brussels, but it failed. The dukes of Burgundy and the Hapsburgs were unable to untangle the Gordian knot of established rights and privileges that made the lowlands an administrative nightmare. Philip II, in addition, attempted to re-establish the exclusivity of the Catholic religion in his territories by repressing the Reformation. He had a heavy hand, and before long the whole country was against him: the nobility for undermining their position as feudal lords, the cities for imposing onerous taxes, the peasants for his unrealistic programme of land reform, and the entire population for the religious persecution carried out by the 'Bloody' duke of Alva. The tensions this created were the direct cause of the Eighty Years War and the division of the Netherlands into north and south.

THE UNION | On January 23, 1579, a minority of the seventeen Netherlandish provinces – those in the north of the lowlands – signed articles of confederation called the Union of Utrecht, after the city where the representatives met that day. The date is still accepted by the textbooks, a bit uneasily, as the founding moment of the Dutch state. Yet January 23rd goes by each year without raising anyone's temperature enough to hang out the flag. The event was too much of a board meeting to fire the imagination, even in retrospect. The real process of Dutch emancipation was more heroic than that, but also more diffuse and paradoxical. It was often hard to say who was the main instigator. Now the landed nobility was in the lead, then the cities, now the aristocracy, then the gentry, now the southern provinces, then the northern. Some Netherlanders were fighting for religious freedom, others for political liberty, still others for the right to do business as they pleased. At the successful end of the conflict, each group of victors had its own notion of what had been won. Militarily, the war was never an all-out effort by either side. Fighting was sporadic and local, but no less terrible for that, with much of

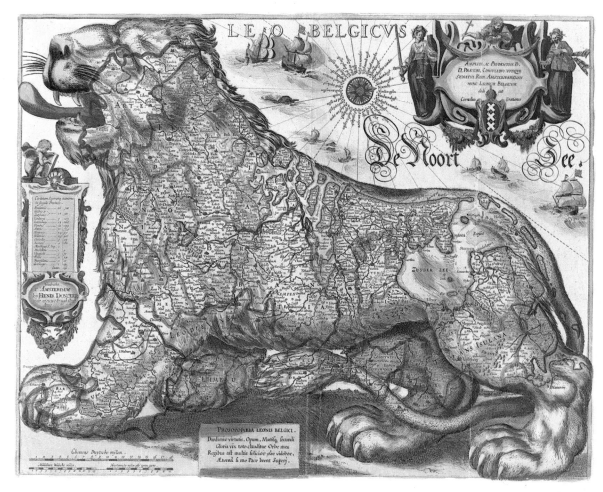

1 *Leo Belgicus: the seventeen provinces in the form of a lion.* Mid-seventeenth-century edition by Hendrick Donker (1625-1699) of a map originally published by Cornelis Jansz. Visscher in 1611, based on sixteenth-century examples by Petrus Kaerius. Hand-coloured engraving, 44 x 56.5 cm. Amsterdam, University Library.

National consciousness in the Netherlands was not always synonymous with political patriotism. Until well after the end of the Eighty Years War, Dutch publishers continued to bring out maps such as this one, which do not even indicate the boundary between the Dutch Republic and the Spanish Netherlands. The seventeen provinces, which had never been independent state, are given the proud form of a standing lion. The Netherlands was more of a concept than a country.

The cities of Rembrandt's career – Leiden, The Hague and Amsterdam – lie within a few hours' distance of each other in the province of Holland. On the map, they are three red dots pointing from the beast's loin towards his upper haunch. Saskia's Leeuwarden is on the lion's buttock.

it waged by underpaid mercenaries against civilian populations. In 1574 the unsuccessful siege of Leiden and two years later the 'Spanish Fury' in Antwerp cost many thousands of lives.

At the start of the Eighty Years War the 'rebels' maintained for a long time that they were loyal subjects of the king, fighting only because their liege lord was failing to keep up his end of agreements they had made with his father and grandfather. To this day, the Dutch national anthem, composed around 1570, contains a sanctimonious pledge of allegiance to the king of Spain. Not until 1581 did the States-General, after moving from Brussels to The Hague, abjure Philip as lord of the Netherlands.

Whether or not Philip forfeited his sovereignty over the Dutch, he certainly broke the emotional bond between prince and people, which little by little was transferred to William, prince of Orange and count of Nassau. It was the great good fortune of the Netherlanders that William, the king's stadholder, the highest noble in their lands and one of the richest men in Europe, could be recruited for their cause. His assassination by an agent of Philip's in 1584 put the seal on his image as father of his country. William the Silent and his descendants owe more to hero worship than to any of the contracts, hedged about with provisos, that successive Orange

stadholders and kings have been able to conclude with the provinces, the Republic and, in the nineteenth century, the Kingdom of the Netherlands.

The signatories of the Union of Utrecht managed to wrest themselves and part of North Brabant free from Spain, but the former heart of the country, in the present Belgium, had been retaken. The sons and successors of William the Silent, Maurits and Frederik Hendrik, were eager to recapture the south, where they still owned land, but Amsterdam no longer thought that was a good idea. The risk of losing a new campaign did not worry them as much as the possibility of winning. The border between north and south may have been nothing more than a frozen battle line, but once it was there, Amsterdam was not slow in seeing its advantages. Antwerp, which in the sixteenth century had been the trade capital of Europe, could be kept under blockade indefinitely. A nation consisting of the northern provinces alone, moreover, was a nation Amsterdam could dominate. Without money from Amsterdam, the States army had no hope of retaking the south, and it never got the money.

THE REPUBLIC | The make-up of the new country is fascinating to contemplate. The duchy of

Gelderland, the counties of Holland and Zeeland, the seignories of Groningen and Overijssel and the bishop's see of Utrecht had become equal partners, as provinces, in a joint political venture. Their equality, however, was tempered by the insistence of each province on its old feudal rights and by the fact that Holland, by far the richest partner, was more equal than the others. The States General, the closest approximation to a national assembly, derived its authority from the States of each province, which were all constituted slightly differently. In Utrecht, for example, a college of Calvinist clergy had a vote in the provincial States, in the inland provinces the nobles still held real power, and in Groningen and Friesland the peasants too were represented.

The other main offices and organs in the Republic were the Council of State, the pensionary (actually the secretary of the Holland delegation to the States General), the five admiralties, the Court of Holland, the provincial and municipal courts throughout the country, the city governments and the stadholder. For all the care that was bestowed on protocol, the limits of these offices and of the States were bounded only by what their incumbents could get away with, and sometimes not even by that. Decisions came to pass, if at all, in a perennial round of swaps and deals, some implicit, some committed shamelessly to paper.

Although the Dutch did not feel the lack of a central government, they did miss the old bond of common allegiance to a single lord. When Philip's rule was renounced in 1581, the States looked for candidates to assume all or some sovereignty over all or some of their lands. Their efforts failed, and around 1590, they began, by default, to call the United Provinces a 'republic,' a name borrowed from ancient Rome, with overtones of the Italian city-states. The institution of the Republic left the state exactly the same as it was before: a patchwork of overlapping powers, the most paradoxical of which was that of the stadholder, a deputy 'taking the place of nobody' (Huizinga). The stadholders of the House of Orange may not have had very far-reaching political rights at this stage, but to many Dutchmen, as the States General and the regents of Amsterdam knew, they were the most charismatic men in the country, and practically kings.

RELIGION | The revolt also marked a watershed in the religious history of Holland. In 1560 virtually all government posts in the land were filled by Catholics, in 1600 by Protestants. About half the · population of the northern Netherlands was still Catholic; the rest were Lutherans, Calvinists, Anabaptists, Mennonites or adherents of smaller Protestant denominations. Each of the communities was subdivided, generally into factions we would instinctively call right or left. Outside the hard dogmatic core of each party, however, most people in those confused times, no matter what their church, tended towards a middle-of-the-road religiousness with elements of all the prevailing religions, in varying mixtures. Humanists like Desiderius Erasmus and Dirck Volckertsz. Coornhert gave written expression to such bland Christian feelings, and William of Orange, born a Catholic, friend of the Lutherans, converted to Calvinism, would have liked everyone in the country to be as broad-minded about religion as he was.

Philip II, on the other hand, was not interested, when it came to faith, in right and left or north and south. For him every departure from the straight and narrow path, as the Council of Trent had mapped it out for the modern Catholic, was heresy. The Catholics, who were the sole winners on their side of the border, were able to re-establish the exclusivity of their faith. In the northern provinces, no one group was in a position to impose its cult on the rest of the country, although the Calvinists would have liked to. They controlled the established church and the theological faculties of the universities, and disputed the right of many local secular governments to rule without them.

In Holland, the seventeenth-century aftermath of the religious struggle of the sixteenth was not a mopping-up operation against the remnants of Catholicism. Nor was it a fresh outbreak of Reformation radicalism. It was a split within the close ranks of Calvinism, over the minutest issues for which people ever killed. What began in the first decade of the century as a disagreement between two Leiden theologians over whether man was damned before the creation of the world (Franciscus Gomarus) or after it (Jacobus Arminius) reached a climax in 1619 with the execution of the pensionary, Johan van Oldenbarnevelt, and near civil war. It was not just dogma that brought things to that pass. Once sides had been drawn up, the Arminians and Gomarists (they were also called the Remonstrants and Counter-Remonstrants) began taking opposite sides in all the new religious and political controversies that came along, while the antagonists in assorted, older conflicts now gravitated to opposing camps in the new battle lines. The Counter-Remonstrants were supported by the established church, with the result that the Dutch Catholics and the disenfranchised Protestants of smaller cults were driven into the arms of the Remonstrants.

The most explosive of the issues dividing the two parties was that of war or peace. In 1609 the first phase of the Eighty Years War came to a formal close with the signing of a truce with Spain for twelve years. The initial reaction was one of triumph and relief, but soon enough the debate began over whether or not to resume the fighting in 1621. The Remonstrants, who were more conciliatory and tolerant than their opponents all along the line, came out for peace. Among the Counter-Remonstrants were many refugees from the southern Netherlands driven out by the Spanish for religious reasons, and they were living for the day they could return to their homeland behind a conquering army of the States General and impose a Calvinist regime on the cities of Flanders and Brabant. The sides were so evenly matched that the decision was left up to the last one to cast his vote – the stadholder, Prince Maurits. When he tilted towards the Counter-Remonstrants in 1617, the issue was decided. Maurits used force to depose the more combative Remonstrants in city government, as in Leiden and Utrecht, and lent his support to the national synod held in Dordrecht in 1618-1619, which was dominated by the Counter-Remonstrants and ended by condemning their opponents.

The Remonstrant leaders were persecuted. Johannes Wtenbogaert, who had been Maurits's tutor and court chaplain, fled the country, Hugo de Groot (Grotius) was sentenced to life imprisonment (he escaped in 1621) and Johan van Oldenbarnevelt was beheaded. The disturbances stopped just short of civil war. As the last outbreak of internal violence in the Republic until the stadholder attacked Amsterdam in 1650, the events of 1618 and 1619 remained fresh in the memory of many Dutchmen until mid-century. The fanaticism itself did not last long. Frederik Hendrik, who succeeded Maurits in 1625, was a more subtle man, who dealt with all parties, even Catholics, with a minimum of prejudice. Around the same time, the 'libertine' regents, who favoured an effective separation of church and state, gained the upper hand in the large cities, especially Amsterdam. This group tended to be tolerant of anything that was good for business.

These were some of the brutal checks and balances in the early Republic. There was a cleft between the form and function of the body politic that sometimes made it hard to locate the roots of power, opening the way to corruption and favouritism, just as in the other countries of Europe. Those who had to deal with the system, as participants, as outside agents or as dependants, all learned one basic truth: the Dutch state was a respecter of persons.

Leiden

On October 3, 1942, the Dutch historian Johan Huizinga addressed his fellow internees at the camp of Sint Michielsgestel. His audience consisted of Dutch intellectuals who were being held hostage by the Germans. The subject of his talk was 'The relief of Leiden.' On that day 368 years earlier the Spanish siege of Leiden, the most traumatic episode of the Eighty Years War for the northern Netherlands, had been lifted. The siege had been going on for four and a half months, and a full third of the inhabitants had died of hunger and disease. Resistance had been about to collapse, and if it had, the Spaniards would have cleaved Holland in two and crushed the rebellion for good. The last rations were almost gone when the rebels broke the dykes and breached the Spanish lines in boats, blown by storm winds over the inundated polders. The land had been devastated but the country was saved. Huizinga did not have to draw a moral for his listeners. They knew it would take the same courage and sacrifice to drive out the Germans, and that the lives of hostages like themselves might have to be forfeited in the struggle. In closing, he asked them to sing with him a song of the rebellion that compared Leiden to Jerusalem, saved by God from Sennacherib's army.

From 1574 on Leiden was a byword to the Dutch for perseverance, bravery and victory. October 3rd is still celebrated in the city with white bread and herring, the breakfast of the survivors of 1574.

Within months of the end of the siege, upon the proposal of William of Orange, Leiden became the seat of the first Protestant university in the Netherlands. The humanist Jan van der Does, governor of Leiden and one of the main opponents of capitulation during the siege, was appointed dean. Leiden never forgot that its university was born out of blood. It was called an academy, but with none of the belittling overtones that often cling to things academic. Even the curriculum was heroic. Classics, theology, law, medicine, engineering – in Leiden they were treated as matters of national importance.

And international. Leiden soon became a leading European centre of learning. The community of scholars and the thousands of Flemish and Walloon refugees from the southern Netherlands, many of them cultivated people, gave Leiden a sophistication it never had before the war. Most of the newcomers were Protestants.

The traditional mainstay of the Leiden economy was the manufacture of textiles. In the third quarter of the sixteenth century the industry, after a gradual decline, had been practically wiped out, and when the rebellion began Leiden was an impoverished city. After the siege, it recruited skilled textile workers from the southern Netherlands and manoeuvred itself into position to take advantage of a new period of growth.

When Rembrandt was born, Leiden was still the walled medieval town it was in 1400, with a population of about 17,000 living in 5,000 houses. An attractive new extension was added in the 1610s, but the planners could not keep up with the demands of the boom. Speculators split houses into the smallest possible units, and those unable to pay the rent even for those cramped quarters were forced to put up huts illegally outside the walls. By 1625, when Rembrandt began his career as an artist, there were 45,000 Leideners – four times as many as in 1574 – living in not quite 7,000 houses. Around the time the artist moved to Amsterdam, his home town was desperate again. In the winter of 1633, nearly half the population was on relief. Leiden had become the second largest city in the country after Amsterdam, but it had grown beyond its strength, and was not to recover economic health during Rembrandt's life.

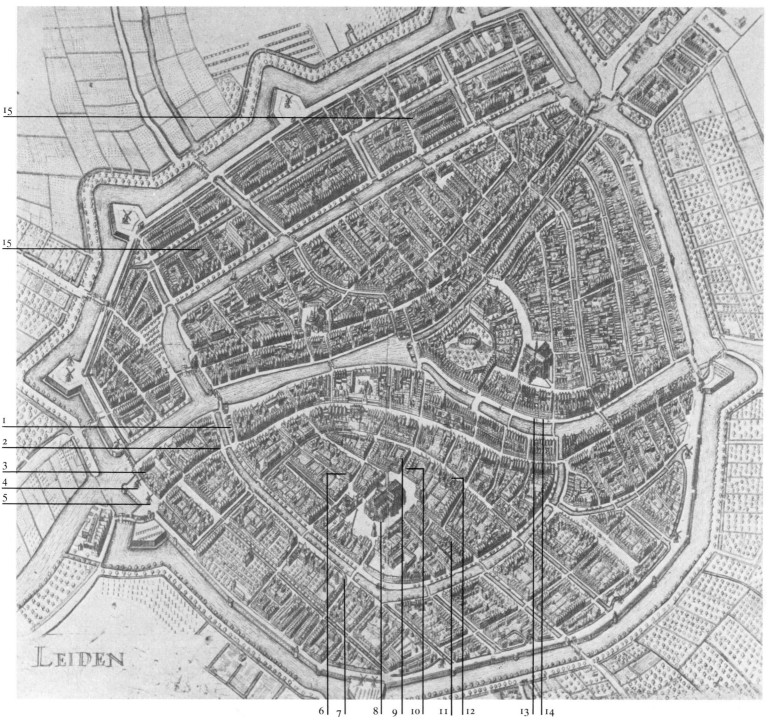

15

15

1
2
3
4
5

LEIDEN

6 7 8 9 10 11 12 13 14

2 *Proof of the map of Leiden published by Joan Blaeuw in 1633*

1 The home of Gerrit Dou in the Korte Rapenburg.

2 The inn, The Arms of France, and the family home of Isaac Jouderville, in the Noordeinde.

3 Rembrandt's paternal home in the former Weddesteeg. The buildings opposite had been demolished in order to improve the fortifications.

4 Windmill partly owned by Rembrandt's paternal grandfather Gerrit Roelofsz. His widow sold her share in 1575 after Gerrit's death.

5 The windmill that Rembrandt's paternal grandmother Lysbeth Harmensdr. bought from Jan van der Does, hero of the siege, and moved to this location on the city walls.

6 The Latin School that Rembrandt attended about 1615-1619, in the Lockhorststeeg.

7 The University of Leiden where Rembrandt was registered in 1621.

8 The Pieterskerk where Rembrandt's parents were married and where they and all their children but Rembrandt were buried, in the family grave beside the pulpit.

9 The home of the Lievens family in the Pieterskerkchoorsteeg.

10 Jan Jansz. Orlers, city official and, as town historian,

author of the earliest biographies of Rembrandt and Lievens, lived across the street from the latter.

11 Hendrick Zwaerdecroon's house in the Nieuwe Steeg, where Joannes Wtenbogaert was a lodger from 1626 to 1631.

12 In 1622, around the time when Rembrandt studied with him, Jacob Isaacsz. van Swanenburg lived here on the Langebrug.

13 Jacob's father Isaac Claesz. van Swanenburg, burgomaster and the leading painter of Leiden for the entire second half of the sixteenth century, lived on the Nieuwe Rijn, the New Rhine.

14 Rembrandt's first patron, Petrus Scriverius, lived two doors from the van Swanenburg house and was a friend of the family.

15 The extension added to Leiden in the 1610s.

3 Rembrandt's family

The family into which Rembrandt was born is
recorded in Leiden from 1484 on. The paternal side
of the family tree shows five generations of millers,
in each of which the oldest son was named for his
father's father. Gerrit Roelofsz. begat Roelof
Gerritsz. and Roelof Gerritsz. begat Gerrit
Roelofsz.

The distaff side, which has been traced back two
generations, was a family of bakers. Rembrandt was
the product of a sensible marriage between the son
of a miller and the daughter of a baker, Harmen
Gerritsz. van Rijn and Neeltgen Willemsdr. van
Zuytbroeck. They were both twenty-one years old
when they married on October 8, 1589. Rembrandt,
the ninth of their ten known children, was born
when they were thirty-eight and practically old
people for those times. The family trees on these
pages show how rare old age was, and how fragile
infancy.

The Reformation was a disaster for Rembrandt's
family. His mother was related to two important
Leiden clans, the van Tethrodes and van Banchems,
most of whose members remained Catholic after
Leiden went Protestant. From then on they were
excluded from public office in the city. As for the
van Rijns – Rembrandt's father was the only one of
his brothers and sisters who left the Catholic church
to become a Calvinist.

Even if Harmen Gerritsz. were a lifelong member
of the official church, Rembrandt would still have
been known as someone whose most important
relatives were Catholics and, therefore, politically
untrustworthy. For a Leiden painter, these family
connections were useless in acquiring official
commissions for portraits and history paintings.

*The family trees on these pages
were compiled for the present
publication by
P.J.M. de Baar of the Leiden
municipal archives*

4 Learning in Leiden: school, studio, the first patron

Nearly everything we know about Rembrandt's early youth is derived from one source, a 350-word biography written by Jan Jansz. Orlers in 1641. Orlers (1570-1646), a bookseller and writer, was the local historian of Leiden, a staunch supporter of Maurits and the author of books in several languages on the military exploits and ancestry of the stadholder. After Maurits took over the Leiden town government by force in 1618, Orlers became a member of the ruling Council of Forty and eventually, in 1631, burgomaster.

In 1614 he published the first edition of his *Beschryvinge der Stadt Leyden* (description of the city of Leiden) a characteristically seventeenth-century mixture of chronicle, guidebook and who's who. At the end of the first part of his book he sketches the lives of the artists who contributed to Leiden's glory.

Orlers was a conscientious writer. He continued to keep track of noteworthy developments in his city, and in 1641 he came out with a much expanded second edition of his *Description*. Among the new matter is the first biography of Rembrandt. 'Rembrandt van Rijn, son of Harmen Gerritsz. van Rijn and Neeltgen Willemsdr. van Zuytbroeck, was born in the city of Leiden on July 15, 1606. His parents sent him to school with the idea of teaching him Latin and then bringing him to the Leiden Academy [University]. That way, when he grew up he could use his knowledge for the service of his city and the benefit of the community at large. But he hadn't the least urge or inclination in that direction, his natural bent being for painting and drawing only. His parents had no choice but to take him out of school and, in accordance with his wishes, apprentice him to a painter who would teach him the basics [of his art]. Once having made up their minds, they brought him to the able painter Jacob Isaacsz. van Swanenburg for training and instruction. He stayed with him for about three years, during which time his great progress

impressed art-lovers tremendously. Everyone was certain that he was going to develop into an outstanding painter. For that reason his father consented to have him taken to the famous painter [Pieter Lastman], who lived in Amsterdam, to receive more advanced and better training and instruction. After about six months with him, he decided to practice painting on his own. He has succeeded so well that by now he has become one of the most famous painters of the century.

Because his art was so well liked and popular among Amsterdamers, and he was requested so often to go there to paint portraits or other paintings, he decided to move from Leiden to Amsterdam. He left here about 1630 and took up residence there, where he is still living now, in 1641.'

REMBRANDT'S SCHOOLING | For the period until 1628, Rembrandt is mentioned in only two documents (as opposed to later sources concerning those years, like Orlers), and one of them seems to contradict the writer. On May 20, 1620, the rector of Leiden University, Reinier de Bondt, entered Rembrandt's name in the registry of matriculated students: 'Rembrandt Harmensz. of Leiden, student of letters, 14 years old, living at home.' It has generally been assumed by the artist's biographers that the entry implies that Rembrandt had completed Latin School, and that Orlers did not mean it when he said that the boy never finished school. However, the only entrance requirement for the university was a working knowledge of Latin, at a level that a pupil of the Leiden Latin School would have reached long before graduation. Matriculation in the university, moreover, did not always mean that one was actually a student, as we shall see. Orlers tells his story so convincingly, and what he tells fits in so well with certain other facts, that there seems to be no reason not to take him at his word: Rembrandt was removed from school before getting his diploma.

To figure out when that happened one has to work backwards. As we shall see below (pp. 40-41), of the four paintings by Pieter Lastman that Rembrandt knew the best, three are dated 1622 and the other 1623. He was familiar with several earlier works by Lastman, but no later ones, leading one to assume that his six months with Lastman began in 1622 and ended in 1623. The only other piece of evidence concerning Rembrandt's years of apprenticeship is the Leiden poll tax register, which lists him as living with his parents on October 18, 1622. Putting together this information and filling it out with what is known about schooling at that time, we arrive at the following chronology:

year	age	
1612-1615	6-9	Rembrandt learns to read and write at a city school
1615-1619	9-13	He attends the Leiden Latin School
1619-1622	13-16	Apprenticeship with Jacob Isaacsz. van Swanenburg
Late autumn 1622-summer 1623	16	Advanced training under Pieter Lastman in Amsterdam
Summer 1623	17	Rembrandt returns to Leiden to set up on his own

The question remains: why was Rembrandt enrolled in Leiden University in May 1620 if he was already working with Swanenburg and had no 'urge or inclination' to go to school? It has been pointed out that registration in the university had certain non-academic advantages, such as the right to buy beer and wine free of excise taxes and exemption from service in the civic guard, the *schutterij*. The latter was an important issue in the family. Rembrandt's father had injured his hands in an accident with a musket around 1610. Requesting on those grounds to be discharged from the guard, he was provisionally relieved of duty on the condition that he pay six guilders a year until one of his sons became a guardsman. This moment came in 1617, when one of them – presumably the oldest, Gerrit – did join. But sometime before 1621 Gerrit too damaged his hands, even more seriously than his father, making him unfit for service and unable to support himself. With Adriaen and Willem, the next two sons, having left home or about to leave, only Cornelis (about whom we know nothing) seems to have stood between Rembrandt and call-up. With

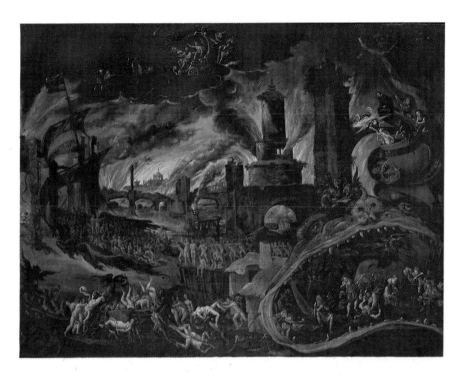

the Twelve Years Truce about to expire, at a time when the Leiden militia had actually to bear arms against a Remonstrant mercenary force, and with his family history of bad luck with muskets, the painter in training had good reason to capitalize on his knowledge of Latin to take a student exemption.

REMBRANDT'S FIRST MASTER AND THE
REMONSTRANT CRISIS | We now know *when* Rembrandt was taken out of school. But *why* would his parents remove him from one of the best secondary schools in the country such a short time before he could have graduated? Orlers was probably not being altogether sincere when he wrote that Rembrandt's parents were obliged to take him out of school only because the boy preferred drawing and painting to studying. The choice of Jacob Isaacsz. van Swanenburg as Rembrandt's first master tells us that more was involved. That Jacob Isaacsz. was a Catholic has been known for a long time. But the implications of that fact, and of the religious affiliation of the rest of his family, have not yet been taken into account in biographies of Rembrandt. Thanks to the publication in 1978 by R.E.O. Ekkart of a family chronicle of the Heemskercks and van Swanenburgs, we now know much more than before about the mysterious Jacob Isaacsz. and his position in Leiden.

On the one hand, the van Swanenburgs were long one of the foremost families in Leiden, with members in the city government, the civil service and the art world. For fifty years, Isaac Claesz. van Swanenburg (1537-1614), Jacob's father, was the

3 Jacob Isaacsz. van Swanenburg (1571-1638), *The sibyl showing Aeneas the underworld* (Virgil, Aeneid, book 6). Date unknown. Panel, 93.5 x 124 cm. Leiden, Stedelijk Museum De Lakenhal.

One of Jacob Isaacsz.'s specialties was scenes of the occult. In Naples, where he worked with a group of painters from northern Europe, he had been called to order by the Inquisition for selling a painting of a witches' sabbath. His other known specialties were scenes from the commedia dell'arte, the Italian street theatre, and views of Rome, including papal pageants. Not many of his works have been identified, and we do not have a clear picture of him as an artist.

This panel is in terribly poor condition and was virtually completely overpainted in the nineteenth century. Before it was placed in the Lakenhal, it was in the town hall of Leiden for as far back as its history can be traced. Could it have been placed there by the artist's brother, Isaac Isaacsz., who was under-secretary of Leiden until his death in 1625?

most important painter in Leiden, thanks less to his talent than to his outstanding access to patronage: from 1576 until his death, Isaac Claesz. had a seat in the town council and served thirteen terms as alderman and five as burgomaster. During that period he executed most of the official commissions for paintings and designed most of the stained glass for the city. Three of his sons became artists and three more secretaries and under-secretary of Leiden. His daughters married major figures in Leiden public life.

On the other hand, the chronicle reveals that the family was nearly completely Remonstrant. As a result, the political influence they still held after the death of Isaac Claesz. came to an end in October 1618 when Prince Maurits deposed the sitting government of Leiden by force and replaced it with a body of Calvinists like Orlers. It was all the van Swanenburgs could do to hold on to their jobs. The remarks in the chronicle concerning Jacob's brother Isaac are very revealing in this regard. Isaac was 'the under-secretary of this city from February 8, 1610 until his illness [in 1625]. He was reliable and punctilious to a fault. After his death all his documents and files were found to be unbelievably neat and well arranged, as Aelbregt van Hoogeveen (his successor as secretary) told me orally. That is why, when the entire town council was removed in 1618, and everyone else suspected of Remonstrant sympathies was fired, he was allowed to keep his job. This was practically a miracle, since most of his brothers and sisters were of that persuasion and he himself did not attend services with the Counter-Remonstrants, let alone partake of communion. He himself said often enough that he expected to be dismissed, but he was allowed to keep his post.'

This passage captures perfectly the gradations of religious-political partisanship in the years after 1618. Those who attended communion in the church were the hard core of the Counter-Remonstrant membership. It was a privilege to be admitted to communion, and this group was kept deliberately small. The rest of the Calvinist faithful demonstrated their adherence to the church by going to all services. Those who did not attend, and were not known as Catholics, Mennonites or Lutherans, were either libertines – non-churchgoers – or Remonstrants, secret members of a forbidden and politically untrustworthy sect. What made the Remonstrants particularly odious – and dangerous – to the Calvinists was that, until 1618, they were part of one and the same church, whose adherents held all the important government posts in the country. Only a small number of those who did not pray with the Calvinists were actually members of the Remonstrant Church, but to the Calvinists this made little difference. Those who were not with them were against them. Members of the other dissenting churches, who were virtually excluded from government, had no choice but to line up with the Remonstrants. The atmosphere in Holland at the end of the Twelve Years Truce was that of a civil cold war.

The purge of pro-Remonstrants in Leiden even extended to the Latin School where Rembrandt was a pupil. In September 1619 the Remonstrant sub-rector Hendrik Zwaerdecroon resigned his position after refusing to take a new oath of office prescribed by the Synod. Zwaerdecroon was to become related by marriage to Rembrandt's family in 1624. If the boy was known in school as a child of untrustworthy elements, his departure may have been forced the same way as Zwaerdecroon's. This is the kind of information that Orlers never mentions in his book.

FROM THE FAMILY CHRONICLE OF WILLEM VAN HEEMSKERCK (1613-1692)

Notes concerning the events and memorable occurrences in the lives of the relatives of both [Willem van Heemskerck and his wife Maria van Swanenburg], gleaned from old records

The birth of Uncle Jacob
April 21, 1571: birth of Jacob Isaacsz. van Swanenburg, second child and first son of Isaac Claesz.

Birth of Uncle Willem
January 29, 1580: birth of Willem van Swanenburg, sixth child and fourth son of Isaac Claesz.

Death of Uncle Willem van Swanenburg
May 31, 1612: death of my wife's father's brother Willem van Swanenburg (after a long illness) between ten and eleven in the morning, with great trust in God's mercy, admonishing his brothers not to live as worldly and vain a life as his, in order not to be excluded from God's kingdom. Yet by human standards he lived a very pious and sober life.
The root of his illness lay in his lungs, and was aggravated at the last with thrush and fever. He was about thirty-two years old, and had been a captain in the town militia since 1605. He had begun to excel in the art of engraving, so that many were saddened that he was carried off at such an early age.

Uncle Jacob van Swanenburg moves here from Italy
On December 21, 1615, being a Wednesday, there arrived in Leiden my wife's father's brother Jacob van Swanenburg, who had been gone for about twenty-four years without having visited home, during which time he was in Italy, where he married Margaretha de Gordon, the daughter of a Naples grocer. He had married her about fifteen years earlier without telling his parents. He had seven children by her, of whom three were still alive at the time, being Maria, Sylvester and Catharina. He had left his wife behind in Naples with her father and mother, who were then still alive.

Uncle Jacob's journey to fetch his wife and children in Italy
On April 4, 1617, he left to bring his wife and children to come and live here.

His return with wife and children
On January 6, 1618, he returned home, bringing his wife and three children, being Maria, fifteen years old, Sylvester, ten, and Catharina, four. He had departed from Naples on October 28, 1617.

Death of Uncle Jacob van Swanenburg
On October 16, 1638, a Thursday, about eight o'clock in the morning, Jacob Isaacsz. van Swanenburg, my wife's father's brother, passed away in the city of Utrecht, where he had been ill for a short time. The envelope of his own letter (which he had written to his wife and children that morning, telling them of his illness and asking some of the children to come to him) reported his passing away, so his family heard simultaneously of his sickness and death, whereupon his sons picked up the body immediately. It was brought here on Saturday evening and buried in the Sint Pieterskerk in grave number 30 with his father and mother.
He was a man of middle height, fair, and with a very good nature. As to his outstanding talent for the art of painting, it is proven clearly by many different works that he painted.

AN ADVANTAGE OF WORKING WITH VAN SWANENBURG | The prominent Isaac Claesz. van Swanenburg would seem to be the kind of painter that Carel van Mander would have liked to boast about in his book on the painters of the Netherlands (see p. 46). Curiously, however, he is mentioned only in the Appendix, as the teacher of a painter to whom van Mander does dedicate a section of his own – Otto van Veen (1556-1629). The van Veens were the second family of Leiden artist-politicians and they were related to the van Swanenburgs.

The combination of art and politics was practiced by the van Veens at an even higher level. Otto lived in Antwerp but maintained lively contact with the north through his brother Pieter, pensionary of Leiden and The Hague, and a respected painter in his own right (see p. 95). In 1612 Pieter sold to the States General a series of twelve paintings by his brother depicting the Batavian revolt against the Romans, an open allegorical glorification of the Dutch revolt against Spain. It is also worth mentioning that in 1618 Otto performed a valuable service for the stadholder; after the death of Maurits's brother Philips Willem, van Veen appraised the paintings in the captive family palace in Brussels.

CONNECTIONS WITH RUBENS | The greatest achievement in the combined area of art and politics in the Netherlands was reserved for a pupil of Otto van Veen's in Antwerp, the painter-diplomat Peter Paul Rubens (1577-1640). Rubens did not come from a family of nobodies – his father had a high position at the court of the stadholder before north and south were split (and before he was sent to jail for committing adultery with the wife of William the Silent). After his apprenticeship with Otto van Veen and a decade of youthful success in Italy and Spain between 1600 and 1609, Rubens settled in Antwerp and became court painter to the regents of the southern Netherlands, Albert and Isabella. He even acquired the honorary title 'secretary of the king in his secret cabinet.' As resounding as it was, his success did not mean that Rubens could do without the help of his old master – and his master's master. Rubens's income from the court, the church and the merchants of Antwerp was not sufficient to finance his princely way of life. The wealthy northern Netherlands would have been a rich market for him to mine. At first he probably hoped that the Twelve Years Truce would make the border between north and south porous enough to let the Dutch find their way in droves to his studio. When this failed to happen, he took the initiative himself, acquainting them with his work by means of prints.

In 1611 we find Willem Isaacsz. van Swanenburg (1580-1612), the son of Isaac Claesz., the younger brother of Jacob Isaacsz. and an up-and-coming political figure himself, producing the first of a number of engravings after Rubens paintings (figs. 4, 28). The collaboration began promisingly, but in May 1612 Willem died, and that was that.

After one more abortive attempt, this time in Haarlem, Rubens hired an artist from the northern Netherlands, Lucas Vorsterman (1595?-1675?) to produce engravings after his paintings in his own studio. Before he published the prints, Rubens sought protection against copyists. The first one he turned to for help, in January 1619, was Pieter van Veen in Leiden.

VAN SWANENBURG'S CONTACTS AT COURT | In the northern Netherlands as well, despite his twenty-five-year absence and the death of his father and brother, Jacob Isaacsz. had valuable connections. His mother was still alive, and her brother Willem Dedel was a professor of law at Leiden University. His son Johan, the later president of the high court of Holland, was a member of the circle around the stadholder. He had been the governor of the young Constantijn Huygens (1596-1687), the son of the stadholder's secretary, whose lifelong friend he remained. In 1623 Johan Dedel married into Huygens's family, a short time before Constantijn himself was appointed secretary to Frederik Hendrik and became the main adviser in matters artistic to the stadholder and his wife Amalia van Solms. It is probably via this route that Jacob acquired commissions for two or three mantelpiece paintings in the chambers of Amalia and her daughter in the Orange palaces in The Hague. Jacob or his brother Claes also decorated with painted bouquets the screens put into the fire-places in the princely quarters in the summer.

Rembrandt's family did not have to give up altogether their old dream of seeing him rise to a place in the public service. With a bit of luck, Jacob Isaacsz. would help him become a court painter, and with a lot of luck he might even develop into the Dutch Rubens. The first wish came true within a decade, the second not until two centuries later.

A FRIEND OF THE FAMILY | There was a third, somewhat less conspicuous career possibility for a van Swanenburg pupil: he might become a painter for the regents of Amsterdam – at least, some of them. In the course of time this was to prove the most important opening for Rembrandt. Two doors from the van Swanenburg family home on the Nieuwe Rijn, separated by the house of a man who

was kin to both of them, Willem Govertsz. van der Aar, lived a Leiden member of a family of Amsterdam regents, Pieter Hendricksz. Schrijver, or Petrus Scriverius, as he called himself.

Scriverius was a humanist – a student of the classical writers and all their subjects – and an authority on the Dutch Middle Ages. Dutch poetry was also a passionate interest of his. He was in the habit of pushing the good poets he knew to publish their work, sometimes even helping them along, if they moved too slowly, by having their poems printed without their authorisation. In 1615 he performed this unasked favour for his fellow Leiden humanist Daniel Heinsius, and he is suspected of having done the same for the Amsterdam poet and playwright Gerbrand Adriaensz. Bredero in 1616. In this unorthodox manner, Scriverius became the main patron of vernacular Renaissance poetry in the Netherlands, poetry written in a Dutch worthy of the Latin of Cicero or the French of Ronsard. In his preface to the authorised 1616 edition of Heinsius's *Neder-duytsche poemata* (Dutch poems), Scriverius wrote: 'Netherlandish poetry, you needn't cede the pride/Of place to ancient Greek or Roman. Spread your wings now wide,/As Heinsius taught you to…'

Competition with the ancients and with the modern French and Italians was a leading leitmotiv of the Dutch Renaissance. Scriverius, the author of several popular histories of Holland, had been praised (by Heinsius) as 'the writer to whom the Hollanders owe their fatherland.' He wanted others to follow his example in their own fields, to help him build a native Dutch culture that could vie with that of any country past or present – a Dutch province in the republic of letters.

Although he had less knowledge of engraving and painting than of history and poetry, he did what he could to encourage those arts as well. The first of the twenty-eight eulogies in Carel van Mander's *Schilder-boeck* (1604; see below, p. 46) is by Scriverius, making one wonder whether he did not play a part in getting that seminal book published too. Petrus Scriverius was a good friend of Willem van Swanenburg. He composed Latin captions for a series of prints by van Swanenburg after drawings and paintings by four living masters of Netherlandish art, all of them court painters: Paulus Moreelse, Abraham Bloemaert, Michiel van Mierevelt and, as we have seen, Peter Paul Rubens. Scriverius wrote captions for sixteen of van Swanenburg's nineteen prints in this mode. Two more were written by Cornelius Plempius and Nicolaes à Wassenaer.

In a eulogy to his departed friend, Scriverius

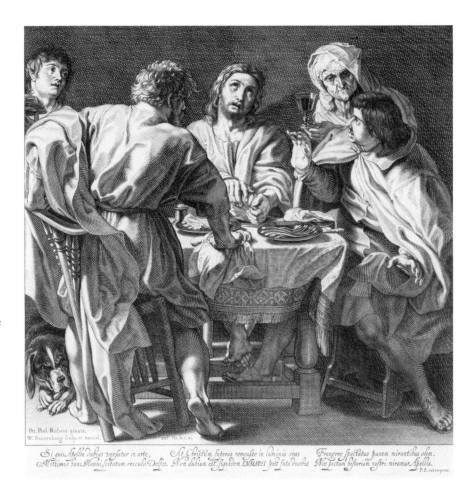

4　Willem van Swanenburg (1580-1612) after Peter Paul Rubens (1577-1640), *Christ at Emmaus*. Signed and dated 1611. Engraving, first state of three, 32.2 x 31.8 cm. Amsterdam, Rijksprentenkabinet.

———

Apart from one unsuccessful attempt by a Flemish engraver, this is the first known reproduction in a print of a painting by Rubens, and is therefore a milestone in his career as well as in that of the Dutch engraver. The caption, by Petrus Scriverius, refers to the owner of the painting, the tax collector Boudewijn de Man, as Mannius, and his city, Delft, as Delphi: 'Should anyone harbour doubts concerning the art of Apelles, O Mannius, we shall send him to Delphi to consult the oracle. But that Christ rose from the dead cannot be doubted, since the Saviour broke bread before the eyes of the astonished onlookers in Emmaus. We gaze in admiration at the occurrence as painted by this Apelles.'

Decades later, Boudewijn de Man was to become the first person in Delft to acquire a painting by Rembrandt.

mourned Leiden's loss of 'he who brought Lucas to life after death.' A hundred years earlier, Lucas van Leyden's brilliant career as a painter and engraver had promised great things for his home town. Scriverius, carried away by his subject, wrote that 'This city has been praised as much through Lucas's fame/As for the wools and linens that also bear its name.' Now that Willem was gone, Leiden needed a new Lucas, and Scriverius another artistic accomplice to help him realise his cultural – and political – ambitions.

As a citizen of Holland, Leiden and the republic of letters, Scriverius's politics were as pure and

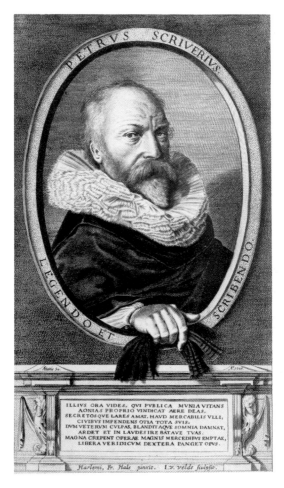

ILLIVS ORA VIDES, QVI PVBLICA MVNIA VITANS
AONIAS PROPRIO VINDICAT AERE DEAS.
SECRETOSQVE LARES AMAT, HAVD MERCABILIS VLLI,
CIVIBVS IMPENDENS OTIA TOTA SVIS.
IVM VETERVM CVLPAS, BLANDITAQVE SOMNIA DAMNAT,
ARDET ET IN LAVDESIRE BATAVE TVAS.
MAGNA CREPENT OPERAE MAGNIS MERCEDIBVS EMPTAE,
LIBERA VERIDICVM DEXTERA PANGET OPVS.

Harlemi, Fr. Hals pinxit. I.v. velde sculpsit.

5 Jan van de Velde
(1593-1641) after Frans Hals
(ca. 1585-1666), *Petrus
Scriverius*. Signed and dated
1626. Engraving, second state
of two, 26.8 x 15.1 cm.
Amsterdam,
Rijksprentenkabinet.

'This is the portrait of a man
who shunned office,/
protected the Muses with his
own money,/ and loved the
seclusion of his house. A man
who cannot be bought,/ who
devotes all his time to his
fellow citizens,/ condemning
the faults and idle dreams of
generations past,/ and who is
burning to sing your praise,
Batavians./ Let those who
have been bribed with gifts
shout as loudly as they
please./ He continues to write
his truthful books with a free
hand.'

In 1626, van de Velde made
several prints of notable
Haarlemers after portraits by
Frans Hals and others.
Scriverius had been living in
Leiden for nearly thirty years
by then, but he never forgot
his home town. In 1626 he was
there often, first on account of

the death of both his aged
parents, within eight days of
each other in July, and then
for the preparations he was
making for the printing of
Samuel Ampzing's
*Description and praise of
Haarlem*, for which he was the
main influence. He came into
contact not only with Hals and
van de Velde, but also with
Theodore Matham, Pieter
Saenredam and other
distinguished Haarlem artists.
 The earliest connection
between Rembrandt and
Haarlem, of which there are
not many, also pertains to the
year 1626. That is the
probable date of his earliest
published etching, *The
circumcision of Christ* (Singer
398), which in its second state
bears the publisher's mark of
Jan Pietersz. Berendrecht.
Berendrecht was a Haarlem
artist and print-seller from the
circles in which Scriverius was
moving in 1626. Two years
earlier he was the witness to
the baptism of a child of Frans
Hals. There is every reason to
believe that is was Scriverius
who apprised Berendrecht of
the existence of Rembrandt.

SCRIVERIUS AND ART AND/OR PROPAGANDA

year	age		
1604	28	Contributes the opening commendatory poem to Carel van Mander's *Schilder-boeck*.	Scriverius's portrait was painted, engraved or etched by Willem van Swanenburg (1609), Jan Lievens (probably between 1622 and 1631), Michiel Jansz. van Mierevelt (before 1641), Pieter Soutman (1645) and Jan de Vos (ca. 1650), in addition to the Hals/van de Velde portraits of 1626 and a portrait of 1620 known only from a poem in Ampzing. So unassuming was Scriverius that this supporter or patron of Carel van Mander, Peter Paul Rubens, Frans Hals, Pieter Saenredam, Jan van de Velde, Rembrandt, Jan Lievens and Cornelis Saftleven has never until now been mentioned in the literature of art except in passing.
1609-1611	33-35	Collaborates with the Leiden engraver Willem van Swanenburg, the brother of Rembrandt's later master, on the publication of captioned prints after compositions by Mierevelt, Jan Saenredam, Moreelse, Bloemaert and Rubens.	
1614	38	Publication of his eulogy on the late Willem van Swanenburg, the 'new Lucas van Leyden.'	
1618	42	Has a portrait engraving made of the imprisoned Remonstrant Rombout Hogerbeets, with a provocative poem by himself, for which he is fined by the university court.	
1621	45	Commissions the fourteen-year-old Cornelis Saftleven to paint a parody on the Counter-Remonstrant Synod of Dordt (fig. 18).	
1622	46	Publishes a portrait print of Desiderius Erasmus, the hero of Dutch religious tolerance.	
1625	49	Gives Rembrandt his first known commission, for the *Stoning of St. Stephen*, a large painting referring to the execution of the Remonstrant pensionary Oldenbarnevelt.	
1626	50	Has his portrait painted by Frans Hals and engraved by Jan van de Velde (fig. 5); orders a second large history painting, presumably with similar Remonstrant overtones, from Rembrandt.	
1627	52	Works with Theodore Matham and other Haarlem artists on title page and illustrations for Samuel Ampzing's *Praise of Haarlem*, the publication of which he encouraged.	
1629	53	His album is enriched with drawings by three Haarlem artists he called friends: Jan Bouckhorst and Pieter Saenredam, both of whom worked on the illustrations to Ampzing, and the imprisoned Rosicrucian Johannes Torrentius.	
1635	59	Peter Couwenhorn, a painter in stained glass (like Bouckhorst), teacher of Gerrit Dou and Constantijn Huygens's sons, adds a drawing to his album.	
1646	70	Writes a commemorative couplet for Rembrandt's etched portrait of Jan Cornelisz. Sylvius, a Reformed preacher who had been Saskia's guardian.	

unselfish as one could hope. He made a point of avoiding office, and prided himself on purchasing his independence with his own money (or at least that of his wife). These were not his only affiliations, however. He came from a family of Amsterdam regents, and among his close relatives were mercenary men with strong party ties. The Schrijvers were one of the leading Remonstrant clans, a circumstance that was of great influence on Scriverius's life.

THE PRO-REMONSTRANT VAN BEUNINGENS | In Leiden, the disadvantages of being associated with the Remonstrants were grave. Amsterdam was a different story. There, Maurits was not able to proceed as brutally as in Leiden. He removed only seven pro-Remonstrants from the council, replacing them with seven relatives of sitting Counter-Remonstrants, in order to provide that party with a majority – not a monopoly, as in Leiden – of votes. One of those to lose his seat was Scriverius's uncle Pieter Thijsz. Schrijver (1558-1634). But the pro-Remonstrants began regrouping immediately, under two much more powerful leaders: Andries Bicker (1586-1652) and another uncle of Scriverius's, Geurt Dircksz. van Beuningen (1565-1633).

Scriverius, while avoiding the smoke-filled rooms where the regents did their dirty work, came out on their side in his own way. He published a portrait print of the imprisoned Remonstrant leader Hogerbeets with a subversive poem, for which he was fined two hundred guilders. (When the sheriff came to collect, Scriverius refused to pay. He took the man to his library, pointed at the books, and said: 'Get the money from them. They're the ones who taught me right from wrong.') He was caught sending secret messages to Hogerbeets and Grotius is prison. (He wrote the messages in Latin verse, had them set in type, and inserted them among the proofs of a book of poems he was editing. Lovely.) He lent his support to cultural initiatives in Amsterdam which came from Remonstrant circles, and was honoured there in turn with public commissions (see fig. 124).

After the reversal of power in Leiden in 1618, Scriverius had little to expect there for his two sons, who were not scholars and did need offices. The oldest, Willem, was later to become a member of the Amsterdam town council, and the second, Hendrik, burgomaster of Oudewater, the birthplace of Arminius. Scriverius, whether he liked it or not, needed his cousins and uncles and in-laws in Amsterdam.

6 Jan Tengnagel (1584/85-1635), detail of *Banquet of seventeen guardsmen in the company of Geurt Dircksz. van Beuningen, 1613.* The whole painting measures 155 x 264 cm. Amsterdam, Rijksmuseum (on loan from the city of Amsterdam since 1885).

The seated figure in conversation with the ensign is Geurt Dircksz. The presence of this powerful personality is felt behind the scenes in the early stages of Rembrandt's career, but there is no evidence that he patronized Rembrandt directly.

The membership of Geurt Dircksz.'s company gives us a cross-section of what we can call the military-artistic complex in the Sint Anthonisbreestraat in 1613. The man on the top left is Hans van der Voort, owner of the house where his brother Cornelis van der Voort ran a studio and gallery. Two of the other sitters are painters Adriaen van Nieulandt and

Jan Tengnagel himself, whose kinswoman was married to Andries Bicker and who was also related to Rubens.

In 1626, Geurt Dircksz. van Beuningen turned over the captaincy of his precinct to Reynier Reael, the brother of his son-in-law Bartholomeus Reael and the business partner of his son Dirck Geurtsz. Reynier was also the uncle of Joannes Wtenbogaert who, in the same year, met Rembrandt in Leiden. It was in 1626 at the latest that Cornelis van der Voort's shop was taken over by Hendrick Uylenburgh, into whose family Rembrandt was to marry.

The network of Remonstrant regents, their families and their artist protégés who took up Rembrandt in his early years was in existence long before he came on the scene.

THE VAN BEUNINGENS AND ART | Scriverius's Amsterdam relatives were not humanists but they had their own kind of professional interest in the art of painting. In 1617, his cousin Geurt Dircksz. van Beuningen had used his influence as alderman to have his brother Jan Dircksz. appointed beadle of the orphans' court, a post that Jan transferred in 1627 to his son Daniel Jansz., who occupied it until his dismissal in 1646. Nicolaas de Roever, the historian of the court, characterized the behaviour of the van Beuningens as a classic example of favouritism, machination and abuse of power.

One of the responsibilities of the beadles was to organize auctions of the estates of those who died leaving minor dependants. In addition, they were licensed to hold voluntary auctions for anyone who brought them goods to be sold. Since this facility was frequently used by the artists and art dealers of Amsterdam, from 1617 to 1646 the van Beuningens were the main art auctioneers of Amsterdam, together with their colleagues the Haringhs.

The charter of their office prohibited the beadles from bidding at their own sales, but that did not keep the van Beuningens from dealing on the side. To get away with this, it was necessary to have the collusion of the official appraiser, who was delegated by the city to fix minimum values and keep an eye on things. The senior appraiser (all of them were women) was Barber Jacobsdr., the widow of a former beadle of the orphans' court who lost his post in 1578 on acount of militant Catholicism. She lived conveniently next door to Geurt Dircksz. in the Sint Anthonisbreestraat, in a house full of assorted relatives, among them her two sons, the engraver Nicolaes and the painter Pieter Lastman.

The recovery of the Amsterdam pro-Remonstrants took four years to get under way. In spring 1622, Andries Bicker and Geurt Dircksz. van Beuningen entered the council and inaugurated a new era in city politics. For an aspiring artist who was alienated from the Counter-Remonstrants, there was no better protector in the country than one of those two men. In autumn 1622 – he who wants to put this down to chance may do so – Rembrandt left Leiden where his first master's parental home adjoined that of Petrus Scriverius, for Amsterdam, where he moved in with his second master Pieter Lastman, next door to Geurt Dircksz.

5 Pieter Lastman

Connections meant a lot in the Republic, but they did not mean everything. Those of Jacob Isaacsz. van Swanenburg may not have been bad, but his qualities as an artist left a lot to be desired, not to speak of his infernal choice of subject matter. Constantijn Huygens may have helped him get commissions from the court, but in his autobiography he writes slightingly of 'Rembrandt's teachers' (see p. 73). Nor can it be said that Jacob Isaacsz. made the most of his social advantages. If Rembrandt wanted to benefit from his master's strategic position, he would first have to see to it that he became a good painter. In any case, it could do no harm to be exposed to the teachings of someone really good before Jacob Isaacsz. turned his pupil into an old-fashioned painter of scenes of Rome and hell.

Pieter Lastman also had good connections, but he had much more besides. In 1604, Carel van Mander had written of the then twenty-year-old Lastman, who was in Italy at the time, that much was expected of him. And he fulfilled the expectations. After his return to Amsterdam, some time before 1607, he established himself in his home-town as a painter of Biblical, mythological and historical paintings, a specialty that in the seventeenth century was called history painting.

Van Swanenburg too qualified as a history painter, technically speaking. But how narrow were his interests in comparison with Lastman's. Lastman practiced history painting in high style, not as a specialty, but as the sum of all specialties. In doing so, he laid claim to a higher status than that of a specialist. The history painter had to be a painter of faces and figures, nudes and animals, still lifes, landscapes and genre scenes as well as of multi-figured compositions. (In fact, Lastman did paint a small number of works in most of those categories.) Over and above his attainments as a painter, he also had to know the literary and pictorial sources of the stories and the allegories he depicted. More than

other painters, he was considered an equal of playwrights and poets, the princes of art.

A DANISH COURT PAINTER AND HIS AMSTERDAM STUDIO | A precious insight is gained into Lastman and his milieu from documents concerning a commission he shared with several others in the late 1610s. The total commission comprised twenty-two New Testament scenes on uniform copper plates for the private chapel of King Christian IV of Denmark in Frederiksborg Castle. Five painters participated: Pieter Isaacksz. – a Dutchman who travelled between Amsterdam and Copenhagen, where he was personal painter to the Danish king – Pieter Lastman, Adriaen van Nieulandt, Werner van den Valckert and Everard Crijnsz. van der Maes. The latter lived in The Hague, but his cousin was an officer of the Amsterdam painters' guild. The other four lived, around the time of the commission, in the same street, the Sint Anthonisbreestraat. The coincidence – which of course is no coincidence – is interesting enough in itself. But in a book on Rembrandt, it is fascinating. The Breestraat, where Rembrandt was to study in 1622-1623 and live from 1631 to 1635 and 1639 to 1658 – twenty-five years in all – was a street with its own community of artists.

The Sint Anthonisbreestraat was not developed until the turn of the seventeenth century, and from early on it housed artists and art dealers. Pieter Isaacksz. (1568-1625) was one of the first to come there. In 1603 he built a house facing the lock – the Sint Anthonissluis – half way up the new street, where he worked as a painter and art dealer. He named the house Cronenburg after Kronburg, the castle of his patron, the king of Denmark. The artist was born in Helsingør (the Elsinore of *Hamlet*) as son of the Dutch resident in Denmark. All his life he worked on and off for the Danish court, except for a period of a year-and-a-half in 1616-1617 when he was banished from the country in the wake of a nasty scandal. He held an official appointment from

the Dutch government, and after his death it became known that he was in the hire of Denmark's enemy, Sweden, as well.

Like his historian brother Johannes Isaac Pontanus, the author of a life of King Christian III of Denmark and the best seventeenth-century book on the city of Amsterdam, Pieter Isaacksz. was a man of importance in Amsterdam as well as Copenhagen. In both places he used whatever political influence he had to further his commercial activities. In 1596 and 1599 he received two of the most honourable and lucrative commissions Amsterdam had to offer: group portraits of the Kloveniers and Voetboog civic guards. Pieter Isaacksz. was not a universally respected man. In 1624 a colleague had to sue him for the return of paintings that he had taken to Copenhagen six years earlier. The colleague also accused him of having had the originals, by Dutch sixteenth-century masters, copied without permission.

ARTISTS EMERGING FROM THE AMSTERDAM DEMI-MONDE

Lastman came to the Sint Anthonisbreestraat by a very different route. Until 1578, his father, Pieter Seegers, was a beadle of the Amsterdam orphans' court and lived in a small street off the Dam, the Pijlsteeg, with the other beadles and with the sheriff's men. According to custom, only the latter were allowed to run brothels in the city, and the Pijlsteeg was therefore the forerunner of the red-light district. Not that Amsterdam prostitutes of the sixteenth century solicited from windows as they do today. One of the reasons for entrusting the monopoly on sin to civil servants was to ensure discretion. When in 1578 the town government took the side of William of Orange and the Reformation, an end was put to the practice, at least officially. Moreover, Pieter Seegers lost his job at that juncture, since he remained a militant supporter of the Catholic church.

Fortunately, his wife Barber Jacobsdr. was not ejected from her post as estate appraiser for the city, a function that was often held by women whose main profession was dealer in second-hand clothes. The couple moved one street north, to the Sint Jansstraat, where the dealers in second-hand goods lived. It was there that Pieter Lastman was born in 1583. The work of both Pieter Seegers and his wife entailed a thorough familiarity with art and artists in Amsterdam, and in this light we can understand the decision to apprentice young Pieter to an artist, now that his father no longer had a position to pass on to him. The choice of a master fell on a man whose connections with the town government were still intact: Gerrit Pietersz., the brother of the town

7 Pieter Lastman (1583-1633), *The Volscian women and children beseeching Coriolanus not to attack Rome*. Signed and dated 1622. Panel. Dublin, Trinity College.

Coriolanus, a semi-legendary figure of the sixth century B.C., was about to lead the Volscian troops in an attack on Rome when his mother and wife brought the women and children of the tribe to his tent in order to dissuade him.

In 1622, the date of the painting, the Twelve Years Truce with Spain had just expired, and the Dutch, like the Volscians, were divided on the question of whether to go to war. As we saw in the *Jephthah* of 1615 (fig. 10), in that year Lastman was involved with a mixed group

of moderates. After 1618, however, when the party lines were firmed up, he fell in – necessarily, as a Catholic – with the anti-war party of pro-Remonstrants or libertines. 1622 was the year in which they re-entered the Amsterdam town government, having been ejected from it by Maurits in 1618. With their rise to power, the stadholder saw his chances disappear of financing an expedition to capture Antwerp. Coriolanus reflects the anti-war stance of the libertines, which had less to do with women and children, than the desire to keep Antwerp harbour blockaded.

Lastman's *Coriolanus* served Rembrandt as a source for motifs in his first three history paintings in horizontal format (figs. 15, 17, 19). In

particular, Rembrandt seems to have been unable to break away from the idea that the right foreground of a history painting should be occupied by a kneeling figure. See in addition to those works, figs. 20 and 65.

organist, the famous Jan Pietersz. Sweelinck. Gerrit Pietersz. (1566-after 1604) was newly returned to Amsterdam around 1600 after an apprenticeship in Haarlem and a trip to Antwerp and Rome. Probably by the time he was twenty, Pieter Lastman had gone off on his own Italian journey, from which he returned by 1607. The move to the Breestraat followed in 1608, when Barber Jacobsdr. bought the house of a Flemish artist, Jonas van Maerle, the son-in-law and studio help of the distinguished Flemish landscape painter Gillis van Coninxloo.

The Sint Anthonisbreestraat was too long and important to become a 'street of the painters' in the same way that the Pijlsteeg was the street of the beadles and the Sint Jansstraat that of the old clothes dealers. The broad thoroughfare (Breestraat means just that) had a mixed population of people who could afford to live well. Wealthy immigrants from the cities of Flanders, including some of the first Sephardic, Jews in Amsterdam, were there in larger numbers than elsewhere. These groups tended to be more sophisticated than native Amsterdamers, and showier, so it is not surprising that their street became the main centre in the city for artists and art dealers. A contributory factor was certainly the location of the guild of St. Luke, to which the painters and the more artistic craftsmen belonged, in the Sint Anthoniswaag, the weighing hall in the square where the Sint Anthonisbreestraat begins.

In addition to the painters who lived there, we find the Breestraat housing artist-dealers like Paulus van Ravesteyn, Pieter Isaacksz. and Cornelis van der Voort. The latter, a Fleming, is of particular interest to us. He was a personal friend of Lastman's, and did business with him in a number of ways. Not only did he buy and sell paintings by Lastman, he also traded in copies after works by him and older Dutch masters. Van der Voort conducted his business diagonally across the lock from Pieter Isaacksz.'s Cronenburg (fig. 125).

The Breestraat painters were strikingly successful in getting commissions to paint group portraits of Amsterdam civic bodies. In addition to Pieter Isaacksz. himself, group portraits were painted by Gerrit Pietersz., Nicolaes Lastman (Pieter's brother), Adriaen van Nieulandt, Werner van den Valckert, Cornelis van der Voort and two other closely related figures from elsewhere in the city: Jan Tengnagel and Nicolaes Moyaert. All of them, moreover, painted history paintings as well, as in the commission for Christian IV, which was not an isolated incident.

With its art dealers, painters and copying studios, the Breestraat was something of an artistic industry zone. Pieter Isaacksz. was not the only one who was

8 Pieter Lastman (1583-1633), *Bileam's ass balking before the angel.* Signed and dated 1622. Panel, 41.3 x 60.3 cm. New York, collection of Richard L. Feigen.

Lastman's source for his *Bileam*, known to us only in a fragmentary drawing, was a work by Dirk Vellert, a prominent Antwerp artist of the early sixteenth century known mainly for his stained-glass windows. Lastman too, early in his career, was called on to design a large window, and at that time he may have studied examples by Vellert.

In 1626, Rembrandt adapted Lastman's composition for a *Bileam* of his own (fig. 21), a derivative at third hand, if not still further, from the original invention. For the subject, see p. 41.

9 Pieter Lastman (1583-1633), *The baptism of the eunuch.* Signed and dated 1623. Panel, 85 x 115 cm. Karlsruhe, Staatliche Kunsthalle.

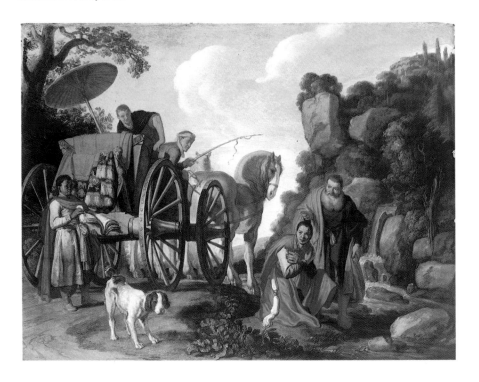

trying to capitalize on the production – it must have been over-production – of art by diverting some of it to the art-starved Scandinavian courts. Towards 1620, Sir Theodore Rodenburg (ca. 1578-1644), a well-born Amsterdamer who lived by diplomatic, literary and commercial intrigue, travelled to Copenhagen with 350 paintings, attempting to arouse interest in a grandiose scheme to export entire branches of Dutch industry and craft to Denmark, including living artists like Werner van den Valckert and the architect Salomon de Bray. In 1618, Rodenburg wrote an ode to Amsterdam, praising many of the painters we have mentioned.

His fascinating career hints at intricate ties between literature, art, politics and business. In the absence of a study of these ties, and even of a biography of Rodenburg, one is at a loss to place Amsterdam painting of the early seventeenth century in its proper context.

OTHER AMSTERDAM PAINTERS FROM THE PIJLSTEEG | We have traced Pieter Lastman's family back to the Pijlsteeg, the street of the beadles and the brothels. Is it coincidence that at least three more of the Amsterdam history painters came from there: Adriaen van Nieulandt, Claes Moyaert, who

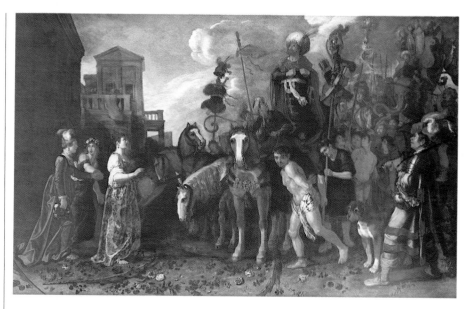

11 Pieter Serwouters (1586-1657) after David Vinckboons (1578-1629), *The Christian knight*. Signed by Vinckboons, Serwouters, the printer J.A. Ravestein and publisher Abraham de Koning, who devised the programme. Dated 1614. Engraving, 29.8 x 36 cm. Hollstein 10. Amsterdam, Rijksprentenkabinet.

A GLIMPSE INTO THE COMPLICATED RELIGIOUS POLITICS OF ARTISTS AND POETS

10 Pieter Lastman (1583-1633), *Jephthah's daughter welcoming her father home from the battlefield*. Ca, 1614. Panel, 123 x 200 cm. The Hague, S. Nystad Oude Kunst (1984).

The Old Testament hero Jephthah (Judges 11) promised God, in return for a victory over the Ammonites, to sacrifice the first living creature to greet him on his return home. His triumph turned into tragedy when his procession was met outside the city by his own daughter.

In his *Hymn to the Christian knight* of 1614, the Mennonite poet Joost van den Vondel alludes to Jephthah as well as David as Hebrew counterparts of the Christian knight. The opening words of

his poem may be read as a reference to a play on Jephthah, probably of the same year, by the Amsterdam playwright Abraham de Koning, who was also an art dealer. In the latter capacity, de Koning must have been involved in the writing of Vondel's poem. In 1614 he commissioned a visual parallel to the poem in a print of the same subject by Pieter Serwouters after David Vinckboons. In several important respects, Lastman's painting resembles Serwouter's print, giving reason to believe that de Koning also commissioned the *Jephthah* from the Catholic Lastman.

The print of the Christian knight is dedicated by de Koning to a kinsman of his in

Leiden, the theologian Johannes Polyander, who, like de Koning, was a Counter-Remonstrant of the more tolerant kind.

There can be no doubt that the images of the Hebrew and Christian warriors symbolize the feelings towards war of the men behind them. All of them, Mennonite, Catholic, Counter-Remonstrant and Remonstrant, were men of the middle ground, capable of entering into close ties with members of other groups. It is exactly in this area that one encounters the most complex standpoints, full of tricky pros and cons. The story of Jephthah, an ode to bravery but a warning against impetuosity, served de Koning and Lastman well in that respect.

The reader will undoubtedly be confused by the complexities and ironies of these relationships. Well, so is the author, and so were the people who were trapped in this mire of politicking, masquerading as religion.

lived around the corner, and Jan Tengnagel? These are men who not only carried out valuable commissions for group portraits, they also commanded positions in the guild and the city government. Moyaert was to serve on the board of directors of the town theatre and Tengnagel to become assistant sheriff. They had the right family connections to get city portrait commissions; and as history painters they had the advantage of knowing the men who could provide them with nude female models. (There are later documents concerning prostitute models that suggest the painters sometimes served as middlemen, to use a neutral term, between their models and patricians who purchased history paintings from them.)

In the Breestraat, these young men on their way up from the Pijlsteeg, found an art dealer who could get them commissions at a foreign court. (None of them ever worked for the House of Orange, as Lievens and Rembrandt succeeded in doing. Of all the Amsterdam painters mentioned in this chapter, only one of them, Pieter Lastman, was represented in the stadholder's collection, with a single work.) Ironically, Pieter Isaacksz., courtly connections and all, had a personal problem that would have been familiar to the Amsterdamers who worked for him: he attempted to disinherit his painter son Isaac for prostituting his girlfriend in Antwerp and Amsterdam.

6　The Leiden period

After about half a year with Lastman, Rembrandt returned for unknown reasons to Leiden, and began working on his own. His reception was cool, but what else could a pupil of Catholic masters and the protégé of Remonstrant regents expect in Leiden?

The only Leiden humanists with whom we know him to have had contact were Petrus Scriverius and – though perhaps not until later years, in Amsterdam – Caspar Barlaeus (1584-1648). Both were known as Remonstrants. Scriverius prided himself on not having an official position, while Barlaeus lost both his academic appointments in Leiden on account of his Remonstrant sympathies before the start of Rembrandt's career. Neither of them, in other words, could be of all that much use to him in terms of gaining commissions.

Rembrandt's first important commission – the only one he ever received in Leiden, as far as we know – dates from 1625 and 1626, when Scriverius ordered two large history paintings from him with a Remonstrant political message. (This is not documented, but I consider the indirect proof strong enough to regard it as a fact.)

The other paintings by Rembrandt which found their way into Leiden collections were small, inexpensive genre paintings and portraits of his own family and other models. Of the ten Leideners to have owned paintings by Rembrandt during the seventeenth century, four were from families of town officials and notaries from the circle of Jacob Isaacsz. van Swanenburg's brothers and brothers-in-law. The most important of them was Aelbert van Hoogeveen, who we know as the sympathetic successor to Isaac Isaacsz. van Swanenburg (p. 22). Two others, including Scriverius, were Remonstrants, one was a Mennonite, another an art dealer named van Rhijn and the last two a neighbour of Rembrandt's pupil Isaac Jouderville and a friend of the neighbour. One senses the mood of Rembrandt's market in Leiden: well-meaning acquaintances would buy small, cheap paintings

from him, mainly to do someone else a favour. Rembrandt's association with Jan Lievens, another ex-pupil of Lastman's from Leiden, could only have done him good: Lievens was a protégé of Orlers.

In 1626 there appeared on the scene a new figure who re-animated the dream of commissions from city governments, the States General and princely courts, like those that his masters painted. The eighteen-year-old Joannes Wtenbogaert (1608-1680) came to study in Leiden that year and moved in with his fellow Remonstrant Hendrick Zwaerdecroon, who had meanwhile married into Rembrandt's family. Wtenbogaert was not just any Remonstrant. He was the nephew and godchild of Johannes Wtenbogaert, one of the founders of the Remonstrant church. (For the spelling of the names – Johannes Wtenbogaert for the older, and Joannes for the younger man – I follow the lead of S.A.C. Dudok van Heel.)

Before Joannes came to Leiden he had lived in Utrecht, where he was a private pupil (on his godfather's recommendation) of Hendrick's father Bernardus Zwaerdecroon. The older Zwaerdecroon had been rector of the Utrecht Latin School until his dismissal in August 1619. Joannes was being groomed for a leading position in the Remonstrant community, and he was being passed lovingly from hand to hand by trusted Remonstrant teachers. The hostile university of Leiden was then the only place in the country where he could complete his studies, but his family depended on Hendrick Zwaerdecroon to protect him from bad influences and injury.

For young Wtenbogaert, whose father was a brother-in-law of Geurt Dircksz. van Beuningen, being a Remonstrant had more advantages than disadvantages. Moreover, he had outstanding connections of his own. His cousin Jacques de Gheyn III was a court painter in The Hague, and his uncle Pieter Reael was receiver-general of taxes in the Amsterdam quarter for the States General. The importance of this post, in a political system whose

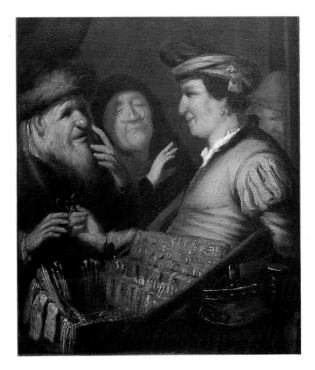

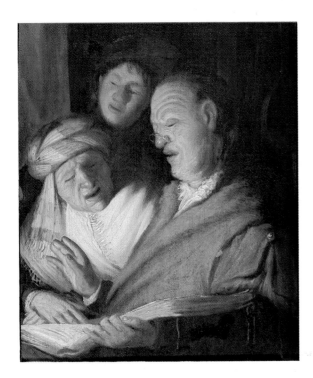

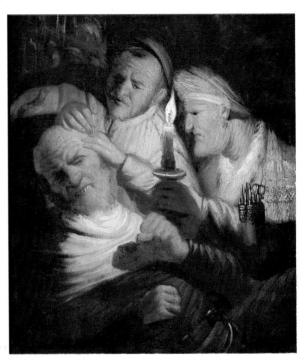

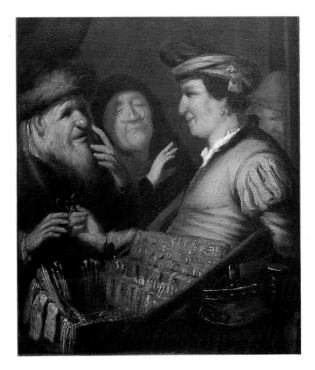

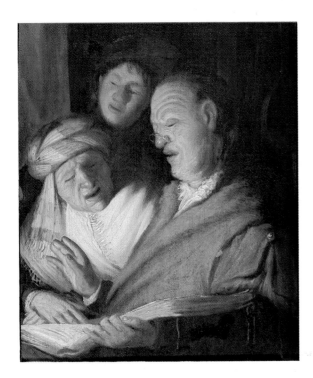

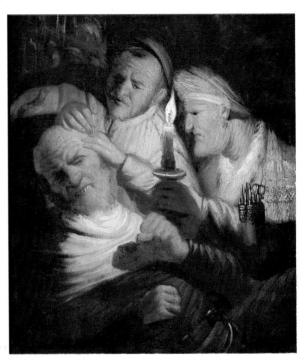

chief functionary, the stadholder, was dependent for half his income on the taxes from an increasingly recalcitrant Amsterdam, can hardly be exaggerated. Wtenbogaert's clan guarded it jealously for a century. Pieter Reael had inherited it from his father, and in 1638 he passed it on to his nephew Joannes.

In 1978 Dudok van Heel advised Rembrandt's future biographers that Joannes Wtenbogaert played a more important role in Rembrandt's life than had been realized. I have taken his words to heart. For the moment, suffice it to say that various important developments in Rembrandt's art and career in the difficult Leiden years – his introduction to Jacques de Gheyn III, his second avenue of approach to Constantijn Huygens and to the Remonstrant regents of Amsterdam – can be attributed to the interest shown in him from 1627 on by Joannes Wtenbogaert.

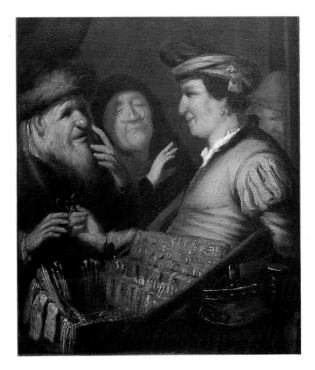

12 *The spectacles seller: the sense of sight.* Ca. 1625. Panel, 21 x 17.8 cm. Not in Bredius. Rembrandt Research Project B3. Daan Cevat Collection.

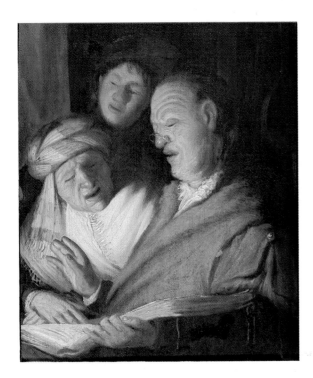

13 *Three singers: the sense of hearing.* Ca. 1625. Panel, 21.6 x 17.8 cm. Bredius 421. The Hague, Hans M. Cramer

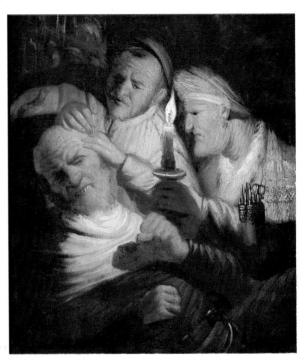

14 *The operation: the sense of touch.* Ca. 1625. Panel, 21.5 x 17.7 cm. Bredius 421A. The Hague, Hans M. Cramer

These paintings have so much in common with other early works by Rembrandt, especially figs. 22 and 23, that they cannot be kept out of his oeuvre on grounds of style or quality alone. See also the surprising similarities between the primitive *Operation* and the very accomplished *Healing of Tobit* of 1636 (fig. 188). There is every reason to assume that these three paintings of the senses (where are the other two?) are the earliest surviving works by Rembrandt, although not all scholars agree on this.

The subjects are satirical depictions of three of the senses. The Rembrandt Research Project has shown that the painter is poking fun at three proverbial fools: the vain old singer, the man who tries to have his intelligence improved be removing the rocks from his head and the willing victim of fraud. This corresponds well with Rembrandt's other known genre paintings: the old man (and a young one) who lets himself be guided by a courtesan (fig. 23) and the rich old fool infatuated with his own money (fig. 30).

In 1668 the Leiden art appraiser Jan Jansz. van Rhijn owned a 'singer by Rembrant' that may have been another version of fig. 13. It is probably not the same painting, since the three works illustrated here remained together until the eighteenth century. The Rembrandt Research Project reaches that conclusion on the basis of the fact that all three were enlarged in the same way with added pieces of wood. (They are illustrated here without the additions.) However, the same treatment was accorded to *Christ driving the money-changers from the Temple* (fig. 22), making one wonder whether the changes were not originally carried out in the seventeenth century, after all, by Rembrandt himself.

Rembrandt's beginnings as a master

Not until recently did art historians begin to suspect that Scriverius patronized the young Rembrandt. The evidence had to be pieced together from several sources. In 1663, three years after the death of the humanist, his magnificent library was auctioned, and with it a few paintings and sculptures that belonged to him and his late son Willem Schrijver (1608-1661). The third lot of paintings, from Scriverius's estate rather than Schrijver's, is described in the catalogue as 'Two imposing large pieces by Rembrandt.' The language of the entry suggests that the 'pieces' were not portraits, and that they were companions. When this information was published in 1894, it meant little, because no large pair of non-portraits by Rembrandt was then known. Not until 1962, when Horst Gerson discovered in Lyon *The stoning of St. Stephen* (fig. 15) and pointed out its close resemblance to another large history painting in Leiden (fig. 17), which had turned up in 1924, was there a chance to pin down the identity of Scriverius's Rembrandts. That step was taken, after an intermediate archival discovery by S.A.C. Dudok van Heel in 1969, by M.L. Wurfbain of the Lakenhal Museum, Leiden, in 1976.

The most obvious explanation for the presence of the paintings in Scriverius's estate is that the humanist commissioned them from the young artist. Although there is no documentary proof of this, the hypothesis is supported by a multitude of circumstances in the life of Scriverius and the work of Rembrandt. As the reader will discover in the course of this chapter, many problems concerning works from 1626 and 1627 can be solved by relating them to Scriverius.

Not only does the hypothesis fit into what we know about Rembrandt's work, but it also makes equal sense for that of Scriverius. In the 1620s, Scriverius patronized two other artists the same age as Rembrandt, in similar ways as we assume him to have patronized Rembrandt. Letters to him survive from Cornelis Saftleven (b. 1607) and Theodore Matham (b. 1606); moreover, his portrait was painted by Jan Lievens (b. 1607). All of these boys were a year or two older than Scriverius's own son Willem (b. 1608), who must have been a schoolmate of Rembrandt's in the Leiden Latin School, and must have undergone considerable harassment on account of his father's Remonstrant sympathies. Later in life, this Willem Schrijver was to play a role of inestimable importance in Rembrandt's career. There is every reason to believe that the bond between them was forged in Leiden, with the active help of Willem's father. After centuries of being ignored, Scriverius's manifold influences on Rembrandt deserve the most sympathetic attention we can give them.

THE FIRST KNOWN WORKS | If Rembrandt returned from Amsterdam to Leiden in 1623, as suggested above, then the first two years of his activity as a master are a blank to us. No signed works from 1623 or 1624 have come to light, and none of the unsigned paintings that have been put down to Rembrandt in this period have met with general acceptance.

At present the earliest universally acknowledged painting is *The stoning of St. Stephen*. There can be no mistaking the subject. With considerable, though not total regard for the Bible text and artistic tradition, Rembrandt created an unmistakeable depiction of the first martyrdom in the Christian church. Stephen the deacon, accused of blasphemy, was taken outside the walls of Jerusalem and stoned to death. 'And the witnesses laid down their garments at the feet of a young man named Saul' (Acts 7:58). All of the significant details in the right half of the painting, even in the background, derive from the text, while the horseman on the left is sanctioned by artistic tradition, as in Elsheimer's version of the subject.

The simplicity of *The stoning of St. Stephen* is in direct contrast to the difficulty of its companion.

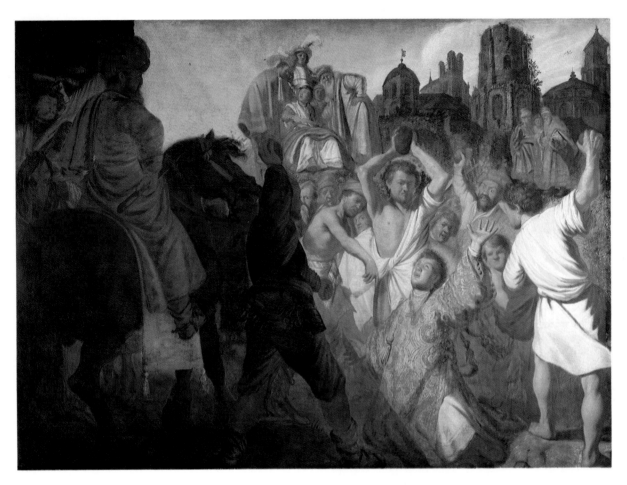

15 *The stoning of St. Stephen: a biblical analogy to the execution of Johan van Oldenbarnevelt* (Acts 7:58-60). Signed and dated *Rf. 1625.* Companion to fig. 17. Panel, 89.5 x 123.6 cm. Bredius 531A. Lyon, Musée des Beaux-Arts.

In all likelihood, this, the earliest known painting by Rembrandt, was commissioned by Petrus Scriverius as an accusation against those who executed the Remonstrant pensionary in 1619. Foremost among them was the stadholder, Maurits. It is probably not a coincidence that the painting was made in the year of Maurits's death, when he was succeeded by his more fair-minded brother Frederik Hendrik.

For his painting of the proto-martyr, Rembrandt drew on a variety of sources in Italian art and the work of northern artists who had been to Italy. The re-discovery of the painting by Horst Gerson in 1962 opened a new chapter in the study of the early Rembrandt.

Since 1924, dozens of art historians have occupied themselves with attempts to identify the subject. Eight main suggestions have been offered, and if the proposer of each new one did not add a question-mark himself to his hypothesis (as most did), others soon did it for him. The most recent catalogue of Rembrandt's paintings, *A corpus of Rembrandt paintings*, by the Rembrandt Research Project, calls it simply a history painting.

The most tempting solution offered so far is *Palamedes before Agamemnon*, suggested by M.L. Wurfbain, following a clue provided by J.G. van Gelder. Palamedes, the son of the Greek admiral Nauplius, was responsible for having Odysseus sent to the Trojan War against his will. In revenge, Odysseus forged a conspiratorial letter from Priam, king of the Trojans, to Palamedes, and hid gold coins in his tent. On this evidence, Agamemnon, the leader of the Greek forces, had Palamedes stoned to death by the army. This proposal opens up far wider perspectives than any of the others. In 1625 the poet Joost van den Vondel published his play *Palamedes, or innocence murdered*, whose main characters, as we shall see, neatly match the major figures in the painting. Vondel's play was written to commemorate the executed pensionary Johan van Oldenbarnevelt, and to protest at the persecution of the Remonstrants.

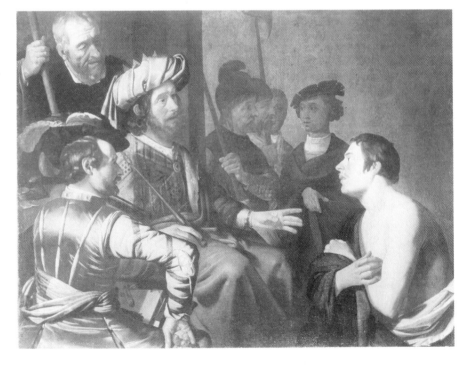

16 R. van Adelo, *Palamedes before Agamemnon*. Signed and dated *R. van Adelo fecit 1625*. Panel, 165 x 220 cm. Formerly Cologne, Wallraf-Richartz-Museum. Present whereabouts unknown.

This painting almost certainly depicts the key scene in Vondel's *Palamedes*, also of 1625. Stylistically, it is related to a group of Leiden drawings and paintings that art historians have been tossing back and forth between Rembrandt and Lievens. If the identification of the subject, the date and the location in Leiden are correct, then we may be certain that van Adelo worked for Leiden Remonstrants.

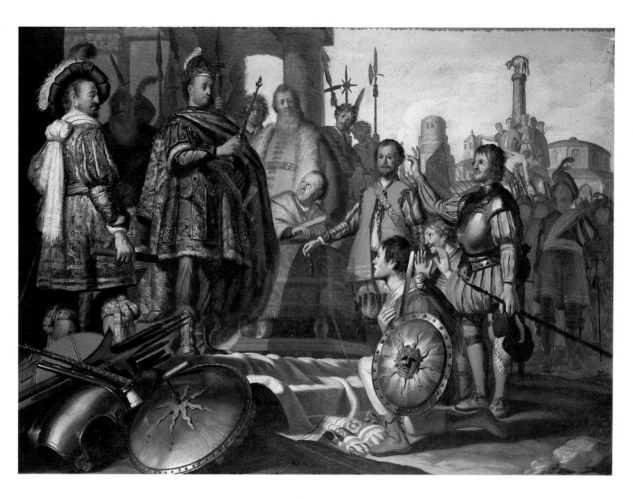

As Vondel later explained to the Remonstrant historian Gerard Brandt, all the characters in his play have a double identity, one from the Greek story and one from the events leading up to Oldenbarnevelt's execution. Agamemnon of course is Prince Maurits and Palamedes, Oldenbarnevelt. The plotters Odysseus and Diomedes are the Counter-Remonstrants François van Aerssen and Count Willem Lodewijk van Nassau, stadholder of Friesland, while Nestor is Adrianus Junius, one of the impartial judges at the trial. As Vondel also told Brandt, the idea of protesting against the execution in this way was urged on him by Albert Coenratsz. Burgh, a leading figure in Scriverius's Amsterdam clan. Burgh first suggested that Vondel simply write a drama about the execution, and when the playwright expressed fear of the danger involved, it was Burgh who came up with the idea of cloaking it under a false mantle. When the play came out in 1625, Vondel was tried before the Amsterdam magistrates, some of whom were out for his blood. Fortunately, the sitting magistrate was Burgh himself, who condemned Vondel to a 300-guilder fine, which he then is said to have given to the poet out of his own pocket.

These are the kind of artistic politics we have come to expect from Scriverius (see above,

17 *Palamedes before Agamemnon: a historical analogy to the trial of Johan van Oldenbarnevelt.* Signed and dated *Rf* or *RH 1626*. Companion to fig. 15. Panel, 90.1 *x* 121.3 cm. Bredius 460. Leiden, Stedelijk Museum De Lakenhal (on loan from the Netherlands Office for Fine Arts).

Upon the instigation of one of Scriverius's relatives in Amsterdam, Albert Coenratsz. Burgh, Joost van den Vondel wrote an attack, in the form of a theatrical tragedy, on the trial and execution of pensionary Johan van Oldenbarnevelt. At the advice of Burgh, he cloaked his criticism in a flimsy Greek disguise, calling the play *Palamedes, or innocence slaughtered.* The play was published (though not performed) in 1625, and became a household word overnight throughout the country.

It was only to be expected that Scriverius himself, who since 1618 had been commissioning prints and paintings supporting the Remonstrant cause, would also make use of this handy new label. Given the suggestions from the documents that this painting came from his estate, and the likelihood that it represents the trial of Palamedes, the conclusion seems unavoidable that it was commissioned by Scriverius from Rembrandt, like the *St. Stephen,* for purposes of propaganda. Palamedes and what he stood for were so well-known in Scriverius's milieu that anyone seeing a painting like this one in his home in 1626 would certainly have been inclined to see it as Palamedes and Agamemnon acting out the fateful confrontation between Oldenbarnevelt and Maurits.

The details in the painting that cannot be found in Vondel's text were undoubtedly suggested by Scriverius in order to enrich the analogy in ways that have not yet been deciphered. For a straightforward depiction of the subject by the unknown R. van Adelo, see fig. 16.

The moment of publication of *Palamedes* was of great

significance. It appeared after the death of Maurits ('Agamemnon'), during the first months of the stadholdership of Frederik Hendrik, and was later to be seen as the opening shot in a campaign for freedom of worship by the Amsterdam Remonstrants. In December 1625 the entire play was read aloud to Frederik Hendrik by his Remonstrant courtier Cornelis van der Mijle, the son-in-law of Oldenbarnevelt ('Palamedes'). The reading took place in a room that happened to be hung with tapestries in which the story of Palamedes occurred. The prince admitted that he enjoyed the play, but added 'That tapestry had better be removed; otherwise people might think that I belonged to Palamedes' party.' He was only half joking. In 1632, when the inventory of the princely collections was taken, the tapestries 'normally in the new hall of Noordeinde' were being stored in the attic.

chapter 4). We could bolster the argument with a list of the many contacts between Vondel and Scriverius in these years, but that would be overdoing things. Suffice it to say that it lay in the line of expectation that Scriverius's clan would encourage Vondel to write *Palamedes*, and that Scriverius would commission Rembrandt to paint it. As a companion to his *St. Stephen*, it was made to order. Just as Stephen was the proto-martyr of the Christian church, standing for all those ever killed for their faith, to the classical world Palamedes was the archetypal victim of judicial murder.

A PROTOTYPE OF PALAMEDES | One of the reasons why art historians have been reluctant to accept Wurfbain's proposal is that, in the absence of an iconographical precedent, no one knows what a painting of Palamedes before Agamemnon should look like. This objection can now be removed. There is another painting on the subject, preceding Rembrandt's, and it bears more than enough resemblance to his painting in Leiden to put the matter beyond reasonable doubt.

In 1625 the otherwise unknown master R. van Adelo produced a bare but unmistakeable depiction of the key scene in Vondel's tragedy, lines 1151-1326 (fig. 16). Besides the protagonists, the only other characters on stage in that scene are Nestor, Diomedes, Odysseus and the torturers who Nestor convinces Agamemnon not to use. All of them, and no others, are present in the painting. The clinching argument for the identification of the subject, however, is the pile of coins on the table at the left, the faked evidence against Palamedes.

Van Adelo's figures correspond so closely in type and position to the five main leftmost figures in Rembrandt's painting that all thought of a purely coincidental resemblance can be ruled out. And the differences between the two works? In one important one, Rembrandt is closer than his predecessor to Vondel's text. In the play, Palamedes remains armed until the end of his rigged trial (line 1322). By showing him with sword and shield, and even more weapons in easy reach, Rembrandt dramatises the fact that Oldenbarnevelt went to his death without resorting to armed resistance – that he allowed himself to be martyred.

The other differences cannot be accounted for by an appeal to Vondel. Rembrandt departs from the text and from his prototype, even to the point of omitting the telltale pile of coins. What seems most likely is that Scriverius was adding to and subtracting from Vondel's metaphor in ways that remain to be deciphered. The problem is not yet completely solved.

WAS REMBRANDT RUNNING A RISK IN WORKING FOR SCRIVERIUS? | These were the years when the public display of Remonstrant feelings was being punished by the courts with stiff sentences and by the mobs with stonings in the street. Was Rembrandt in any danger?

No instances are known to me of artists – as opposed to writers – being prosecuted for the pro-Remonstrant content of their work. If they escaped legal punishment, however, it was no thanks to their patrons. In 1618, when Scriverius was tried for bringing out his print of Hogerbeets, he coolly told the court that if anyone were punishable, it was not he but his publisher, Govert Basson. A print, of course, is a more public form of art than a painting, and for that reason alone we cannot equate the position of a printmaker with that of a painter.

A sculptor then? In 1622 Rembrandt's future patron Abraham Anthonisz. Recht (see fig. 132) was brought to court for causing a riot by displaying a bust of Oldenbarnevelt on the front of his house. His defence was that the bust was the idea of his carpenter and the work of his stonemason. All he had done was to provide the mason with a print of Oldenbarnevelt as a model and give his permission. What if Scriverius had displayed his paintings of *St. Stephen* and *Palamedes* – hanging them, say, in the window of a Remonstrant house of prayer? If he had been charged, would he have hidden behind the painter? Going by the record, one cannot deny the possibility.

SCRIVERIUS AS INTELLECTUAL AUTHOR OF ANOTHER REMONSTRANT PAINTING | In the Rijksprentenkabinet in Amsterdam is a unique document that provides confirmation of Scriverius's role as designer of pro-Remonstrant paintings, while illustrating how he worked with young artists. It is a drawing (fig. 18) and letter of April 16, 1621, by the fourteen-year-old Cornelis Saftleven (1607-1681), addressed to Scriverius and recapitulating the latter's instructions for a painting parodying the Synod of Dordt. Saftleven was writing to his patron for approval of his design and for clearer instructions concerning the Latin inscriptions, which he had trouble understanding. On the back of the letter is a sketch of the proposed painting.

What Scriverius had asked the youngster to do was paint nine of the chief participants in the Synod as animals in a barn. The programme consisted of the same one-for-one substitution of fictional characters for real ones that we find in Vondel's *Palamedes*. It seems remarkable that Scriverius would draw a mere boy into such a dangerous enterprise, but he did it all the same.

18 Cornelis Saftleven (1607-1671), *Poultryhouse parody on the Synod of Dordt*. Drawing on the back of a letter to Petrus Scriverius, dated 16 April 1621. Amsterdam, Rijksprentenkabinet.

The letter reads: 'This is the design for the painting as you commissioned it from me. Hans or Haan [rooster] Boogerman [the chairman of the Synod], perched on the back of the chair like a rooster crowing revolt and persecution, against the chair a large open book, written on the side acta synodalia and on the other side Canones Synod: dordracena, in front of the book below sits the little Zeeland owl Harme Fokel [Hermannus Faukelius, delegate from Zeeland], with glasses on his nose and the candle in his hand, as vice-chairman or deputy, beside him a fat horned owl Jacob Rollant [Jacobus Rolandus, delegate from North Holland], as second deputy. Bastiaen Damman [delegate from Gelderland],

sits as first secretary in the corner next to Rollant and in front of Rollant sits the second secretary Festo Hom [Festus Hommius, delegate from South Holland] and the small owl in the foreground is supposed to represent Florens Jansen [of Friesland]. In the foreground is the political secretary Daniel Heyns [Heinsius, secretary of the delegation from the States General; his participation in the Synod led to a public row with Scriverius] with a sheet of paper in his claws and behind the chair Sybrant Lubbersz [professor at Franeker University] as hireling of Haan Bogerman; above in the window sits the cat or mouser as the sheriff of Dort [a play on the man's name, Hugo Muys – Dutch mouse – van Holy] and against the wall the portrait of Calvin as a calf's head [a standard visual pun].

If this drawing, which I made from your description, satisfies your expectations, may I ask your once more to send me a fair draft of the Latin names since I do not understand them, remaining,

Mr. Peter Scryver, your friend, C. Saftleven. Rotterdam, 16 April 1621.'

As far as we know, Scriverius did not take the following step and commission Saftleven to make a painting of his design. Forty years later, however, after the death of Scriverius, the artist did paint a number of animal satires on the trial of Oldenbarnevelt. One in the Rijksmuseum, dated 1663, is inscribed *Trucidata innocentia*, the Latin translation of the subtitle of Vondel's *Palamedes*: Innocence slaughtered.

A SUCCESSOR TO THE STEPHEN AND PALAMEDES REJECTED? | In 1627, Rembrandt painted a small oil sketch of *David with the head of Goliath being presented to Saul* (fig. 19). The Rembrandt Research Project has pointed out that the painting is 'a modello for a larger history piece comparable with those of 1625 and 1626.' The comparison extends to the point that the *David* and *Palamedes* are both enriched with a multitude of extraneous details which do not belong to the story they depict. Building on these observations, it is a short step to the conjecture that *David* too was made upon the instructions of Scriverius, to be submitted to him, like Saftleven's drawing, for approval before being executed in full scale.

That approval was apparently not given (for that matter, no painting by Saftleven of the composition in his sketch has ever turned up either), so that the *David* has come down to us only in the form of a brightly coloured oil sketch, an object unique in Rembrandt's work.

The large history paintings of 1625 and 1626 were not destined to be followed by another in 1627. In 1628, work on the next one – *Judas returning the silver* – was begun, to be completed in 1629. By then, however, Scriverius had been more than partially eclipsed as Rembrandt's chief mentor by

the far more influential Constantijn Huygens.

THE TEENAGE REMBRANDTS | Rembrandt's first paintings are so different from what is thought of as Rembrandtesque that none of them were acknowledged as his work in the eighteenth and nineteenth centuries. The eight paintings dealt with in this chapter were lost from sight altogether for over two hundred years before their re-attribution to Rembrandt in our century. The most recent new discovery dates from 1976, when the Utrecht art historian Henri Defoer recognised, researched, exhibited and published *The baptism of the eunuch* (fig. 20). He found it hanging above the sideboard in the home of a Dutchwoman who had inherited it from her grandfather. Defoer spontaneously made the connection with Rembrandt, and the rest followed easily from there. The painting fits comfortably into the pattern of works by the young Rembrandt whose elements the reader will have begun to recognise.

The theme of the baptism of the eunuch, unlike those of the first two histories, is not an unusual one in Dutch art. Rembrandt's own master Pieter Lastman painted it at least four times (see fig. 9), and many other representations of the subject are known in paintings, prints and drawings. The story

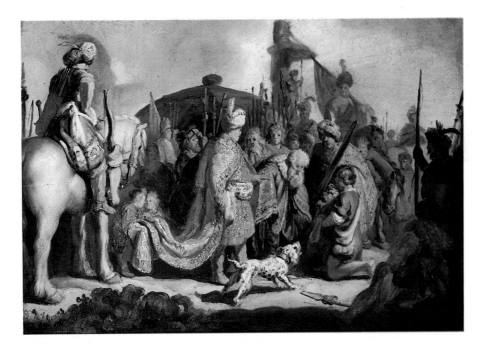

19 *David with the head of Goliath being presented to King Saul* (I Samuel 17:57-58). Signed and dated *RH 1627*. Panel, 27.2 x 39.6 cm. Bredius 488. Basel, Öffentliche Kunstsammlungen.

Presumably made for Scriverius as a model for a new large history painting like the *Stephen* and the *Palamedes*. The iconography has no known parallel in earlier or later art. Like *Palamedes*, it combines a nucleus taken from a text – in this case the kneeling David being presented by Abner to Saul – with a multitude of major details, absolutely unjustified by the text, that can only have been invented by the artist or the patron. The import of the scene remains to be analyzed.

The formal sources, in contrast to the textual ones, are quite transparent borrowings from compositions from Lastman and Rubens of totally different subjects (see figs. 7 and 47).

follows almost immediately upon that of St. Stephen in chapter 8 of Acts. Stephen and Philip were the first two of the seven deacons chosen by the apostles from among their disciples. The deacons were appointed to perform worldly business – tending the widows and serving at table are the duties mentioned by name – while the apostles prayed all day. They also did more interesting things. Philip preached, performed miracles and baptized converts in Samaria, and was then directed by the angel of the Lord to go south from Jerusalem towards Gaza. On the Gaza road he overtook a high official of the queen of Sheba, a eunuch, who was riding along in his chariot reading the book of Isaiah. Philip was commanded by the Spirit to approach the man. He offered him help with his reading of Isaiah 53:7 – 'He was… like a lamb that is led to the slaughter…' – and interpreted it as a prophecy concerning Christ. The eunuch was convinced, and asked to be baptized. Philip did the job, and was then carried off by the Spirit.

Rembrandt's treatment of the subject is quite sparse compared to those of Lastman. The older master, in each of his depictions, typically chose a horizontal format and smallish figures, leaving room for lots of landscape and plenty of detail. Lastman's paintings are chatty and atmospheric. They look as if the artist first constructed an ample stage setting, then placed his figures in it, with care for perspective, grace and elegance of design. Rembrandt chose a standing format in the ratio 4:3, and piled the figures into an even more vertical grouping, of about 5:3. He seems to have built the rest of his composition around the central action,

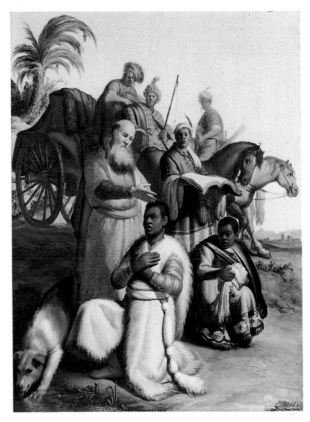

20 *The baptism of the eunuch* (Acts 8:26-39). Signed and dated *RH 1626*. Panel, 63.5 x 48 cm. Not in Bredius. Rembrandt Research Project A 5. Utrecht, Rijksmuseum Het Catharijneconvent.

The baptism of the eunuch was painted by Rembrandt three times, which was very unusual for him. In the last of the three versions, the subject is worked into a landscape (fig. 282), the second is known only from prints and copies, and the first, the present work, was totally unknown until its discovery in 1976 by Henri Defoer.

The painting reveals Rembrandt as a graduate of the Breestraat, adapting a work by his master and recasting it in another form (cf. fig. 9). It is interesting that while he changes a horizontal painting into a vertical one, exactly the opposite was done by the print-maker Claes Jansz. Visscher in his engraving after Rembrandt's second *Baptism of the eunuch*.

The motive of 'whitening the souls, not the skin of the black man,' as the caption to Visscher's print puts it, must have appealed to the Dutch in the early days of the East and West India Companies.

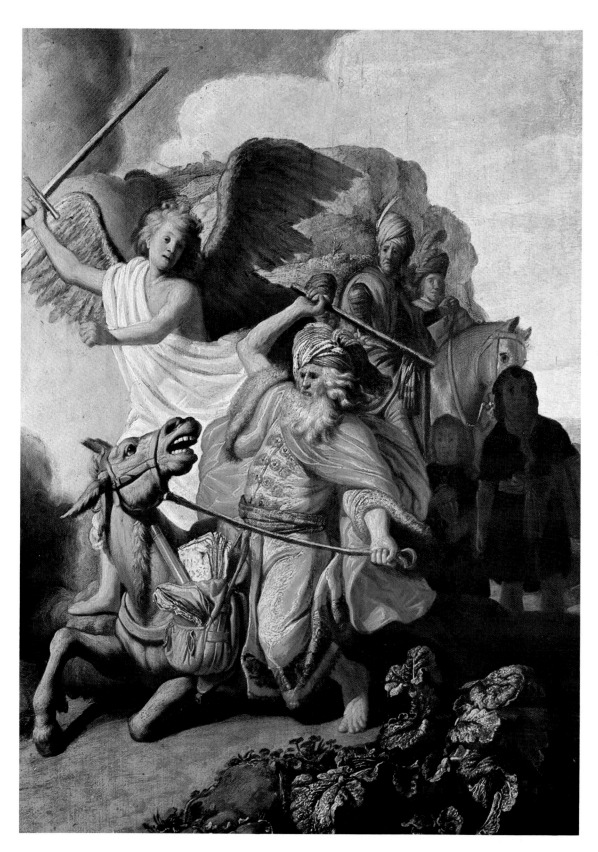

21 *Bileam's ass admonishing its master* (Numbers 22:21-30). Signed *RL 1626*. Panel, 65 *x* 47 cm. Bredius 487. Paris, Musée Cognacq-Jay.

The heathen prophet Bileam was on his way, against his will, to Barak, king of the Moabites, in order to curse the Jews, when his path was barred by an angel of the Lord, visible only to his ass. He struck the animal, which was given the power of speech by God and said 'What have I done to you that you have struck me these three times?' When Bileam finally reached his destination, he blessed the Jews rather than cursing them, and prophesied: 'A star shall come forth out of Jacob, and a sceptre shall rise out of Israel' (Numbers 24:17). This was seen by Christian authors as a prediction of the coming of Christ.

Scriverius, in his commentary on Heinsius's poem *Christus*, attributes great importance to the story: 'No prophecy of Christ the lord, his coming and his might, is plainer, more comforting to the believer, more terrible for the unbeliever.'

Fittingly, the painting was bought from Rembrandt by a man who had converted from Judaism to Christianity, Alfonso Lopez. (See p. 214-215).

23 *The music-lesson of lascivious love.* Signed and dated *RH.1626.* Panel, 63.4 x 47.6 cm. Bredius 632. Amsterdam, Rijksmuseum.

Rembrandt's beautiful singer combines features that are depicted in three different figures in an emblem by Jacob Cats entitled *Amor docet musicam,* Love teaches music (fig. 24). But she also resembles the shameless woman from another emblem in the same book (fig. 25). Combining these hints with the evidence of the painting itself, one can identify Rembrandt's subject as Lascivious love teaching music, subtitled: Men of all ages can be lured by love into doing sinful things they didn't know they could.

No other depictions of the subject are known in painting, and it seems likely once again that the iconography was invented by Petrus Scriverius. Not only was he the link between Rembrandt and the emblems, which were not yet published in 1626, but he also had a well-known weakness for erotic poetry.

22 *Christ driving the money-changers out of the Temple* (John 2:14-16). Signed *RH 1626.* Panel, 43.1 x 32 cm. Bredius 532. Moscow, Pushkin Museum of Fine Arts.

One of the few early history paintings with an easily identifiable subject, but so jarring in composition and colour that several art historians vehemently deny that Rembrandt could have painted it. Nonetheless, its authenticity now seems indisputable.

The composition is an extreme adaptation of a horizontal print by the Flemish-Italian artist Johannes Stradanus (1523-1605). Apparently in an attempt to see how far he could go compressing figures and motifs into a confined space, Rembrandt oversteps the bounds of artistic propriety. The work left no trace of itself in documents or copies by other masters until its rediscovery in the early twentieth century.

and to have added the frighteningly steep front stage as an afterthought.

Rembrandt's first Old Testament subject – *Bileam's ass admonishing its master* (fig. 21) – leans as heavily on Lastman as *The baptism of the eunuch,* and departs from its model (a Lastman painting of 1622; fig. 8) in the same way: it is high rather than wide, crowded rather than spacious. Rembrandt's interpretation is again perfectly literal, but no more so than Lastman's, or than the apparent source of Lastman's composition, a drawing by the Antwerp artist Dirk Vellert (active 1511-1540).

Bileam's ass was the first of the teenage

Rembrandts to gain acceptance in modern art history. The painting had a lot going for it: it is visibly derived from a Lastman painting of 1622, it is signed and dated *R f 1626,* and a document of 1641, first published in 1764, established that Rembrandt sold a painting with that subject, painted by himself, to Alfonso Lopez, a prominent French collector. In 1894, E.W. Moes ended an article on the document with the challenging words: 'Where is Rembrandt's *Bileam?*' A decade later, in 1905, it was re-discovered when the Dutch painter Simon Maris dared to attribute the painting, in his collection, to Rembrandt. Even then, one of the leading Rembrandt specialists of all time, Cornelis Hofstede de Groot, refused for ten years to acknowledge the master's hand in the work.

It would be dishonest to pretend that we can't see the problem. The teenage Rembrandts are airless, aggressive compositions in harsh colours, light-years away from our image of Rembrandt's art. They may compare favourably with the output of other young Leiden painters of 1625 and 1626 (with the exception of Jan Lievens), but this is not the standard against which we are used to judging Rembrandt.

Excessive praise would also have been out of place for two other works of the first half of 1626, *Christ driving the money-changers out of the temple*

VII. 19
Amor docet Muſicam.

Ferlicke
Vryagie

GHy, die op defe prente fiet,
 Maer weet daer van de meyning niet,
En vraegt wat defe kleyne Guyt,
Wat Venus Iongen hier beduyt;
Ick bidde ftaet een weynigh ftil,
En hoort eens wattet feggen wil.

 C 2 Daer

XLVII. 141
Mulier ſine verecundia, lampas ſine lumine.

Vraeght yemant wat ick draeg, en wattet is te feggen?
 Hoort toe, ick neemet aen met woorden uyt te leggé,
Ick gae doch altijt rondt, oock daer een ander fwijght,
 En daer een flechte duyf befchaemde wangen krijght.
Ick draegh een aerdigh tuygh, dat konftigh is gedreven,
Dat fchoon is op-gedaen, en wonder net gewreven,
 Ick draegh een noodigh ftuck, dat aen een ruftigh man,
 Oock midden inder nacht, ten dienfte wefen kan:

 S 3 Ick

24-25 Unknown engraver after Adriaen van de Venne (1589-1662), *Amor docet musicam* (Love teaches music), emblem VII, and *Mulier sine verecundia, lampas sine lumine* (A woman without shame is as a lamp without light), emblem XLVII, from Jacob Cats, *Spiegel van den ouden ende nieuwen tijdt*, The Hague 1632. Engravings, 13 x 13 cm. The Hague, Royal Library.

The drawings for the emblems in Cats's book must have been finished, at least in part, by 1626, the date on the earliest engravings. Books of emblems – maxims or mottos illustrated by prints which in turn are explained by moralizing texts – were a popular form of literature in the seventeenth century. Often they provide us with insights in the way people 'read' works of art at the time, insights that can be gained in no other way.

In very few works by Rembrandt have direct references to emblems been found.

(fig. 22) and *The music lesson of lascivious love* (fig. 23). The subject of the latter painting has been another of the unsolved riddles of Rembrandt's early work until now. Art historians have been divided between interpreting it in a positive sense, such as an allegory of moderation, or a negative one, such as the prodigal son. The dignified manner in which the figures make their music points in one direction, and the piquant veiling of the young woman's breasts in another. On the back wall is a painting within the painting, showing Lot and his daughters being led out of Sodom by the angel. This was a fairly common way for artists to clarify or amplify the symbolic meanings of their subjects in the seventeenth century, one which Rembrandt very seldom used. Here, the device leads our thoughts to sin and its deserts.

That association is reinforced by resemblances between Rembrandt's painting and two illustrations from the most famous Dutch emblem book of the seventeenth century, *Spiegel van den ouden ende nieuwen tijdt* (Mirror of olden times and new), by Jacob Cats (1577-1660), the learned pensionary of Dordrecht. Rembrandt's singer combines features of the three music-making girls in Cats's emblem *Amor docet musicam*, Love teaches music (fig. 24): she sings from a score like the woman on the right,

keeps time with her hand like that on the left, and wears a tiara like that of the woman in the middle. Cats interprets the scene in a positive sense: he who falls in love will soon master more of the social graces than he ever knew existed. In another emblem in the same book, however, a female occurs who is clearly a sister of Rembrandt's, and Cats calls her a shameless woman, under the motto: *Mulier sine verecundia, lampas sine lumine*, A woman with no shame is as a lamp with no light (fig. 25).

If we see Rembrandt's painting as a combination of both emblems, we can read it as a depiction of love teaching music, but in a negative sense. The young woman would then be a hetaera, a courtesan, the old woman her procuress and the males the living proof that young men and old will gladly play to the tune of a beautiful woman – to any tune she cares to sing, as the multitude of music books seem to say.

Cats's *Spiegel* was not published until 1632. But the engravings, after designs by Adriaen van de Venne (1589-1662) were a long time in the making. The earliest ones, dated 1626 and 1627, include several by the Haarlem engraver Theodore Matham (1606-1676). And as it happens, Matham was working in those very years with none other than Petrus Scriverius. Dr. P. Tuynman kindly informed

me of the existence of an undated letter from Matham to Scriverius which can be dated by internal evidence to 1626 or 1627. This explains how Rembrandt could have come to see illustrations from Cats's emblem book as long as six years before it was published.

What the twenty-year-old Matham wrote to Scriverius, by the way, was a request for better instructions regarding a print he was making for the humanist. Scriverius does not seem to have been very good at making himself clear to the young artists he liked to patronize.

A SUBTLER STYLE AND SUBTLER SUBJECTS | On July 15, 1626, Rembrandt turned twenty. Around that time, his art took a turn as well, in his first truly accomplished painting, *Tobit praying for death* (fig. 26). Blind, devout old Tobit has falsely accused his wife Anna of stealing a kid. When she explains that she received it as a bonus from her employer, and accuses her husband in turn of being more generous to strangers than to his own wife, he breaks down. To Anna's astonishment, Tobit now prays to God to let him 'depart and become dust' (Tobit 3:6). Rembrandt's painting is the earliest known treatment of this theme in Dutch art. More usual is the preceding part of the story, when Tobit accuses Anna and she defends herself.

Two sources in Dutch print-making can be cited for the composition, both of them connected in different ways, with Petrus Scriverius. One is a *Tobit accusing Anna* engraved around 1620 by Jan van de Velde after a drawing by Willem Buytewech (fig. 27). In 1626, the year of the painting, Scriverius

26 *Tobit praying for death* (Tobit 3:1-6). Signed and dated *RH. 1626*. Panel, 40.1 x 29.9 cm. Bredius 486. Amsterdam, Rijksmuseum.

Recognizable as the scene may be to one familiar with the book of Tobit, the painting nonetheless represents an iconographic innovation not to be repeated. Tobit is shown as a penitent in much the same position as a lost drawing of St. Peter by Abraham Bloemaert (see fig. 28). The Synod of Dordrecht rejected the sanctity of the book of Tobit and the other Old Testament apocrypha.

27 Jan van de Velde (1593-1641) after Willem Buytewech (1591-1624), *Anna berating Tobit for accusing her falsely of stealing the kid* (Tobit 2:14-15). Signed *WB* Willem Buytewech, draftsman), *J.V. Velde* (engraver) and *C.J.V.* (Claes Jansz. Visscher, publisher). Caption signed with the unidentified initials *VR*. Engraving, 14.7 x 10.4 cm. Amsterdam, Rijksprentenkabinet.

'His wife, says Tobit, is carrying a stolen she-goat, which he sees, although he is blind, with his heart.'

The traditional iconography of Tobit and Anna, as in this print, shows the two arguing. Rembrandt must have had van de Velde's engraving before him when he

painted the interior of his own first representation of Anna and Tobit (fig. 26).

Jan van de Velde engraved the portrait of Petrus Scriverius (fig. 5) in the same year that Rembrandt – for the one and only time in his career – adapted a work of van de Velde's for a painting.

commissioned van de Velde to engrave his own
portrait, after a new painting by Frans Hals (fig. 5).
This was a form of recommendation that Rembrandt
would certainly have noticed, even if Scriverius did
not push the print under his young friend's nose,
challenging him to do better.

The other source is even closer to Scriverius. It is
one of the prints after Abraham Bloemaert by
Willem van Swanenburg for which Scriverius
composed Latin captions in 1609-1611 (fig. 28). The
subject of the series is the penitents of the Old and
New Testaments. St. Peter, in contrition for having
denied Christ three times, raises his hands in a
clenched double fist. The gesture was not invented
by Bloemaert; it has been found in a South
Netherlandish print of about 1570, depicting Jacob,
and is probably even older than that. It was used to
express extreme emotions of various kinds – sorrow,
contrition, amazement. Rembrandt was to take it
over as his own, and to become famous for it. As we
shall see, it was his adaptation of this stock gesture
in a painting of 1628-1629, *Judas returning the thirty
pieces of silver* (fig. 65), which was to establish his
reputation at court.

There is an interesting parallel between the
subjects of *Tobit* and *Judas*. Both of them illustrate
biblical subjects which had hardly ever before been
depicted in art, and in both of them the main figure
is a penitent. J. Bruyn has suggested in the case of
Judas that Rembrandt chose the figure first and then
sought out an appropriate subject. This seems to be
true of the *Tobit* as well. It can be seen practically as
an exercise in the manipulation of texts and motifs.
In order to insert the figure of a penitent into a
composition of *Tobit and Anna*, it was necessary to
shift the subject from *Tobit accusing Anna* to *Tobit
praying for death*. One senses here too the touch of
the humanist Scriverius, a man who lived for the
study of texts. If so, Scriverius will have provided
Rembrandt not only with the double formal source
for his first outstanding painting, but the subject
matter as well.

28 Willem van Swanenburg
(1580-1612) after Abraham
Bloemaert (1564-1651), *The
repentant St. Peter*. Signed
A. Bloemaert (draughtsman)
and *W. Swanenburg*
(engraver and publisher).
Engraving, first state of four,
27 x 17.2 cm. Amsterdam,
Rijksprentenkabinet.

'Thrice, at the cock's crow,
had I denied God and Christ.
I was (I admit it) Peter the
rock in name alone. But the
Lord forgave me, penitent
sinner, while ordering me to
take first place among his
followers. Moreover, God's
word gives me the keys and
the right to open and close the
doors of heaven.'

One of a series of six penitent
sinners of the Old – King Saul
– and the New Testament:

Mary Magdalene, the
publican Zacchaeus, Judas
Iscariot, St. Peter and St.
Paul. Mary Magdalene is
dated 1609 and three of the
others are dated 1611. (For
van Mander's account of the
origins of the series, see the
caption to fig. 65). The
caption to the print of the
Magdalene is by the Catholic
humanist Cornelius Gisbertus
Plempius, while all the others
are by his kinsman Petrus
Scriverius.

Rembrandt made grateful
use of the clenched-fist motif
for several works of the 1620s
and '30s. The fact that he
applies it in a reverse direction
in *Tobit* (fig. 26) may mean
that he knew the original
drawing by Bloemaert as well
as the print after it by van
Swanenburg.

In 1618 the second edition appeared of the most influential book on art ever published in Dutch: *Het schilder-boeck* (The painter's book) by Carel van Mander (1548-1606). It consists of four distinct, unequal sections: a rhymed treatise on 'the foundations of the noble, liberal art of painting'; three books of biographies of the famous painters of antiquity, Italy and northern Europe; a prose digest of Ovid's *Metamorphoses*, the source for so many mythological subjects; and a very brief guide to the depiction of allegories and ancient gods. The anonymous author of the preface to the second edition tells us that the first one, published in Haarlem in 1604, sold out so quickly and completely that it was difficult to lay hands on a copy from which to set the new edition.

If Rembrandt read a single book on art, that book would have been van Mander's. Not only was it the sole Dutch language painter's book in existence but it was also commended by his patron Scriverius and taken up by the Amsterdam milieu in which Rembrandt was trained. The new edition was published during Rembrandt's apprenticeship. The printing took place in Amsterdam, in the Sint Anthonisbreestraat, at Paulus van Ravesteyn's. The new title print was designed by Werner van den Valckert and engraved by Nicolaas Lastman. It was dedicated to Volckert Overlander and Jan ten Grootenhuys, two prominent libertine councilmen. Van Mander himself had moved at the end of his life from Haarlem to Amsterdam, into the circuit of the Breestraat painters. In 1604 he shared a rich commission with Pieter Isaacksz. for the painting of the harpsichord used by the town organist, Jan Pietersz. Sweelinck, the brother of Lastman's master Gerrit Pietersz. He needed the money. The writing of the *Schilder-boeck* had cost him unpaid years of his life and in Haarlem he was not earning them back.

Van Mander's father was the beadle of Thielt, in West Flanders. His family prided itself on its descent from old Netherlandish nobility. Carel grew up writing and painting, working on theatre decors as well as panel paintings and writing hymns, morality plays and farces. The combination of literature and art was not unusual in Flanders, where the painters' guilds were closely associated with the chambers of rhetoric to which the poets and playwrights belonged. High intellectual demands were made on artists in that world, and van Mander was more than able to meet them. From 1574 to 1577 the young artist-writer travelled to Rome, Basle and Vienna, where he worked for Emperor Rudolph II.

Back in Flanders, van Mander's life was so disrupted by social upheaval and epidemic that he emigrated within a few years to Holland. From 1582 to 1604 he lived in Haarlem, painting, teaching and writing. He became the central figure in a small group of artists with the same broad range of literary, artistic and philosophical interests as himself. Together with Hendrick Goltzius and Cornelis Cornelisz. van Haarlem, he founded an 'academy' where the human nude could be studied with proper dignity. In the company of humanists like Dirck Volckertsz. Coornhert, the Haarlemers were able to pursue their studies at an exceptional level of learning, sophistication and moral concern, rivalling contemporary groups in France and England. They set a standard that was looked up to by history painters throughout the Netherlands. A high standard, based on definable and defensible moral principles, was a matter of life and death for Dutch painting. Van Mander and his colleagues never forgot that the works of their predecessors were destroyed as idols by iconoclasts in 1566 in an outburst of religious and social hatred that could always repeat itself.

Van Mander's outline of Ovid, complete with the humanistic morals of his tales, was a boon to his less learned colleagues and a help in elevating the literary level of Dutch art. It was by far the most popular and most frequently reprinted part of the book. The *Schilder-boeck* is aimed not only at the practising painter but is also intended to attract talented youngsters to art and to convince collectors and patrons of the value of art. In his new country, where painting was seen as a skilled craft and was paid for accordingly, van Mander praised it as one of the liberal arts, with a value that can barely be expressed in terms of money. In the preface to the *Schilder-boeck* he defends the status of painting with proofs of its glory from classical antiquity: the sceptre of Alexander the Great crossed by the brush of his court painter Apelles in only one of the proud insignia of the art of painting.

In modern times, van Mander goes on, the superior dignity of painting is proven by the rewards lavished on painters by Emperor Rudolph II and other royal lovers of art. Anyone who examines the evidence will have to admit that painting is a 'noble, outstanding, splendid, honourable profession that need not take second place to any other science or liberal art.'

Van Mander protests too much. In reality, painting in Holland was a middle-class craft with something of a stigma attached to it, whose practitioners could simply not be named in the same breath with scholars like Scaliger or scientists like Bacon. Thanks to his own broad interests and abilities, van Mander may have approached his own ideal. But most of his Dutch colleagues, reading those words, will have laughed either at themselves or at van Mander. His readers will certainly have recognized his phrases as clichés, but many will have hoped with him that painting was at least on its way to achieving something of the status he hopefully assigned to it.

Between the first and second editions of the *Schilder-boeck* the Netherlands did produce one painter, though only one, who ranked with the scholars of his day: Peter Paul Rubens (1577-1640). If not an aristocrat, Rubens was at least a courtier, and fully deserved the title of the modern Apelles. But he was a southern Netherlander, and his artistic and social status was derived largely from commissions for church and court.

The northern Netherlands, van Mander's adopted home, did not yet have much of a court, and its church was antagonistic to art. Painters in search of more status and security than could be provided by the patronage of Dutch merchants had to look abroad. Van Mander's own son worked for many years for Christian IV of Denmark, selling him large tapestries in endless series.

The situation of the arts was grave, and van Mander did not attempt to make a virtue of its defects. He did not attribute beneficial properties to the free market, as have modern art historians who do not concern themselves with the financial problems of the artists they study.

Van Mander's book of biographies deals with four great ages of patronized painting: Greek and Roman antiquity, the Italian Renaissance and northern Europe in the fifteenth and sixteenth centuries. The years in which he was writing marked a low ebb of official patronage in Holland. It was van Mander's hope to encourage an interest in and respect for art on the part of Dutch civic and national leaders.

If van Mander's message struck a sensitive chord anywhere, it was on the Breestraat, where Amsterdam officialdom flowed over into the world of art. However, those particular officials, with their working relationships with Catholic artists and Mennonite dealers, were of the libertine party, and there was little they could do during the first two decades of the seventeenth century, while the Calvinist faction was in power. Between 1622 and 1625 the balance shifted, and Amsterdam passed into the hands of the men whose names we associate with patronage of the arts: Bicker, de Graeff, Huydecoper. Amsterdam, like the other Dutch cities, was slow to develop the habit of giving commissions on a large scale, but in the long run the investment in the second edition of the *Schilder-boeck* certainly paid off.

It was in 1625 too that the basic requirement for patronage an a national level was finally met. In that year Frederik Hendrik became stadholder, and for the first time since the Middle Ages a proper Dutch court was called into being. In that year the new stadholder appointed as his secretary one of the most knowledgeable and enthusiastic art lovers in the country, Constantijn Huygens. And in that year the painting career of Rembrandt van Rijn began.

The compositions in light and shade: Rembrandt and Utrecht

EMULATING THE OLD MASTERS | In 1627, the same old man and old woman who had modelled for *Anna and Tobit* took on New Testament roles for Rembrandt: the prophetess Hannah and pious old Simeon blessing the Christ child and his parents in the Temple (fig. 29). The compositions are similar – gesticulating half-length figures filling a shallow stage, with daylight streaming in through a window in the upper left. Only now the light, instead of illuminating the figures directly plays around them and silhouettes them from behind. The colours of their clothes are difficult to make out, and the five characters can be outlined in one massive form. The transition from light to shade in the background follows the course described by Samuel van Hoogstraten. His tract, *Inleyding tot de hooge schoole der schilderkonst* (Introduction to the academy of painting), was published in the year of his death, 1678. But many of the author's insights go back to his apprenticeship under Rembrandt in the early 1640s. His description of a particular lighting technique could have been written with this painting in front of him: 'Raking is when light does not fall directly on objects, but glancingly, passing them by. It can be demonstrated very well on a round column, because the light falls on it in full strength only closest [to the source]. As it follows the rounded form it rakes more and more until it is finally lost in shadow' (p. 264).

For the figure of Hannah, Rembrandt drew from the fountainhead of Renaissance classicism, Raphael himself, through an engraving by Marcantonio Raimondi. Raphael in his turn took the pose from one of the most characteristic motifs of ancient and early Christian art, the 'orant.' This makes *Hannah and Simeon* the most Roman painting that Rembrandt ever executed.

Yet it was not to Rome itself that Rembrandt's gaze was turned in 1627. It was to Utrecht. The most important new element in his work of that year – his abrupt change to chiaroscuro painting – as well as

the borrowings in that period from Bloemaert, Honthorst and Elsheimer, all point in the direction of Utrecht. *Hannah and Simeon* fits into the same pattern, not just for its lighting but even for its Roman motifs. For a painter from Leiden, Utrecht was half way to Rome.

UTRECHT AND ROME | The ties between Utrecht and Rome are so old and ingrained that nothing, not even the Reformation, could break them. For a thousand years, Rome ruled Utrecht outright. Under the Empire, there was a camp of legionaries there, and when the church of Rome reached the Netherlands, it was within the walls of the imperial fortress that the bishop built his church. From that day to the present, Utrecht has always been the main seat of Catholic authority in the northern Netherlands.

Relations between the two cities reached a climax in 1522-1523, when a native of Utrecht became Pope Adrian VI. For Dutch art, this brief and puritanical papacy nonetheless had lasting effects. As curator of the Vatican collections, Adrian appointed the most learned, best travelled and most sophisticated painter that the Netherlands ever produced, Jan van Scorel (1495-1562). When he returned north after the death of his patron, it was in Utrecht that he ended up, as canon of the Mariakerk, painter, musician, architect, hydraulic engineer, entrepreneur and friend of the great. The Latin poem under his engraved portrait, which van Mander translated into Dutch, puts these words into Scorel's mouth: 'I have always been famed as the first one to prove to the Dutch that he who wants to be a painter must visit Rome' (fol. 236b). The artists of his adopted home Utrecht were the ones who took Scorel's admonishment most seriously, probably because of Roman patronage to which they had better access than their colleagues in other cities. In Leiden, by contrast, the great example was Scorel's contemporary Lucas van Leyden (1494-

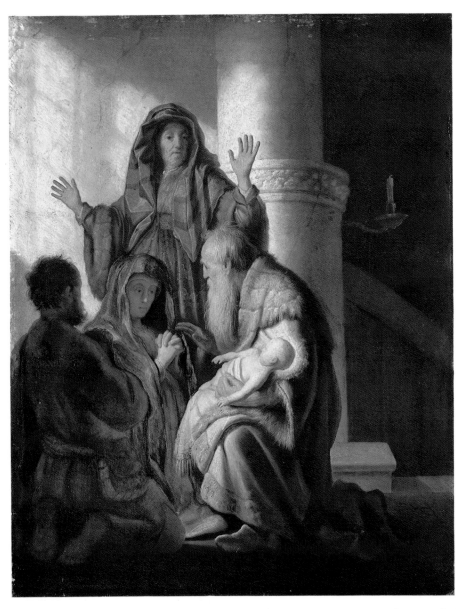

29 *Hannah and Simeon in the Temple* (Luke 2:29-35, 38). Signed, but not by Rembrandt. Ca. 1627-1628. Panel, 55.4 x 43.7 cm. Bredius 535. Hamburg, Kunsthalle.

When an inventory was taken of the stadholder's collections in 1632, Frederik Hendrik's small cabinet in the Binnenhof contained 'A painting in which Simeon, being in the Temple, holds Christ in his arms, made by Rembrandt or Jan Lievens' (nr. 111). Of the three known early paintings of the subject by the two artists, this is the only one that was not signed, and is therefore the only one that could have left the stadholder's careful clerk in doubt.

By the late eighteenth century, when it passed through a succession of aristocratic French collections, it had become one of Rembrandt's most famous works, without anyone realizing that it is one of his earliest.

1533), who was as single-minded as Scorel was versatile, and who never left the Netherlands.

After the Reformation, it was the sons of Catholic families who became artists in Utrecht. Abraham Bloemaert (1564-1651) trained many of them, and left the mark of his intelligent personality on all. With his encouragement, many Utrecht artists went to Rome, which, despite Scorel's 'proof,' was still an exceptional undertaking for a young Dutch painter. Many of them were able to compete successfully in Italy with local artists, building reputations which preceded them back home.

During Rembrandt's youth, Utrecht saw the return of Hendrick Goudt in 1611, Hendrick ter Brugghen in 1615, Gerrit Honthorst (or Gerard van Honthorst) in 1620, Dirk van Baburen in 1623 and Cornelis Poelenburgh in 1626. Their more or less individual blends of Dutch and Italian ingredients were regarded very highly all over northern Europe. The most successful was Honthorst, who by 1627

was a court painter to the king of Bohemia, whose court was in The Hague, Frederik Hendrik and Charles I of England, and deacon of the Utrecht guild of St. Luke. For the painters of Utrecht, the years 1626 and 1627 brought recognition and reward on a grander scale than ever. At the end of 1626, the States of Utrecht decided to purchase works by local masters to send to the wife of the stadholder, Amalia van Solms, upon the birth of her son Willem. In December 1626, for an animal painting by Roeland Savery, who had once worked for the Holy Roman Emperor in Prague, they paid seven hundred guilders; in April 1627, for a *Banquet of the gods on earth*, Poelenburgh received five hundred and seventy-five guilders – amounts on which a modest family could live for a year. Amalia responded graciously in May 1627 with the promise to hang the paintings in her cabinet in honour of the States of Utrecht. In those parts of the world of patronage where the painters of Utrecht operated so smoothly

– the courts of Italian princes and cardinals, the Holy Roman Emperor, Charles I of England, the King of Bohemia and his cousin the stadholder of the Netherlands – those of Leiden were unknown. In comparison with their sophisticated colleagues from Utrecht, they were social primitives.

RUBENS IN UTRECHT | In July 1627 the reputation of the Utrechters was raised higher still when they received a state visit from the prince of Netherlandish painters, Peter Paul Rubens. His visit to Utrecht came at the end of a secret diplomatic mission to weaken the alliance between the Netherlands and England. He considered this alliance a hindrance to the re-establishment of Netherlandish unity, an opinion that was not shared in The Hague. The fact that Honthorst was the favourite of the queen of Bohemia, the sister of Charles I of England, may have guided Rubens's steps to Utrecht, in addition to his more professional motives.

Rubens had much to gain from a permanent peace between the north and the south Netherlands. A treaty would have enabled him to try to extend his artistic dominion to the wealthy cities of Holland and the Dutch court. However, his diplomatic attempts to bring about peace failed, and earned him mistrust in both camps. As long as the war was still in progress, he would need the help of intermediaries in order to market his art in Holland. We have already seen him trying to get copyright for engravings after his work through Pieter van Veen in 1619. That request was denied, but when the artist re-applied the following year, with the recommendation of the English ambassador Sir Dudley Carleton, he was given protection against Dutch copyists for seven years. In 1627 the term elapsed, and we find Rubens visiting the north in person, establishing ties with the best-connected artists in the country.

In Utrecht, Honthorst was his host. He put him up in a hotel run by Hendrick ter Brugghen's brother, and had the Utrecht guild give a reception in his honour for all the painters in the city. Rubens also visited Honthorst in his studio, and the studios of Poelenburgh and Bloemaert. At that point, Rubens was ready to take an art tour of Holland, but Honthorst did not accompany him. Claiming indisposition, he turned Rubens over to his young German assistant, Joachim von Sandrart, who, as a foreigner, could not be compromised by closer association with the Fleming.

In Leiden, this show of favour to the artists of Utrecht must have caused more than a little jealousy. As we have seen, fifteen years earlier, Scriverius and Willem van Swanenburg had produced masterful engravings after Rubens's work and poems extolling his greatness as a painter. Had Willem lived longer, Leiden may have become a Dutch extension of the Rubens studio. But the year after Willem's death, when Rubens came to Holland in search of someone to replace him, it was to Haarlem that he went, to Hendrick Goltzius and his pupils. And now he was going to Utrecht. Leiden had lost its access to the centre stage of world art. It was no longer even in the wings, and no one knew this better than Scriverius.

EMULATING THE MODERNS | Rembrandt's new awareness of what was happening in Utrecht can undoubtedly be attributed in part to a new influence in his life. After Scriverius, with his connections in Amsterdam and Haarlem, Rembrandt now made the acquaintance of Joannes Wtenbogaert, who came from Utrecht to study in Leiden in autumn, 1626. He had postponed the move for several years beyond the ordinary age for commencing university studies, apparently because his family feared for his safety in Leiden. But in September 1626 his godfather Johannes was allowed to return to Holland under Frederik Hendrik's personal guarantee, and a month later Joannes came to Leiden. When he registered at the university, his address was the house of Hendrick Zwaerdecroon, the Remonstrant schoolmaster and Rembrandt's new relative. (In 1624, Zwaerdecroon's brother-in-law Willem van der Pluym married a niece of Rembrandt's mother.)

With his lifelong interest in art and his high social standing, Wtenbogaert would certainly have made the acquaintance of the artists of Utrecht, just as he cultivated Rembrandt and Lievens in Leiden and a large circle of artists in Amsterdam. When Rembrandt heard what was going on in Utrecht from Wtenbogaert, he would have had to be a saint not to wonder whether, despite all of Scriverius's interest in him, he had been born in the wrong city. In 1627 he tried his hand at being an Utrecht artist, as it were, by adopting the most striking external feature of that school: chiaroscuro lighting. The night effects that gained Honthorst his Italian nickname, Gherardo della Notte, were based on concealing the light source within the painting, or, if the illumination came from outside, concentrating it into a single strong shaft of light generating equally strong shadows. The technique was popularized in Italy by Michelangelo Merisi da Caravaggio and his followers.

Some of the new works were painted for customers in Leiden, but with the *Hannah and*

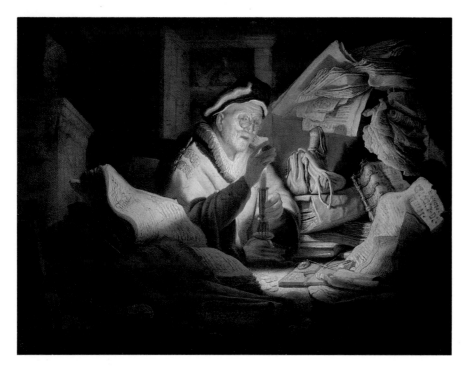

30 *The rich fool* (Luke 12:19-20). Signed *RH. 1627.* Panel, 31.9 x 42.5 cm. Bredius 420. Berlin-Dahlem, Gemäldegalerie.

The sources for Rembrandt's motif come from Utrecht: a painting by Honthorst (fig. 31) and a print by Bloemaert representing avarice in the form of an old lady counting her treasures by night. The substitution of a man for the old woman puts Christian Tümpel in mind of Christ's parable of the rich man: 'Fool! This night your soul is required of you, and the things you have prepared, whose will they be?' The moral is no more forgiving of human weakness than is that of *The music lesson of lascivious love* of the previous year (fig. 23).

A Leiden document of 1659 mentions 'A candlelight scene by Rembrandt' in the estate of the widow of Dirck Segers van Campen. In 1667 a friend of the family, the painter Henric Bugge van Ring, had 'a painting by Rembrandt of a doctor with his books.' Even if neither of these items is identical with *The rich fool*, they prove that Rembrandt's early genre scenes were collected by Leiden burghers.

31 Gerard van Honthorst (1590-1656), *An old woman inspecting a coin.* Signed *G. Honthorst 1634* (over an earlier signature and date of 1624). Canvas, 70.5 x 59 cm. The Netherlands, private collection.

A contemporary print of this subject after Honthorst's fellow Utrechter Abraham Bloemaert is identified as a personification of the vice of avarice. There is no reason to doubt that the painting had the same overtones of disapproval. Old people, the message seems to be, should do more worthy things with their remaining time than counting and appraising their fortunes.

Rembrandt must have known this painting or another version of Honthorst's composition when he made his *Rich fool*, with its equally stern moral.

Simeon, I believe, Rembrandt made his first sale to the stadholder, who was to become the most important single patron he ever had. If there was one person in Rembrandt's circle in Leiden who could have arranged this for him, it was Joannes Wtenbogaert. (See chapter 15.)

In his most dramatic painting in light and shade, *Christ at Emmaus* (fig. 32), Rembrandt lights the main figure itself from behind, which the Caravaggists rarely did. The composition is based on an etching by the Utrecht artist Hendrick Goudt after a famous painting by Adam Elsheimer (fig. 33), a painting that Rubens too adapted for a composition of his own.

Christ at Emmaus is in a way the most daring painting that Rembrandt ever made. In it, he vies with Elsheimer, Caravaggio, Rubens, Honthorst – in short, with the biggest reputations of the day. In another way, it is a nearly timid re-casting of his own earlier *Hannah and Simeon*. The painting shows

Rembrandt caught on the horns of a familiar dilemma: how to please a patron with more of what he liked the first time while trying to improve on it. Painted on paper, it was apparently meant as a model for a new painting for the court, but one which was not ordered.

On the whole, Rembrandt's appropriation of some aspects of Utrecht painting had the desired results. When the first inventory of the collections of Frederik Hendrik and Amalia van Solms was drawn up in 1632, Rembrandt was one of the few living artists not from Utrecht or Antwerp to be represented, with works that were modelled along Utrecht lines. One of them, his portrait of Amalia van Solms (fig. 64), was actually made to match a portrait of Frederik Hendrik by Honthorst (fig. 63).

Not only was it in all likelihood the half-Utrechter Wtenbogaert who introduced Rembrandt at court, it was under the camouflage of a Utrecht painter that he presented himself.

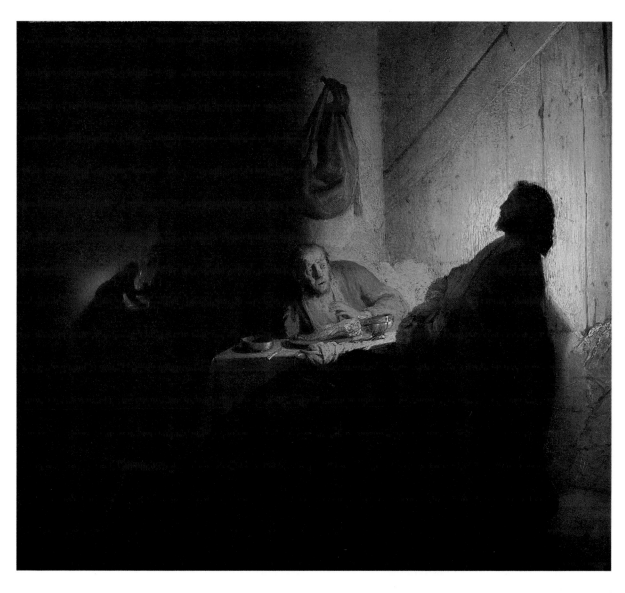

32 *Christ at Emmaus* (Luke 24:30-31). Signed *R*[HL]. Ca. 1628. Paper stuck to panel, 37.4 *x* 42.3 cm. Bredius 539. Paris, Musée Jacquemart-André.

Hannah and Simeon (fig. 29) and *Christ at Emmaus* both depict the revelation of Christ's divinity: the former after his birth, by day, and the latter after his death, by night. Both scenes are placed against a column in the middle background lit by raking light. In both, the main bystander raises his hands in astonishment, while a second bystander kneels with the soles of his feet facing the spectator. The similarities become even more striking if one looks at *Christ at Emmaus* with a mirror, to reverse the direction of the composition. Then one discovers that the transverse plank on the wall of the inn at Emmaus follows the same line as the shadow on the Temple wall, and that the silhouettes of Joseph and Christ are quite similar.

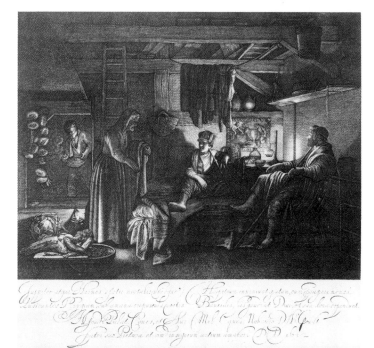

33 Hendrick Goudt (1582/83-1648) after Adam Elsheimer (1578-1610), *Jupiter and Mercury in the house of Philemon and Baucis*. An engraving of 1612 after a painting of 1608-1609. 16.4 *x* 22 cm. Amsterdam, Rijksprentenkabinet.

'When the pleasant shades of night fell on Jupiter and Hermes (both in the guise of mortals) as they roamed Phrygia, they chanced upon welcome hospitality at the humble table of Baucis, whom they repaid by showing themselves as gods to her and her husband. H. Goudt, Count Palatinate and Knight of the Golden Fleece, dedicated to his noble father D.S. Goudt, lover of painting and all outstanding arts. 1612.'
 The engraving is one of seven by Goudt after paintings by Elsheimer, engravings that gave the German artist his cult following among the artists and collectors of northern Europe. Goudt had returned to his native Utrecht in 1611 with paintings by Elsheimer under his arm and glorious but empty titles, granted by the Pope, attached to his name.
 Rembrandt transformed the composition of this print into his *Christ at Emmaus* of 1629 (fig. 32).

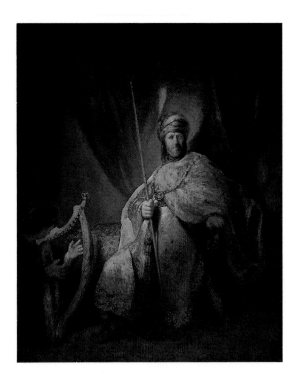

34 *David playing the harp to Saul* (1 Samuel 18:10 or 1 Samuel 19:9). Ca. 1629. Panel, 61.8 x 50.2 cm. Bredius 490. Frankfurt, Städelsches Kunstinstitut.

This is one of three compositions of about 1630 by Leiden artists – Rembrandt, Lievens and Dou – that were reproduced in etchings by the Antwerp artist Willem de Leeuw (1603?-ca. 1665), with Latin verse captions by the Amsterdam Catholic humanist Cornelis Gijsbertsz. Plemp (1574-1638). The Lievens was a *St. Paul* and the Dou (inscribed 'Rembrandt' in the plate) a *Tobit and Anna*.

Plemp was a distant relative of Petrus Scriverius, and had written one of the captions for the Swanenburg/Scriverius prints after Bloemaert around 1610 (p. 28). In attempting to explain the origins of the three prints, one should consider the possibility that Plemp had organized the initiative, using his contacts in the southern Netherlands to help spread the fame of his kinsman's

protégés. Another possible intermediary was Jan Jorisz. van Vliet. This Leiden engraver who was in close contact with Rembrandt, Lievens and Dou, and reproduced work by them, was in Antwerp in 1632.

Plemp's convoluted caption to the print (which was made after a copy of the painting by Rembrandt, not the original) reads: 'His eyes bulge with his bile; angry and bitter is the mind of Saul; yea, putrid ruin devours his bowels with envy. Because of this he sees no longer his own royalty, bravest of youths, but is consumed from within and with grim countenance sees none but yours. O, mighty is your excellence which in its humbleness conquers your enemy with the sound of strings, while even without a battle your military renown inflicts a wound.'

In Utrecht itself, they were not impressed. When the Utrecht humanist Arnoldus Buchelius (1565-1641) visited Leiden in 1628, his friend Theodorus Screvelius, the rector of the Latin school, told him all the latest art news. He showed him his own painted portrait by Frans Hals, the portrait drawings by David Bailly of Matthijs van Overbeke and his wife (in 1627 Joannes Wtenbogaert had been engaged to their niece for a few months), and gave him the portrait print of their mutual friend Petrus Scriverius (fig. 5). When he jotted down his notes on their conversation, he penned the remark: 'The son of the Leiden miller is highly praised, but prematurely.' Yet it was a nephew of Buchelius's, Carel Martens, who in 1630 was the first known purchaser of etchings by Rembrandt (see p. 150).

On the other hand Martens was also the nephew, and even the legal ward, of Daniel Mostaert, who was related to Wtenbogaert and like him a fervent Remonstrant.

As far as his fellow artists were concerned, Rembrandt's emulation of the Utrecht school remained unreciprocated. In later years he inspired followers in all the art centres of the country except Utrecht.

9 The Leiden studio

On February 14, 1628, the fourteen-year-old Gerard Dou (1613-1675) was apprenticed to Rembrandt. As far as we know, this was Rembrandt's start as a teacher, a professional activity he was to practice nearly uninterruptedly for thirty-five years.

Far from being a beginner in art, Dou was a stained glass painter in his own right by 1628. It was only, Orlers tells us, because he was all too unafraid of falling from ladders and scaffolds that his glazier father grounded him by sending him to Rembrandt to be trained as an easel painter. His former master was an interesting man, about whom too little is known, named Pieter Couwenhorn, a friend of Petrus Scriverius, the drawing teacher of Christiaan Huygens, and painter of stained glass for the town of Leiden and the States General.

It has always fascinated students of Dutch art that Dou of all artists should have studied with Rembrandt. As mature painters they were as different as two Dutch artists of the seventeenth century could possibly be. Rembrandt developed a broad, painterly style, growing more and more careless of details and attributes, while Dou became a legend of meticulousness, labouring with the patience of a clockmaker over his highly contrived subjects. Yet, in the 1620s and early '30s, their works were so similar that art historians are still sorting out their respective contributions to a particular group of Leiden works from this period. There are even paintings ascribed to the two of them jointly, and one that is today given to Dou, although it was published as a work by Rembrandt in the 1630s, (fig. 35)!

The young Rembrandt, like most of his predecessors and contemporaries, does not seem to have been interested in matters of authorship and attribution as we define them. Starting with his very first documented collaboration, with the apprentice Gerard Dou, Rembrandt has left us a legacy of ambiguity in questions of artistic ownership.

A third partner in this relationship was Jan Lievens (see chapter 14). If Rembrandt and Lievens shared one studio, as seems to be the case, then it must have been there that Dou worked.

Dou's later career, compared with those of Rembrandt and Lievens, presents us with a stunning paradox. The other two were painters of historic themes, portraits and later, landscapes, subjects of universal interest. While still young they began to be seen as artists of international importance. They both left Leiden for greener pastures, and both foundered financially in the long run. Dou chose to remain in Leiden, cultivating a style and a genre that were idiosyncratic and local to the point of obscurity. Yet within a few years after his older colleagues left Leiden, Dou was established more firmly than either of them was ever to be. Beginning around 1637, he received a thousand guilders a year, a sum one could live on, from the Swedish resident in The Hague, Pieter Spiering. This payment was merely for the right of first refusal on Dou's new paintings. Any works that were actually purchased were well paid for in addition. In the 1660s, when Rembrandt and Lievens were impoverished, Dou went from strength to strength, actually turning down a position at the court of Charles II of England and a commission from the town of Leiden.

JOUDERVILLE | Rembrandt's other Leiden pupil, Isaac Jouderville (1612/13-between 1648 and 1653),was orphaned at the age of seventeen during his apprenticeship to Rembrandt. His father was a Frenchman who had come to Holland in 1607 as a soldier in the States army, and left it at the start of the truce to take over an old inn in Leiden just a stone's throw from Rembrandt's home. Prince Maurits, his old commander, paid him the honour of lodging at the inn in October 1618 when he came to Leiden to eject the Remonstrants from the city government.

Thanks to the records of the Leiden orphans' court, we have a fairly detailed picture of

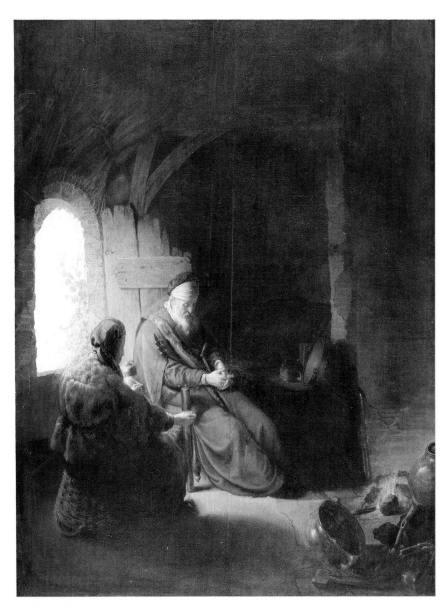

35 Gerard Dou (1613-1675), *Tobit and Anna awaiting the return of Tobias* (Tobit 10:1-8). Ca. 1630. Panel 63.8 *x* 47.7 cm. London, National Gallery.

Like *David playing the harp for Saul* (fig. 34), this composition too was reproduced in a print by Willem de Leeuw, presumably in Antwerp, with a poem by Cornelius Plempius: 'Tobit meditates devoutly, beneath his shabby roof, upon the vanity of human pleasure and the transitoriness of joy. Fate lets riches come and has them go. To you, O piety, be ever praise and honour.'
 An inscription in the plate attributes the composition to Rembrandt. Scholars are convinced, however, that it is the work of Dou, around the time of his apprenticeship to Rembrandt. We do not know how or from whom the engraver obtained his impression that the painting was done by Rembrandt.

Jouderville's background and training. His parents patronized painters, poets and musicians, owned quite a few paintings and a clavichord, and apprenticed their other son to a bookseller. Isaac's sister and both his daughters married painters. The Joudervilles lived next door to the van Campen family, whom we have already met as the owners of one or two genre paintings by Rembrandt. After the death of his mother within a month after his father died, in November-December 1629, Isaac became the ward of two Reformed preachers; one of whom, Cornelis van Tethrode, was undoubtedly related to Rembrandt's maternal grandmother, who was the daughter of a Cornelis van Tethrode. (There was also a Burgomaster van Tethrode of Leiden who was an amateur painter.) The woman that Isaac married, Maria Lefevre, was re-married after his death between 1648 and 1653 to an Amsterdam art dealer with extensive connections in Rembrandt's circles. We see that the intermingling of family and

business relations in Holland could be found in burgher families as well as patrician clans. Rembrandt's relation to a pupil like Jouderville was not a one-to-one affair. There were many others, on both sides, with financial or personal interests in the apprenticeship and its aftermath.

Isaac's guardians paid Rembrandt one hundred guilders a year for two years to complete the boy's training as an artist. This was an unusually high rate for tuition, not including room and board. In Delft, where the records have been analyzed by Michael Montias, fifty guilders was considered a lot to pay a master for straight training. There were masters who would provide tuition, room and board for less than a hundred guilders. However, Rembrandt seems to have been able to command this fee throughout his life. The status of the Jouderville family was typical for the background of many of Rembrandt's apprentices: cultured, in business for themselves, with enough money to pay a renowned

36 *A young painter in his studio.* Ca. 1629. Panel, 25.1 *x* 31.9 cm. Bredius 419. Boston, Museum of Fine Arts.

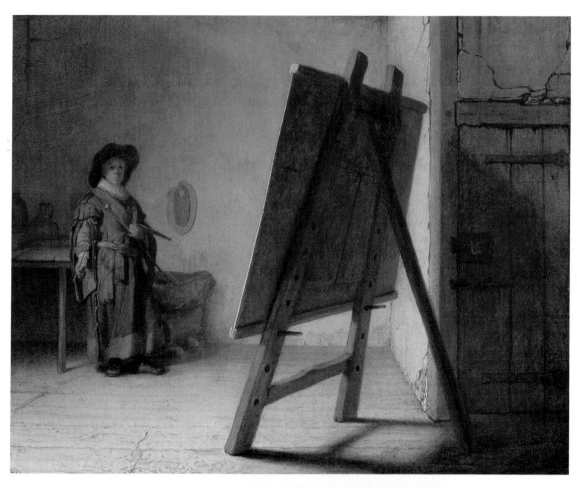

The painting technique of the young Rembrandt has been the subject of concentrated study in recent years, especially by the Rembrandt Research Project. Ernst van de Wetering, the scientific specialist of the team, has been able to reconstruct the 'more or less set working method' of Rembrandt in Leiden. He identifies the following steps:

1 Purchase of a support. In Leiden, except for one painting on paper and a few on copper, Rembrandt worked exclusively on oak panels of standard sizes and manufacture.

2 Priming the panel, first with glue, then with a yellowish mixture of chalk and glue, and finally a thin coat of oil paint. This was not necessarily done by the artist himself.

3 Drawing the composition on to the ground in thin brown oils. Rembrandt seems to have conceived his compositions at the easel, rather than drawing them first on paper.

4 The 'working-up,' in colour. A surprising result of van de Wetering's research is the discovery that Rembrandt 'worked, basically in planes – from the rear to the front, starting with the sky or rear wall and finishing with the foreground figures.'

Van de Wetering considers Rembrandt's *Painter in his studio* an accurate impression of the artist himself at work in Leiden. It may look normal to us that the painter is standing, and has stepped back to get an overall view of his work. According to van de Wetering, however, both things are exceptional. Painters usually sat at their easels and worked on their compositions piecemeal. Rembrandt's pose shows him to be the kind of artist who had an overall conception of the work in progress. We see him making a 'concept in his imagination' (van Mander, *Foundations*, fol. 8b).

There seems to be a discrepancy between van de Wetering's reconstruction of Rembrandt's technique and his interpretation of the way he conceived his compositions. The young painter in the studio is holding a handful of brushes, so he must be working up his panel in colour, rather than creating the composition, which was done in monochrome. At that stage, if the painting was worked up from rear to front, all of its major elements must already have been blocked in. The moment when the artist transferred the conception in his mind's eye to the panel has already passed.

It seems more likely that Rembrandt saw his subject as a character sketch – something like 'the young painter,' in contrast to the type of 'old painter' that we see in a work such as fig. 37. That does not mean, of course, that the young painter cannot be an evocation of Rembrandt in his studio.

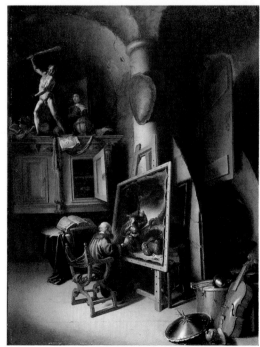

37 Gerard Dou (1613-1675), *An old painter in his studio.* Signed *G. Dou 1635.* Panel, 92.5 *x* 74 cm. Maastricht, Noortman and Brod Gallery (1985).

The possessions that the old painter has assembled bear an unmistakable resemblance to those that Rembrandt had already begun to acquire (see the inventory of his goods, pp. 288-291): plaster casts of ancient sculptures, objects of natural history, weapons and other attributes of universal learning. This image of the history painter must have been shared by the youngsters in the studio of Rembrandt and Dou. Rembrandt was later to personify it.

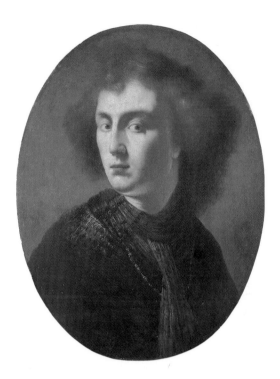

38 Isaac Jouderville
(1612/13-between 1648 and
1653), *Self-portrait(?)*. Ca.
1630. Panel, 48 x 37 cm.
Dublin, National Gallery of
Ireland.

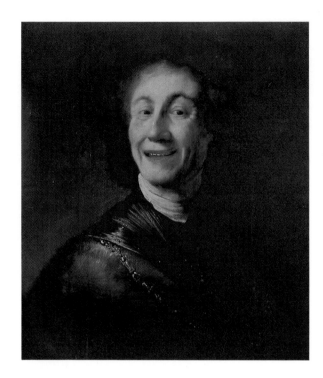

39 Isaac Jouderville,
Self-portrait laughing(?). Ca.
1630. Panel, 52 x 49 cm. The
Hague, Bredius Museum.

This pair of works is the
clearest demonstration we
possess of how expression was
studied in Rembrandt's
Leiden studio. There are
self-portrait etchings by
Rembrandt from this period
that show him practising the
same kind of exercise.

Van Mander says that the
sixteenth-century Haarlem
artist Cornelis Ketel painted
himself as the laughing Greek
philosopher Democritus.
From Orlers we learn that Jan
Lievens copied a Democritus
by Ketel with its companion
painting of Heraclitus, the
crying philosopher. More
research will have to be done
before we know whether both
references are to the same
painting. It they are, then
Lievens deserves the credit
for introducing into their joint
studio a motif that was to
prove so fruitful for
Rembrandt and Jouderville.

painter a premium price for their children's training.

Isaac Jouderville was not, any more than Dou, a
mere recipient of an education provided by
Rembrandt. He produced derivations, variants and
copies of face, figure and history paintings by
Rembrandt, Dou and Lievens, adding his share to
the confusion concerning Leiden painting in the
early 1630s. And not just Leiden painting:
Jouderville moved with Rembrandt from Leiden to
Amsterdam and stayed with him as a post-
apprentice.

One of the instructive items for the Rembrandt
biographer among the documents pertaining to
Jouderville is his registration in Leiden University.
This took place on April 26, 1632, when he was
certainly a full-time professional painter, spending
most of his time in Amsterdam. It must have been
for non-academic reasons like Rembrandt's, twelve
years before, that Jouderville took this step.

10 | Familiar faces

The specialty known in Dutch as 'conterfeiten' – painting the faces of portrait sitters or studio models – was judged in different ways in the seventeenth century. Carel van Mander, in the *Schilder-boeck* (1604), tends to look down on it. He calls it 'a side-road of art,' and warns young artists to avoid it. Face-painting, he says, is nothing but an adjunct to history painting, and practising it on its own is often a sign of laziness or thirst for easy money.

Rembrandt's pupil Samuel van Hoogstraten, whose treatise on painting was published in 1678, does not dismiss face-painting quite so categorically. Ranking the various specialties according to the degree of 'soul' or 'intellect' they contain, he is ready to place portraiture above landscape, still life and animal painting, as long as the artist gives his faces 'intellect' (pp. 85-87). Otherwise, they are nothing but 'pretty depictions of eyes, noses and mouths,' and belong to the lowest of Hoogstraten's categories.

A much more positive attitude towards 'painters who study the features of the human face' was held by Constantijn Huygens. Portraitists make us immortal, allow us to commune with our ancestors, and afford us the pleasure of reading the character of our fellow men in their physiognomies. The human face, wrote Huygens, is 'a miraculous digest of the whole man, both in body and in spirit.'

All of these observations, contradictory as they are, are applicable to Rembrandt, the 'conterfeiter.' He earned his easiest money as a portraitist, and his reputation for profundity as a painter of the face. But he was also criticized repeatedly during his lifetime for painting poor likenesses and charging too much for them. Constantijn Huygens, while he lavished praise on the figures and faces in Rembrandt's history paintings, did not have a high opinion of him as a portraitist, a fact that was to have important consequences for Rembrandt's career.

THE MARKET FOR FACE PAINTINGS | Intellectuals may have had their doubts as to the value of face paintings, but the market did not. No type of painting was easier to sell to as many different kinds of collectors, from painters to princes. The first documents to mention works by Rembrandt, from 1628 and 1629, refer to face paintings in the collections of an Amsterdam patrician and a painter. Probably in 1630, the artist sold a self-portrait and a portrait of his mother to the stadholder to be presented to an English emissary who gave them in turn to Charles I of England (figs. 45, 68). Jan Lievens, who was working very closely with Rembrandt in this period, had by 1630 not only established a solid reputation as a portraitist, but also sold anonymous heads to various important collectors. Constantijn Huygens wrote in 1630: 'My master, the prince, has a portrait said to be of a Turkish commander, done from the head of some Dutchman or other; [Thomas] Brouart, [the prince's treasurer,] owns an old man's face, wrinkled like that of a philosopher; [Jacques] de Gheyn [III], if I am not mistaken, owns a few portrait of youngsters; [the Amsterdam collector Nicolaas] Sohier several others that he [Lievens] made long ago as a boy.' To this list we can add the Leiden burgomaster and historian Orlers, who also collected works by Lievens, as did several other Leideners. Leiden, The Hague, Amsterdam and England were where Lievens and Rembrandt had their earliest success, mainly with their face paintings. Lievens was undeniably in the lead in 1630, but Rembrandt was sparing no effort to catch up with him. The evidence above provides us not only with a good indication of how broad the market was for face-paintings, but how varied the subjects were. Lievens introduced theme after theme: portraits of his mother, philosophers and Turkish commanders in addition to the unspecified heads of young men and women in various guises. In the course of time Rembrandt got around to painting all of Lievens's variants and

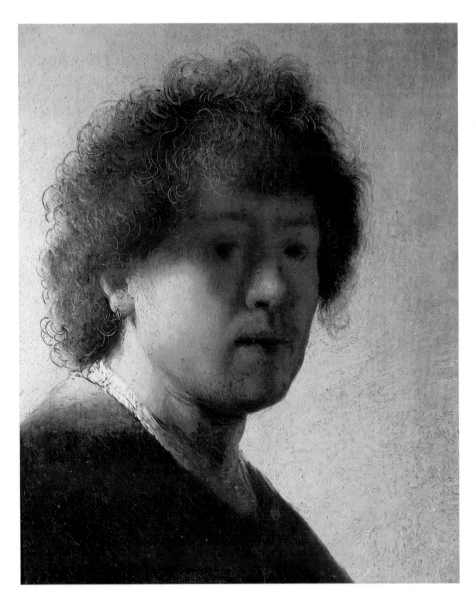

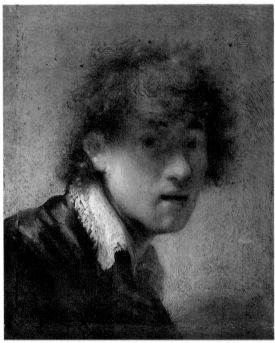

40 *Self-portrait*. Ca. 1628. Panel, 22.5 x 18.6 cm. Not in Bredius. Rembrandt Research Project A 14. Amsterdam, Rijksmuseum.

For several decades, this painting has been pitted against a close replica in Kassel in a battle for the cachet of the earliest self-portrait by Rembrandt. The Amsterdam version seems to have carried the day. It was copied in an etching dated 1634 by Jan Jorisz. van Vliet.

41 *Self-portrait*. Signed *RHL 1629*. Panel, 15.5 x 12.7 cm. Bredius 2. Munich, Alte Pinakothek.

Like two other tightly composed works of the Leiden period, this self-portrait was later pieced out with added strips of wood to give the main motif more room. The other two are *Christ driving the money-changers from the Temple* (fig. 22) and *The young artist in his studio* (fig. 36). The same treatment was applied to the three genre paintings of about 1625 that may or may not be by Rembrandt (figs. 12-14).

more, but in Leiden his repertoire was limited to four types: self-portraits; young men, mostly officers; old men, mostly officers; and old women of the type known as 'Rembrandt's mother.'

Until now, no commissioned portraits from the Leiden period have been identified.

EARLY SELF-PORTRAITS | Rembrandt was not a shy or modest person. He must have been pleased with his own features to have been able to depict them at least eighty times in drawings, etchings and paintings. He was as unembarrassed about putting himself into the action of history paintings as he was dedicating whole compositions to himself, in heads, busts, half-lengths and full-lengths.

Self-portraiture was not uncommon in Dutch art. Van Mander tells of painters portraying themselves alone and with their wives, as witnesses to historical scenes and as staffage figures. The father of Rembrandt's teacher, Isaac Claesz. van

Swanenburg, painted himself as a musician at the wedding in Cana, in a work commissioned, appropriately, by a wine seller, who also had himself, his wife and his children put into the scene. The Leiden publisher and engraver Hendrick Hondius owned a collection of self-portraits and portraits of Dutch artists that he issued in 1610 in an impressive series of prints. One doesn't have to look far, then, for precedents to Rembrandt's interest in self-portraiture. What no one before him had ever done, however, was to turn it into a full-blown specialty.

We can only guess his reasons. The assumption that the self-portraits constitute a kind of spiritual autobiography is unlikely, if only because Rembrandt seems not to have kept the finished works. One motivation will certainly have been the success he achieved with the sale of an early self-portrait to the court, and the hope of repeating it. But by the time he painted that work he had already

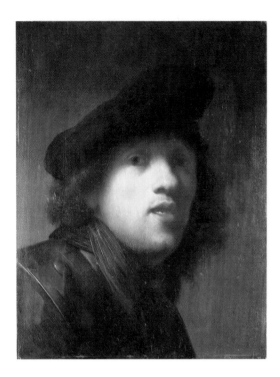

42 *Self-portrait*. Ca. 1629.
Panel, 49.7 x 37.3 cm. Not in
Bredius. Rembrandt
Research Project A 22.
Atami, Japan, Museum of
Art.

The resemblance between this
work and a second version in
the Indianapolis Museum –
signed *RHL* – is even closer
than that between the two
earlier self-portraits in
Amsterdam and Kassel. The
Rembrandt Research Project,
on the basis of a subtle
reading of the painted surface
of the two works, judges the
Japanese version to be the
original and that in
Indianapolis, along with at
least five other early versions,
to be copies. If so, the
Indianapolis version is almost
certain to have been produced
in Rembrandt's studio.

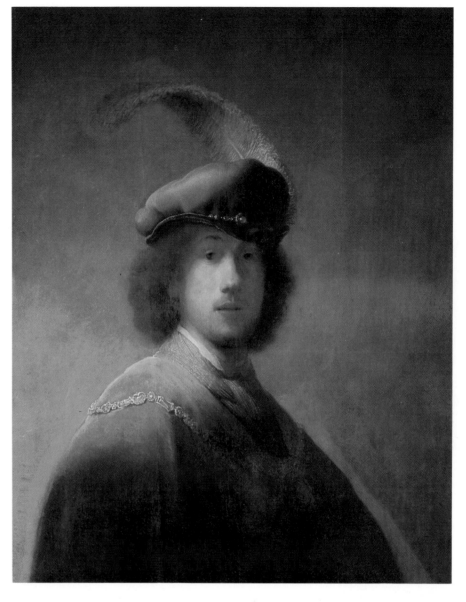

43 *Self-portrait*. Signed *RHL*
[162]9. Panel, 89.5 x 73.5 cm.
Bredius 8. Boston, The
Isabella Stewart Gardner
Museum.

After the small,
close-cropped self-portraits in
Amsterdam, Munich and
Japan, Rembrandt allows
himself a larger scope in this
more glamorous self-image.

made some ten other self-portraits on panel and
paper, so that cannot be the whole reason. The
Rembrandt Research Project suggests that the
self-portraits in rich dress – the majority – are
representations of vanity. In terms of iconography,
there is little to be said in favour of this idea, but
psychologically it may hit the nail on the head.

The self-portraits painted in Leiden (figs. 40-46,
48) progress from straightforward mirror gazing to
military and seigneurial posing to masquerading as a
Persian prince. For each type of painting we can
point to earlier examples, but in the case of
Rembrandt they form the beginning of a campaign
of self-depiction that is unique in the history of art.

Another reason that has repeatedly suggested
itself to writers on Rembrandt is that the artist was
his own most convenient model. This applies to all
artists, but it tells us some important truths as well.
The quality of Rembrandt's self-portraits is often
better than his portraits and studies of others. This
may be due to the extra time the artist could devote
to self-portraits or to added insight born of
familiarity and repetition. Samuel van Hoogstraten
quotes a pertinent saying of Michelangelo's that he
may have heard from his master Rembrandt: 'All
painters are best at painting their own likeness'
(p. 168). Michelangelo said it in jest, but for
Rembrandt it was to become a fact of life.

OTHER YOUNG MEN | Except for the facial features,
there are few differences between Rembrandt's
early paintings of himself and of other young men
(figs. 50-52). He and they wear the same plumed
hats, the same breastplates, the same gold chains;
they are posed the same way in paintings with the
same degree of finish. Only the first two self-
portraits, the most informal and intimate of the
group (figs. 40, 41), have no known parallel in
paintings of other models.

The characterizations are not terribly specific,

44 *Self-portrait*. Ca. 1629. Panel, 37.9 x 28.9 cm. Bredius 6. The Hague, Mauritshuis.

In this self-portrait we see more of the gorget that Rembrandt also wears in fig. 42. Around this time the artist must have spent a lot of time in The Hague, with its many Dutch and foreign soldiers. 1629 was the year of the siege and capture of 's-Hertogenbosch, and Frederik Hendrik and his troops were national heroes. Since it is only during his 'Hague period' that Rembrandt painted himself in armour, we may hypothesize that this imagery was inspired by acquaintances or impressions acquired at court.

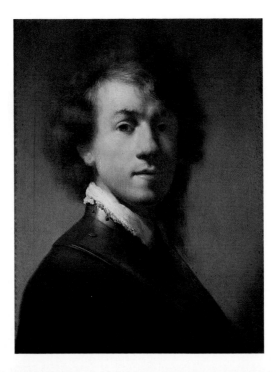

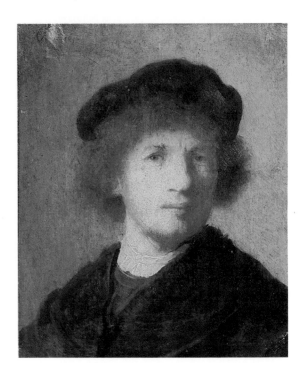

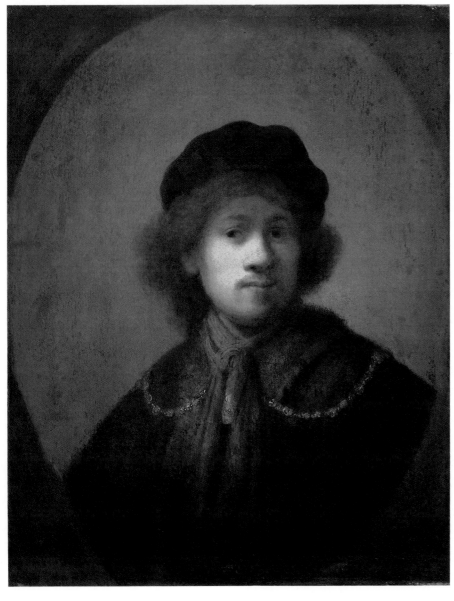

45 *Self-portrait*. Signed, but not by the artist. Ca. 1630. Panel, 69.7 x 57 cm. Bredius 12. Liverpool, Walker Art Gallery.

The first period of self-portraiture culminated in this panel, whose surface is unfortunately in poor condition.

This is undoubtedly the painting listed in the inventory of Charles I in 1639 as having been presented to the king, together with fig. 58, by Lord Ancrum, Sir Robert Kerr. Because this nobleman was sent to The Hague in 1629 to attend the funeral of Charles's nephew, the young son of the king and queen of Bohemia, it has been assumed that he acquired it on that occasion, possibly as a gift from Frederik Hendrik. (Compare Orlers's similar story regarding a commission to Lievens; p. 79.) The style of the painting points to a later date, however, which rather leaves the matter up in the air. What does seem certain is that the painting was purchased or commissioned via the stadholder's court, and that it was a major triumph for the young artist for works of his to be used in this way. For Rembrandt self-portraits in other royal collections, see below, p. 347-348.

46 *Self-portrait*. Signed *R*[HL] *1630*. Copper, 15 x 12.2 cm. Bredius 11. Stockholm, Nationalmuseum.

One of three small paintings from the Leiden period on copper, with a gold-leaf ground; the others are figs. 49 and 60. The copper plates are all the same size and the unusual ground is identical, but the treatment of paint in the three works is quite different. Yet it would seem all too arbitrary to accept only one or two of the three and not the others.

and there is no reason for thinking that the heads were intended to have a well-defined meaning. At most one can wonder whether the military attributes have any function beyond adding dash to their bearer. Even this does not seem likely, however. For a man who avoided service in the civic guard, Rembrandt is remarkably quick to arm himself and his models, young and old. Nor is he very discriminate in the way he dresses them with the gold chain and plumed hat that recur so often in this group of works, in any number of combinations.

OLDER MEN | Two of Rembrandt's paintings of older men display the same attributes as those of youngsters and the self-portraits, and one does not. The exception is a small, finely painted bust, dated 1630, of an old man with a scraggy beard, in a sable hat and a brown fur collar (fig. 53). The hat has been identified as the garb of a Polish Jew, and the fact that Rembrandt gave similar headgear to the Jewish priests in the *Judas* of 1629 lends support to the notion that the artist was aware of this. As there were no Polish Jews in Leiden in 1629 or 1630, it must have been in Amsterdam that Rembrandt acquired the hat and the knowledge that it was Jewish. The possibility that the painting is a portrait of a Polish Jew wearing his own hat is too unlikely even to be considered, since the same old man was painted and etched by Rembrandt and other Leiden painters for years on end in dozens of guises. He has also been called Rembrandt's father, a supposition that also has to be dismissed on the same grounds.

Unfortunately, this robs us of the chance to identify Rembrandt's father in a painting by his son.

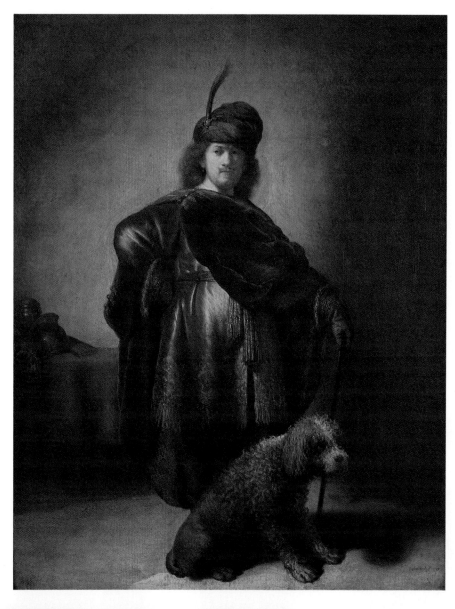

47 Anonymous engraving after a print by Lucas Vorsterman after a painting by Rubens, *The adoration of the Magi*. The painting is from 1617 or 1618 and is in the Museum of Lyon. The print by Vorsterman (57 x 73.5 cm.) is dated 1621. Haarlem, Teylers Museum.

Rembrandt borrowed details from this composition for his own pose in fig. 48 and for Saul and his pages in fig. 19. Because Vorsterman's print bears the formula of protection by the States General, we may be certain that an impression of it was sent to The Hague, where Rembrandt could have seen it.

48 *Self-portrait*. Signed *Rembrandt f* […] 1631. Panel, 66.5 x 52 cm. Bredius 16. Paris, Musée du Petit Palais.

This panel is no larger than the one on which the self-portrait in Liverpool is painted, but it contains a much grander type of self-portrait, full-length, in oriental garb, with armour and a noble dog as attributes. In fact, a figure in much the same pose is buried beneath the painted surface of the Liverpool self-portrait, visible only by X-ray. The pose is derived from that of the black king in a print after Rubens's *Adoration of the Magi* (fig. 47).

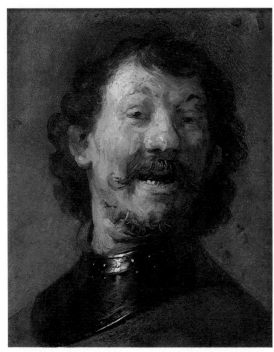

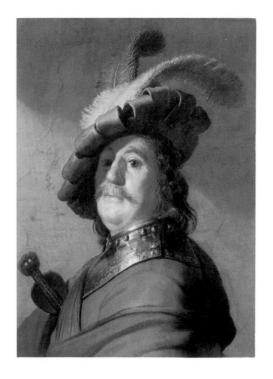

50 *Bust of a man in a gorget and cap*. Ca. 1628. Panel, 40 x 29.4 cm. Bredius 132. Switzerland, private collection.

The first known painting by Rembrandt of the head of a studio model is painted over an earlier one, depicting an old man looking downwards. Throughout his life, Rembrandt showed little hesitation in covering unfinished works with new compositions. From this we may deduct that he was frugal in his use of panel and canvas, which were indeed expensive, and that he was not too sentimental towards efforts of his own that fell short of his expectations.

49 *Bust of a laughing man in a gorget*. Signed *Rt*. Ca. 1628. Copper, 15.4 x 12.2 cm. Bredius 134. The Hague, Mauritshuis.

The unusually free brush stroke has led Gerson to dismiss, and the Rembrandt Research Project to doubt, the authenticity of this work. See, however, the remarks to fig. 46.

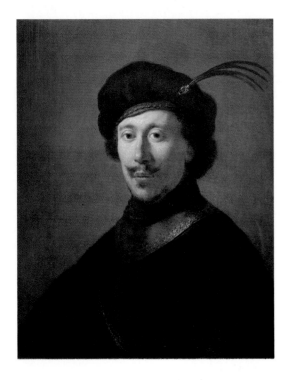

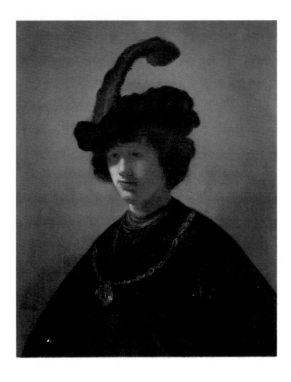

52 *A young man with a plumed hat*. Signed *RHL 1631*. Panel, 80.3 x 64.8 cm. Bredius 143. Toledo, Ohio, Museum of Art.

The only Leiden paintings that may have been paid portraits are these two, of sitters who do not look like studio models. The two busts share a quality of lethargy than makes me doubt whether they were painted by Rembrandt in the same year as some of his most dynamic early works.

51 *A young man with gorget*. Signed *RHL 1631*. Panel, 56 x 45.5 cm. Bredius 144. San Diego, Fine Arts Gallery.

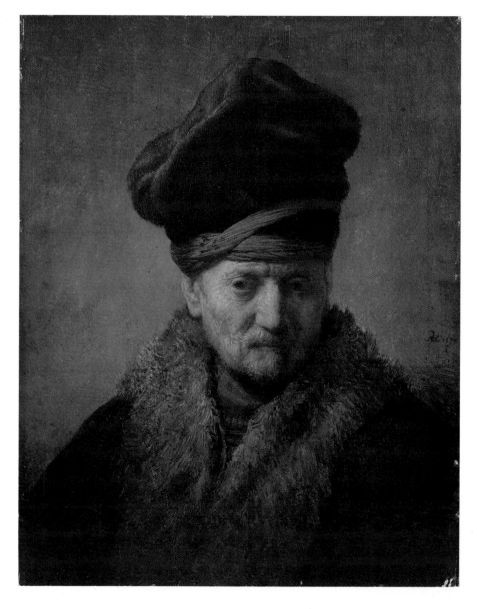

53 *Bust of an old man in a fur cap.* Signed *RHL 1630.* Panel, *22.2 x* 17.7 cm. Bredius 76. Innsbruck, Tiroler Landesmuseum Ferdinandeum.

The first of Rembrandt's paintings of old men is an exercise in what the Dutch call *stofuitdrukking*, giving expression to materials. The short, velvety fur of the cap, the wrinkled old skin and bristly beard, the long-haired fur of the collar, we feel, were painted as much for our fingertips as for our eyes.

And such paintings seem to have existed. As early as 1644 a Leiden inventory mentions a 'head of an old man, being the portrait of Master Rembrandt's father.' Without going into the vexed question, it is enough to say that there is either too much evidence against or not enough for, each of the existing hypotheses for us to feel confident in labelling any particular painting 'Rembrandt's father.'

THE OLD WOMAN: REMBRANDT'S MOTHER? | In the case of 'Rembrandt's mother' something like the opposite is the case. There is a perfectly good candidate – the only old woman Rembrandt portrayed in Leiden, who appears in five paintings (figs. 26, 29, 58, 60) and six etchings. But what evidence is there that she is the painter's mother? Not until 1679, in the inventory of the estate of the Amsterdam art dealer Clement de Jonghe, is mention made of Rembrandt's mother, as the subject of an etching plate that cannot be identified.

This is a bit too late in the game and too far afield to be considered compelling evidence. Moreover, the same old woman also sat for Lievens and Dou, so that her tie to Rembrandt was not exclusive.

We do know from Orlers that Jan Lievens was praised highly for a youthful painting of *his* mother, who died in 1622. The closeness and the competition between the two young masters – especially Rembrandt's habit of taking over themes from Lievens – makes it not unlikely that Rembrandt imitated him in this as well, which would strengthen the case for regarding the old Leiden woman as Neeltge Suydtbrouck. Another small piece of bolstering evidence is that one of Rembrandt's etchings of the old woman is dated 1633, and his last painting 1639, when Rembrandt was living in Amsterdam. An old Leiden woman appearing in works of the Amsterdam period, one would say, is more likely to be the artist's mother than a hired studio model.

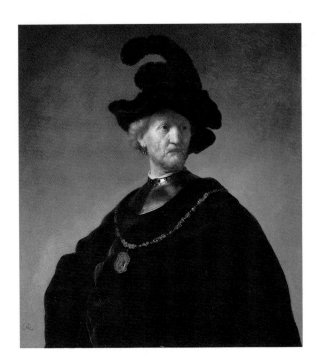

54 *An old man in a gorget and black cap.* Signed *RHL*. Ca. 1631. Panel, 83.5 x 75.6 cm. Bredius 81. Chicago, The Art Institute.

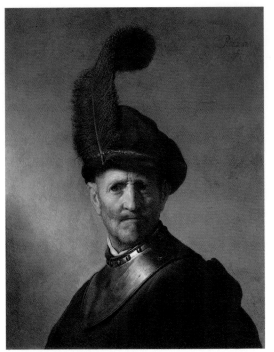

55 *A man in a gorget and plumed cap.* Signed (falsely) *Rembrandt f* over a (genuine?) *RHL*. Ca. 1631. Panel, 65 x 51 cm. Bredius 79. Malibu, The J. Paul Getty Museum.

In 1630 and 1631 dozens of paintings of the same few old men emanated from Leiden, apparently from the studio where Rembrandt, Lievens, Dou, Jouderville and perhaps others, were working. Nearly all of them have been attributed at one time or another to Rembrandt. Of the sixteen works of this kind that were still accepted as authentic in 1935 by Abraham Bredius, only two are included in the *Corpus of Rembrandt paintings*. None of the fourteen others have been reassigned by the authors to another hand. This gives the 'fathers' and other early old men the highest mortality rate of any group of Rembrandt paintings.

The impressive painting of the old woman in Windsor Castle presents us with a delectable puzzle (fig. 58). The evidence suggests strongly that the painting was ordered by Constantijn Huygens for the stadholder in order for it to be presented to an English emissary who in turn gave it to Charles I. X-rays reveal another head beneath the surface, that of an old man (fig. 59), which Rembrandt apparently covered when still wet. The X-ray image is described by the Rembrandt Research Project as a man 'with deep-set eyes, a long nose, a protruding ear, one lock of hair over the top of the head and others to the side' – and of course he also had a long, wavy beard. The same model appears in works by Lievens and Dou, in different poses, but in no other known work by Rembrandt.

The same head *is* found, however, in an amateur drawing of 1645 after a lost painting by Rembrandt (fig. 57). At the age of sixteen, Christiaan Huygens, the future mathematician and scientist, and the son of Constantijn Huygens, wrote to his brother Lodewijk in The Hague: 'I have copied [in dry colours] the head of an old man by Rembrandt painted in oils. You can hardly see the difference [between the pastels and the oils].'

The painting of the old woman left a trace of a different kind. In his last will, the painter Jacques de

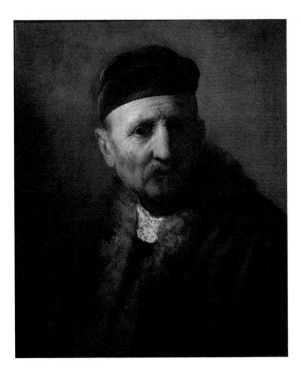

56 *Bust of an old man in a cap.* Ca. 1630. Panel, 46.9 x 38.8 cm. Bredius 77. The Hague, Mauritshuis.

Despite the many apparent similarities between this work and fig. 53, and despite the fact that the panel for the painting in The Hague was hewn from the same tree as that for figs. 29 and 113, the Rembrandt Research Project denies that Rembrandt could have painted this old man. They point out a certain crudeness in the handling of paint, an unusual yellowness in the skin and redness in the eye, and especially 'a lack of formal clarity' in the illuminated eye. Others will have to decide whether their judgment is a triumph of connoisseurship or a case of what can happen to you if you stare for too long at the same thing.

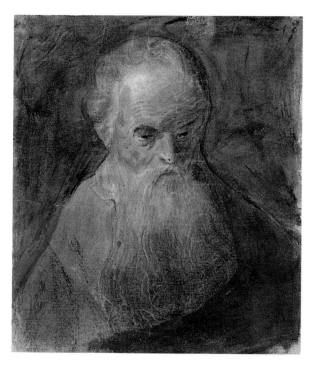

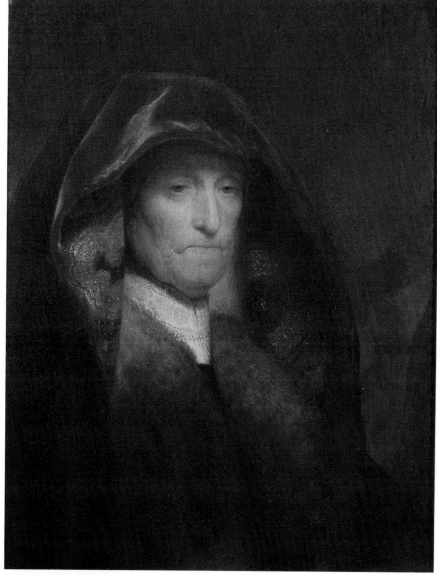

57 Christiaan Huygens (1630-1695) after Rembrandt, *Head of an old man.* 1645. Graphite, black and red chalk and black wash on paper, 18.1 x 16 cm. The Hague, Gemeentemuseum.

As students in Leiden, Christiaan and his brother Constantijn Jr. are known to have had drawing lessons from Pieter Couwenhorn (see p. 53). He was probably the one who gave Christiaan the assignment to copy the Rembrandt.

The only documented Rembrandt of an old man in a Leiden collection is a 'head of an old man, being the portrait of Master Rembrandt's father,' listed in 1644 as part of the estate of Sijbout Symonsz. van Caerdecamp, from a family of Leiden

notaries. If it can be shown that this was the work copied by Christiaan Huygens, then we may have the vital clue to a more reliable identification than before of Rembrandt's father. The same old man seems to have sat as model for one of the *Two old men* of 1628 (fig. 83) that also belonged to Jacques de Gheyn III, like fig. 56. See also chapter 15.

58 *Rembrandt's mother(?).* Ca. 1630. Panel, 61 x 47.4 cm. Bredius 70. Windsor Castle, H.M. Queen Elizabeth II.

This splendid painting, like fig. 45, was presented by Lord Ancrum to Charles I in the 1630s. It was not until long after the artist's death, however, that his works began to be collected in England.

The description of a painting owned by Jacques de Gheyn III in 1641 comes so close to this work that we can only assume that a copy was made for that court artist by Rembrandt or someone in his studio. Another copy, a miniature on vellum signed by the unknown monogramist *WP* (Rijksmuseum), was in the collection of the Dutch stadholders.

59 *X-ray of lower right of fig. 58.*

The head of a bald, bearded old man looking down and right was sacrificed by Rembrandt when he re-used the panel on which it was painted for the portrait of his mother in Windsor Castle. Apparently, however, he had already made a copy of the head. See fig. 57.

Gheyn III bequeathed to Maurits Huygens, Constantijn's brother, a 'life-size painting of an old face, the head covered with [a cloth of] purple velvet lined in gold linen.' The painting is mentioned in the same breath as Rembrandt's portrait of de Gheyn himself, which was also left to Maurits Huygens (see below, p. 92).

As if it isn't remarkable enough that these records – one in pastel by Huygens's son, the other in words intended for his brother – match the underlying and upper surfaces of one and the same panel, there is the additional puzzle that the painting to which they refer, ordered by Huygens himself, was sent to England as soon as it was finished, years before de Gheyn's will was written or Christiaan Huygens's copy was drawn.

It is no use attempting, on this scant basis, to reconstruct the relationship between the painting in Windsor Castle, the one in Jacques de Gheyn's will and that copied by the young Huygens in Leiden, where he was studying. All that we can say is that Huygens, his family and Jacques de Gheyn III were in the thick of the action. The incident also provides additional evidence that Rembrandt sent some of his Leiden paintings into the world in more than one version. This interesting fact makes one wonder just how sensible it is to look for the one and only authentic version of each Rembrandt subject of which we know.

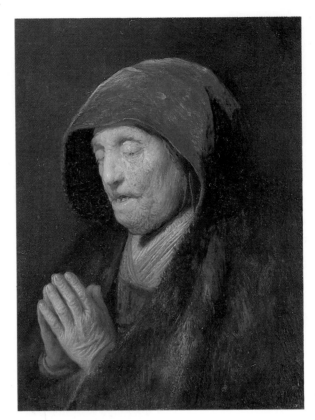

60 *An old woman (Rembrandt's mother?) praying.* Signed *R*. Ca. 1630. Copper, 15.5 *x* 12.2 cm. Bredius 63. Salzburg, Landessammlungen – Residenzgalerie.

The third of Rembrandt's paintings on copper and gold leaf. *See also* figs. 46 and 49. This is the most finely painted of the three, and the only one to be accepted unconditionally by the Rembrandt Research Project.

Paintings for The Hague

Except for six months of training in Amsterdam
under Pieter Lastman, Rembrandt lived in Leiden
from birth until he was twenty-five, and thereafter,
for the rest of his life, in Amsterdam. Yet it is
misleading to divide his career into a Leiden period
and an Amsterdam period or periods, and to leave it
at that. There was a time when most of Rembrandt's
efforts, and perhaps his hopes for the future, were
focused on a place where he never lived, The Hague.
During his last three or four years in Leiden,
Rembrandt's most promising patronage came from
the court of the stadholder. After the move to
Amsterdam in late 1631, he continued to work for
the court. In 1632-1633 he painted at least five
portraits, two paintings of Christ's Passion, and
several mythologies for the court, and in the late
thirties another three Passion paintings. In many
ways, these works are unlike his contemporaneous
paintings for customers in Leiden and Amsterdam,
and deserve separate consideration.

Those at court for whom Rembrandt worked
were the prince and princess of Orange, Frederik
Hendrik and Amalia van Solms, the prince's
secretary Constantijn Huygens, the latter's brother
Maurits, and a court artist who was a childhood
friend of the Huygenses, Jacques de Gheyn III. To
them we can add two non-courtiers: Jacques Specx,
who lived in The Hague before and after his
governorship of the Dutch Indies (1628-1632), and
Joris de Caullery, a wine merchant and lieutenant in
the Hague civic guard.

There is no direct evidence telling us how
Rembrandt broke through to the court at such a
young age as one of the very few Dutch artists not
from Utrecht or The Hague. Two possible
intermediaries have already been mentioned: Jacob
van Swanenburg, who was related to Constantijn
Huygens and worked for the court himself, and the
more influential Joannes Wtenbogaert, cousin of
Jacques de Gheyn III, nephew of the tax-collector
of Amsterdam and son of the paymaster of the

Amsterdam mercenaries. Both van Swanenburg
and Wtenbogaert were from the Remonstrant camp,
and after all that we have said about the prevailing
antagonisms one would assume that this would have
worked against Rembrandt at court.

In fact, the opposite is the case. At the very
moment when Rembrandt was brought to court,
new political developments changed things in his
favour. In the course of 1627, as the English
historian Jonathan Israel has demonstrated,
Frederik Hendrik entered into a tactical alliance
with the Remonstrant factions in all the city
governments of the Republic. For the next few years
he worked through them to get the money he needed
for his military campaigns, while curbing the
Counter-Remonstrants in the cities and at his own
court. The positions of Wtenbogaert's father and
uncle took on a new, national significance. A
recommendation from Joannes in The Hague in
1627 was worth a lot.

The value of his protection was diminished greatly
in the second half of 1633, when Frederik Hendrik
reversed his tactics, stopped favouring the
Remonstrants and unleashed François van Aerssen
and the other Counter-Remonstrants at court. .
From then on, the relations between the stadholder
and the regents of Amsterdam began a long downhill
slide that lasted for twenty years.

As we have already seen, it was in 1627 that
Rembrandt adopted the Utrecht-like style that was
favoured at court, and that he painted his *Hannah
and Simeon*, probably the first painting of his to be
bought by the stadholder. Between 1627 and 1633
Rembrandt received commissions from the
stadholder for at least thirteen paintings. After that
year he was given none at all, except for two in 1646,
under exceptional circumstances.

The following chapters isolate the paintings and
documents of Rembrandt's 'Hague period.' They
tell a story that opens with the promise of great
things to come, only to end in disappointment.

Frederik Hendrik

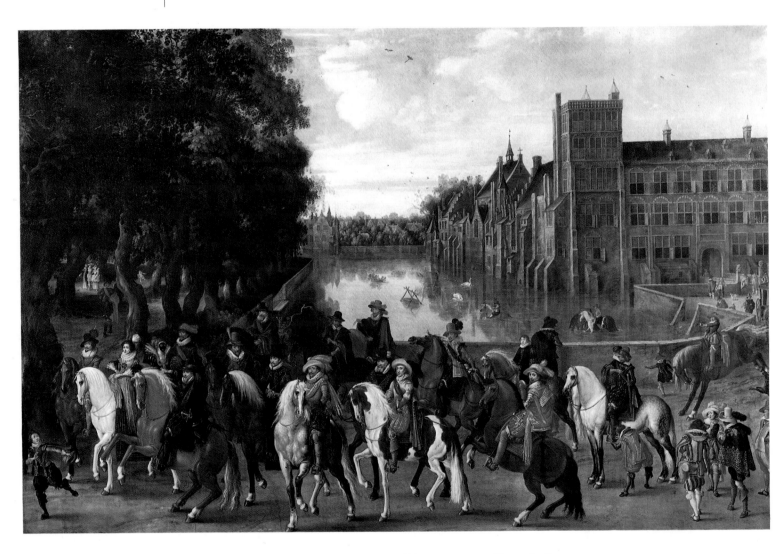

61 Hendrick Ambrosius Pacx (1602/03-after 1658), *A hierarchic cavalcade of the princes of Orange and their families*. Ca. 1625-1630. Canvas, 145 x 214 cm. The Hague, Mauritshuis.

In the right background are the stadholder's quarters, in the block of the Binnenhof (inner court) nearest to us. The Binnenhof as a whole is the former court of the counts of Holland. From the time the northern provinces abjured the rule of Philip II, it belonged to the States General, and the stadholder was considered to be their guest.

The cavalcade is not understood in all its details, but the basic form is clear. Leading the train is Frederick V of Bohemia, the Winter King, and his queen Elizabeth Stuart, daughter of James I of England. The second group, which occupies the foreground of the painting, is formed by the princes of Orange, foremost among them Frederik Hendrik. The riders bringing up the rear are thought to be Willem Lodewijk, the first Frisian count of Nassau, and the count of the Palatine.

The stadholder was unquestionably the most important man in The Hague, but his freedom of movement was hedged in, even in his own court, by the ceremonial and territorial rights of others.

When William of Orange was assassinated in 1584, his heirs were left in a difficult position. The hereditary title that he undoubtedly would have acquired had he lived – count of Holland – was not theirs and never would be: they were still princes of Orange and counts of Nassau, but for a dynasty whose fortunes lay in Holland, there was little consolation and less profit to be had from fiefdoms in the lands of the French king and the German emperor. William's successor as stadholder, his second-oldest son Maurits, did not inherit even those titles directly. They went to the oldest son, Philips Willem (1554-1618), who was a prisoner of Spain and a Catholic. From the moment Maurits became prince of Orange, he was incontestably the most important man in The Hague, a place whose most important man was historically the count of Holland. The very name The Hague, 's-Gravenhage, the count's enclosure, speaks of its subjection to one man. The perennial challenge to the stadholders of the House of Orange was to become that man without being able to lay claim to his title.

THE WINTER KING | In his consciousness of his relationship with the rulers of Europe, Frederik Hendrik was sensitive to the fact that he was not even the highest-ranking nobleman on his own territory. From 1621 to 1632, there was a king in The Hague, complete with a princess of the blood as royal consort and a cultured French-speaking court. The king was Frederick, elector of the Palatinate, Frederik Hendrik's nephew and the husband of Elizabeth Stuart, the daughter of James I of England. He had ruled Bohemia, at the invitation of that country's nobles, for one short year, and was called by the Dutch, half in mockery and half in wonderment, the Winter King. His prospects of returning to Bohemia or to his own lands in Germany were extremely slim, which only made things worse for Frederik Hendrik. For the sake of his country's alliance with England, Frederik Hendrik was forced to help support the extravagant court of a king whose kingship consisted largely of royal airs. Moreover, when his budding dreams of founding a dynasty obliged him to sacrifice his bachelorhood at the age of forty-two, in 1625, he took as his bride one of Elizabeth's ladies-in-waiting, Amalia, countess of Solms.

ART AT THE COURT | Palace-building was of course Frederik Hendrik's first artistic concern. With an eye to Whitehall and the new palaces of his cousin Christian IV in Copenhagen, he set about building even more modern palaces than those. With the

REMBRANDT'S PAINTINGS FOR THE COURT

Between 1627 and 1646, Rembrandt painted an unknown number of paintings for Frederik Hendrik – at least fifteen and perhaps more than twenty – and one for Constantijn Huygens. Some are firmly documented, others have histories suggesting a pedigree from the court, and concerning a final category of undocumented, unpedigreed paintings, there is internal evidence of one kind or another pointing to a court commission. In the following list the three categories are identified with a D for documented, a P for pedigreed and an H for hypothetical.

1627-1628	*Hannah and Simeon in the Temple*, Hamburg (fig. 29). D; may conceivably refer to fig. 97 of 1631
1629-1630	*Samson and Delilah*, Berlin (fig. 69), P
	Self-portrait, Liverpool (fig. 45). D, P
	Rembrandt's mother in a rich scarf, Windsor Castle (fig. 58). D, P
1631	*Christ on the Cross*, Le Mas d'Agenais (fig. 80). H
	The abduction of Proserpina, Berlin (fig. 114). D, P
1632	*Portrait of Amalia van Solms*, Paris, Musée Jacquemart-André (fig. 64). D
	Charlotte de la Trémoille as Minerva, Berlin (fig. 113). D, P
1633	*Raising of the Cross*, Munich (fig. 98). D, P
	Descent from the Cross, Munich (fig. 99). D, P
ca. 1633	*Portrait of the Marquis d'Andelot*, Frederik Hendrik's great-uncle, lost. D
1636-1639	Present for Constantijn Huygens (fig. 123?). Apparently not accepted. D
	The Ascension of Christ, Munich (fig. 105). D, P
1639	*The Entombment*, Munich (fig. 106). D, P
	The Resurrection, Munich (fig. 106). D, P
1646	*The adoration of the shepherds*, Munich (fig. 261). D, P
	The circumcision, lost (copy in Braunschweig, fig. 262). D

Not included are a number of paintings, including a portrait of Frederik Hendrik, which are listed in the House of Orange inventories as Rembrandts, but which are believed to be mistaken entries.

62 *Joris de Caullery (ca. 1600-1661)*. Signed *RHL van Rijn 1632*. Canvas, 102.2 x 83.8 cm. Bredius 170. San Francisco, M.H. de Young Memorial Museum.

The sitter was an innkeeper and wine merchant in The Hague who in the 1630s served as a lieutenant in the civic guard and in later years as a naval officer. He was a court hanger-on with more than a small streak of vanity. In 1635, he was in command of the company of guardsmen who were given the ceremonial task of planting a tree in the prince's court on May Day. He used the hundred-guilder present to have a medal struck showing the tree and the court on the obverse, and on the reverse the rhyme:

In honour of the prince
This Mayday tree
was planted by our
lieutenant
Joris de Caullery.

De Caullery was in the habit of having portraits of himself and his family painted by famous artists. We know of his collection from a document he drew up in June 1654. He was about to go to sea on a dangerous campaign, and, fearing that if he failed to return his portraits would be seized by his creditors, he distributed them as gifts among his children. There were five portraits of himself

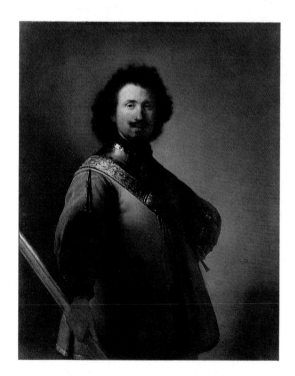

painted by Paulus Lesire of Dordrecht, Moses Wtenbroeck of The Hague, Anthony van Dyck of Antwerp and Jan Lievens and Rembrandt of Leiden, as well as portraits of his wife by Lievens and van Dyck and

one of his son Johan by Rembrandt.
All these artists also worked for the stadholder.

advice of his cousin Johann Maurits of Nassau and his secretary Constantijn Huygens, two gifted patrons of architecture, he had the best living Dutch architects, Jacob van Campen and Peter Post, put up palaces for him in and around The Hague: Honselaersdijk, Rijswijk, Noordeinde, Huis ten Bosch. The first painters to work at the stadholder's court were those Frederik Hendrik had inherited, as it were, from Maurits: the Delft portraitist Michiel van Mierevelt (1567-1641), the Middelburg publisher-painter-engraver Adriaen van de Venne (1589-1662), the Hague artist-scientist Jacques de Gheyn II (1565-1629). They were outstanding artists in their respective genres, and de Gheyn and van de Venne were strikingly intelligent and versatile as well, but none of them made the leap to serious international recognition that would have raised their prestige at home by that much more.

The first Dutch painter to be taken up by the court of the king – and especially the queen – of Bohemia was the Utrechter Gerard van Honthorst. Honthorst did not have to prove himself abroad – he had already done so. Before establishing himself in Utrecht in 1622 he had spent ten years in Rome working for Marquis Giustiniani and Cardinal Scipio Borghese. The patronage of Elizabeth launched Honthorst on the most financially successful career of any Dutch artist of the seventeenth century. In addition to many well-paid commissions for The Hague, for Elizabeth's brother Charles I of England and for the courts of Prussia and Denmark, there were also constant sales to the burghers of Utrecht, who of course were dazzled into paying princely fees for his work. On a lesser scale, Honthorst's fellow Utrechter Cornelis Poelenburgh benefited from the same patronage.

The stadholder's court, for which Honthorst also worked, was not at all as potent a motor of artistic advancement as that of the Winter King. When Honthorst and Poelenburgh went to England with introductions from Elizabeth, they carried away splendid commissions and were treated like celebrities. Lievens, who went there presumably with the recommendation of Frederik Hendrik (see chapter 14), made little impression, and did not get very far.

THE ARTISTIC BALANCE OF PAYMENTS | Apart from prestige and all the other reasons one could have for commissioning and buying works of art, Samuel van Hoogstraten discusses a motivation that is peculiar to a head of state. To us it is interesting because Hoogstraten ascribes it to Henry IV of France, Frederik Hendrik's model as a prince; because he explains how it could be used in Holland;

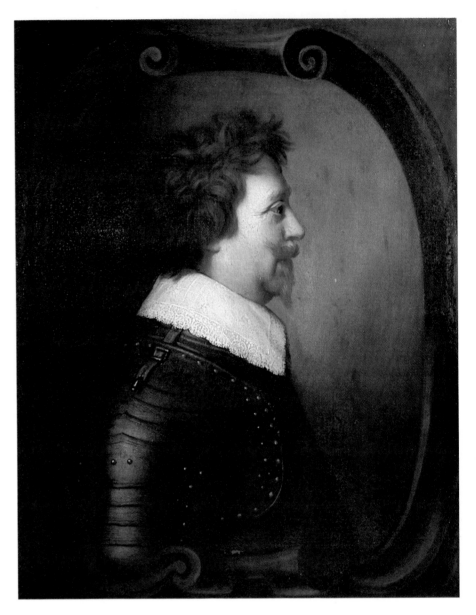

63 Gerard van Honthorst (1590-1656), *Frederik Hendrik (1583-1647)*. Signed and dated 1631. Canvas, 77 x 61 cm. The Hague, Huis ten Bosch.

In the spring of 1631, Frederik Hendrik realized one of his great ambitions, when the States General reserved the stadholdership for his son. Until then his hereditary title had applied only to localities in Germany, France and the Netherlands. Now he had a national position – albeit an office rather than a noble title – to pass on to his son, if not to all his future descendants.

The medals and portraits he commissioned in that year seem to reflect his enhanced status. One of them is this profile portrait by Gerard van Honthorst. Honthorst was the favourite painter of the Winter Queen, and although Frederik Hendrik seems to have kept him at a distance throughout the 1620s, he was now making headway in the stadholder's court as well.

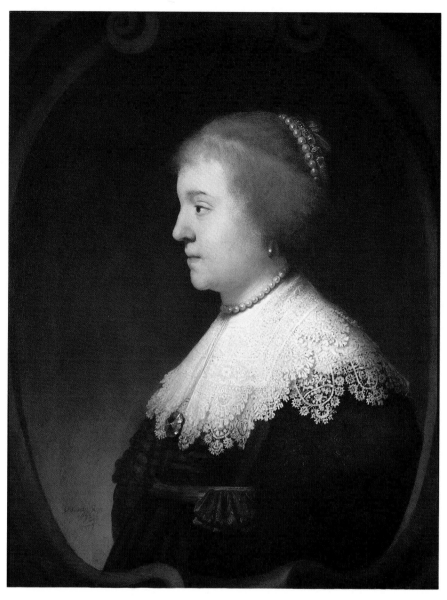

64 *Amalia van Solms
(1602-1675)*. Signed *RH*[L]
van Rijn *1632*. Canvas, 68.5 *x*
55.5 cm. Bredius 99. Paris,
Musée Jacquemart-André.

In 1632, this portrait hung in
Amalia van Solms's 'cabinet,
between [her]two galleries,'
without a companion
painting. Yet the portrait was
certainly modelled after
Honthorst's of Frederik
Hendrik of the year before.

This was one of the two
portraits of Amalia in the 1632
inventory. Jacob van
Swanenburg too executed
more paintings for Amalia
than for Frederik Hendrik.

In 1630, Barlaeus and
Scriverius ingratiated
themselves with Amalia by
publishing, in Latin and
Dutch verse, a letter
purportedly written by her to
Frederik Hendrik at the siege
of 's-Hertogenbosch.

and because it is convincingly down-to-earth. 'Henry the Great, king of France, keenly aware of the amounts of money that left the country every year to buy paintings in Italy, was the first to call into being art of a national character, in order to appropriate for himself that goldmine that in fact has increased so much since then that Italy seems to have been moved to France. To imitate this in some measure, I would like to advise – to supplicate – our high and mighty authorities of the Republic to be aware that painting in our country is at the height of her bloom, as if in a new Greece; … that they devise means by which … the cabinet paintings of our own country … will thrive abroad; that they support the merchants who deal in such; or – and this would be a great honour to art – when their High and Mightinesses are pleased to give presents to neighbouring or distant princes, that these should consist largely of uncommonly good new paintings.'

Frederik Hendrik and the States General did in fact give away paintings – even paintings by Rembrandt – to distinguished foreigners. It is even possible that the stadholder was interested in fostering art of a national character. Virtually all the living artists named in the 1632 inventory of his possessions are Netherlanders, most of them from the north. Patronizing identifiably Dutch artists made sense for his court, but not for the Winter King's, whose nation was Bohemia. This consideration should be kept in mind when reading what Constantijn Huygens has to say about Rembrandt (chapter 13). For the rest, Hoogstraten's remarks echo van Mander's plea for state support of art.

Constantijn Huygens

As a statesman and soldier, Frederik Hendrik was renowned for his prudent dilatoriness. The same characteristic would undoubtedly have marked his behaviour as a patron of the arts if he was the one who had made all the decisions. Fortunately for the artists he patronized, that was not the case. Most of his artistic affairs were delegated to his secretary Constantijn Huygens, who dealt with them decisively and without delay.

Constantijn was born in 1596 as the son of Christiaen Huygens (1551-1624), secretary of William of Orange, Prince Maurits and the Council of State. The family, originally from Brabant, was not landed, not titled and not moneyed; it was up to each of its members to make his own way in the world. Christiaen helped his sons Constantijn and Maurits with the best tutors he could find, men like Johan Dedel, the later chief justice of the high court.

By the time he was twenty, Constantijn was a complete gentleman. He was a prodigy in language, able to converse, correspond and compose poetry of all kinds, from metaphysical sonnets to dialect farces, in all the modern languages and in Latin and Greek. This was not merely a knack – it was a gift. Much of Huygens's poetry still provides enjoyment to the reader who does not mind pondering every line, looking up a lot of obscure words, and missing the poet's point now and then. Huygens had played the lute (he did so divinely, he tells us) for the king of England, and in the course of his life was to write some 800 pieces of music. He commanded a thorough knowledge of physics, astronomy, theology, philology and philosophy and of course architecture and painting. His charm was considerable. As he boasts in a nearly naïve passage in his Latin autobiography, written when he was in his early thirties, it served him well in cultivating the prominent and famous. His confidence in his own taste and judgment was nearly limitless.

When Constantijn, at the rather late age of twenty-nine, accepted his definitive appointment as secretary of the new stadholder, many of his friends felt he was underselling himself. His brother was already secretary of the Council of State, so in a way they were sharing their father's former dignities between them. In one respect those friends were right: Huygens never became a political principal, with vested rights of his own. For sixty-two years he remained a servant to the House of Orange, subject to their favour. But not completely. His spirit remained independent, and what is more he had a powerful protector at court: François van Aerssen, the political Counter-Remonstrant *par excellence*, the Ulysses of Vondel's *Palamedes*. Van Aerssen was one of the authors of the Dutch alliance with France, and therefore a bitter opponent of peace with Spain. Huygens took the same position in the prince's secret council, with such satisfactory results that we find his name on a list drawn up by Cardinal Richelieu of foreign recipients of a French state emolument.

Thanks to his sincere good nature, Huygens was able to support a man like van Aerssen without becoming a Counter-Remonstrant bogeyman himself. He was able to preserve close friendships with the Remonstrant Barlaeus and other scholars and poets in all the parties and factions in the Republic and abroad. Yet he was not always easy to get on with. The atmosphere around Huygens crackled with electricity, from sheer friction.

Huygens was not entirely dependent for his income on the prince. He was an investor in several land development projects, and received a prebend from the Order of St. Catherine in Utrecht. (The actual payment was made by a tax collector of the States of Utrecht named Wtenbogaert, undoubtedly a relative of Joannes.) Such prebends were paid out of the income from lands that had been seized in the Reformation from the Catholic church. They were managed for the benefit of a small, select group of patricians. What made this strange construction even stranger is that some of the personal

requirements for participation had not been changed in the takeover. A 'bailiff of the order' like Huygens, for example, was not supposed to be married, and when he took a bride in April 1627 he required special dispensation from Utrecht in order to hold on to his prebend.

In later years Huygens married off his son, and Joannes Wtenbogaert his daughter, to the granddaughter and son respectively of Frederik Hendrik's banker, the Amsterdamer Guillelmo Bartolotti van den Heuvel. (For one large loan of several million guilders, the Bartolotti group held Amalia van Solms's jewels in pledge.) From the moment they first learned of each other's existence, Huygens and Joannes Wtenbogaert must have been aware of the similarities in their positions. Both of them were non-aristocrats who owed much of their influence and wealth to the same patrons.

For the first twenty years of his career, Huygens was the junior of Frederik Hendrik's two secretaries, and he had to exert extra effort to maintain his position. Not only did he take care to shine in his official duties, but he also cultivated the adornments to court life of which he was a master: music, architecture, learning, poetry and painting. When Rembrandt came his way, he saw in him an artist who could add great lustre to the prince's court. It can only have been Huygens who stimulated court patronage of Rembrandt. By April 1633, however, his enthusiasm had cooled to freezing point. He wrote a series of perfectly insulting poems on a Rembrandt portrait (p. 97), and stopped giving him commissions. From Rembrandt's first letter to Huygens, we know that the final commissions of the 1630s – probably from mid-1633 – came not from Huygens but the prince himself. For a few years Huygens was Rembrandt's greatest admirer, and then he turned against him.

CONSTANTIJN HUYGENS ON REMBRANDT AND LIEVENS

In 1629 or 1630, the thirty-three-year-old Constantijn Huygens wrote an autobiographical memoir that is one of the most interesting first-person documents of the seventeenth century. In it he reviews his family and personal history as well as the life and times of the great men he knew.

At the end of a section on the artists of his acquaintance, a veritable who's who of Dutch art at the time, he devotes a self-contained block of text to Rembrandt and Lievens. The essay is famous, but it seems never to have been translated in its entirety from Huygens's difficult Latin into any other language but Dutch. The following version is based on the Dutch translations by A.H. Kan and L. Schwartz, and on the invaluable advice of Dr. P. Tuynman concerning the passages on the works of the two painters. Some of his notes were published in volume 1 of *A corpus of Rembrandt paintings* in 1982. Dr. Tuynman has shown that Huygens's critical vocabulary is that of classical and Renaissance rhetoric. With his help, an attempt has been made to arrive at a correct understanding of the way Huygens applied those terms – the only critical terms at his disposal – to the art of painting.

The outline in the margins represents the present author's analysis, inspired by certain of Dr. Tuynman's observations, of the structure of the essay. As the reader will notice, Huygens is not the disinterested critic he is usually taken for. The point of some of the most important sections in the text has to do with Huygens's own career as a courtier, a poet and the instrument of Frederik Hendrik's cultural politics.

I INTRODUCES TWO YOUNG ARTISTS BY

A Their artistic rank and future potential

B Their family background, from commoners, which provides the author with an argument against nobility of blood. [A sensitive issue to Huygens, whose measure of blue blood was distinctly dilute for his position at court], and

C their training, under inferior masters.

I have deliberately held in reserve for the last a noble pair of young men from Leiden. [Huygens has just gone over the longish list of Dutch artists he knew, telling a bit about their specialties and backgrounds.] To say that they alone are destined to equal the greatest of the superior mortals I have described above [including Rubens] would yet beggar their achievement; if I predict that they will soon surpass them, I will not be exceeding the expectations that their astonishing beginnings have aroused even among those [art-lovers] of the most conservative cast.

Their family background forms the weightiest argument I know against the so-called nobility of blood. For that matter, I recall that those who pride themselves on that quality alone, as some do, were put squarely in their place by that keenest of Italians Trajanus Boccalinus, a modern author with an eminently sensible and clear way of expressing himself. In a story about the autopsy of a nobleman, he tells that the physicians who were present examined the blood vessels minutely and then denied unanimously that nobility was seated in the blood, since this man's was no different in any way from that of a commoner or peasant.

One of my young men has an embroiderer – a commoner – for a father, and the other a miller, though of quite a different grain than himself. Who could fail to be amazed to see such miracles of talent and ability produced by such everyday instruments. As for the teachers they are known to have had, I find them to be the kind that barely merit praise from the man in the street, the kind to whom one sends such beginners because their

D Conclusion: they owe their artistic rank only to themselves, not to their background or training.

II CHARACTERIZES THE TWO BY

A name,

B appearance and

C works, delegating the latter task to the painters themselves. Riding a hobbyhorse, wishes they would keep a written record of their works, as he wishes Rubens would.

III HUYGENS'S OPINION of their relative merits.

A Qualities in which Rembrandt surpasses Lievens, and

B vice versa.

IV HUYGENS LINKS THE OPINIONS UNDER III to his readings of the characters of the two.

A Lievens
B Rembrandt

V PITS THE YOUNG DUTCHMAN REMBRANDT against all the artists of Italy and classical antiquity, taking

A *Judas* as an example. Describes the main figure in pregnant terms

parents are of course unable to pay more than a modest fee. If you ask me, they would be as embarrassed to see their former pupils today as would the teachers who taught Virgil poetry, Cicero rhetoric and Archimedes mathematics. To give each his due without hurting the feeling of either [masters or pupils] – and what do I have to gain from that? – let me put it this way: the youngsters owe nothing to their teachers, and all to their own gifts. In fact, I am actually convinced that even if no one had set them an example, even if they had been left on their own all their lives and developed a strong inclination towards painting, they would have reached the same heights they have now attained – under guidance, as people erroneously believe.

The name of the first one, who I have called the embroiderer's son, is Jan Lievens, and the second, who comes from a miller's family, is Rembrandt – both beardless, with the frames and faces of boys rather than young men. It would exceed both my abilities and the purpose of this [memoir] to examine their individual paintings and the way each of them works. I only wish that they would do what I said I wanted Rubens to do, that is keep a record of their work, a list of their paintings. A book with the works of each described in a few lines would be a source of wonder and profit to future ages, summing up the methods and reasoning behind the way they conceive, compose and work out their individual paintings.

As to my own opinion concerning the two, I dare say no more than this: Rembrandt surpasses Lievens in the faculty of penetrating to the heart of his subject matter and bringing out its essence, and his works come across more vividly. Lievens, in turn, surpasses him in the proud self-assurance that radiates from his compositions and their powerful forms. Because Lievens's spirit – and this is due in part to his youth – is charged with the great and the glorious, he is inclined to depict the objects and models before his not life-sized but larger than life. Rembrandt, on the other hand, obsessed by the effort to translate into paint what he sees in his mind's eye, prefers smaller formats, in which he nonetheless achieves effects that you will not find in the largest works by others. The painting of the repentant Judas returning to the high priest the pieces of silver, the price of our innocent Lord, illustrates the point I wish to make concerning all his works. It can withstand comparison with anything ever made in Italy, or for that matter with everything beautiful and admirable that has been preserved since the earliest antiquity. That single gesture of the desperate Judas – that single gesture, I say, of a raging, whining Judas grovelling for mercy he no longer hopes for or dares to show the smallest sign of expecting, his frightful visage, hair torn out of his head, his rent garment, his arms twisted, the hands clenched bloodlessly tight, fallen to

(citing it as an argument in a polemic the author was engaged in elsewhere, concerning the possibility of surpassing the ancients), claims that it unites particulars with universals, and since

B The ancients were incapable of even thinking in such terms, concludes that

C the Dutchman Rembrandt has performed a greater feat than the ancients, and has moreover

D raised Dutch art above the level of ancient.

VI LIEVENS'S CHARACTER.

A Positive features, recapitulated from IV A and restated.

B Negative ones, which

the author reproves with the help of Scripture and the classics.

VII LIEVENS'S CAREER.
A Positive: Productivity

Excellence as portraitist.

B Negative: Above-mentioned character flaw prevents Lievens from taking advantage of his greatest strength,

his knees in a heedless outburst – that body, wholly contorted in pathetic despair, I place against all the tasteful art of all time past, and recommend to the attention of all the ignoramuses – I have disputed them elsewhere – who hold that our age is incapable of doing or saying anything better than what has already been said or the ancients have achieved. I tell you that no one, not Protogenes, not Apelles and not Parrhasios, ever conceived, or for that matter could conceive if he came back to life, that which (and I say this in dumb amazement) a youth, a born and bred Dutchman, a miller, a smooth-faced boy, has done: joining in the figure of one man so many divers particulars and expressing so many universals. Truly, my friend Rembrandt, all honour to you. To have brought Ilium – even all of Asia Minor – to Italy was a lesser feat than for a Dutchman – and one who had hardly ever left his home town – to have captured for the Netherlands the trophy of artistic excellence from Greece and Italy.

My earlier parenthetical remarks about Lievens have already shown well enough, I believe, what kind of person he is: an inspired young man who, if he is not nipped in the bud, gives promise of I don't know what kind of greatness. His strength lies in his judgment on the most miscellaneous matters, which is incisive, profound and more mature than that of a grown man. In conversations with him, I have been able to put this quality to the test more than once, and the only point on which I must fault him is that, perhaps as a result of his excessive self-confidence, Lievens is as stubborn as they come. Either he brushes off criticism completely or, if he acknowledges it, does so with bad grace. This flaw would deface people of any age, but in a youngster it is especially baneful. Aren't people always saying that 'a little leaven leavens the whole lump' [Galatians 5:9], and doesn't Scripture say of the person in the grip of this or a similar vice that 'he deceives himself' [Galatians 6:3]? Much wisdom can be acquired by the man who, in the conviction that God metes out to each 'a sufficiency, with sparing hand' [Horace, *Carmina*, 3.16.44], and that no one on earth can do everything, accepts the premise that if one opens one's susceptible mind and receptive spirit to another, there is no one from whom nothing can be learned.

The oeuvre of this youngster is immense for his years; seeing the artist on the one hand and the enormous number of his paintings on the other, it defies comprehension how a stalk as thin as that can produce such a bounty of fruit.

What he does in portraiture borders on the miraculous, and if this vast but unruly flood of talent, which is now so full of ambition and daring that it dominates his entire character, could only be dammed, one could persuade him, to his advantage, to specialize in that branch of art that is the

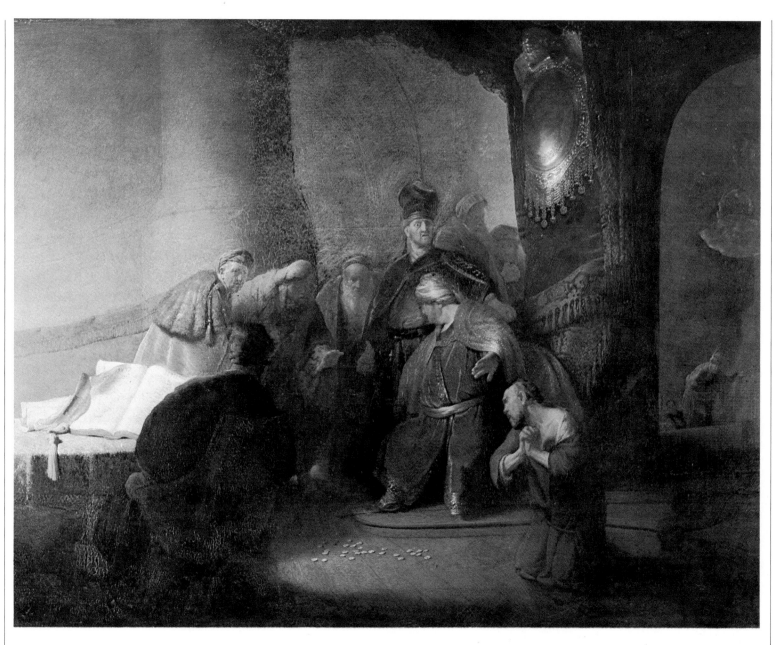

65 *The repentant Judas returning the thirty pieces of silver to the chief priests and elders* (Matthew 27:3-9). Signed *RL 1629*. Panel, 79 x 102.3 cm. Bredius-Gerson 539A. England, private collection.

This is without a doubt the painting that Constantijn Huygens had in mind – or in front of him – when writing the passage in his autobiography on Rembrandt's *Judas*. The preparatory drawings and X-rays bear out Huygens's characterization of Rembrandt as an artist who creeps inside his subject and belabours it endlessly. The Rembrandt Research Project has distinguished three stages through which the composition passed between early 1628 and some time in 1629.

The closest known antecedent to the rare subject is one of the prints in the series of penitents by Willem van Swanenburg after Abraham Bloemaert, with captions by Scriverius, on which Rembrandt drew so often in Leiden. The pose of Judas is a variant on that of St. Peter in the same series (fig. 28).

According to van Mander (fol. 275b), the idea for a series of six penitents was born around 1584, when Cornelis Ketel painted the Amsterdam mystic Rutger Jansz. as the repentant St. Paul for one Hans Ophoogen.

The patron then ordered a copy of the painting, filled out with five other penitents – the same group, including Judas, as in van Swanenburg's prints – for his brother Thomas in Danzig.

Probably without knowing any of this background, Huygens singled out exactly that aspect of the paintings for praise: Judas as an exemplar of the penitent. What particularly impressed him was that Rembrandt's Judas is both 'the penitent' in general and a portrayal of one repentant man, complete with an astonishing number of perfectly observed psychological and physical particulars.

When he says that the demigods of Greek art could not even conceive of what Rembrandt accomplished, Huygens apparently means that the Greeks thought exclusively in terms in ideal form. He sees Rembrandt as the first champion of a new Dutch art that would analyze and pin down phenomena that earlier art had only been able to handle as categories.

Huygens himself had attempted to improve on the Greeks in a comparable fashion. In 1625 he published a volume of Dutch poetry under the Greek title *Characteres*. Each poem was, in Huygens's word, a 'print' of one type of humanity, compounded of an accumulation of observations from nature.

Judas remained in Rembrandt's hands. For decades he lent or hired it out to be copied by various artists, including several who had invested in the business of Hendrick Uylenburgh.

in an area of great spiritual depth: portraiture, insisting instead on competing with Rembrandt on ground where the latter is unbeatable: history painting.

C Proofs of success. Paintings of heads in collection of stadholder and three other court officials, as well as

the portrait of Huygens himself, whose flattering story he tells, and which is greatly admired by good judges of art.

wondrous compendium of the whole man – not only man's outward appearance but in my opinion his mind as well. For when it comes to what we usually call history painting, this masterly, admirable artist will not easily equal Rembrandt's powers of evocation.

In the collection of my prince [the stadholder] there is a portrait of a so-called Turkish commander for which some Dutchman or other posed; [Thomas] Brouart, [the prince's treasurer,] owns the wrinkled head of an old man, a so-called philosopher; [Jacques] de Gheyn [III] has one or two heads – I'm not sure how many – of children; [the Amsterdam tax collector Nicolaas] Sohier has several [heads] that Lievens painted long ago as a boy – piece for piece paintings of incalculable value and incomparable artistry. May their maker be long among us.

If I may be allowed an aside: before I even knew Lievens, my brother and I happened to see him, and he was seized with such a desire to paint my portrait – which I was pleased to let him do, on the condition that he come to The Hague and stay with me, as indeed he hurried to do only a few days later – that, he told me, from that moment on he could not sleep well at night, and was unable to attack his daytime labours with fresh energy. My face was always in his mind's eye, preoccupying him so much that impatience to satisfy his urge finally got the better of him, and he seized the first opportunity to leave that presented itself. He did this moreover in spite of his habitual aversion – the astonishing consequence of being blessed with great powers of imagination – to painting anything from life. Because winter had already set in, and the days were at their shortest, while I myself was so busy that I was unable to give him enough time, he contented himself with painting – elegantly and perfect in the details – my clothes and ungloved hands, postponing the face until early spring, when he once more was so impetuous that he showed up long before the appointed day. Such intense dedication did not fail to leave its mark on the painting when he finally finished it, and it is so delightful that I shall always keep it out of esteem for its distinguished author. Not a day passes without [Michiel van] Miereveld or [one of] countless others studying it in vast admiration, although there are those who claim that the pensive expression on the face belies my geniality. [In the painter's defense,] I must point out that, as I freely admit [to those critics], this is entirely my own fault, since I was weighed down at the time by serious family matters, and although I tried to keep my worries to myself, I apparently displayed them for all to see in my features and eyes, as one always does.

Yet I cannot help but criticize these two otherwise outstanding youngsters, whom I can hardly stop talking about, for one flaw:

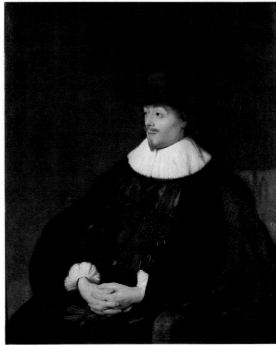

A Both Lievens *and* Rembrandt are so opinionated that

B they refuse to visit Italy.
This is a psychological aberration the cure of which would

allow them to repair their art,

study Raphael and Michelangelo, and better [them, the present greatest masters, and thereby] all existing art [the ancients, as we know from V, have already been bettered by Rembrandt], so that Holland would take over the artistic role now filled by Italy.

C Their feeble excuses for not doing so:
the journey is dangerous and a waste of precious time, there are better Italian paintings in the north than in Italy.

IX CONCLUDING REMARKS on their behaviour.

A Positive. The boys are exceedingly industrious and single-minded to an extreme, qualities which however entail the

as I have already said of Lievens, they are know-it-alls, and do not think it worth their while to sacrifice the few months that it would take them to visit Italy. This is plainly a touch of idiocy in intelligences that in other respects are quite exceptional, and he who succeeds in driving it out of these young minds will have given them more than they need to repair the only lack in the perfection of their art. Oh, how I would like them to become acquainted with Raphael and Michelangelo and to take the pains to absorb the monuments of these great minds with their own eyes. How quickly would they then be able actually to surpass all, so that [from then on it will be] the Italians [who would] come to Holland [rather than the other way around] – these two who, whether they know it or not, were born to raise art to consummate perfection. Nor will I pass in silence over the pretext with which they always seek to excuse what is nothing but sheer laziness: they say that their responsibility towards the best years of their lives leaves them no time to waste on a pilgrimage; moreover, they say that the kings and princes of northern Europe have been collecting with such possessive avidity that nowadays the best [Italian] paintings are to be found outside Italy, so that the things one would laboriously have to track down in various locations [there] are presented to you here on a silver platter in well-chosen collections. Concerning the validity of these mitigating arguments I will not pass judgment. What I do wish to state, with my hand on my heart, is that I have not encountered such diligence and dedication in people of any quality, occupation or age whatsoever. It is absolutely true that they 'make the most of their time' [Colossians 4:5] and do nothing else besides.

66 Jan Lievens (1607-1674), *Constantijn Huygens (1596-1687)*. Ca 1628. Panel, 99 x 84 cm. Amsterdam, Rijksmuseum (on loan from the Musée de la Chartreuse, Douai).

Begun in the winter either of 1627 or 1628, and finished the following spring. Huygens's story of how the portrait came into being is a rare account of the genesis of a seventeenth-century portrait by its sitter. Of particular interest is that it was made upon the instigation of the artist.

A similar incident took place a few years later, when the architect and painter Jacob van Campen was seeking contact with Huygens. In July 1633, van Campen asked a mutual friend, Joannes Brosterhuysen, to write to Huygens that 'Mr. van Campen is very eager to paint a white [portrait of] you to match Lievens's black one. He asks if he can have the painting, frame and all, to measure it and see how the face and figure are placed. So please pack it in a crate with enough room for another piece like it – he will return it with its contents doubled.'

Hardly had one done a piece of good work at court than competitors began breathing down one's neck to show that they could do better.

VIII CRITICISM OF MAJOR FLAW, already alluded to in VIB.

B negative features of driving themselves too hard and sapping their strength. [Huygens has already touched on this in VIA and VIIC], with regard to Lievens's health].

Moreover, to make the miracle complete, they are less tempted by the innocent pleasures of youth – which they naturally consider a waste of time – than the couple of old men they resemble, full of years and far beyond such futilities. How often have I not wished that these marvellous boys would ease up on the unrelenting energy they put into their all-consuming occupation – even if that is the way to make great leaps forward – for the sake of their weak bodies, which have already been robbed of youthful vigour by their sedentary way of life.

We will be returning below to several of Huygens's fascinating observations. One thing that should be pointed out at once, though, is that Huygens was a dilettante of the visual arts, not a professional. He was not soaked in the sources and the life of the studio, as were Rembrandt and Lievens. His relative ignorance on this score, along with the specific nature of his interest in Dutch art and his own stubbornness, which should not be overlooked, lead him into several serious misjudgments.

Huygens becomes vehement and even a bit vicious when his young friends turn down his good advice: Lievens will not specialize in portraiture, and both artists refuse to visit Italy. Lievens's behaviour, he says, is due to a personal aberration that is sure to bring about his ruin, which would be too bad for him, since, Huygens implies, he stands a good chance of succeeding the present chief portraitist of the stadholder's court, van Mierevelt. But by refusing to visit Italy, the youngsters are probably robbing their nation of a unique chance to become the leading artistic power in the world, which, we read between the lines, would be a tragedy not for them but for him, Constantijn Huygens. In a matter of months, he fantasizes, these artists of the stadholder's court could, under his patronage, become the greatest painters in the world. All they had to do is visit Italy, size up the present champions, Raphael and Michelangelo, and improve on them. He knows that they – and they alone – can do it, but the idiots, for reasons that are too ridiculous even to dispute, won't listen to him.

As the reader is aware, however, Rembrandt and Lievens were not being wilful at all. They let themselves be guided by the wisdom of the studio, as we know it from van Mander. By keeping his distance from portraiture, Lievens was bravely avoiding the path of least resistance to a lucrative but unpraiseworthy career. As for Rome, van Mander calls it the

…chief of Pictura's schools

But also the place where dissipate fools
And prodigal sons consume all they own.
Where parents are worried to send off their son.
We know at first hand many who left
There for home down at heels and bereft.
It's a nourishing ground for folly and sin,
A nest of betrayal, the first origin
Of all of the evil all over the world.
These are the milder charges once hurled
By Petrarch at Rome, and they're hard to
 disprove.

Rembrandt and Lievens as Huygens describes them are in fact living examples of the young artist in van Mander's *Foundations of the noble, liberal art of painting*: they do not waste their time on music, drinking, girls or trips abroad, they avoid bad company and seek out the right workmates, they resist the temptation to make easy money as portraitists and diligently attempt to master all the elements of history painting. Huygens, failing to realize this, berated them for some of their purest features which happened to stand in the way of his own ambitions.

In one of his positive judgments too, Huygens is misled by lack of information. The gesture of Judas that he singles out as Rembrandt's challenge to the art of the past is in fact a stock figure straight out of that past (see p. 75). Abraham Bloemaert had used it before him (fig. 28), and even included the clenched hands in a model book that he left to posterity.

Huygens's distinction between the manners of the two young painters, however, is quite telling. It is even borne out by X-rays, which reveal Rembrandt to have been a fussy worker, and Lievens a quick one. One could wish that he had been less categorical and more open-minded in his judgments. Rembrandt and Lievens, as their later works show, felt the same way.

14 Rembrandt and Lievens

The biographer of Rembrandt is jealous of the attention paid to Jan Lievens in the only two written sketches of the artists that date from their own lifetime – those by Constantijn Huygens (ca. 1630; pp. 73-77) and Jan Jansz. Orlers (1641; p. 79). Sections VI and VII of Huygens's essay, on the character and career of Lievens, have no parallel with Rembrandt; Orlers gives us a few facts and generalities on Rembrandt and paragraphs of detailed information on Lievens.

In the later history of art, the imbalance was redressed with a vengeance. Rembrandt became the subject of a countless stream of articles, books and exhibitions, while Lievens has had to be content with one monograph (1932) and one exhibition (1979). In order to understand the relationship between the two in the 1620s and '30s, one has to try to forget one's preconception of Rembrandt as a great genius and Lievens as one of his many inferior followers, and accept the testimony of the evidence: in their early years Lievens made more of an impression on his contemporaries than Rembrandt.

The following reconstruction is based on archival documents concerning the ownership of paintings, clues contained in the works themselves and biographical conjecture, guided by the near certainty of first-person testimony. In virtually all the evidence, the predominance of Lievens over Rembrandt is implicit, and the opposite view unlikely or impossible.

WHAT WERE YOU DOING ON OCTOBER 4TH, 1618? To begin with, Lievens had a head start. Rembrandt was not apprenticed to his first master Jacob Isaacsz. van Swanenburg until Lievens, his junior by fifteen months, was back from Amsterdam and had set up on his own. Orlers suggests that this happened by October 1618, in his seemingly innocent anecdote about the unflappable young Lievens ignoring the Leiden insurrection.

In that anecdote, Orlers slyly provides Lievens with an alibi for the fateful day when the writer himself was installed by Prince Maurits, by force, in the Leiden city government. If Lievens was back from Amsterdam by then, his association with the Remonstrants of Amsterdam through Pieter Lastman was not a culpable one.

In Leiden, unlike Amsterdam, the replacement of Remonstrants by Counter-Remonstrants took firm hold. For over twenty years, Orlers retained a position of power, which he used to further the career of Lievens – but not that of Rembrandt. Not only did he play a role in getting city commissions for Lievens, he also collected work by him and his brother Dirk for himself and his daughter. They owned more paintings by Lievens than by any other master – and none by Rembrandt.

And where was Rembrandt in October 1618? Safely in school, was he not? Yes, but what then? If our reconstruction of events in chapter 6 is correct, in 1619 – *after* the condemnation of the Remonstrants, when it *was* culpable to be associated with them – Rembrandt accepted the protection of the Remonstrant Petrus Scriverius, and in 1621 that of one of the new Remonstrant councilmen of Amsterdam, Geurt Dircksz. van Beuningen. In 1625 Rembrandt went to work for the always controversial Scriverius. The flirtation with Remonstrantism ran in the family, on the mother's side, which had a Catholic branch dependent on the Remonstrants for political protection. In 1630, the moment her husband died, Rembrandt's mother changed the family notary to the Remonstrant Adriaen Paets, who had been removed from office during the crisis of 1618. The Leideners who collected Rembrandt included a good percentage of Remonstrants and Mennonites, among them the leaders of the Leiden Mennonites, the van Hogemades.

The religion of a painter or the people he worked for did not *have* to play an important role in his career. Lievens is the living proof of that. He was

raised Calvinist, trained Catholic, and worked for Protestants in Holland, Jesuits in Antwerp, for the Dutch court, the English court, the Calvinist city fathers of Leiden and, in later decades, the Remonstrant ones of Amsterdam without offending anyone. He showed the right attitude from the start by keeping his nose clean, and to the grindstone, on October 4, 1618. Rembrandt is an example of an artist who was marked by his association with patrons – in his case, dissident Protestants. The orthodox Orlers, who became burgomaster of Leiden in 1631, may have thought that Rembrandt was too hot to handle.

REMBRANDT IN THE WAKE OF LIEVENS | Because Lievens seldom signed and never dated his early paintings, it is very difficult to reconstruct the artistic give-and-take between him and Rembrandt. The traditional notion that they shared a studio,

although undocumented, is probably correct. If it is, the studio they shared is most likely to have been Lievens's. The only evidence that tells us anything at all on the subject is Orlers's remark that Lievens worked in his father's house. What *is* known is that Lieven Henricxsz. helped 'his son Jan Lievens and three other master painters' (no doubt including Rembrandt) to sell their paintings at auction in 1629. Lievens's father enlisted the aid of the town auctioneer, but the tax arrangements they made were disapproved, and fines were levied on the participants.

Lievens's work as a painter can be traced, like Rembrandt's, from 1625 on. His earliest signed paintings, which date from around that year, are a pair of half-lengths, both showing a boy blowing an ember to life. The motif has a rich history in sixteenth- and seventeenth-century painting, from Correggio and Michelangelo to El Greco, Rubens,

THE BIOGRAPHY OF JAN LIEVENS IN THE 1641 EDITION OF JAN JANSZ. ORLERS, DESCRIPTION OF LEIDEN, PP. 375-377.

Jan Lievens was born in the city of Leiden on October 24, 1607, to respectable parents: Lievens Hendricxsz., a skilled embroiderer, and Machtelt Iansdr. van Noortsant. In view of his strong inclination towards painting, his father apprenticed him at the age of eight or so to the able painter Mr. Joris van Schooten to learn the essentials of that art. In the master's studio he acquired and absorbed not only the principles of painting but of drawing as well.

When he was about ten years old, his father, in view of his strong desire to study and make progress, allowed him to be taken to the famous painter Pieter Lastman, who lived in Amsterdam, in whose studio he stayed for about two years, making great advances in art.

After leaving the above-mentioned Lastman, he took no other master. He stayed in his father's house, filling all his time diligently by painting many different objects from life. This he did so well that the connoisseurs were incredulous, hardly being able to believe that such works were made by a youngster not much older than twelve. Most of these paintings, moreover, were original compositions of his

own. Around that time he copied two excellent pieces by the outstanding painter Mr. Cornelis Ketel of Haarlem, representing Democritus and Heraclitus. He followed them so well that knowledgeable art-lovers were unable to distinguish between the originals and the copies. They were sold from the estate of Mr. Boudewijns as originals and sent to Germany.

In the year 1621, when he was fourteen years old, he painted his mother's portrait so well and skilfully that everyone stood amazed.

He was so industrious and eager to progress in art that he could not be distracted from his goal by anything else at all. This went so far that on October 4, 1618, when there was a tremendous tumult and riot in Leiden between the Remonstrant mercenaries and the regular citizens, with all the doors and windows locked and the magistrates forced to call the militia to arms in order to calm the uprising, he was not upset by it in the least, nor prevented from making drawings of certain prints by Witty Willem [Buytewech] since love of art meant more to him than all the commotion in the world.

In his early years and for

some time thereafter he made many different subject paintings and portraits, which are still held in high esteem today: among those now owned by the heirs of Pieter Huygen du Boys are several portraits and a Cupid with a basket full of almanacs, around his neck a small white-hooped barrel filled with turnips and other vegetables, executed most remarkably. Adriaen van Leeuwen owns the five senses on one panel, Jan van der Graft a Pilate and many other different pieces, too numerous to name.

Some time later he made a life-size figure with a round cap on its head, studying beside a burning turf fire, painted so intelligently that his Highness, my lord the Prince of Orange, had it purchased and presented it to the ambassador of the king of Great Britain, who gave it in turn to his lord the king, and which can still be seen in Westminster.

Driven by the urge to see another country and inspect its opportunities, in the year 1631, being about twenty-four years old, he left for England, where his skilful works promptly made him well-known, even to the king, whom he portrayed together

with the queen his wife, the Prince of Wales his son and the princess his daughter, as well as many great gentlemen. For this he was richly rewarded by the king of Great Britain.

After spending about three years in England, he returned to Calais and from there to Antwerp, where he settled, and where he painted many different outstanding pieces for the Jesuit church as well as for private individuals, to the great admiration of connoisseurs there. In Antwerp he married the daughter of Michiel Colijns, an excellent and skilful sculptor and stonemason. In the year 1640 he painted two extraordinarily beautiful paintings for His Highness the Prince of Orange and the burgomasters of the city of Leiden, the second of which I have mentioned above in my description [of the town hall]. From all I have related in general concerning our Leiden master Jan Lievens, all those with understanding of art many conclude that many skilful paintings can be expected from him in the future.

Honthorst and Ter Brugghen. In this case, however, Lievens was not copying one of these older masters. He was working directly from the even older source – a literary one – in ancient Greece. Pliny, the art historian of the ancients, describes a 'boy blowing a fire' painted by Antiphilus of Alexandria, the rival of Apelles. The Renaissance artists who revived the theme were engaging in an exercise of extreme refinement – recreating from life descriptive passages from ancient literature. In 1624 Joris van Schooten had done exactly this, on a far more ambitious scale, in painting for the Latin School a complex moral allegory based on a doctrine ascribed to Cebes of Thebes. To paint an ekphrasis (Greek for description) was to advertise oneself as a learned painter and an heir to the classical tradition. Somehow, Lievens must have acquired enough education to justify this claim. (His younger brother was to become a Latin teacher; the family was not as backward as Huygens suggests.)

Comparing Lievens's half-lengths of 1625 with the earliest similar work by Rembrandt – the *Soldier* of about 1627 (fig. 50) – we have the feeling that Lievens's chronological lead over Rembrandt was also one of quality. In his works we sense the spontaneity and self-assurance that Huygens speaks of, and the originality mentioned by Orlers. Nearly every category that Rembrandt turned to in these years – character heads, self portraits, mothers, apostles, even history paintings – had already been pioneered by Lievens, with greater ease and mastery than Rembrandt in his first attempts.

The evidence of the market tells the same story. Lievens was collected widely by prominent Leideners and Rembrandt was not. A handful of those who owned paintings by Lievens also had some by Rembrandt, but we know of no one in Leiden, not even Scriverius, who patronized Rembrandt and not Lievens. References to only eleven paintings by Rembrandt have been found in the Leiden archives for the years of Rembrandt's life – six heads, three genre paintings and three whose subject is unidentified. Orlers and his daughter alone owned nine paintings by Lievens.

After Rembrandt left Leiden in 1631, he never painted there again, and no one in Leiden is known to have bought any of the works he did in Amsterdam. Lievens, as we know from Orlers, was called back for an important commission in the town hall. His home town shared in his later success, but not in Rembrandt's.

All of this evidence points consistently in a particular direction. Certainly from 1625, and probably from 1622, Rembrandt followed Lievens's wake in his training, his choice of specialties and his

working arrangements. Leiden saw Rembrandt as a junior associate of the well-known Lievens.

BREAKING THROUGH TO COURT, 1627-1628 | That was until Huygens came upon the scene. In Leiden, Lievens may have been the leader and Rembrandt the sidekick, but in The Hague it was Lievens and Rembrandt and Rembrandt and Lievens, over and over again. Not only in the pages of Huygens's autobiography, but also in the commissions for the court, and even in the 1632 inventory of the stadholder's collections. Confronted with an apparently unsigned Leiden painting, the stadholder's clerk wrote: 'A painting of Simeon in the Temple, Christ in his arms, done by Rembrandt or Jan Lievens.'

As suggested above, Rembrandt had two separate entrées to the court. Jacob Isaacsz. van Swanenburg had recently become related to Constantijn Huygens, a circumstance to which he undoubtedly owed his own commissions for Amalia van Solms. Then there was the young Joannes Wtenbogaert, the lodger of Rembrandt's distant in-law Hendrick Zwaerdecroon, cousin of the court artist Jacques de Gheyn III and the son and nephew of two powerful Amsterdamers.

As for Lievens – from what Huygens tells us about

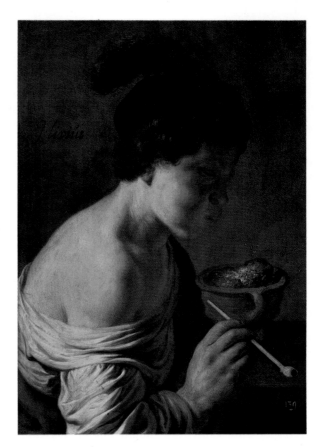

67 Jan Lievens (1607-1674), *Boy blowing a pot of embers to life*. Signed *J. Livius*. Ca. 1625. Panel, 82 x 64 cm. Warsaw, National Museum.

In this clever composition, the light coming from the left leaves the boy's face in shadow. He creates his own lighting by blowing on the coals. The panel has a companion, showing a somewhat older boy lighting a taper from a glowing coal, at night.

The themes of the two works are rich in allegorical overtones, such as the element of fire and the age of youth. Rubens used a similar motif to depict the transmission of the spark of life from generation to generation. The pipe, on the other hand, just as often signifies degeneration, and the coal the love of a whore. We are not sure what meaning Lievens attached to the paintings, which are his earliest signed works.

The signatures, in Latin, lend support to J. Bialostocki's hypothesis that Lievens was recreating in modern guise a work of ancient painting, described by Pliny in this way: 'Antiphulus was praised for a boy blowing a fire to life and for the handsome room that was thus illuminated, along with the boy's own face.' (*Natural history* 35.138).

Three years later, Rembrandt began using a Latinized monogram, a practice he discontinued after he left Leiden. Lievens continued to call himself Livius on occasion all his life.

their first meeting (p. 76), there was no question of an arranged introduction. (Although one does suspect Orlers of having had a hand in the matter.) Huygens and his brother 'happened to see' Lievens, whom they did not know, were unceremoniously clamped on by him, and wheedled into letting Lievens paint Constantijn's portrait. The most likely time for the meeting was October 15th or 17th, 1627. On those days, Huygens and his brother travelled together from The Hague to Amsterdam and back, a journey that took them through Leiden twice. The 'serious family matters' which Huygens tells us are visible in his face in Lievens's portrait would have been his wife's first pregnancy and the birth of their son Constantijn in March 1628.

The breakthrough to the court put the youngsters into a different league. It was not just a matter of prestige to work for Frederik Hendrik. The earnings were incomparably higher than on the open market in a city. We know of only one price for a Rembrandt painting in a Leiden collection: a 'painting in an ebony frame' was appraised in 1649 and again in 1653 at six guilders. The average value of the nine Jan Lievens paintings owned in 1640 by Jan Orlers and his daughter was a little under eleven guilders; that for all 132 of their paintings was eight guilders and some. These figures are typical of small-time collections in Delft as well. The average figure there for a large sample of paintings in the inventories of wealthier collectors was sixteen-and-a-half guilders for a painting with an artist's name attached to it. The biggest single commission ever given by the city of Leiden – the six group portraits of civic guard companies painted in 1626 by Lievens's master Joris van Schooten – was paid for at the rate of twelve guilders a head.

Well, for five paintings that Rembrandt made for the stadholder in the 1630s, he was paid six hundred guilders apiece. The difference between selling paintings to the burghers of Leiden and to the court could be a hundred times more. There was that much at stake for Rembrandt and Lievens in making it at court.

THREE SAMSONS, 1628-1629 | In 1632, Stadholder Frederik Hendrik owned 'a small painting of Samson's hair being cut off, by Jan Lievens of Leiden' (nr. 87). In 1707, the heirs of his grandson Willem III owned a 'Samson and Delilah by Rembrandt' (nr. 41). The two entries correspond nicely with two known works – a small Lievens in the Rijksmuseum (fig. 68) and a Rembrandt in Berlin (fig. 69). Art historians have been reluctant, however, to believe that Frederik Hendrik would have displayed 'a monochrome sketch' in his gallery

(Rembrandt Research Project, vol. 1, p. 256), and have searched for ways of attaching some other work, preferably the Rembrandt in Berlin, to the 1632 entry. Actually, the very next item in the inventory was also a monochrome, made with the pen on panel or canvas, which turns the objection into a piece of positive evidence. I am inclined to accept the obvious and assume that Frederik Hendrik owned two paintings of Samson and Delilah, one by Lievens, of about 1628, and the other by Rembrandt, of 1629. The Rembrandt may have been purchased after the inventory was drawn up. Physical investigation has proved that the monogram and date – an inaccurate date of 1628! – were added by the artist after the paint was dry.

The similarities between the Lievens and the Rembrandt go further than those between any known earlier works by the two. If we look past the overwrought poses of Lievens's figures, we discover that the setting, the attributes, the head of Delilah and the tiptoeing Philistine in his painting served as models for Rembrandt's much more finished composition. We hear the echo of Huygens's words: Lievens plunges into paint and is finished before he begins, while Rembrandt never quite finishes working out the implications of his compositions.

If both works were bought by Frederik Hendrik, then the prince must not have minded owning two quite similar treatments of the same subject. That is to become even more apparent when we discuss the two *Christs on the Cross* of 1631, where Lievens and Rembrandt come so close to each other that one begins to worry about two bodies occupying the same space at the same time. One suspects that Huygens was dropping blunt hints, and that Rembrandt and Lievens were outdoing themselves picking up on them.

A DUTCH GIFT TO AN AMBASSADOR OF CHARLES I, 1629-1630 | Rembrandt and Lievens were quicker to accept Huygens's patronage than his advice. No sooner had the courtier observed that Lievens would be wise to leave history painting to Rembrandt, than the ambitious youngster who could not take criticism began, starting with *Samson*, to paint histories for the court.

Nor would Rembrandt resign himself to the idea that Lievens was good at painting portraits and he wasn't. If no one would give him a commission to paint a portrait, why then he would submit portraits of himself and his mother to the court. It must have been a great satisfaction to Rembrandt when those two paintings (figs. 45, 58) were chosen to be presented to the English diplomat Sir Robert Kerr, who gave them in turn, some time before 1633, to

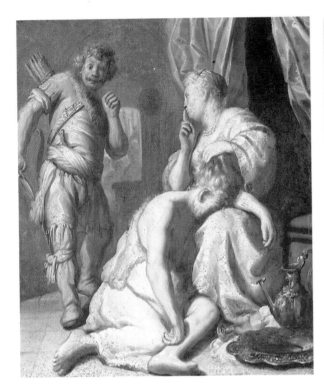

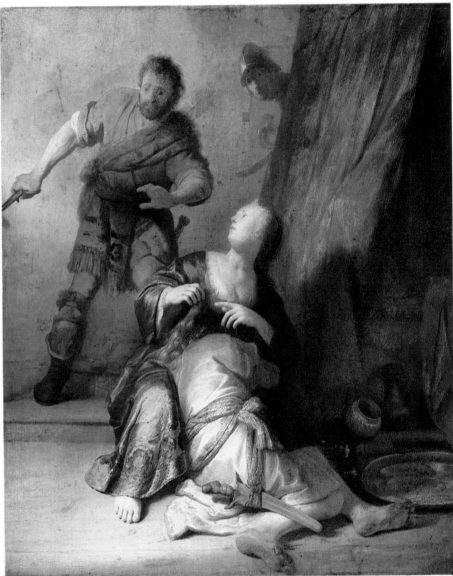

68 Jan Lievens (1607-1674), *The capture of Samson* (Judges 16:19). Ca. 1627-1628. Panel, 27.5 x 23.5 cm. Amsterdam, Rijksmuseum.

At first sight, Lievens's oil sketch looks inept and even comic and I must admit that that is how I saw it for a long time. For once, however, the art historian's fond belief that new information can increase one's appreciation of art actually worked in this case. The Rembrandt Research Project has shown that the Lievens is not a derivative of Rembrandt's *Samson and Delilah* in Berlin – a painting that has always been a favourite of mine – but its model.

With this knowledge, I found myself admiring Lievens's sketch for its originality, daring and spontaneity. This in turn has influenced my judgment of the painting's history. I am now inclined to see it as the painting inventoried in 1632 in the stadholder's collection rather than the left over 'sketch' of Samson that Lievens never sold and which was appraised in his estate at four guilders.

That document of July 3, 1674, by the way, puts Lievens's sad end into guilders and stuivers. After one of the most successful careers of any Dutch artist, he died leaving two hundred guilders worth of goods and debts amounting to over six thousand.

69 *The capture of Samson* (Judges 16:19). Signed and dated *RHL 1628*, but painted no earlier than 1629. Panel, 61.4 x 40 cm. Bredius 489. Berlin-Dahlem, Staatliche Museen, Gemäldegalerie.

The signature and date on the painting were added by Rembrandt later, and the date is undoubtedly too early. Until this was discovered by the Rembrandt Research Project, Rembrandt's painting was always thought to have preceded the oil sketch by Lievens.

Rembrandt carries on where Lievens leaves off, doing everything he can to heighten tension. Although his painting does not have much more colour than Lievens's, his use of chiaroscuro suggests a complete tonal range.

The panel seems to have entered the Prussian princely collections directly from those of the stadholder, but the records are not unambiguous.

Charles I. Both paintings were types of works on which Lievens's early reputation was built. We know of his famous portrait of his mother from Orlers. A self-portrait from the early twenties is preserved in Copenhagen, where it entered the royal collection in the seventeenth century, perhaps even before the Rembrandt self-portrait made it to England (fig. 82).

As Orlers tells us, Frederik Hendrik also bought a work by Lievens for the ambassador of the king of Great Britain, a full-length, life-size painting, now lost, of a student at a fire (see below, pp. 92-94).

FIVE RAISINGS OF LAZARUS, 1630-1632 | In the five treatments of the *Raising of Lazarus* that have survived from 1630 to 1632 – a painting, etching and drawing by Rembrandt and a painting and etching by Lievens – the relationship between the two youngsters begins to resemble rivalry. Lievens, challenging Rembrandt on his own ground, brought

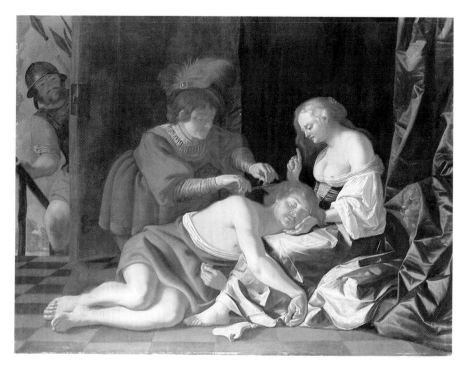

THE CAPTURE OF SAMSON: A CAUTIONARY TALE

70 Christiaen van Couwenbergh (1604-1667), *The capture of Samson*. Signed *CB*. About 1632. Canvas, 156 x 196 cm. Dordrecht, Dordrechts Museum.

The young Delft master Christiaen van Couwenbergh, in his version of the capture of Samson, combines a composition by Rubens (fig. 71) with stylistic devices from the Utrecht school. The painting was bought in 1632 by the town of Dordrecht for seventy-five guilders to be hung in the meeting room of the town hall. (The pensionary of Dordrecht, the moralizing poet Jacob Cats, seems to have been related to the Couwenbergh family.)

The greatest issue before the town government of Dordrecht in that year, as before every important ruling body in the country, was whether or not to accept the peace offer being held out by some of the enemy (among them Rubens!). The council meeting below this painting was certainly meant by the one who hung it there to see it as a contribution to that debate. Samson had allowed himself to be seduced by the enemy, he let the ass's jawbone with which he killed a thousand Philistines drop from his hand, and had thereby helped to bring about his own downfall.

The stadholder's court too was divided over the issue. One of those who was dead against peace was Huygens. If he were the one who ordered the paintings of *The capture of Samson* by Rembrandt and Lievens, then they too were undoubtedly meant to convey a warning against making peace with Spain.

In 1630, Christiaen van Couwenbergh married the daughter of a burgomaster of Delft, the city where William the Silent had held court. It is a curious coincidence that Rembrandt was soon to marry the daughter of a burgomaster of Leeuwarden, the site of the only other court in the Netherlands, that of the Nassau stadholders of Friesland. Saskia's father had actually witnessed the assassination in Delft of William, by whom he had just been received.

Van Couwenbergh was to become one of Frederik Hendrik's favourite painters, with two specialties: paintings of weapons and genre scenes of a type one can only call semi-pornographic. *The capture of Samson* is a happy combination of van Couwenbergh's twin interests, sex and violence.

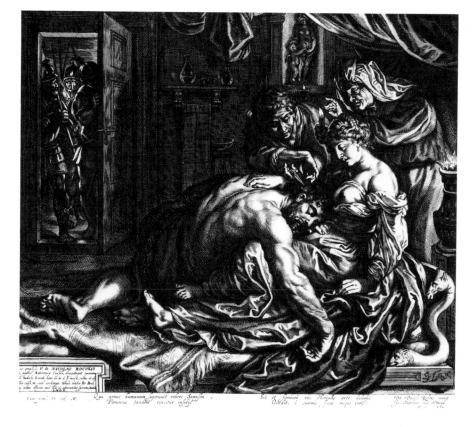

71 Jacob Matham (1571-1631) after Peter Paul Rubens (1577-1640), *The capture of Samson*. Signed. Ca. 1613. Engraving, 37.6 x 44 cm. London, British Museum.

The painting on which the print is based was made in 1610 for Nicolas Rockox, burgomaster of Antwerp, patron of the arts and collector of antiquities. This added to the fame of the painting and the prestige of Rubens.

The print was probably commissioned from the Haarlemer Matham by Rubens himself, when he came to the northern Netherlands after the death of Willem van Swanenburg. That made the composition particularly famous in Holland.

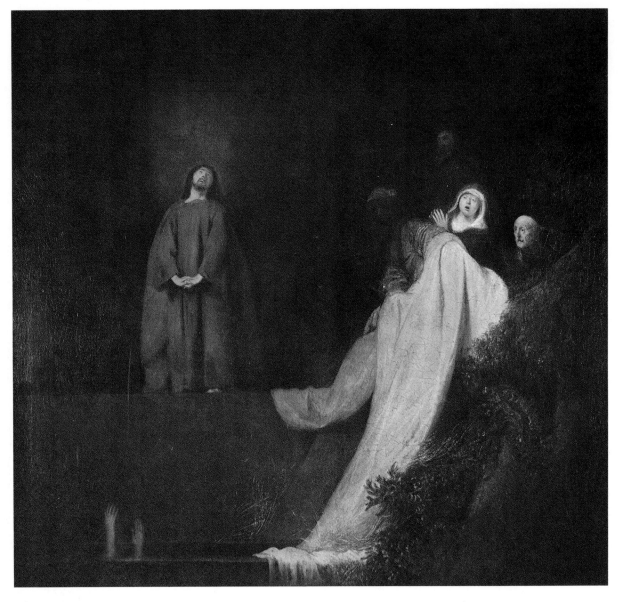

72 Jan Lievens (1607-1674), *The raising of Lazarus*. Signed and dated 1631. Canvas, 103 x 112 cm. Brighton, Art Gallery and Museum.

For the first time, Lievens attempts to achieve big effects with small figures, like Rembrandt.

All the other paintings by Rembrandt and Lievens discussed in this chapter are here said to be commissions from Frederik Hendrik. Only the *Raisings of Lazarus* by the two have no known connection with the court. Since the inventory of Rembrandt's goods (1656) includes paintings of the theme by both painters, it is possible that Rembrandt kept these works for twenty-five years.

his work to the eyes of the world in a large etching, and Rembrandt followed suit. The evolution of the works is not easy to reconstruct. Rembrandt's etching went through ten states, Lievens's three. X-rays reveal that Lievens's painting is done over an older composition, and that Rembrandt's passed through three distinct stages. Even his drawing contains one subject superimposed over another. That yields a total of twenty stages to be compared and placed in chronological order. Only the Rembrandt drawing and the Lievens painting bear dates, and that on the drawing is suspect. The Rembrandt Research Project, on the basis of a close reading of the visual and technical evidence, hypothesizes that Lievens's versions are sandwiched between the early and late stages of Rembrandt's painting and etching. There remain good reasons, however, as we shall see, to adhere to the older view, which placed Rembrandt's etching last.

This time the starting point was a painting by

Rembrandt (fig. 73). Like the earlier *Bileam* and *The baptism of the eunuch*, it is a recasting in vertical format of a horizontal composition of 1622 by Pieter Lastman. On the left are the animated figures of the living – a commanding Christ, Mary and Martha and three old men. Below them (and originally closer to the centre, where the bystanders are still looking) is Lazarus, rising feebly from his tomb.

Lievens responded with a painting in the mood of Rembrandt's (fig. 72). He poses the young women and old men on the right, set off on the left by a quietly praying Christ above an eerie pair of hands reaching out from the grave. As with the *Samsons*, Lievens's forms are more closed, his composition more contained. Lievens's etching (fig. 75) is a fairly straightforward version of his painting (in reverse, as a result of the printing process).

Rembrandt's etching, though (fig. 76), is a new staging of the subject, more dramatic than any of the preceding versions. The corpse rises in the

73 *The raising of Lazarus* (John 11:38-44). About 1630. Panel, 96.2 x 81.5 cm. Bredius 538. Los Angeles, County Museum of Art.

The rivalry between Rembrandt and Jan Lievens is best exemplified in the five known versions they made of *The raising of Lazarus* between 1630 and 1632. Rembrandt's painting was the starting point of the exchange. The X-rays show that the artist changed the composition twice during his work on the panel, probably in response to what Lievens was doing. Lazarus was originally in the centre of the space, where Christ and the others are still looking.

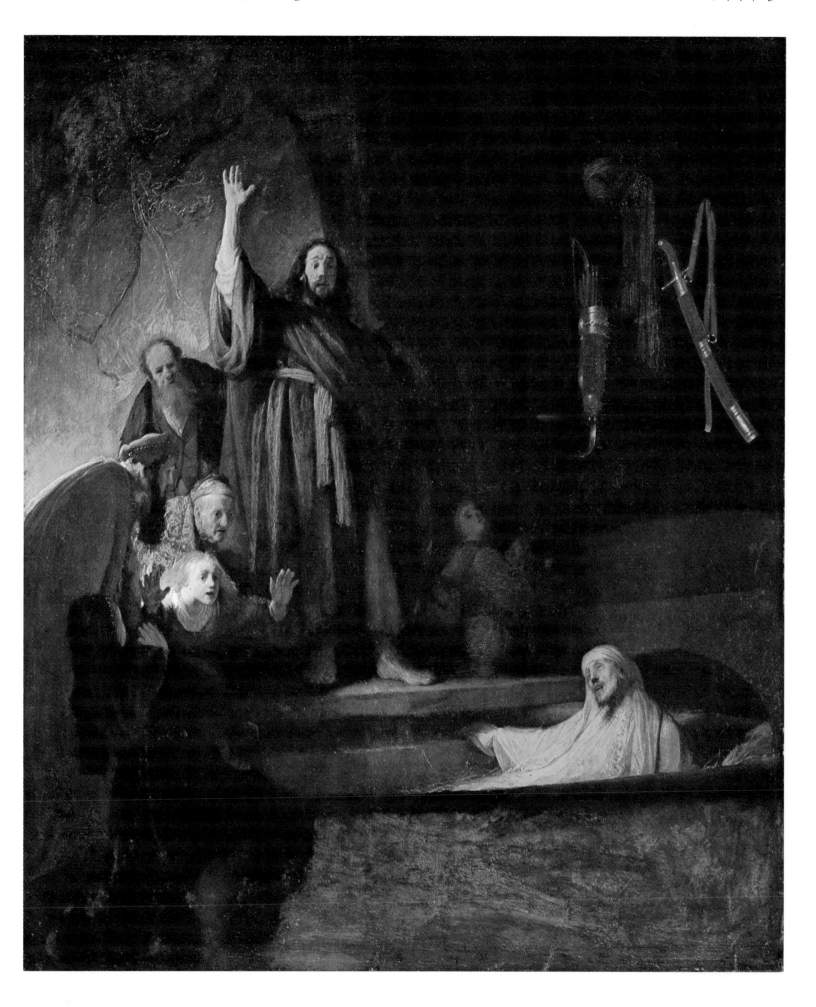

centre, surrounded on three sides by madly flailing onlookers, one of them a variation of the Judas of 1629 that Huygens praised so highly. On the fourth side towers Christ.

The reasons for dating Rembrandt's etching last are its signature, size and shape. The form of the signature, present from the first state on, is *RHL van Ryn*, which the artist used otherwise only in works dated 1632. It is marginally higher than Lievens's quite large etching, which would place it last in order of oneupmanship. Most suggestive, however, is the arched shape of the plate. The form, unique in Rembrandt's work as an etcher, can only have been inspired by a new court commission of 1631, for a painting of *Christ on the Cross* with exactly that shape.

TWO CHRISTS ON THE CROSS, 1631 | There are no documents concerning the two paintings of *Christ on the Cross* done by Rembrandt and Lievens in 1631 (figs. 79, 80). Yet one can draw certain conclusions about the circumstances under which they were made. They bear such a close resemblance to each other that the two painters must have been looking over each other's shoulders as they worked. They must also have been looking at impressions of an engraving of that same year reproducing a Rubens painting of about 1610 (fig. 78). They may also have been looking ahead, towards the promise of a commission from the stadholder to paint a series of the Passion of Christ. In the following year, Rembrandt started work on the Passion series, which is related to *Christ on the Cross* in subject and form. In any case, it seems safe to say, as nearly all writers on the subject have done, that the paintings were made for Frederik Hendrik.

The two Leiden painters must also have been aware of the source of Rubens's composition – a *Christ on the Cross* of 1602 by the Flemish artist Gortzius Geldorp. The neutral background, the angle of the arms and the curve of Christ's body, particularly in Rembrandt's version, are closer to Geldorp than to Rubens. Geldorp's *Christ* was a conspicuous public painting with a quite specific function, and was famous in its day. A 'Christian guidebook' to Cologne published in 1619 describes it as 'a most precious image of the Crucifix, depicted by Geldorp Gortzius … in a new mode. The burgomasters and town council … put it up above the place in the Senate where the emperor [the liege lord of Cologne], is accustomed to sit when he is present, in acknowledgment of his absent majesty.' That is where a heavy Dutch delegation to Cologne in 1630 would have seen it. By 1705, and perhaps in 1630 as well, the *Christ* was flanked by portraits of the emperor and his consort.

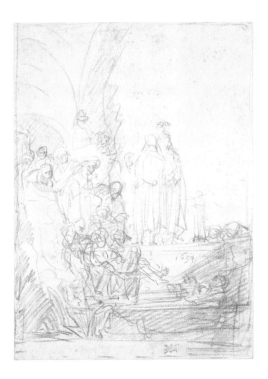

74 *The raising of Lazarus* (turned into *The entombment of Christ*). Dated 1630, although it cannot have been made before 1631. Red chalk drawing, 28 x 20.3 cm. London, British Museum.

At its earliest stage, this sheet was a sketch of Lievens's etching (fig. 75) of 1631. This is the second known instance, after the *Capture of Samson*, of Rembrandt pre-dating a work of his own based on a Lievens composition.

At some later moment, perhaps after receiving the commission to paint a Passion series for the stadholder, Rembrandt re-worked the drawing. In the foreground he added a group of figures carrying Christ to his grave – trying the new subject on for size, as it were, in the space of Lievens's scene.

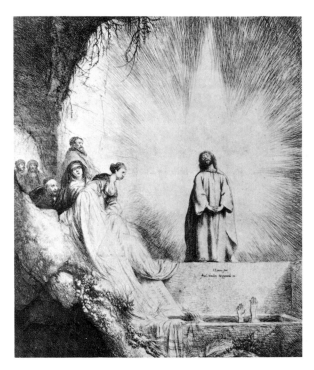

75 Jan Lievens (1607-1674), *The raising of Lazarus*. Probably 1631. Etching, 35.9 x 31.1 cm. London, British Museum.

From the very start of their careers, Rembrandt and Lievens were etchers as well as painters. Not until 1631 did they begin to reproduce paintings of their own in print, and when they did, they did it together, after paintings of the same subject. *The raising of Lazarus* is Lievens's largest etching. In its lighting it is almost a negative of the dark painting on which it is based. The composition, however, is unchanged, although reversed.

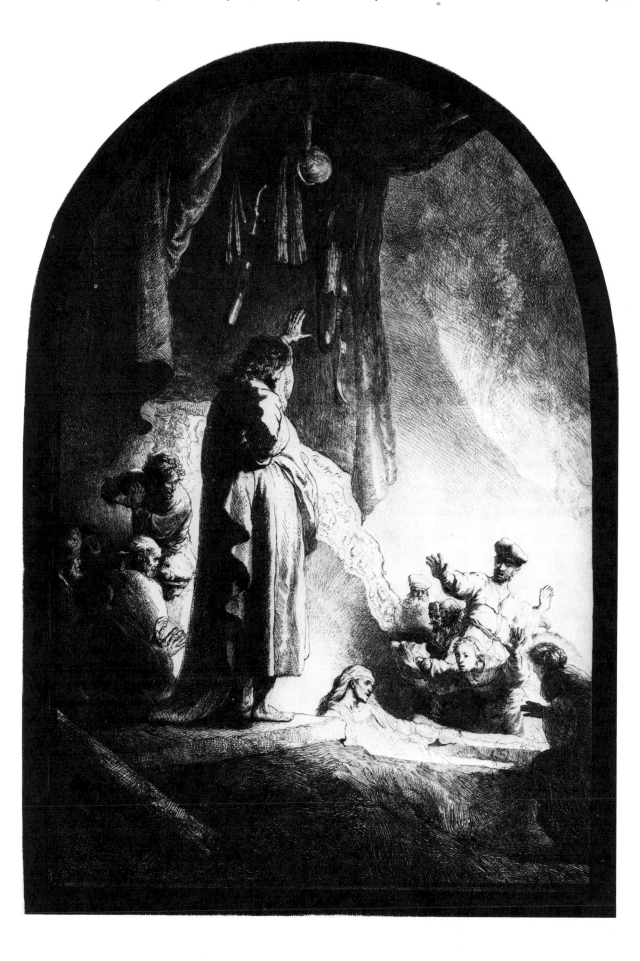

76 *The raising of Lazarus.* Signed *RHL van Ryn f.* About 1632. Etching, eighth state of ten, 36.6 x 25.8 cm. Bartsch 73. Haarlem, Teylers Museum.

Even if Rembrandt's intention had been to publish his painting of *Lazarus* unchanged, as Lievens had done, he found himself incapable of doing so. Pulling out all the stops, he etched a new staging of the miracle, larger than Lievens's etching and more dynamic than his own painting. At the foot of a towering Christ, blinding light illuminates the grave of Lazarus. The onlookers react, finally, with adequate astonishment. The standing figure on Christ's left repeats the gesture of the repentant Judas of 1629, the borrowing, one could say, that made Rembrandt famous. In the arched plate Rembrandt demonstrates his ability to meet the demands of the stadholder's new project, a series of paintings of the Passion of Christ in this form.

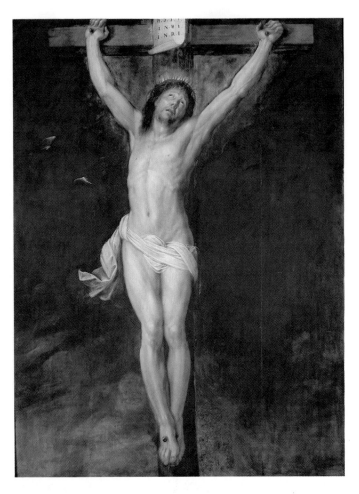

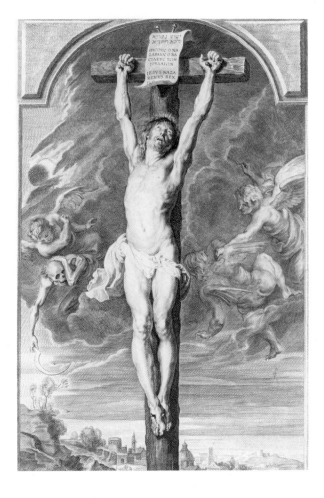

77 Gortzius Geldorp (1553-1616), *Christ on the Cross*. Painted in 1602 for the senate chamber of the town hall of Cologne. Panel, 222 x 171 cm. (cut down at top?). Cologne, Wallraf-Richartz-Museum.

When the meeting hall of the Cologne senate was rebuilt at the turn of the seventeenth century, the city hung there a newly commissioned *Christ on the Cross* by Geldorp. This Flemish artist had settled in Cologne twenty years earlier after working for the court of Aragon. The painting was intended to symbolize the majesty of the absent lord of Cologne, the Holy Roman Emperor, in the form of the divine Lord with his crown of thorns and his royal insignia, INRI, Jesus of Nazareth, King of the Jews.

In 1610, Geldorp's artist son George moved to Antwerp, around the time that Rubens – like George Geldorp a Fleming raised in Cologne – arrived there from Italy. Probably in the same year, Rubens painted his own

version of Gortzius's *Christ on the Cross*. (This may be the same work that Rubens offered to Sir Dudley Carleton in 1618 for five hundred guilders, as part of a trade of paintings for antique sculptures. Rubens's list includes a 'Crucifixion, life-sized, considered perhaps the best thing I have ever done. 12 x 6 feet.' Carleton, the English ambassador to the Republic, turned it down as being 'too large for these low buildings [in The Hague], and also those of England.')

It was either this painting or one much like it that was engraved for Rubens by Paulus Pontius in 1631, the year of his last visit to the northern Netherlands.

In that year Rembrandt and Lievens each painted his *Christ on the Cross*, apparently for a commission by the stadholder. In most respects, their paintings are closer to Geldorp than to Rubens, making us wonder whether they were meant to serve a similar function. There were several territories, among them

Catholic ones, of which Frederik Hendrik was the absent lord.

On the other hand, in another (lost) painting of 1631, Rembrandt shows a painting like his *Christ on the Cross* hanging above the house altar of a solitary saint or Christian scholar. (See the copy in Stockholm, fig. 96). We must, therefore, also keep open the possibility that his and Lievens's *Christs on the Cross* were meant for private rather than public devotion.

78 Paulus Pontius (1603-1658) after Peter Paul Rubens (1577-1640), *Christ on the Cross*. Signed and dated 1631. The Rubens painting was made about 1610. Engraving, 59.6 x 38.3 cm. Leiden, Rijksprentenkabinet.

It may seem inconceivable that the Protestant prince Frederik Hendrik would have hung such a painting – a veritable icon – in an official chamber. There is, however, another possibility that presents itself: Frederik Hendrik was not just the stadholder of the Protestant Netherlands, he was also the prince of the mixed Protestant and Catholic city-state of Orange, enclaved a thousand kilometers away in the south of France. In 1630 he had nearly been unseated from his main hereditary position by a French coup; in that year he had the corrupt commandant of his fortress there assassinated and replaced by his relative the Count of Dohna. In June

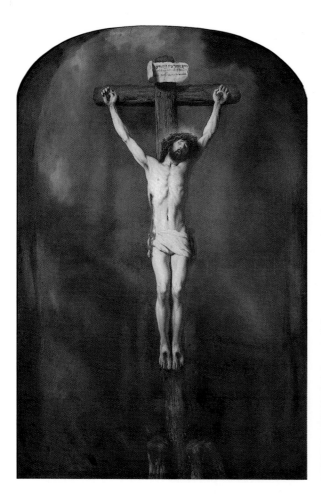

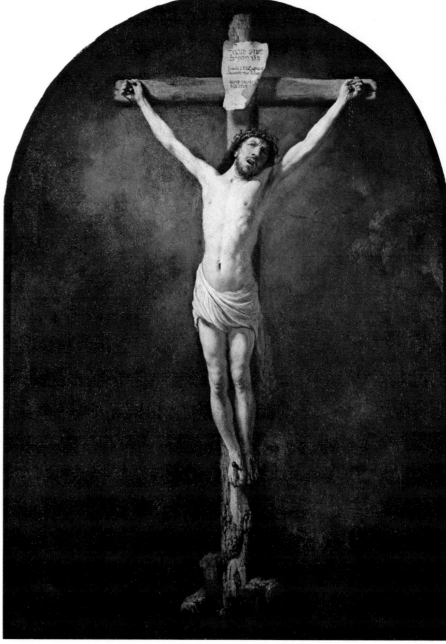

79 Jan Lievens (1607-1674), *Christ on the Cross*. Signed and dated 1631. Canvas, 129 x 84 cm. Nancy, Musée des Beaux-Arts.

80 *Christ on the Cross*. Signed *RHL 1631*. Canvas on panel, 92.9 x 72.6 cm. Bredius-Gerson 543A. Le Mas d'Agenais, France, parish church.

1631 the Countess of Dohna joined her husband in Orange, and nothing could have been more fitting than for her to bring the paintings by Rembrandt and Lievens as tokens of Frederik Hendrik's absentee rule. Interestingly, Rembrandt's painting has never been recorded in Holland. It turned up in the early nineteenth century in France. I must admit, however, that my search in the archives of The Hague and Orange has failed to uncover any support for this hypothesis.

THE OUTCOME | Constantijn Huygens's attempts to channel the careers of Rembrandt and Lievens

towards the stadholder's court, where one would paint histories to rival those of Michelangelo and Raphael, and the other succeed Mierevelt as court portraitist, did not succeed. Lievens would not co-operate with him by becoming a portraitist, and even if he had, there was no assurance that Huygens would be able to place him at court. The connections of Mierevelt and Honthorst with their high-born sitters were often older and better than those of Huygens himself.

In 1632, Lievens left for England, working there for three or four years without leaving a trace. Then he moved to Antwerp, where we find him

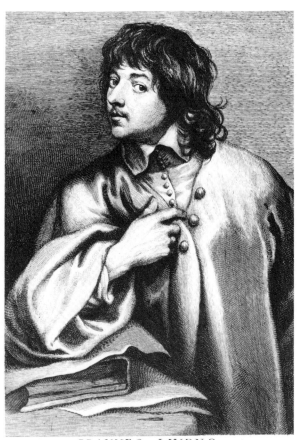

IOANNES LIVENS
PICTOR HVMANARVM FIGVRARVM MAIORVM LVGDVNI BATTAVORVM.
Ant. van Dyck pinxit. *Cum privilegio*
Vorsterman sculp.
G.H

81 Lucas Vorsterman (ca. 1595-1675?) after Anthony van Dyck (1599-1641). *Jan Lievens*. Engraving, 24.2 x 15.8 cm. Braunschweig. Herzog Anton Ulrich-Museum.

The Flemish painter Anthony van Dyck worked for years on a publication of the portraits of contemporary princes, statesmen, scholars and artists. Most of the prints in the series were engraved by others after oil sketches by van Dyck. Among the few Dutchmen included were Constantijn Huygens and Jan Lievens (not Rembrandt). Van Dyck painted Huygens in The Hague on January 28, 1632, about half a year before he moved to England. He may have met Lievens through Huygens, and painted him at the same time. The last record of Lievens in the Netherlands before *his* departure for England was in February 1632. Both artists were to work for the English court.

It is striking that the caption on the print identifies Lievens as a 'painter of large figures, from Leiden' – exactly the terms in which Huygens characterized him in his autobiography.

Lucas Vorsterman, who engraved the portrait, went from his birthplace 's-Hertogenbosch to Antwerp in the late 1610s to work for Rubens. Within a few years, relations between the two had deteriorated to the point that Vorsterman was accused of having threatened Rubens's life, and was ordered by the courts to stay away from him.

82 Jan Lievens (1607-1674), *Self-portrait*. Signed. Ca. 1626. Panel, 52 x 40.5 cm. Copenhagen, Statens Museum.

By all appearances, a rare example of a profile self-portrait. The painting was copied at least four times soon after it was created. Lievens seems to have made his mark as a self-portraitist earlier than Rembrandt.

performing artistic errands for Huygens. After his return to the northern Netherlands, he worked not only for the city of Leiden but also for the court, participating in the decoration of the palace of Huis ten Bosch. Rembrandt, by way of contrast, received no further commissions from the court after 1633 except for one isolated one, from the stadholder, in 1646, and in Leiden he did nothing else at all. Even in Amsterdam, in the 1650s and '60s, Lievens actually received more public and private patronage than Rembrandt. (See below, p. 318.)

The total eclipse of Lievens by Rembrandt did not take place until after the deaths of the two artists. When Amsterdam conferred on Rembrandt posthumous fame on a scale befitting the greatest painter in the greatest city in the world, it was winner-takes-all. Even the most original qualities of Lievens's early work now came to be credited to Rembrandt. The process was helped along by certain deeds of Rembrandt's in the 1630s. In that decade he pre-dated two of the works we studied in this chapter: the *Samson and Delilah* and the drawing for *The raising of Lazarus*, making it appear that his contributions preceded Lievens's. And in mid-decade he published etchings of character heads after Lievens under his own name.

Thanks to the sympathy of scholars like Schneider, Gerson, Ekkart and Klessmann, Lievens has had his personality restored to him in the past half-century. In this chapter and the following ones, the reader can form a picture of what Lievens and Rembrandt were like when they were still young colleagues together, with no idea that one of them was destined to be regarded by posterity as a semi-divine master, and the other as a member of what absurdly came to be called his 'school.'

Jacques de Gheyn III, Joannes Wtenbogaert, the Huygens brothers, Rembrandt and Lievens: cross-references

The young inexperienced Leideners cannot have been Huygens's first choice as artists to bring glory to the Dutch court. The painters he most admired were Rubens and Jacques de Gheyn II, but they were unavailable or unwilling. After them the most likely candidate was Jacques de Gheyn III. Rather than becoming a client of Huygens's, however, de Gheyn preferred to be a patron himself – of Rembrandt and Lievens. In the long run this did not endear either Rembrandt or Jacques III to Huygens, who turned first against the one and then against the other.

THE UNATTAINABLE RUBENS | Constantijn Huygens's love for the artist he admired above all others, Peter Paul Rubens, was doomed to frustration. Rubens was the living proof that the age and place where Huygens was born could become a centre of artistic culture as great as any the world had ever seen. But the artist was on the other side of the line in a civil war, preventing Huygens from even communicating with him directly, let alone meeting with him and working with him. In November 1635, Huygens asked his brother-in-law David de Wilhem to forward to Rubens a letter in which he lamented: 'My desire to enjoy your wonderful conversation is not a passing thing.... I don't know what demons have robbed me of your company until now.' Not until July 1639 did circumstances permit him to write: 'Her Highness... has ordered me to enquire whether you would consent to decorate a chimney, whose measurements you will be sent, with a painting of a subject you are entirely free to choose yourself.' The painting was found unfinished in Rubens's studio after his death the following year. Jan Lievens, who was in Antwerp, offered Huygens – again via de Wilhem – to finish it himself. The Rubens painting for which Huygens had been waiting all these years was turning before his very eyes into a Lievens.

De Wilhem apologized even for relaying the message, explaining that his wife had insisted on it. His wife was Huygens's sister Constantia, to whom he was very devoted, and who apparently had taken Lievens under her protection. When we do not know.

THE HARD-TO-GET DE GHEYN | Jacques de Gheyn II could not pass for the Dutch Rubens if only, as Huygens writes, because he was not all that strong on the human body. But he had other undeniably great qualities. The old de Gheyn, who served Maurits and Frederik Hendrik for over thirty years, was an artist of the Leonardo da Vinci type, putting his gifts at the service of science, engineering and warfare. What most indebted the stadholders to him was his manual on the musket and pike (1607-1608), which was of great help to Maurits in making the Dutch army the most disciplined in Europe. Publication of the book was actually held up for a decade (it was drawn by de Gheyn in the latter 1590s) so that the enemy could not take advantage of it. The value of proper drilling was immense: think only of Rembrandt's father and brother and their accidents with muskets in the irregular civic guard of Leiden.

Among the miscellaneous jobs that Jacques de Gheyn II performed for Maurits were painting a life-size portrait of a famous war horse that was captured for him at the battle of Nieuwpoort in 1600, designing a commemorative medal for his glorious victory there, drawing for publication the sailing cars invented for the stadholder by Simon Stevin, and laying out a large garden for him in The Hague.

Huygens's relationship with the elder de Gheyn left much to be desired. When he was a child, Constantijn's father had asked de Gheyn to give the boy drawing lessons, but de Gheyn, 'who was already quite well-off and therefore gave few lessons,' declined. The sourish quotation is from

Constantijn's autobiography. Nonetheless, Constantijn stood by him in his cranky old age, attending his final sick-bed assiduously, 'like a Christian,' Constantijn wrote, where one expects the words 'like a son.' But de Gheyn had a son of his own, an artist, and before Jacques the elder died, he managed without Huygens's help to pass on to him the commission for the stadholder's garden, and the salary attached to it, which Huygens calls 'very high' and 'quite advantageous.'

CONSTANTIJN'S OWN CLOSE FRIEND JACQUES DE GHEYN III, 1596-1641 | No one should have been more pleased by this development than Huygens. He and the younger Jacques had long been close friends, and the bond between them had been art. They took advantage of their parents' status to gain access to the best collections of art and antiquities in Holland and England, operating on dazzling intellectual and social heights. In 1618, they visited the legendary antiquities collection of Lord Arundel in London, where de Gheyn drew a copy or cast of the famous masterpiece of Hellenistic sculpture, *Laocoön and his sons attacked by serpents*. The next year the young artist published the drawing in a print, while Huygens translated Virgil's lines on Laocoön into Dutch and wrote a Latin quatrain and a Dutch paraphrase of it on his friend's print. This was the first of his hundreds of poems on works of art; it began 'Old Laocoön, rescued from the land/ Of ruined Rome by a Batavian hand…'

While they were away in England, Sir Dudley Carleton had traded part of *his* collection of antiquities for five paintings (and some cash) by Rubens. Among the paintings was *Prometheus attacked by the eagle*, which is based on the *Laocoön*. Huygens and de Gheyn went to see it.

If Rubens was beyond reach, and the elder de Gheyn too vain, well off and strong at court to accept Huygens's protection, there was surely Jacques III, Huygens's own comrade-in-arts. But his friend let him down. As Constantijn wrote in his autobiography, 'I cannot conceal my aggravation that … a man who was obviously born among the Dutch to grow into an undying ornament to his fatherland has buried his talent and dozed off in an unproductive, unpraiseworthy slumber. This is the result, I am inclined to say, of a certain ease in personal circumstances.' The de Gheyns, father and son, earned too much money for their own good – even worse, for Huygens's good. In the case of Jacques III, the judgment is all too apt. His production of the 1620s is meagre, and after 1630 he stopped working altogether. In 1635 he took a sinecure as canon of the Mariakerk in Utrecht, and

FROM THE WILL OF JACQUES DE GHEYN III

The first two legacies To his cousin Joannes Wtenbogaert, receiver of the Amsterdam district, the large vase of flowers topped by a bunch of lilies painted by the father of the deceased … as well as all of his cockle-shells and seashells, both those rare ones that are perfect in form and the rough imperfect ones, in addition to all his minerals, stones and corals … Furthermore another painting, by Rembrandt, with two old men sitting and disputing, one with a large book on his lap and sunlight streaming in. Another old man sleeping by the fire, his hand on his breast, also made by Rembrandt. Also a handsome woman's head together with an old woman painted by Jan Lievens. Another head of a young girl laughing, also painted by Jan Lievens…. He also bequeaths to Maurits Huygens, secretary of the Council of State in The Hague, his own portrait, painted by Rembrandt, and a painting of the head of an old woman, covered in purple velvet lined with gold cloth, life-size, in a frame …

there he vegetated until his death in 1641 at the age of forty-five.

This was the man who, while driving Huygens to despair by refusing to fill his destiny as 'an undying ornament to his fatherland' and a feather in his friend's cap, became Rembrandt's patron. He acquired two or three of Rembrandt's paintings from 1628-1630 and paid Rembrandt well to paint his portrait in 1632.

Jacques III was not a man to spend his time searching for fresh talent in the studios of young artists. If he bought paintings by Rembrandt and Lievens, we must assume that they were called to his attention in no uncertain terms by someone to whom he had good reason to listen.

We do not have to look far for a possible intermediary. In his last will, Jacques III left two paintings by Rembrandt and two by Lievens to his cousin and executor Joannes Wtenbogaert, who lodged in the 1620s in Leiden with a relative of Rembrandt's and whom we know from later years as a patron of both Rembrandt and Lievens. The fact of the legacy alone suggests that Wtenbogaert played a role in de Gheyn's acquisition of the works.

MORALITY PICTURES | As it happens, slumber is the theme of one of the paintings by Rembrandt that Jacques de Gheyn owned (fig. 84). It is dated 1629, the year in which Jacques II died and his son succeeded him. Some time earlier, Jacques III had published an undated etching of Sleep as an allegorical figure in a poppied hood, his arm in his breast like Rembrandt's old man. The French poem beneath the print praises sleep as the leveller of king

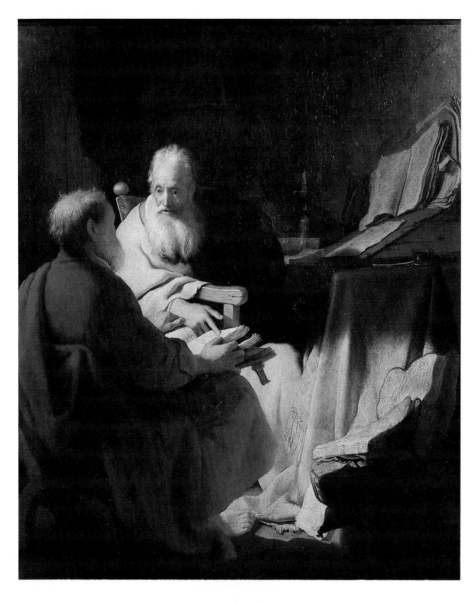

83 *Two old men disputing.*
Signed *RL*. About 1628.
Panel, 72.3 x 59.5 cm. Bredius
423. Melbourne, National
Gallery of Victoria.

The subject is another of the
unsolved mysteries of
Rembrandt iconography.
Christian Tümpel has
demonstrated that it comes
closest to earlier depictions of
St. Peter and St. Paul; the
Rembrandt Research Project
is inclined to accept this
identification of the figures,
despite the absence of their
usual attributes.

If that is who the two old
men are – Paul facing us and
Peter seen from the back –
then the captions to Jacques
de Gheyn's earlier, undated
prints of the apostles open
fascinating perspectives for
the interpretation of
Rembrandt's painting:

Converted Paul, the zealous
 one, who'd always been a
 teacher,
Explains the mystic meaning
 of an esoteric book.

Here sits Peter, primate of the
 church, possessor of the
 key,
Now closing, now disclosing
 the secrets of the book.

The uniqueness of the subject
and its close match with an
existing work by the painting's
first owner lead us to suspect
that *Two old men disputing*
was a private painting, made
for an audience of one. If it is,
then its mysteries may never
be explained.

From the description of the
painting in Jacques de
Gheyn's will, one could
conclude that even he was not
sure what the painting meant.

In the Bible, the
controversy between Peter
and Paul is alluded to in
Galatians 2. It had to do with
the implications of preaching
Christianity to the whole
world, as Paul did, rather than
to the Jews alone, like Peter.
The attributes behind the Paul
figure in the painting – the
globe and the snuffed candle
of the Old Testament – fit in
well with this interpretation.

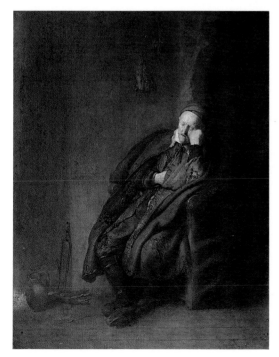

84 *An old man sleeping
beside a fire.* Signed *RL*
[16]*29*. Panel, 51.9 x 40.8 cm.
Bredius 428. Turin, Galleria
Sabauda.

As his expensive but worn
garments testify, the old man
was once rich, like the *Old
fool* (fig. 30). But whereas the
other guarded his possessions
up to the last moments of his
life, this old man dozes off
towards death.

The first owner of the
painting, Jacques de
Gheyn III, was accused by his
friend Constantijn Huygens
of having exactly this kind of
unpraiseworthy attitude to
life.

De Gheyn did not let
himself be embarrassed by
Huygens's attacks. He even
brought out a print (Hollstein
24) in praise of sleep, with an
allegorical figure nodding in
the smoke of an opium fire.

and peasant, as the bringer of an end to sorrow. Rembrandt's painting too shows the comfort of sleep, but its tragedy as well. The old man is dressed in rich clothing gone threadbare, demonstrating that laziness is a destroyer of wealth. In that regard, we can add the sleeper to the list of foolish old men Rembrandt had been painting since 1625.

The other subject painting by Rembrandt that belonged to de Gheyn shows two old saints or scholars in dispute (fig. 83). No convincing explanation of the scene has yet been advanced. In any case, it too is connected to prints by Jacques de Gheyn III. His series of the seven sages of Ausonius and his paired prints of Saints Peter and Paul show similar figures, though always in isolation (fig. 85).

The Rembrandtesque painting of an old woman in Jacques de Gheyn's collection has already been discussed above (p. 65), where we saw how closely it resembled a painting that Frederik Hendrik bought from Rembrandt to give to Sir Robert Kerr.

On that subject, it is interesting to note the similarities between Rembrandt's *Old man asleep by a fire* for de Gheyn and the Lievens *Young man studying at a fire* that was also given to Kerr. In the inventory of the English royal collection of 1639 the latter is described as 'a young Scholler Sitting upon a Stoole In a purple capp and black gown reading in a booke by a seacole fire, a paire of tongs lyeing by.' Orlers remembers it as 'a lifesize figure with a round cap on his head studying beside a burning turf fire.' We find ourselves in a jumble of cross-references between Rembrandt and Lievens, de Gheyn and Huygens, pointing unmistakably to a close and intense working relationship in 1629 and 1630. Related to all of them is Joannes Wtenbogaert, who may well have played a role in their collaboration.

The subjects of these interrelated works are all unique, and the object of continuing debate among art historians. We are not even sure whether they are histories or genre paintings. However one chooses to categorize them, on a more fundamental level they are all painted character sketches. In this they resemble works like *The old fool* (fig. 30), *The artist in his studio* (fig. 36) and perhaps even *Rembrandt's mother reading* (fig. 93). They seem to call out for adjectives in their titles, such as 'The learned men,' 'The saintly woman,' 'The diligent young artist' and so forth. In 1625 Constantijn Huygens published a collection of poetic sketches along those lines under the Greek title *Characteres, that is Pictures*. In a later edition he named them more explicitly *Zedeprinten*, morality pictures. The poems describe various types of humanity – the good preacher, the professor, the ignorant physician, etc. – by means of long metaphorical

85 Jacques de Gheyn III (1596-1641), *Chilo the Lacedaemonian*, nr. 3 in a series of seven etchings and a title print: *Ausonius, Septem sapientes Graeciae icones* (Pictures of the seven sages of Greece). Signed and dated 1616. Etching, 31 x 18.3 cm. Hollstein 13. Amsterdam, Rijksprentenkabinet.

Decimus Magnus Ausonius (ca. 310-395), an unobtrusively Christian poet of Roman Gaul who rose to governorship of the province and finally to the consulship, was a prime example of a writer who succeeds in politics. The work of his that de Gheyn evoked in his prints was *The masque of the seven sages*, in which seven wise men of Greece expound their philosophies.

Constantijn Huygens was also an admirer of Ausonius. When travelling in France in later life, he composed a tribute to Ausonius's masterpiece, *Mosella*, on the Moselle River. A long poem that Huygens began writing in 1627 may be a re-creation of Ausonius's *Ephemeris: the daily round, or the doings of a whole day*. Huygens called his poem *Dagh-werck*, which can be translated in exactly those words.

catalogues of their strengths and especially weaknesses. The paintings we are discussing could by the same token be called *morality pictures*. Since Huygens considered his poems an exercise in practising a Greek mode of literature in Dutch, this would make the paintings a contribution to the Dutch Renaissance even more vital than making prints after the *Laocoön*. (For Lievens's imitation of the antique, see fig. 67.)

Some of Huygens's dreams survived de Gheyn and his lassitude to come true forty years later. In 1668-1669 a mutual friend of Huygens and Wtenbogaert, the Remonstrant and amateur draftsman Jan de Bisschop (1628-1671), brought out his *Signorum veterum icones*, the most important collection of etchings of the antique ever to be published in Holland. The two volumes were dedicated to Constantijn Huygens II and Joannes Wtenbogaert, who were then related by marriage. Most of the drawings that served as models for the prints in the second volume came from Wtenbogaert's collection, and were by Jacques de Gheyn III. They were drawings he had made, like that after the *Laocoön*, in the 1610s. He had never done anything with them, and after his death they ended up, together with his paintings by Rembrandt and Lievens, in the hands of his cousin Joannes.

86 Jan Davidsz. de Heem (1606-1683), *The daydreaming student*. Signed and dated 1628. Panel, 60 x 82 cm. Oxford, Ashmolean Museum.

De Heem is one of the few artists of Rembrandt's youth to move from Utrecht to Leiden, where he worked with David Bailly. This painting and others suggest that he also exchanged ideas with Rembrandt and Lievens.

The works by Rembrandt that come closest to de Heem are the kind we called 'moral pictures' and associated with the patrons Joannes Wtenbogaert and Jacques de Gheyn III. De Heem's scene contains more clues than Rembrandt's for the interpretation of his scene. The key is the print portrait pinned to the wall. It depicts Christian, duke of Braunschweig and Lutheran bishop of Halberstadt, known as 'The Crazy Halberstädter' or 'The Crazy Bishop.' In the service of the Winter King, he led an army of 15,000 men on a campaign of pillage through Germany. In 1623 he joined the States army but was decommissioned after three months because of the lack of discipline of his troops.

The wall map, travelling chest, sword, purse and gaming board tell us exactly where the student's thoughts have strayed. We can easily imagine the young man ending his days, if he lived that long, like Rembrandt's *Old man by the fire*.

We begin to understand better why Huygens was so excited about Rembrandt and Lievens, why he admired their diligence so much, why he praised them as Dutch rivals of the ancients and what the words meant to him. We also sense the extent of his ambitions for them, and why he was so annoyed when they balked at his suggestion to visit Italy.

At the same time, we are forced to wonder how realistic Huygens was being, whether it was not expecting too much of Rembrandt and Lievens that they become learned artists like the de Gheyns or the Hague statesman-painter Pieter van Veen, whom Huygens praised in a poem of 1633 for his 'geleerd gesmeer' (erudite daubing).

But then again, Huygens expected too much of everybody. His poetry was considered inhumanly demanding from the start. In 1622 Jacob Cats, who helped Huygens get his first book of poems published, wrote a commendatory rhyme 'defending' Huygens against charges of flaunting his foreign languages and being deliberately abstruse. Cats concludes 'But don't forget, my friend – and this is all that matters – / That no one at the court will serve from open platters.' However, even the court – even the courtiers in Huygens's own family – couldn't follow him. On May 30, 1622, his brother Maurits wrote to say that he had read Constantijn's latest work to their parents, and that no one, himself included, had understood a word of it.

A SENTIMENTAL GESTURE | We have already run across brother Maurits in Leiden on that day when Jan Lievens attached himself to Constantijn to paint his portrait. We encounter him once more as the second beneficiary in Jacques de Gheyn's will (see p. 92) and as the sitter for a portrait not by Lievens but by Rembrandt.

Jacques and Maurits must have known each other from childhood, but something new grew between them in 1630, which was observed and reported on in a letter of November to Constantijn by his most intimate friend, Joannes Brosterhuysen. In 1632, the two performed a rare sentimental gesture. They both had their portraits painted by Rembrandt in two panels of the same smallish size, Maurits left and Jacques right (figs. 87, 88). Apparently they agreed that each would keep his own portrait and that the first to die would leave it to the other. The portraits were re-united in 1641 after the death of de Gheyn, who was outlived by his friend for only one year. The companion portraits remained together for at least another 120 years, but at some point after 1764 they were separated.

Was Constantijn pleased that Rembrandt painted

87 *Maurits Huygens (1595-1642).* Companion to fig. 88. Signed *RHL van Rijn 1632.* Inscribed on the back *M. Huygens, secretaris van den Raad van Staten in den Hage* (secretary to the Council of State in The Hague). Panel, 31.2 x 24.6 cm. Bredius 161. Hamburg, Kunsthalle.

88 *Jacques de Gheyn III (1596-1641).* Companion to fig. 87. Signed *RHL van Rijn 1632.* Inscribed on the back *Jacobus Geinius Iunr / H*[uyge]*ni ipsius* [effigie] *extremum munus morientis* [R]*… moi*[.]*i ste*[.]*un*[.] *habet ista secundum hev:* (Jacques de Gheyn Junior gave Huygens his portrait as the last gift of a dying man…). Panel, 29.9 x 24.5 cm. Bredius 162. London, Dulwich College Gallery.

The most famous companion portraits of male friends are those of Erasmus and Petrus Aegidius, painted in 1517 by Quinten Matsys. The sitters ordered the paintings, which were hinged together in a diptych, in order to give them to their mutual friend Thomas More in England.

In the autumn of 1631, Constantijn Huygens asked his friend Joannes Brosterhuysen to find a copy of Erasmus's letters for him, which contain information about the Matsys portraits. Did the inspiration for Rembrandt's portraits come from Erasmus, through Constantijn? This would make Constantijn's annoyance at the results all the more puzzling.

these touching portraits of his brother and their friend? He was not. He was piqued, and took it out on Rembrandt. In February 1633, Constantijn wrote eight sharp Latin verses on Rembrandt's portrait of de Gheyn, which seem never to have been translated in the Rembrandt literature (p. 97). In 1644 Huygens published seven of the poems, omitting the one mentioning Rembrandt's name, perhaps to avoid adding injury to insult. The squibs show that it was not all joy to be patronized by Constantijn Huygens. Any portraitist should be able to take it when a sitter's friends complain about a poor likeness. But for a mutual friend to write eight poems on the subject? In the second one, moreover, Huygens suggests that Rembrandt was jealous of de Gheyn's inherited wealth and that he was charging the sitter half his fortune for a portrait that looked at best like the brother de Gheyn didn't

have. (Interestingly, Huygens says nothing about the portrait of his own brother.) The spitefulness of the poems makes one wonder what was really bothering Huygens. Those less skeptical than I about the value of psycho-analyzing the dead will find rich material here. It is clear that by 1633 the 'honeymoon' between Huygens and Rembrandt was over.

One week after writing the eight squibs, Huygens composed a perfectly polite distych on a Lievens portrait of an ugly English courtier. He had not yet changed his mind about Lievens being a better portraitist than Rembrandt, and probably never did. By the time of the squibs, though, Rembrandt probably could not have cared less about Huygens's preconceived idea. He had moved to Amsterdam, where he had become an overnight celebrity – for his portraits.

SQUIBS ON A LIKENESS OF JACQUES DE GHEYN THAT BEARS ABSOLUTELY NO RESEMBLANCE TO ITS MODEL

If this were how the face of Jacques de Gheyn had
 looked,
Then this would be a portrait of de Gheyn.

Begrudging Gheyn his father's whole estate,
An able painter thought to claim the half
For a belated brother he'd created.

Whose eyes, whose face do I behold in this
 portrayal?
Viewer, ask no longer. I really don't recall.

It's likely, so they say, that one pea's like another.
But this pea, if you ask me, is quite unlike the other.

Between this portrait and de Gheyn there lies a gap
No larger than the one that sunders fact from fiction.

As lovely as a painting is, a painting it remains.
But this nice painting's more, for the fiction it
 contains.

Whose face is this? It's anyone's who paid its price.
But does that really make it his?

The hand is that of Rembrandt, the features are de
 Gheyn's.
Admire it, reader, though it's not de Gheyn at all.

Prophets and apostles

Biblical histories, Christs on the Cross, mythologies, moralizing figure paintings, heads, portraits – from 1628 to 1632 Lievens and Rembrandt had their hands full supplying the stadholder and his court with paintings, often in pairs, in all those categories. And one more: apostles, mainly in prison.

From this period date a good number of Peters and Pauls and, in a similar mode, several other Biblical figures in half and full length. They form a discrete group in Rembrandt's oeuvre that was to be closed off in 1631. Not until nearly thirty years later was he to paint anything like them. Some of these paintings were taken by Rembrandt to Amsterdam, but at least one was sold in The Hague.

In order to understand the demand for these works and their significance, we must look at parallel paintings by Lievens as well. In The Hague, for example, documentation has survived concerning the sale of a *St. Peter* by Lievens and an early owner of a *St. Paul* by Rembrandt; both buyers were relations of Constantijn Huygens and both have fascinating stories.

ST. PETER PREACHES REPENTANCE TO THE BISHOPS | On April 1, 1632, Constantijn Huygens sent off a Lievens painting of the repentant St. Peter, now lost, to a military lady named Louise van der Noot. She was the daughter of one commander of the West Flanders border town of Sluis and the widow of another, Philips Zoete van der Lake, called Haulthain. Huygens's letter covering the shipment tells us details of the transaction that one would never have been able to guess. Mrs. Haulthain, it seems, was engaged in secret negotiations, with the blessing of the Dutch government, and the painting was one of her weapons. She had tactical allies in the enemy camp, among the bishops of Spanish Flanders, and was seeking their aid in a conflict she had with their colleague, the bishop of Ghent. They seemed to have been shying away from their commitment to her, and she was sending them the

painting as a gift in order to reprimand and encourage them at the same time. Huygens writes: 'The apostle you are sending to teach repentance to the bishops is going off herewith. God willing, he will remind their Pomposities how many cocks have crowed since they denied their master in heaven to serve another on earth. May your conspiracies succeed, for the good of the state – because they are for the good of the church, without which there would be no state. It is of some importance to the Republic that you maintain your quarrel with the bishop of Ghent…, the only prelate to take the side of [Cologne?]. In that regard, [your bishops] will regret that Jan Lievens has not given St. Peter his sword to cut off the gentleman's most reverent ear…' Even if part of this is just Constantijn Huygens spinning out a metaphor, the essence is clear enough: the subject of Lievens's painting contained a message from Mrs. Haulthain to the bishops. The work was chosen, perhaps even commissioned, for the relevance of its subject to certain specific diplomatic circumstances.

Huygens must have received Lievens's painting a few weeks before he forwarded it to Mrs. Haulthain. On March 19, 20 and 21, he wrote four poems on it, three in French and one in Latin and Greek. The second French poem criticizes the expressionlessness of the figure:

If Peter had seen himself repenting
The way this painter did,
He would have repented [also repainted!] the
 memory, augmenting
The feelings he practically hid.

Was Huygens thinking of Rembrandt's penitent Judas when he wrote this, and of his advice to Lievens not to try to improve on Rembrandt? Why then did he turn to Lievens for Mrs. Haulthain's commission in the first place? Whatever the answers to these questions, we notice that Huygens is

capable in 1632 of criticizing a figure painting by Lievens with a cool detachment that is far from the paean of two or three years earlier.

The painting by Lievens is lost, but as it happens – and by now we may be sure it is no meaningless coincidence – the same subject was also painted once and possibly twice by Rembrandt in the preceding year, 1631 (fig. 89; the second, disputed painting – could it be a copy of the lost Lievens? – is in the Museum of Fine Arts, Boston). The apostle is shown in the pose of the penitent, but in the setting of a prison, combining, for no discernible reason, two unrelated episodes in Peter's life. The same old man modelled in 1630 for a *Jeremiah* in a scene to which no Biblical text can be attached (fig. 92). Both of these paintings are highly evocative – but of what? With the Haulthain affair fresh in our memory, we cannot help but wonder whether they too were not devised by Huygens for some specific, unguessable purpose. Huygens was always thinking of painting in terms of literature. The occasional poetry that was such an important part of literary life in his day may have led him, when commissioning paintings for a particular occasion, to invent themes that cannot be deciphered in terms of traditional iconography.

What of the two paintings in this group that do have a standard subject – the two depictions of *St. Paul* (figs. 90, 91)? The setting and lighting of the earlier one, dated 1627, comes close to that of *Hannah and Simeon in the Temple* (fig. 29), which I believe was the first painting by Rembrandt to be sold to the stadholder. Both *St. Pauls* betray a knowledge of the *Seven sages of Greece* by the court artist Jacques de Gheyn III (fig. 85). It is not unlikely, then, that Rembrandt had his eye on The Hague when painting these figures, even if neither of them was commissioned by the court.

A SAINT FOR A SINNER | One of them indeed found a buyer from The Hague. The estate of Jacques Specx (1589-1652) included five paintings by Rembrandt, the earliest of which was a *St. Paul*, apparently our fig. 90 or 91.

Specx was one of the most colourful Dutchmen of his day. He was the man who, with the help of the legendary Will Adams, opened up Japan for the Dutch in 1609. He undertook the first of the ritual journeys to the Shogun, by means of which the Dutch were able to maintain their monopoly on trade with Japan for over two hundred years. He was a bald, bearded charmer who found it easier to travel ten thousand miles and carry off the treasures of an island empire than to keep a balanced set of books. For twelve years he managed to run one of

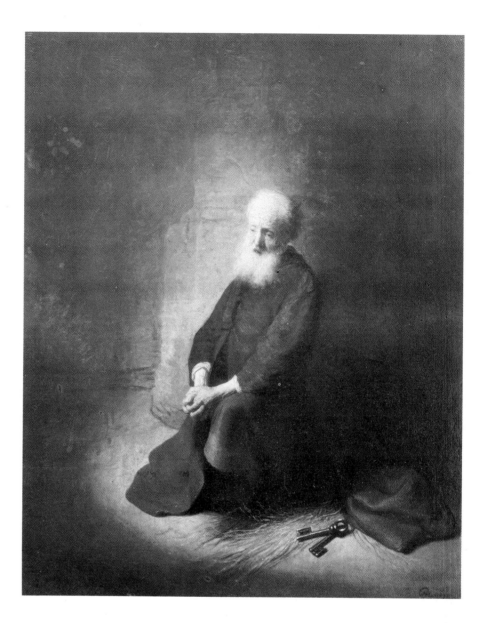

the most profitable enterprises on earth, as an employee of the Dutch East India Company, without submitting accounts of any kind. When he was recalled to Company headquarters in the east, in Batavia, in 1621, he brought with him a hopelessly inadequate box of bills and receipts and his half-Japanese daughter Saartje.

In 1627, Specx had to come back to Holland to account for his free and easy ways – especially when it came to private dealing in Company territories – to the directors of the East India Company. That he did, to their apparent satisfaction. On the same visit he did something else that pleased his superiors. He married a respectable Dutchwoman from his own place of residence, The Hague, and took her and her sister – Maria and Petronella Buys – back east with him. One of the gravest difficulties facing the Dutch in Batavia was the lack of well-bred women there, and the social irregularities that that entailed.

The problem could not have been dramatized

89 *St. Peter in prison.* Signed *RHL 1631.* Panel, 59.1 x 47.8 cm. Bredius 607. Belgium, private collection.

For once, Rembrandt includes an unambiguous attribute – the keys – in a painting of a saint, allowing us to identify the figure as St. Peter (the guardian saint of Leiden). But then he complicates matters by combining two distinct scenes from the apostle's life: his repentance after betraying Christ (see fig. 378) and his much later imprisonment.

Old copies show a view on the left, through an arch, of soldiers around a fire, increasing the resemblance of the painting to *Jeremiah*. This does not bring us any closer, however, to an understanding of either work.

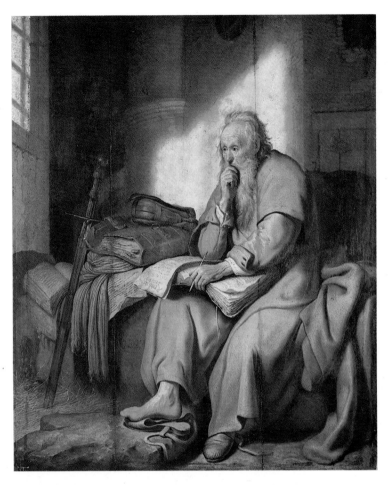

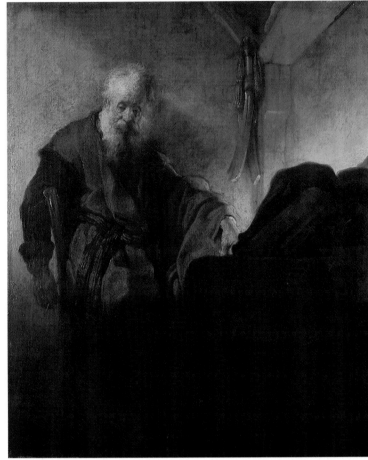

90 *St. Paul in prison*. Signed *R*[H or L] *1627*. Panel, 72.8 *x* 60.2 cm. Bredius 601. Stuttgart, Staatsgalerie.

One of Rembrandt's earliest experiments in chiaroscuro.

The figure is inspired at least in part by Jacques de Gheyn III's old men, such as fig. 85. The painting belonged to the German noble family the Schönborns as early as 1719.

91 *St. Paul at his desk*. Late 1629 or 1630. Panel, 47.2 *x* 31.6 cm. Bredius 602. Nürnberg, Germanisches Nationalmuseum.

The writer temporarily out of inspiration is modelled even more directly than its predecessor on the sages of Jacques de Gheyn III. This painting or fig. 90 must have been the *St. Paul* owned by the flamboyant Jacques Specx, the most devoted private collector of paintings by Rembrandt who we know.

92 *Jeremiah lamenting the destruction of Jerusalem*. Signed *RHL 1630*. Panel, 58.3 *x* 46.6 cm. Bredius 604. Amsterdam, Rijksmuseum.

Framed in an archway, a flying creature with a torch hovers over a burning city being entered by a party of armed men. In the foreground, an old man sits sadly beside a colossal column, with metal vessels, a book, a pouch and a bottle.

The reference seems to be to Jeremiah during the destruction of Jerusalem, but no satisfactory explanation of the details or the implications of the theme has yet been advanced.

more poignantly than by certain events that had taken place while Specx was in Holland. During his absence, he had left Saartje behind with the governor-general, Jan Pieterszoon Coen, a hard-headed, God-fearing Company man, a creature of another species to Specx. Coen was trying to enforce Calvinist moral standards in that community of mixed blood and mixed manners, and when one night a seventeen-year-old half-native boy broke into the girls' dormitory in his compound and climbed into bed with Saartje, Coen had him executed and Saartje lashed.

Coen died the day before Specx landed with instructions that enabled him to claim the governorship. For two years he presided over the East Indies and waged war on the strict Calvinists in Batavia who had approved the punishment of Saartje. As long as the church continued to admit them to communion, he refused to attend himself. The conflict fractured the Dutch community in Batavia along the lines of the Remonstrant-Counter Remonstrant split.

In 1632 Specx was summoned back to Holland for good. The legitimacy of his governorship was rescinded after the fact, but he was awarded a princely pension of 1200 guilders a month. In 1638, after the death of Maria Buys, Specx got married again, to the widow of a cousin of Constantijn Huygens, with whom he was already acquainted. A little later he moved to Amsterdam, where he lived grandly for the rest of his life without working very hard, and building up his small but choice collection of paintings.

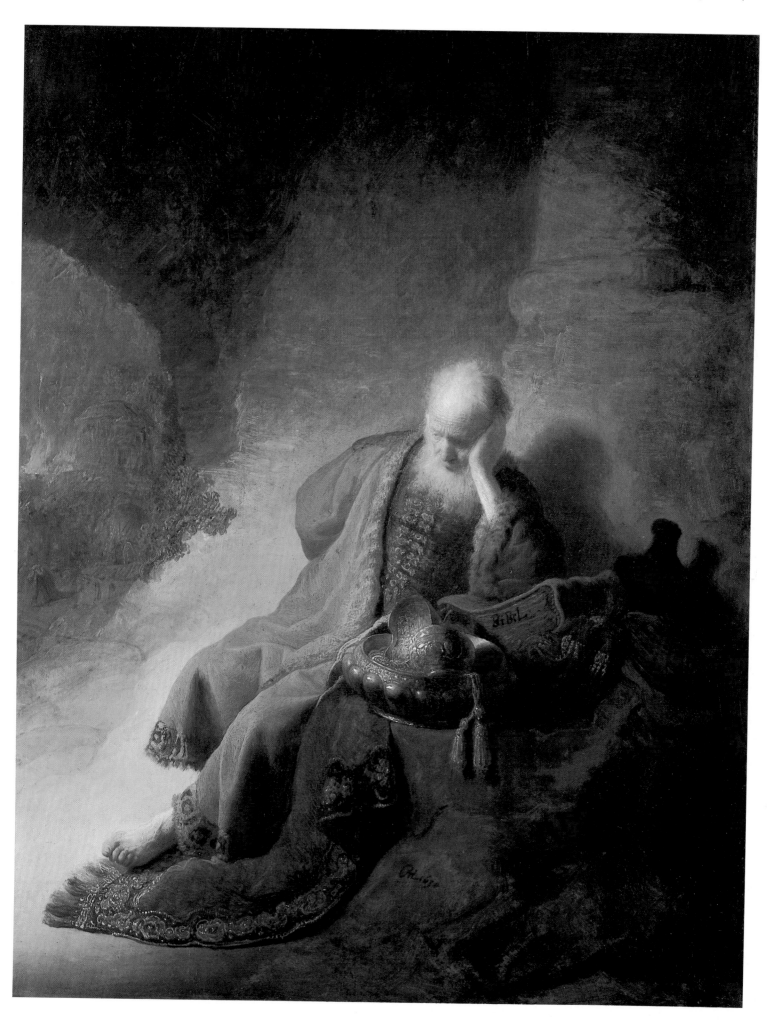

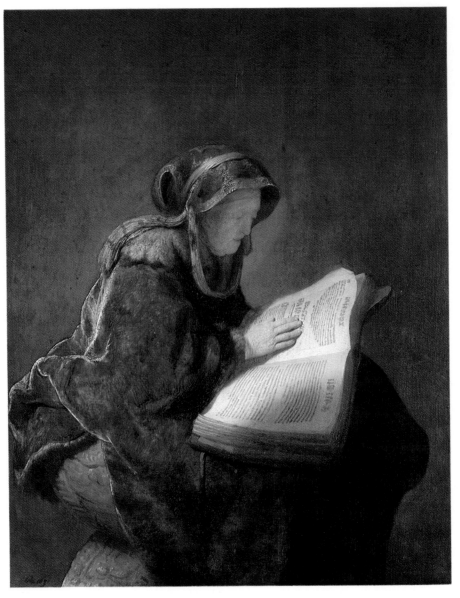

93 *An old woman reading: Rembrandt's mother as the prophetess Hannah.* Signed *RHL 1631.* Panel, 59.8 x 47.7 cm. Bredius 69. Amsterdam, Rijksmuseum.

The classic 'Rembrandt's mother,' probably derived from a print after the sixteenth-century Antwerp artist Maarten de Vos depicting the prophetess Hannah. This denizen of the Temple in Jerusalem earned her place in the Gospels by recognizing the infant Christ as the Lord as soon as she saw him.

Rembrandt's painting was published in a print in his own studio by van Vliet with no caption, and was imitated by Paulus Lesire in 1632 for a painting of the Cumaean Sibyl. Both facts suggest that the panel was not a commission, and that it was taken by Rembrandt to Amsterdam when he moved there. Together with the *St. Paul* of 1627 (fig. 90), it was in the Schönborn collection in 1719.

Among them were no less than five by Rembrandt, all of which seem to date from 1628-1635. The question whether Specx bought his *St. Paul* during his leave in 1628-1629 or after his repatriation is as yet unsolved. The prevalence in Specx's collection of paintings by artists associated with Hendrick Uylenburgh and of Leiden artists suggests that he may have been one of those who helped Rembrandt bridge the gap between Leiden (and The Hague) and Amsterdam.

Specx's other four Rembrandts – *The abduction of Europa* (fig. 116), *St. Peter's boat* (perhaps fig. 172) and the portraits of Petronella Buys and the Company official she married in Batavia, Philips Lucasz. (figs. 162, 163) – pepper the chapters to come.

THEOLOGICAL STANDPOINTS IN PAINT | While the most appropriate text from the writing of St. Paul for Specx might have been 1 Corinthians 7:9, 'It is better to marry than to burn,' there is evidence that even heavier issues were involved. As so often, Rembrandt leaves us in ignorance of the exact meaning of his subject. Lievens, in *his* painting of *St. Paul* from 1629 (fig. 94), is more accommodating. He displays the text, in Greek, that the apostle has just composed; 'Now concerning the second coming of our Lord Jesus Christ and our assembling to meet him, we beg you brethren' (2 Thessalonians 2:1 – which goes on) 'not to be quickly shaken in mind or excited, either by spirit or by word, or by letter purporting to be from us, to the effect that the day of the Lord has come.'

Whatever the verse meant in early Christian times, in seventeenth-century Holland it was a warning against the heresy called milleniarism, or the false belief in the Second Coming. According to orthodox Protestant dogma, Christ would return at the end of time. But among the Anabaptists, Mennonites and Socinians were groups who

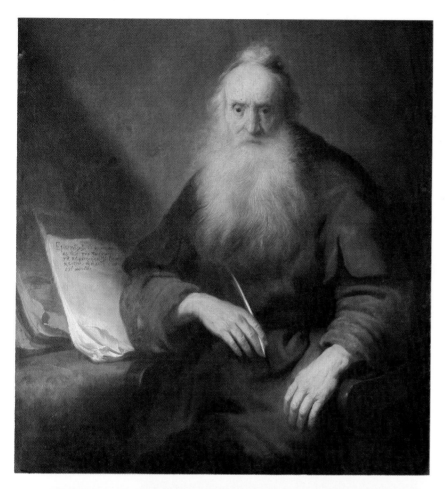

94 Jan Lievens (1607-1674), *St. Paul*. About 1629. Canvas, 110.5 x 101.5 cm. Bremen, Kunsthalle.

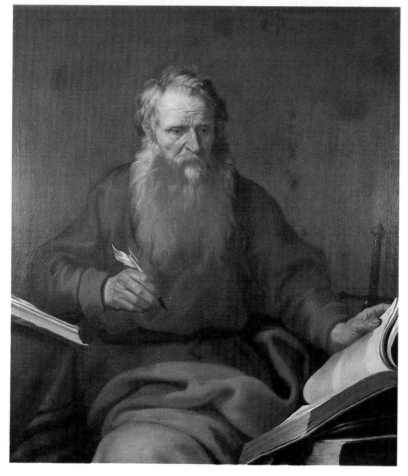

95 Lambert Jacobsz. (ca. 1598-1636), *St. Paul*. Signed and dated 1629. Canvas, 114 x 101 cm. Leeuwarden, Fries Museum.

The resemblances between these two works of the same period are made all the more puzzling by the conflict between the text on Lievens's painting and the creed to which Lambert Jacobsz. adhered. Upon the death of Lambert Jacobsz., his estate included one painting by Lievens and two copies after his work.

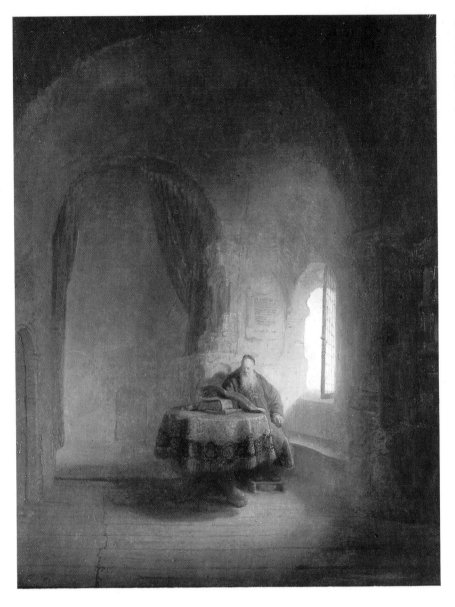

96 Copy after Rembrandt, *St. Anastasius*. After a lost painting of 1631. Signed and dated 1631. Panel, 60.8 x 47.3 cm. Bredius 430. Stockholm, National Museum.

The Rembrandt Research Project has argued persuasively that the execution of this panel, which has always been accepted in the past as an original, is too poor to be by Rembrandt. The composition is certainly his, however. In the 1640s, the original painting was engraved by an Antwerp artist under the title 'S. Anastasius.'

On the pier behind the old man is an altar adorned with a painting of *Christ on the Cross* very much like those that Rembrandt and Lievens painted in the same year.

believed that Christ could be expected to return any day, in the guise of a mortal. In the sixteenth century, Reformed Christianity had been traumatized, and discredited, by several outbreaks of messianism. Paul's epistles to the Thessalonians provided one of the biblical sources by which Catholics and orthodox Protestants disproved the claims of their heretic brethren.

In the same year that Lievens painted his *St. Paul*, an artist from Leeuwarden, Lambert Jacobsz., produced a work so similar, even in size, that one of them must have been emulating the other (fig. 95). From what we know about the two artists – Lievens a youngster who prided himself on the originality of his compositions and Lambert Jacobsz. a dyed-in-the-wool painter-dealer whose shop was full of copies – we can draw our own conclusions as to who was copying who. What makes the case so interesting is that Lambert Jacobsz. was the leader of the Waterland Mennonites of Leeuwarden! (For

more information on the sect, see below, p. 139.) His painting does not show a text, but we can be sure that it was not intended to convey the same cautious, authoritarian meaning as Lievens's.

The only one of Rembrandt's saints from this period who comes complete with a theological message is his *St. Anastasius*, known today only in a painted copy (fig. 96) and an early print by Pieter de Baillu. The caption to the print reads 'S. Anastasius,' and although scholars have recently belittled its significance, I see no reason to do so. It could well refer to the seventh-century Abbot Anastasius of the cloister of St. Catherine at Mount Sinai, whose writings have survived. He was an opponent of the Monophysite heresy, which denied the double nature of Christ. In the seventeenth century this heresy was laid at the feet of the Mennonites and Socinians. The painting above the saint – which the print reveals to be very similar to *Christ on the Cross* (fig. 80) – is exactly the kind of

icon of Christ we would expect Anastasius to worship. It was at the moment of his death that Christ was most fully man, while his divinity was also revealed to the world.

In anticipation of the theological study that may some day solve the problems around this group of paintings, we can tentatively call Lievens's *St. Paul* and Rembrandt's *St. Anastasius* painted defences of orthodox Calvinism against Mennonite and Socinian heresy.

MENNONITES IN LEIDEN | Not that Rembrandt and Lievens were hostile to Mennonites. Paintings by both of them are found in the collections of Mennonite Leideners, like the Hoogmades, the family into which Lambert Jacobsz.'s son Abraham van den Tempel was to marry in 1640. Lievens's contacts with Lambert Jacobsz. must have been close enough for them to compare notes on St. Paul in 1629. In the 1630s, Lambert Jacobsz. sold copies after Rembrandt and Lievens in Leeuwarden, in the 1650s Rembrandt painted the portrait of Lambert Jacobsz.'s sister-in-law (fig. 385), and in 1665 Abraham van den Tempel helped Rembrandt's son Titus get a commission in Leiden to copy a portrait by van den Tempel (see p. 298).

The most significant tie between either of the young Leideners and a member of the Mennonite church was Rembrandt's partnership with Lambert Jacobsz.'s fellow Waterlander Hendrick Uylenburgh, who was to bring Rembrandt into contact with so many Amsterdam Mennonites. That side of the master's life will be dealt with below. We cannot however close this chapter without noting that the business partnership between Rembrandt and Uylenburgh was cemented by a thousand-guilder loan by Rembrandt before spring 1631, more than half a year before the artist moved to Amsterdam. In fact, Uylenburgh is recorded in Leiden in March 1628, giving testimony to protect the interests of his dead brother's wife and children, who lived in the city of Rembrandt and Lievens. On that occasion he called in as a witness a prominent Leiden jurist, with whom he must have had a connection of some kind: Nicolaas Dedel, who was related both to Jacob Isaacsz. van Swanenburg and Constantijn Huygens. It seems not unlikely that it was that early that Uylenburgh met Rembrandt and began selling his paintings in Amsterdam.

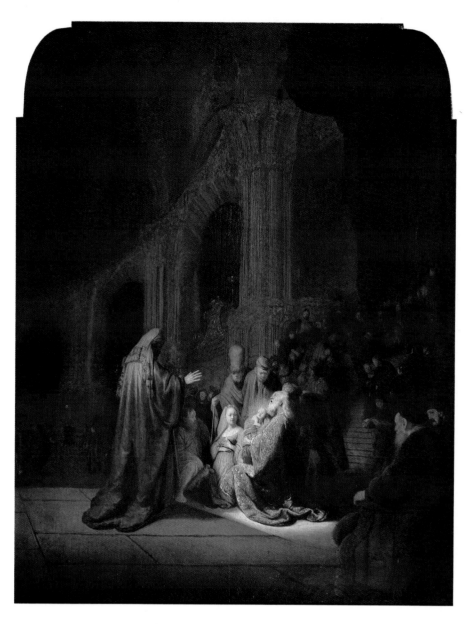

97 *Simeon in the Temple* (Luke, 2:25-38). Signed *RHL 1631*. Panel, 60.9 x 47.8 cm. (The rounded top corners are a later addition.) Bredius 543. The Hague, Mauritshuis.

This is a very different type of composition to the paintings of single figures in the rest of this chapter. I include it here because of its technical, stylistic and thematic affinity to the *Jeremiah* and *Hannah*. Scientific examination of the panel, by a process known as dendrochronology, has revealed that the left plank comes from the same tree as the wood used for the *Hannah*. The two works are among the last ones Rembrandt did in Leiden.

17 The Passion

Before we follow Rembrandt to Amsterdam, where his destiny lay, there is some unfinished business to be attended to in The Hague. Two strands of work anchored in court commissions from the period of Huygens's autobiography – the Passion series and the mythologies – dangle into the mid- and late thirties, and we must trace their course before moving on to the new subjects and specialties that Rembrandt began in Amsterdam.

The *Raising of the Cross* (fig. 98), the *Descent from the Cross* (fig. 99), the *Ascension* (fig. 105), the *Entombment* (fig. 106) and the *Resurrection* (fig. 108) are all the same size, and depict five traditional scenes in cycles of the Passion of Christ. In that sense they may be called Rembrandt's Passion series. But insofar as the term suggests that the paintings were commissioned and conceived as a closed group, it is misleading. The first two, probably ordered for the stadholder by Constantijn Huygens and delivered around 1633, are closely linked to the earlier *Christ on the Cross* (fig. 80) in subject, size, shape and derivation from Rubens. The other three were ordered by the stadholder himself after the first two were in his possession, to complement them. They were completed in two phases: the *Ascension* in 1636, the *Entombment* and *Resurrection* in 1639. The derivations from older art in these works, and their mood, are more Venetian than Flemish.

This fragmented history is reflected in the works themselves, which do not fit together well stylistically and do not form a complete Passion cycle. It was such a loose assortment of paintings that in the 1640s, when the stadholder ordered his last two paintings from Rembrandt – the *Adoration of the shepherds* (fig. 261) and the *Circumcision* (fig. 262) – which have nothing to do with the Passion, he had them made the same size, with the same frames, and hung them alongside the Passion paintings.

THE RAISING OF AND DESCENT FROM THE CROSS, 1632-1633 | Whatever lingering hopes Frederik Hendrik and Huygens may have had of employing Rubens at the Dutch court were dashed in December 1631. The painter persisted in playing the enemy diplomat. In that month he paid the last of his three visits to the northern Netherlands, on a mission to Frederik Hendrik that called for a quick and decisive rejection. Rubens was sent packing nearly as soon as he arrived.

It cannot have been very long afterwards that Rembrandt was commissioned to paint for the stadholder adaptations of the central panels of two famous altarpieces by Rubens: the *Raising of the Cross* in the church of St. Walburga in Antwerp (1611; fig. 100) and the *Descent from the Cross* in the Cathedral there (1612; fig. 101). Art historians have been inclined to stress the differences between Rembrandt and Rubens and play down the similarities. From the point of view of those giving the commission, though, it must have been the similarities that mattered. Huygens and Frederik Hendrik were in agreement that Rubens was a model worth following, and that Rembrandt was a Dutch artist capable of doing so. He was welcome to try to improve on Rubens, but who expected him to succeed? The rhapsody on Rembrandt in Huygens's autobiography speaks of improving on the ancients and the Italians, not on Rubens. In any case, the paintings ordered from Rembrandt were less than one-twentieth the size of Rubens's.

Yet they were well received at court. We know from one of Rembrandt's letters to Huygens that the stadholder commissioned the artist to do three more to match the first two, which we can only see as a pure sign of favour. The continuation order, however, was to drag on for six years, and end in mutual dissatisfaction.

LETTERS, PACKING SLIPS, AN INVOICE, A PAYMENT REMINDER, A PAYMENT ORDER AND THE PAINTINGS THEY COVERED | The story of the last three Passion paintings tells itself in seven documents written by Rembrandt to Constantijn Huygens, two in February 1636 and five in early 1639. Apart from one letter of 1662 which has survived only in an Italian translation, these are the only first-hand records of Rembrandt's own not very articulate voice. They are here given in full, in the English translation of Yda D. Ovink.

For the sake of continuity, clarity and fun, I have taken the liberty of adding fictional reconstructions of Constantijn Huygens's replies, which have been lost.

The first letter, February 1636

My Lord
My noble Lord
Huygens, Councillor and
Secretary of His
Excellency.
Postage [paid] The Hague.

My Lord, my gracious Lord Huygens, I hope that your lordship will please inform His Excellency that I am very diligently engaged in completing as quickly as possible the three Passion pictures which His Excellency himself commissioned me to do: an Entombment, and a Resurrection and an Ascension of Christ. These are companion pictures to Christ's Elevation and Descent from the Cross. Of these three aforementioned pictures one has been completed, namely Christ ascending to Heaven, and the other two are more than half done. And should it please His Excellency to receive this finished piece at once or the three of them together, I pray you my lord to let me know concerning this matter so that I may serve the wishes of His Excellency, the Prince, to the best of my ability.

And I also can not refrain, as a token of my humble favour, from presenting my lord with something of my latest work, trusting that this will be accepted as favourably as possible. Besides my greetings to your lordship, I commend you all to God in health.

My Lord, your humble and
devoted servant
Rembrandt

I am living next door to the
pensionary Boereel
Nieuwe Doelstraat.

Huygens's hypothetical reply, February 1636

Dear Sir,
His Excellency was pleased to hear of your progress on his three paintings. He is impatient to have them after all this time, and therefore requests you to send at least the one that is completed without further delay.

The etchings you sent me are among the most outstanding examples of the art I have ever seen, a judgment with which all those to whom I have shown them here are in full agreement. I have presented them to His Excellency in your name, and he wishes to thank you.
Yours,
Constantijn Huygens

The first delivery, February 1636
Rembrandt ships the *Ascension* to Huygens, who takes it to the stadholder's quarters in the Binnenhof, where the *Raising* and *Descent* were hanging, and installs it beside them.

Huygens's hypothetical reaction to the painting, February or March 1636
Dear Sir,
Your painting of the *Ascension of Christ* arrived safely and has been installed next to the others. When His Excellency saw them together, he remarked that the new piece does not match the older ones quite as well as he had hoped. What he particularly admired in the earlier works, as you know, was the naturalness of the emotions, while those in the *Ascension*, if I may presume to interpret His Excellency's mind and criticize your artistry, seem so much more conventional. So much of it, moreover, is in deep shadow.

May I impose upon your goodness and ask you to come to The Hague at your earliest convenience to see if anything can be done about this. If not for the *Ascension* then for the two remaining pieces.

May I also know how much money you expected to be paid for the painting.
Yours,
Constantijn Huygens

The second letter, February or March 1636

My Lord
My Lord Huygens
Secretary of His Excellency the Prince.
The postage is paid.

My Lord,
After offering you my kind regards, I assure you

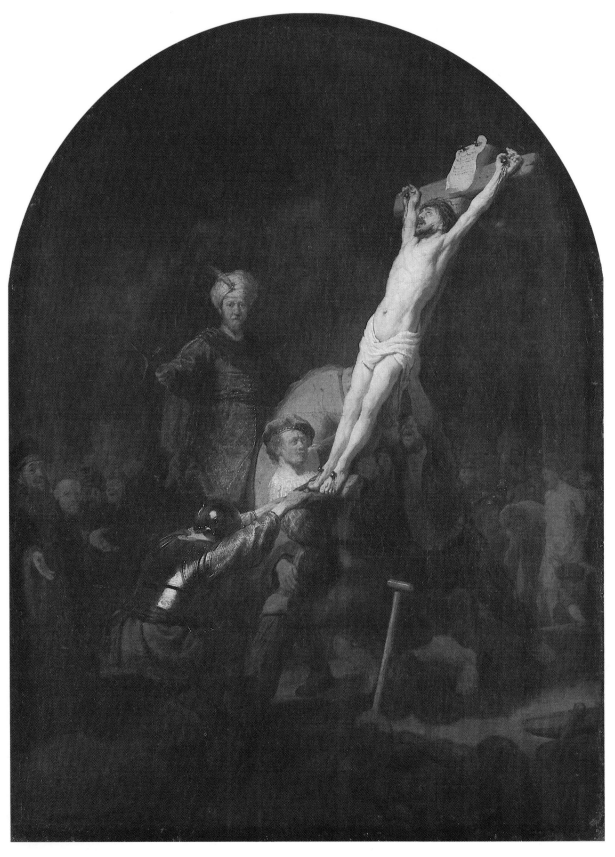

98 *The raising of the Cross*.
About 1633. Canvas, 96.2 *x*
72.2 cm. Bredius 548.
Munich, Alte Pinakothek.

The head of the young man
helping to raise the Cross is
seen, probably correctly, as a
self-portrait.
 Van Mander cites several
examples of artists inserting
themselves into their own
compositions, though none
from Rembrandt's milieu. Of
Dürer he says: 'His portrait
can also be seen in his prints;
it is the visage of the prodigal
son as he kneels with the
swine and looks towards
heaven.' Art historians have
generally assumed that
Rembrandt, like Dürer, was
giving expression to his own
Christian commitment.
 The artist's presence in this
scene of all scenes may have
less to do with the convictions
of the painter than with those
of the patron. Around this
time, Constantijn Huygens
was enraptured with the
metaphysical poems of the
English clergyman John
Donne (see p. 118). One of
those he translated into Dutch
was a poem on the
Crucifixion, in which the poet
tries to imagine how awful it
would have been to be present
at the Crucifixion.

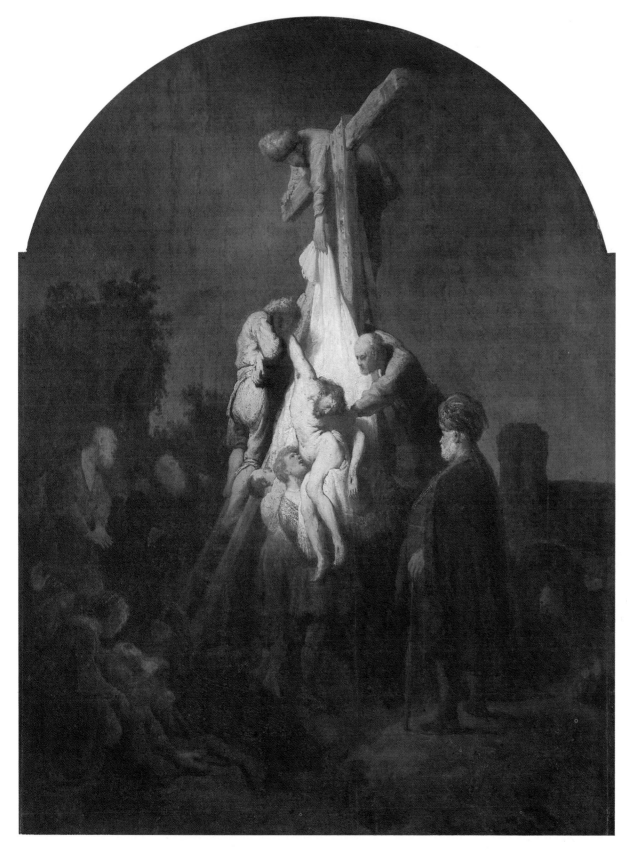

99 *The descent from the Cross*. About 1633. Panel, 89.4 x 65.2 cm. Bredius 550. Munich, Alte Pinakothek.

Going by Rembrandt's remark in his second letter to Huygens, we can conclude that the *Raising* and *Descent* were hung in the stadholder's quarters in the Binnenhof, but not in Frederik Hendrik's 'gallery.' Perhaps in his adjoining 'cabinet,' which in 1632 already housed an anonymous *Crucifixion* and a *Simeon in the Temple* by Rembrandt. The new works, painted to match the *Christ on the Cross* after Rubens, were based on the two famous altarpieces that had established Rubens as the premier painter of Antwerp more than twenty years earlier.

If this was Rembrandt's big opportunity to measure himself against Rubens, it was not a fair one. The surface of his paintings for the stadholder was less than one-twentieth the size of Rubens's altarpieces.

100 Peter Paul Rubens (1577-1640), *The raising of the Cross*. Central panel of triptych painted in 1610-1611 for the church of St. Walburga, Antwerp. Panel, 462 x 341 cm. Antwerp, Cathedral.

This was the first important commission that Rubens received after moving to Antwerp in 1608. Since early in the nineteenth century it has stood in the cathedral as a companion to the *Descent from the Cross*. It has always been one of Rubens's most accessible and most imitated works.

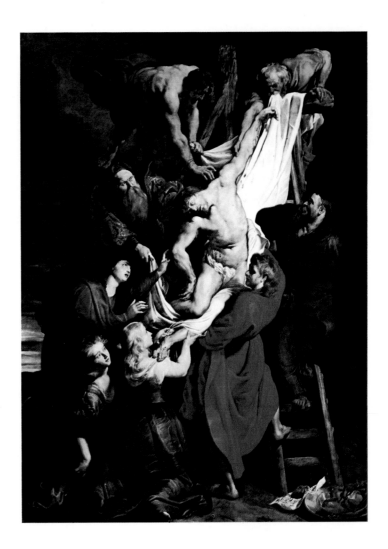

that I agree that I shall follow anon to see how the picture accords with the rest. And as far as the price of the picture is concerned, I have certainly deserved 200 pounds [1200 guilders] for it, but I shall be satisfied with what His Excellency pays me. My lord, should your lordship not take this liberty amiss, I shall leave nothing undone by which I can repay it.

 Your lordship's humble
 and devoted servant
 Rembrandt

The best place to show it is in the gallery of His Excellency since there is a strong light there.

Huygens's hypothetical response to the second letter, February or March 1636

 Dear Sir,
We are looking forward to your visit. As to the price of the painting, I am afraid His Excellency sees no reason to pay any more than what he paid for each

101 Peter Paul Rubens (1577-1640), *The descent from the Cross*. Central panel of triptych painted in 1612 for Antwerp Cathedral. Panel, 420 x 360 cm. Antwerp, Cathedral.

Much has been written about the emulation of one artist by another as an element of the classical theory of art. There is a more down-to-earth way of seeing the phenomenon. In the present case, for example, from the moment the *Raising* and *Descent* were put in place, Rubens took over the lead in Netherlandish painting. He became the man to beat, and to beat him convincingly one had to do it on his terms.

Rubens's supremacy was felt just as keenly in the northern Netherlands as in Flanders. The year the altar was placed, Petrus Scriverius and Willem van Swanenburg published the first of their prints after paintings by Rubens.

Their attempt, and Rubens's first follow-up, were abortive, however, and it was not until later in the decade that Rubens found an effective way of publishing his paintings in print. Towards 1620 he hired a young Dutchman, Lucas Vorsterman (1595?-1675?) to make engravings after his compositions under his direct supervision. Before he brought out the first group of prints, he assured himself of copyright protection in as many countries as possible. Emulation may be the sincerest form of flattery, but it can also be a dangerous form of competition. In 1620

the States General granted him copyright against the imitation of his compositions in the northern Netherlands, for a period of seven years. He was aided in this by the English ambassador to The Hague, Sir Dudley Carleton. In gratitude to Carleton, Rubens dedicated Vorsterman's print after the *Descent* to him.

Ironically, Carleton himself remained Rubens's best customer in Holland. All of Rubens's attempts to break into the rich Dutch market fizzled out, apparently for political reasons, leaving the field of heroic history painting wide open to contenders like Rembrandt.

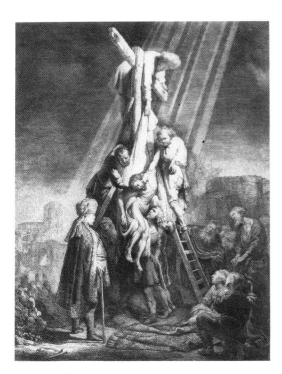

102 *The descent from the Cross.* Signed *Rembrandt f. cum pryvl° 1633* and marked, from the third state on, *Amstelodami Hendrickus Ulenburgensis Excudebat.* Etching, 53 x 41 cm. Bartsch 81/II, second state of five. Haarlem, Teylers Museum.

This free reproduction of Rembrandt's *Descent* in the stadholder's collection is the only Rembrandt etching to bear the name of Hendrick Uylenburgh as publisher. Apparently the man who sold Rembrandt's paintings in Amsterdam was eager to show him at his most Rubens-like.

The work is in fact so Rubens-like that we wonder whether Rubens would have considered it an unauthorized copy of his *Descent*, in Vorsterman's engraving (fig. 101). Even if he did, there would have been nothing he could have done about it. The copyright on the engraving by Vorsterman expired in the northern Netherlands in 1627, and in the south in 1632, the year before Rembrandt's.

It seems surprising that the inscription on Rembrandt's print fails to mention that the painting on which the etching is based was in the stadholder's collection.

One of the differences between the print and the painting is that the Virgin has been left out. In this way

Rembrandt avoided having to choose between showing the mother of God in static resignation, as Rubens did, or in a dead faint, as in his own painting. There was a Catholic-Protestant dispute on this issue, and Rembrandt may have preferred leaving the matter in the air in a work intended for international circulation.

The etching was copied in paint in the 1640s for the altarpiece of a church in Hela, across the bay from Gdansk, by the painter-burgomaster of Gdansk, Adriaen van de Linde. It was also copied in 1645, for purposes unknown, by the painter-burgomaster of Weesp, Gijsbert Sibilla.

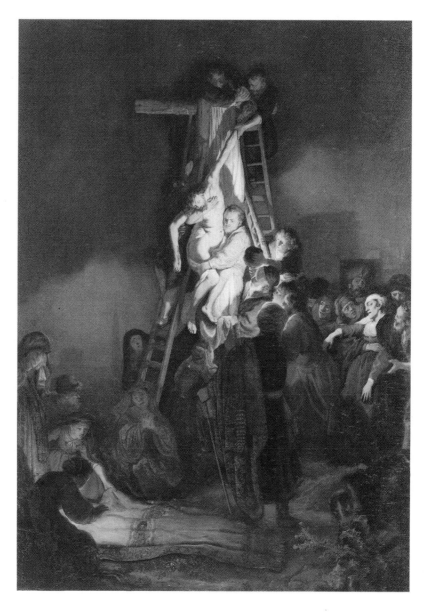

103 *The descent from the Cross.* Signed *Rembrandt f. 1634.* Canvas, 158 x 117 cm. Bredius 551. Leningrad, Hermitage.

This enlarged and enhanced version of the *Descent* seems to have remained in Rembrandt's possession until the sale of his goods in 1656. It served as a model for copies in the intervening years and also no doubt as an advertisement, like the etching of the same subject.

The pose of the Virgin, fainting on her feet, is midway between the dignified sorrow of Rubens's Madonna and the prostration of Rembrandt's in his *Descent* for the stadholder.

of the former scenes, which as I recall was six hundred guilders.

Yours,
Constantijn Huygens

Three years pass: the third letter, hand-delivered, 12 January 1639

My Lord
My noble Lord van Schuylemburgh [Huygens's title was Lord of Zuylichem]

My Lord,
Because of the great zeal and devotion which I exercised in executing well the two pictures which His Highness commissioned me to make – the one being where Christ's dead body is being laid in the tomb and the other where Christ arises from the dead to the great consternation of the guards – these same two pictures have now been finished through studious application, so that I am now also disposed to deliver the same and so to afford pleasure to His Highness, for in these two pictures the greatest and most natural emotion has been expressed, which is also the main reason why they have taken so long to execute.

Therefore I request my lord to be so kind as to inform His Highness of this and whether it would please my lord that the two pictures should first be delivered at your house as was done on the previous occasion. I shall first await a note in answer to this.

And as my lord has been troubled in these matters for the second time, a piece 10 feet long and 8 feet high shall be added as a token of appreciation, which will be worthy of my lord's house. And wishing you all happiness and heavenly blessings, Amen.

Your lordship, my lord's humble and
devoted servant
Rembrandt
This 12th January
1639
My lord I live on the Binnen Amstel. The house is called the sugar bakery.

Huygens's hypothetical response to the third letter, 14 January 1639

Dear Sir,
It was very good to hear from you again. Personally, I am as pleased as is His Highness that we are finally to receive the last two Passion paintings, to join the three that give us so much pleasure every day, and give us food for pious meditation in the midst of our work.

Please do ship the paintings to my address.

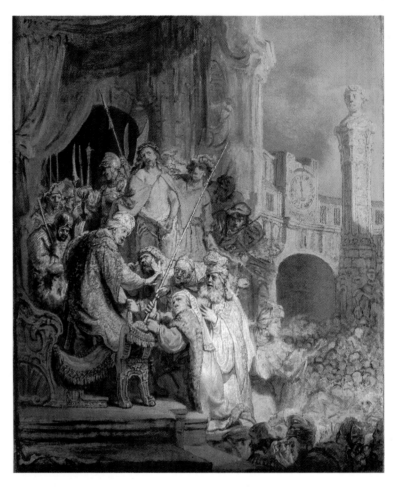

104 *Christ before Pilate and the people* (John 19:1-16). Signed *Rembrandt f. 1634.* Paper stuck on canvas, 54.5 x 44.5 cm. Bredius 546. London, National Gallery.

This painting in grey and brown is an oil sketch made as a model for an etching with the same dimensions (Bartsch 77). The first, unfinished state of the etching is dated 1635, the second state, 'with privilege,' 1636. The plate is a bit larger than the *Descent* of 1633, and was probably made to match it. These two plates are the only ones for which Rembrandt claimed copyright privilege (from whom? – not the States General, who never issued any such right). By all appearances, Rembrandt was using the Passion series as a point of departure for a set of strictly commercial etchings, equally loose in form. (See also fig. 102.)

This etching and the *Descent* helped establish Rembrandt's reputation abroad. John Evelyn, in his 1662 book on print making, singled them out as Rembrandt's best etchings. They were both copied in Poland: in the same church in Hela that had a painted copy of the *Descent* there also hung one of *Christ before Pilate.* Yet another painted copy was in the town hall of Reval, further up the Baltic coast. Hendrick Uylenburgh seems to have made good use of his old connections in Poland (see p. 139) to sell these particular works abroad. They were cheaper than paintings, but not all that much. This etching was called *The thirty-guilder print*, which sounds a likely figure for what Rembrandt or Uylenburgh were asking for impressions.

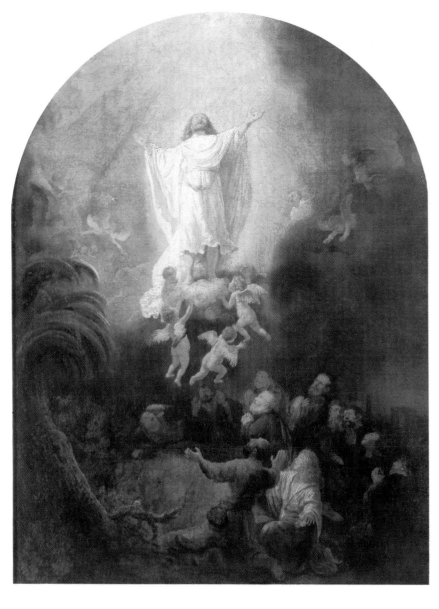

105 *The ascension of Christ* (Luke 24:50-51; Acts 1:9). Signed *Rembrandt f. 1636.* Canvas, 92.7 x 68.3 cm. Bredius 557. Munich, Alte Pinakothek.

After the *Raising* and *Descent* were hanging in the stadholder's quarters, Frederik Hendrik ordered three more paintings from Rembrandt to match them. The first one, delivered three years later, was the *Ascension*, derived from Titian and Rubens. In a lost letter to the artist, Constantijn Huygens seems to have complained about the lack of unity between this and the earlier works.

While I appreciate the generosity behind your offer, I must ask you most emphatically *not* to send me a gift, and certainly not a painting ten by eight feet large. I am only too happy to help you, knowing that in doing so I am also helping His Highness.

Yours,
Constantijn Huygens

Covering letter accompanying the shipment of Rembrandt's gift to Huygens (usually called the fifth letter), 27 January 1639

My Lord,
I have read your lordship's agreeable missive of the fourteenth with extraordinary pleasure. I find there your lordship's good favour and affection so that I cordially remain obliged to you to repay your lordship with service and friendship. Because I wish to do this, I am sending this accompanying canvas, against my lord's wishes, hoping that you will not take me amiss in this as it is the first token which I offer my lord.

The tax-collector, Wtenbogaert, paid me a visit when I was busy packing these 2 pieces. He wished to have a look at them first. He said that if it pleased His Highness he was prepared to make me the payments from his office here. Therefore I would request you my lord that, whatever His Highness grants me for the 2 pieces, I may receive this money here as soon as possible, which would at the moment be particularly convenient to me. If it pleases my lord I await an answer to this and I wish your lordship and your family all happiness and blessings besides my regards.

Your lordship's humble and affectionate servant
Rembrandt

In haste this 27th January 1639

My lord hang this piece in a strong light and so that

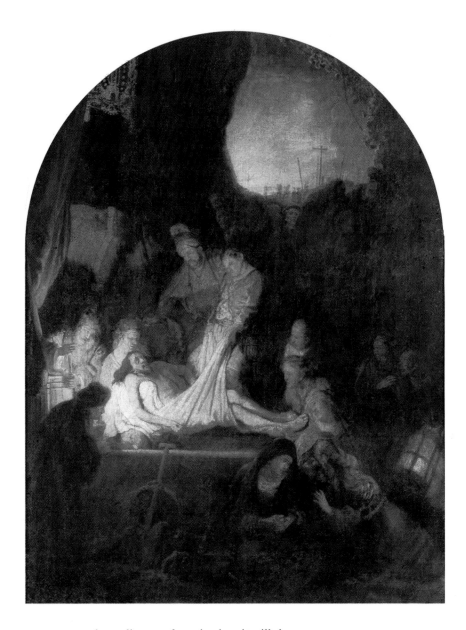

one can stand at a distance from it, then it will show at its best.

Covering letter and invoice with shipment of the Entombment *and the* Resurrection *(usually called the fourth letter), 27 January 1639 or a day or two later*

My Lord,
It is then with your permission that I send your lordship these 2 pieces which I think will be considered of such quality that His Highness will now even pay me not less than a thousand guilders each. But should His Highness consider that they are not worth this, he shall pay me less according to his own pleasure. Relying on His Highness' knowledge and discretion, I shall gratefully be satisfied with what he pays. And with my regards I remain his
 Humble and devoted servant
 Rembrandt

106 *The entombment of Christ* (Matthew 27:60-61; Mark 15:46-47; Luke 25:53-55; John 25:53). Completed in 1639 after three or more years of work. Canvas, 92.5 x 68.9 cm. Bredius 560. Munich, Alte Pinakothek.

One week after signing the contract for his expensive new house, Rembrandt broke a long silence and wrote to Huygens saying that he had completed the last two paintings in the Passion series – the *Entombment* and *Resurrection* – and was eager to deliver them. To judge by their deplorable condition, these paintings must have been finished in that week and shipped to Huygens in a rush before they were dry. The few patches where the original colour of the *Entombment* can be retrieved show unexpectedly bright, pastel-like tones very different from the extreme light-and-dark contrasts that the painting now exhibits.

107 *Studies of the mourning Madonna in various poses.* Latter 1630s. Inscribed *een dyvoot thresoor dat in een fijn harte bewaert wert tot troost haere beleevende siel* (A devout treasure that is preserved in a sensitive heart as a comfort for her compassionate soul). Red chalk and brown ink, 20.6 x 14 cm. Benesch 152. Amsterdam, Rijksprentenkabinet.

Preparatory sketches for the Madonna in the *Entombment*. The meaning of the inscription is not altogether clear. One wonders whether it may not be an impromptu translation of a Latin phrase from the book on the Virgin that was being written in those years by Frederik Hendrik's court chaplain André Rivet. Rembrandt seems to have had some difficulty finding a theologically and artistically acceptable mode for depicting the Virgin in scenes of the Passion.

What I have advanced for the frames and crate is 44 guilders in all.

Huygens's hypothetical reaction to the last Passion paintings and the gift, first week of February 1639

Dear Sir,

As much as I would like to oblige you in the matter of the price of the two paintings for His Highness, I am afraid that you yourself have made this impossible. Three years ago you promised to deliver them speedily, and we have waited in vain all that time. Now that they have arrived, we note to our dismay that you have ignored the agreement we made after the delivery of the *Ascension* concerning the unity of the series. Nonetheless, I did broach the subject with His Highness, who replied somewhat curtly, 'We'll pay what we paid for the others, and no more.' So please refresh my memory concerning the price that you received for the earlier paintings.

I hear from Mr. Wtenbogaert that you have just bought a new house and that you require speedy payment. I will do my best for you. The crate with the large painting you wished to present to me is being returned forthwith to the sugar bakery. I am sorry that you mistook my refusal for coquettishness.

Yours,
Constantijn Huygens

The last letter (usually called the sixth), in reply to Huygens's last, 13 February 1639

My Lord
My Lord van
Suijlijkum, Councillor and
Secretary of
His Highness the Prince
of Orange at the Hague
postage [paid].

Honoured Lord,

I have confidence in the good faith of your lordship in everything and in particular as regards the remuneration for these last 2 pieces and I believe your lordship that if the matter had gone according to your lordship's pleasure and according to right, there would have been no objection to the price agreed upon. And as far as the earlier delivered pieces are concerned, not more than 600 carolus guilders have been paid for each. And if His Highness cannot in all decency be moved to a higher price, though they are obviously worth it, I shall be satisfied with 600 carolus guilders each, provided that I am also credited for my outlay on the 2 ebony

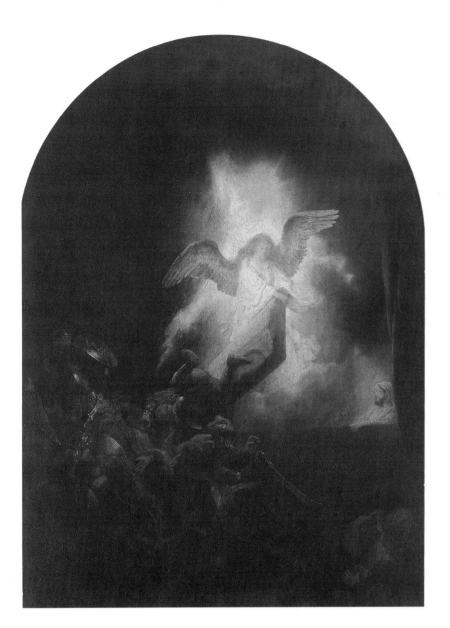

108 *The resurrection of Christ*. Signed *Rembr*[and]*t163*[9]. Canvas transferred to panel, 91.9 x 67 cm. Bredius 561. Munich, Alte Pinakothek.

The doubts Rembrandt underwent with respect to the Madonna in the *Descent* and *Entombment* overcame him again regarding the figure of Christ in the *Resurrection*. In the Bible, the Mary's find an empty tomb, and that is how Rembrandt painted the subject in the first instance. But in the final state of the painting, Christ is shown rising from the tomb. This is the way the scene is described by Jacob Cats in his poem *Trou-ringh* (Wedding ring), published in 1637, and that is how it is shown by Pieter Lastman, in a painting of 1610

that Rembrandt used as a model for other elements of this painting. In Lastman's painting, however, Christ is already airborne, whereas Rembrandt shows him in a more 'natural' pose.

frames and the crate, which is 44 guilders in all. So I would kindly request of my lord that I may now receive my payments here in Amsterdam as soon as possible, trusting that through the good favour which is done to me I shall soon enjoy my money, while I remain grateful for all such friendship. And with my regards to my lord and to your lordship's closest friends, all are commended to God in long-lasting health.

Your lordship's humble and affectionate servant Rembrandt

the 13th February 1639

Payment order from the prince's treasurer in The Hague to his Amsterdam paymaster, 17 February 1639

Upon attest of the Lord of Zuylichem, the following payment order in favour of the painter Rembrandt has been dispatched:

His Highness herewith orders his treasurer and paymaster-general Thyman van Volbergen to pay to the painter Rembrandt the sum of 1244 carolus guilders for two paintings, the one the *Entombment* and the other the *Resurrection of Christ our Lord*, made by him and having been delivered to His Highness. With reference to the above statement, etc.

ƒ 1244.0.0

The following document requires a word of explanation. Volbergen, as was his corrupt habit, delayed payment as long as possible in order to extract the maximum personal benefit from his use of the Prince's money. Rembrandt was to be paid from the revenues of a particular source of income, which Volbergen denied having received. At a given moment, probably as May 1st was drawing near, the day when Rembrandt's first payment on his new house fell due, the artist called in the aid of Joannes Wtenbogaert, who had offered from the start to pay the bill from his office. (It would not surprise me if Wtenbogaert's appointment as receiver-general in July 1638 had not prompted Rembrandt to cash in on the six-year-old commission.) Wtenbogaert gave Rembrandt inside information that contradicted Volbergen. Rembrandt passed this on to Huygens, after which he apparently received his money.

Payment reminder, usually called the seventh letter, April (?) 1639

My Lord,
My noble Lord van Suijlijkum
Councillor and secretary
of His Highness at The Hague.
Postage [paid].

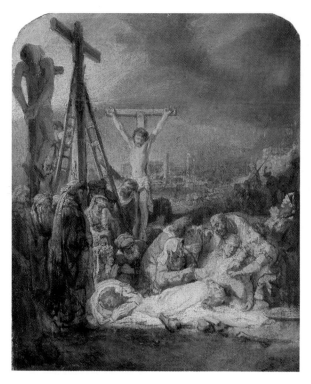

109 *The lamentation over the dead Christ.* Worked on for several years from about 1637 to 1643. Paper and canvas stuck on panel, 31.9 x 26.7 cm. Bredius 565. London, National Gallery.

Sir Joshua Reynolds, who once owned this painting, wrote on the back of the panel, 'Rembrandt has labour'd this study... & had so often changed his mind... that my Father and I counted I think seventeen pieces of paper.' This is exaggerated, but what it says about the patchwork nature of the support is true. The centre of the composition is painted on an irregular sheet of paper, and the rest is fitted out with scraps of paper and canvas.

We recognize the painful uncertainty that Huygens described in his remarks on Rembrandt. More than any of his other groups of works, the commissions for the court brought out Rembrandt's indecision.

The *Lamentation* recombines motifs from several paintings for Frederik Hendrik, as do several drawings and etchings from the same years.

My Lord,
My noble Lord, it is with hesitation that I come to trouble you with my letter and I am doing so because of what was told me by the collector Wttenboogaert to whom I complained about the delay of my payment and how the treasurer Volbergen denied that dues were claimed yearly. The collector Wttenboogaert now replied to this last Wednesday that Volbergen has claimed the same dues every half year up till now, and that more than 4000 carolus guilders were now again payable at the same office. And this being the true state of affairs, I pray you my kind lord that my warrant might now be prepared at once so that I may now at last receive my well-earned 1244 guilders and I shall always seek to recompense your lordship for this with reverential service and proof of friendship. With this I cordially take leave of my lord and express the hope that God may long [keep] your lordship in good health and bless you. [Amen].

Your lordship's humble and affectionate servant Rembrandt.

I live on the Binnen Amstel in the sugar bakery.

However one chooses to interpret the nuances of the correspondence, one cannot help feeling that

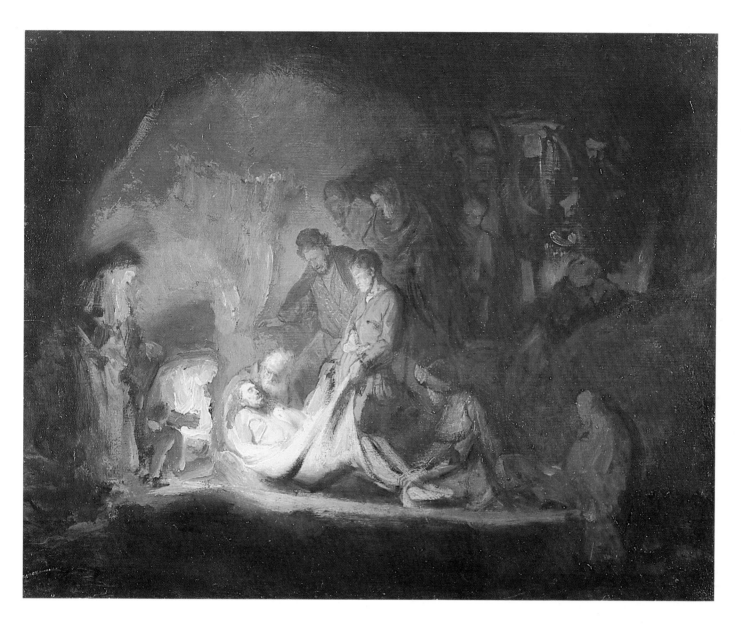

Rembrandt behaved with a minimum of consideration towards Huygens and the stadholder. He treated the commission like an apple for a rainy day, delivering new paintings only when his own financial needs grew acute. This is demonstrated most dramatically by the letter of January 12, 1639. For all its protestations of zeal, studiousness, natural emotion and the rest, the fact is that Rembrandt wrote it, following a silence of three years, exactly one week after he signed the contract for his new house. By all indications, he finished the two paintings in a mad rush in that week, and delivered them before they were properly dried, so that the fresh paint never adhered properly to the underlying layers. In 1755 the restorer of the *Resurrection* had such an extensive job on his hands that when he was finished he added the unique inscription *Rimbrand Creavit me. P.H. Brinckmann resuscitavit Te/ 1755* (Rembrandt created me. P.H. Brinckmann brought me back to life./1755).

The *Entombment* had been in the restoration laboratory of the Alte Pinakothek in Munich for several years when I saw it there in spring 1983. The chief restorer, Dr. H. von Sonnenburg, told me that his staff could only work on it for so long at a time before growing too depressed to continue.

'THE GREATEST AND THE MOST NATURAL EMOTION' | Considering the tenor of the convoluted, rather insincere sentence in which these words occur, in the third letter, it is sad to have to observe that they are regarded as Rembrandt's most profound comment on his art. They have given rise to a not inconsiderable sub-class in the Rembrandt literature. Without wanting to have the last word in the discussion, I would like to point out that a similar term is used – precisely in connection with paintings of the Passion – by Samuel van Hoogstraten, who came to Rembrandt's studio as an apprentice the year after the letter was written and the paintings

110 *The entombment of Christ* (Matthew 27:60-61; Mark 15:46-47; Luke 25:53-55; John 25:53). About 1639. Panel, 32.2 x 40.5 cm. Bredius 554. Glasgow, University, Hunterian Art Gallery.

The purpose of the panel is unclear. It seems to be a variant on the *Entombment* for Frederik Hendrik (fig. 106), perhaps intended to show to potential patrons. It is about the same size as *David with the head of Goliath* (fig. 19), which fulfilled a similar function.

delivered. To Hoogstraten the term refers to the Protestant as opposed to Catholic mode of painting the Virgin at the death of Christ. 'I cannot refrain [from telling] how we painters are accustomed, in [scenes of] the bitter Passion of Christ, to depict Mother Mary, as the one closest to the Saviour, with the *grootste beweeging* [the greatest emotion] in our power: usually this means having her faint and fall unaided into the arms of the other Mary's: great masters have considered this to be not inappropriate, and we have followed their example. However, a certain Johannes [Johannes Neercassel, bishop of Utrecht from 1663 to 1686], now appointed by his own [fellow Catholics] bishop of Utrecht, asserts in a particular tract that this feminine tenderness does not befit the haughty and highly enlightened Virgin, who had taken it upon herself so thoroughly to suffer with patience all that befell her at the hands of God' (pp. 110-111).

This was indeed a key issue separating Counter-Reformation Catholics from Protestants. Protestants like André Rivet, for example, Frederik Hendrik's court chaplain, who in the very year of 1639 published a book (with which Huygens had been helping him) entitled *Apologia pro sanctissima virgine Maria matre Domini* (Defence of the most holy Virgin Mary, Mother of God).

The distinction that Hoogstraten makes between the two kinds of Madonna can be observed in perfect form in Rubens's *Descent from the Cross* (fig. 101) and Rembrandt's (fig. 99). The *Ascension*, in those terms, lacks natural emotion, with the figures falling into conventional poses, while in the *Entombment* and the *Resurrection* greater stress is again placed on true-to-life reactions. In fact, that is exactly what Rembrandt was trying to bring out in the latter paintings, as we know from a preparatory drawing for the Madonna in Amsterdam (fig. 107).

This reading of the Passion series fits in very nicely with the theory concerning John Donne's poem (see opposite) and with Huygens's praise of Rembrandt's *Judas*. What he calls the simultaneous expression of universals and particulars (see pp. 74-75) can very well be compared with the depiction of divine suffering in human terms. Even on the visual level, it is easy to see the connection between Judas returning the silver and the Madonna bemoaning the dead Christ in the *Entombment*.

Having made the comparison, one can understand why Huygens complained about the *Entombment*, as the letter of 13 February 1639 seems to imply. The endless pains that Rembrandt had taken in 1629 to impress the court with his command of psychological and technical detail had given way, in 1639, to callous, even contemptuous haste.

One notices that the letters lack any reference to new commissions, in a decade when Frederik Hendrik was busily ordering paintings right and left for his new palaces at Honselaersdijk and Rijswijk. Rembrandt didn't ask for new commissions and he didn't get any.

JOHN DONNE AND REMBRANDT

From 1630 to 1633, Constantijn Huygens was in the thrall of John Donne (1573-1631). In 1622 he had met the English clergyman-poet in London, and was profoundly impressed by his sermons in St. Paul's, of which he was dean. In 1630, friends in England sent Huygens some privately printed poems by Donne, poems that were not to be published until 1633. He was ravished by them, and circulated them among his literary correspondents, with a steadily increasing number of his own Dutch translations. (By 1634 he had made nineteen.)

One of the poems was 'Good Friday. Riding Westward,' whose central image is of a rider traveling on the day of the Crucifixion in the opposite direction to that in which Christ was facing on the Cross. 'Hence is't, that I am carryed towards the West / This day, when my Soules forme bends toward the East.

/ There I should see a Sunne, by rising set, / And by that setting endlesse day beget...'

Could Rembrandt's horseman – the soon to be converted centurion, facing westward on the original Good Friday – be a visualization of Donne's? Personal involvement in the divine tragedy also speaks in Rembrandt's insertion of his own portrait into the painting, as one of those erecting the Cross. There is another reason, aside from Huygens's rapture over Donne, to take this posssibility seriously.

On 19 December 1619, John Donne, on a visit to Holland, preached a sermon in The Hague for which the States General awarded him a medal of honour. That medal had been struck to commemorate the Synod of Dordt, which had just ended. To receive it from the States General was to receive a Calvinist nihil obstat. John Donne was a Protestant whose orthodoxy had been

certified by the Dutch state with the seal of the Dutch church. Frederik Hendrik had already been attacked by the clergy for the Venuses and Madonnas in his art gallery. And here he was, in 1633, ordering images of the Saviour himself, based on a famous altarpiece in a Catholic church. The thought that tempts one is that the *Raising of the Cross*, despite its derivation from Rubens, is a Protestant version of the theme, inspired by the imagery of the unimpeachable John Donne.

Mythological paintings

Rembrandt the Latin school dropout shied away from classical subjects. Among his 380-odd etchings, there are only four or five mythologies, and at least two of them were commissions. Concerning the seven ancient gods and heroes he painted between 1655 and 1665, we have documentation on four: at least three were commissioned. Apart from the *Palamedes*, that leaves eleven paintings of classical subjects – five erotic tales from the *Metamorphoses*, five goddess figures and a Carthaginian queen. All were done between 1630 and 1636. A sixth painting of a goddess, Minerva, dated 1635, has been kept hidden from the view of scholars for several decades, and is left out of consideration in this book. The accidents of survival and uncertainties of attribution render all these figures relative.

If the dates are the years of Rembrandt's Hague period, and if the subjects smack of the court, this is no accident. We know the first owners of three of the paintings: the stadholder had two, and Jacques Specx one, while a fourth is related to Jacques de Gheyn II. Only two or three of the paintings were made for the Amsterdam market, works whose classical character is so dilute that many scholars do not even consider them mythological. The final chapter in our section on Rembrandt as a court artist provides a transition to Amsterdam.

ANDROMEDA, 1630 | Probably Rembrandt's earliest mythological painting is a small panel – made even smaller by having been reduced in size – depicting the Ethiopian princess Andromeda (fig. 111). Her mother Cassiopeia was a famous beauty who claimed to outshine Juno, and what with one thing and another, this brought on Andromeda's well-known plight: being chained to a cliff and attacked by a sea monster, until she was rescued by Perseus.

Rembrandt's depiction of the subject, which shows Andromeda without the serpent threatening to devour her or the flying Perseus come to save her,

is so unusual it can be termed unique. The only known precedent is an illustration in a Latin manuscript of the ninth century, a copy of a lost antique original (fig. 112). This would certainly be too obscure a source to cite for the work of a Dutch painter, if the manuscript concerned were not in Leiden, where it was one of the most famous treasures of the university library, even having been published by Hugo Grotius with prints by Jacques de Gheyn II. In fact, the miniatures still bear the unfortunate marks of the metal point he used to trace their outlines for the engravings.

The manuscript was an *Aratea* – Latin translations by Cicero of astronomical poems by the Greek scholar Aratus (ca. 315-240 B.C.) after a prose treatise by Eudoxus of Cnidos (ca. 390-332 B.C.). The Leiden *Aratea*, as a stage in the transmission of ancient wisdom from Asia, the birthplace of astronomy, to Greece to Rome to the Carolingian court to modern Europe, was a prime relic of humanism. The edition of the *Aratea* by Grotius and de Gheyn was considered a milestone in Dutch learning.

The reputation of Aratus was enhanced even further by the fact that he was quoted approvingly in the New Testament. As Scriverius wrote in his commentary to Heinsius's poem *Christus*, 'Ambrosius demonstrated that the Holy Apostle Paul (Acts 17:28) deigned to use the words of the poet Aratus when speaking to the Athenians.' If Paul could quote Aratus, then why should the Christian humanist Heinsius not do the same, and quote other heathens too?

The refinement and esotericism of this work, as well as its relation to Jacques de Gheyn II, recall the Rembrandt of the late 1620s, standing on intellectual tiptoe to satisfy the expectations of Huygens and Jacques de Gheyn III. No other work by him is a more direct application of Huygens's principle of 'bringing Italy to Holland.'

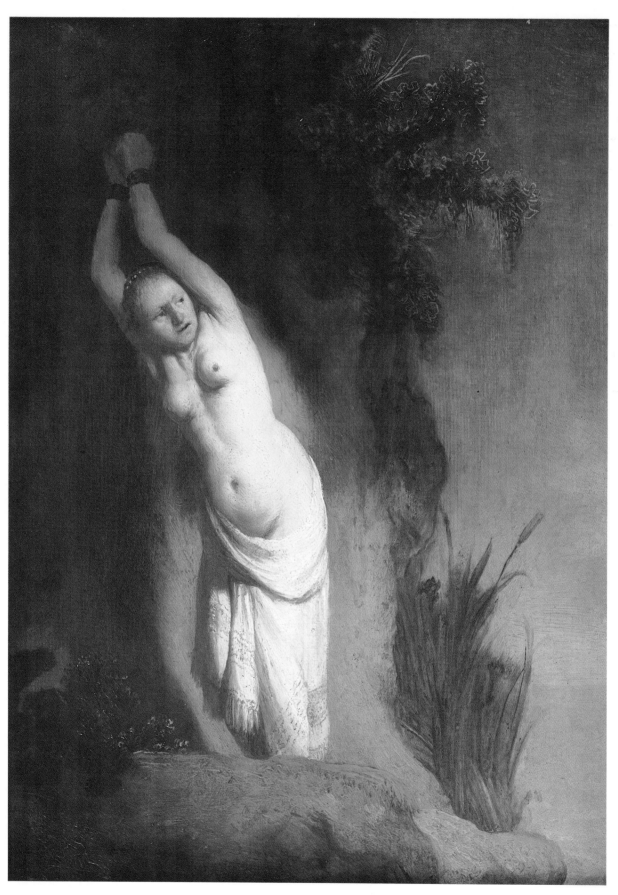

111 *Andromeda*. Ca. 1630. Panel, 34.5 x 25 cm. Bredius 462. The Hague, Mauritshuis.

Depictions of Andromeda in Netherlandish art often allude to politics. The naked princess in bondage was seen as a symbol of a helpless land, preyed upon by a monstrous enemy, rescued in the nick of time by a forceful leader. The allegory was applied to William of Orange, among others. In Rembrandt's painting, both the monster and the saviour, Perseus, are missing, so that it cannot be read as an allegory. Andromeda on her own is known in art only as a figure for the astronomical constellation. (The monster and Perseus are the neighbouring constellations.) As it happens, a famous depiction of a constellation in a form not all that different from Rembrandt's was close at hand (fig. 112).

PALLAS OR MINERVA, 1632 | If the evidence that *Andromeda* was made for the court is purely circumstantial, with the following two paintings we are on firmer ground. Both have provenances leading straight back to the stadholder's court.

Upon the demise in 1702 of Frederik Hendrik's grandson Willem III (King William III of England), the direct line of legitimate male descendants of William the Silent died out. Many of the houses and goods that had been accumulated by the Oranges in the sixteenth and seventeenth centuries now passed into the hands of Frederick I of Prussia, whose mother was the daughter of Frederik Hendrik and Amalia van Solms. One result of this turn of events was that a number of early Rembrandts were shipped to Berlin, to form the nucleus of what is now the largest collection of Rembrandt paintings in the world.

One of these works was a full-length portrait of a seated woman with the attributes of the Roman goddess of war and wisdom, Minerva (fig. 113). Usually, the painting is identified with the following item from the 1632 inventory of the stadholder's collections: 'In the gallery of His Excellency… A painting of Melancholy, being a woman seated on a chair at a table on which lie books, a lute and other instruments, by Jan Lievens.' Under duress, scholars sometimes may be forced to impugn the accuracy of a document. But in this case, their willingness to assume that a perfectly competent clerk mistook the subject, composition *and* author of a painting he described with such self-assurance goes too far. The resemblance of the painting in Berlin to the description of Lievens's *Melancholy* in the prince's gallery is more likely to have been due to a borrowing by Rembrandt than to a mistake on the part of the clerk.

In fact, there is another entry in the same inventory that is much more satisfying, and, if it is correct, tells us a lot more about the painting: 'In the gallery of Madame the princess… A portrait of Mrs. Stranges in the guise of Pallas or Minerva.' (No author is mentioned, but then again, the painting in Berlin is not signed, and we know that the clerk of 1632 did not have a good grasp of Rembrandt's style.)

'Mrs. Stranges' was Charlotte de la Trémouille (1599-1664), granddaughter of William the Silent, niece of the Winter King, and wife of James Stanley, Lord Strange, who in 1642 was to become the Seventh Earl of Derby. Charlotte married Lord Strange in 1626, and lived thereafter in England. In April 1632, however, she visited The Hague for family reasons, and on this occasion she could have been painted by Rembrandt for Amalia's gallery. It

112 Anonymous artist of the mid-ninth-century, *Andromeda*, after a leaf in a lost antique codex of the *Aratea*. Vellum, 22.5 x 20 cm. Leiden, University Library.

The Carolingian artist posed Andromeda much like Christ on the Cross. Rembrandt subdued this resemblance, but there can be no doubt that Andromeda was on his mind when he painted his own *Christ on the Cross* in 1631 (fig. 80).

was in that year that Rembrandt was painting the portrait of Amalia (fig. 64), while Honthorst must have made his double portrait of Amalia and Charlotte during this visit (Milton House, near Cambridge, unpublished). The resemblance between Rembrandt's Minerva and the later portrait of Charlotte in a family group by van Dyck in the Frick Collection provides further support for the identification.

The mantelpiece painting in Amalia's gallery, whose walls were covered with red-and-cloth leather, was a pastoral by Honthorst. The authors of the other paintings there were virtually all from Antwerp or Utrecht – the works presented to Amalia in 1626 by the States of Utrecht hung here – and the paintings themselves tended towards a certain preciousness. Banquets of the gods, landscapes with nymphs and shepherds, Prince Willem and the princesses leading a tiger, set about with fruit, and so forth. Frederik Hendrik's biographer J.J. Poelhekke suggests that Amalia fled into frippery to avoid having her walls defaced by the Papist imagery that her husband seemed to prefer. Rembrandt's commissions back up this view: he painted Calvaries and Ascensions for the prince and for the princess, portraits of court ladies as Minerva. The guise was more fitting, by the way, than anyone could have known in 1632. In 1647, Charlotte earned her right to Minerva's mantle by fighting like a man in defence of her husband's castle when it was attacked by Cromwell's troops.

As a competitor with the painters of Utrecht, Rembrandt made some headway in The Hague – but in Utrecht he made none at all. The only three Utrecht collections in which he was represented were those of the half-Utrechters Jacques de Gheyn III, who moved there from The Hague, and Cornelis van Werckhoven, who did the opposite, and the full Utrechter Carel Martens, who however probably met Rembrandt in Leiden (see p. 150).

The entire city seems to have shared the opinion of its foremost humanist, Arnoldus Buchelius: 'The miller's son is made much of, but before his time' (1628). In Utrecht, that time never came.

PROSERPINA, 1632 | The 1632 inventory describes another painting in the prince's gallery as 'a large painting in which Pluto abducts Proserpina, made by Jan Lievens of Leiden.' Again, this pertinent piece of information has been doubted by art historians who identify the entry with the Rembrandt *Proserpina* in Berlin. There is no handy alternative this time in the rest of the inventory, but one fails to see how the cataloguer of a collection including paintings of quite grand format could have

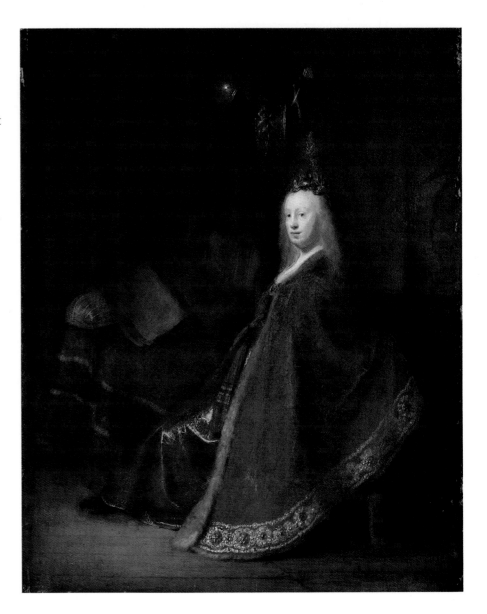

113 *Charlotte de la Trémouille, Frederik Hendrik's niece, as Minerva (?)*. April 1632 (?). Panel, 60.5 x 49 cm. Bredius 466. Berlin-Dahlem, Gemäldegalerie.

If a portrait, this painting is of a type known as a 'portrait historié,' in which the sitter takes on the guise of a biblical, mythological or historical personage. The provenance of the painting goes back to the court of Frederik Hendrik, who in 1632 owned only one painting of this type, a 'portrait of Mrs. Stranges [Charlotte de la Trémouille], as Pallas or Minerva.'

The genre was better known in England than in Holland. In The Hague, the English wife of the Winter King was fond of having herself and her children painted by Honthorst as shepherds and shepherdesses. In that respect, it is understandable that Charlotte, who was married to the Earl of Derby and lived in England, should have shown a preference for a costume portrait.

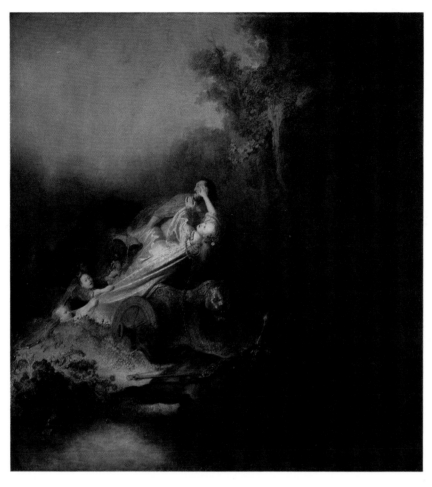

114 *The abduction of Proserpina.* About 1632. Panel, 84.8 x 79.7 cm. Bredius 463. Berlin-Dahlem, Gemäldegalerie.

The abduction of Proserpina is the only mythological painting Rembrandt is known to have made for the stadholder. Like both the biblical subjects he had already painted for him – *Samson and Delilah* (fig. 69) and *Christ on the Cross* (fig. 80) – this work too is based in part on a print after Rubens, an etching by the Haarlem artist Pieter Soutman (ca. 1580-1657), a friend of Petrus Scriverius who bore the title 'court painter to the king of Poland.' The original by Rubens belonged to Charles I, making it all the more appropriate as a model for a painting for Frederik Hendrik. It cannot be said that in his work for the prince Rembrandt departed very far from the trodden path.

singled out this moderately sized panel as the only one of the fifty-five paintings in the prince's gallery to be called 'large.' I am more inclined to assume that the stadholder owned one Proserpina by Lievens and that he or Amalia had another by Rembrandt. The latter is the painting now in Berlin (fig. 114), which arrived there via the same route as the *Minerva*.

Like *Andromeda, Proserpina* testifies to a knowledge of late antique learning that could only have been spoon-fed to Rembrandt. The literary source is not the overly familiar text of Ovid, but a fourth-century epic by Claudianus, *De raptu Proserpinae* (On the abduction of Proserpina). The nature myth is the same – the daughter of the goddess of grain, Ceres, is taken by Pluto to the underworld, where she is doomed to spend six months of every year – but the stories are enriched with elaborate descriptions, making Claudianus a nearly pictorial source for an artist.

We can make things easy on ourselves, and assume that Constantijn Huygens was the one to tip Rembrandt on Claudianus. But there is a more interesting candidate. In January 1632, Huygens received a letter from his old friend Caspar Barlaeus (1584-1648), who had just moved from Leiden to Amsterdam to teach at the new university there, a letter in which Barlaeus appeals to the authority of Claudianus as a literary model for his own poetry. In a caption to a portrait of Barlaeus, Joost van den Vondel compares him to Claudianus. If *Proserpina* was painted in Amsterdam, as I am inclined to believe, then Barlaeus may well have been Rembrandt's adviser. One cannot help thinking that the painting conveyed some topical meaning, like Claudianus's poem itself, which is thought to refer to the loss of a harvest. The Romans did not believe in the literal meaning of the tales of the gods any more than the Dutch.

ANOTHER DIVINE ABDUCTION OF 1632 | The Dutch artist's main source of mythological stories – van Mander's 'Explanation' of Ovid's *Metamorphoses* – certainly did not content itself with literal meanings. Proserpina, for example, is loaded by van Mander with morals: she stands for the bounty of the earth, and Pluto for insatiable greed, turning to 'falsehood, deceit and merciless cruelty, convinced that there is no other way to become rich quick' (fol. 46b).

His moralization of Jupiter's abduction of Europa, which Rembrandt painted in 1632 (fig. 116), is less disapproving. The bull, he says, was actually a ship of that name. The eastern princess

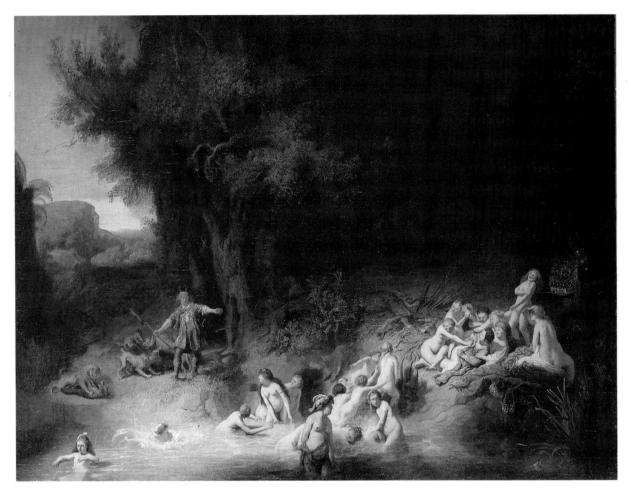

115 *The goddess Diana bathing, with Actaeon turned into a stag and Callisto's pregnancy discovered*. Signed *Rembrandt fe. 1634*. Canvas, 73.5 x 93.5 cm. Bredius 472. Anholt, West Germany, collection of the prince of Salm-Salm.

In the last of the narrative mythologies, we are again confronted with an unprecedented iconography: a combination in one scene of two distinct Diana myths. On the left is the hunter Actaeon, who pays for his inadvertent view of the naked goddess by being transmuted into a stag and devoured by his own dogs. On the right we see Diana's nymphs exposing the scandalous pregnancy of one of their own, Callisto. The girl's punishment was similar to Actaeon's: she was turned into a she-bear and killed.

There is no record of this painting in the collections of the House of Orange. It differs from the documented paintings for Frederik Hendrik in two interesting respects: it is signed and dated, and it has a unique iconography. Yet we should not look too far from the court for the identity of the patron who commissioned it. The Actaeon part of the painting was copied for an illustrated edition of Ovid published in Brussels in 1677, a hint that may enable us someday to reconstruct the early history and meaning of this intriguing work.

Europa was seduced by her own curiosity into boarding it, whereupon she was spirited off to Crete. In the end, she was quite pleased to lend her name to 'a third of the earth' (fol. 21a).

Rembrandt's painting of the subject was owned when he died by Jacques Specx, and it takes little imagination to see it as a glorification of Specx's career – enticing the treasures of Asia on to ships bound for Europe. Whether it was actually commissioned by him, must remain an open question. The painting is dated 1632, and while Specx received his order to return to Holland in that year (see above, p. 101), he did not arrive there until 1633. He could have commissioned the painting by mail from Batavia, or it could have been ordered for him as a present by someone else. He could even have purchased it after his return from the artist or from Uylenburgh.

Whether or not Rembrandt was thinking of Jacques Specx when he painted *Europa*, he was

certainly aware of van Mander. The masts and harbour installations above the bull in his painting speak, for Rembrandt, in plain pictorial language.

A WAR GODDESS, 1633 | After his move to Amsterdam, Rembrandt began making large paintings of large figures. In Leiden, where Lievens had been famous for paintings of that kind, Rembrandt avoided them. Only one mythological painting falls into this category, the war goddess *Bellona* (1633; fig. 117).

Martial subjects are more likely to have been painted for The Hague, which was filled with Dutch and foreign military people, than for mercantile Amsterdam. The war rhetoric in these years – and Rembrandt's painting is a form of war rhetoric, is it not? – was certainly not coming from Amsterdam. The very year of the painting, 1633, saw the last serious peace negotiations with Spain before 1646. Amsterdam came out for peace, and Frederik

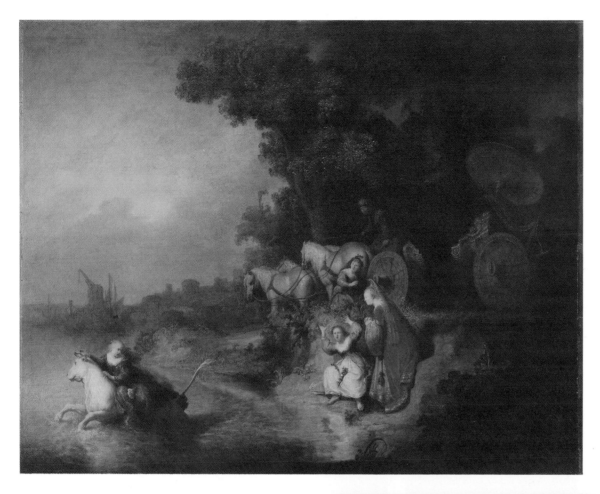

116 *The abduction of Europa*. Signed *RHL van Rijn 1632*. Panel, 61 x 77.5 cm. Bredius 464. New York, private collection.

In his 'Explanation' of Ovid, Carel van Mander attempts to explain the deeper meanings of the heathen tales, like so many Christian commentators before him. His own preference is for ethical messages. Concerning Europa, he quotes an ancient source that compares the abducted princess to 'the human soul, borne by the body through the troubled sea of this world' (fol. 21a). In a less profound vein, he says that the bull should be seen as a ship of that name, taking the beauty from the east to the western continent to which she will give her name.

Hendrik, after wavering for a long time, opposed it. In late 1633, the man who carried the day for the prince in the States of Holland and kept the war going was François van Aerssen, Constantijn Huygens's patron. He and his party are the ones who would have hung a Bellona in their homes in 1633, and not the Remonstrants, Catholics and Mennonites who Rembrandt was working for in Amsterdam.

TWO FLOWER GODDESSES, 1634-1635 | What they *were* hanging in their homes were paintings of the least warlike Roman goddess, Flora. In 1634 and 1635 Rembrandt painted two splendid versions of the subject, apparently using Saskia as his model (figs. 118, 119). The paintings have about the same height and scale as *Bellona*. Unlike it, however, and all the others we have placed in The Hague, which were hardly ever copied in the seventeenth century, the *Floras* became fixtures of the Amsterdam art scene, inspiring many copies and imitations. In fact, an inscription by Rembrandt on the back of a drawing of the latter 1630s notes that Rembrandt sold *Floras* by his studio – undoubtedly derivations or copies after these originals.

The *Floras* occupy a middle ground between depictions of the flower goddess and shepherdess

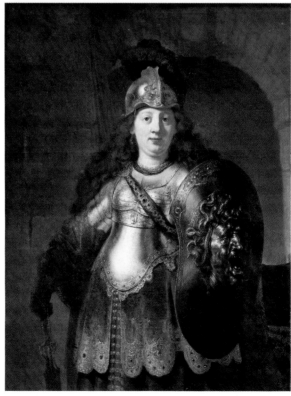

117 *Bellona, the goddess of war*. Signed *Rembrandt f. 1633*. Inscribed *Be[ll]on[a]*. Canvas, 127 x 97.5 cm. Bredius 467. New York, Metropolitan Museum of Art.

Very much in the pose of Rembrandt himself in a self-portrait of 1631 (fig. 48), borrowed in its turn from a figure in a print after Rubens (fig. 47), Bellona casts her less-than-fiery gaze upon us. She is brought closer to the foreground than in the self-portrait of two years before, but not to the point of overpowering the viewer, as do some of Lievens's lifesize figures.

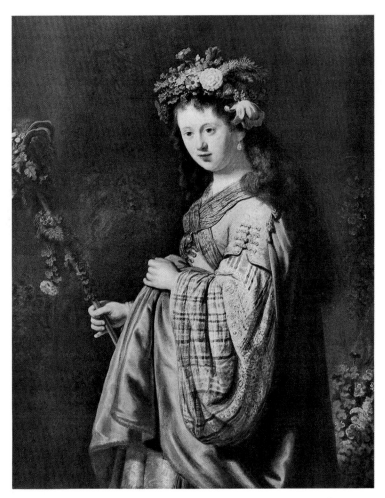

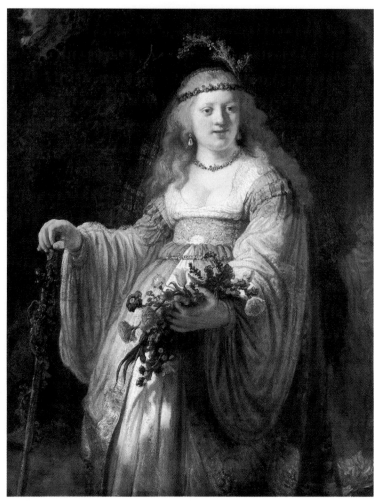

118 *Saskia (?) as Flora.*
Signed *Rembrandt f. 1634.*
Canvas, 125 x 101 cm. Bredius
102. Leningrad, Hermitage.

119 *Saskia (?) as Flora.*
Signed falsely and dated 1635.
Canvas, 123.5 x 97.5 cm.
Bredius 103. London,
National Gallery.

Rembrandt's first painting of
Saskia in this fetching guise –
if it is she – dates from the year
of their marriage. Before
getting sentimental about the
matter, though, we must take
account of the X-rays of the
second version. They show
that the painting was begun as
a *Judith with the head of
Holofernes*, and that it was
converted with a minimum of
changes. Originally, then,
Flora's lapful of flowers must
have been the bloody head of
the man Judith had just
decapitated. The *Judith* was
modelled very closely on a
painting by Rubens of 1616,
which shows the heroine
bare-breasted.

The quick-change act from
Judith to *Flora* serves as a
warning against being too
specific in our interpretations
of the poses and expressions
of Rembrandt's figures.

paintings. Works of the latter kind had become popular, mainly in Utrecht, in two varieties: serious-minded evocations of poetic inhabitants of the countryside and anything but serious-minded pictures of low-bodiced pastoral bawds. Flora herself embodied both these sides of life: she was an innocent personification of spring and the patron goddess of prostitutes.

In Amsterdam, Rembrandt's main forerunners as painters of pastoral scenes were artists with whom he had close ties: Pieter Lastman and Dirk Santvoort. Lastman went in for outdoor seductions of exciting explicitness, and Santvoort for terribly decent portrayals of rich children as shepherds and shepherdesses.

Rembrandt's *Floras* are not as unequivocal as those, and seem to have a different background. There may be a clue in the inscription to which I have just referred, on the back of a Rembrandt drawing after Lastman's *Susanna* (Benesch 448). It concerns two *Floras*, by pupils Ferdinand Bol and Leendert van Beyeren, that Rembrandt was selling. We know that Bol later adapted one of Rembrandt's Saskia's of the mid-1630s for an etching of a kind of Flora in a book of poetry by Jan Harmensz. Krul (*Pampiere wereld*; Paper world, 1644). A beautiful woman approaches a man sitting in a garden and points at the figure of Death waiting behind his back. The blend of sensuality and morbidity was typical of Krul.

The connection between Rembrandt and Krul is at least as old as 1633, when Rembrandt painted the poet's portrait (fig. 150). In 1634 and 1635 Krul was producing his own plays, among them expensive costume productions of the pastorals that had made him famous. (See below, pp. 154-158, 187). Rembrandt's *Floras* are closer in spirit to Krul's stage plays than to mythological or pastoral paintings or costume portraits.

A ROYAL WAR VICTIM, 1634 | In 1634, the model for *Bellona* posed, without much emotion, as the tragic Carthaginian beauty, Queen Sophonisba (fig. 120). In the midst of a war between her country and Rome, she was claimed in marriage and executed with poison all in the same day by the impetuous King Masinissa. At court, the story had a sentimental association. In all likelihood, a depiction of the subject by Rubens (1612) was the only painting to be left hanging in the former quarters of Frederik Hendrik's mother, Louise de Coligny, in Noordeinde Palace after her death in 1620. It has been suggested by J. Kusnetzov that Rembrandt's version of the subject was inspired by Rubens's, which would give one reason to suppose

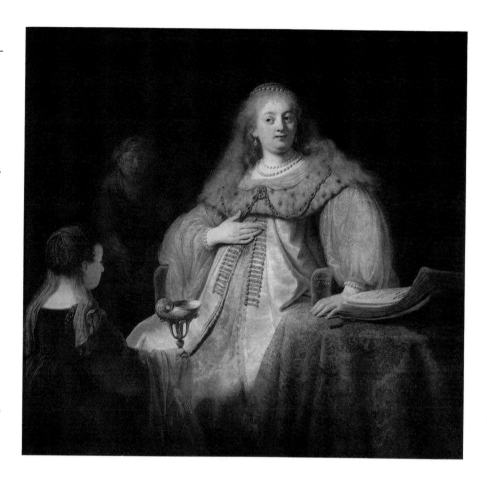

that it was a court commission. It did end up in a palace – that of the kings of Spain. It is the only work by Rembrandt now in the Prado, where it shares the company of more than eighty Rubenses!

I would not eliminate the possibility that the painting was made for an Amsterdam patron, however. In 1635 there was published in Amsterdam the play *Sophonisbe Africana* by Guilliam van Nieulandt (1584-1635), Adriaen's brother. If the play was produced on the stage before being printed, it may have provided Rembrandt with his subject.

The issue is not merely one of provenance. Our interpretation of the painting depends in part on knowing for whom it was made. If for a soldier in The Hague, then the moral accent would have lain on the glorification of self-sacrifice in war; if for an Amsterdam merchant, then on its evils.

GANYMEDE, 1635 | The difficulty of interpreting a history painting when we do not know for whom it was made is illustrated by the *Ganymede* (fig. 121). There are no documents of any kind concerning the painting before it appeared in an anonymous auction in Amsterdam in 1716.

Working in the dark, art historians have nothing to guide them but their own sense of direction. An observer of style, taste and sensibility like Lord

120 *Sophonisba receiving the poisoned cup* (Livy 30.12.15). Signed *Rembrandt f. 1634.* Canvas, 142 x 153 cm. Bredius 468. Madrid, Prado.

According to Ludwig Burchard and J.G. van Gelder, this romantic tale of patriotism, love, chivalry and death at court was the subject of a painting by Rubens that hung in the apartments of Frederik Hendrik's mother Louise de Coligny. That work, they say, was misidentified in the 1632 inventory as a painting of Artemisia, the widow of Mausolos. Sophonisba was also the subject of a play by the brother of one of the Breestraat artists – Guilliam van Nieulandt, Adriaen's brother – so that a commission in Amsterdam also has something to be said for it.

Clark was convinced that *Ganymede* was an 'anti-classical' reaction against a famous composition by Michelangelo, made for his intimate friend Tomaso Cavalieri. He therefore interpreted the painting as a 'protest not only against antique art, but against antique morality' by an artist filled with 'Protestant-Christian revulsion against the sexual practices of paganism.'

A student of iconography like Margarita Russell relates the same painting to the neo-Platonic tradition of Ganymede as 'the reunification of the pure infantile soul with God in the Christian sense,' pointing out that Rembrandt's pupil Nicolaes Maes painted five portraits of (dressed) children as Ganymede to commemorate deceased infants of the van Ruytenbeeck family, in the 1670s. She adds that Ganymede having been transformed by Jupiter into the constellation Aquarius, which provides the earth with rainwater, Rembrandt's pissing child also has an astronomical significance. She finds support for both aspects of her interpretation in van Mander.

Clark's interpretation of the painting as 'protest art' removes it so completely from the historical context we have taken such pains to reconstruct that I have no hesitation in dismissing it. What Russell says fits in well with the astronomical interpretation of *Andromeda* (fig. 111) and even with the hint of Christian mysteries in *Two old men disputing* (fig. 83). This would place *Ganymede* in the world of Jacques de Gheyn III.

Before deciding in favour of neo-Platonism, however, we should be aware that not everyone in Holland would have interpreted the painting so philosophically. The one other bare-bottomed baby Ganymede in Dutch art, by Carel van Mander's grandson Carel van Mander III (ca. 1600-1672), was seen quite differently in its time. If we take at face value an interior by Pieter de Hoogh (1629-after 1683; fig. 122), we can only conclude that the *Ganymede* by Carel van Mander III was the mantelpiece painting in a high-class brothel. (De Hoogh's painting had more subtle meanings as well, but the literal one cannot be ignored.) The ideas it would have put into the heads of those who saw it there were just as far removed from the reunification of the soul with God as from Protestant revulsion against homosexuality. They are more likely to have taken it as a joking apology for pederasty.

The subject was of course taboo. Yet in the research for this book I did come across one cautious reference to it. Arnoldus Buchelius confided to his diary on August 4, 1638: 'among the poems of de la Case published in Venice is one in the vernacular entitled *Il furno*, a statement, objected to by many Papists, on temperate sodomy. It once belonged to

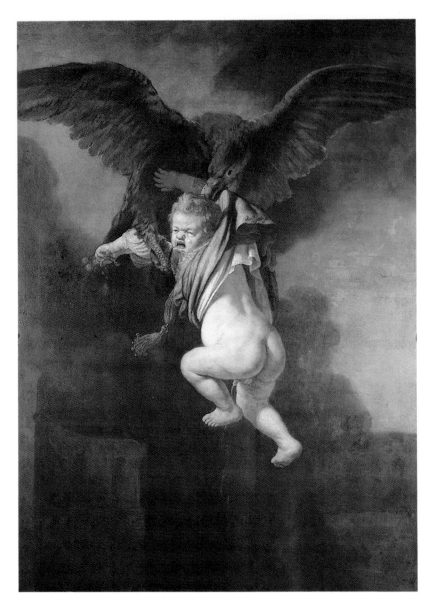

the advocate Arnold van der Lingen, from whom it passed on to [Cornelis] van Werckhoven.' Buchelius repeated this information in different words in his entry for October 25, 1639. We already have come across van Werckhoven as one of the three collectors in Utrecht to have owned a painting by Rembrandt. The complete reference, with the preceding item in his death inventory of 1655, is: 'The head of a young man painted by Jan Lievens, The portrait of an old man painted by Rembrandt.'

Ganymede is dated 1635, the year when Jacques de Gheyn III moved to Utrecht with his own old men by Rembrandt. Coincidence?

This evidence does not prove that Cornelis van Werckhoven was a homosexual or that Rembrandt painted *Ganymede* for him. What it does show is how vital the identity of the patron can be to the understanding of a work of art. If a painting like *Ganymede* was ordered by a Christian humanist it meant one thing, and if by the proprietor of a brothel

121 *Ganymede being carried off by Jupiter.* Signed *Rembrandt ft. 1635.* Canvas, 171 x 130 cm. Bredius 471. Dresden, Gemäldegalerie.

In a preparatory drawing – the only drawing from the 1630s for a complete composition – Rembrandt shows Ganymede's parents waving their arms in the lower left. This detail places the subject in the tradition of the child lost young to the gods. In the painting, however, the parents are absent, which leaves loose ends.

quite another. If it was commissioned by a cultivated Christian adherent of moderate pederasty it might mean both things at the same time.

AEGINA VISITED BY JUPITER, 1636 | The same no man's land – or is it everyman's land? – between morality and sensuality is occupied by Rembrandt's most succulent painting of a female nude (fig. 123). Nearly everyone who has studied the painting agrees that it depicts a woman being visited by a lover, but from there on everyone has his own, unverifiable thoughts on the matter. The most widely accepted theory identifies the woman as the virgin Danaë, locked up by her father in a tower, about to be ravished by Jupiter in the form of a shower of gold. Like all the other identifications, this one too is full of incongruities that need to be explained. Once more, Rembrandt has befuddled his interpreters by leaving out, or so it seems, the identifying attributes of his figures. In fact, there is an identification, not yet proposed, that does cover the visual facts – almost, at least: Aegina visited by Jupiter.

Aegina, according to the sources available to Rembrandt, was the daughter of the river-god Asopus. She was wooed by Jupiter in the form of fire and taken by him to the tiny island of Delos, which is also known by her name. This time, Juno's jealousy led her to send a snake to the island that poisoned all its water, causing a deadly plague. When the island was completely depopulated, Aegina's son Aeacus called on Jupiter in the name of his dalliance with Aegina to restore his subjects. Jupiter complied by turning the island's ants into people.

What Aegina was famous for, however, is what convinces me that Rembrandt's painting shows her and no one else: the people of her island (burrowing, like the ants they were, for ore, and exposing it to the divine flame brought to their island by Aegina) invented copper, bronze and brass, and fashioned them into coinage, statues of gods and men and *bedposts*. This information is from page 3 of Franciscus Junius's extensive handbook on ancient art published in Amsterdam in 1637, but which was already in circulation in 1636.

Now, the details of Rembrandt's painting that compete for our attention with the nude itself – the brass furniture and sculpture – can be seen as an attribute of Aegina. Moreover, the glow beyond the bed curtains is certainly more like an approaching flame than a shower of gold.

One aspect of the theory, at least, can be proved: Rembrandt had brass plague charms on his mind in the late 1630s. In 1639 he included in his portrait etching of Joannes Wtenbogaert (fig. 222), as a

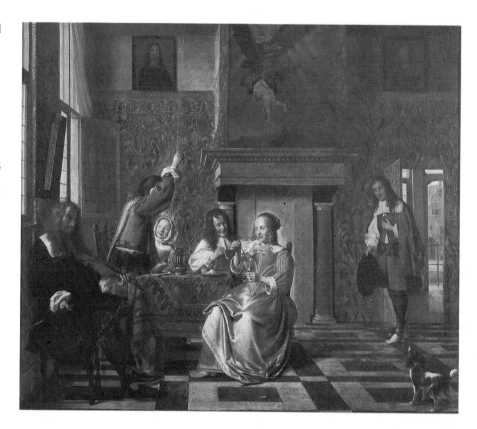

122 Pieter de Hoogh (1629-after 1683), *Brothel with a painting of Ganymede*. Ca. 1663-1665. Canvas, 64 x 75 cm. Lisbon, Museu Nacional de Arte Antiga.

The painting above the mantel, by Carel van Mander III, is now lost. It is also known from an engraving by Albert Haelwegh (ca. 1610-ca. 1675), who like van Mander was in the service of the king of Denmark. Another Dutch painter who worked for and in Denmark, Isaac Isaacksz. (see p. 32), gave testimony in 1649 concerning a 'valuable and large' painting of *Ganymede* he had seen often at the house of his neighbour Samuel Pits van der Straaten in Amsterdam.

In 1647, van der Straaten, an unreliable if not criminal character, offered his *Ganymede* for sale to Frederik Hendrik and, when it was rejected, proposed that Constantijn Huygens accept it as a gift in exchange for a loan. First van der Straaten said the painting was by Guido Reni, then by Frans

Badens, but I am convinced that it was the lost work by van Mander.

Knowing as we do from the testimony of his own father that Isaac Isaacksz. was a pimp, we seem to have entered, via archival documents, the very milieu in which de Hoogh places this *Ganymede*. Let us hope that Rembrandt's version of the theme had a more respectable genesis and early history. Art historians have suggested that Carel van Mander based his painting on Rembrandt's. We do know that van Mander, who moved to Denmark in 1623, was on a visit to Holland in 1635, the year of Rembrandt's *Ganymede*.

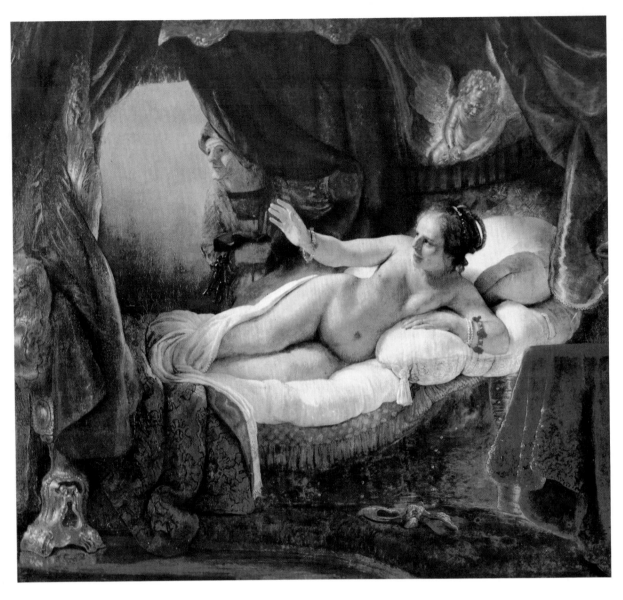

123 *Aegina visited by Jupiter in the form of fire (?)*. Signed *Rembrandt f. 1636*. Canvas, 185 x 203 cm. Bredius 474. Leningrad, Hermitage.

This painting has been known under eleven different titles, of which the most generally accepted is *Danae*. It was probably known by that name in Rembrandt's own time, although the documents that have been related to it are a troublesome mixture of references to a 'Venus,' a 'Dianae' or 'Danae' and a 'Dané' in various Amsterdam collections from 1644 to 1660. Technical and stylistic analysis indicates that Rembrandt repainted the nude in the 1640s.

In the text, the identifications of the subject are rounded off to an even dozen, and the theory is advanced that this is the painting Rembrandt offered to Constantijn Huygens as a gift in 1639. See also the caption to fig. 229.

prominent background detail, a painting of Moses curing the Israelites of the plague. He did it by means of a brass sculpture, the famous brazen serpent.

Joannes Wtenbogaert: the cousin and friend of Jacques de Gheyn III, soon to inherit two of his Rembrandts. Wtenbogaert the prince's receiver-general in Amsterdam, who dropped in on Rembrandt to look at the *Entombment* and *Resurrection* before they were crated for shipment to Constantijn Huygens. The man who tipped Rembrandt on the state of Treasurer Volbergen's coffers so Huygens could force payment out of him. This Wtenbogaert, a Remonstrant and a relative of his more famous namesake (fig. 132), had himself portrayed by Rembrandt beneath a brazen serpent, the charm that Moses fashioned, out of brass collected from his people, to cure them of the plague. The plague was again rife in Wtenbogaert's Holland. The previous epidemic before 1639 was

in 1635-1636, the year of the *Aegina*.

Rembrandt's etching of Wtenbogaert was the artist's way of thanking his old well-wisher for his help. We know from the letter of January 1639 that Rembrandt wished to thank Huygens for *his* help with the even more spectacular gift of a painting eight feet high and ten feet wide. Usually, this is said to be the *Blinding of Samson* (fig. 185), which is nine-and-a-half by seven-and-a-half Rhineland feet. No one has ever been really happy, however, with the idea that Rembrandt would send a painting of such a gruesome subject to a man who wrote: 'No one can depict something ugly so that it gives pleasure.' Huygens even said of a painting by Rubens of the head of Medusa that he would rather see it at the house of a friend than in his own home.

Let us hypothesize that Rembrandt's gift was not *Samson* but *Aegina*, begun in 1636 and reworked over the following years. Its present dimensions come to six by six-and-a-half Rhineland feet, but it

has been proven by Ernst van de Wetering that it was cut down by the artist from a size slightly larger than the *Samson*. This not only provides us with a more attractive gift suggestion, but with one that fits the circumstances much better. If the painting does depict *Aegina*, it conveys the same fascinating references as the portrait of Wtenbogaert to supernatural intervention in a plague epidemic and to sculptures made of brass. The combination tingles with promise; the hypothesis pines to be proved.

WHEN AND WHY WAS REMBRANDT DROPPED BY THE COURT? | In the absence of all further mention of Rembrandt's gift in Constantijn Huygens's well-documented life, we are forced to conclude that he returned it. In 1639 he was not accepting presents from Rembrandt, nor was he doing him any favours, except for securing payment for him, under some pressure. Most significantly, there is no mention in any of the letters of any new commissions from the court.

The commission for the last three Passion paintings, given 'by his Highness himself,' could have dated from as early as 1633, when the *Raising* and *Descent* were delivered. 1633 is also the year of the last court portrait, the lost *Marquis d'Andelot*. After that year, even the theoretical possibilities for court commissions (until 1646) are nil.

This chronological limit is important for one reason: it disproves the usual argument given for Rembrandt's decline at court. It has always been said, rather too easily, that Rembrandt and the court parted ways over matters of style and taste: Rembrandt the individualist refusing to adapt his increasingly idiosyncratic style to the demands of a court growing increasingly Flemish-minded. This explanation will not hold water. Rembrandt stopped receiving commissions from court during the period when he was at his *most* Flemish, in years when he was bending over backwards to emulate, to use that polite word once more, the art of Rubens.

We simply do not know why the commissions stopped. The only document that has any bearing on the question is Huygens's poetic squelch of the portrait of Jacques de Gheyn, from spring 1633. For whatever personal or political reasons he may have had, it would seem that the man who made Rembrandt at court also broke him there.

Looking back in 1631 on the first six years of his career as a young master, Rembrandt was able to add up an impressive list of successes. In 1625 and 1626 he had painted his first large histories, with their strong political colouring, for Petrus Scriverius. His moralizing genre paintings of those years and 1627 found a market among the burghers of Leiden.

In 1628 his career leaped into a new dimension with the first sales to The Hague: Jacques de Gheyn, Frederik Hendrik and probably Jacques Specx began in that year buying and ordering heads, portraits, figure paintings, genre paintings, biblical histories and mythologies from him, for which they paid considerably more than the collectors of Leiden. Between 1628 and 1635, those three collectors alone were to buy about twenty-five paintings from Rembrandt.

The breakthrough to Amsterdam took place in 1628 as well. In March of that year Hendrick Uylenburgh was in Leiden, and could have begun representing Rembrandt as his dealer. It is in any case certain, as we shall see below, that a regent who lived across the street from Uylenburgh in the Sint Anthonisbreestraat, Joan Huydecoper, bought a head by Rembrandt in June 1628. The arms buyer for Cardinal Richelieu, Alphonso Lopez, the first owner of *Bileam* (fig. 21), is most likely to have made that purchase on a visit to Amsterdam in 1628.

How did Rembrandt's future look in 1631? In Leiden he was not getting very far. His associate Jan Lievens was selling work to prominent townsmen, but Rembrandt was not. Moreover, Leiden was becoming poverty-stricken at an alarming rate, and despite the decline of the financial means of its burghers, the city was unwilling to protect the market for local artists. Measures to prevent the sale of paintings by outsiders, such as those that guilds in other places were able to enforce, had not yet been taken in Leiden.

Nor did things look bright in the long run in The Hague. The position of Gerard van Honthorst was

growing stronger, to the detriment of Rembrandt's chances at court. Moreover, there was no reason why he could not paint for the court from Amsterdam as well as from Leiden, as indeed he was able to do for a few years.

Amsterdam, on the other hand, was full of potential for Rembrandt. Most of the older generation of painters were dead or, like Pieter Lastman, ailing. Younger artists like Thomas de Keyser, Nicolaes Eliasz. Pickenoy and Dirk Santvoort each occupied a niche in the Amsterdam art world, but between them they could not begin to cover the vast and growing field. With an active and well-connected dealer like Uylenburgh and introductions to Amsterdam society from patrons in Leiden and The Hague, Rembrandt could be certain of more sustained and varied patronage in Amsterdam than in both of the former combined. Last but not least, Rembrandt's associations with Remonstrants, which had been such a hindrance in launching a career in Leiden, were an advantage in Amsterdam.

If these were some of the reasons guiding Rembrandt's choice, they turned out to be on the mark. In his very first year in Amsterdam, he painted more commissions than in his entire previous career, and in the second year he exceeded even that impressive total.

However, there were developments that he could not foresee. The truce between the stadholder and the city of Amsterdam was not destined to last very long, and the ensuing tensions made it difficult for artists to work at a high level in both cities at once. After 1633, when he lost the support of Huygens, The Hague fell away for Rembrandt. And in Amsterdam, after that year, he was unable to sustain his initial volume of business. Extraordinary as it seems, Rembrandt failed nearly totally in cultivating new sources of patronage in Amsterdam. He took some areas of society by storm, but was pointedly avoided by others. And those others included the

inner circle of the city's rulers. The equivalent in Amsterdam of the stadholder's favour would have been public support from Andries Bicker and Cornelis de Graeff. But neither of them, as far as we know, ever wanted to have anything to do with Rembrandt.

AMSTERDAM | It is hardly an exaggeration to call seventeenth-century Holland the city-state of Amsterdam. From the late sixteenth to the mid-eighteenth century, Amsterdam's 'reign, like those of Venice and Antwerp before her, was the reign of a city – the last in which a veritable empire of trade and credit could be held by a city in her own right, unsustained by the forces of a modern unified state.' As unlikely as it may seem, this newcomer among the cities of Europe, in a shallow recess of the Zuider Zee, governed by *nouveau riche* families unrelated to the rulers of the rest of Europe, was the foremost economic power in the world.

She owed her wealth as much to the ill fortune of others as to her own good luck. Thanks to the Eighty Years War, Antwerp was blockaded and Amsterdam free. Dutch arms and the Dutch fleet – more than half of it based in Amsterdam – controlled the grain traffic from the Baltic to the Mediterranean. During the widespread famine in southern and western Europe from the late sixteenth through to the mid-seventeenth century, Amsterdam made fabulous profits out of Baltic grain. The city's merchants knew exactly how to use the capital that came into their hands. The power of the purse enabled them to buy up or force out of business the owners of any profitable enterprise that interested them, anywhere in the world. They could buy English textiles for cash at lower prices than local merchants, who had to ask for credit, and thereby undersell the English in their own market.

Buyers of any kind of merchandise from any of the four continents (Australia did not yet count) found that there was no better place to acquire their goods than Amsterdam. Even if the city's merchants had not cornered the market in a particular commodity, which they often had, the buyer would be able to get better terms from Amsterdam middlemen than from the original suppliers. The Swedes had to come to Amsterdam to buy French wine, and even to buy the arms that were manufactured by Dutch firms in their own country. Amsterdam had a near stranglehold on the world economy.

POPULATION AND HOUSING | The growth of the Amsterdam population followed the growth of the city's wealth. In 1600 it housed about 60,000

inhabitants, and in 1630 about 115,000. The greatest single decade of growth was that in which Rembrandt moved to Amsterdam. Between 1630 and 1640 the population rose by about 20,000, to some 135,000. Nearly three-quarters of the population of Rembrandt's Amsterdam had been born elsewhere. The city drew its human resources from a hinterland extending throughout the northern and southern Netherlands to neighbouring areas of France and Germany. And whereas Leiden was also growing rapidly, the average worth of the new Amsterdamer was many times that of the new Leidener. When wealthy Antwerpers who could no longer invest their money profitably in their own country – ruled by the Spanish and besieged by the Dutch – decided to move north, it was to Amsterdam they nearly always came.

The physical growth of Leiden and Amsterdam illustrates the difference. The most Leiden could muster by way of new housing was the modest extension we saw in the upper section of fig. 2, intended for craftsmen and small shopkeepers. In Amsterdam, large extensions were laid out in 1585 and 1593 (the foremost residential street in these plans was the Sint Anthonisbreestraat), and in the decades after 1615 the territory within the walls was more than doubled with the building of the famous canals, the Herengracht, Keizersgracht and Prinsengracht. The new areas, as any visitor to the city knows, were intended not for a mixed population but for the upper stratum alone. Others – even those who formerly lived in the small houses in the canal belt – were forced into left-over corners of the map, mainly the Jordaan (fig. 124).

THE REGENTS | That rearrangement of the living space inside the city brings out an all-important fact. The Amsterdam that imposed its will on the rest of the Netherlands and dominated world trade was not the Amsterdam of all its hundred thousand dwellers. There was a city within a city, a closed group of families who controlled Amsterdam's wealth and its government. To a large extent, they ran Amsterdam for their own profit, and there was no one on earth to whom they were accountable.

The source of their extraordinary power goes back to the day in 1578 when the city, after remaining Catholic for longer than any other place in the northern Netherlands, went over to the Reformation and took the side of William of Orange. That shift is known in Amsterdam history by the mystic-sounding name 'The Alteration.' The men who took over the city from the Catholic oligarchs who preceded them were able to pass on their power to their successors – who with increasing

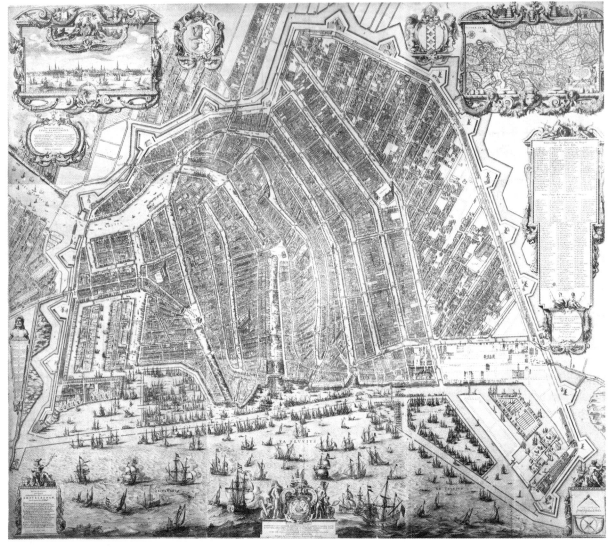

124 Balthasar Florisz. van Berckenrode (1591-1645), map of Amsterdam in nine engraved plates, measuring 140 x 160 cm. 1625. Amsterdam, municipal archives.

This monumental wall map was a tribute to the glory of Amsterdam at the beginning of her ascendancy. From left to right, the parts of the city can be described roughly as the new extension of the late sixteenth century (city wall to the Nieuwmarkt, in the first seam); the Oude Zijde (Old Side: Nieuwmarkt to Dam, in the centre of the map); Nieuwe Zijde (New Side: Dam to Singel, the first of the broad, regular canals); the early seventeenth-century canal belt (Singel to Prinsengracht, the outermost canal, with the church in the bend); and the Jordaan (Prinsengracht to city wall). Later the canal belt was to be more than doubled in area by being extended to the Amstel, below the upper cartouche on the left of the map.

The choice of Scriverius to write the eulogies indicates how well he stood with the town government. The chief burgomaster in 1625 was the pro-Remonstrant Dirck Bas.

frequency were their own sons – for more than two hundred years. These regents, as they were called, were divided into clan groupings and religious affiliations that in many cases pre-dated 1578. The ruling coalition would confide its executive power to an individual in its midst. That man held what was known as the *magnificat*, a title that does not appear in any official documents, but which mattered more than all of those that do. From 1628 to 1650, the *magnificat* was in the hands of Andries Bicker (1586-1652), hotly pursued by his brother-in-law Cornelis de Graeff (1599-1664), who took over from him at mid-century.

In the seventeenth and eighteenth centuries, Amsterdam history was written around the regents and their doings. This approach has fallen so far out of favour that the latest general history of the Netherlands, published in the 1970s and '80s in fifteen volumes, does not even mention a man like Cornelis de Graeff. However, for the understanding of Rembrandt, who, as we shall see, was a client of the de Graeff clan, the history of personalities is too important to be neglected.

JOAN HUYDECOPER BUYS A 'WARMBRANT,' 1628 |
For nearly seventy-five years, the earliest known document referring to a painting by Rembrandt was an item in the 1629 inventory of an obscure Amsterdam artist, Barent Theunisz. Drent (1577-1629). In November 1983, during work on this book, the history of Rembrandt's beginnings were rewritten when my fellow villager E.A.J. van der Wal discovered an earlier and far more significant reference. In the Utrecht state archives, he found the following note in the accounts of a man who was destined to become one of the most prominent Amsterdamers of the century, Joan Huydecoper (1599-1661):
15 June 1628
Two paintings purchased

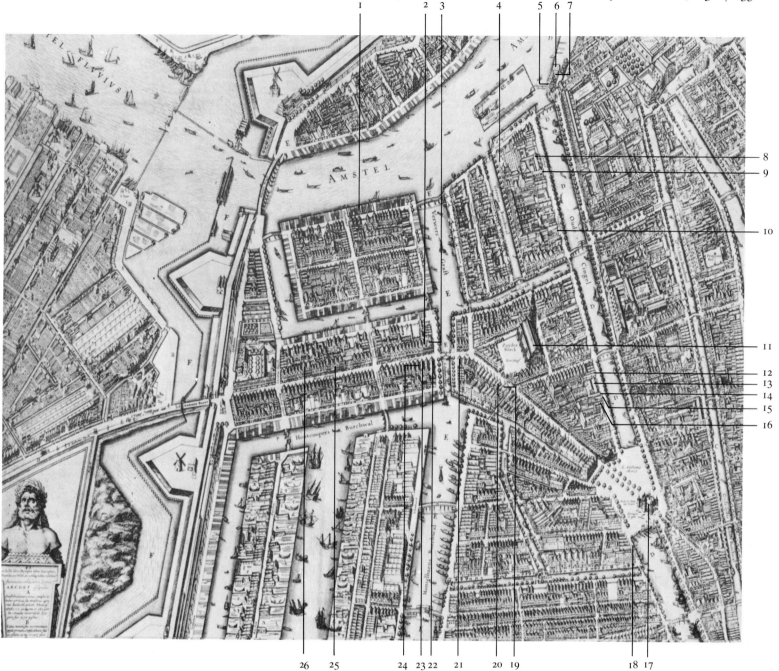

125 Detail of fig. 124: the middle plate on the left. Many of Rembrandt's patrons lived in the adjoining Precincts XI and XV, captained respectively by Reynier Reael and Dirck Geurtsz. van Beuningen. The former was an uncle of Joannes Wtenbogaert, the latter a cousin's cousin of Petrus Scriverius and Wtenbogaert's next-door neighbour.

1 The Suikerbakkerij (Sugar Bakery), where Rembrandt and Saskia lived from 1637 to 1639

2 Rembrandt's house in the Sint Anthonisbreestraat, 1639-1660
3 Cornelis van der Voort, subsequently Hendrick Uylenburgh, Rembrandt and Saskia, and Nicolaes Eliasz. Pickenoy
4 The meeting hall of the sampling officials of the drapers' guild
5 The shooting range and headquarters of the Kloveniers civic guard
6 Jannetge Martensdr. Calff, in whose house Rembrandt and Saskia lived in 1636

7 Willem Boreel
8 Floris Soop
9 Anna Wijmer and Jan Six
10 Nicolaes van Bambeeck
11 The Zuiderkerk, where three of Rembrandt's children were buried
12 Tymen Jacobsz. Hinlopen
13 Hendrick and Louys Trip. A former house on the site was rented by Johannes de Renialme
14 Augustijn and Joannes Wtenbogaert, tenants of Adriaan Jan Bartolotti van den Heuvel
15 Dirck Geurtsz. van Beuningen

16 Albert Coenrats Burgh
17 Sint Anthoniswaag (weighing hall), site of anatomical theatre and meeting place of the painters' guild
18 Abraham Wilmerdonx
19 Geurt Dircksz. van Beuningen
20 Barber Jacobsdr., Pieter Lastman
21 Pieter Isaacksz., later Hendrick Uylenburgh
22 Widow van Collen
23 Adriaen van Nieulandt
24 Joan Huydecoper (until 1622; when he moved out, he

rented the house to Jan Cock, the father of Frans Banning Cock)
25 Louys Trip
26 Nicolaes van Bambeeck

The locations were identified for this book by S.A.C. Dudok van Heel, to whom I am greatly indebted for having pointed out to me the high concentration of Rembrandt's patrons in these streets.

ONE HUNDRED RELATED DUTCHMEN: MUCH OF
REMBRANDT'S PATRONAGE FROM THE BEGIN-
NING TO THE END OF HIS CAREER CAME FROM
THE MEMBERS OF THIS EXTENDED CLAN

Legend:

☐ Portrait sitters, patrons and owners of work by Rembrandt

▨ Amsterdam regents with documented ties to Rembrandt

☐ Other Amsterdam regents

✳ Married

| Parent-child

— Brother or sister

⋯ More distantly related, though with demonstrated close ties

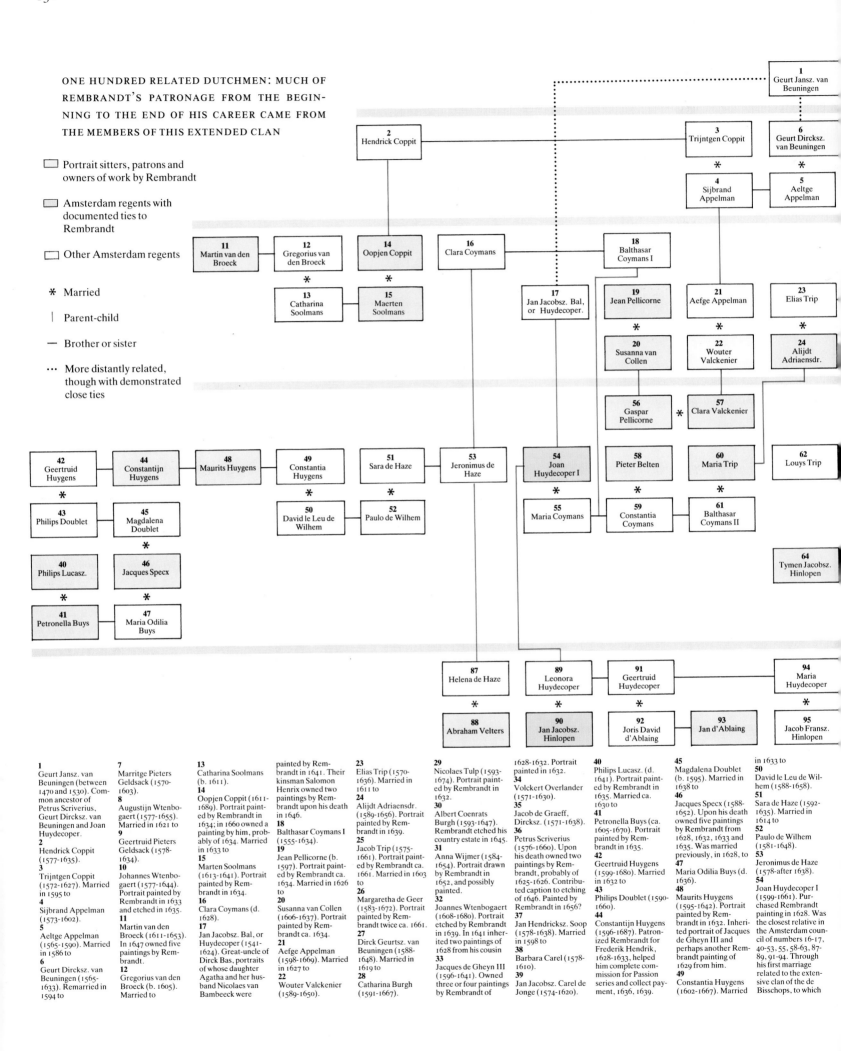

Chart boxes:

1 Geurt Jansz. van Beuningen
2 Hendrick Coppit
3 Trijntgen Coppit
4 Sijbrand Appelman
5 Aeltge Appelman
6 Geurt Dircksz. van Beuningen
11 Martin van den Broeck
12 Gregorius van den Broeck
13 Catharina Soolmans
14 Oopjen Coppit
15 Maerten Soolmans
16 Clara Coymans
17 Jan Jacobsz. Bal, or Huydecoper
18 Balthasar Coymans I
19 Jean Pellicorne
20 Susanna van Collen
21 Aefge Appelman
22 Wouter Valckenier
23 Elias Trip
24 Alijdt Adriaensdr.
40 Philips Lucasz.
41 Petronella Buys
42 Geertruid Huygens
43 Philips Doublet
44 Constantijn Huygens
45 Magdalena Doublet
46 Jacques Specx
47 Maria Odilia Buys
48 Maurits Huygens
49 Constantia Huygens
50 David le Leu de Wilhem
51 Sara de Haze
52 Paulo de Wilhem
53 Jeronimus de Haze
54 Joan Huydecoper I
55 Maria Coymans
56 Gaspar Pellicorne
57 Clara Valckenier
58 Pieter Belten
59 Constantia Coymans
60 Maria Trip
61 Balthasar Coymans II
62 Louys Trip
64 Tymen Jacobsz. Hinlopen
87 Helena de Haze
88 Abraham Velters
89 Leonora Huydecoper
90 Jan Jacobsz. Hinlopen
91 Geertruid Huydecoper
92 Joris David d'Ablaing
93 Jan d'Ablaing
94 Maria Huydecoper
95 Jacob Fransz. Hinlopen

Footnotes (numbered entries):

1
Geurt Jansz. van Beuningen (between 1470 and 1530). Common ancestor of Petrus Scriverius, Geurt Dircksz. van Beuningen and Joan Huydecoper.
2
Hendrick Coppit (1577-1635).
3
Trijntgen Coppit (1572-1627). Married in 1595 to
4
Sijbrand Appelman (1573-1602).
5
Aeltge Appelman (1565-1590). Married in 1586 to
6
Geurt Dircksz. van Beuningen (1565-1633). Remarried in 1594 to

7
Marritge Pieters Geldsack (1570-1603).
8
Augustijn Wtenbogaert (1577-1655). Married in 1621 to
9
Geertruid Pieters Geldsack (1578-1634).
10
Johannes Wtenbogaert (1577-1644). Portrait painted by Rembrandt in 1633 and etched in 1635.
11
Martin van den Broeck (1611-1653). In 1647 owned five paintings by Rembrandt.
12
Gregorius van den Broeck (b. 1605). Married to

13
Catharina Soolmans (b. 1611).
14
Oopjen Coppit (1611-1689). Portrait painted by Rembrandt in 1634; in 1660 owned a painting by him, probably of 1634. Married in 1633 to
15
Marten Soolmans (1613-1641). Portrait painted by Rembrandt in 1634.
16
Clara Coymans (d. 1628).
17
Jan Jacobsz. Bal, or Huydecoper (1541-1624). Great-uncle of Dirck Bas, portraits of whose daughter Agatha and her husband Nicolaes van Bambeeck were

painted by Rembrandt in 1641. Their kinsman Salomon Henrix owned two paintings by Rembrandt upon his death in 1646.
18
Balthasar Coymans I (1555-1634).
19
Jean Pellicorne (b. 1597). Portrait painted by Rembrandt ca. 1634. Married in 1626 to
20
Susanna van Collen (1606-1637). Portrait painted by Rembrandt ca. 1634.
21
Aefge Appelman (1598-1669). Married in 1627 to
22
Wouter Valckenier (1589-1650).

23
Elias Trip (1570-1636). Married in 1611 to
24
Alijdt Adriaensdr. (1589-1656). Portrait painted by Rembrandt in 1639.
25
Jacob Trip (1575-1661). Portrait painted by Rembrandt ca. 1661. Married in 1603 to
26
Margaretha de Geer (1583-1672). Portrait painted by Rembrandt twice ca. 1661.
27
Dirck Geurtsz. van Beuningen (1588-1648). Married in 1619 to
28
Catharina Burgh (1591-1667).

29
Nicolaes Tulp (1593-1674). Portrait painted by Rembrandt in 1632.
30
Albert Coenrats Burgh (1593-1647). Rembrandt etched his country estate in 1645.
31
Anna Wijmer (1584-1654). Portrait drawn by Rembrandt in 1652, and possibly painted.
32
Joannes Wtenbogaert (1608-1680). Portrait etched by Rembrandt in 1639. In 1641 inherited two paintings of 1628 from his cousin
33
Jacques de Gheyn III (1596-1641). Owned three or four paintings by Rembrandt of

1628-1632. Portrait painted in 1632.
34
Volckert Overlander (1571-1630).
35
Jacob de Graeff, Dircksz. (1571-1638).
36
Petrus Scriverius (1576-1660). Upon his death owned two paintings by Rembrandt, probably of 1625-1626. Contributed caption to etching of 1646. Painted by Rembrandt in 1656?
37
Jan Hendricksz. Soop (1578-1638). Married in 1598 to
38
Barbara Carel (1578-1610).
39
Jan Jacobsz. Carel de Jonge (1574-1620).

40
Philips Lucasz. (d. 1641) portrait painted in 1632.
41
Petronella Buys (ca. 1605-1670). Portrait painted by Rembrandt in 1635.
42
Geertruid Huygens (1599-1680). Married in 1632 to
43
Philips Doublet (1590-1660).
44
Constantijn Huygens (1596-1687). Patronized Rembrandt for Frederik Hendrik, 1628-1633, helped him complete commission for Passion series and collect payment, 1636, 1639.

45
Magdalena Doublet (b. 1595). Married in 1638 to
46
Jacques Specx (1588-1652). Upon his death owned five paintings by Rembrandt from 1628, 1632, 1633 and 1635. Was married previously, in 1628, to
47
Maria Odilia Buys (d. 1636).
48
Maurits Huygens (1595-1642). Portrait painted by Rembrandt in 1632. Inherited portrait of Jacques de Gheyn III and perhaps another Rembrandt painting of 1629 from him.
49
Constantia Huygens (1602-1667). Married

in 1633 to
50
David le Leu de Wilhem (1588-1658).
51
Sara de Haze (1592-1635). Married in 1614 to
52
Paulo de Wilhem (1581-1648).
53
Jeronimus de Haze (1578-after 1638).
54
Joan Huydecoper I (1599-1661). Purchased Rembrandt painting in 1628. Was the closest relative in the Amsterdam council of numbers 16-17, 40-53, 55, 58-63, 87-89, 91-94. Through his first marriage related to the extensive clan of the de Bisschops, to which

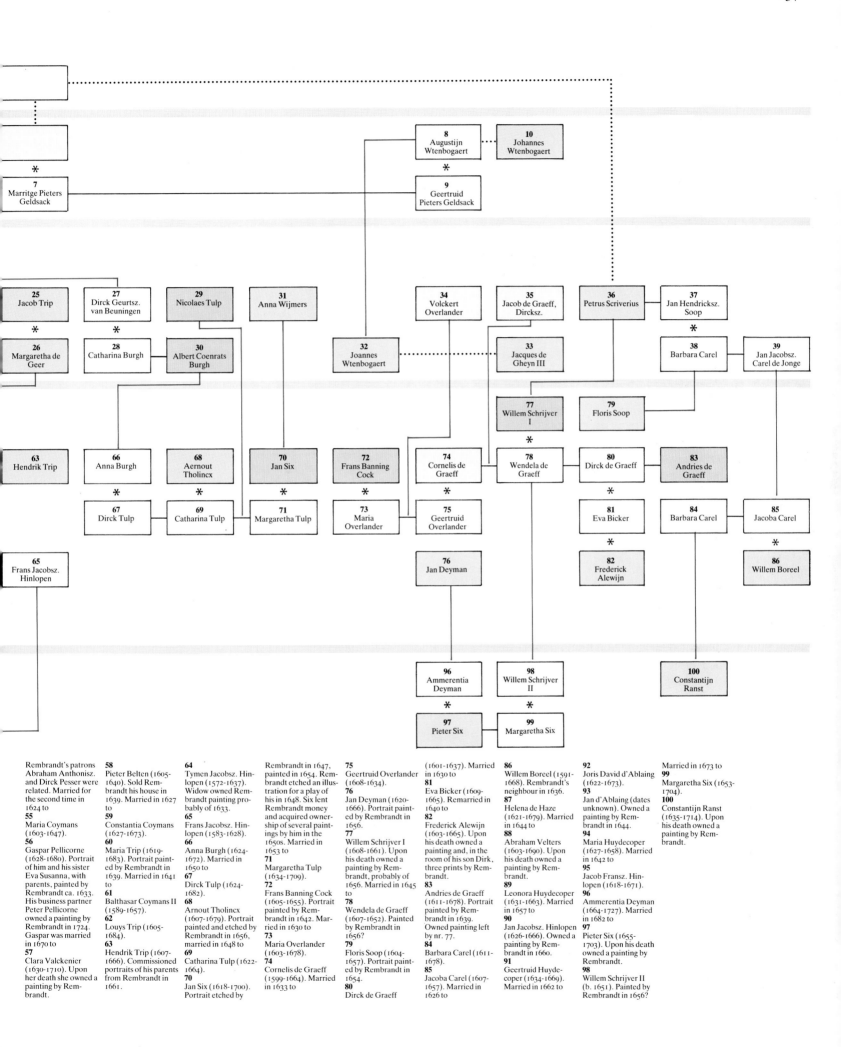

Rembrandt's patrons Abraham Anthonisz. and Dirck Pesser were related. Married for the second time in 1624 to
55 Maria Coymans (1603-1647).
56 Gaspar Pellicorne (1628-1680). Portrait of him and his sister Eva Susanna, with parents, painted by Rembrandt ca. 1633. His business partner Peter Pellicorne owned a painting by Rembrandt in 1724. Gaspar was married in 1670 to
57 Clara Valckenier (1630-1710). Upon her death she owned a painting by Rembrandt.

58 Pieter Belten (1605-1640). Sold Rembrandt his house in 1639. Married in 1627 to
59 Constantia Coymans (1627-1673).
60 Maria Trip (1619-1683). Portrait painted by Rembrandt in 1639. Married in 1641 to
61 Balthasar Coymans II (1589-1657).
62 Louys Trip (1605-1684).
63 Hendrik Trip (1607-1666). Commissioned portraits of his parents from Rembrandt in 1661.

64 Tymen Jacobsz. Hinlopen (1572-1637). Widow owned Rembrandt painting probably of 1633.
65 Frans Jacobsz. Hinlopen (1583-1628).
66 Anna Burgh (1624-1672). Married in 1650 to
67 Dirck Tulp (1624-1682).
68 Arnout Tholincx (1607-1679). Portrait painted and etched by Rembrandt in 1656, married in 1648 to
69 Catharina Tulp (1622-1664).
70 Jan Six (1618-1700). Portrait etched by

Rembrandt in 1647, painted in 1654. Rembrandt etched an illustration for a play of his in 1648. Six lent Rembrandt money and acquired ownership of several paintings by him in the 1650s. Married in 1653 to
71 Margaretha Tulp (1634-1709).
72 Frans Banning Cock (1605-1655). Portrait painted by Rembrandt in 1642. Married in 1630 to
73 Maria Overlander (1603-1678).
74 Cornelis de Graeff (1599-1664). Married in 1633 to

75 Geertruid Overlander (1608-1634).
76 Jan Deyman (1620-1666). Portrait painted by Rembrandt in 1656.
77 Willem Schrijver I (1608-1661). Upon his death owned a painting by Rembrandt, probably of 1656. Married in 1645 to
78 Wendela de Graeff (1607-1652). Painted by Rembrandt in 1656?
79 Floris Soop (1604-1657). Portrait painted by Rembrandt in 1654.
80 Dirck de Graeff

(1601-1637). Married in 1630 to
81 Eva Bicker (1609-1665). Remarried in 1640 to
82 Frederick Alewijn (1603-1665). Upon his death owned a painting and, in the room of his son Dirk, three prints by Rembrandt.
83 Andries de Graeff (1611-1678). Portrait painted by Rembrandt in 1639. Owned painting left by nr. 77.
84 Barbara Carel (1611-1678).
85 Jacoba Carel (1607-1657). Married in 1626 to

86 Willem Boreel (1591-1668). Rembrandt's neighbour in 1636.
87 Helena de Haze (1621-1679). Married in 1644 to
88 Abraham Velters (1603-1690). Upon his death owned a painting by Rembrandt.
89 Leonora Huydecoper (1631-1663). Married in 1657 to
90 Jan Jacobsz. Hinlopen (1626-1666). Owned a painting by Rembrandt in 1660.
91 Geertruid Huydecoper (1634-1669). Married in 1662 to

92 Joris David d'Ablaing (1622-1673).
93 Jan d'Ablaing (dates unknown). Owned a painting by Rembrandt in 1644.
94 Maria Huydecoper (1627-1658). Married in 1642 to
95 Jacob Fransz. Hinlopen (1618-1671).
96 Ammerentia Deyman (1664-1727). Married in 1682 to
97 Pieter Six (1655-1703). Upon his death owned a painting by Rembrandt.
98 Willem Schrijver II (b. 1651). Painted by Rembrandt in 1656?

Married in 1673 to
99 Margaretha Six (1653-1704).
100 Constantijn Ranst (1635-1714). Upon his death owned a painting by Rembrandt.

One of Venus, a copy after rubbens 25 guilders
The other a head by warmbrant 29 guilders
In the same ink, Huydecoper crossed out *warm* and added *rem* above the line.

This find places the earliest Rembrandt in Amsterdam in a milieu we know well by now, that of the artistic regents of the Sint Anthonisbreestraat. Joan Huydecoper grew up across the street from Cornelis van der Voort, and not a hundred yards from the houses of Pieter Lastman and Geurt Dircksz. van Beuningen. His father was actually the guardian of Geurt Dircksz.

As long as his father was alive, Huydecoper was pro-Remonstrant. His first wife was from the most unrelenting Remonstrant clan in the city, the de Bisschops. She died young, though, in 1622, and before re-marrying, Joan waited for his father to die, in spring 1624. Ten weeks later he took as his second bride the daughter of an elder of the Reformed Church, Balthasar Coymans (1555-1634). This alienated him from the de Bisschops, who pestered him in a twenty-year law suit concerning the estate, but it enabled him to serve as a bridge between the more moderate Remonstrants and the Coymanses, who were simply one of the richest families in the city.

All of this had little to do with religion. As an English observer in The Hague noted in 1626, 'political Arminians' like Geurt Dircksz. and Huydecoper persevered 'not for love of truth, but for love of revenge, of money and of rule. For I am sure that no man will alleage conscience, nor religion, who hath any knowledge of this state.' The prince himself worked by preference with pro-Remonstrants who went to church with the Calvinists.

Huydecoper's second marriage brought in not only fortunes of money but also invaluable connections with the house of Orange. Coymans was an international banker, and he lent the cover of his bank to forward confidential packets from Orange to The Hague. A kinsman and business associate of his was the above-mentioned Guillelmo Bartolotti van den Heuvel. This was the soft underbelly of the house of Orange, and Huydecoper was to derive great advantage from being within striking distance of it. Nor was he alone: Constantijn Huygens too did what he could to work his way into the clan of his master's banker. Through the marriage in 1633 of his sister Constantia to David de Wilhem, Constantijn became the kinsman of

HUYDECOPER'S COLLECTION

After the death of his first wife on February 22, 1622, Joan Huydecoper added up the value of his possessions. His total assets in jewels, household goods, paintings, silver, land, houses, cash and outstanding loans were 73,635 guilders. His movable possessions were worth 9,932 guilders. Fifteen per cent of that, or 1528 guilders, was in the form of these paintings:

The large painting by Moyaert	360
Europa by Veronese	250
The flood	145
Adam and Eve	134
Callisto bathing	130
The four evangelists	97
The annunciation	80
My horse	73
The [synger?]	88
The banquet	60
The three Magi	40
Proserpina	36
The brothel	35
	————
	1528

We happen to have a similar statistic for Rembrandt's first collector in Delft, Boudewijn de Man (see fig. 4). In 1644, the auction of his movable possessions after his death fetched 13,081 guilders, including 6,139 guilders worth of paintings, or forty-seven per cent. By that standard, Huydecoper was no more than a mildly interested collector of paintings.

In 1623, Huydecoper had his portrait painted by Cornelis van der Voort for 150 guilders, and that of his deceased wife for 136. Other family portraits, in later years, were ordered in series from Willem Tengnagel for twelve guilders apiece. Huydecoper also patronized Adriaen van Nieulandt, as the owner of the house next door to his.

Do the names ring a bell? Moyaert, Tengnagel, van Nieulandt... We have met them before, in chapter 5, as the sons of township officials from the Pijlsteeg. We know van der Voort as a guild officer, and all of them as painters of corporation portraits for the city. Joan Huydecoper did not shop around when he bought paintings. He spent his money on people who were able to help him in turn, by virtue of their position and connections.

Balthasar Coymans and Joan Huydecoper.

In 1628 Huydecoper and Huygens were not yet in-laws, but they *were* political allies. In April of that year, Frederik Hendrik came to Amsterdam, with Huygens in his train, to intervene in a new crisis in the city government. The Calvinists were attempting to overthrow the Remonstrant council, and whereas in a similar situation ten years earlier Maurits had come out for the Calvinists, Frederik Hendrik took the side of the Remonstrants. One of the Amsterdamers who had called him to the city, by signing a strong open petition, was Joan Huydecoper.

Spring 1628. The Rembrandt biographer stands by in wonder as Frederik Hendrik, Constantijn Huygens and Joan Huydecoper unite to support the reign in Amsterdam – of whom? The chief burgomaster that year was no one but Geurt Dircksz. van Beuningen. That was the year when Rembrandt's career took wings, when Frederik Hendrik and Joan Huydecoper both bought their first Rembrandts.

Hendrick Uylenburgh

The first buyer of a Rembrandt painting in a documented sale was Joan Huydecoper. And the seller? There is no reason to look beyond the most obvious candidate. Hendrick Uylenburgh was the successor to Huydecoper's late portraitist Cornelis van der Voort, across the street from the house in the Breestraat where Huydecoper grew up. Within a short time he was to emerge as Rembrandt's dealer in Amsterdam. Could he have already been it by June 1628? The earliest date we have for a possible meeting between Rembrandt and Uylenburgh is March 8, 1628 (see p. 105). In April 1628, a Leidener made a declaration concerning paintings he had ordered from Uylenburgh in Amsterdam, so we know he was doing business in Leiden. Until better evidence comes to light, we may safely picture the twenty-nine-year-old Huydecoper buying his 'Warmbrant' from Hendrick Uylenburgh for the price, no doubt the product of bargaining, of twenty-nine guilders. (Interesting that it went in one sale with a copy after Rubens. Was there anyone in Holland who did *not* think of Rembrandt as a Rubens surrogate?)

UYLENBURGH'S RELIGION | The man with whom Rembrandt joined forces in Amsterdam could not have been more different from those with whom he worked earlier in his life. After the humanist Scriverius and the universal dilettante Huygens, Rembrandt now went to work for a small businessman whose spiritual horizon was confined by his religious fundamentalism.

Hendrick Uylenburgh (1587-1661) came from a Frisian family, but he grew up, and may even have been born, in Cracow, then the capital of Poland; for many years he lived in Gdansk. His father (or grandfather – our information on the Uylenburghs is very fragmentary) was cabinet-maker to the king of Poland, and his brother Rombout, painter to the king. Hendrick himself was trained as a painter. Like most of the Dutch community in Cracow, the Uylenburghs were persecuted followers of the Frisian Reformer Menno Simons (1496-1561). The Mennonites were a conservative branch of the Anabaptists, a radical sect with a subversive reputation, which, it must be said, it had earned.

In Holland, Anabaptism was associated in the popular mind mainly with Jan van Leyden (d. 1536), who proclaimed himself the Messiah and practiced polygamy. (Before being driven out of the country, Jan van Leyden had been the innkeeper at the very establishment that was later run by Isaac Jouderville's father.) His life ended on the stake in Germany.

The Mennonites accepted a greater degree of personal responsibility for their salvation than any other Christians. Each believer had direct access to the Word, through the Bible, which he was free to interpret according to the personal dictates of the Spirit. The community lived in the borderlands of organized religion, and was always in danger of falling apart into as many schisms as there were members. To combat that danger, the Mennonites made liberal use of ostracism to punish believers who abused their freedom.

Mennonite society was closed off and pervaded by mutual suspicion. Its attitude towards the outside world went beyond suspicion to the certainty that all others were damned, and damned by choice. The doctrinal features of the Mennonite belief that made the greatest impression on outsiders were their refusal to baptize babies, swear oaths, hold public office or take up arms even to defend themselves. Their appearance was distinguished by the strictest sobriety of dress.

Thanks to the acceptance in Poland of Socinianism, another branch of the Anabaptist church, the Dutch Mennonites were able to live there in peace for as long as the suppression of their belief in Holland continued. With the rise to power in Amsterdam of the pro-Remonstrant party in the 1620s, the atmosphere in the city grew more

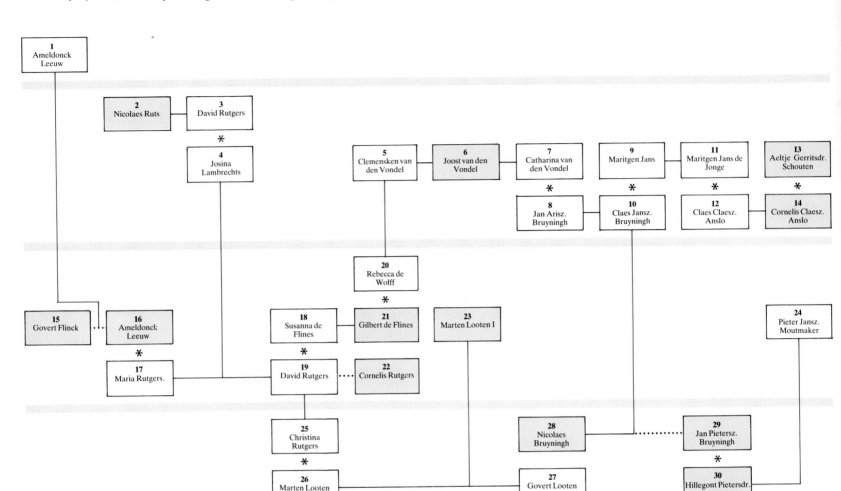

THE FAMILY RELATIONS BETWEEN SOME OF THE MENNONITES
AMONG REMBRANDT'S PATRONS AND ASSOCIATES

1
Ameldonck Leeuw
(16th century). Common grandfather of Ameldonck Leeuw (nr. 16) and Govert Flinck.

2
Nicolaes Ruts (1573-1638). Portrait painted by Rembrandt in 1631.

3
David Rutgers (1555-1623). Married to

4
Josina Lambrechts (ca. 1565-1638).

5
Clemensken van den Vondel (1586-1641).

6
Joost van den Vondel (1587-1679). Author of several plays illustrated by Rembrandt. Wrote poems on portrait prints by Rembrandt in 1641 and 1660.

7
Catharina van den Vondel (1602-1675). Married in 1624 to

8
Jan Arisz. Bruyningh (1602-after 1637).

9
Maritgen Jans (d. 1635). Married in 1595 to

10
Claes Jansz. Bruyningh (1571-1652).

11
Maritgen Jans de Jonge (b. 1590). Married in 1608 to

12
Claes Claesz. Anslo (d. 1636).

13
Aeltje Gerritsdr. Schouten (1589-1657). Portrait painted by Rembrandt in 1641 with her husband.

14
Cornelis Claesz. Anslo (1592-1646), whose portrait Rembrandt also drew and etched in that year.

15
Govert Flinck (1615-1660). Assistant of Rembrandt around 1636 and his successor in Uylenburgh's studio.

16
Ameldonck Leeuw (1604-1647). Owned a painting by Rembrandt upon his death. Married in 1628 to

17
Maria Rutgers.

18
Susanna de Flines (d. 1677). Married in 1626 to

19
David Rutgers (1601-1668).

20
Rebecca de Wolff (1615-1700). Married in 1636 to

21
Gilbert de Flines (1611-1671). Invested money in Uylenburgh's business in 1639.

22
Cornelis Rutgers (d. 1637). Owned painting by Rembrandt upon his death.

23
Marten Looten I (1586-1649). Portrait painted by Rembrandt in 1632.

24
Pieter Jansz. Moutmaker (1570/75-1632/35). Portrait painted by Rembrandt.

25
Christina Rutgers. Married in 1652 to

26
Marten Looten II.

27
Govert Looten (d. 1678).

28
Nicolaes Bruyningh (1629/30-1680). Portrait painted by Rembrandt in 1652.

29
Jan Pietersz. Bruyningh (1599-1646). Portrait painted by Rembrandt together with his wife (married 1623),

30
Hillegont Pietersdr. Moutmaker (1599-1640).

31
Govert Looten II (d. 1727). Owned painting by Rembrandt upon his death.

tolerant, and the Mennonite community there began to grow. With the worst pressure removed, the Mennonites were able to move more freely among their neighbours, and some of them participated fully and easily in Dutch culture and society. Uylenburgh, although he belonged to the least strict group, the Waterland Mennonites, does not seem to have followed their example.

UYLENBURGH AND THE REGENTS | In Amsterdam the Mennonites were able to count on the support of one of the important ruling clans. Burgomaster Cornelis Pietersz. Hooft (1574-1626) stood up for them in the council, even going on record with the admission that his wife attended Mennonite services. In Uylenburgh's time, the Hoofts themselves were not in power, but they did have close ties with the de Graeffs, the most libertine of all the Amsterdam clans. Their leader, Jacob de Graeff (1571-1638), a friend of the humanist Justus Lipsius, after an unfortunate experience in the Remonstrant troubles of the 1610s, simply stopped going to church.

The golden age of the de Graeffs dawned in 1628, when Jacob became burgomaster. From 1630 on he was able to fill the council with men of his own choosing. In that year Laurens Reael and Joan Huydecoper took their lifetime seats. The relationship between the de Graeffs and the Huydecopers was long and intimate. In the crisis of the 1570s, when de Graeff's father had to flee Amsterdam, it was to Huydecoper's father that he entrusted his fortune – sixty thousand guilders in cash, in two iron chests. In 1631 the new councilmen were Pieter Jansz. Hooft (Cornelis Pietersz.'s nephew) and Allard Cloeck. Pieter Jansz. was not only an ally but a personal friend of Jacob de Graeff's. Together they indulged one of the most exciting hobbies in the world – the invention of a perpetual motion machine. They actually claimed to have succeeded, only to have their idea stolen by the adventurer-scientist Cornelis Drebbel.

From 1631 on the Amsterdam Mennonites could breathe easier, and Uylenburgh could begin to make his moves. Pieter Jansz. Hooft was the cousin of two Mennonite Hoofts who were both shareholders in his firm. Allard Cloeck was the cousin of his landlord, Nicolaes Seys Pauw (1607-1640). Overnight, Uylenburgh was in a position to fill the vacancy left behind by his two late predecessors, Cornelis van der Voort and Pieter Isaacksz. With the prospect of civic commissions to come, Uylenburgh began to expand his family business into what would soon become the largest art enterprise in Amsterdam.

UYLENBURGH AS A BUSINESSMAN | Uylenburgh returned from exile some time before 1626, when we find him installed on the Breestraat. He was not wealthy, and to run his capital-intensive business he had to borrow. In these transactions, he managed to create a maximum of confusion between his financial, commercial, artistic, religious and family interests, undoubtedly leaving a lot of parties in doubt as to exactly how they stood with him. In April 1639, when he borrowed sixteen-hundred guilders from two Mennonite co-religionists, Philips de Flines and Pieter Seyen, he pledged as security 'all his paintings…, including those to be acquired in the future.' He even invited the lenders, 'for their peace of mind,' to take home any or all of his stock of paintings. It comes as something of a surprise, then, to hear him declare to a different notary in January 1640 that eighteen other creditors of his, some of more than ten years' standing, also held 'his entire stock of paintings and works of art' as collateral on *their* loans.

Five of the eighteen creditors were fellow Mennonites, including the heirs of Lambert Jacobsz. Eight others, in addition to Lambert Jacobsz., were painters: Rembrandt himself, the Catholic Amsterdamers Claes Moyaert, Simon de Vlieger and Jan Jansz. Treck; the Haarlemers Jacob de Wet and Jan Coelenbier; and, from Leiden, Pieter de Neyn and Johan Adriaensz. van Staveren. This puts the 'emulation' of Rembrandt by several of the members of the 'Rembrandt school' in this group in quite a different light. Moyaert, de Wet and van Staveren are known to us as followers of Rembrandt, starting in the 1630s. Going by appearances, one would say that these artist-capitalists were taking advantage of Uylenburgh's habit of extending to his creditors the right to hold works from his stock in order to copy or imitate works by Rembrandt which belonged to the dealer. When Lambert Jacobsz. died in 1636, he owned one painting *by* Rembrandt and six copies *after* him. We have no evidence that Rembrandt received any money when his paintings were copied in this way, and it seems fair to say that Uylenburgh's practice of using his paintings as collateral for loans robbed Rembrandt of potential income and cheapened the value of his art in the market-place. The same effect may have been caused when in 1641 Uylenburgh borrowed a thousand guilders from the Waterland Mennonites against 125 etching plates, undoubtedly including plates by Rembrandt, without stipulating that the creditor was forbidden to print impressions.

Four of Uylenburgh's shareholders were related to regents, and this gives us an indispensable clue

concerning his connections with the council. Aside from the Hooft brothers, there were Pieter Belten, Uylenburgh's next-door neighbour and the brother-in-law of Joan Huydecoper, and Nicolaes van Bambeeck, son-in-law of Burgomaster Dirck Bas. Van Bambeeck, who also lived in the Breestraat until he moved around the corner to the Kloveniersburgwal, extended financial support to Uylenburgh and his son Gerrit into the 1650s. The Hoofts, Basses and Huydecopers – all of them clients of the de Graeffs – must have been Uylenburgh's main protectors in the Amsterdam political jungle.

And protection he did have. From 1647 to 1654, Uylenburgh rented a house on the Dam from the city, and when he was unable to pay the last two years' rent, the burgomasters gave him credit for three years, at which time they cancelled forty per cent of his debt, and gave him contracts to clean and varnish paintings belonging to the city, for a larger amount than he owed. The year that arrangement was made was the third term of Burgomaster Joan Huydecoper.

THE UYLENBURGH-REMBRANDT MERGER

Rembrandt's father died in April 1630, his oldest brother Gerrit in September 1631. Sometime in November or December 1631, Rembrandt left his mother's depleted household to move in with Hendrick Uylenburgh and his wife Maria van Eyck. He brought with him from Leiden one or perhaps two associates: Isaac Jouderville, who was still his apprentice, and possibly Jan Jorisz. van Vliet, an etcher from Rembrandt's old neighbourhood who helped him with his etchings and made reproductions in print of the young master's paintings. He also brought in capital – in June 1631 Uylenburgh acknowledged having received a thousand-guilder loan from Rembrandt, at five per cent.

Within a very short time, they must have been joined by another alumnus of the Breestraat, Salomon Koninck (1609-1656). Koninck had been a pupil of Pieter Lastman's Remonstrant brother-in-law François Venant and of the Catholic Claes Moyaert. As if these connections were not close enough, he was later to marry Adriaen van Nieulandt's daughter Abigail. Koninck, who had been a guild member since 1630, did little else for the remainder of his career after 1632 than produce copies and derivations of Rembrandt's compositions and stylistic innovations beginning with such Leiden works as the *Judas*. Whether he did this on his own account, or on that of Uylenburgh's shareholder Moyaert, is unknown.

This was the beginning of the growth of Uylenburgh's gallery to a much larger scale than the usual studio with apprentices and showroom. The Italian artist and writer Filippo Baldinucci, basing his statement on the information of a Danish artist who worked in Amsterdam in the late 1630s before moving to Italy, described the establishment as 'Uylenburgh's famous academy.' We have come across that term in connection with van Mander and his humanist colleagues in Haarlem, but applied to Uylenburgh it means something quite different. We can isolate the following activities of the Uylenburgh academy:

1 Buying and selling old paintings and other works of art.
2 Producing new paintings by Uylenburgh, Rembrandt, their apprentices and assistants.
3 Having copies made of works in stock and of new compositions.
4 Acquiring and executing portrait commissions for Uylenburgh, Rembrandt and the assistants.
5 Making etched copies after paintings and making original etchings.
6 Publishing etchings.
7 Trading in etching plates.
8 Training apprentices and assistants.
9 Giving art lessons to amateurs.
10 Appraising works of art for legal purposes.
11 Cleaning and varnishing paintings.

Apart from these commercial occupations, Uylenburgh also, as we have seen, used stock and services as tools in his financial dealings.

It would seem that in 1631 Rembrandt became the artistic heart-and-soul of an enterprise that remained the property of Uylenburgh. There was no doubt an arrangement – knowing Uylenburgh, an opaque one – for the sharing of costs and income from sales, commissions and tuition fees. The arrangement will not have become clearer when after two years Rembrandt was engaged to and then married Uylenburgh's cousin. Another two years after that, Rembrandt and Uylenburgh parted ways, to the artistic disadvantage of the academy, and the financial loss of the artist.

Portraits, 1631-1635

If Rembrandt was not getting his share of portrait commissions in Leiden and The Hague, in Amsterdam he received it and more. In the first fifty months that he lived there, from November 1631 to December 1635, he painted about fifty portraits, which probably made him the best-patronized portraitist in the city in that period. From estimates and other information, we know that Rembrandt's charge for a portrait varied from fifty guilders for a single head to five hundred guilders for a full-length, life-size work. One hundred guilders was the going fee for bust portraits and for the individuals in a group portrait. Most of Rembrandt's portraits from 1631 to 1635 were of the more expensive kind.

Once Rembrandt got his chance, it became clear that there was a demon of a portraitist in him. It cannot be said that he re-invented the art. He practiced a not particularly personal variation of the international mode of the time, derived from Titian via van Dyck. Only in the larger works, especially the group portraits, did he coin strikingly new solutions to old problems.

THE ANATOMY LECTURE OF DR. NICOLAES TULP, 1632 | If any single work symbolizes Rembrandt's new status in the world, it is the *Anatomy lecture of Dr. Nicolaes Tulp* (fig. 127). The painting of group portraits of civic bodies in Amsterdam was the highest form of patronage the city had to bestow on portraitists, and Rembrandt benefited from it within weeks of having entered through the city gates. He rose to the challenge by creating one of the great dramatic group portraits in art.

It had become a minor tradition in the surgeons' guild to display paintings of anatomical demonstrations by the guild prelector, or public anatomist. The three earlier ones had been painted, in 1603, 1619 and 1625, by Amsterdam artists with extensive connections in the city government: Aert Pietersz. (ca. 1550-1612), Thomas de Keyser (1596/97-1667) and Nicolaes Eliasz. Pickenoy (1590/91-

1654/56). The *Tulp* was somewhat less official than the usual group portrait of a civic body. Generally, the persons portrayed were the governors or board. The surgeons in the *Tulp* are simply some of the wealthier guild members. The occasion too seems less worthy of commemoration than those immortalized in the previous *Anatomies* – not the inaugural but the second public anatomy conducted by the prelector, held on January 31, 1632 and the days following. Not to put too fine a point on the issue – the commission for the *Tulp* has a somewhat forced quality, while the choice of the painter – a brand new Amsterdamer who was not even a guild member – is a conspicuous departure from previous guild practice.

Corporation portraiture in Holland had been evolving away from the stiff row of heads we know from the sixteenth-century examples to more fluent and integrated compositions. There was a built-in conflict between the desire of the individual sitters to show up clearly and handsomely, and that of the various corporate bodies to decorate the walls of their meeting places with worthy pieces of art. The conflict was complicated by the circumstance that the sitters usually paid the entire cost of the painting, while the guild or the city would own it.

Rembrandt took as his model for the *Tulp* not an earlier example of the same type of work, but a history painting by Rubens, *The tribute money*, known in many painted copies and in a print by Lucas Vorsterman. The painting is from the 1610s, the period of the many Rubens works from which Rembrandt borrowed. The device worked splendidly, enabling Rembrandt to avoid the defensive attitude of the group portraitist and to lend his sitters the intensity and sense of purpose of characters in a divine drama.

For that is what a public dissection was in seventeenth-century Holland: a demonstration, in the words of an oration given by Tulp as a student in Leiden, 'of the sympathy between body and soul,'

between human clay and the spark of divinity in man. The deeper meaning of anatomy was put into words by Joost van den Vondel in 1633, in a poem on a Dutch translation by Vobiscus Fortunatus Plempius of an anatomical treatise by Bartholomaeus Cabrious.

On the dissection of the human body, translated into Dutch by V.F. Plemp

'Know thyself' were words engraved
Above a Delphic architrave
As enlightenment divine
From the mistress of that shrine.
Today the same is taught to us
By doctors like wise Cabrious....
He who seeks to comprehend
From beginning until end
What our human skins encase,
What keeps all our parts in place,
How the wisdom of the Lord obtains
Throughout our nerves, throughout our veins,
How artists all are put to shame
By the artful human frame –
Should his book help such a one succeed
To know himself and then proceed
To knowledge of God's nature too,
Then Plemp will feel he's had his due.

This is the nearly invariable association evoked in Rembrandt's contemporaries by anatomical demonstrations, and there is no reason to think that of Tulp was an exception. Public dissections like that depicted here had a more specific moral too. The cadaver was always that of an executed criminal, prompting reflections on how good can come from evil.

THE ANATOMY OF AN ANATOMY | Claes Pietersz. (1593-1674), as Dr. Nicolaes Tulp was baptized and as he preferred to call himself throughout life, was a physician, surgeon, author of a respected treatise on pathological anatomy and prelector of the surgeons' guild. He was also a member of the Amsterdam town council from 1622 on, alderman for numerous terms starting in 1622, and four times burgomaster, beginning in 1654. The two careers were not at all separate from each other, nor was Tulp the first one to combine them. Two of his five predecessors as prelector also became burgomasters. Anatomy was one of the few fields of science in which Amsterdam was able to compete with Leiden; it was particularly proud of that fact, and of the men who upheld the name of the city in the world of learning.

The month of Tulp's second anatomy is of

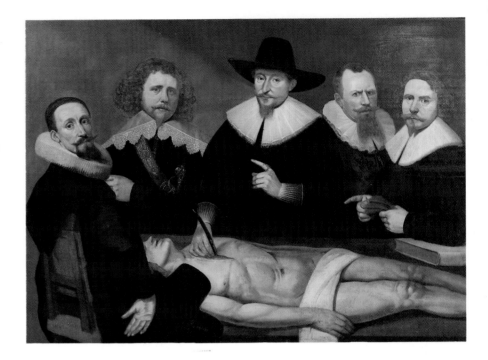

particular significance in that regard. January 1632 saw the opening of a university in Amsterdam that was intended to rival that of Leiden. The city and university of Leiden had opposed this development bitterly, but was unable to stay it any longer. The two founding professors of the new institution of higher learning were Remonstrants who had been dismissed from their chairs in Leiden in 1619: Caspar Barlaeus (1584-1648) and Gerard Vossius (1577-1649).

Vossius attended at least one of Tulp's anatomies, learning from it that when the Scriptures tell of water and blood running out of Christ's wound after his death, the process was not necessarily a miracle. On January 9, 1632 Barlaeus held an inaugural lecture 'on the wise merchant,' pleading for co-operation between commerce and culture. This was pitched a lot lower than the claims of Leiden University, which saw itself as Holland's gift to the Reformation, the bastion of Protestant orthodoxy and a shrine to the martyrs of the Eighty Years War.

The new school in Amsterdam was a triumph for the Remonstrants. The first curator appointed by the city was Albert Coenrats Burgh, whom we know as Vondel's protector and Scriverius's kinsman. Scriverius in fact wrote a Latin poem on the event, full of jibes at Leiden, which Vondel translated into Dutch in honour of Scriverius's cousin Daniel Mostart, the Remonstrant town secretary (see fig. 133).

By holding his second public dissection within weeks of Barlaeus's lecture, Tulp was not only reaffirming the position of Amsterdam in his discipline. He was also reminding the wise

126 Christiaen Coevershoff (1600-1659), *The anatomy lecture of Dr. Zacheus de Jager, town physician of Enkhuizen*. Signed and dated 1640. Panel, 122 x 161 cm. Gouda, Stedelijk Museum Het Catharina-Gasthuis.

The artist was clearly inspired by Rembrandt's painting. The choice of a painter so inferior to Rembrandt goes to show that quality was not the only consideration when it came to dispensing guild patronage.

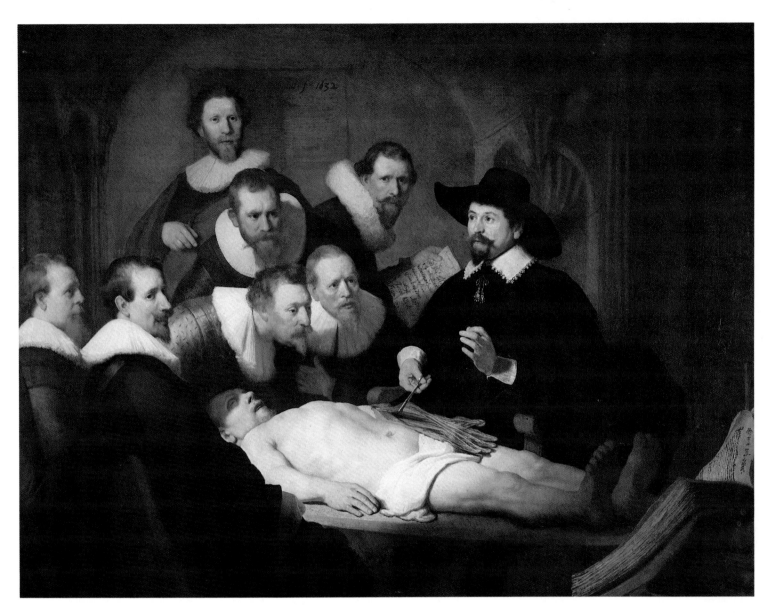

merchants of his own city that his prelectorship – a kind of professorship, after all – preceded those of the newcomers, and even predated the beginnings of Leiden University.

Even the *day* of Tulp's anatomy, January 31, 1632, is charged with political meaning. January 31st was the last day of the political year in Amsterdam, the day before the election of new burgomasters and aldermen. We can better understand how Tulp received permission to hold a second anatomy, and how he acquired the cadaver he needed for that purpose, if we check to see who the departing chief burgomaster and chief alderman were on that day. (It was the latter official who presided over the bodies of executed criminals, which were seldom made available for science.) The findings are interesting: chief burgomaster was Jacob de Graeff and chief alderman Diederik Tholincx. De Graeff, as lord of Sloten, had been the protector of Tulp's late brother, the local preacher;

127 *The anatomy lecture of Dr. Nicolaes Tulp (1593-1674).* Signed *Rembrandt ft: 1632.* The other sitters are Jacob Jansz. Colevelt, Adriaen Cornelisz. Slabberaen, Frans Jacobsz. van Loenen, Jacob Dielofsz. Block, Jacob Jansz. de Witt, Mathys Evertsz. Calkoen and Hartman Hartmansz. The cadaver is that of Adriaen Adriaensz. (Aris) 't Kint of Leiden, a multiple offender convicted of stealing a coat and executed on 31 January 1632. Canvas, 169.5 x 216.5 cm. Bredius 403. The Hague, Mauritshuis.

One or two of the sitters may have been added after the painting was finished, which underlines the fact that this is not a real scene. Another proof is provided by the

cadaver. Dissections always began with the opening of the ventral cavity and the removal of the perishable internal organs. (Compare fig. 315.)

Two Dutch anatomists have recently suggested that Rembrandt painted the arm not from life or a printed illustration but from a prepared specimen. In fact, a visitor to his house one week before his death saw there, among the 'antiques and curios collected by Rembrandt over a long period of time,... four arms and legs dissected by Vesalius.'

and Tholincx was from a family of doctors who were dependent on Tulp. His nephew Aernout, who had just received his medical degree in April 1631, was to hold municipal appointments under Tulp and even marry his daughter. In 1656, Rembrandt was to paint him as well (fig. 314).

Three of the other eight aldermen were newly appointed protégés of de Graeff, among them Joan Huydecoper and Pieter Jansz. Hooft. On the first day of February each year, the sitting and former aldermen and burgomasters met to elect the new burgomasters. In the preceding days they were courted lavishly (or put under pressure) for their votes.

January 28th was the day for filling the seats in the council that had been vacated in the past year. The choice in 1632 was a signal that could not be misread. One of the two new men was Jan Claesz. van Vlooswijk, an extremely militant Remonstrant whose appointment in 1628 to the captaincy of a civic guard company was the occasion for an uprising and attempted takeover by the Calvinists. His election to the council on January 28, 1632 marks the day that Amsterdam was finally safe for Remonstrants.

Needless to say, the choice of a painter for a guild *Anatomy* could not remain untouched by politics. When we learn that the new chief burgomaster for 1632 was Nicolaes Bas, the father-in-law of one of the backers of Uylenburgh's gallery, and that he was elected with the votes of other patrons of the art dealer, we get a strong sense of a possible connection.

It is fascinating to observe that as the city government fell into the hands of the libertine and Remonstrant factions, municipal patronage was channelled with increasing regularity to Hendrick Uylenburgh. Rembrandt's *Anatomy lecture of Dr. Nicolaes Tulp* was the first of a long series of commissions for important group portraits for the painters of Uylenburgh's academy.

UYLENBURGH'S CONTACTS, MAINLY MENNONITES
The largest single group of sitters among the identified or documented portraits consists of Mennonites. Since this sect accounted for barely five per cent of the population of Amsterdam, we need not doubt that those painted by Rembrandt were brought to him by Hendrick Uylenburgh.

In fact, we can place a number of them in a family tree that includes one of the Mennonite financiers of Uylenburgh's business, Gilbert de Flines. Among his relatives were four of the first Amsterdamers to be painted by Rembrandt – two unnamed members of the Rutgers family, a man and a young girl whose

PARTY MEN AND FENCE-SITTERS IN AMSTERDAM: A CALVINIST PAMPHLET OF 1628

These are the Toms, Harries and Dicks
Who want to open the Arminian bag of tricks:
Abraham Boom, Anthony Oetgens van Waveren, Geurt Dircksz. van Beuningen, Andries Bicker, Dirck Bas, Albert Coenrats Burgh, Dirck Tholincx, Gerrit Schaep, Jan ten Grootenhuys, Pieter Pietersz. Hasselaer, Pieter Opmeer, Willem Becker, Jacob Jacobsz. van Hinlopen, Jacob Reael, Volckert Overlander.

These are the floppy caps
Who owe their position to the orthodox chaps:
Adriaen Pietersz. (or Pieter Adriaensz.) Raep, Hendrick Hudde, Jacob Pietersz. Hoogkamer, Pieter de Vlaming van Oudtshoorn, Jacob van Neck, Henrick Reynst, Jacob Jansz. (or Jacob Jacobsz. or Pieter Egbertsz.) Vinck, Claes Pietersz. Tulp, Matthys Raephorst.

Will you please stop flopping and take a stand.
Line up with the orthodox in the band
And see to it – listen to what I say! –
That we don't get Arminians on Candlemas Day.

These are the orthodox:
Reynier Pauw, Jan Gijsbertsz. de Vries, Frederick (or Cornelis) de Vrij, Jan Willemsz. Bogaert, Hillebrand Schellinger, Simon van der Does, Ernest Roeters, Gillis Jansz. Beth, Claes Jacobsz. van Harencarspel.

Reprinted in Wagenaar's *History of Amsterdam*, vol. 1, p. 492. I have filled in the full names, where the pamphlet only gives surnames.

Candlemas, February 2, was the day on which the new burgomasters and aldermen of Amsterdam would be installed each year. On February 1st three of the four sitting burgomasters would resign, leaving the fourth one to serve a second term. For the year to come, this man held the highest official position in the city, the chief burgomastership. Read in connection with the family chart on pp. 136-137, the list reveals that all of Rembrandt's patronage, insofar as it came from the officeholders of 1628, was bestowed by pro-Remon- strants, with the single exception of Tulp.

Tulp never did take off his floppy cap. In 1622, when the Remonstrant Geurt Dircksz. van Beuningen and pro-Remonstrant Andries Bicker were installed as councilmen, the amiable Tulp was put in too to mediate between them and the Calvinists. He took an orthodox stance in matters of religion, but managed not to alienate the Remonstrants.

There is a anecdote about Tulp and Geurt Dircksz. in 1628 that Vondel immortalized in a poem. The chief burgomaster was seriously ill and under Tulp's care on the day of a critical vote in the council, a vote that could have resulted in the return of the Calvinists to power. Tulp forbade Geurt Dircksz. to leave his bed; but instead of obeying him the invalid got a Catholic physician to accompany him to the town hall.

Like Joan Huydecoper, Tulp was kept out of the burgomaster's chamber for as long as Andries Bicker held the *magnificat*. He was first elevated to the burgomastership by Cornelis de Graeff, and served his four terms in 1654, 1656, 1666 and 1671.

128 *Nicolaes Ruts (1573-1638)*. Signed *R*[H?]*L 1631*. Panel, 116.8 x 87.3 cm. Bredius 145. New York, The Frick Collection.

Nicolaes Ruts was born in Cologne to a Flemish émigré family of Mennonites. He himself later joined the Calvinist Church. Ruts, who settled in Amsterdam some time before 1617, was engaged in the Russian trade. The end of his career demonstrates that not every Amsterdam trader was destined to grow richer and richer. Half a year before his death, his creditors agreed to settle for payment of one-third of what he owed them.

Dr. van Eeghen has suggested that Rembrandt's portrait of Ruts was ordered by his daughter Susanna and her rich husband Johannes Boddens. From 1636 to 1649, and perhaps from the time it was painted, the portrait would have hung in Susanna's shop on the Oudezijds Voorburgwal, where she sold the silk and cloth that the Dutch exported to Russia.

The savoir faire that Rembrandt demonstrates in what might be his first commissioned portrait was acquired by work on such non-commissioned paintings as the *Old man* in Innsbruck (fig. 53).

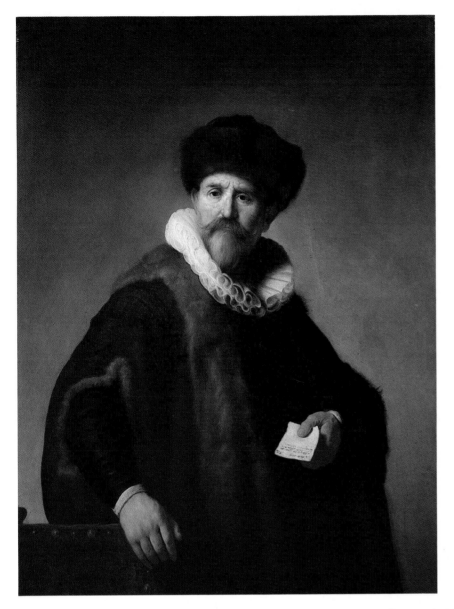

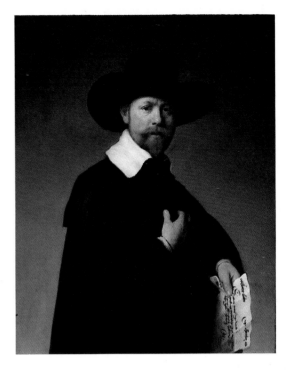

129 *Marten Looten (1586-1649).* Signed *RHL,* inscribed *XVII. Januwary 1632.* Panel, 91 *x* 74 cm. Bredius 166. Los Angeles, County Museum of Art.

Marten Looten's family, like that of his kinsman Nicolaes Ruts, fled from the southern Netherlands to the north in the Eighty Years War. Marten grew up in Leiden, where his parents were in the textile business. He moved to Amsterdam around 1615 to become the partner in a

trading company. Looten's religious background is the converse of Ruts's: he was a Mennonite member of a Calvinist family.

That difference is reflected in the dress of the two sitters. The Mennonites prided themselves on their extreme black-and-white sobriety, accusing the Calvinists (yes, the Calvinists!) of sinful extravagance. The portrait of Nicolaes Ruts was once owned by the great collector J. Pierpont Morgan, that of Marten Looten by the parsimonious J. Paul Getty. When Morgan died and was found to be worth sixty-four million dollars, Henry Ford remarked 'Just imagine, the man wasn't even wealthy.' Getty was said to be the richest man on earth.

portraits are known only from documents, and two sitters who were immortalized by Rembrandt as soon as he moved to their city, Nicolaes Ruts (fig. 128) and Marten Looten (fig. 129).

The dating of those portraits – 1631 on the *Ruts* and the unique 17 January 1632 on the *Looten* – proves that Uylenburgh provided Rembrandt with sitters immediately, so that the surgeons of the guild did not have to take his word for it that Rembrandt could paint. Viewed in a mirror, the figure of Looten actually bears a strong resemblance to that of Tulp, down to the position of the hands.

Archival documents indicate that Rembrandt also painted a double portrait of the Mennonite couple Jan Pietersz. Bruyningh and his wife Hillegont Pietersdr. Moutmaker as well as a single portrait of her father Pieter Jansz. Moutmaker. Among the surviving works, there is only one candidate for the double portrait, and there seems no harm in tentatively assigning to it the names from the

documents (fig. 131). The dress of the woman does not have the Mennonite simplicity of say Marten Looten, but the man's does. Perhaps she was less committed to her church than her husband.

In any case, it is not true that Mennonites had themselves painted only in basic black. The inventory of Jan Pietersz. Bruyningh's collection included another portrait, by Rembrandt's associate of those years, Salomon Koninck, for which the sitter had put on 'antique' costume. We know too that Maria van Eyck, Uylenburgh's wife, sat for a portrait by Rembrandt in Oriental garb. Even Mennonites sometimes let themselves go, at least in the painter's studio. However, the lace, brocade and uncovered hair of the woman in fig. 131 are indeed irreconcilable with Mennonite principles of dress.

The final portrait of the early 1630s that can be brought into connection with Uylenburgh is a portrait of 1635 in an American private collection

(fig. 130), inscribed on the back 'Antoni Coopal, marquis of Antwerp, former ambassador to the courts of Poland and England, pensionary of Vlissingen in Zeeland, etc.' The man so identified was the brother of François Coopal, the husband of Uylenburgh's cousin Titia, godfather to three of Rembrandt's children. From 1666 until his death in 1672 Anthonis was indeed pensionary of Vlissingen. Concerning his ambassadorships I have no information, and for the quite astonishing explanation of the title marquis of Antwerp the reader will have to wait until chapter 28. Suffice it to say here that he was by far the best-connected relative Rembrandt ever had. His position was so desirable that when he died, the Zeeland regent Justus de Huybert wrote to Huygens suggesting that he might be replaced by Huygens's son Lodewijk. In the letter, de Huybert refers to Coopal as his 'cousin,' a relationship I have been unable to define precisely. He adds that the job is a sensitive one, whose incumbent must be absolutely trusted by the prince. In Anthonis Coopal, therefore, Uylenburgh and Rembrandt had a relative who worked in the political system of Zeeland for the private interests of the house of Orange. This was the far right wing of the Uylenburgh connection, and a long way from the pacifist Mennonites of Amsterdam and Leeuwarden.

REMONSTRANTS | As we could expect from our reconstruction of Rembrandt's beginnings under the wing of Petrus Scriverius, when he arrived in Amsterdam he was patronized by Remonstrants and members of the van Beuningen clan. The diary

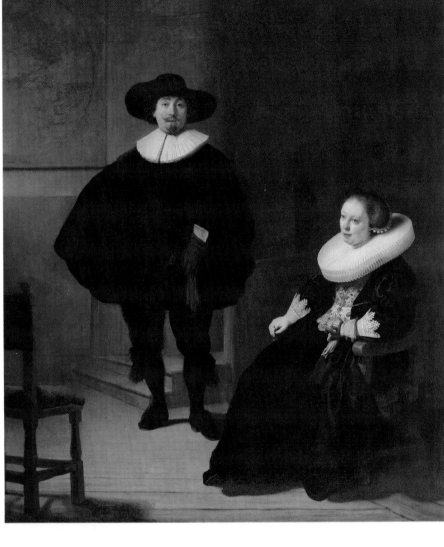

130 Antonis Coopal (1606-1672). Signed *Rembrandt f. 1635.* Inscribed on the back *Antoni Coopal, Marckgraef van Antwerpen, Gewesene Ambassaduer aan 't Hof van Polen en Engelant, Raetpensionaris van Flissinge in Zelant etc.* (Anthonis Coopal, marquis of Antwerp, former ambassador to the courts of Poland and England, grand pensionary of Vlissingen in Zeeland, etc.). Panel, 83 x 67 cm. Bredius 203. Private collection. Reproduced by courtesy of the Museum of Fine Arts, Boston.

For Coopal, the brother of Rembrandt's brother-in-law François and a secret agent of the stadholder's, see below, pp. 236-238.

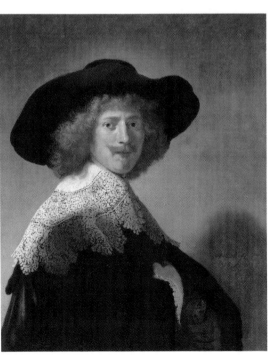

131 *Jan Pietersz. Bruyningh (1599-1646) and Hillegont Pieters Moutmaker (1599-1640)?* Signed *Rembrandt f. 1633.* Canvas, 131.5 x 106.5 cm. Bredius 405. Boston, Isabella Stewart Gardner Museum.

This is the only known painting that corresponds to an entry in the death inventory of Jan Pietersz. Bruyningh. The Bruyninghs lived in a small, bare dwelling behind their cloth shop in the Nieuwe Nieuwstraat, but they had quite a nice collection of paintings.

Originally, there was a young boy playing in the foreground, but he was covered over before the paint was dry.

of old Johannes Wtenbogaert provides us with this precious information: '13 April 1633. Painted by Rembrandt for Abraham Anthonisz.' (fig. 132). We have met him before: Abraham Anthonisz., who later took the surname Recht, is the man who let his mason put a bust of Oldenbarnevelt on the front of his house, and talked his way out of being sentenced for it (pp. 38). Originally a member of the Reformed Church, he joined the Remonstrants around 1615, and soon became one of the most active fighters in Amsterdam for their cause. In 1634, Abraham Anthonisz.'s daughter married the son of Arminius himself, an occasion that brought

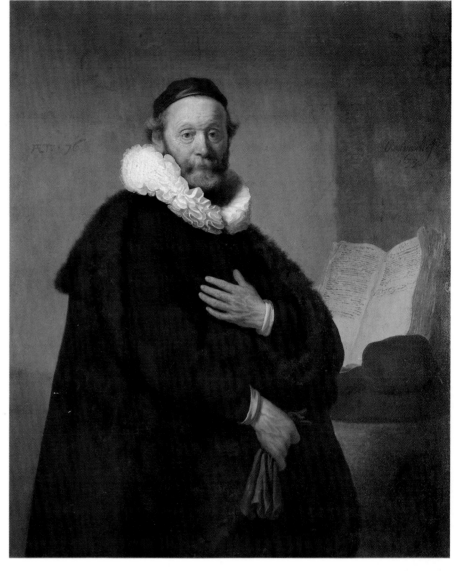

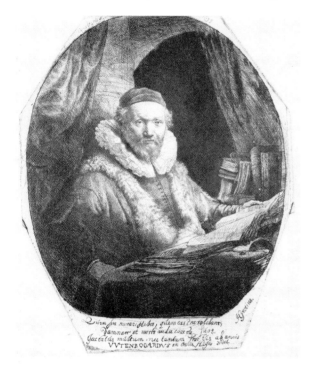

131a *Johannes Wtenbogaert (1557-1646).* Signed *Rembrandt f. 1635.* Inscribed *Quem pia mirari plebes, quem castra solebant,/ Damnare et mores aula coacta suos./ Jactatus multum, nectantum fractus ab annis,/ Wtenbogardus sic tuus Haya redit. H. Grotius.* Etching, fourth state of six, 25 x 18.7 cm. Bartsch 279. Amsterdam, Rijksprentenkabinet.

'The pious in the land and the army spoke well of this man,
But what he preached was damned by the assembled clergy.
The years imposed heavy tribulations on him without breaking him.
Behold, The Hague, your Wtenbogaert comes home.'

The reference to the army alludes to Wtenbogaert's position as chaplain, held until he was driven out of the country in 1618. In 1626 he returned, but the scope of his influence was limited from then on to his fellow Remonstrants. For the connections of Rembrandt's Remonstrant patrons with the Amsterdam armed forces (see p. 268).

Hugo Grotius (1583-1645) remained in exile until his death. His one visit to Amsterdam took place in December 1631, at the same time as Rembrandt moved there. Among those who paid him honour and consulted him during his clandestine visit were a number of Rembrandt's Remonstrant patrons.

132 *Johannes Wtenbogaert (1557-1646).* Signed *Rembrandt f. 1633.* Marked *Aet 76.* Canvas, 132 x 102 cm. Bredius 173. Mentmore, Buckinghamshire, collection of the Earl of Rosebery.

At the age of seventy-six, Wtenbogaert had long been a living symbol to his fellow Remonstrants of the dignity of their church. For fifty years, he had been exerting his influence to further a humane and tolerant Reformed Christianity. In 1610 he penned the Remonstrance itself, the document that gave its name to a powerful political and religious movement and to a Dutch Protestant sect that survives today. He intended the document to be an instrument of reconciliation,

but it became a shibboleth dividing the Dutch church irreparably.

AN UTRECHT REMBRANDT COLLECTOR AND HIS TIES TO AMSTERDAM: CAREL MARTENS (1602-1649)

The earliest document pertaining to the sale of Rembrandt etchings is an entry in the accounts of the Utrecht patrician Carel Martens. Between 12 May and 30 July 1631 Martens bought six etchings by Rembrandt for two guilders and eight stuivers: eight stuivers, less than half a guilder, apiece.

The item occurs in a column of payments made 'in Amsterdam and Leiden.' If in Leiden, then Martens may have bought the prints from Rembrandt himself. In the mid-1620s Martens had studied in Leiden, and he could have met the artist there. If in Amsterdam, it must have been from Uylenburgh. One of Martens's best friends was Nicolaes Seys Pauw, Uylenburgh's landlord. Martens's mother, who had died in 1612, was a Bacher from Antwerp, and a relative of the Thijs family, who lived in the house next to Uylenburgh (see pp. 202-203), later to be bought by Rembrandt.

As an orphan, Carel was placed by the court under the charge of two guardians. One of them, who he calls 'uncle' in his accounts, was Daniel Mostart (see below). Martens himself was not a Remonstrant, like Mostart. In 1639 he became an elder of the Utrecht church council.

His first wife's uncle was the extreme Counter-Remonstrant Buchelius.

In 1633 Carel became receiver for the States of Utrecht of income from its lands under benefice, which made him a colleague of the Utrecht Wtenbogaert.

On 10 July 1645 he bought, in Utrecht, 'a personage painted large by Rembrandt van Rijn, with a pearwood frame' for fifty-four guilders.

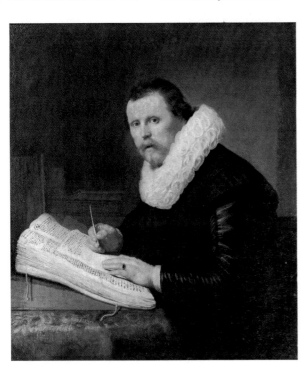

133 *Young man at a desk.* Signed *RHL 1631.* Canvas, 104 x 92 cm. Bredius 146. Leningrad, Hermitage.

The book which the sitter is consulting or from which he is making a transcript is of the elongated kind used by merchants and by town clerks or secretaries. Since the contents of the book consist of running text rather than columns of figures, and since merchants do not generally have themselves portrayed at the writing table, the sitter is most likely to have been a town clerk.

If he is a Leidener, the best candidate is Aelbrecht van Hoogeveen, the successor to Isaac Isaacsz. van Swanenburg (p. 22). The estate of his son Gerard contained two 'heads' by Rembrandt.

A more promising, though undocumented, candidate is the Amsterdam town clerk Daniel Mostart (1592-1646). A Remonstrant, he was appointed secretary in 1622 to take the place of Albert Coenrats Burgh. The ring on his finger – one of the very few worn by a Rembrandt portrait sitter – signifies his marriage (if he *is* Mostart) to Marie Jansdr. van Beuningen, the niece of Geurt Dircksz. As one of the secretaries of Amsterdam, Mostart published an edition of the town charters and a memorandum on the duties of the secretary. He was also a poet and a member of the Muiderkring, the literary salon of Pieter Cornelisz. Hooft. In 1631 he brought out a Dutch translation of several essays by Seneca dedicated to Geurt Dircksz. His inscription in the *album amicorum* of Petrus Scriverius dates from 1630. From 1629 on his nephew and ward David Martens was the partner in Marseille of Nicolaes Ruts's son Nicolaes Jr. (see above).

Wtenbogaert once more from The Hague to Amsterdam.

Abraham Anthonisz. was the kind of partisan figure who would prefer to give his patronage to an artist who was, if not a Remonstrant himself, at least sympathetic to their cause. Rembrandt must have come to him with a recommendation that inspired his trust. His circle included several people who could have given Rembrandt such a reference. If not his kinsman the young Joannes Wtenbogaert, there were Geurt Dircksz. van Beuningen and his son Dirck Geurtsz., with both of whom he was on very close terms. The two connections, in fact, were themselves connected: in 1633 Joannes Wtenbogaert lived with his father Augustijn on the Kloveniersburgwal two doors away from where Dirck Geurtsz. van Beuningen shared a house with Albert Coenrats Burgh. For all its hundred thousand souls and its global reach, Amsterdam, for Rembrandt, was a small world.

If it were not for Abraham Anthonisz.'s commission, it is doubtful that Rembrandt would have got to portray Wtenbogaert. Portraits of him were in demand, but the old man was not a willing sitter. One likeness of him by Paulus Moreelse, of 1612, served as the model for all effigies for twenty years. In 1619 it was engraved by Mierevelt's son-in-law Jacob Delff, and reprinted constantly. Mierevelt liked to have a portrait in stock of as many celebrities as possible, both in paint and in print. But even he, with all his connections in The Hague, had a hard time getting old Wtenbogaert to sit. In July 1631, during a visit to the ailing burgomaster of Delft, Wtenbogaert noted in his diary: 'In the meantime I permitted the famous painter Michiel Mierevelt, upon his earnest request, to paint my portrait.' Once he had the new likeness, Mierevelt lost no time in copying and reproducing it for as large a market as he could reach. When he died in 1641, his estate included two Wtenbogaerts.

It is interesting that Mierevelt was a Waterland Mennonite.

The only other portrait of Wtenbogaert to follow Rembrandt's also came from out of the Uylenburgh milieu – in 1634, undoubtedly on the occasion of the above-mentioned wedding, he was painted by – the Friesland Mennonite – Jacob Backer (1608-1651), in more than one version. The reader will have to take my word for it that there really were very few Mennonite artists in Holland.

With the examples of Mierevelt and Backer before him, Rembrandt realized that there was a market for portraits of old Wtenbogaert, and he joined them in producing some. In 1635 he made his portrait etching of him (fig. 131a), the first such print he made of anyone outside his family. The signed and dated etching has a provocative Latin verse caption by the exiled Grotius, linking Rembrandt's name with those of the most prominent pastoral *and* political leaders of the Remonstrants.

Even in exile, Grotius was the focus of attention in Amsterdam in 1635. In that year his biblical drama *Sophompaneas* was put on stage, in a translation by Vondel, a former Waterland Mennonite, aided by the Remonstrant Johannes Victorinus. The play was based on the Biblical story

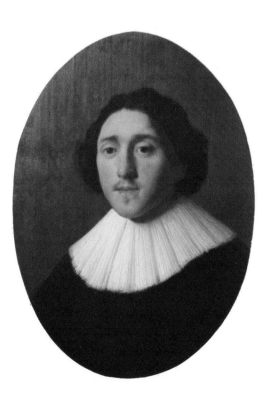

134 *Young man sharpening a quill.* Signed *RHL van Rijn*. Ca. 1631. Canvas, 101.5 x 81.5 cm. Bredius 164. Kassel, Gemäldegalerie.

The action depicted in the painting – writing a letter addressed to RHL van Rijn – implies a more personal relationship between the sitter and painter than in any other portrait by Rembrandt. If the painting and signature are authentic, it is all the sadder that we do not know who the sitter was.

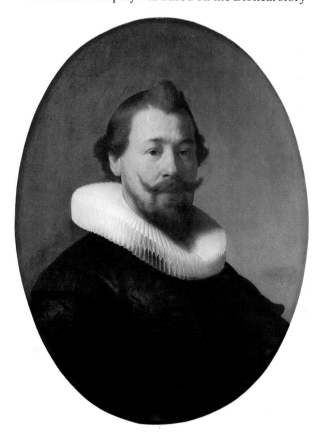

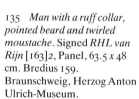

135 *Man with a ruff collar, pointed beard and twirled moustache*. Signed *RHL van Rijn* [163]2, Panel, 63.5 x 48 cm. Bredius 159. Braunschweig, Herzog Anton Ulrich-Museum.

Oval portraits were in fashion in Amsterdam when Rembrandt arrived there. In Leiden, he had painted an oval frame around a rectangular self-portrait (fig. 45), but not until 1632 did he paint his first ovals – self-portraits as well as portraits of others.

136 *Young man with a high flat collar*. Signed *RHL van Rijn 1632*. Panel, 63 x 46 cm. Bredius 155. Wanås, Sweden, private collection.

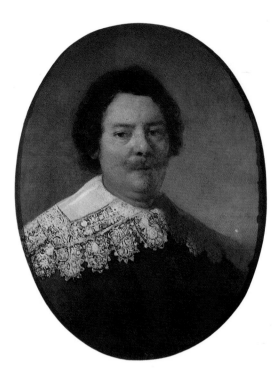

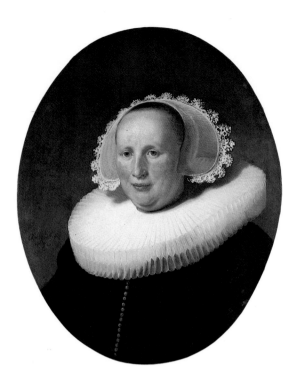

137 *Willem Burchgraeff (1604-1647)*. Signed *Rembrandt f. 1633*. Companion to fig. 138. Panel, 67.5 *x* 52 cm. Bredius 175. Dresden, Gemäldegalerie.

138 *Margaretha van Bilderbeecq*. Signed *Rembrandt f. 1633*. Inscribed on the back with the name of the sitter. Companion to fig. 137. Panel, 67.8 *x* 55 cm. Bredius 339. Frankfurt, Städelsches Kunstinstitut.

I have been unable to find information concerning the sitters.

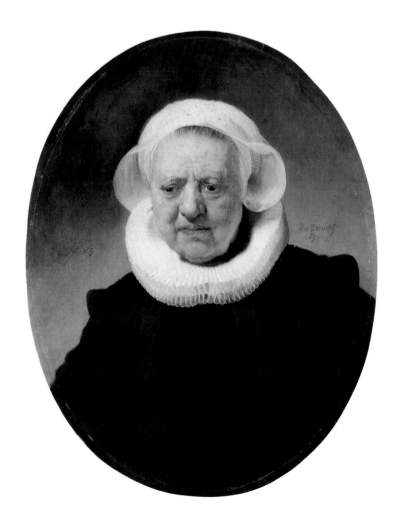

139 *An eighty-three-year-old woman in a small ruff collar and a white cap*. Signed *Rembrandt f. 1634* and marked *Ae*[tatis] *sue 83*. Panel, 71.1 *x* 55.9 cm. Bredius 343. London, National Gallery.

An inscription on a lost eighteenth-century drawing after the portrait of the old lady identifies her as the widow of the Remonstrant preacher Eduard Poppius (1576/77-1624). Poppius was one of the Remonstrant leaders to be condemned by the Synod of Dordt. He was locked up in Loevestein and died there in 1624.

Although the sitter cannot be Poppius's widow, Françoise van Wassenhoven, who was much younger in 1634, the inscription should not be dismissed altogether. The author of the drawing, Hendrick van Limborch, belonged to a leading Remonstrant family. He was a descendant of Simon Episcopius, who in the year of this portrait founded the Remonstrant seminary in Amsterdam. If van Limborch's inscription is taken to imply that he saw the Rembrandt portrait in the home of one of Poppius's descendants, then it may depict some other relative of his – his mother, perhaps, concerning whom I have no information.

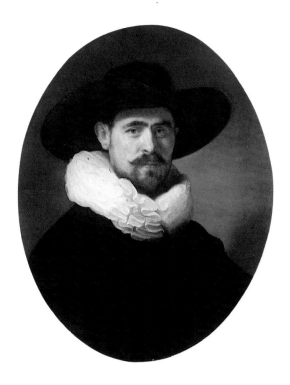

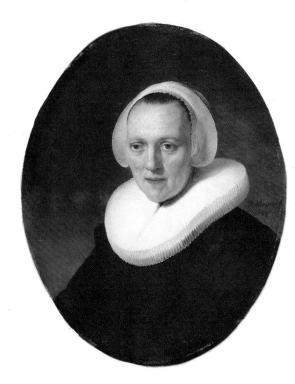

140 *Bearded man in a wide-brimmed hat.* Signed *Rembrandt f. 1633.* Companion to fig. 141? Panel, 69.3 x 54.8 cm. Bredius 177. Pasadena, California, Norton Simon Inc. Foundation.

141 *Woman in a ruff collar and white cap.* Signed *Rembrandt f. 1634.* Companion to fig. 140? Panel, 66.2 x 52.5 cm. Bredius 344. Louisville, Kentucky, J.B. Speed Art Museum.

Figs. 140 and 141 come from the same English collection and seem to be companion pieces. At an auction in 1960 they were sold separately, and will probably never be re-united.

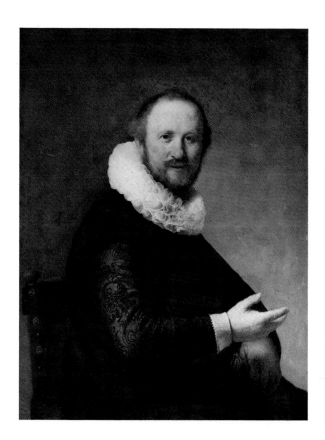

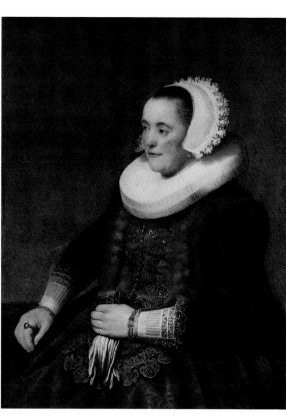

142 *Seated man with a loose ruff collar.* Ca. 1633. Companion to fig. 143. Panel, 90 x 68.7 cm. Bredius 163. Vienna, Kunsthistorisches Museum.

143 *Seated woman with a double ruff collar and a standing lace cap.* Ca. 1633. Companion to fig. 142. Panel, 90 x 67.5 cm. Bredius 332. Vienna, Kunsthistorisches Museum.

142 and 143 were acquired for the imperial collection by Emperor Joseph II some time before 1783.

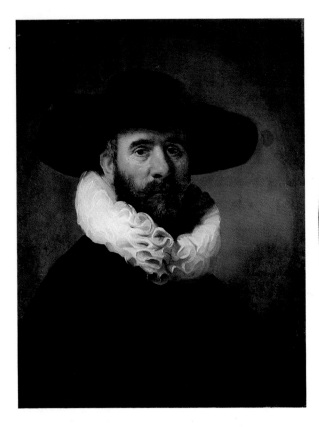

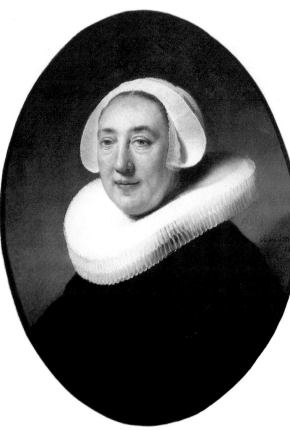

144 *Dirck Jansz. Pesser (1587-1651).* Signed *Rembrandt ft. 1634.* Inscribed *Aet 47.* Companion to fig. 145. Panel, 67 x 52 cm. (originally oval). Bredius 194. Los Angeles, County Museum of Art.

145 *Haesje Jacobsdr. van Cleyburg (1583-1641).* Signed *Rembrandt f. 1634.* Companion to fig. 144. Panel, 68.5 x 53 cm. Bredius 354. Amsterdam, Rijksmuseum.

Pesser, a brewer, belonged to a large Rotterdam clan of active Remonstrants. His sister-in-law was the wife of Simon Episcopius (de Bisschop), the successor of Arminius as professor of theology in Leiden in 1610. In 1634, the year of Pesser's portrait, Episcopius became the first director of the new Remonstrant seminary in Amsterdam, which was considered by many the theological counterpart to the Athenaeum. In the same year Rembrandt's Remonstrant kinsman Hendrik Zwaerdecroon became rector of the Latin school in Rotterdam.

of Joseph, who in *his* exile in Egypt rose to vice-regency of the realm. *Sophompaneas* was intended to hold up a mirror to the governments of Holland, to provide them with an ideal standard against which to measure their own attainments.

Rembrandt's reputation in the Remonstrant world was not confined to Amsterdam. Thanks to the investigations of Marianne Buikstra-de Boer for the Rembrandt Research Project, we now know that in 1634 Rembrandt painted one of the leading Remonstrants in Rotterdam, the brewer Dirck Jansz. Pesser and his wife Haesje Jacobsdr. van Cleyburg (figs. 144-145). Rembrandt may not even have needed the help of his Amsterdam connections for that commission. In 1634 his Remonstrant relative Hendrik Zwaerdecroon moved to Rotterdam to become the new rector of the Latin school.

CATHOLICS | In 1632 and 1633 Rembrandt painted portraits of six Catholics, apart from the two in the group around Tulp, Thereafter, apart from some of the figures in group portraits, he never painted a Catholic again, as far as we know.

The pair of small oval portraits from 1632 of the gunpowder manufacturer Albert Cuyper and his wife Cornelia Pronck (figs. 148-149) was a minor commission that could have come Rembrandt's way by any number of routes: Cuyper was born in Gdansk, where he could have known Uylenburgh; his wife's father was the landlord of two of Rembrandt's sitters of the following year, the Bruyninghs. If not for the strange concentration of Catholic sitters in these two years, one would not think anything of the paintings.

A life-size half-length of the following year, on the other hand, is full of significance for Rembrandt's career. The sitter is the Catholic poet Jan Harmensz. Krul (fig. 150), who was as political as you can get without holding office. Writing in time stolen from the family metalware business, he made a name for himself as author of pastoral plays, love lyrics and moral treatises in verse. Like King Solomon, to whom are ascribed The Song of Songs, Proverbs and Ecclesiastes, Krul was equally happy writing erotic poetry, bland moralisms or cynical reflections on mankind. His first published work was entitled *Werelthatende nootsakelijckheyt* (No choice but to hate the world.) Krul was capable of signing a volume of playful love poems with his motto *Gedenck te sterven* (Remember to die, or Memento mori).

In the literary wars of the 1620s and '30s between the Amsterdam chambers of rhetoric, Krul was the

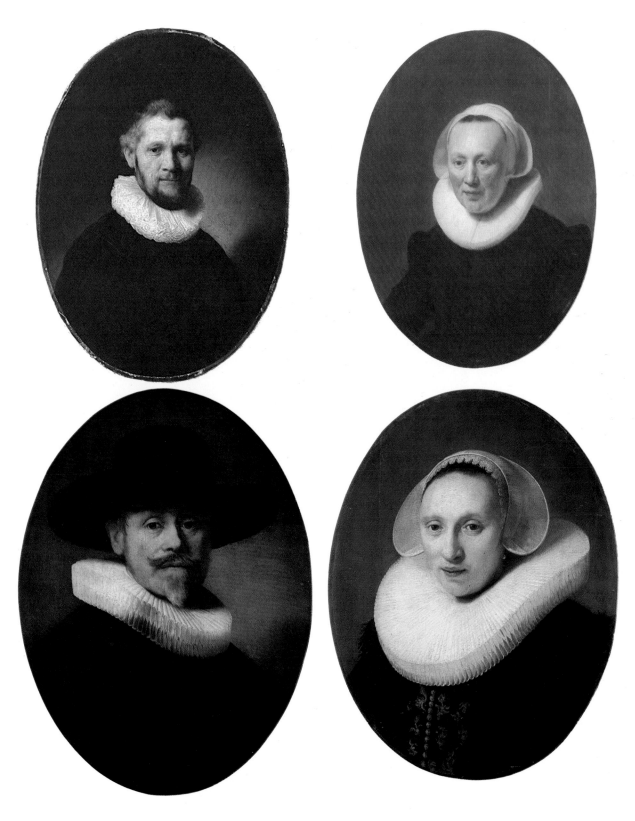

146 *A forty-year-old man.* Signed *RHL van Rijn 1632.* Marked *Aet*[atis] *40.* Companion to fig. 147? Panel, 75.6 x 52.1 cm. Bredius 160. New York, The Metropolitan Museum of Art.

147 *Woman with a flat ruff collar and a close-fitting white cap.* Signed *Rembrandt f. 1633.* Companion to fig. 146? Panel, 67.9 x 50.2 cm. Bredius 335. New York, The Metropolitan Museum of Art.

These two ovals both conform to a standard type of life-size portrait head that was being produced widely by Rembrandt and others in Amsterdam in the 1630s. They are now both in the Metropolitan Museum, but they have distinct histories, and something in the way they interact tells me that they are not companion pieces.

Because they are painted on panel, the museum did not allow them to be taken to the Brookhaven National Laboratory, where the autoradiography sessions were conducted on so many of their Rembrandts on canvas (see p. 163).

148 *Albert Cuyper (1585-1637).* Signed *Rembrant f. 1632* and marked *Ae*[tatis] *47.* Companion to fig. 149. Panel, 61 x 45 cm. Bredius 165. Paris, Musée du Louvre.

149 *Neeltgen Cornelisdr. Pronck (1600/01-1667).* Signed *Rembrandt f. 1633.* Marked *Aet. 33* and inscribed on the back *Cornelia Pronck.* Companion to fig. 148. Panel, 60 x 47 cm. Bredius 336. Paris, Musée du Louvre.

Albert Cuyper was born in Elbing near Gdansk to a Dutch merchant. By 1614 he was living in Amsterdam, working in the Baltic – especially the Muscovite – trade. After his marriage in 1622 to Neeltgen Pronck, he went into his father-in-law's business, gunpowder manufacturing. Cuyper and his wife were Catholics.

The quality of these portraits has always disappointed me, and I wonder whether they are copies, reduced from some such three-quarter length portraits like that of the young woman in Vienna (fig. 151). This was not an unusual procedure.

ally of Theodore Rodenburgh (see above, p. 31) and the champion of the Old Chamber. In 1626 he was attacked by Vondel, who favoured the Academy and the Brabant Chamber, to which he belonged. The squabbles between men of letters were ripples on deep waters – behind the poets were oligarchs and city institutions with vested interests in the writers. The Old Chamber was run by the governors of the Old Folks' Home, and the Academy and Brabant Chamber by those of the Orphanage. With the opening of the Athenaeum in 1632, the position of the Academy (which also had an educational function) was undermined, and the burgomasters decided to merge it with the Old Chamber and the Brabant Chamber and to pool their incomes. Two-thirds of the profits from the new Amsterdam Chamber was reserved for the orphans and one-third for the aged. The governors of the Old Folks' Home were dissatisfied with the new arrangement, and they sought means of re-establishing a separate source of funds. Through a group of mainly Catholic doctors and lawyers, they induced Krul to form a subsidiary chamber called the Music Chamber, the revenues of which would go to them alone.

Krul's biographer N. Wijngaards assumes that this group of backers, who did all they could in 1633-1634 to glorify Krul, commissioned Rembrandt to paint the poet's portrait. Other arguments in support of this theory can be added to Wijngaards's. As M.M. Tóth-Ubbens has pointed out, Krul's partner in the Music Chamber, Jacob Dielofsz. Block, was painted by Rembrandt the year before: he is the middle figure in the clump of Tulp's auditors. Moreover, it is almost certain that one of the four governors of the Old Folks' Home, Tymen Jacobsz. Hinlopen, was the owner of a Rembrandt painting of that same year 1633. This leads to a strong presumption that Rembrandt was a favoured artist of the proponents of the Music Chamber. For Jacob Dielofsz. Block, as for Tulp, Rembrandt was the right portraitist to patronize in 1631-1633.

An important link between the Old Folks' Home, the Music Chamber and the surgeons' guild was undoubtedly the artists' guild, the guild of St. Luke. Many of the connections we can only attempt to reconstruct at second hand, must have come together in that important body, all of whose records have been lost. The guild of St. Luke shared a building – the old weighing hall on the Nieuwmarkt – with the anatomical theatre, and maintained close ties with the world of the theatre and therefore with the charitable institutions behind them. One of the few Amsterdam painters whose admission to the guild can be dated is Rembrandt, thanks to the preservation of his 'funeral medal.' Guild members

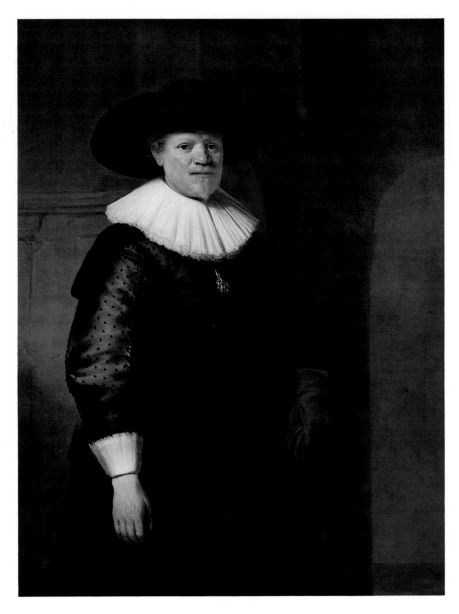

150 *Jan Hermansz. Krul (1601/02-1646).* Signed *Rembrandt f. 1633.* Canvas, 128.5 x 100.5 cm. Kassel, Gemäldegalerie.

The Catholic poet Jan Hermansz. Krul was approaching the climax of his career when he was painted by Rembrandt. He was about to launch his 'Music Chamber' – a semi-official theatre for staging grand musical productions of plays by the sitter and others.

In 1631 Krul's brother married a sister of Krul's wife. The bride had lived for the past few years in Leeuwarden, and Krul's biographer feels certain that she knew Rembrandt's wife Saskia. On the eve of his marriage to Saskia in 1634, Rembrandt adapted a line of Krul's poetry as a personal motto (p. 187). Krul's most popular plays were pastoral, and it strikes me that Rembrandt painted his first pastoral – the *Flora* of 1634 (fig. 118) – in the year that the Music Chamber opened. In fact, the paintings have nearly the same dimensions and correspond in structure as well. Is it too daring to suppose that there is a link between the two paintings?

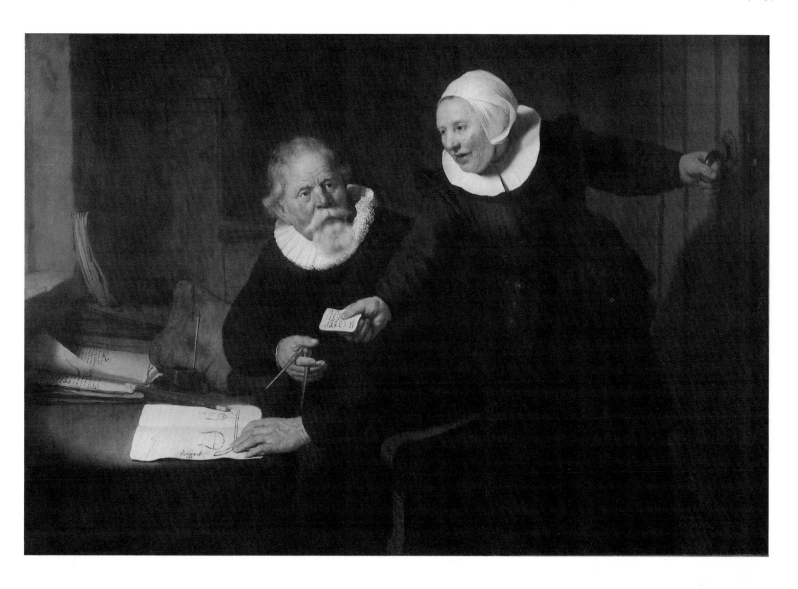

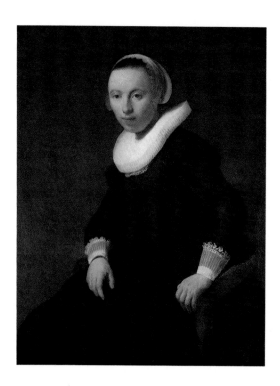

151 *Young woman in a ruff collar, white cap and lace cuffs*. Signed *RHL van Rijn 1632*. Canvas, 92 x 71 cm. Bredius 330. Vienna, Akademie der bildenden Künste.

152 *Jan Rijksen (1560/61-1637) and Griet Jans (ca. 1560-after 1653)*. Signed *Rembrandt f. 1633*. Marked *Den* [eersame...] *ende* [...] *Jan Heykensz.* [...] *tot* [...] *Port.* (The honourable and... Jan Heykensz..., living in ... Postage paid). Canvas, 114.3 x 168.9 cm. Bredius 408. London, Buckingham Palace, collection of Her Majesty Queen Elizabeth II.

Master shipbuilder of the Dutch East India Company. He and his wife both came from families of shipbuilders, and both were Catholics. Despite the specific attributes and inscription, it was not until 1970 that the identity of the sitters was discovered, by I.H. van Eeghen, in a classic piece of archival detection work.

It remains a riddle why Rembrandt inscribed the letter with another name than that of the sitter.

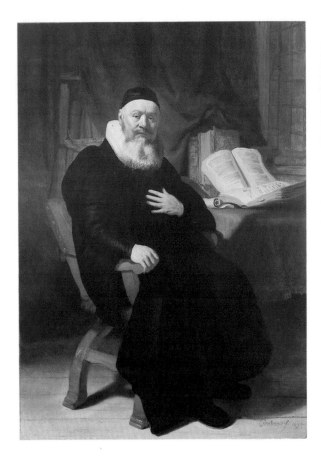

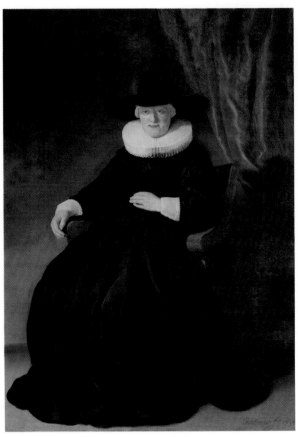

153 *Johannes Elison (ca. 1581-1639).* Signed *Rembrandt ft. 1634.* Companion to fig. 154. Canvas, 173 x 124 cm. Bredius 200. Boston, Museum of Fine Arts.

154 *Maria Bockenolle (d. 1652).* Signed *Rembrandt f. 1634.* Companion to fig. 153. Canvas, 176.5 x 124 cm. Bredius 347. Boston, Museum of Fine Arts.

The Calvinist preacher Johannes Elison was born in England, and studied theology in Leiden before taking the pulpit of the Dutch Reformed Church in Norwich, England, in 1604. He remained there, turning down an offer from the Dutch church in London in 1621, until his death, and was succeeded by his son Theophilus.

Two other sons, Johannes Jr. and Jacob, moved to Amsterdam, where they served the Reformed church as deacons in the 1640s and '50s.

The portraits remained in Amsterdam until the death of Johannes Jr., when they were shipped to England. The successive generations of Elisons kept them until 1860.

In 1632 or later Rembrandt painted the portrait of young Elison's neighbour Salomon Walens (d. 1658). Both lived on the Deventer Houtmarkt, the small square on the Nieuwezijds Voorburgwal where the open-air postage-stamp market is now held. Several other acquaintances of Rembrandt lived in the same row of houses.

were required to pay last respects to departed colleagues, and to make sure they did, they were given personal medals which they had to turn in at the funeral or the home of the deceased. Rembrandt's, which is now in the Rembrandt House, is dated 1634.

The Music Chamber burst upon the scene in May 1634. In June 1634 Rembrandt adapted a line from Krul in his only piece of strictly personal writing that has come down to us (p. 187). In 1634 or 1635 Rembrandt drew his first sketches of actors – of the Music Chamber? If so, the drawings must be from early 1635 at the latest. Less than a year after its glamorous launching, the chamber ended in a financial debacle that left Krul in difficulties he never overcame.

In 1633 Rembrandt painted the Catholic couple Jan Rijksen and Griet Jans (fig. 151); he also painted, probably at the same time, an octagonal portrait of their son Harder that is now lost or unidentified. Jan Rijksen built ships for the Dutch East India Company, of which he was one of the founding shareholders. The background of this important commission (*The shipbuilder and his wife* is one of Rembrandt's very few double portraits) is unknown. It strikes me as significant that the portrait of these wealthy Catholics

was painted in the same year as the *Krul*.

It also seems worth mentioning that one of the directors of the East India Company from its inception was Geurt Dircksz. van Beuningen. If Rembrandt was chosen by his Catholic sitters and patrons for his proximity to that regent, we can understand why all those commissions were from 1632 and 1633. On November 14, 1633, Geurt Dircksz. died. Earlier in the same year, on the 4th of April, Rembrandt's oldest Catholic connection in the city, Pieter Lastman, also passed on. From then on, the Catholics in the Uylenburgh circle had themselves painted by their fellow religionist Moyaert.

CALVINIST SITTERS, 1634 | His close ties with the Mennonites, Remonstrants and Catholics of Amsterdam did not bring Rembrandt to opt unequivocally for one or another of their sects. In 1634, in fact, he chose in a sense for Calvinism by marrying into the family of the preacher of the Oude Kerk, Jan Cornelisz. Sylvius. Saskia was also the cousin of the Mennonite Uylenburgh, but since she herself was Calvinist, her tie to Sylvius was more to the point.

1634 saw a rash of commissions for portraits of Calvinists, a development that must be related at

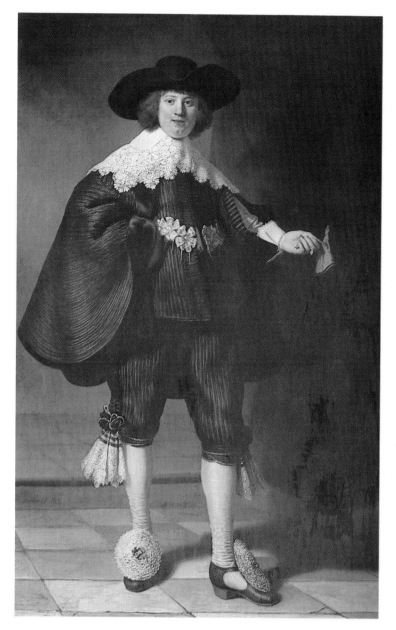

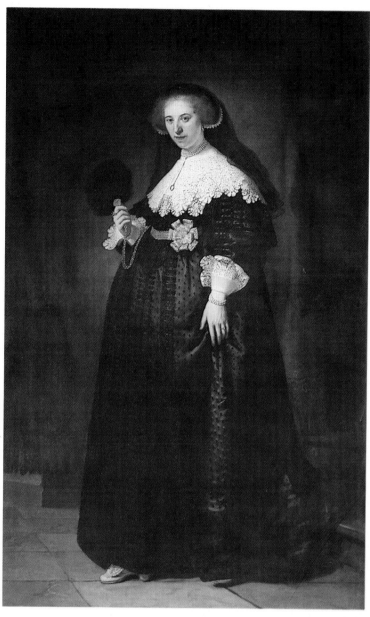

155 *Maerten Soolmans (1613-1641)*. Signed *Rembrandt f. 1634.* Companion to fig. 156. Canvas, 209.8 x 134.8 cm. Bredius 199. Paris, private collection.

156 *Oopjen Coppit (1611-1689)*. Ca. 1634. Companion to fig. 155. Canvas, 209.4 x 134.3 cm. Bredius 342. Paris, private collection.

The rich young couple were married in Amsterdam in June 1633. Rembrandt undoubtedly knew the bridegroom, who studied in Leiden, where his mother lived, from 1628 to 1633. The names of Maerten Soolmans and Rembrandt occur in adjacent documents in the records of the Leiden notary Caerl Outerman for March 24, 1631. Outerman, incidentally, owned a head or portrait by Rembrandt.

The bride too came from a milieu that was not unfamiliar to Rembrandt. Her aunt Trijntgen was a sister-in-law of Geurt Dircksz. van Beuningen. The relationship was through the family of Geurt Dircksz.'s first wife, Aeltge Appelman. The costume of young Maerten gives us some idea of what the Mennonites meant when they accused the Calvinists of sinful frivolity in dress.

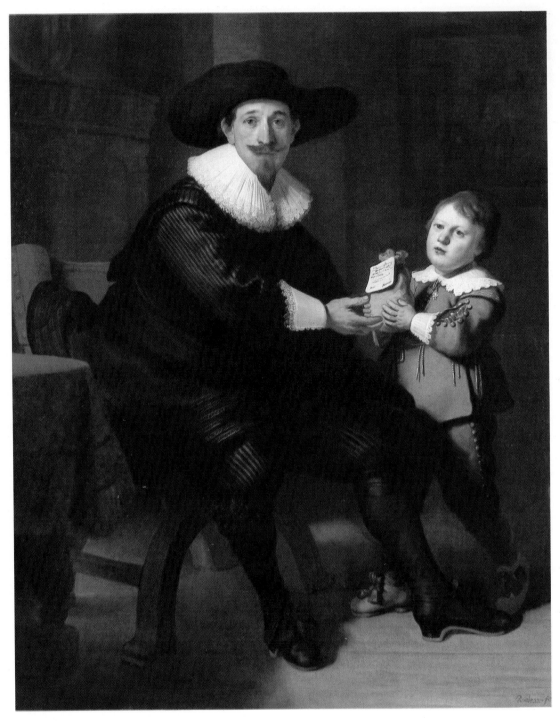

157 *Jan Pellicorne (1597-after 1639) and his son Gaspar (1628-1680)*. Signed *Rembran*[dt] *ft*. Companion to fig. 158. Ca. 1634. Canvas, 155 x 122.5 cm. Bredius 406. London, The Wallace Collection.

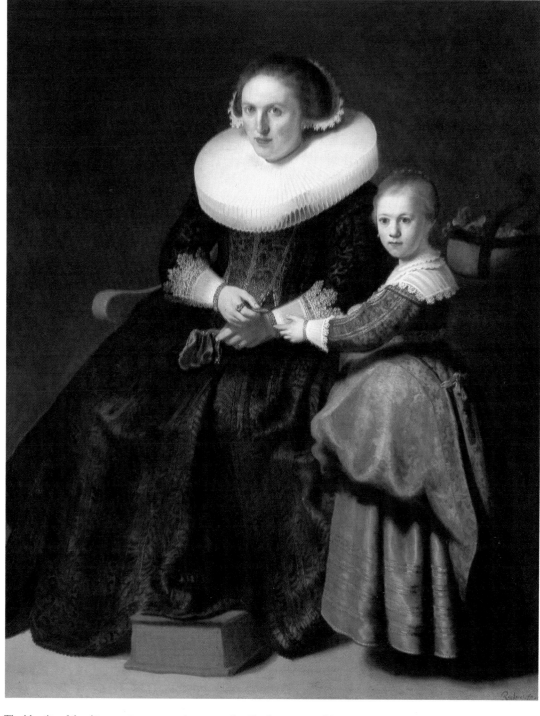

158 *Susanna van Collen (1606-1637) and her daughter Eva Susanna (b. 1627).* Signed *Rembrandt ft. 16[..].* Companion to fig. 157. Ca. 1634. Canvas, 155 x 122.5 cm. Bredius 407. London, The Wallace Collection.

The identity of the sitters rests on a family tradition that seems accurate. If the portraits date from 1634, the couple were thirty-seven and twenty-six years old respectively, their daughter seven and their son six.

Jan Pellicorne was born in Leiden, but he and his wife (the granddaughter of a Pellicorne) lived in Amsterdam. There he ran a firm in partnership with a kinsman of his wife. The van Collens were connected by marriage and business to many important families in The Hague and Amsterdam. Susanna's brother-in-law was Marcus de Vogelaer, a cousin of the Huygenses and the Dedels. Another family marriage a few years after the paintings linked them with the de Hazes and therefore with Balthasar Coymans and Joan Huydecoper.

The future wife of young Gaspar, Clara Valckenier (a cousin of Oopjen Coppit's), owned when she died in 1710 'a head by Rembrandt and a flowerpot' valued at five guilders.

The Pellicorne pendants contain the most explicit attributes of any of Rembrandt's portraits of the 1630s, and they penetrate right to the heart of the matter: money and progeny. The money-bag being handed from father to son no doubt stands for the family fortune (Gaspar was an only son), and the coin passing from mother to (only) daughter is for her dowry. The Dutch still call a family consisting of one son and one daughter 'a rich man's wish.' The strategy enabled the Pellicornes to pass their fortune intact to their children, but it had disadvantages as well. Eva Susanna seems to have died before marrying, so that Gaspar eventually inherited all his parents' property. His wife Clara Valckenier took over his business upon his death in 1680, and six years later married off *their* only daughter, also named Eva Susanna, to a young Valckenier. The Pellicorne estate now belonged to the Valckeniers, where it remained. The paintings were theirs until 1842, when the dowager J. van de Poll, née Valckenier, sold them at auction. When they were knocked down for 35,046 guilders, there was approving applause in the hall.

least in part to the marriage. The most prominent among his Calvinist sitters were Sylvius's colleague Johannes Elison and his wife Maria Bockenolle (figs. 153, 154). Elison was the preacher of the Dutch colony in Norwich, England. Rembrandt painted him and his wife during a visit they paid to their children in Amsterdam.

Even in painting the Elisons, Rembrandt was not straying as far from Remonstrant circles as it may seem. The paintings were ordered by Elison's son Jan Jr., who in those days was not as orthodox as his father. Through his brother-in-law Johannes Victorinus he was in contact with a literary circle of outspokenly Remonstrant character around Daniel Mostart.

Even larger than the full-length, life-size but seated Elison portraits are the standing ones of Maerten Soolmans and Oopjen Coppit (figs. 155,156) of 1634. The couple also bought a painting of the Holy Family from Rembrandt, probably the large one painted in the same year as their portraits (fig. 175). And the brother of Maerten's brother-in-law, Martin van den Broeck, also became an important customer for Rembrandt; in 1647 he owned five paintings by him.

The final pair of full-length life-size portraits depicts Jan Pellicorne and Susanna van Collen and their children Gaspar and Susanna (figs. 157, 158). The Pellicornes were related to just about everyone in Amsterdam and Leiden, but preferred to marry in the family and have as few children as possible. Susanna's mother, the wealthy old widow van Collen, lived in the corner house across the Breestraat from Rembrandt.

These three pairs of portraits are among the largest Rembrandt ever painted, and they undoubtedly brought top prices. In the thirty-five years to come, Rembrandt received only four or five commissions for portraits of private individuals on the scale of these six works from 1634.

JACQUES SPECX'S IN-LAWS AND THREE MISCELLANEOUS SITTERS | Jacques Specx's sister- and brother-in-law are already known to us: Petronella Buys (fig. 163) was the sister of Maria, Jacques Specx's wife. Philips Lucasz. (fig. 162) is the man she married when she accompanied the Specxes to Batavia in 1629 (see p. 100). They stayed on in the east when Jacques Specx and Maria Buys sailed home in 1632. In December 1633 Philips commanded the merchant fleet that sailed from Batavia to Holland. He and his wife spent about a year at home before setting sail for the Indies on May 2, 1635. Philips was now director-general of trade, a post he held until his death in 1641, on an

expedition to Ceylon under his command.

Rembrandt's portraits of Philips and Petronella are dated 1635, and must have been painted before May of that year. They remained in Holland, in the home of Jacques Specx, who left them to his daughter Maria upon his death in 1653. In view of the fact that Specx owned three other paintings by Rembrandt, while no other ties are known between Philips Lucasz. and the painter, it would seem reasonable to assume that Specx is the one who ordered the portraits.

SUMMING UP | In this chapter we have discussed all the surviving and documented portraits painted by Rembrandt outside The Hague in 1631-1635. As we have seen, nearly all the sitters fit into a few small categories: Mennonites from Uylenburgh's circle, Remonstrants from Wtenbogaert's, a few Catholics in the years 1632 and 1633, a few Calvinists in 1634. A grouping by profession would not have looked all that different. Most of the sitters dealt in textiles, in the overseas trade or were connected to the Dutch East India Company. It deserves notice that nearly all those engaged in the Baltic trade dealt mainly with Russia rather than Poland or Scandinavia (see also below, p. 335).

The same categories, and many of the same individuals, recur in the following chapters as documented owners of history paintings and face and figure paintings of the same period. This encourages my conviction that the large sample of this chapter – half of all the portraits of 1631-1635 are identified – gives an accurate picture of Rembrandt's circle of patrons in his first years in Amsterdam.

The information at our disposal also suggests that there was a direct line between his patronage in Leiden and in Amsterdam. In particular, we notice that Uylenburgh first met Rembrandt in Leiden, and that Wtenbogaert graduated from Leiden University on May 13, 1632 and moved to Amsterdam, half a year after Rembrandt.

As the reader has noticed, I have filed the unknown portraits in categories formed by the named ones, on criteria of size, type and costume. There is no known reason to assume that they came from different milieus than the known sitters. Yet we must not forget that fully half of the portraits are unidentified. Should future research uncover firm evidence that one or another of these paintings portrays a bitter Counter-Remonstrant like Reverend Adriaen Smout, Jan Willemsz. Bogaert or Reynier Pauw, then the thesis of this chapter, and large parts of the book, will have to be revised.

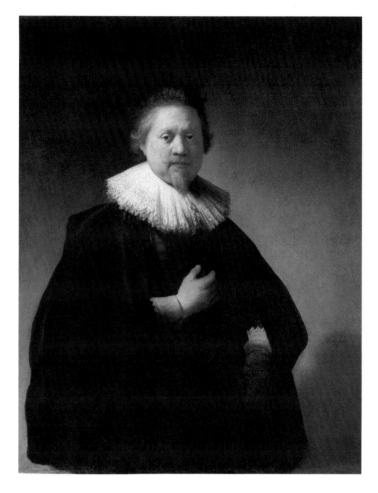

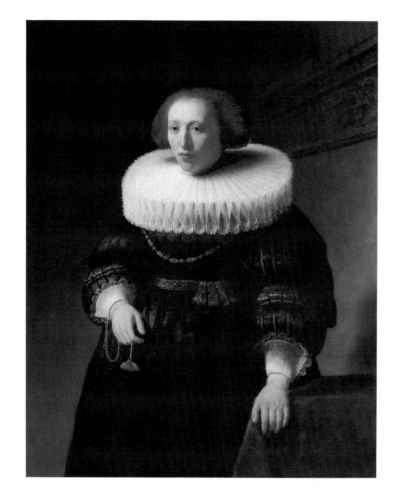

159 *Standing man with a pointed beard*. Signed *RHL van Rijn 1632*. Companion to fig. 160. Canvas, 111.8 x 88.9 cm. Bredius 167. New York, The Metropolitan Museum of Art.

160 *Standing richly dressed woman with a ruff collar*. Signed *RHL van Rijn 1632*. Companion to fig. 159. Canvas, 111.8 x 88.9 cm. Bredius 331. New York, The Metropolitan Museum of Art.

As the earliest paintings by Rembrandt in the Metropolitan Museum of Art, the second largest collection of Rembrandts in the world after Berlin, these are the earliest paintings by the master to have been autoradiographed, a technique that has hitherto been applied only to the Rembrandts in that collection. With this technique, a painting is made mildly radioactive, and the resulting emissions are recorded in a series of films. The early, short-exposure autoradiographs of fig. 159 show that the background is laid in with a rich variety of long and short, crossing and parallel strokes that are now invisible but which must have livened up the painting considerably.

The later, long-exposure radiographs, which record other elements in the pigments, reveal something about Rembrandt's procedure that had long been suspected. Rather than basing his paintings on preparatory drawings, he made his sketches directly, in boneblack, on the panel or canvas.

Another revelation of the autoradiographs is that the woman's portrait underwent more radical changes in the course of composition than that of the man. This is apparently true of many pendant portraits. It confirms the observations of Gerson on the differences in expression between Rembrandt's male and female portraits, but disproves his theory that the woman of this and other pairs should therefore be assigned to other artists.

It is particularly frustrating not to know who the sitters were for Rembrandt's first pair of life-size portraits. The paintings that come closest to them – two other pairs of life-size three-quarter length paintings (figs. 142, 143) – are also unidentified.

161 The eighth autoradiograph of fig. 160.

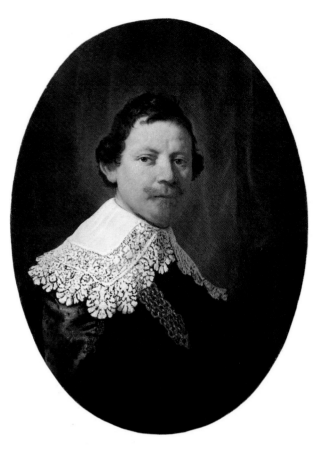

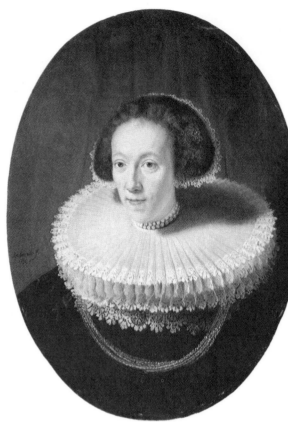

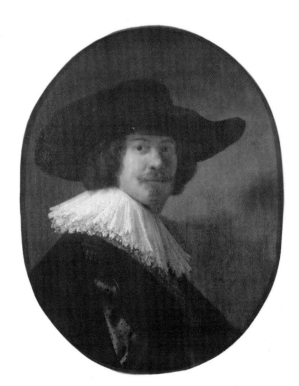

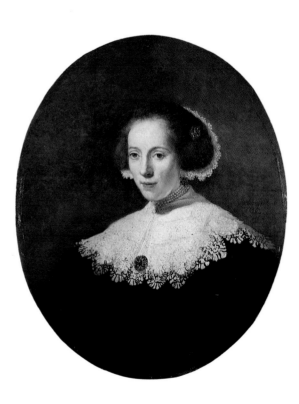

162 *Philips Lucasz.* (1590-1641). Signed *Rembrandt 1635*. Companion to fig. 163. Panel, 79.5 *x* 58.9 cm. Bredius 202. London, National Gallery.

163 *Petronella Buys* (1605-1670). Signed *Rembrandt f. 1635*. Inscribed on the back: *Jonckvr. Petronella Buijs: sijne Huijsvr.* [n?]*aer dato getrout aen de Hr Borgermr Cardon*. (Miss Petronella Buys, his wife, later married to Burgomaster Cardon). Companion to fig. 162. Panel, 76 *x* 58 cm. Bredius 349. Auction New York (Sotheby Parke-Bernet), 20 October 1980.

The inscription on the back of the female portrait leaves no room for doubt that the sitter is Jacques Specx's sister-in-law Petronella Buys, and that the companion painting portrays her first husband Philips Lucasz. After his death in the east, she returned to Holland and married Jean Cardon, a burgomaster of Vlissingen.

164 *Man with a pointed beard, bushy moustache and wide-brimmed hat*. Signed *Rembrandt fec. 1635*. Companion to fig. 165? Canvas transferred to panel, 77.5 *x* 64.8 cm. Bredius 201. Indianapolis, collection of Earl C. Townsend Jr.

165 *Woman with a four-strand pearl choker and a small lace cap*. Signed *Rembrandt f. 1635*. Companion to fig. 164? Panel, 77.5 *x* 64.8 cm. Bredius 350. Cleveland, Museum of Art.

With the paintings of Philips Lucasz. and Petronella Buys, these charming unidentified likenesses are Rembrandt's last oval portraits. With them, a type of painting he practiced so successfully for four years comes to a dead stop.

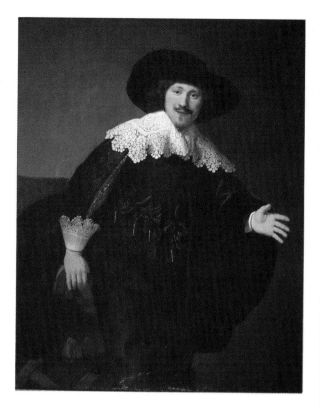

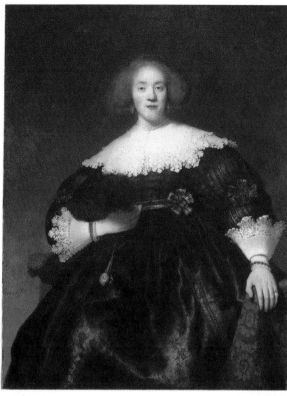

166 *Man rising from a chair.*
Signed *Rembrandt f. 1633.*
Companion to fig. 167.
Canvas, 124.5 x 99.7 cm.
Bredius 172. Cincinnati,
Ohio, Taft Museum.

167 *Woman with a fan.*
Signed *Rembrandt ft. 1633.*
Companion to fig. 166.
Canvas, 125.7 x 101 cm.
Bredius 341. New York, The
Metropolitan Museum of Art.

The similarities between these
portraits of 1633 make it seem
certain that they are
companion paintings of a man
and his wife. The
autoradiographs of the
woman's portrait reveal a
strong, broad under-drawing
of the black dress from the
stage preceding the addition
of the fan.

A contemporaneous
black-chalk drawing in
Hamburg shows Saskia
roughly in the pose of this
sitter, in reverse, with a letter
in her hand instead of a fan.
Could it be that Rembrandt
used his wife and other
models to substitute for his
sitters when working up
portraits?

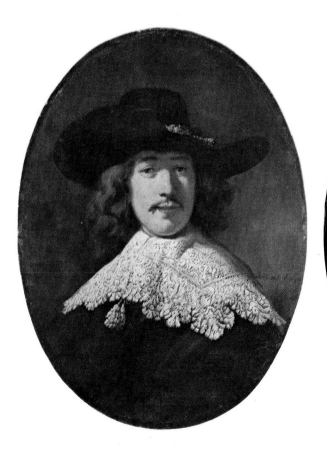

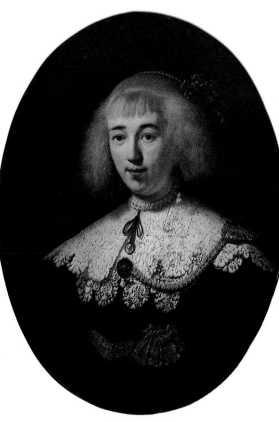

168 *Young man with a thin
moustache, wide-brimmed hat
and lace collar.* Signed
Rembrandt f. 1634.
Companion to fig. 169? Panel,
70 x 52 cm. Bredius 196.
Leningrad, Hermitage.

169 *Richly dressed young
woman with flowers in her
hair.* Signed *Rembrandt f.
1634.* Companion to fig. 168?
Panel, 71.1 x 53.3 cm. Bredius
345. Edinburgh, National
Gallery of Scotland (on loan
from the Duke of Sutherland).

The provenances of the two
paintings are distinct, and
there is doubt whether they
are companion pieces.

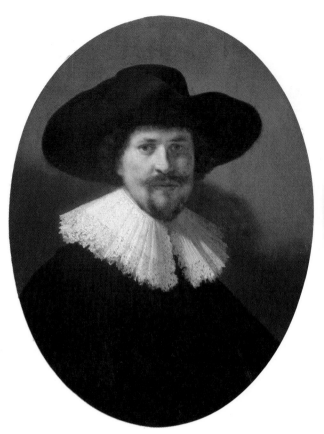 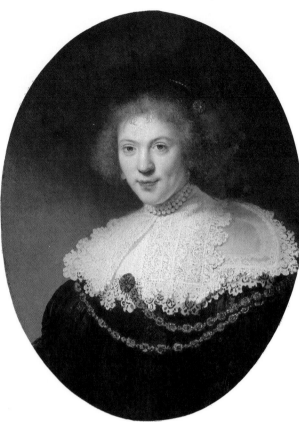

170 *Man with a pointed beard, a wide-brimmed hat and a lace collar*. Signed *Rembrandt f. 1634*. Companion to fig. 171. Panel, 69.8 x 52.1 cm. Bredius 197. Boston, Museum of Fine Arts.

171 *Woman with a flat lace collar and rich jewelry*. Signed *Rembrandt f. 1634*. Companion to fig. 171. Panel, 69.8 x 52.7 cm. Bredius 346. Boston, Museum of Fine Arts.

The judgment of Constantijn Huygens that Rembrandt was a better history painter than a portraitist was not shared in Amsterdam. Even after the move to Amsterdam, for several years he continued selling more history paintings to The Hague than to his new fellow burghers, which is quite a contrast to the ratio of his portrait commissions in the two places. If we scrutinize the evidence carefully, we discover that in his first ten years in Amsterdam, Rembrandt painted fewer than ten history paintings for Amsterdam collectors.

'ST. PETER'S BOAT,' 1633 | The provenance of Rembrandt's first New Testament painting in Amsterdam presents an embarrassing problem: two separate histories can be written for it, and both fit into Rembrandt's career as neatly as one could wish. The Hinlopen collection was said by Arnold Houbraken to have contained a painting by Rembrandt of this subject in the late seventeenth century. Dudok van Heel has tentatively identified it with a work that belonged in 1644 to the widow of Tymen Jacobsz. Hinlopen (1572-1637), and that could well be identical to fig. 172.

Tymen Jacobsz. is a Rembrandt patron after my own heart. In Amsterdam he lived two doors from Joannes Wtenbogaert, was a Remonstrant like him, and their country homes east of Amsterdam were also nearly adjacent. He was a governor of the Old Folks' Home that sponsored Jan Harmensz. Krul in 1633, the year both of 'St. Peter's boat' and Rembrandt's portrait of Krul. The reader knows by now how much value I attach to such information.

Imagine my feelings, then, when discovering that a 'St. Peter's ship by Rembrandt' was also included in the inventory of Jacques Specx, another star patron, when he died in 1653. The date of fig. 172, Rembrandt's only known painting of the subject, is not only the year of Specx's return from the Indies, but its maritime subject seems to mark it as a likely adornment to the collection of the governor-general of the Dutch East Indies.

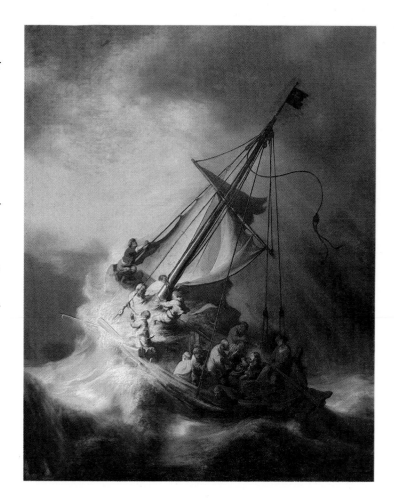

172 *Christ in the storm on the sea of Galilee ('St. Peter's boat')*. (Matthew 8:23-26, Mark 4:37-39, Luke 8:23-24). Signed *Rembrandt f. 1633*. Canvas, 160 x 127 cm. Bredius 547. Boston, Isabella Stewart Gardner Museum.

Houbraken incorrectly called the painting *'St. Peter's boat.'* As the gospels have it, Christ fell asleep in a boat while crossing the sea of Galilee with his disciples. When the storm broke out, they awoke him in panic, and he, rebuking them for their lack of faith, calmed the sea with equally harsh words. The painting was Rembrandt's largest when it was done, but the figures were still on the small scale of the mythologies from the same period.

The composition is based on a print by the sixteenth-century Antwerp master Marten de Vos.

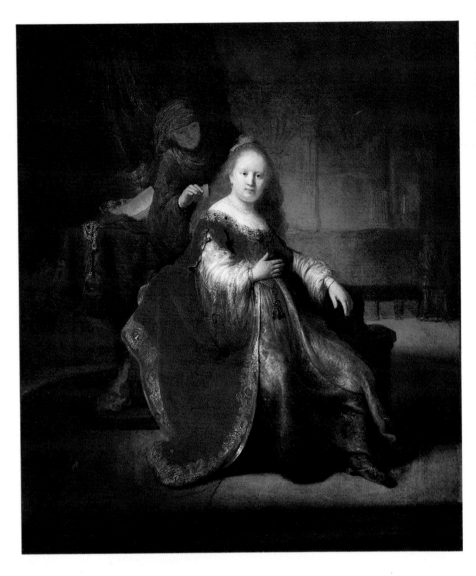

173 *Bathsheba being groomed for King David (2 Samuel 11:4). Signed Rembrandt f. 163[.]. Ca. 1633. Panel, 110.5 x 94.3 cm. Bredius 494. Ottawa, National Gallery of Canada.*

In his speech to the Leiden guild of St. Luke in 1641, the painter Philips Angel described a painting by Jan Lievens with the same elements as this work by Rembrandt: an old woman, wise in the ways of love, bringing King David's message to Bathsheba in the form of a letter. That painting also had a cupid who pierced Bathsheba's heart with shafts of fire rather than steel. Angel praises Lievens for having invented these appropriate embellishments to the bare Bible text. If his account is accurate, then Rembrandt's version must have been derived from Lievens's lost work – the final example of a phenomenon that began in 1628 with the *Samsons*.

However, Rembrandt painted his version in Amsterdam rather than Leiden, and it was adapted there by his inseparable follower Salomon Koninck and by others as well. In one of those adaptations (Bredius 495), the unknown artist gave the woman a crown and turned the love letter into a four-page document, thus transforming the subject into *Esther preparing to intercede with King Ahasuerus to beg him to retract his decree against the Jews*. The confusion between the two subjects persists to this day.

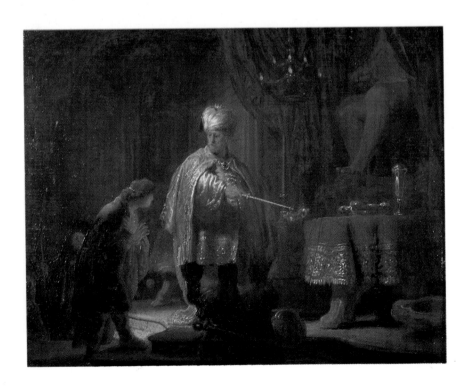

174 *Daniel and Cyrus before the statue of Bel* (The apocryphal fourteenth chapter of Daniel, verses 2-20). Signed *Rembrandt 1633*. Panel, 22.5 x 28.7 cm. Bredius 491. Great Britain, private collection.

The smallest of Rembrandt's histories when it was painted. Perhaps identical with the 'painting of Daniel by Rembrandt, with a black frame' that was among the possessions of the bankrupt art dealer Pieter Croon on February 20, 1650. (Two other items in Croon's estate, which were kept by the bankruptcy court for the benefit of his creditors, were printing plates. In 1660 the court lent them, together with plates that had belonged to Vondel and several others, to the printer Otto Sminck. This was another way in which artists or dealers could lose control of their own work.)

Daniel and Cyrus is Rembrandt's seventh history painting in horizontal format, and it is the first one in which he abandoned the device of placing a kneeling or stooping figure in the middle foreground, a motif he derived from Lastman. The two biblical histories of 1633 – the year of Lastman's death – are exceptional in not being derived from his work. In 1634 and 1635 most of the biblical histories are borrowed by Rembrandt from his late master.

The evidence that both Hinlopen and Specx owned a painting by Rembrandt of this subject is early and reliable. For the moment, we must leave in abeyance the question as to which of them owned this particular one.

The distinction is worth being jealous of. Houbraken praises the painting as proof that Rembrandt 'had more patience in his earlier years to work his creations out in detail… The effect of the figures and the way they are characterized are expressed as naturally as one could possibly imagine, each according to its own status and function.'

This is indeed a quality of other works of the period, specifically the *Judas*, the mythological works of 1632 and 1633 and the first two paintings of the Passion series (1633). They are qualities we have come to associate with the works painted for The Hague, and it would be interesting to know whether Rembrandt found that his first buyers in Amsterdam were attracted by them too. *'St. Peter's boat'* raises the question of quantity as well as quality. Measuring 160 *x* 127 cm., it is by far the largest history painting Rembrandt had done until then, with nearly twice the area of his paintings for Scriverius, three times that of the Passion scenes, and more than four times that of Specx's *Europa*. This is not without significance in a market where size was an important factor in the price of a painting. This consideration adds weight to the Hinlopen provenance – Tymen Jacobsz.'s paintings hung in the 'salet' (a hall or room for entertainment, in the seventeenth century) of the Hinlopen country home. The leap into new dimensions itself seems to reflect the expansive mood of Rembrandt's move to Amsterdam.

LEIDEN HISTORIES FOR AMSTERDAM CATHOLICS, 1633 | The only history painting of the 1630s with a provenance from an Amsterdam Catholic collection is a *Daniel*, probably fig. 174 of 1633. In that year – the year of the *Krul* – another, more prominent member of that community showed enough interest in Rembrandt's histories – of the Leiden period – to write a caption for a reproduction of one of them.

We have already referred to the prints after Rembrandt, Lievens and Dou by the Antwerp etcher Willem de Leeuw (fig. 34). Neither of the three plates after history paintings by the young Leiden artists is dated, but de Leeuw made several other prints after works of 1630-1632 by or said to be by Rembrandt, and one of these is dated 1633. Since de Leeuw's connection with Rembrandt has all the appearances of being a one-off affair, we are safe in assuming that the histories too were etched around 1633.

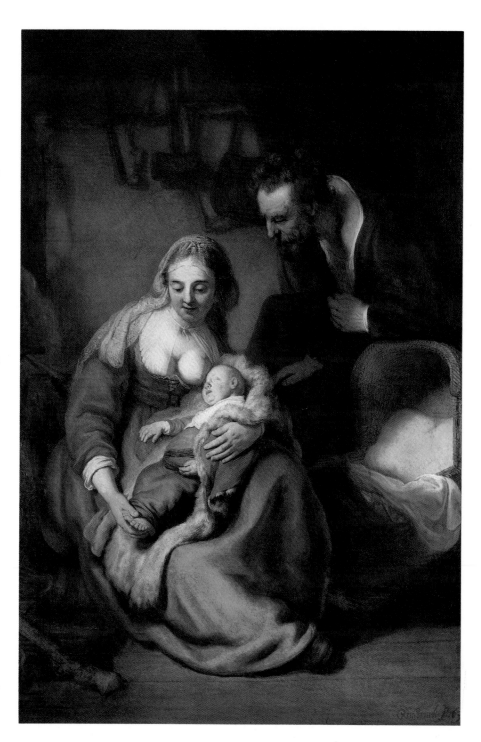

175 *The holy family*. Signed *Rembrandt 163*[.]. Ca. 1634. Canvas, 183.5 *x* 123 cm. Formerly ended above in a low arch with two straight shoulders. Bredius 544. Munich, Alte Pinakothek.

It was not until Rembrandt was no longer being patronized by Constantijn Huygens, who preferred his small paintings with small figures, that the artist made his first large history paintings with full-length, life-size figures.

In 1632, as Martin Royalton-Kisch has discovered, Jan Jorisz. van Vliet – another engraver of Rembrandt's Leiden histories – was in Antwerp. It stands to reason that he too played a role in this unique example of the dissemination of Rembrandt's work in the city of Rubens.

The three prints bear highly wrought Latin verse captions by the Amsterdam Catholic advocate and humanist Cornelius Gisbertus Plempius. (Plemp had written another of his very few captions for a print as long back as 1609 – for Willem van Swanenburg, in the series of penitents for which the rest of the captions were by Scriverius; see fig. 28). Plemp's brother was the surgeon Vobiscus Fortunatus Plempius, whom we have already introduced as the translator of Cabrious's book on anatomy. The Plemps were related to another family of Catholic surgeons and advocates – the Fonteijns – who in 1633 were instrumental in advancing the cause of Krul and the Old Folks Home. As Catholics, the Fonteyns and Plemps were excluded from public office, and were therefore dependent for political favours on the regent to whom they were most closely related. In Elias's invaluable reconstruction of the family ties of the regents of Amsterdam, the Plemps and Fonteyns are both filed under number 109: Geurt Dircksz. van Beuningen. That Cornelis Plemp attached considerable importance to this connection may be deduced from the fact that he dedicated his own autobiography to Petrus Scriverius.

THE HOLY FAMILY, 1634 | The grand new scale of *Christ on the Sea of Galilee* was surpassed by a painting probably of 1634 (fig. 175) of the holy family, Rembrandt's first history painting with life-size figures. The provenance of the painting can be traced no further back than 1735, when it was sold at an auction in Amsterdam. However, it seems to me more than likely that this is the 'painting of Joseph and Mary, done by Rembrandt' which is documented in 1660 as having belonged to Oopjen Coppit and Maerten Soolmans. In 1634 they had themselves painted in the two largest single portraits Rembrandt ever painted (figs. 155, 156). The flashy young couple, who lived two blocks away from Rembrandt and around the corner from Tymen Jacobsz. Hinlopen, were obviously pleased with themselves and their wealth. Were they also sentimental? Their first child, Hendrick, was baptized on August 25, 1634, and was suckling for the rest of the year, like the Christ child.

MENNONITE COLLECTORS, 1634-1635 | Ameldonck Leeuw (1604-1647) is a new name in our

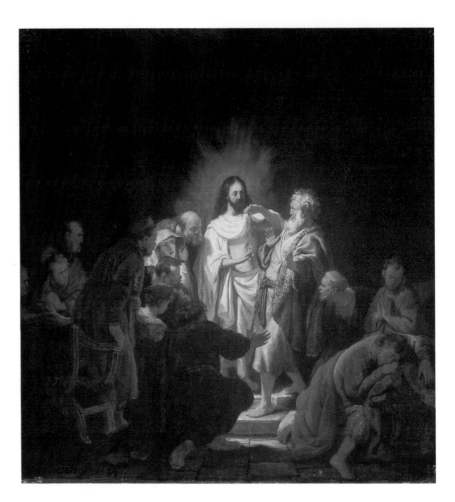

list of Rembrandt's patrons, but the reader will not have any difficulty placing him: he was a member of the Waterland Mennonite congregation of Amsterdam, like Uylenburgh. One of the possessions he left to his heirs was 'A painting by Rembrandt, being Thomas with Christ,' which fits the description of fig. 176. The other paintings in Leeuw's collection provide us with a roster of Uylenburgh's artists. There were Uylenburgh himself and his son Gerrit, followed by three of the artists who were investors in Uylenburgh's business: Rembrandt, Simon de Vlieger and Claes Moyaert. Then there were three artists who worked for Uylenburgh in his 'academy': Jurriaen Ovens and the Mennonites Govert Flinck and Jacob Backer. These masters provided Leeuw with nineteen of the twenty-five paintings in his collection by named artists.

Not all of these masters got an equal share of Ameldonck Leeuw's patronage. Nine of his paintings, including his own portrait and that of his son David, were by one man alone – Govert Flinck (1615-1660). Now it is true that Flinck happened to be the collector's cousin and a fellow Mennonite, but we will also see in the pages to come that starting in 1636 Flinck began encroaching on Rembrandt's base of patronage until in the 1640s he conquered it altogether.

176 *The risen Christ showing his wound to the Apostle Thomas* (John 20:26-29). Signed *Rembrandt f. 1634.* Panel, 53 x 51 cm. Bredius 552. Moscow, Pushkin Museum.

This painting has an unbroken provenance from the collection of the Amsterdam Mennonite Ameldonck Leeuw, a cousin of Govert Flinck. Yet its status as the original painting of the subject by Rembrandt has been disputed recently, in favour of a previously unrecorded version in private hands.

In 1634, Rembrandt made a group of paintings, etchings and drawings with night scenes, all of New Testament subjects with a miraculous cast. This is the only one to which the name of a specific customer can be attached.

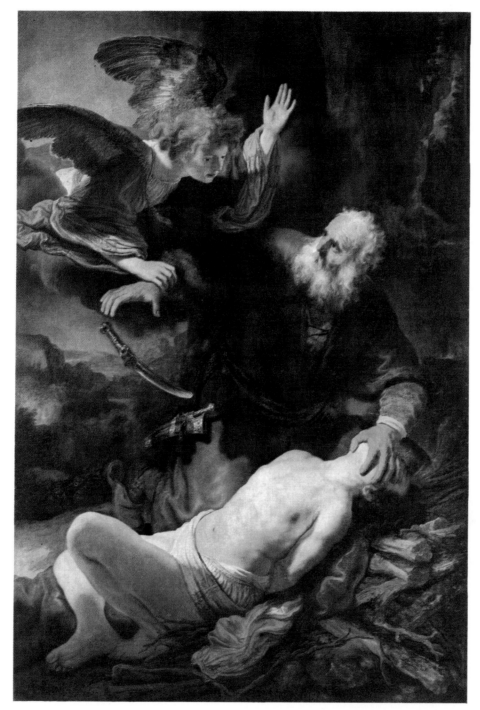

177 *The angel stopping Abraham from sacrificing Isaac to God* (Genesis 22:10-12). Signed *Rembrandt f. 1635*. Canvas, 193 x 133 cm. Bredius 498. Leningrad, Hermitage.

One of the two versions of the composition; the other, in which the angel comes straight forward from the background, is in Munich. The latter is inscribed with the ambiguous words *Rembrandt verandert en overgeschildert* (Rembrandt revised and repainted). A debate over the relationship between the two paintings and a drawing of the composition has been smouldering for a long time. Writing before the appearance of the second volume of the Rembrandt Research Project *Corpus*, I will do no more than express my agreement with the judgment of Horst Gerson that the painting in Leningrad is completely by Rembrandt, and the one in Munich only partially. There are documents concerning paintings of the subject by at least two of Rembrandt's younger associates of the mid-1630s, Govert Flinck and Leendert van Beyeren.

Ben Broos has suggested that Rembrandt based his composition on an undated Lievens in the Galleria Doria in Rome. He supports his argument by pointing out that in 1635 Rembrandt produced his etchings of heads after Lievens, which he inscribed *Rembrandt geretuckert* (Rembrandt retouched), a similar qualification as that on the Munich *Abraham*, and a most unusual one for any artist. A derivation from a Lastman painting of 1614 seems to me more convincing.

The process may have begun as early as 1636. In 1635 Rembrandt painted a *Sacrifice of Isaac*. Now, the collection of the Mennonite Jan Pietersz. Bruyningh included an 'Abraham's sacrifice by Govert Flinck.' None of Flinck's works match this description, and the entry is thought to refer to a painting in Munich which is signed *Rembrandt verandert en overgeschildert 1636* (Rembrandt revised and painted over, 1636). Even before the document came to light, the painting – a varied copy of Rembrandt's version of 1635 – had been assigned to Flinck. If it is partly his work, we can conclude that in 1636 Rembrandt was helping Flinck to sell

paintings based on his own work to his own old customers. Within a few years, Flinck was able to do this without Rembrandt's help.

Govert Flinck was born in 1615 in Kleve, a Dutch-speaking town in a Brandenburg duchy bordering on Gelderland. According to Houbraken (see p. 282), he was the son of the town tax collector. His parents were Mennonites, and they apprenticed Govert to a Mennonite master, Lambert Jacobsz., who was on a visit to Kleve to preach to the faithful. After his basic training in Leeuwarden, he was sent on to Amsterdam to work for Hendrick Uylenburgh, a route that had already been travelled

by yet another Mennonite pupil of Lambert Jacobsz., Jacob Adriaensz. Backer (1608-1651), a native of Friesland. For his first few years in Amsterdam, Flinck busied himself largely with mastering Rembrandt's repertoire. Whether or not the Munich painting is by Flinck or some other associate of the Uylenburgh academy, it serves to illustrate the kind of work Flinck was doing in those years.

When Flinck came to Amsterdam he moved in with Uylenburgh, a short time after Rembrandt left. He does not seem to have been employed by Rembrandt, although he worked for a year under his guidance. He was an associate of Uylenburgh's with his own independent contacts in Kleve and among the Amsterdam Mennonites. Yet Uylenburgh put him to work producing derivations of original compositions by Rembrandt, even after Rembrandt left the academy.

In this case, it is a bit too much to call

178 *The flight of the Holy Family into Egypt* (Matthew 2:14). Signed *Rembrandt f. 1634*. Panel, 52.1 x 41.3 cm. Bredius-Gerson 552A. Formerly London, collection of Lord Wharton.

Based on a Lastman composition of 1608 in Rotterdam that Rembrandt also drew on for two etchings of the subject, one dated 1633 (Bartsch 52), the other 1651 (Bartsch 53). A night effect is also employed in *Christ and Thomas* (fig. 176) and a drawing of *Christ with his disciples* (Benesch 89), both dated 1634.

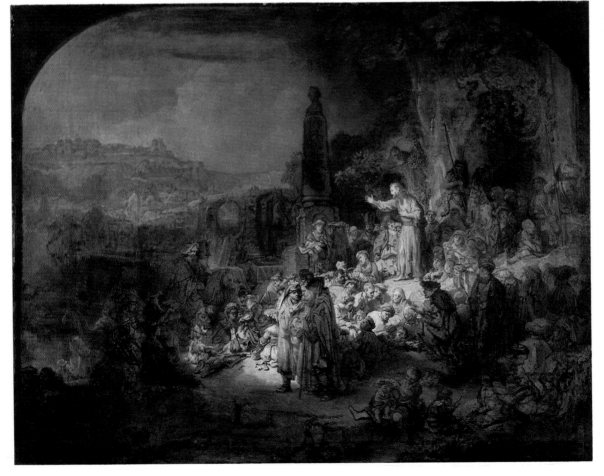

179 *St. John the Baptist preaching* (Luke 3). About 1634. Canvas laid down on panel. 62 x 80 cm., enlarged from 38 x 52 cm. Bredius 555. Berlin-Dahlem, Gemäldegalerie.

In the mid-1630s Rembrandt and Uylenburgh seem to have had the ambition to create a series of large etchings that could be sold for prices of twenty and thirty guilders. The only two that were actually issued were the *Descent from the Cross* and *Christ before Pilate and the people* (fig. 104). *St. John the Baptist preaching* was apparently made as a model for a similar etching that was never executed. The column with an emperor's head here and in *Christ before Pilate* underlines the political aspects of the scenes: both Christ and the Baptist were at odds with the government of Judea, and were doomed to be executed at its command.

Rembrandt's *Sacrifice of Isaac* an 'original' and leave it at that. It combines motifs from several compositions rather close at hand: a Rubens that was published in Holland in a print in 1614 and a Lastman grisaille of about the same time, now on loan to the Rembrandt House. One wonders whether there was a relationship or at least an understanding between Uylenburgh and Lastman in the years when they were near neighbours in the Breestraat.

REMBRANDT'S GRISAILLES | Three biblical histories of the mid-1630s were not made as independent paintings at all. Painted in grey and brown tones, in a technique known as grisaille, they were made as models for etchings. The earliest of the grisailles, *Christ before Pilate and the people* (fig. 104), was painted in 1634 for the etching of 1635-1636. (Since the two other biblical histories of 1634 – figs. 178, 180 – are based on compositions by

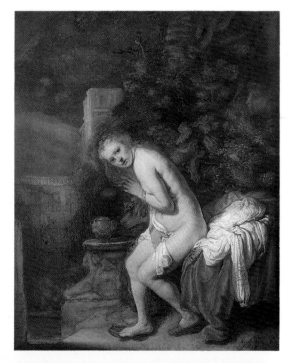

180 *Susanna surprised by the elders* (Apocryphal addition to Daniel, chapter 13, verses 19-21). Signed *Rembr[...]f. 163[.]*. About 1634. Panel, 47.2 x 38.6 cm. Bredius 505. The Hague, Mauritshuis.

One of Rembrandt's three adaptations of Lastman compositions from the period after his master's death (1633), together with figs. 177 and 178. Rembrandt the history painter of 1631-1635 was trying to be a Rubens for The Hague and a Lastman for Amsterdam.

A curious technical detail is that the panel for the *Susanna* is the same size as that for *The healing of Tobit* (fig. 188), and that both of them seem to have been cut down on the right. In the case of *Susanna* about one centimeter of the original panel was trimmed off. Today an added strip of 4 cm., not by Rembrandt, accommodates the end of the signature and the peeker in the bushes. However, one wonders whether there was not an intermediate stage in which a larger panel was attached, and the composition was horizontal, like the *Susanna* of 1647 and the Lastman painting that both are modelled on. We know from an old copy of the *Healing of Tobit* that it too was extended on the right.

181 *Joseph relating his dream* (Genesis 37:9-10). Signed *Rembrandt 163[.]*. About 1635. Paper attached to panel, 51 x 39 cm. Bredius 504. Amsterdam, Rijksmuseum.

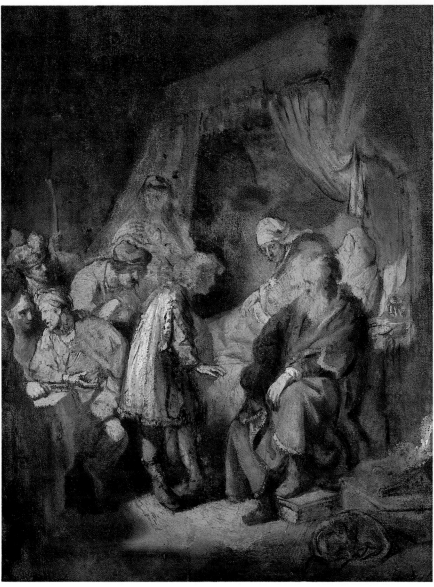

This grisaille is the central element in a project that never quite left the drawing board. A figure drawing for Jacob dates from 1631, a drawing for the dog in the lower right from about 1633. The grisaille is the next stage, but the large etching that should have followed was never made. Instead, Rembrandt rearranged the details for a more modest etching in 1638 (Bartsch 37).

In the 1630s, Rembrandt etched and drew several other episodes from the story of Joseph. The main association of Joseph in that decade was as the hero of Grotius's play *Sophompaneas*, translated into Dutch by Vondel with the aid of Daniel Mostart and Johannes Victorinus for publication and performance in 1635. Rembrandt's contact with this group (see figs. 135, 153, 154) give us grounds to assume that they inspired his depictions of Joseph. He had never depicted him before, and was not to do so again until 1655, when Vondel's play was once again performed (figs. 309-310).

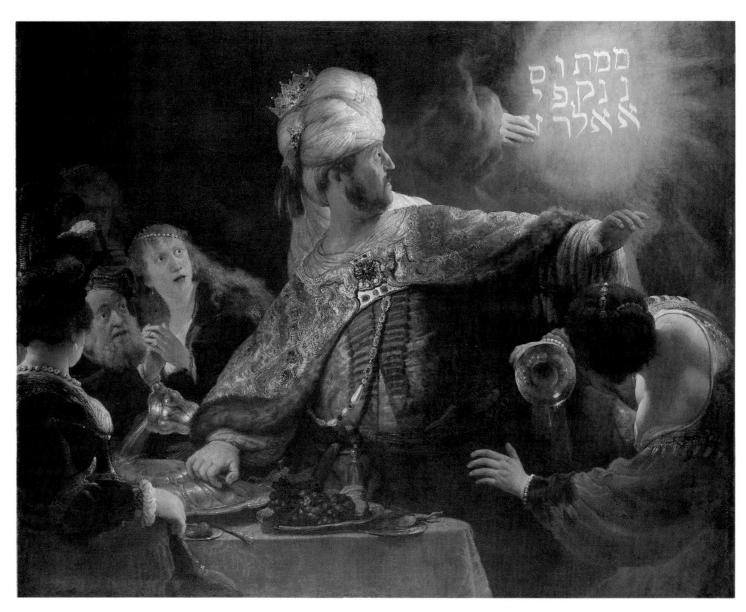

Lastman, it seems likely that Rembrandt's use of grisaille in that year was also a return to the lessons of his late master.)

From the same period comes an oil sketch of *Joseph relating his dreams*, adapted for a smaller etching of 1638, and *St. John the Baptist preaching*, apparently made for an etching that was never executed. The first two works are on paper attached to panel, the third on canvas attached to panel. It appears likely that Rembrandt and Uylenburgh were taking steps to follow up on the large etchings of *The descent from the Cross* and *Christ presented to Pilate and the people*, but the series never got off the ground.

The *St. John* was the first to be elevated to the status of an independent painting. Its original dimensions were 38 x 52 cm., about the same size as the other two, but at some point Rembrandt enlarged it on all sides to its present format. In the 1650s he designed a frame for it and sold it to Jan Six.

182 *Belshazzar's feast* (Daniel 5:1-7). Signed *Rembrandt f. 163[.].* Ca. 1635. Canvas, 167.6 x 209.2 cm. Bredius 497. London, National Gallery.

'Belshazzar […] commanded that the vessels of gold and of silver which Nebuchadnezzar his father had taken out of the temple in Jerusalem be brought, that the king and his lords, his wives and his concubines might drink from them […] Immediately the fingers of a man's hand appeared and wrote on the plaster of the wall of the king's palace, opposite the lampstand; and the king saw the hand as it wrote, and his thoughts alarmed him; his limbs gave way, and his knees knocked together.'

The writing on the wall is of course the dread 'Mene mene tekel upharsin,' which Daniel was able to interpret as a message of doom.

The subject is rare in Dutch art, although something of the kind was known in the Breestraat. The auction of Cornelis van der Voort's goods on May 13, 1625 included 'A large painting of Belshazzar' bought by the painter François van Uffelen.

In the theatre, the story provided the material for a drama that was staged in the southern Netherlands from 1591 on, but as far as I know not in the north.

Christ before Pilate remained in Rembrandt's studio until his bankruptcy in 1656, and is next encountered in the collection of the seascape painter and manufacturer Jan van de Cappelle (p. 259). The regent Six and the painter van de Cappelle were in related businesses: Jan van de Cappelle was a dye manufacturer and Six, until 1653, a fabric dyer. Interesting that people in the dye business should be attracted to colourless paintings.

The auction of the collection of Jan Six's younger kinsman Willem Six in 1734 included three grisailles by Rembrandt, among which may have been one, two – perhaps all three? – of these works of the 1630s.

St. John preaching is the earliest example we know of a specific painting by Rembrandt to have been subjected to adverse criticism by contemporaries. The critic was not an outsider, but Rembrandt's own pupil of the early 1640s, Samuel van Hoogstraten. Hoogstraten was the master in turn of Arnold Houbraken, whose praise of *Christ on the sea of Galilee* we have already quoted. Hoogstraten opens his remarks on *St. John* in the same admiring terms as Houbraken, approving the 'amazing attention to the bystanders of all conditions.' However, he then complains that 'you also saw a dog quite unceremoniously mounting a bitch. Tell me that this is a natural, everyday event, and I will reply that in this history it is an execrable piece of indecency. The addition would make you think sooner that it was a painting of the shameless dog Diogenes rather than the saintly John. Depictions of this kind betray the master's lack of intellectual sophistication, and are all the more ludicrous when they contain mistakes in minor observations.'

In his recollection, Hoogstraten substituted the defecating dog in the painting with a pair of fornicating ones, but the point of his criticism is taken: Rembrandt builds up a splendid scene full of first-rate observations, and then ruins the effect with offensive details that do not even have anything to do with the story.

These brief and isolated passages come from sources close to Rembrandt and give us, I feel, a reliable indication of how his histories of the first Amsterdam years were judged by younger contemporaries. They saw his strength in the variety of poses of his figures and the accuracy with which they express emotions, to which Houbraken adds that his early works show a praiseworthy finish and attention to detail. On the other hand, Hoogstraten feels that Rembrandt goes too far. When he runs out of relevant details, he begins adding gratuitous ones, and thereby lapses into tastelessness and self-contradiction.

This analysis rings all the truer because it corresponds so well with Huygens's judgment in his unpublished autobiography. He too praises Rembrandt's power of evoking feelings through figures and for the wealth of carefully worked out detail in the *Judas*.

REMBRANDT AND A JEW, 1635 | The first proven connection between Rembrandt and a member of the Sephardic community of Amsterdam is an Aramaic inscription of a particular form on a painting of 1635, *Belshazzar sees the writing on the wall* (fig. 182). In 1635 there was only one man in the world who believed that the divine warning to the king of Babylon took exactly that shape: Menasseh ben Israel (1604-1657). He was not to publish his theory until 1639, so we must assume that Rembrandt derived his information directly from Menasseh, who lived across the street from him in the Breestraat. The Jews were the smallest and most defenceless minority in the Republic, and the most dependent on the help of the libertine and Remonstrant regents. From the Calvinists they had little to expect. While in the 1610s Hugo Grotius drafted a document for the States General outlining a code of civil rights for Jews, the Counter-Remonstrant preacher and professor Gisbert Voetius was capable in 1636 of opening a public academic debate on the Jews with the question: should they be killed or not? Of course there were more humane figures among the Calvinists, but they always had to compromise with the Voetiuses in their ranks.

Rembrandt did not penetrate deeply into the Jewish community. His contacts were limited to a few of the figures who ventured the furthest into the Christian world. Menasseh ben Israel was the most prominent of these. He was an ordained chacham or rabbi of one of the three Portuguese congregations of Amsterdam, Neve Shalom, although it is unclear exactly what function he filled there. He was famous for his speeches, his knowledge of Jewish and non-Jewish learning, his scholarly and mystical writings and his printing shop, which was the leading Jewish press in northern Europe. Because of his many direct contacts with Christians, Menasseh lost the unquestioning trust of his fellow Jews. This was not a question of religious observance – Menasseh's orthodoxy was never put in question. It was the politics of Jewish life in Holland that put a wedge between Menasseh and the leaders of his people. The Sephardim of Amsterdam, exactly because of their total lack of family ties with the Dutch, enjoyed a unique position in the Dutch state of which the Mennonites and even Remonstrants were jealous.

They were considered a semi-autonomous 'nation' with its own laws, government and, for all but capital cases, even its own justice. This was a right of which the leaders, the Parnassim, were extremely protective. An ironic result was that, while the Jewish community as a whole enjoyed more freedom in Amsterdam than anywhere else in the world during Rembrandt's life, the individual members of that community were subjected to the arbitrary rule of their own leaders, from whose decisions there was no appeal.

A versatile, urbane Jew like Menasseh, who was consulted on points of Hebrew by the Protestant translators of the States version, who was put up as a serious candidate for a professorship at the academy, and who cultivated ties of his own with the regents of Amsterdam, represented a danger to the powers of the Parnassim and to their ability to maintain discipline within their community. After the publication of his major scholarly work, *El conciliador* (1632), the Parnassim instituted censorship of all publications brought out by Jews in Amsterdam – and that in one of the few countries in Europe where advance censorship was not practiced by the state! It must be said, though, that Menasseh's activities attracted a lot of attention, not all of it welcome, from Christian theologians and the regents behind them. As the leaders of a people who in the recent and more distant past had endured catastrophes as a result of slight political shifts in the surrounding world, it is no wonder that the Parnassim kept a close watch on Menasseh.

The names of Menasseh's protectors are known to us from the dedications of his books in 1635 and 1636: Huygens's brother-in-law David de Wilhem, who was an orientalist himself; Laurens Reael and Albert Coenrats Burgh, the curators of the university; and two other prominent Amsterdamers: Willem Nooms (who used to live in the Sint Anthonisbreestraat) and Joachim van Wicquefort, a good friend of both Barlaeus and Huygens. Moreover, one of the main investors in Menasseh's press was Ameldonck Leeuw. In 1636, Rembrandt etched a portrait of Menasseh, but in the same year he was *painted* by Govert Flinck.

In 1635 Rembrandt painted another Old Testament subject with a strong thematic connection to *Belshazzar: King Uzziah stricken with leprosy* (fig. 183). Both stories show the downfall of a biblical king who desecrated the sanctity of the Temple in Jerusalem. The warning to Belshazzar, followed by his death later the same day, followed upon his use of the Temple vessels at a feast, and Uzziah was stricken with his dread disease – as a result of which he was immediately dethroned and

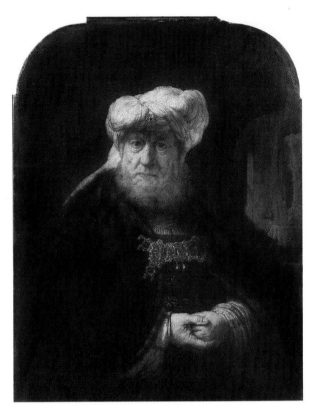

183 *King Uzziah stricken with leprosy*. Signed *Rembrandt f. 1635*. Panel, 101 x 79 cm. Bredius 179. Chatsworth, Derbyshire, Devonshire Collection.

Robert Eisler identified the subject of this painting on the basis of a passage in Flavius Josephus's *History of the Jews:* in the year 3170 or 794 B.C., King Uzziah 'donned the garments and adornments of the high priest and wore them to the Temple to sacrifice incense on the golden altar,... which only the priests were ordained to do.... As he was doing this, a great earthquake occurred, rending the roof of the Temple, whereupon a burning hot ray of sunlight struck the king's face, giving him leprosy on the spot.'

The use of the brass serpent in the background to identify the site as the Temple must have had powerful overtones in the plague year of 1635. The serpent had been fashioned by Moses in the desert to cure the Israelites of the plague. (See also fig. 222.)

ejected from Jerusalem – while he was performing sacrifices in the Temple, a function that was reserved for the priests.

Uzziah, of which many copies are known, is first mentioned in the collection of the Duke of Devonshire in 1764; the seldom copied *Belshazzar* in that of one T. Fulwood in 1725. The latter especially is an unusual provenance for a Rembrandt painting, and one wonders how it got to England. What makes the question all the more intriguing is that the only other known instance of collaboration between Rembrandt and Menasseh concerns England, in the strangest way imaginable. Menasseh was convinced that the English ban on Jews was hindering the coming of the Messiah, and he spent many years attempting to have it rescinded. For his final campaign, in 1655, he wrote a Messianic tract that was illustrated by Rembrandt. But Menasseh had started his efforts long before, in the 1630s. There is a small chance that the paintings of *Belshazzar* and *Uzziah* were connected to Menasseh's attempt to speed the coming of the Messiah.

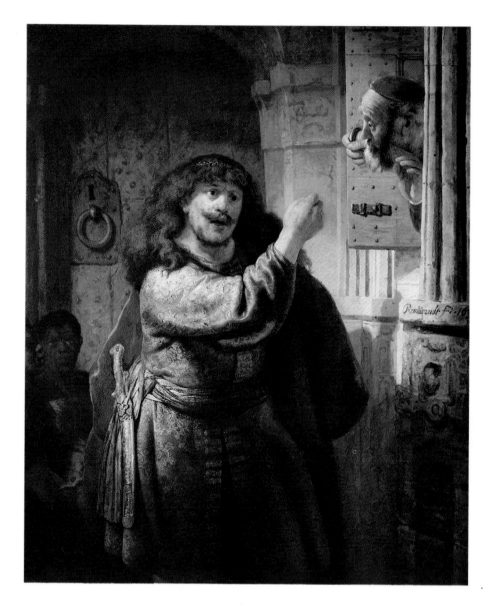

184 *Samson threatening his father-in-law* (Judges 15:1-2). Signed *Rembrandt ft. 163[.].* Ca. 1635. Canvas, 158.5 x 130.5 cm. Bredius 499. Berlin-Dahlem, Gemäldegalerie.

When Samson returned after an absence to the home of his first Philistine wife (not Delilah), her father told him, without letting him into the house, that she had been given to his best man, and offered him her younger sister instead. In his fury, Samson burned the crops in the fields of the Philistines, whereupon they burned the father-in-law and his twice-wed daughter to death.

Of the several early copies of the painting from English and German collections, one shows two additional figures on the left, in an added area that turns the composition from a standing to an oblong shape. Previously it was thought that this reflected the original state of the painting in Berlin. The most recent catalogue of the Berlin museum denies this, suggesting that the extra figures – black servant-boys carrying the kid that Samson was bringing for his bride – were added to the copy in order to clarify the subject.

SAMSON IN SOME TIGHT SPOTS, 1635, 1636, 1638 | A few facts that I would like to submit raw to the reader:

1 In 1635 Rembrandt painted an Old Testament subject virtually without precedent in Dutch art: *Samson threatening his father-in-law* (fig. 184).

2 The painting is totally unrecorded in the Netherlands; it makes its first appearance in the Brandenburg court at Berlin in the eighteenth century.

3 The painting was not inherited by the Brandenburgs from the house of Orange, like several other Berlin Rembrandts.

4 The Brandenburg who was most active as a collector was the Great Elector Friedrich Wilhelm (1620-1688).

5 In 1635 Friedrich Wilhelm was living in Holland, during his four-year period of study at Leiden University, 1634-1638.

6 The Brandenburgs were the lords of the Dutch-speaking town of Kleve, for which they had a special affection.

7 In 1635 Kleve was captured by the Spanish; in 1636 the army of the Dutch Republic, which was allied to the Protestant Brandenburgs, re-took it.

8 In Dutch art, paintings of the story of Samson often contain allusions to matters of war.

9 In 1638, Friedrich Wilhelm's father borrowed thirteen thousand guilders (which he never repaid) from the Amsterdam Mennonite David Rutgers, the brother-in-law of Flinck's cousin Ameldonck Leeuw.

10 Govert Flinck's father had a high official post in Kleve.

11 Govert Flinck was the only Amsterdam artist ever to paint a portrait of the Great Elector.

12 There is a full-size copy of the *Capture of Samson*, unsigned and undated, that has long been attributed to Flinck.

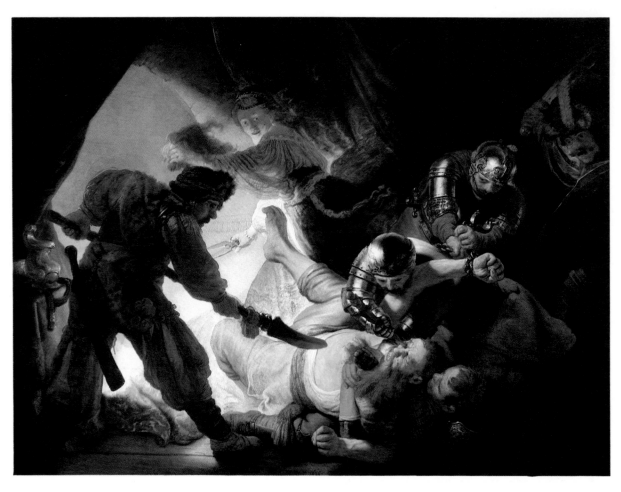

185 *The capture and blinding of Samson* (Judges 16:20-21). Signed *Rembrandt f. 1636.* Canvas, 205 x 272 cm. Bredius 501. Frankfurt, Städelsches Kunstinstitut.

The climax to the story of Samson was never before depicted as gorily as in this painting. The composition and its details were culled from a variety of familiar and exotic sources, but none of them contains the shocking central element.

The earliest record of the painting is in the collection of the prince-bishop of Würzburg in the mid-eighteenth century. The only other Dutch painting of the capture of Samson to be based on Rembrandt's composition – an unsigned, undated work attributed variously to Govert Flinck and Claes Moyaert – is in an old collection on the Ebenrod estate outside Würzburg. There was a seventeenth-century copy of the *Capture of Samson* in Kassel of slightly larger dimensions, that was destroyed in the Second World War.

How far, I wonder, would the reader go in building these facts into a theory concerning the commission for *Samson threatening his father-in-law*? This far I am prepared to go: although we do not know whether the young Friedrich Wilhelm, on his visits to Amsterdam during his years at the university, met Rembrandt or Flinck, there is a strong chance that he did, and that the Berlin *Samson threatening his father-in-law*, as well as the copy after it by Flinck, came into being as a result of their acquaintance. The subject, I would suggest, refers to the fighting in Kleve.

The problem is, in fact, greater than I have indicated. In 1636 and 1638 Rembrandt painted two more extremely rare Samson subjects: the *Capture and blinding of Samson* (fig. 185) and *Samson posing the riddle to the wedding guests* (fig. 186). Of the *Blinding* it is often said that it was the painting that Rembrandt gave to Constantijn Huygens in 1639, a notion that has always been more of an embarrassment than an aid to our understanding of painter, painting and patron alike, and that I have attempted above to replace with a better one (pp. 130-131). In fact, neither of these large, striking works has left any trace in Holland (except for a famous speech of 1641 to which we will come in a moment).

What, then, *is* their earliest history? Speaking of coincidence, both of them turn up for the first time in the collections of German princes in the early eighteenth century: the *Blinding* in that of the Schönborn prince-bishops of Würzburg (in the estate of Friedrich Karl von Schönborn, 1746), and the *Wedding* in that of the electors of Saxony in Dresden (inventory of 1722). In addition to the *Blinding*, the Schönborns also owned, among other Rembrandts, the *St. Paul* of 1627 (fig. 90), *Rembrandt's mother as the prophetess Hannah* of 1630 (fig. 93), *Susanna surprised by the elders* of 1647 (fig. 268) and a copy of *Tobias curing his father's blindness* of 1636 (fig. 188). They also owned paintings by Flinck from the 1630s and '40s: a *Hagar in the desert* and, most strikingly, a *Portrait of Rembrandt* (cf. fig. 202). Unlike the Brandenburgs, neither the Schönborns nor the electors of Saxony were Protestants, nor were members of those families in Holland in the 1630s. There is little ground, therefore, to suppose that he bought his Rembrandts directly from the artist. Whatever the source was, however, it was obviously close to Rembrandt and his world.

The only certain reference to any of the *Samsons* in the seventeenth century is in an oration spoken by Philips Angel (ca. 1618-1662) at the annual dinner

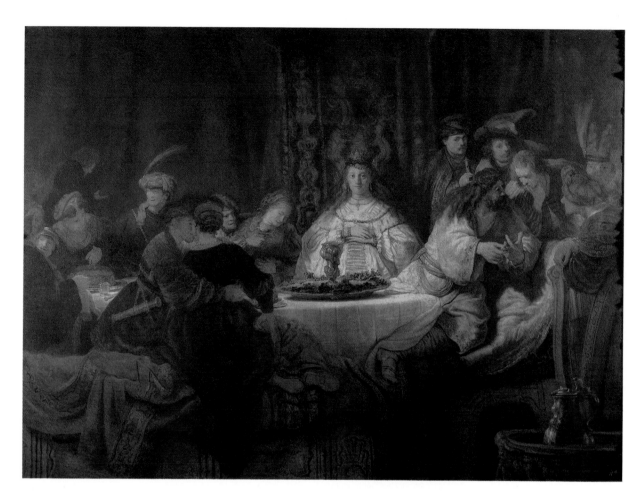

of the Leiden guild of St. Luke on October 18, 1641 and published in 1642 and again in 1661. Angel described *Samson's wedding*, which he had 'once' seen, in considerable detail. He praises Rembrandt for the historical accuracy and truth to life of the representation. 'Behold, this fruit of appropriate, natural depiction came into being through reading the story well and fathoming it with deep and wide reflections.' The main point of Angel's speech was to show painters how to compete with poets and sculptors in winning patronage from princes. His eighth recommendation was to develop 'a mind experienced in knowledge of historical subject matter, to avoid the misunderstandings in depiction that are often committed by the inexperienced through their negligence in not reading.' Rembrandt's painting was one of his examples (followed by two Lievenses) of a painter thinking through the implications of an historical subject and taking account of them in the details of his work.

Comparing Houbraken's criticism with Angel's praise, we hear the echos of an old dispute concerning Rembrandt's histories: were his departures from the text worthy enrichments or arbitrary impertinences? In the case of *Samson's wedding*, I am not even sure they should be attributed to Rembrandt at all. Judging by what we

186 *Samson posing the riddle to the wedding guests* (Judges 14:10-14). Signed *Rembrandt f. 1638*. Canvas, 126 x 175 cm. Dresden, Gemäldegalerie.

The story immediately precedes that of Samson threatening his father-in-law, and conveys the same general message: the Philistines used Samson's first bride to deceive him, and he took revenge on them.

Leonard Slatkes has shown that Rembrandt must have known a group portrait by Jan Lucasz. van Hasselt of a wedding company dressed in oriental clothing. In the 1620s, van Hasselt had been a court painter to the shah of Persia. This was also an ambition of Philips Angel, who praised Rembrandt so highly for the eastern authenticity of this painting. In 1652 he succeeded van Hasselt in Persia, but was later recalled by the Dutch East India Company for corruption.

have learned so far about Rembrandt's dependence on his patrons and advisers in the choice of subjects and details, I would be inclined to seek the source of the biblical and oriental knowledge in the painting, as well as in the other Samsons, not in the artist's reading but in the help of someone like Menasseh ben Israel. (For their intended audience, I would look in the direction of the German princes, perhaps through the intermediacy of the Amsterdam Mennonites.)

THE HAPPY ENDING OF THE STORY OF TOBIAS, 1636-1637 | Writers on Rembrandt have long been fascinated by the juxtaposition, in the year 1636, of the violent *Blinding of Samson* and the gentle *Curing of Tobit's blindness* (fig. 188). As Raphael and Anna look on, Tobias carries out the archangel's instructions and heals his father. The ensuing scene – the miraculous departure of the angel – was depicted by Rembrandt in a somewhat larger painting the following year (fig. 189). Both compositions were worked on assiduously by the artist in preliminary drawings.

What has escaped attention until now is that the three compositions have what we might call overlapping provenances. As we know, the *Samson* was first recorded in the Schönborn collection in the 1740s. In April 1738 a sale of part of that collection was held in Amsterdam, and it included a painting of 'Tobias [Tobit is meant] cured of his blindness, by Rembrandt, one foot one inch high, one foot nine inches wide': 34 x 56 cm. It fetched 36 guilders. Another painting of the same description was sold in July 1738 in the Count Fraula sale in Brussels for 175

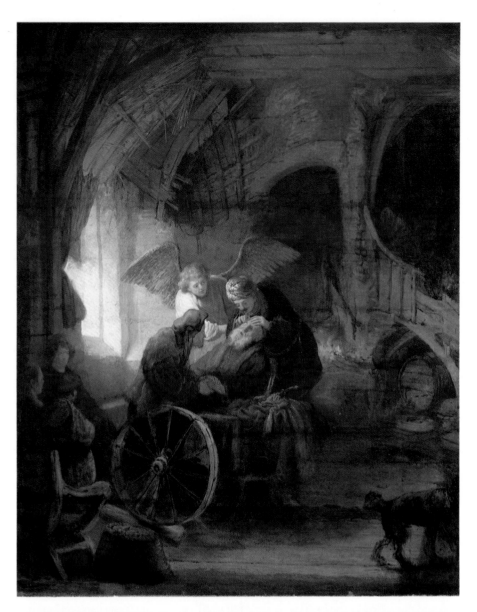

187 *The parable of the workers in the vineyard* (Matthew 20:1-16). Signed *Rembrandt f. 1637*. Panel, 31 x 42 cm. Bredius 558. Leningrad, Hermitage.

The parable tells of the householder who hired workers for his vineyard at various times of the day, and who, when evening came, paid them all the same wage, regardless of how long they had worked. Those who had begun in the morning grumbled, but could not bring the master to change his mind. The moral of the parable was: 'The last will be the first, and the first the last.' Even death-bed converts to Christianity, in other words, will enjoy full salvation.

This sketch-like painting served as the model for many copies and adaptations by masters in Rembrandt's circle, beginning with Salomon Koninck and his cousin Philips. On this criterion, one would be inclined to say that this was one of the few history paintings of the 1630s to remain in Rembrandt's hands after being finished.

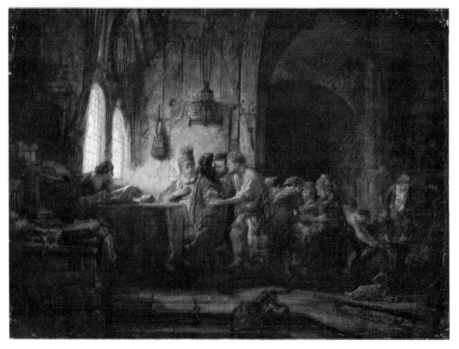

188 *Tobias healing his father's blindness* (Tobit 11:10-13). Signed *Rembrandt f. 1636*. Panel, 47.2 x 38.8 cm. Bredius 502. Stuttgart, Staatsgalerie.

189 *The angel leaving Tobias and his family* (Tobit 12:20-22). Signed *Rembrandt f. 1637*. Panel, 68 x 52 cm. Bredius 503. Paris, Musée du Louvre.

Rembrandt's first paintings of scenes from Tobit since 1626 (fig. 26). They were painted in the period that the devaluation of the book by the Calvinists became a fact, with the publication of the official translation of the Bible into Dutch. The composition of fig. 188 is related to that of one of the primitive genre pieces of about 1625 (fig. 14).

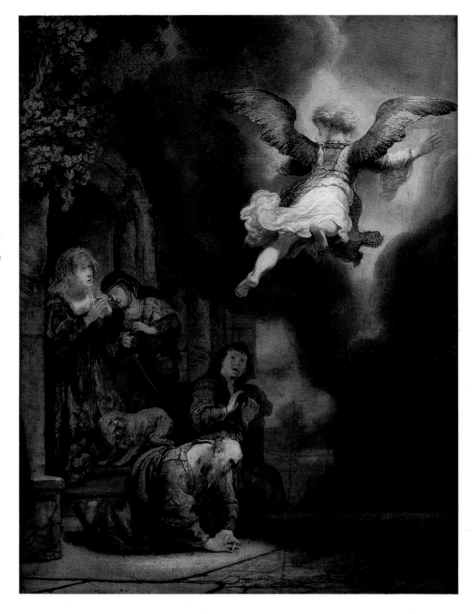

guilders. Also in that sale was *The angel departing from Tobias*, which sold for 300 guilders. The latter painting was the work now in the Louvre (fig. 189), whose history before 1738 is unknown. The *Healing* in the Schönborn and Fraula sales, however, cannot be identical with fig. 188. That painting has a standing format, while the eighteenth-century auction catalogues record an oblong one, with smaller dimensions, at that. However, as in the case of *Samson threatening his father-in-law*, *The healing of Tobit* too existed in two early versions: one vertical and one horizontal. The paintings in the Schönborn and Fraula auctions must have been smaller copies of the horizontal version. No other Rembrandt paintings on the subject are known.

This dry piece of salesroom history is important for what it suggests about the *Tobits* and the *Blinding of Samson*: that the obvious thematic ties between the three works are not accidental. Their early histories show that they travelled through the

world together for a hundred years, suggesting that the original compositions or copies after them were sold to the same first customers, whoever they may have been.

One thing we can say with some certainty about the first owners is that they were not Calvinists. In 1636 the first copies of the official Dutch Bible translation – the Statenbijbel or States version – came off the press; in 1637 they were generally available. One of the controversies surrounding the new Bible was its downgrading of the Old Testament apocrypha. The Synod of Dordt, which had commissioned the translation, ordered these 'Jewish fables' to be distinguished typographically from the canonical books and to be printed without commentary. In the States version the apocrypha are preceded by a 'Notice to the reader' saying that the books are included mainly in order to avert complaints. The preface to Tobit points out inconsistent and inconceivable passages in the book.

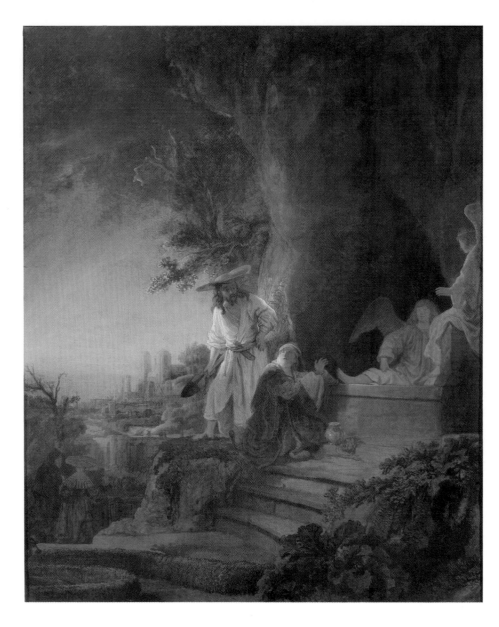

190 *The risen Christ appearing to Mary Magdalene* (John 20:14-17). Signed *Rembrandt f. 1638.* Panel, 61 x 49.5 cm. Bredius 559. London, Buckingham Palace, collection of Her Majesty Queen Elizabeth II.

The risen Christ is one of the Rembrandts that was copied several times, once apparently by Flinck.

In later years, Jeremias de Decker wrote this poem on the painting:

On the depiction of the risen Christ and Mary Magdalene, painted by the outstanding master Rembrandt van Rijn, for H.F. Waterloos

When I read St. John's description of this scene
And turn to see it in this splendid painting, then
I ask myself if brush has ever followed pen
As aptly, or dead paint so near to life has been.

Christ seems to say 'Marie, don't tremble. I am here,
It's me. Your master's free of Death's authority.'
Believing, though not yet with all her heart and mind, she
Seems poised between her joy and grief, her hope and fear.

As art dictates, the tomb's a tall and rocky tower,
Rich with shade, thus lending sightliness and power
To all the rest. Because, friend Rembrandt, I once saw
This panel undergo your deft and expert touch,
I wished to rhyme a verse on your most gifted brush,
To add praise with my ink to the paints with which you draw.

If we take the poem literally, the friendship between Rembrandt and de Decker must date at the latest from 1638.

The words 'for H.F. Waterloos,' as I read them, refer to the dedication of the poem and do not imply, as is usually said, that Rembrandt painted the panel for Waterloos. In the eighteenth-century edition of the collected works of de Decker the words are omitted.

Partly for this reason, the States version was initially rejected by the Mennonites, who had a particular affection for the book of Tobit, as did the Catholics.

The subjects from Tobit that Rembrandt depicted in 1636 and 1637 were exactly the kind to which the theologians of the Synod took exception, with the archangel Raphael dissimulating his true nature.

The overlapping subjects and provenances of the Old Testament paintings of 1635-1638 correspond to the overlapping connections between the most likely patrons behind them. The elector of Brandenburg was in debt to David Rutgers, Menasseh ben Israel to Ameldonck Leeuw. Both borrowers gave commissions to Govert Flinck and Rembrandt, no doubt in order to please their Mennonite creditors. If this analysis is correct, it follows that Rembrandt's most important sources of patronage in those years came from Flinck's relations. No one would have denied that Rembrandt was the better painter, yet he owed his commissions to the connections of his younger associate.

23 Rembrandt's marriage

THE REFORMED UYLENBURGHS | Saskia
Uylenburgh was the cousin of an art dealer, but the
daughter of a burgomaster. Her father was
Rombertus Uylenburgh, one of the most important
men in Friesland until his death in 1624. For a time
he was a figure of national importance, serving as
attorney-general until in 1591 that office was taken
from him on the grounds that a man who was already
a burgomaster and pensionary of Leeuwarden could
not also hold an office covering the entire Republic.

Rombertus's sons became lawyers like him, and
his daughters married men of some standing. Antie
was the wife of Johannes Maccovius, a Polish
professor of theology at the university of Franeker,
which Rombertus had helped to found; Titia's
husband was François Coopal, a patrician from
Zeeland; and Hiskia's, Gerrit van Loo, was a lawyer
and town clerk of Het Bildt.

Saskia, born in Leeuwarden on August 2, 1612,
was the youngest child of eight. When she was six
years old she lost her mother, and when she was
twelve, her father. In 1628 she became the ward of
her brother-in-law Gerrit van Loo. From 1624 to
1633 she probably circulated among the households
of her married sisters, until November 1633, when
her sister Antie died, and Saskia apparently was
sent by the family to care for the widower, Prof.
Maccovius.

By then, however, she was engaged and soon to
be married to Rembrandt. To be precise, the
engagement took place on June 5, 1633, and the
wedding on June 22, 1634, in Sint-Anna-Parochie,
Friesland, near Het Bildt.

Saskia had two relatives in Amsterdam, both of
them older cousins: the daughter of her uncle Pieter,
Aaltje, and the son of her uncle (or great-uncle)
Gerrit, Hendrick. Hendrick we know as a member
of the Mennonite branch of the family which had
been long resident in Poland. Aaltje was married to
the clergyman Johannes Cornelisz. Sylvius (an
alumnus of Franeker), minister of the Grote Kerk

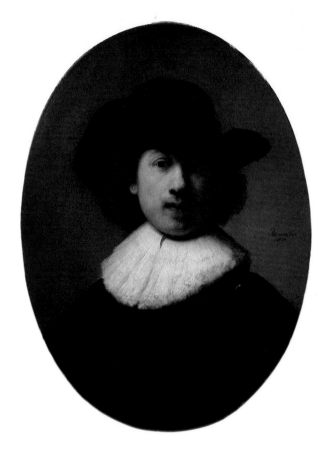

191 *Self-portrait*. Signed
RHL van Rijn 1632. Panel,
63.5 x 47 cm. Bredius 17.
Glasgow, Art Gallery and
Museum.

With the similar etching
Bartsch 7, this was the fresh
guise under which Rembrandt
first presented himself to
Amsterdam. Many early
copies are known. In 1633 he
was to abandon the
boyishness of this look for a
more mature image.

(now called the Oude Kerk). Saskia was so much
more familiar with Aaltje than with Hendrick that
we may assume it was with the Sylviuses she stayed
when she visited Amsterdam, whenever that was.
But there must have been enough contact between
the two Amsterdam Uylenburghs for Saskia to have
been able to visit Hendrick and meet Rembrandt.

Although the prominence of the Uylenburghs in
Leeuwarden began and ended with the career of
Rombertus, their social position was still
immeasurably more exalted than that of the van
Rijns. In 1633 Maccovius was appointed to a second
term as rector of Franeker University and François

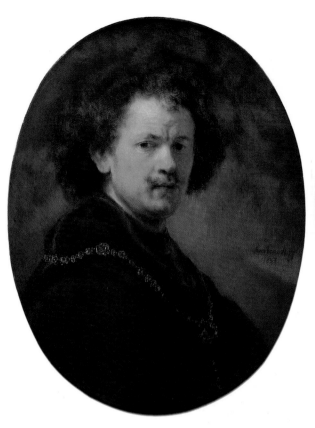

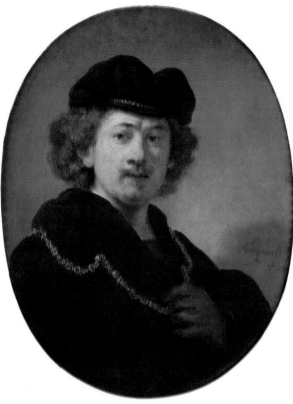

192 *Self-portrait*. Signed *Rembrandt f. 1633*. Panel, 60 x 47 cm. Bredius 18. Paris, Musée du Louvre.

193 *Self-portrait*. Signed *Rembrandt f. 1633*. Panel, 70 x 53 cm. Bredius 19. Paris, Musée du Louvre.

The inventory of the Louvre gives the provenance of these paintings as 'ancienne collection.' The authors of the 1979 catalogue of the Flemish and Dutch paintings in the Louvre explain: 'This vague term… was used for paintings that almost certainly came from the collections of émigrés, seized during the Revolution.'

They have been able to trace one of these works beyond that watershed, but not the other. Fig. 192 or 193 was seized from the collection of the duc de Brissac; formerly it was owned by the duc de Choiseul, who had a large collection of Dutch and Flemish paintings.

Coopal's brother Anthonis took his seat in the town council of Vlissingen; in 1634 François himself became Head of Naval Recruitment in Vlissingen.

Nonetheless, from the Uylenburgh point of view Rembrandt was an interesting if speculative match for Saskia. Much of their authority in Friesland had derived from Rombertus's personal ties to the stadholder's court; these had been severed by the deaths of Rombertus in 1624 and Maurits in 1625, leaving the family without office in Leeuwarden and without status in The Hague. Titia's patrician husband from Zeeland was well connected (and her brother-in-law even more so) but that was too roundabout a route to help the family in Friesland.

As it happened, the Uylenburghs had already discovered that art could attract the favour of princes. In 1622 a more distant relative of Saskia's, Hendrickien Uylenburgh, had married the Leeuwarden painter Wybrand de Geest (1590-1659), who in the following years fulfilled his promise by becoming the most important court artist of Friesland. By 1633 he was firmly established as the portraitist of the Nassau stadholder of Friesland, and had even worked for the courts of the Winter King and the stadholder.

In Delft, where there also had been a stadholder's court (until the day in 1584 when William of Orange was assassinated – while leaving a meeting with Rombertus Uylenburgh), the painter Christiaen van Couwenbergh had married the daughter of a burgomaster in 1630, and was well on his way to becoming a personal favourite of Frederik Hendrik's.

In 1633, the most eligible bachelor among the court painters of Holland was unquestionably Rembrandt. (Lievens would probably have been an even better catch, but he had moved to England in 1632.) The Uylenburghs could have been aware of Rembrandt's existence for several years, from the time Hendrick began representing him. Certainly there is no sign that the match was a whim, or that the Uylenburghs objected to it. Rembrandt was taken into the family with open arms.

It was Rembrandt's family which did not respond warmly to the marriage. Was it a matter of religion? Rembrandt's mother also had burgomasters among her ancestors, from the van Tethrodes and van Banchems in her mother's line, but their descendants had remained Catholic after the Reformation, and were excluded from high office. Even Rembrandt's father's family was Catholic – Harmen Gerritsz. was in fact the only one of his brothers and sisters to become a Calvinist. After his death in 1630, Rembrandt's mother removed herself

from the Calvinist camp entirely, moving towards Remonstrantism. (Was she related to the van Banchem who became a Remonstrant burgomaster of Rotterdam in 1634?)

On June 14, 1634, Neeltgen Willemsdr. put her mark to an affidavit expressing her consent to the marriage, thanking the Amsterdam authorities for excusing her from giving it in person. (Her mark was a cross; the model for the reading prophetess Hannah (fig. 93) was one of the illiterate majority of Dutchwomen of her generation and several to come.) This is the last document to mention any member of Rembrandt's family in connection with his marriage. The van Rijns and Suytbroecks are conspicuously absent as witnesses to the baptisms of his four children, even of the two daughters (each of them lived for only two weeks) named Cornelia, apparently after Neeltgen. (Or were they named after Sylvius's father?). Although this in itself may be due to a technicality – one had to be a member of the Reformed Church to witness a baptism, which Rembrandt's mother and brothers may not have been – it bolsters our impression that Rembrandt became estranged from his family after his move to Amsterdam.

The relatives who did witness the baptisms were Saskia's most distinguished in-laws: on December 15, 1635, Johannes Cornelisz. Sylvius and his wife Aaltje Pietersdr. represented Commissioner François Coopal as witnesses to the baptism of Rombertus, named of course for Saskia's father. (Rombertus died at the age of two months.) The baptism of the first Cornelia, on July 22, 1638, was witnessed and conducted by Sylvius (who died in November of that year) and that of the second Cornelia, on July 29, 1640 in the presence of the François Coopal and Titia Uylenburgh. (Both babies died at the age of two weeks.) Titus's, on September 22, 1641, was witnessed by Gerrit van Loo, François Coopal and Aeltje Pietersdr. The boy was named after Titia, who had died three months earlier.

Insofar as Rembrandt's marriage represented a choice for Reformed respectability, its effect was short-lived. In the year of his wedding, 1634, Rembrandt was treated to the grand patronage of a handful of Amsterdamers on the edges of the Calvinist community – the Elisons, the Pellicornes, the Soolmanses – but there it stopped.

JOHANNES CORNELISZ. SYLVIUS | The central figure in Rembrandt's new connection to the Amsterdam Calvinists was his clergyman cousin Sylvius. For a short biography of the man, we can consult the caption to Rembrandt's unusual portrait

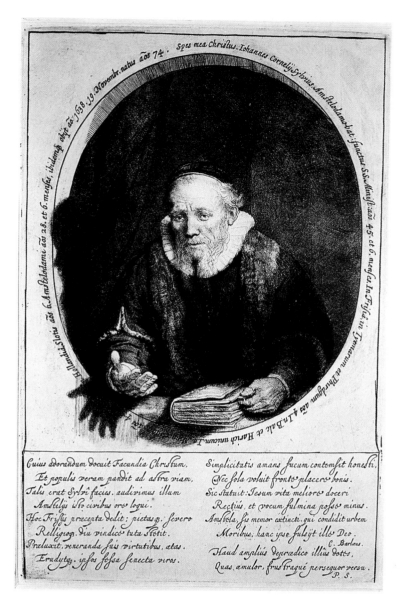

194 *Johannes Cornelisz. Sylvius (1564-1638).* Signed *Rembrandt 1646.* Etching, 27.8 x 18.8 cm. Bartsch 280. Amsterdam, Rijksprentenkabinet.

The text around the oval reads: 'My hope is Christ. Johannes Cornelisz. Sylvius, Amsterdamer, filled the function of preaching the holy word for forty-five years and six months. In Friesland, in Tjummarum and Firdgum, four years; in Balk and Haring one year; in Minnertsga four years; in Sloten, Holland, six years, in Amsterdam twenty-eight years and six months. There he died, on 19 November 1638, 74 years of age.'

Barlaeus's poem:
'This is how Sylvius looked – he whose eloquence taught men to honour Christ And showed them the true path to heaven. We all heard him when with these lips He preached to the burghers of Amsterdam. Those lips also gave guidance to the Frisians. Piety and religious service were in good hands As long as their strict guardian looked over them. An edifying era, worthy of respect on account Of Sylvius's virtues; he tutored full-grown men In catechism until he himself was old and tired. He loved sincere simplicity and despised false appearance.

He did not attempt to ingratiate himself To society with outer display. He put it this way: Jesus can better be taught By living a better life Than by raising your voice. Amsterdam, do not let his memory fade; he edified you Through his righteousness and represents you illustriously to God.'

Scriverius's:
'This man's gift I cannot paint any better. I attempt to emulate him, but in verse I fail.'

print of him, made eight years after his death (fig. 194). The records of the tempestuous church life of Amsterdam during Sylvius's 28-year tenure there are remarkably silent about him. That, and the fact that he was able to maintain his office throughout a period when so many colleagues were being ejected, is enough to tell us that he was a moderate in religious affairs and did not participate in the political raids on the Remonstrants conducted by some members of the church council. This is not surprising in light of the fact that he was called to Amsterdam as the protégé of Jacob de Graeff (1571-1638), the least churchly of all Amsterdam regents. De Graeff was the lord of Sloten, Sylvius's last post before Amsterdam, and the promotion would have been unthinkable without his support.

From 1610 to 1622, Sylvius was preacher of the city hospital. He was given his own chancel in 1622, the year of the Remonstrant recovery: the Oude Kerk, where the de Graeffs buried their dead. There is a certain parallel here with Nicolaes Tulp, another Calvinist who owed his career to the co-operation of the Remonstrants, and who entered the council in 1622. One wonders whether it is coincidence that the successor of Sylvius as minister of God's word in de Graeff's Sloten was Dirk Tulp, Nicolaes's brother. We scent a whiff of simony in this anecdote about a pithy exchange in the Amsterdam chancery forty years after the death of Tulp's brother.

'Burgomaster Tulp,… conversing with the oldest clerk, a man named Vos, said that he, Vos, was too quick for the town secretaries, and pocketed much personal profit [from township business]. Tulp added that he knew [Vos's] father well, and that he was an honest man. Whereupon the said Vos replied, 'Ah yes, that was in the days when your brother Dirk Pietersz. was preacher of Sloterdijk.''

For us, the most important indication of Sylvius's acceptability to the Remonstrants is shown by the signatures under the two eulogies on Rembrandt's posthumous portrait of his cousin the poems were by Caspar Barlaeus and Petrus Scriverius. That portrait was made a year after the marriage of Scriverius's son to de Graeff's daughter – an event to which we will naturally return below. But it also reflects back on the years when Sylvius was alive and a member of the church council, and Barlaeus a Remonstrant professor under attack from that body.

Barlaeus obviously did not consider Sylvius an enemy, and that tells us all we need to know about the latter's stand in matters of religious politics.

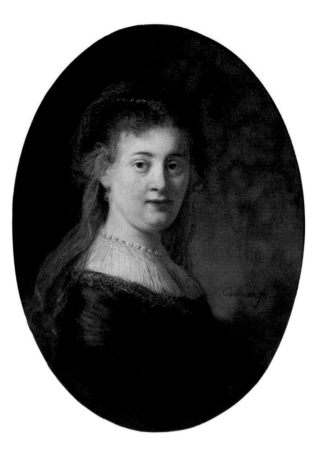

195 *Saskia with a veil*. Signed *Rembrandt ft. 1633*. Panel, 65 x 48 cm. Bredius 94. Amsterdam, Rijksmuseum.

Painted in the year of Rembrandt's engagement to Saskia, probably between June and November. Because Saskia is facing right, the portrait cannot have had a male companion. In seventeenth-century pendants, the male is always facing right and the female facing left.

A GERMAN 'AMICUS' | Thanks to the interesting hobby of a German travelling salesman, a personal statement by Rembrandt on the eve of his wedding has been recorded and preserved. Burchard Grossmann, a merchant from Vinas in Saxe-Weimar, kept an 'album amicorum' – a friendship album, in which he collected hundreds of entries from distinguished people – rulers, military men, university professors, humanists, government officials, artists – he encountered in his travels. Because so many of the entries are the signatures and painted arms of princes fighting in the Thirty Years War, and so many others those of the builders and designers of fortifications, I assume that Grossmann was in the arms business. And since so many artists also signed his album and decorated it with drawings, predominantly of erotic subjects and symbolic representations of the vanity of life, I would keep open the possibility that he traded in art on the side. The only other thing I have been able to find out about Grossmann is that he matriculated in Jena University in 1614, and his son in 1639. He must have been born, then, around the turn of the seventeenth century.

On a visit to Holland in June 1629, Grossmann collected one signature that I could find: that of Daniel Heinsius in Leiden. In June-July 1634 he was

back, and this time he solicited more entries for his book. In addition to the Lutheran pastors of Amsterdam and Leiden and several other foreigners, he had his book inscribed by five Dutchmen: Franciscus van Schooten, professor of mathematics (and fortification) in Leiden, Cornelis Michielsz. Soetens, treasurer of Delfland, in The Hague, and in Amsterdam, Joachim van Wicquefort (1600-1670), the learned agent of the duke of Saxe-Weimar in the Republic (and the protector of Menasseh ben Israel), Hendrick van Uylenburgh and Rembrandt.

The possibility that Grossmann may have been doing business with Uylenburgh and Rembrandt, or that he was the middleman in the sale of works to Germany (see figs. 102, 104) has never been investigated, and all I can do here is suggest this might be the case. Rembrandt's entry in the album consists of the drawing of a man's bearded head (fig. 196) – the only page in the book that has to be turned sideways to be seen properly – and the inscription

Een vroom gemoet
Acht eer voor goet
Rembrandt
Amsterdam 1634
([A person with] an upright disposition has more regard for honour than for possessions.)

Uylenburgh's reads

Middelmaet hout staet
Hendrick Ulenborch consthand.
Amsterdam den 18 juni 1634.
(Moderacy perseveres.)

It has mostly been assumed, rightly I believe, that Rembrandt's entry was also made on the 18th, which happened to be four days before his marriage in Friesland to Uylenburgh's cousin.

Rembrandt's motto is the kind of verselet that a Dutchman might use to identify himself in one of the anonymous lotteries which were so popular at the time. It has usually been interpreted to mean: 'An honest artist strives for glory, not gain.' A similar sentiment speaks from the motto of Hendrick Goltzius (1558-1617): 'Eer boven Golt' (Honour above gold).

However, the context in which Rembrandt's rhyme is found in Dutch poetry points in a different direction. In the play *Moortje* (1616) by Gerbrand Adriaensz. Bredero, the tart Moy-aal defends herself against the charge of being as faithless as a whore by saying: 'Ick bender so niet an, te vroom is myn ghemoedt' (I'm not like that – my nature is too

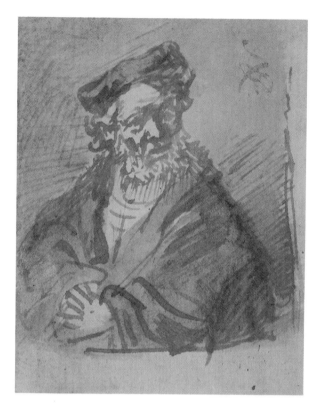

196 *A bearded man (Hendrick Uylenburgh?)*. Pen drawing in sepia in the *album amicorum* of Burchard Grossmann, June 18, 1634. The Hague, Royal Library.

Grossmann owned a large album and a small one. The pages of both have been cut out of their original bindings and mounted in the same large album, apparently in arbitrary order.

If we think of Rembrandt, Uylenburgh and Grossmann sitting around the same table as the two Dutchmen sign the album, it is more likely that Rembrandt portrayed Uylenburgh in the sketch – Grossmann was a much younger man.

Uylenburgh's motto recurs on Samuel Coster's designs for an arch of triumph for the celebrations in Amsterdam marking the Peace of Westphalia (1648). He entitles an allegory on the mild reign of William of Orange 'Moderata durant. That is: Moderation perseveres.'

upright; line 433). And Jan Hermansz. Krul, in an 'ABC of lovemaking' he published in 1628, wrote a poem under the motto

Een trou gemoedt
Gaet boven goedt.
(A faithful disposition is more important than possessions.)

The message was addressed to the parents of unmarried girls, advising them to pay more attention to the character of prospective bridegrooms than to their wealth.

Rembrandt's turn of phrase, on the eve of his wedding, seems to me to come closer to Krul than to Goltzius. He had painted Krul's portrait the year before, and may well have known the 'ABC.' His motto, however, is not intended as good advice to the parents of the bride but as a description of the bridegroom. His is the 'upright disposition' with more regard for honour than for fortune – in the bride. It is as if he were telling the bride's family that he, being of a sincere cast of mind, would not be dissuaded from his intention of marrying their virtuous young relative just because her dowry has turned out to be a disappointment. This not very chivalrous message was obviously addressed not to

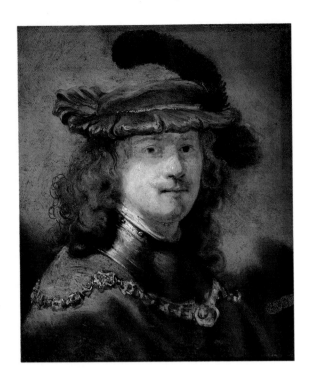

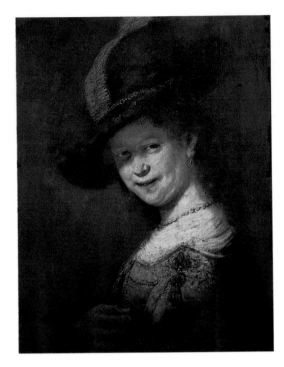

197 *Self-portrait*. Signed *Rembrandt ft. 1633*. Companion to fig. 198? Panel, 55 x 46 cm. Bredius 23. Berlin-Dahlem, Gemäldegalerie.

198 *Saskia*. Signed *Rembrandt ft. 1633*. Companion to fig. 197? Panel, 52.5 x 44.5 cm. Converted from an octagon. Bredius 97. Dresden, Gemäldegalerie.

If any paintings of Rembrandt and Saskia can be companion pieces, it must be these two. Yet they do not fit together quite as comfortably as pendants should, apart from the fact that the *Saskia* seems to have been an octagon formerly. Moreover, the paintings have different histories. The *Rembrandt* was in the Prussian princely collection by 1786, the *Saskia* in Dresden since 1812.

Grossmann, who would have read it as a commonplace moralism, but to Uylenburgh.

SASKIA'S MONEY | In fact, from what is known of the finances of the Uylenburghs, it is perfectly possible that Rembrandt expected more by way of a dowry in 1633 when he was engaged to Saskia than he received in 1634 upon their marriage. It was probably a handsome sum, but certainly not enough to live on. Rombertus Uylenburgh was a wealthy man, but he did have eight children, and he left them each an equal share in his estate.

This brought with it another complication in Rembrandt's life. Because there were legal eventualities under which Rombertus's estate might have to be reapportioned among his heirs, they were inclined to look over each other's shoulders to see how the others were spending their money. Rembrandt and Saskia having been married in community of goods, he too became an object of intense interest to seven Frisian families, and they to him.

The involvement apparently went beyond the immediate family to include in-laws of in-laws. Exactly a month after his wedding, Rembrandt, as guardian to Saskia, gave Gerrit van Loo power of attorney to collect her debts in Friesland. The first

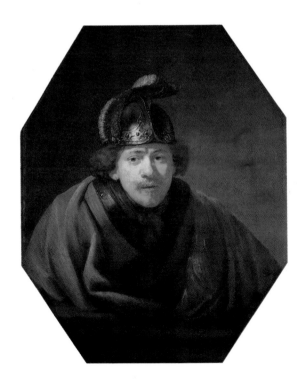

199 *Self-portrait*. Signed *Rembrandt f. 1634*. Panel, 80.5 x 66 cm. Bredius 22. Kassel, Gemäldegalerie.

Octagonal portraits were fairly common in the early seventeenth century. Many of them, like fig. 198, were later converted into standing rectangles, when the octagon went out of fashion.

The painting first appeared in a Delft collection in the eighteenth century. The martial image fits in with such works as the *Bellona* that, we have suggested, was painted for collectors in The Hague rather than Amsterdam.

Gerson's tentative attribution to Govert Flinck should be kept in mind.

200 *Self-portrait*. Signed *Rembrandt f. 1634*. Panel, 58.3 x 47.5 cm. Bredius 21. Berlin-Dahlem, Gemäldegalerie.

This panel has the same dimensions and history as fig. 197. Both turned up at the Prussian court in the eighteenth century, without having been part of the Orange inheritance. Fig. 200 was copied in 1736 by the somewhat unbalanced King Friedrich Wilhelm I.

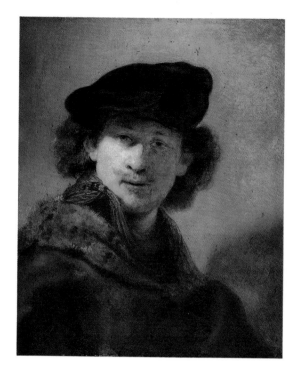

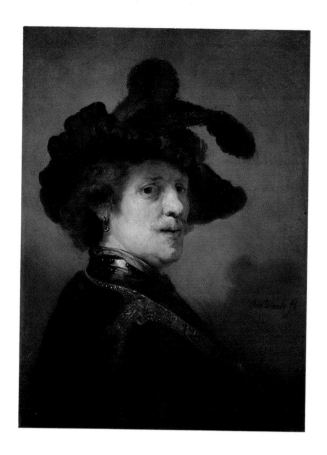

of these was for money owed to her by Albertus van Loo, a relative of Gerrit's. There was a legal battle over the claim which went beyond the court-room, with Albertus and his sister Maycke gossiping that Saskia 'had squandered her parents' legacy through flaunting and ostentation.' Rembrandt sued them for libel in July 1638, declaring that 'he the plaintiff and his wife were blessed richly and *ex superabundanti* with wealth (for which they can never be sufficiently grateful to the Almighty).' He lost the case.

This was far from the end of Rembrandt's problems with Saskia's money. For decades after her death, he was in and out of the courts on account of her ownership of half his possessions, which she left to Titus, and which came to be administered by the Orphans' Court.

REMBRANDT AND HENDRICK UYLENBURGH PART WAYS | For about a year after the wedding, Rembrandt and Saskia lived with Hendrick Uylenburgh. In the course of 1635, however, all of them vacated the house on the south-east corner of the Sint Anthoniessluis – Uylenburgh for the premises on the north-west corner, where Pieter Isaacksz. had formerly had a shop, and Rembrandt and Saskia for rented quarters in a new house on the

Nieuwe Doelenstraat, with a view over the Amstel. The house was two doors away from the Kloveniersdoelen (one of the three practice ranges for the civic guard), for which Rembrandt was to paint the *Nightwatch* in a few years, and next door to the house of Willem Boreel (1591-1668), the pro-Remonstrant pensionary of Amsterdam. Boreel had built both houses in 1635, one to live in himself and the other to let. Rembrandt and Saskia's landlady was a wealthy widow, Jannetge Martensdr. Calff, who lived with her two daughters.

Boreel was one of the oldest friends of Constantijn Huygens, and one of those to whom Huygens turned when he needed favours done in Amsterdam. Although he had the reputation of grossness, and his wife of grossness and ignorance, Boreel was one of the main links between Amsterdam and the outside world, beginning with The Hague.

We know of Rembrandt's new living arrangements from the return address on his first letter to Constantijn Huygens: 'next door to Pensionary Boreel.' Dr. van Eeghen has doubted that a rich widow would be inclined to rent rooms to strangers, and suggested that Rembrandt and Saskia lived two or three doors from Boreel. However, the reader of this book will find it easier to believe

201 *Self-portrait*. Signed *Rembrandt f*. Ca. 1635-36. Panel, 62.5 x 47 cm. The Hague, Mauritshuis.

The last of the military self-portraits, from the late Hague collection of Govert van Slingelandt (1694-1767).

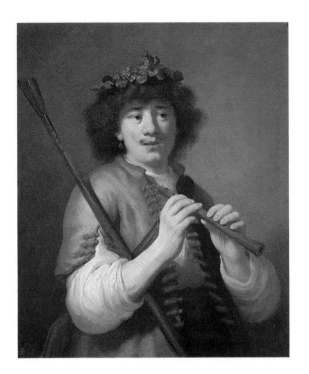

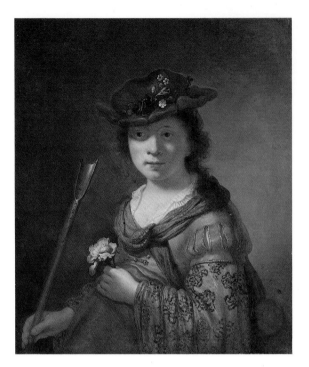

202 Govert Flinck (1615-1660), *Rembrandt as a shepherd*. Signed *G. Flinck f.* Ca. 1636. Canvas, 74.5 x 64 cm. Amsterdam, Rembrandt House (on loan from the Rijksmuseum).

203 Govert Flinck, *Saskia as a shepherdess*. Signed *G. Flinck f. 1636*. Canvas, 74 x 63 cm. Braunschweig, Herzog Anton Ulrich-Museum.

The pastoral mode became fashionable in Amsterdam in the 1630s, a fashion in which Rembrandt and Saskia participated. The identification of the figures has been cast into doubt, to my mind needlessly.

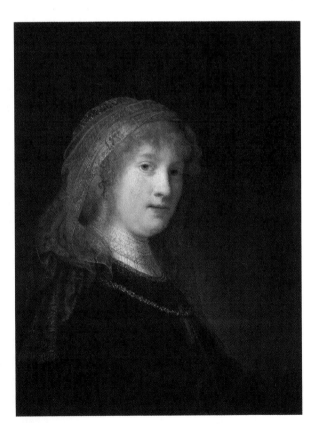

204 *Saskia*. Ca. 1634. Panel, 60.5 x 49 cm. Bredius 96. Washington, D.C., National Gallery of Art.

The veil over Saskia's head is taken by the costume historian Margaret Louttit to refer to the garb of a shepherdess. She notes that Dutchwomen of all classes were fond in the 1630s of dressing up in pastoral costume.

205 *Saskia*. Ca. 1634. Panel, 99.5 x 78.8 cm. Bredius 101. Kassel, Gemäldegalerie.

This striking painting remained in Rembrandt's hands until 1652 or 1658, when it was transferred to Jan Six. At the auction of the latter's collection in 1702 it was bought by his son Nicolaes, from whose ownership it passed into that of his cousin Willem Six. After Willem's death in 1733, his paintings were sold at auction, and *Saskia* was bought by the Delft collector and dealer Valerius Röver, whose widow sold it in 1750, along with all the rest of her paintings, to Wilhelm VIII of Hesse-Kassel. It is one of the few paintings by Rembrandt whose history is known from the artist's studio to its present owner.

In 1644, Rembrandt's pupil Ferdinand Bol used this *Saskia* for the figure of death in his etching of *The hour of death* in an edition of the play *Den Christelyken Hovelingh* (The Christian courtier) by Jan Hermansz. Krul. Margaret Louttit calls

Saskia's exotic gown 'theatrical' and points out that 'theatrical features of dress are often interchangeable with pastoral features in this period.' We may take this as a hint that fig. 205, like the '*Floras,*' was inspired by the rich theatrical productions in Krul's Musyck-Kamer in these years, perhaps even with Krul's costumes.

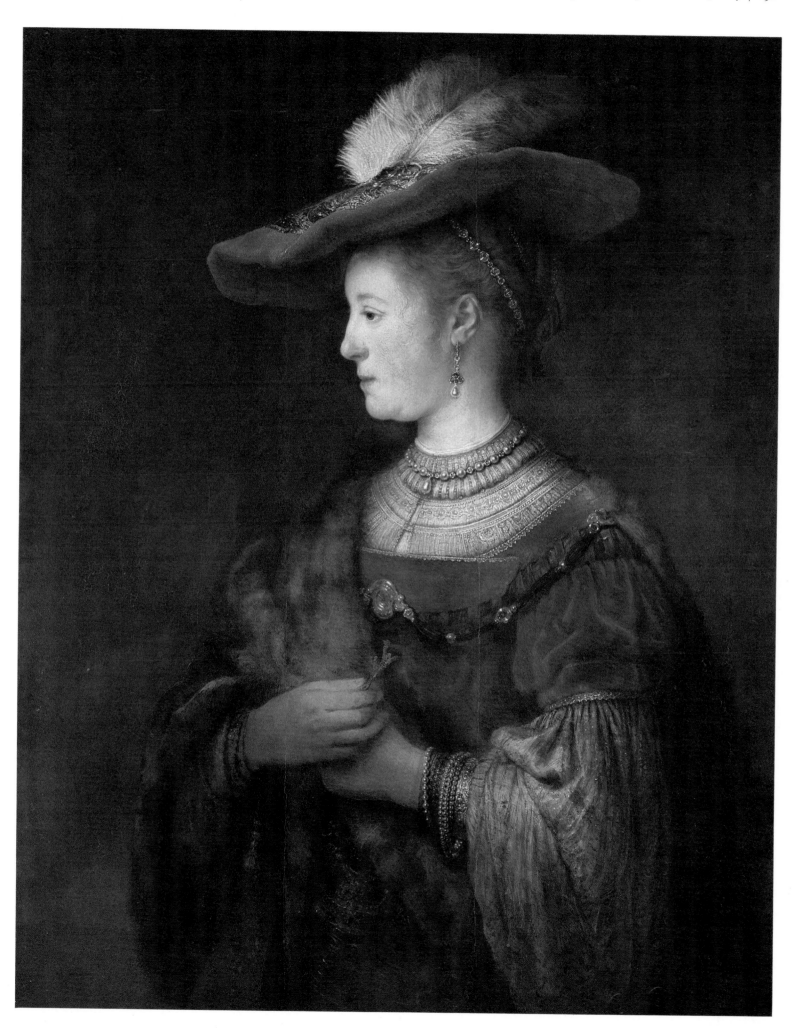

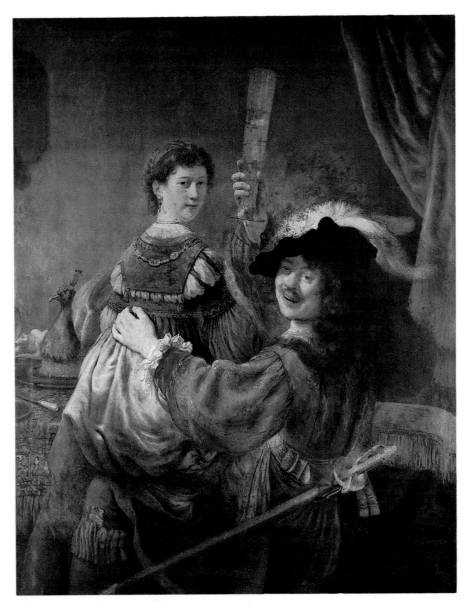

206 *Rembrandt and Saskia.* Signed *Rembrandt f.* Ca. 1635-1636. Canvas, 161 x 131 cm. Bredius 30. Dresden, Gemäldegalerie.

In his life of Hans van Aken (1552-1615), Carel van Mander described the master's best work, painted in Rome, in these terms: 'He also painted himself laughing, beside a woman named Madonna Venusta playing a lute. He stood behind her with a glass of wine in his hand. The execution was such that good judges of art declared never to have seen better work by him or anyone else.'

The 'madonna' in question, whose name means 'enchanting lady,' was undoubtedly a courtesan. Two lines further, van Mander tells us that in Florence van Aken painted another 'witty poetess named Madonna Laura, a face alone, of which he kept a copy that now belongs to his disciple Pieter Isaacksz. in Amsterdam' (fol. 290r).

Portraits of distinguished courtesans became popular in Holland in the 1630s. The beginning of the decade saw the appearance of Crispijn van de Passe's *Miroir des plus belles courtisannes de ce temps*, with its portraits of well-known courtesans and praise of their cultural and artistic gifts. In 1626 Petrus Scriverius had helped

Theodore Matham with the Latin inscriptions for a print of the pastoral courtesan Phyllis. (This puts us in mind of the resemblances between this work and fig. 23, to which it can be read as a sequel.) What the passage from van Mander adds to our knowledge is that the best painting by one of the heroes of the Breestraat art world, Pieter Isaacksz.'s master, showed a laughing painter raising a glass of wine with a courtesan.

The guise was being adopted playfully by the ladies of Amsterdam, along with bucolic costume, and Saskia seems to have had a taste for both.

Rembrandt at his word when he hears that the widow Calff was the sister-in-law of Pieter Thijsz. Schrijver, Scriverius's uncle, and therefore not all that much of a stranger to Rembrandt. We can also understand why, in writing to Huygens, Rembrandt would have preferred to name Boreel rather than his actual landlady, whose brother-in-law was one of the victims of the stadholder's purge of 1618.

PORTRAITS OF SASKIA | Rembrandt used Saskia as a model, and painted, etched and drew portraits of her before and during their marriage. The paintings were in demand from the start, and Rembrandt had more trouble holding on to them than selling them, as we shall see. They even helped him sell self-portraits as well. The first two documents referring to portraits of Saskia mention them as companions to portraits of Rembrandt. One of these sets was in the collection of Martin van den Broeck, who in 1647 traded five paintings by Rembrandt for marine

supplies. S.A.C. Dudok van Heel was able to identify him for me as the brother-in-law of Maerten Soolmans and Oopjen Coppit, adding even greater weight to their already considerable importance as patrons of Rembrandt. Van den Broeck's other three Rembrandts were 'Abraham with the three angels,' the 'Wetnurse' and a 'Landscape.' These subjects sound like they were painted in the late thirties or forties, while the paired portraits of Saskia and Rembrandt are more likely to date from 1633-1635.

In 1648, the unmarried master of a French school, Abraham Bartjens, made a will in which he left to his sister 'two portraits of the gifted painter Rembrandt and his wife.'

Finally, the widow of the Amsterdam lawyer Louys Crayers (1623-1668) owned 'a portrait of Rembrandt van Rijn and his wife.' The latter is likely to have been the painting in Dresden of 1635 or 1636 (fig. 206). Its provenance from that

particular collection leaves a bad taste in one's mouth. Crayers was Titus's legal guardian, upon the appointment of the Orphans' Court, from 1658 to 1665; one suspects that his acquisition of the painting took place then, and that it was not entirely ethical. It was in 1658 that Rembrandt lost his most stunning portrait of Saskia (fig. 205) to Jan Six.

The paired portraits of Rembrandt and Saskia are not easy to pinpoint. The small paintings in Berlin and Dresden (figs. 197, 198) may belong together, but even that is uncertain. None of the other portraits of Saskia has a counterpart in the self-portraits.

Saskia and Rembrandt were popular models with other artists in Rembrandt's surroundings, especially Govert Flinck, who made a sweet pair of paintings of them as shepherd and shepherdess (figs. 202, 203).

THE SELF-PORTRAITS OF THE THIRTIES | Our review of the documented portraits of Saskia nearly exhausted at the same time the known references to self-portraits by Rembrandt. After the painting for Sir Robert Kerr (fig. 45), the next two references to self-portraits are the ones that were paired off with *Saskias* in the collections of Martin van den Broeck and Abraham Bartjens. The only other self-portrait documented during Rembrandt's life was 'Rembrandt's portrait à l'antique,' in the stock of the late Johannes de Renialme in 1657.

De Renialme was an important art dealer, a Catholic, who in 1629 married a cousin of Jan Pellicorne's and in 1640 moved into the house on the Kloveniersburgwal, the Salamander, where Joannes Wtenbogaert had lived some time before. In the 1640s he seems to have succeeded Hendrick Uylenburgh as Rembrandt's dealer – without an academy – and in this capacity we shall return to him below. The self-portrait that comes closest to the description is fig. 231, from the first year of Rembrandt's association with the dealer.

UYLENBURGH'S REACTION TO REMBRANDT'S MARRIAGE | Rembrandt's marriage to Uylenburgh's cousin did not cement the relationship between the artist and his Mennonite dealer. If anything, it seems to have helped dissolve it. After Rembrandt and Saskia moved out of Uylenburgh's house, the 'academy' was never the same, and neither was Rembrandt's career. From then on, the main benefactor of the business that came Uylenburgh's way was to be not Rembrandt but Flinck. This lowered the artistic level of the Uylenburgh studio to the second rank, and it wiped out entire provinces of patronage for Rembrandt.

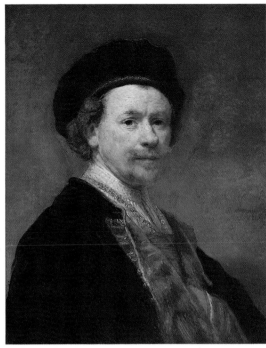

207 *Self-portrait*. Signed *Rembrandt f. 163*[.]. Ca. 1638. Panel, 63.2 x 50.2 cm. Bredius 32. Pasadena, California, The Norton Simon Foundation.

The consequences of this will become clear in the following chapters.

The parting note is sounded in Rembrandt's *Self-portrait with Saskia* at around the moment of the move away from the Sint Anthoniessluis. For years audiences were charmed by the autobiographical side of this scene, while more recently that aspect of the work has been denied in favour of a moral interpretation: Rembrandt as the prodigal son, in a warning against the sins of pride, luxury and concupiscence. This may be so, but it is also undeniable that the costumes of the two figures are no more luxurious than in the other depictions of Rembrandt and Saskia in those years. Moreover, the fact that Rembrandt kept this particular painting is nearly an autobiographical deed itself. The boasting language of his libel suit in Friesland (not to mention the charges) show us a Rembrandt and Saskia very much like the pair in the painting.

The elements of the painting – the laughing painter, the complaisant lady, the glass of wine – correspond to those in a sixteenth-century self-portrait with courtesan described by van Mander (see caption to fig. 206), and there is little reason to doubt that Rembrandt's work was conceived in the same spirit. There may be irony in the image, but it also reflected a reality, one which could not have appealed to Hendrick Uylenburgh.

REMBRANDT THE ART DEALER | Rembrandt's shift of the mid-thirties was not merely of style. After his departure from Uylenburgh he began to participate as a principal in the Amsterdam art market. His art purchases at auction, which totalled 18 guilders in

1635, rose to 130 guilders in 1637 and 224 in 1638. (The auctioneer in all four sales involved was Daniel Jansz. van Beuningen, Geurt Dircksz.'s nephew.) Some of the works purchased remained in his collection, but others he sold. The one transaction from these years which happens to be documented concerns the purchase and sale of a painting by Rubens. On October 8, 1637, he bought the *Hero and Leander* (now in New Haven, Yale University Art Gallery) for 424½ guilders, and sold it around 1644 for 530.

Rembrandt was no more ethical as an art dealer than he had to be. One proof is the way he acquired his Rubens. The seller was a Catholic accountant, Trojanus de Magistris, who held the painting as a pledge against a debt of his client Jan Jansz. Uyl, a still-life painter. (De Magistris lived next door to Plempius.) The Catholic Uyl may have been a kind of agent of Rubens's in Amsterdam and the other way around. Upon his death Rubens owned three of his works. The day before the accountant sold Rembrandt the painting, Rembrandt did Uyl an illegal favour. On October 7th, Uyl sold some paintings of his at auction, and Rembrandt sat in the hall as a stooge, bidding up the prices. For this he was paid two-and-a-half guilders, and it was no doubt also part of his reward that he was given the opportunity to buy the Rubens outside the auction. (By the way, Jan Jansz. Uyl was on close terms with one of the Leiden families that owned work by Rembrandt, the Bugge van Rings.)

In December 1637, Rembrandt was accused by the Portuguese Jewish painter Samuel d'Orta of an even more dubious practice. D'Orta had purchased from Rembrandt the etching plate of *Abraham and Hagar* (Bartsch 30) upon the condition that Rembrandt would keep only a few impressions for his own use, and would not offer any for sale. D'Orta seems to have caught Rembrandt doing just that. These are the only documents pertaining to outright art dealing by Rembrandt before the late 1650s. It is probably just as well that there are no more.

THE BALANCE | Finally we are able to sum up the numerous changes in Rembrandt's life in the first years of his marriage. In 1635 he left Uylenburgh and moved in with the widow Calff. (By December 1637 he had moved again, to the Binnen Amstel.) The Remonstrants, Mennonites, Catholics and Calvinists who had succeeded and overlapped each other as patrons from 1631 to 1635 are nowhere in evidence in the following few years. It may have been the Mennonites who were ordering the large

history paintings in those years, but if they were, they were probably continuing to patronize Rembrandt because of his association with Govert Flinck.

Rembrandt began to use his accumulated fortune and dowry as the capital for a small, somewhat shady, art dealership. Most strikingly, for three years Rembrandt stopped painting portraits, even portraits of himself and Saskia.

In his first four years in Amsterdam, 1632-1635, he painted one portrait a month and even more paintings of other kinds: self-portraits, face and figure paintings, history paintings. The surviving works alone came out at a rate of a finished painting every two weeks, in addition to an etching a month and countless drawings. In 1636, 1637 and 1638, the tempo is one etching every two months – in an altered, simplified technique, as Christopher White has shown – and one painting every four! Moreover, none of those paintings were portraits. Even taking account of the possibility that there were paintings from these years that are now lost, or that Gerson should not have rejected the handful of portraits dated 1637, the radical imbalance remains.

What brought this on? One can imagine a lot of causes: perhaps a fight with Uylenburgh, entailing the loss of the Mennonite patrons; or did the deaths of Geurt Dircksz. and Lastman cut the ties with Remonstrants and Catholics? Were his early patrons disillusioned with Rembrandt because of his failure to stand and be counted on the issue of religion? Was it disgust at the realization that he was being outmanoeuvred by Flinck? Or was it a career decision? A desire to free himself from dependence on his early patrons, or a plan to re-establish himself as a history painter and play down portraiture? The discovery that one's capital can work for one? Was it a more personal reason? A newly discovered taste for luxury and ease; Saskia's influence; the loss of their first child; an illness of Saskia's; of Rembrandt's; the onslaught of the plague, which left no one in Holland unshaken?

Whatever the contributing factors, their effect is unmistakeable. At the age of thirty, Rembrandt lost the drive that had propelled the first ten years of his career. Abruptly, he slowed to a crawl and surrendered the commanding position in the Amsterdam art world he had built up in a few years of unceasing, well-rewarded work.

This phenomenon has gone seemingly unnoticed in the literature on Rembrandt, and I put it to the reader with the amazement I felt when I realized how extremely Rembrandt's life had changed around the time of the *Self-portrait with Saskia*.

Figures and faces

Rembrandt's remaining works of the 1630s are a connoisseur's nightmare. Before the paint was dry on the face and figure paintings of the early Amsterdam period, the copyists came. Some of them were established masters like Salomon Koninck and Dirck Santvoort and some junior associates in the Uylenburgh academy like Isaac Jouderville and Govert Flinck. There were new apprentices like Leendert van Beyeren and Ferdinand Bol, and there were interested parties from out of town like Jacob de Wet and Jan van Staveren. Later in the century the originals, the copies, even etchings by and after Rembrandt, were in their turn adapted and replicated in paint, sometimes by masters who were very gifted at that sort of thing. The often-repeated praise of van Mander, Orlers, Hoogstraten and so many others rings in one's ears: 'and he copied a such-and-such by so-and-so with such consummate mastery that the best connoisseurs were unable to tell the copy from the original.' In Orlers's biography of Lievens, (p. 79), we even see two copies of that kind being sold as originals from the estate of a deceased collector to be exported to Germany, with the happy collusion of heirs, auctioneer, assessor, copyist and everyone else in town.

The Rembrandt documents contain references to no fewer than sixteen face and figure paintings by and after Rembrandt in the years 1637-1639 alone. One is an original and the rest are copies. They came from the estates of the painter-dealer Lambert Jacobsz., the lumber merchant Cornelis Aertsz. van Beyeren (father of Leendert van Beyeren), and the jeweler Aert de Conincx (the uncle of Salomon Koninck). Since all of them had inside access to the Uylenburgh academy, we may assume that the copies they owned were made under Rembrandt's supervision, possibly even with his collaboration. No sooner had Rembrandt produced yet another head than it was cloned and cloned again. This was the lower end of the Rembrandt market,

and the artist worked it as enthusiastically, if not more so than the upper end, with its demanding commissions from courtiers who were never satisfied and rich burghers who let you paint their portrait if you had the right connections. The face and figure paintings represented quick turnover with no questions asked. Some twenty of his own paintings which Rembrandt owned in 1656 were nameless heads and figures of this kind. They were all presumably 'originals,' but by that time how many of the fifteen copies of the 1630s were in circulation under his name, polluting the market for his works? Let us hope that the Rembrandt Research Project will be able to sort out the wheat from the chaff.

CATEGORIES | About all we can do is to pigeonhole the heads and figures from the 1630s, which is one way of getting a grip on the material. The above-mentioned estate inventories form a catalogue on their own:

From the estate of Lambert Jacobsz., 1637:
The head of an old man with a long beard by Master Rembrandt himself
An old woman with a black cap after Master Rembrandt
A woman's face after Rembrandt, 'il re de mendic'
A handsome young Turkish prince after Rembrandt
A soldier with black hair, an iron gorget and veil around the neck, after Rembrandt
Another small oriental woman's face, the portrait of H. Uylenburgh's wife, after Rembrandt
A hermit studying in a cave after Master Rembrandt, in a gilt frame

Cornelis Aertsz. van Beyeren, 1638:
A face painting, being a copy after Rembrandt
A soldier copied after Rembrandt
A woman's face copied after Rembrandt
Another woman's face copied after Rembrandt

HEADS OF YOUNG MEN AND YOUNG WOMEN

208 *Young woman with a fan*. Signed *RHL van Rijn 1632*. Canvas, 72 x 54 cm. Bredius 85. Stockholm, Nationalmuseum.

Rembrandt painted only three profile portraits in his career: one of Amalia van Solms (fig. 64), one of Saskia (fig. 205) and fig. 208. (Fig. 324 comes close.) The similarity between this portrait and that of Amalia suggests that his work of nearly the same dimensions was made as practice for the court commission.

There is little one can say against the theory of H.F. Wijnman that the model was Hendrick Uylenburgh's wife Maria van Eyck, who was about thirty years old in 1632. In its favour is at least the knowledge that Maria did pose for Rembrandt. However, Wijnman saw the same face in several other works of this period, including the Mary in *The holy family* (fig. 175). The problem with this is that when one begins to compare the faces of the young women in Rembrandt's paintings feature by feature, one discovers that nearly all of them are different models whom he made look the same. This is the reverse of Huygens's complaint about Jacques de Gheyn III not resembling his own portrait, but it says the same thing: Rembrandt's strong point as a portraitist was not his ability to capture a likeness.

Between 1631 and 1632, Rembrandt changed from young men to young women as models for his unknown faces.

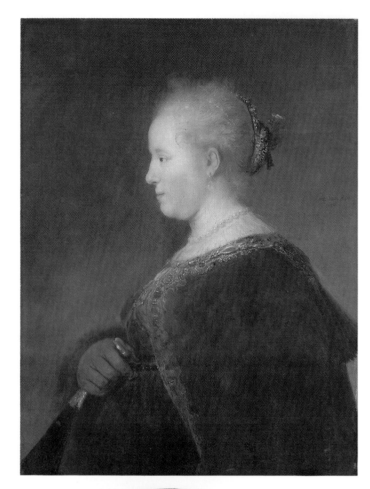

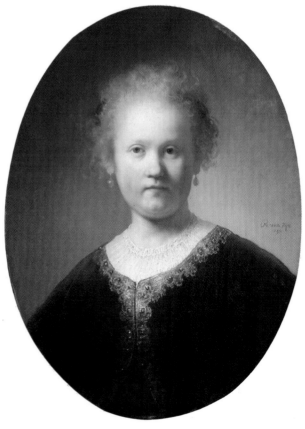

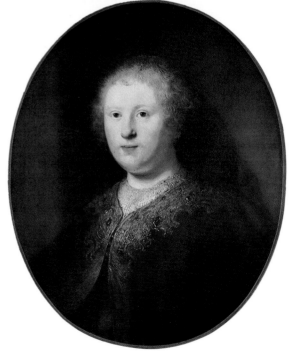

209 *Youg woman with an embroidered robe*. Signed *RHL van Rijn 1632*. Panel, 57.8 x 42.9 cm. Bredius 89. Boston, Museum of Fine Arts.

210 *Young woman with an embroidered robe*. Signed *RHL van Rijn 1632*. Panel, 55 x 48 cm. Bredius 87. Milan, Brera.

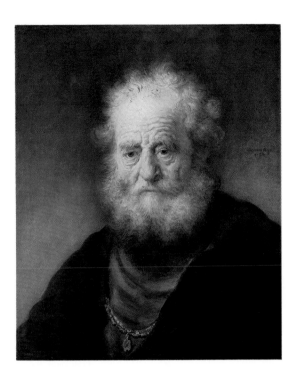

211 *Bearded old man with a gold chain*. Signed *RHL van Rijn 1632*. Panel, 59.3 x 49.3 cm. Bredius 152. Kassel, Gemäldegalerie.

Neither of the two examples of an 'old man's head' recorded in the 1630s can refer to this painting. The one in the estate of Lambert Jacobsz. had 'a long broad beard,' which makes the model sound more like the Leideners in Rembrandt's work than his Amsterdamers, while that in the estate of Aert de Conincx was a copy. This painting, by all accounts, is not. Its first known owner was Valerius Röver (1654-1693), whose son of the same name was the well-known Delft collector. The father of the first owner was also named Valerius Röver, and he was a younger contemporary of Rembrandt in Amsterdam.

The many other old men of the early 1630s that were still accepted by Bredius have declined in the esteem of connoisseurs, leaving only this one as a generally accepted original.

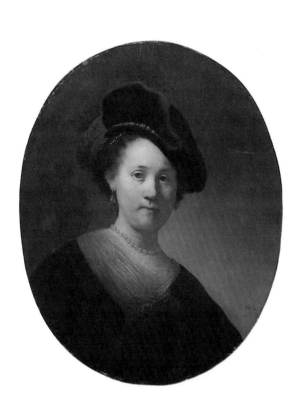

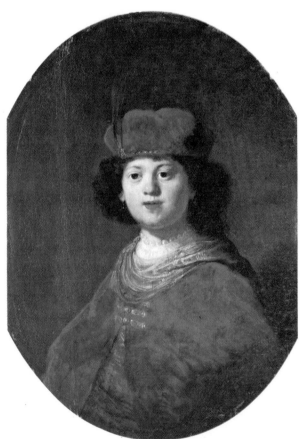

212 *Young woman in a pearl-trimmed beret*. Signed *RHL van Rijn 1632*. Canvas, 27 x 21 cm. Bredius 84. Zürich, collection of Dr. A. Wiederkehr.

213 *Richly dressed young boy*. Ca. 1633. Panel, 67 x 47.5 cm. Bredius 186. Leningrad, Hermitage.

Paintings of children are the only kind of work from the 1630s whose existence is not substantiated in contemporary documents. The works in this category are also those whose authorship by Rembrandt has been most often called into question.

SCHOLARS WITH THEIR BOOKS

214 *Scholar in a room with a winding stair.* Signed *RHL van Rijn 1632.* Panel, 28 x 34 cm. Bredius 431. Paris, Musée du Louvre.

At its earliest appearance, at the Willem Six sale in 1734, fig. 214 was in the company of a similar work by Salomon Koninck (Paris, Louvre), of which it was said to be a pendant. The Koninck had been enlarged to match the size of the Rembrandt. Horst Gerson calls this 'a telling example of the misleading use made of school pictures by later dealers and collectors,' but I wonder whether the confusion was not created in 1633 by Rembrandt and Koninck themselves.

The spiral staircase is lifted from a manual on perspective by the Leeuwarden artist Hans Vredeman de Vries, published in The Hague and Leiden and dedicated to the stadholder, Prince Maurits. The size of the figures and the panel are still on the modest Leiden scale.

The scholar of 1634 (fig. 215) has undergone the same magnification we observed in the mythologies and biblical histories. It is as if the artist zooms in on the main figure, enlarging it enormously, and eliminating ninety per cent of the internal space and detail in his composition.

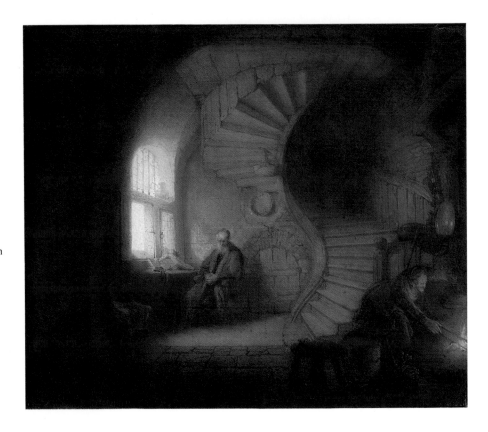

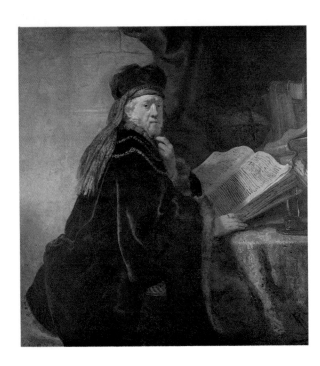

215 *Scholar in his study.* Signed *Rembrandt f. 1634.* Canvas, 141 x 135 cm. Bredius 432. Prague, Národní Museum.

216 *St. Francis at prayer.* Signed *Rembrandt f. 1637.* Panel, 59 x 47.6 cm. Bredius 610. Columbus, Ohio, Gallery of Fine Arts.

In etchings from the 1620s to the '50s, Rembrandt dealt repeatedly with the theme of the hermit saint with a book, sometimes St. Jerome and sometimes St. Francis. He must have painted it too, unless the 'hermit studying in a cave' from Lambert Jacobsz.'s inventory was copied from an etching rather than a painting.

In the 1630s, Rembrandt did paint Catholic subjects for Catholic customers. In 1640, Johannes de Renialme owned 'a priest by Rembrandt' whose value was estimated at one hundred guilders.

ORIENTALS

217 *Man in oriental costume* ('The noble Slav'). Signed *RHL van Rijn 1632*. Canvas, 152.7 x 111.1 cm. Bredius 169. New York, The Metropolitan Museum of Art.

The auction in 1729 of the paintings of Marten Looten's grandson Govert Looten included 'A Turkish prince or grand vizier' by Rembrandt, described further as 'skilful and powerfully painted.' It was sold for 71 guilders. It would be worth finding out whether this could be fig. 217, painted in the same year as the portrait of Marten Looten.

The orientals are the most striking group among the face and figure paintings of the 1630s, and the longest-lived of the ephemeral sub-specialties of the 1630s. Paintings of this kind were very popular among many of the collectors in Rembrandt's milieu. In the Nassau Palace in Brussels there was a 'portrait in oils of a sultan' and one of 'a lady in waiting of Soliman,' the sultan of Turkey. Frederik Hendrik owned a 'Turkish general' by Lievens.

The Mennonites had a weakness for portraits and heads in oriental garb: Uylenburgh's wife posed for Rembrandt as an oriental woman, in a painting that was copied by or for Lambert Jacobsz. Jan Pietersz. Bruyningh had himself painted by Salomon Koninck 'à antique' – a mode that was indistinguishable from that which in other inventories is called 'Turkish,' 'Persian' or 'Oriental.'

Among Remonstrant collectors we find 'a Turkish head by Rembrandt' in the estate of Salomon Henricx, the older colleague of Daniel Mostart as town secretary of Amsterdam. He and Mostart, by the way, were also notaries, and among their clients were some of Rembrandt's first patrons in Amsterdam.

A Calvinist regent, Frederick Alewijn (1603-1665), owned 'a Turkish head by Rembrandt' at his death.

A subject of such universal appeal cannot have a very specific meaning. The most familiar association in the 1630s for paintings of this kind will have been with the stage. The father of Daifilo in the popular pastoral play by P.C. Hooft, *Granida en Daifilo*, was the ruler of Persia. The frontispiece to Krul's *Pastoral Musyck-spel van Juliana, en Claudien*, published in *Eerlycke Tytkorting* (1634), shows an oriental prince marrying an occidental princess dressed in clothing much like that worn by Saskia in the fanciful paintings of those years.

The one exact title of a face painting in the documents – 'A woman's head after Rembrandt, il re de mendic' – also sounds like a character (although a male one!) in a stage play, which to my knowledge has never been tracked down.

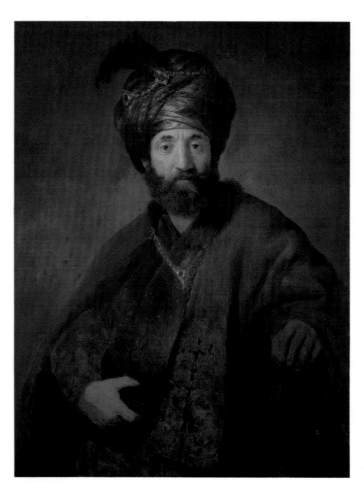

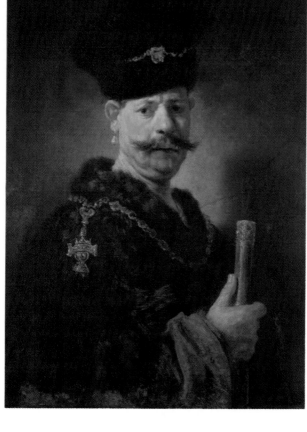

218 *Man in oriental costume.*
Signed [R]*embrandt ft.* Ca.
1636. Canvas, 98 x 74 cm.
Bredius 180. Washington,
D.C., National Gallery of Art.

219 *Man in exotic costume.*
Signed *Rembrandt f. 1636.*
Panel, 97 x 66 cm. Bredius
211. Washington, D.C.,
National Gallery of Art.

Figs. 218 and 219 have
identical histories. Andrew
Mellon bought them, through
art dealers in New York,
London and Berlin, from the
Hermitage in 1930. They had
been acquired by Empress
Catherine II of Russia in the
late eighteenth century from
the collection of Johann Ernst
Gotskowski (1710-1775), the
founder of the Berliner
Porzellanmanufaktur and a
favourite of Friedrich II of
Prussia. Gotzkowski
undertook picture-buying
campaigns in the king's name
in the Netherlands, among
other countries.

Aert de Conincx, 1639:

In the front room above the dining room:

A painting, being an old man's head, without a frame, after Rembrandt

A young man's head after Rembrandt, without a frame

A student's head after Rembrandt, half-length, with a close-fitting cap

A Turkish head after Rembrandt

Fifteen paintings of nine distinguishable types: old men, students, Turks, soldiers, young men, hermits, old women, beggarwomen (if the mysterious 're de mendic' refers to a mendicant) and oriental women.

THE ORIGINS OF THE FACE PAINTINGS | All of these types can be traced back to paintings and etchings of 1630-1635. Most if not all were first painted in the Leiden period. And we recall that in Leiden it was Lievens who pioneered the genre.

Rembrandt's role is close to that of an artistic middleman trading Lievens's themes to a stable of Amsterdam copyists. In 1635 he did something similar in the etchings known as the 'four oriental heads.' Rembrandt copied them from prints by Lievens, signing three of them 'Rembrandt geretuckert' (Rembrandt retouched). There is even a painting (which is not even mentioned by the Rembrandt Research Project – why not?) signed *Rembrandt geretuceer*[d] *Lieve*[ns] (Rijksmuseum). The inscriptions indicate that Rembrandt was not the author of the composition. More often, he changed the composition sufficiently to be able to omit qualifiers of that kind. Yet Rembrandt's face and figure paintings are adaptations or derivations of works that Lievens made before him. This, is almost always so in art and is only mentioned here to counter the widespread misconception of Rembrandt's originality in all matters.

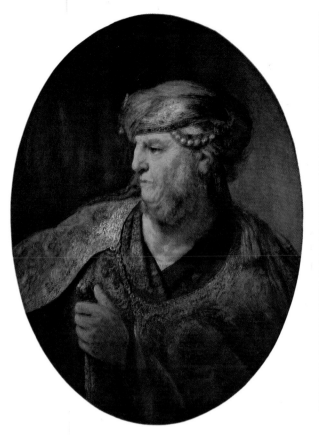

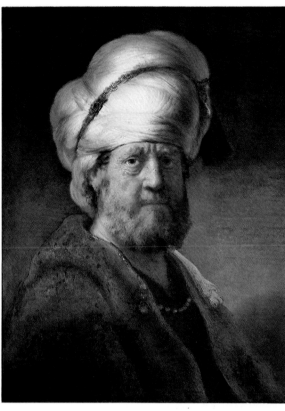

220 *Man in oriental costume*. Signed *Rembrandt f. 1633*. Panel, 85.8 x 63.8 cm. Bredius 178. Munich, Alte Pinakothek.

221 *Man in oriental costume*. Signed *Rembrandt f. 1635*. Panel, 72 x 54.5 cm. Bredius 206. Amsterdam, Rijksmuseum.

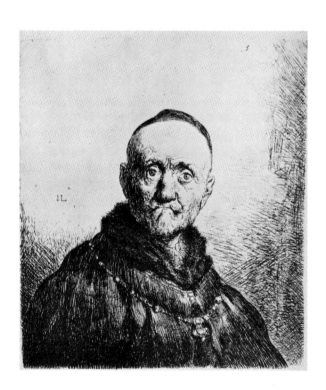

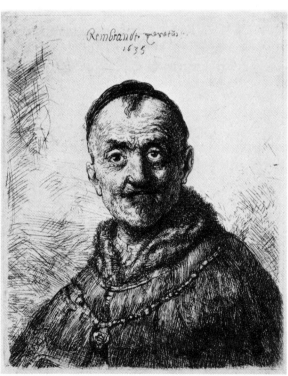

221a Jan Lievens (1607-1681), *'The first Oriental head*. 'Signed *IL*. Nr. 5 of a series of seven prints published under the title 'Variae Effigies a Johanne Livio Lugd. Batav.' Probably Leiden, ca. 1630-1632. Etching, 16.4 x 14.6 cm. London, British Museum.

221b Rembrandt (and a pupil?), *'The first Oriental head.'* Signed *Rembrandt geretuc 1635*. Etching, 15.1 x 12.5 cm. Bartsch 286. Amsterdam, Rijksprentenkabinet.

An adaptation by Rembrandt, in Amsterdam, of a print published previously by Lievens in Leiden. Rembrandt's signature is unmistakable, but the word after it – *geretuc*, the first letters of the Dutch word for 're-touched' – is so difficult to read that it was not interpreted properly under the second half of the nineteenth century.

25 1639

Rembrandt's return to the thick of things was not a gradual process. In the first week of 1639 he bought the house in the Breestraat next to Uylenburgh's old quarters, establishing himself for the first time as an independent householder. In the second week he reactivated the Passion series after a gap of three years with a letter to Constantijn Huygens. In the third and fourth weeks he finished and dispatched the last two paintings in the series as well as the eight-by-ten foot painting he wished to present to Huygens as a gift. And in the remaining weeks of the year, he resumed painting portraits in a grand way, if not on a large scale.

THE HOUSE IN THE BREESTRAAT | Rembrandt and his house – second from the corner north-east of the Sint Anthoniessluis – were made for each other. Construction was begun in the year of Rembrandt's birth by Hans van der Voort (fig. 6), the brother of Lastman's friend Cornelis. Simultaneously, van der Voort put up the corner house, where his brother Cornelis had his studio until 1625. After the deaths of the brothers, the house was sold to Nicolaes Seys Pauw, who let all or part of it to Hendrick Uylenburgh from 1625 to 1635; it was there that Rembrandt lived from 1631 to 1635.

In 1608, Hans van der Voort sold the future Rembrandt House to Pieter Belten (1565-1626). The van der Voorts and Beltens were both natives of Antwerp who had come to Amsterdam with considerable fortunes, part of which they invested in houses.

The elder Belten lived in the house with his children Pieter (1605-1640) and Magdalena, who inherited it jointly upon his death in 1626. Both of them were married the year after: Pieter to Constantia Coymans (thus becoming the brother-in-law of Joan Huydecoper) and Magdalena to her guardian Anthoni Thijs. The Coymanses and Thijses too were wealthy immigrants from Antwerp.

Magdalena and Anthoni now lived in the house on the Breestraat until they moved to the Keizersgracht in 1633. Anthoni died in 1634, whereupon Magdalena promptly married his nephew Christoffel, who now became half-owner of the house, together with his brother-in-law Pieter Belten. In 1636 they put the house up for auction, but withdrew it at twelve thousand guilders, which they considered an unacceptable price. In the meantime it was rented to a merchant named Balthasar Visscher and his wife. When she died in 1638, Thijs and Belten put the house back on the market, and this time found a buyer who was willing to pay their price: on January 5, 1639, they sold it to Rembrandt for thirteen thousand guilders.

The corner houses were the grandest in the block, fully the equal of the houses of the Breestraat regents. Rembrandt paid many times what a simpler burgher would pay for a dwelling. Ten days after January 5, 1639, for example, the history and genre painter Pieter Quast bought the house in The Hague where he was already living for nineteen hundred guilders.

Miss van Eeghen has uncovered a little quirk in the history of the house's owners which is enough to set one's head spinning. One of the last acts of Johan Thijs (d. September 24, 1611), the father of Anthoni and the uncle of Christoffel, was to sell a plot of land on the Wapper in Antwerp to Peter Paul Rubens, the site where Rubens was to build his palatial home, now the Rubens House. In the sale contract, Thijs included the following stipulation: 'It is moreover agreed that above the actual payment the aforementioned Pietro Paulo Rubbens, to mark and commemorate this sale, shall cede and deliver to the aforementioned Hans Thijs a painting by his own hand, as large or small as it shall please the same Rubbens to give him.' This was not an unusual stipulation. Quast did the same. What follows is another story: 'And over and above this, he shall, with no recompense, teach a son of the aforesaid Hans Thijs the art of painting, without withholding

BETTING ON THE WAR
Something of the personal style of the Amsterdamers with whom Rembrandt dealt can be sampled in this entry in Joan Huydecoper's cashbook: 'The fourth of July 1629 I took a bet with Anthoni Thijsen and my brother-in-law Beltens for 300 Flemish pounds that if 's-Hertogenbosch is taken [by the prince] in this siege we win, and if not we lose 600 pounds... 29 September 1629... Received... 600 pounds [for himself and several other winners in the wager].

Huydecoper felt it unnecessary to add that his 'nephew' Dirck Bas was in the prince's camp as the official observer for Amsterdam. In that function, he helped to decide just how vigorously the siege should be pursued.

any of its secrets from him, as he has promised. The only condition is that the young man pay his own board. Tuition will be free, and to acquire it he is to have free access to the master.'

That son was Anthoni Thijs! In 1611, the year when Willem van Swanenburg made the first engraved copy after a painting by Rubens, in Amsterdam an émigré Flemish merchant was trying to turn his fifteen-year-old son into the Dutch Rubens, at a bargain price. In different ways, Rembrandt was the successor to them both.

PORTRAITS OF 1639 | Among Rembrandt's sitters of 1639 is one old acquaintance who can help to introduce the others. Joannes Wtenbogaert was portrayed by Rembrandt in the etched *portrait historié* to which we have already referred in connection with the Passion series. Rembrandt shows him, in an allegory whose fine points have never been understood, as the beneficent receiver and dispenser of worldly goods (fig. 222). Whatever the exact meaning of the scene, it is certain that it shows Wtenbogaert in his capacity as receiver-general of taxes for the States-General in the city and surroundings of Amsterdam, a post in which he succeeded his uncle Pieter Reael in July 1638.

In his new office, Joannes was able to promote Rembrandt's interests in new and marvellous ways. Concerning one such instance we have a rare inside story in Rembrandt's final communication to Huygens, of spring 1639. To remind the reader: Wtenbogaert put into Rembrandt's hands confidential information concerning the state of the Amsterdam treasury which Rembrandt used to force payment for the last two paintings out of Huygens and Volbergen.

If Wtenbogaert was willing to go that far in helping Rembrandt, then it would have been a small favour for him to recommend him, with the backing of his new authority, to his influential friends.

ANDRIES DE GRAEFF | One of these was Andries de Graeff (1611-1679), a country neighbour of Wtenbogaert's in Het Gooi, between Huizen and Naarden, east of Amsterdam. De Graeff and Wtenbogaert were political allies in Amsterdam, and the nature of their alliance is important for our understanding of Rembrandt's position in the city.

The regents of Amsterdam were of two – in fact, three – minds about how to deal with the stadholder and his power. This was especially problematical in the years after 1633, when the stadholder broke with the city on the issue of peace negotiations with Spain. Frederik Hendrik decided that a continued alliance with France – and therefore continued war

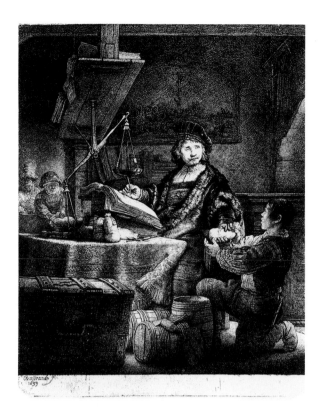

222 *The tax-collector for the States-General in Amsterdam, Joannes Wtenbogaert (1606-1684).* Signed and dated 1639. Etching, 25 x 20.4 cm. Bartsch 281. Amsterdam, Rijksprentenkabinet.

The etching shows Wtenbogaert in nearly allegorical guise, glorifying his function.

with Spain – was more important to him than the goodwill of the regents of Amsterdam, who favoured serious talks concerning the thirty-four-year truce that Spain was proposing. There were those in Amsterdam, like Andries Bicker, who wished to confront the stadholder with a hard line, those – led from 1633 to 1638 by Jacob de Graeff – who preferred compromise and accord, and those who were willing to conspire with the stadholder in order to usurp the others. The man behind that ugly ploy was Anthony Oetgens van Waveren. He made his attempt in February 1639, and failed. Meanwhile, in September 1638, de Graeff died, and his faction was left without powerful leadership. Not until the following spring did his seat in the council – but not the burgomastership – pass on to his oldest son Cornelis, who was to fight and eventually win an uphill battle with Bicker lasting eleven years. The two men were related by marriage, and their struggle had the character of infighting behind the scenes, while both of them were united against the outside to stave off the forces of the Calvinists and the Oetgens van Waveren faction.

All those in Amsterdam who favoured co-operation with the stadholder, or who, like Wtenbogaert, *had* to co-operate with him, rallied around Cornelis de Graeff and his two lieutenants:

his brother Andries and his brother-in-law Frans Banning Cock. When the association with the house of Orange became a political liability in the 1640s, these Amsterdamers were not allowed to drop it. We catch glimpses of protection in action from documents like a letter of 1645 from Pieter Cornelisz. Hooft, bailiff of Muiden (an appointment of the States of Holland), to his friend Huygens. Huygens needed a favour done in Amsterdam for a member of the house of Orange, and Hooft was helping him, though not too vigorously. He explains his problem in these telling words: 'I would be happy to impress upon my cousins [Cornelis] de Graeff and [Frans Banning] Cock the merits of said case, and remind them of the favours that oblige them eternally to His Highness; however, both of them being out of town, I am incapable of getting anything reasonable done either by them or anyone else in the council.' In other words, nothing could be done for the house of Orange in Amsterdam in the 1640s except through the agency of de Graeff and Banning Cock, and then only by putting them under pressure by reminding them of old obligations.

In 1639, Rembrandt painted a full-length, life-size portrait of the most junior member of the de Graeff triumvirate, Andries (fig. 223). In scale and form, the painting is based on a portrait of Cornelis de Graeff, the newly elected councilman and new head of the clan, by Nicolaes Eliasz. Pickenoy (East Berlin).

REMBRANDT'S PATRICIAN PASTIME | The councilmen chosen by the civic guard in 1578 were old-fashioned republicans, men who were proud of their simplicity and economy. Their children were different. In the city itself, under the unsparing gaze of their fellow burghers, they settled for comfortable but not showy houses. The real struggle for status took place in the country, with the de Graeffs leading the pack. One of the results of the Twelve Year Truce was that land in the northern Netherlands that belonged to southerners could now be offered for sale to Dutchmen. In 1610, Cornelis de Graeff bought an estate from Count Arenberg that gave him the right to the title lord of Zuidpolsbroek. From 1612 on, Volckert Overlander was the lord of Purmerland, a title he passed on to his son-in-law Frans Banning Cock. The ownership of country estates brought with it the right to engage in the aristocratic pastime par excellence, the hunt. The de Graeffs in particular were well-known – and often ridiculed – for their love of the hunt.

These were the new aristocrats who adopted Rembrandt in 1639. There will have been an element of calculation involved. Was he not the only

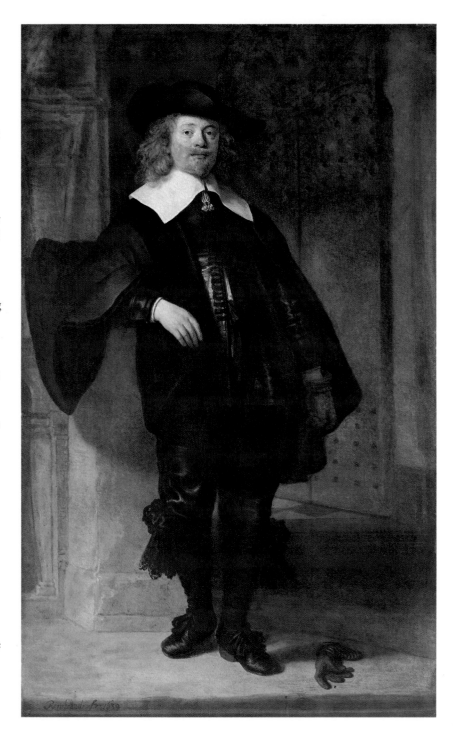

223 *Andries de Graeff (1611-1679)*. Signed *Rembrandt f. 1639*. Canvas, 200 x 124.2 cm. Bredius 216. Kassel, Gemäldegalerie.

Rembrandt's *Andries de Graeff* is very similar to portraits of the sitter's elder brother Cornelis and his wife by Nicolaes Eliasz. Pickenoy. Pickenoy was one of the seven Amsterdam painters who we know to have been guild officials during Rembrandt's life. In 1640, and perhaps in 1639 as well, he was

Rembrandt's next-door neighbour. They also shared in the commissions of 1640 for two of the civic guard group portraits for the Kloveniersdoelen.

Between 1625 and 1645, Pickenoy painted no fewer than five civic guard groups, two of the governors of civic bodies and the *Anatomy lecture of Dr. Johan Fonteyn* (1625), the one preceding Rembrandt's *Tulp*.

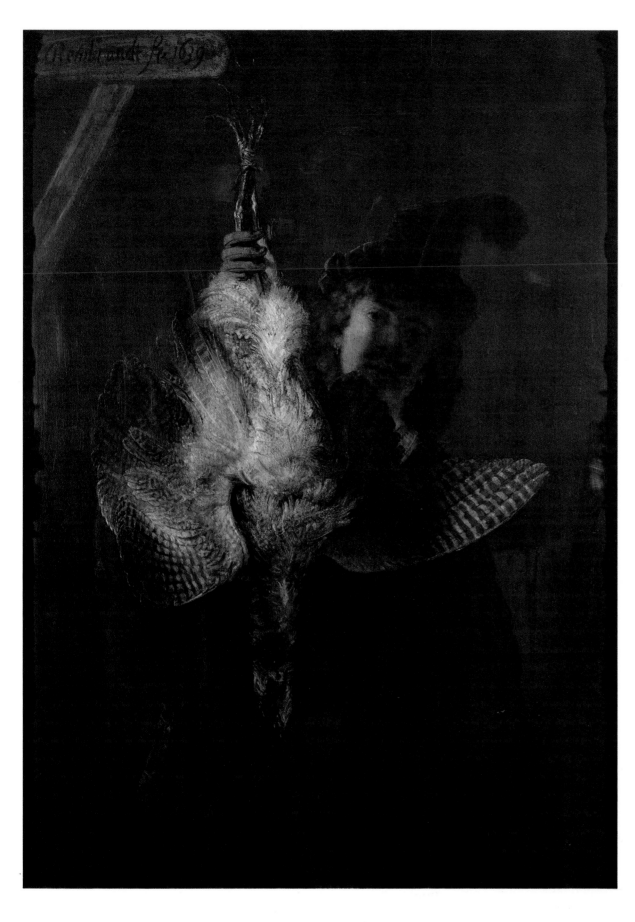

224 *Self-portrait with a dead bittern*. Signed *Rembrandt fc. 1639*. Panel, 121 x 89 cm. Bredius 31. Dresden, Gemäldegalerie.

Rembrandt's pose in this painting, as in the *Self-portrait with Saskia* (fig. 206) comes suspiciously close to certain far less dignified figures by Christiaen van Couwenbergh. In a painting by the latter, a man in the same proud pose holds up a herring he has just gutted. That work is not dated, and I could not say whether there is a direct tie between the two paintings, or if there is, who was commenting upon whom, although I do have my suspicions.

In 1640 van Couwenbergh shared in the commission for the first large tapestry ever ordered by the township of Delft. He made the full-scale weaver's patterns after paintings by Simon de Vlieger. This Amsterdam artist was mentioned by Hendrick Uylenburgh in the same year as one of the backers in his gallery.

Amsterdam painter who had worked for the prince
of Orange? Did he not come recommended by the
latter's tax-collector in Amsterdam? Andries de
Graeff may well have expected a certain princely
aura to emanate from his portrait by Rembrandt.

The effect was mutual. The *Self-portrait with a
dead bittern* of 1639 (fig. 224) and *Girl with dead
peacocks* (fig. 229) hint at Rembrandt's new
standing with these country squires. They also
suggest that with his new house and the newly
elevated status of his main protector, he was
beginning to think of himself as a patrician in the
making.

ALIJDT ADRIAENSDR. | The other two
commissioned portraits of 1639, depicting Alijdt
Adriaensdr. and Maria Trip, widow and daughter
respectively of Elias Trip (1570-1636), are no less
revealing of a certain courtliness (figs. 226, 227). In
August 1638, the Republic was paid an embarrassing
surprise visit by the exiled queen-mother of France,
Maria de Medici. She sneaked over the border from
the southern Netherlands, and challenged the
Republic to negotiate on her behalf with her enemy
Richelieu to mend things between herself and her
son Louis XIII. Maria had not been in The Hague
for more than four days before she let it be known
that she wished to visit Amsterdam. The city fathers,
welcoming a chance to put pressure on France,
dispatched Willem Boreel to The Hague to present
an official invitation, and in the meantime got to
work preparing the first royal visit to Amsterdam in
twenty-five years. In two weeks (or had they been
working on it longer?) they managed to stage a
reception that was one of the grandest of the
century, complete with parades on land and water,
triumphal arches, tableaux vivants and indoor and
outdoor theatricals, all created for the occasion to
glorify Maria and in even greater measure
Amsterdam.

Accompanying the queen-mother was Amalia
van Solms, and while Maria was put up in official
guest quarters, Amalia stayed with Alijdt
Adriaensdr.

Thanks to the elaborate published descriptions of
the event, we have the names of all the scholars,
poets and artists who were mobilized for the
splendid event by the organizers of this tour de
force, Willem Boreel and Daniel Mostart. The main
artistic commission went to Claes Moyaert, and the
main literary ones to Pieter Cornelisz. Hooft,
Caspar Barlaeus and Samuel Coster. But Petrus
Scriverius, who had celebrated Amsterdam from
Leiden in the past, was also called in, and so were
other painters, among them Simon de Vlieger.

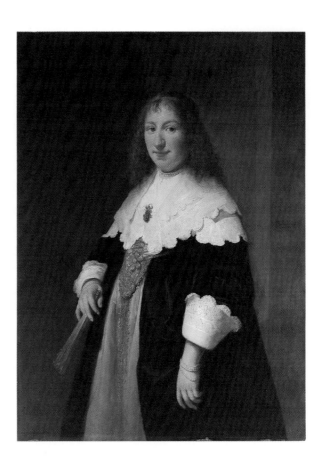

225 Ferdinand Bol
(1616-1680)? *Maria Trip*.
Falsely signed
Rembrandt 1632. Ca. 1639.
Panel, 105 x 78 cm. Aachen,
Suermondt-Ludwig Museum.

This variant on Rembrandt's
portrait, of nearly the same
dimensions (fig. 226), I would
give to Ferdinand Bol mainly
on the grounds that he later
emerged as a favourite of the
Trips. His arrival at
Rembrandt's studio took
place in 1637 at the latest. Bol
was born in Dordrecht of a
good family, and seems to
have had close ties to the
Trips. Rembrandt painted a
portrait of his father Balthasar
in these years. We can see Bol
as a link between Rembrandt
and the Trips, in addition to
those provided by Amalia van
Solms, the Coymanses,
Willem Boreel and the de
Graeffs. In the 1660s,
Rembrandt and Bol were to
share in the patronage of the
Trips when portraits were
being ordered for their grand
new town house, the
Trippenhuis.

If this work is by Bol, it is
his earliest known portrait.

The somewhat finer stroke
than Rembrandt's is
characteristic of Bol's work
from his Dordrecht period,
before he became an associate
of Rembrandt's.

Ignorant as we are
concerning the closeness to
life of the two portraits, one
nonetheless cannot avoid
noticing that Rembrandt's is
the more flattering.

There is also a second
version of the portrait of
Alijdt, smaller than the
original, which seems like a
less likely candidate for
attribution to Bol. It, and the
present painting, are both
catalogued by von Moltke as
works by Govert Flinck,
which seems wrong to me.

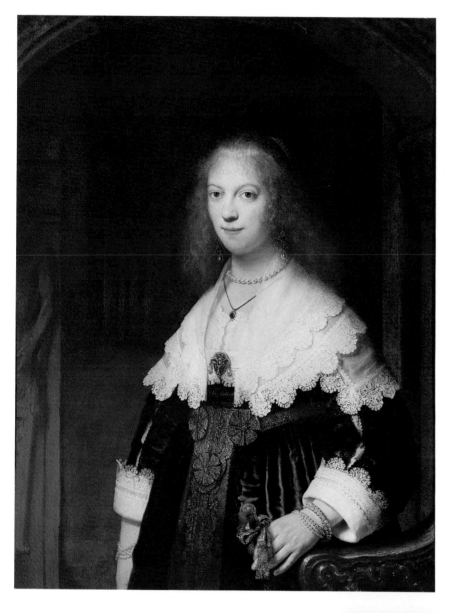

226 *Maria Trip (1619-1683)*. Signed *Rembrandt f. 1639*. Panel, 107 x 82 cm. Bredius 356. Amsterdam, Rijksmuseum (on loan since 1897 from the van Weede Family Foundation).

Alijdt Adriaensdr. was hostess to Amalia van Solms when she came to Amsterdam in September 1638 with Maria de Medici. Aside from the official receptions, the visitors went to see shops and art collections. One story of what went on there is recorded by Buchelius:

'Anno 1639. I understand from cousin Benthem that a certain Reynst, an important collector, married in Amsterdam to his niece, brought back from Venice many antiquities, objets d'art and collector's items that had been gathered in Turkey, Greece and Italy, as well as statues, paintings, medals, prints and the like. Princess Amalia, who didn't know him, requested to see the collection while she was accompanying Her Majesty the Queen of France. She was so taken with a statue of Cleopatra that it was presented to her.'

In September of that year Buchelius traveled to Amsterdam with his nephew, and was shown the collection of Gerrit Reynst, who told him that he had had no intention of parting with his Cleopatra, but that Amalia had made such a show of admiring it that her hosts from the city government had no choice but to buy it for her, 'for a good price. The princess was in love with it, and concerned lest the queen of France take an interest in it.... To avoid that possibility, she had it sent to her palace at Rijswijk.'

In that atmosphere of intrigue, jealousy and one-upmanship, Alijdt commissioned Rembrandt, the only painter in Amsterdam ever to have painted Amalia, to make a portrait of herself in the same dimensions.

The choice of Rembrandt to paint daughter Maria may have been guided by the notion that his contact with the stadholder's court represented a higher status than that of the purely Amsterdam connections of artists like Pickenoy.

One of those whose participation was probably not an idea of Mostart's was Gerard van Honthorst. Upon the specific request of Maria de Medici, he was summoned from The Hague to paint a portrait of her to be presented to the burgomasters.

Rembrandt too took a ride on the coat-tails of Maria and Amalia. In 1639, Alijdt ordered from him a portrait of herself of the same size as the one he had done of Amalia in 1632.

MARIA TRIP | In addition to that fairly modest commission, Rembrandt was given another one for a larger portrait of Alijdt's daughter Maria Trip. Maria was in the marriage market at the time. An Amsterdam satirist, Jan Soet, testified in court on December 8, 1640 that he had been approached about half a year before by two men who 'had told him that Miss Trip's three would-be beaux were Boreel, Coymans and Fabry, asking him to include them [in a pasquinade], which he did not do.'

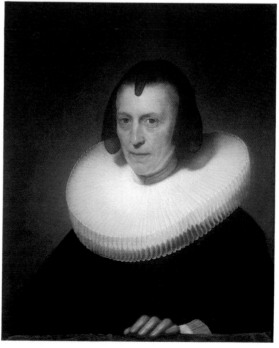

227 Alijdt Adriaensdr. (1591-1656). Signed *Rembrandt 1639*. Panel, 64.7 x 55.3 cm. Bredius 355. Rotterdam, Boymans-van Beuningen Museum.

Her hand was won the next year by Balthasar Coymans, whose brother was already married to her sister. It says something about the persistency of the families concerned that 125 years later, in 1766, another Maria Trip married another Willem Boreel.

One commission of 1639 that Rembrandt did not get nonetheless deserves mention in this chapter. In that year Jacques Specx had portraits painted of himself and his new bride Margaret Doublet, Huygens's sister-in-law. He ordered them from Govert Flinck.

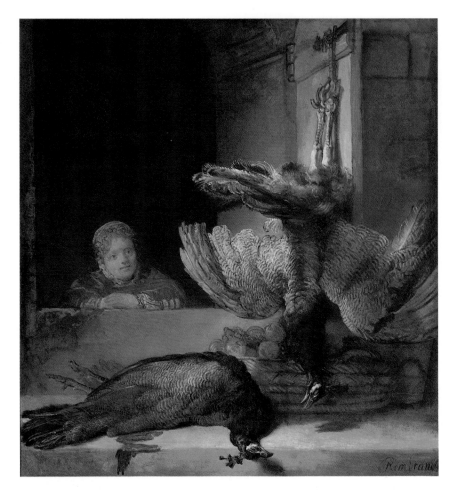

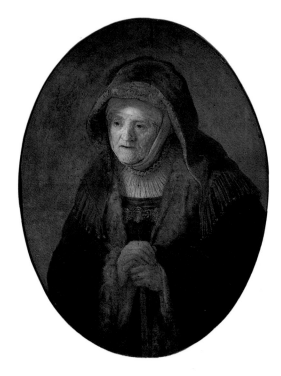

228 *Rembrandt's mother.* Signed *Rembrandt f. 1639.* Panel, 79.5 x 61.7 cm. Originally rectangular. Bredius 71. Vienna, Kunsthistorisches Museum.

This is the only painting of anyone in his family – for that matter, of anyone in Leiden – that Rembrandt is known to have made after he left for Amsterdam. It is dated in the year before Neeltgen Willemsdr.'s death.

After she died in September 1640, Rembrandt sold a mortgage in his share of the inheritance at a loss, and disappeared from the records pertaining to the family. The only official reference to Rembrandt in the Leiden archives after this year is in 1647. The burgomasters of Leiden advised those of

Amsterdam that Rembrandt owed 35 guilders in taxes on the estate of his father, which debt, along with those of several others who had moved from their city to Amsterdam, they were striking from their books and reassigning to Amsterdam, 'so that the commonwealth not be disadvantaged because these individuals have moved.'

229 *Child with dead peacocks.* Signed *Rembrandt.* Ca. 1639. Canvas, 145 x 135.5 cm. Bredius 456. Amsterdam, Rijksmuseum.

In 1685, this painting was in the estate of the historian Tobias van Domselaer, who in 1660 edited a book of occasional poetry containing most of the poems ever written in praise of Rembrandt in his life. Not that van Domselaer bought the painting from Rembrandt. In 1660 it appears in the inventory of his widowed mother's estate, together with 'a large painting by Rembrandt van Rijn being a Dané' and a portrait of her late husband Hendrick van Domselaer.

Van Domselaer's mother was a member of the de Varlaer family. Her kinswoman Anna Michielsdr. de Varlaer was married to Tymen Jacobsz. Hinlopen, in whose country home hung *Christ on the sea of Galilee* (perhaps fig. 172). That country home, Oud-Bussum, bordered to the north on Joannes Wtenbogaert's

Kommerrust and to the east on a small forest beyond which lay Andries de Graeff's Oud Naarden.

It is tempting to believe that the origins and purchase of this painting, with its reference to country life, go back to 1639 in Het Gooi, where so many of the lines cross connecting Rembrandt to his patrons of that year. One wonders too whether the 'Dané' could not be the *Aegina* which, if I am right, was sent back to Rembrandt by Huygens in 1639.

In 1638-1639 van Domselaer was one of the directors of the town theatre, together with Floris Soop, Scriverius's cousin, and Willem van Campen, the cousin of the architect who built the theatre, Jacob van Campen. All three of them owned paintings by Rembrandt, and it seems likely that he was taken up by them in 1639. The protection of this groups – especially van Domselaer's relatives the Hinlopens – played an important role in Rembrandt's life in the years 1654-1662.

The Nightwatch

The cashbook of Joan Huydecoper opens with a list of the offices he occupied in the township and the Amsterdam trading companies. The first entry in this ledger of power precedes his own birth by twenty-one years, going back to the Alteration:

'Anno 1578, the 26th of May. About five o'clock all the Amsterdam councilmen, thirty-two in number, were ejected from the city in a boat together with the grey monks [the Capucins]. On the 28th the members of the civic guard chose a delegate from each squad who on the 29th elected a new council. My late father Jan Jacobsz. Huydecoper belonged to it, and on Sacrament Day he led his company as its captain to the town hall to stand watch.'

For the regents nothing else about the Amsterdam civic guard was more important than the fact that it legitimized their power. There was not a little hypocrisy in this appeal to an ad hoc election as if it were an eternal mandate. But it served its purpose: for two hundred and seventeen years there was no path to power in Amsterdam except in the footsteps of the first captains to march out to the watch in 1578, and no need for new elections.

For the first seventy-five years of the Republic the civic guard was more than that: the captaincy of a company provided its holder with a political base that was indispensable for attaining real power. In part, this was due to the armed might represented by the guard, and to its police and military functions. The twenty companies formed a kind of praetorian guard, albeit composed of citizens.

The captains also occupied an intermediate position between the town government and the four thousand males, including many of the leading burghers of the city, who constituted the civic guard. This was the closest approximation to a representative assembly in Amsterdam, and its voice was heard only through its lieutenants and captains, reporting to two colonels, one for the Nieuwe Zijde and one for the Oude, the new west side of town and the old east. (Huydecoper might have added to his account that his father was the first colonel of the Nieuwe Zijde.)

A further three-part division between the companies was based on the main weapons they employed. There were companies of crossbowmen, archers and musketeers. To accommodate them, there were three different practice ranges, or *doelens*. Each building had its own governors. When they were not being used for practice, banquets or other official purposes, the *doelens* were taverns, run by concessionaires.

The company of Frans Banning Cock was from Precinct II on the Nieuwe Zijde, of which the main artery was the Nieuwendijk, the street of the drapers. Only the captain was from elsewhere. Unusually, Banning Cock rose from lieutenant of Precinct I, where he lived, to be captain of Precinct II.

In the hierarchical society of the day, it cannot have been the footsoldiers who chose the painters, as is sometimes said. The decision will have been taken by the captain of the company and perhaps by the governors of the *doelen*, in the case of the *Nightwatch* those of the musketeers, the Kloveniersdoelen. In the early 1640s those governors were Albert Coenratsz. Burgh, Pieter Reael, Jan Claesz. van Vlooswijck and Jacob Willekens. One of them in particular was concerned with Precinct II. Until some time after August 30, 1638, the captain of that company had been Pieter Reael (1569-1643). Reael was retiring slowly from public life in these years, but he was covering his tracks carefully. When he gave up his office as collector-general of taxes in July 1638, he hand-picked his successor: his nephew Joannes Wtenbogaert. (Joannes's father Augustijn had since 1618 been paymaster of the professional militia of Amsterdam and his uncle Reynier Reael a captain of Precinct XI until 1626.) There is no reason to suppose that Reael was not able to dictate as well

who would take over Precinct II from him. There are two circumstances that make this nearly certain. One is that Reael stayed on as governor of the Kloveniersdoelen after resigning his commission. Another is that when his successor Frans Banning Cock died in 1655, the position that he occupied in the civic guard at that moment was taken over by Joannes Wtenbogaert.

In other words, Frans Banning Cock shared with Joannes Wtenbogaert the inherited mantle of Pieter Reael.

Rembrandt did for the one what he had done for the other. The *Nightwatch*, in addition to its other functions, is a semi-theatrical glorification of Frans Banning Cock in the position he took over from Pieter Reael, just as the portrait etching of Joannes Wtenbogaert is for that sitter.

THE NIGHTWATCH AND MARIA DE MEDICI | The impression of action in the *Nightwatch* is so persuasive that its admirers have long wondered whether the painting does not depict some specific event. In 1834 it was suggested by C.J. Nieuwenhuys that Banning Cock's company was marching out to meet Queen Henrietta Maria of England, Frederik Hendrik and their newly married children on May 20, 1642, a theory that received patchy support for some years before being dropped from the literature. Professor Jan Six's suggestion (1909) of a link with the entry of Maria de Medici in September 1638 was taken more seriously, but was finally rejected in 1967 by Marijke Kok, followed in 1982 by Egbert Haverkamp Begemann, on the grounds that Frans Banning Cock was not yet a captain of Precinct II in 1638.

This counter-argument, I believe, is a bit hasty. There is more to the matter than that.

On August 30, 1638, the captains and lieutenants of the twenty companies met with the colonels and the burgomasters to decide on protocol for the coming ceremonies. One of the lieutenants, Gerard Schaep, noted in his journal (which was brought in as evidence by Marijke Kok): 'There was a mighty to-do among the captains concerning who was to be first or last to march out or back. Ditto concerning where everyone was to stand, and where and when to march.'

Eventually lots were drawn, and the lead position went to Pieter Reael and the men of Precinct II. His lieutenant was Gerbrand Jansz. Pancras, who was replaced in January 1639 by Willem van Ruytenburgh when he became burgomaster. So far there is agreement on the facts: on September 1, 1638, during the visit of Maria de Medici, neither Frans Banning Cock nor Willem van Ruytenburgh

230 *The company of Frans Banning Cock preparing to march out, known as the Nightwatch.* Signed *Rembrandt f. 1642.* Inscribed: *Frans Banning Cocq, heer van Purmerlant en Ilpendam, Capiteijn, Willem van Ruijtenburch van Vlaerdingen, heer van Vlaerdingen, Lu[ij]tenant, Jan Visscher Cornelisen Vaendrich, Rombout Kemp Sergeant, Reijnier Engelen Sergeant, Barent Harmansen, Jan Adriaensen Keyser, Elbert Willemsen, Jan Clasen Leydeckers, Jan Ockersen, Jan Pietersen bronchorst, Harman Jacobsen wormskerck, Jacob Dircksen de Roy, Jan van der heede, Walich Schellingwou, Jan brugman, Claes van Cruysbergen, Paulus Schoonhoven.* Canvas, 363 *x* 437 cm. Cut down all around, though mainly on the left side, from approximately 440 *x* 500 cm. This was done in 1715, when the painting was moved from the Kloveniersdoelen to the Small War Council Room in the town hall. Bredius 410. Amsterdam, Rijksmuseum (on loan since 1808 from the city of Amsterdam).

Between 1620 and 1650, there were twenty companies of civic guardsmen in Amsterdam, each drawn from a different quarter of the city and each comprising about two hundred men. The companies assembled for meetings and practice at one of three indoor ranges, depending on what their main weapon was. There were the crossbowmen, the archers and the musketeers. In those decades, only two of the archers' companies had themselves portrayed – by Cornelis van der Voort in 1623 and by Johan Spilberg in 1650. (Their range, the Handboogdoelen, was notorious for its stinginess, and was dubbed in 1628 the Buttermilk Doelen because too little wine was served there for the taste of the men.)

Crossbow companies were painted ten times in the same period, at regular intervals by, among others, Nicolaes Lastman, Nicolaes Eliasz. Pickenoy (three times) and Govert Flinck.

In the musketeers' range, the Kloveniersdoelen, eight

were ordered in that period, but except for one by Thomas de Keyser in 1632, all were from 1639-1645, shortly after the completion of the new wing of the Kloveniersdoelen. Six were made for specific positions on the walls of that hall. The portraits form the only systematic coverage of the companies attached to a particular range at a specific period.

In contrast to the other commissions, which seem to have come into being upon the initiative of individual companies, the six musketeers' groups, of which the *Nightwatch* is one, appear to have been requested by the governors as well as the captains and the men. In fact, a group portrait of the governors, the first such painting ever made in Amsterdam, complements the guards' ensemble.

This survey is intended to lend new support to the old idea that the *Nightwatch* forms part of a programmatic whole of seven paintings, and that it derives part of its meaning from its function within the whole.

The wealth of historical and artistic associations evoked by the work have been discussed by many scholars, most recently in a very informative monograph by Egbert Haverkamp Begemann in 1982.

Here I would like to point out only one of the sources for the painting, a particularly essential one first noticed in 1947 by Willem Martin. The main function of the Kloveniersdoelen was to provide its companies with a practice range for musketry. In the *Nightwatch* six figures are plying the weapon itself or performing actions necessary to fire it. These details, which provide the painting with one of its main leitmotivs, are derived from the *Wapenhandelinghe* (Manual of arms) by Jacques de Gheyn II, some of them quite literally, others in adapted form. The act performed by the musketeer in red, for example, is illustrated by de Gheyn from the back. (In turning the figure around, Rembrandt misinterpreted the grip of the left hand on the stock.)

This may seem like an

obvious device for a group of musketeers, but it had not been used in any of the civic guard companies painted since the appearance of de Gheyn's book in 1608. Its use by Rembrandt reminds us that in 1641, during the painting of the *Nightwatch*, Joannes Wtenbogaert inherited a painting by de Gheyn from his son Jacques III along with two paintings by Rembrandt. If the reference to the *Wapenhandelinghe* was an idea of Wtenbogaert's, elaborated by Rembrandt, it did not take long for it to catch on. Bartholomeus van der Helst, in his painting for the new hall (1643), places a firing musketeer right out of the pages of de Gheyn in front centre of his composition.

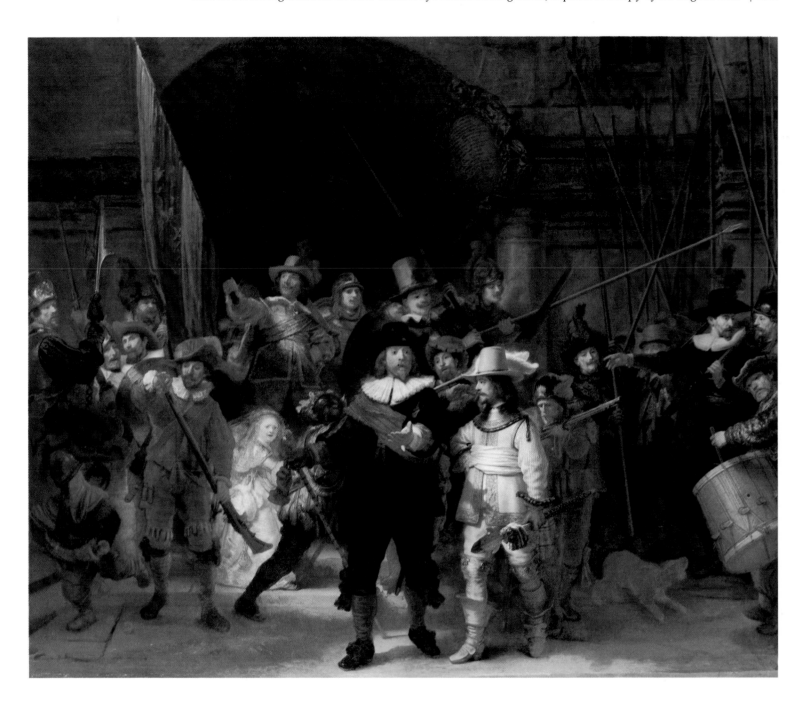

was in command of the company from Precinct II.

However, if we read about actually happened that day, we come across a surprising fact which does not seem to have been taken into account in the argument. I quote from the abbreviated version of Wagenaar: 'Inside the Haarlem Gate and along the streets through which the queen had to pass, the twenty companies of civic guards were lined. The queen was welcomed at the gate by Colonel Andries Bicker, ex-burgomaster, and the civic guard captains Pieter Reael, receiver, Gerbrand Jansz. Pancras, former alderman and councilman, and Jacob Bicker, governor of the East India Company.' In other words, while the men of Precinct II were the first of the twenty companies along the parade route *inside* the Haarlem Gate, their captain and lieutenant were *outside* that gate with Andries and Jacob Bicker. Who, then, was in charge of the company? Who else, one is inclined to answer, but the men who were to succeed Reael and Pancras in a few months anyway: Banning Cock and Ruytenburgh. (Ruytenburgh's sister, by the way, was married to Pieter Reael's brother.)

That assumption remains to be proved, but there is one thing we *can* say with assurance: if any of the Amsterdam companies had reason to commemorate its role on September 1, 1638, it was that in the *Nightwatch*.

THE OTHER GROUP PORTRAITS IN THE HALL | And one company, at least, *did* wish to recall that day. The *Nightwatch* is one of six civic guard pieces painted for the Kloveniersdoelen in 1640-1645, and in one of those, the *Company of Captain Cornelis Bicker*, painted by Joachim von Sandrart in 1640, the men are grouped around a bust of Maria de Medici. In the painting a scroll is depicted with a verse by Vondel that begins: 'Van Swieten's men are waiting to receive Medici.' The company of Cornelis Bicker, lord of Swieten, was thirteenth in order that day. If that company saw the group portrait as a commemoration of their share in the glory of the royal visit, how much more reason would the men of Precinct II have had to do so.

All six paintings show their companies in very specific surroundings, in front of buildings or pageant constructions that are in principle identifiable. All of them, and not just Sandrart's, look very much like evocations of specific occasions. They may be different occasions, moments of glory in the recent history of that particular company. It seems unlikely that in the history of the company from Precinct II anything more noteworthy than the visit of Maria de Medici occurred between September 1638 and December 1640, the last

moment when the commission for the *Nightwatch* could have been given.

Not that the *Nightwatch* is any more accurate than the *Anatomy lecture of Dr. Nicolaes Tulp* as a record of the actual event. There may have been as many as two hundred guardsmen in the company that day (no excuses for absence were being accepted), of whom only sixteen were asked to sit for Rembrandt, or felt like paying his fee.

THE NEW HALL OF THE KLOVENIERSDOELEN | Even without bringing in Maria de Medici, the nearly simultaneous commission for the Kloveniersdoelen of six company portraits and a group portrait of the governors of the Doelen, provides material for inexhaustible discussion. We must force ourselves to leave the subject, but not before taking a backward glance at the entourage.

The hall in which the paintings came to hang was on the upper storey of a newly built wing of Kloveniersdoelen, completed in 1636. It stood at the foot of the Kloveniersburgwal, which was lined with the houses of Rembrandt's richest and most powerful patrons, the Trips, the Soops, the Sixes, the Hinlopens, the van Beuningens, the Wtenbogaerts and the Burghs. Flanking the building were the new houses of Willem Boreel, where Rembrandt was lodging when the wing was finished.

The relations between the captains of the six companies depicted reflect a different order to a topographical one. The pendant to the *Company of Frans Banning Cock* was the *Company of Cornelis de Graeff*. The two captains were married to the two daughters of Volckert Overlander, who had been governor of the Kloveniersdoelen upon his death in 1630. (One of the daughters had also died long before 1642, but in these families the motto was: once a brother-in-law, always a brother-in-law.) The company between theirs was that of Jan Claesz. Vlooswijck, whose son had been engaged to Cornelis de Graeff's sister when he died in 1631. Even Roelof and Cornelis Bicker, on the short walls, were both brothers-in-law of Cornelis de Graeff's. Captain Albert Bas, in fact, was the only one of the six who was not a brother-in-law of all the rest. But here again, his company was not painted until 1645, after the failed Kloveniers conspiracy of 1643, which we shall describe below. The paintings were, therefore, among other things, a graph of the clan alignments between the de Graeffs and Bickers at a sensitive moment in their history.

The ties between the painters chosen for the commissions were as important in their way as those between the captains. It is a fact of hitherto unacknowledged importance that only one of them

was an old-guard Amsterdamer: Pickenoy, who painted the company of Jan Claesz. van Vlooswijck. One of the painters was actually a foreigner: Joachim von Sandrart, who was however on the best of terms with the Bickers.

Of the others, Bartholomeus van der Helst (1613-1670), a native of Haarlem, a pupil of Pickenoy and a protégé of the Bickers, painted the company of Roelof Bicker, of which he himself was a member. The other three painters were from Leiden, Harlingen and Kleve, and all of them came to Amsterdam under the wing of Hendrick Uylenburgh: Rembrandt, Jacob Backer and – with two paintings to his credit, one of them that of the governors – Govert Flinck.

If we consider that Pickenoy lived in the house that Uylenburgh had recently left, and that van der Helst was his pupil, we are justified in calling the painters of the new hall, brothers-in-law of the brush.

The central figure was Uylenburgh, whose position in the Amsterdam art world must have been strengthened considerably by the second marriage of Cornelis de Graeff. After the death of Geertruyd Overlander in 1634, in 1635 he married Catharina Hooft, the niece of the Mennonites Jan and Pieter Gerritsz. Hooft, whom we know as shareholders in Uylenburgh's gallery. She was the only daughter of the most important member of the clan, Pieter Jansz. Hooft. It is interesting that Uylenburgh's predecessor Cornelis van der Voort also enjoyed a privileged position with the musketeers. In 1612 or 1614 he painted a company of which Volckert Overlander was captain, Jan Claesz. van Vlooswijk sergeant and he himself a member.

All the painters who participated in the mass commission for the new town hall enjoyed additional patronage in the years to come from the Bickers and de Graeffs in the paintings. All, that is to say, but Rembrandt. In 1642, he took a bad fall, from which his career never recovered.

During the Nightwatch

It took Rembrandt about a year-and-a-half to complete the *Nightwatch*, from late 1640 to early 1642. Much of his work in that period (how could it be otherwise?) bears traces of his preoccupation with the painting, the largest and most prestigious commission he had executed. Monumental gates appear in an etching of *Haman leading Mordechai* (Bartsch 40) and in the *Meeting of Mary and Elizabeth* (fig. 241) of 1640. In 1641 he designed a political allegory containing references to the civic guard of Amsterdam. As for the portraits – if those of 1639 give one the feeling that Rembrandt may have re-established himself independently, the sitters of 1640-1641 reveal, like the *Nightwatch*, a close dependence on Hendrick Uylenburgh.

We will review all the paintings of the *Nightwatch* period in one chapter not only because of their manifold common ties to that work, but also because they represent a new highpoint in Rembrandt's artistic production, preceding another decline, which was to be longer and more devastating than that of 1636-1638.

THE ARTIST AS A COURTIER AND THE ARTIST'S WIFE AS A COURTESAN | The turn of the new decade is marked by a grand new style of self-portraiture that Rembrandt first worked out in an etching in 1639 and then in a painting in 1640 (fig. 231). Dressed in fur and lace and velvet, the artist rests his right elbow on a balustrade in a pose of lordly ease. The source of the new motif is a painting by Titian that was owned by a man with whom Rembrandt was in contact in 1639 and possibly as early as 1628: Alfonso Lopez (1572-1649). Lopez was certainly the most glamorous man Rembrandt had ever met. He was a converted Portuguese Jew who had established himself in Paris as a dealer in Turkish textiles and as the employer of a diamond cutter who attracted the best stones from all over Europe. Lopez eventually became an agent of Cardinal Richelieu, buying ships, arms and other war

matériel, and dealing on the side, for the cardinal, the crown and himself, in precious jewels and art. In 1628 and again in 1636-1641 he was in the Republic, living in Amsterdam but keeping in close touch with The Hague through Constantijn Huygens among others.

We find Rembrandt and Lopez together in early April 1639 at the auction of the stunning collection of Lucas van Uffelen, a relative of the Coymanses and the Huydecopers. During the bidding on Raphael's portrait of Baldassare Castiglione (Louvre), Rembrandt sketched the painting. The buyer, at 3500 guilders, was Lopez, who outbid Joachim von Sandrart. But there were no hard feelings. In the coming months Sandrart made a drawing of the painting and of several others in Lopez's collection, including the two Titians mentioned in this chapter, to serve as models for engravings.

In April 1639 Lopez was engaged, through Huygens, in negotiations with Frederik Hendrik about the latter's claim of 'fifty or sixty thousand guilders,' in Frederik Hendrik's sloppy phrase, from the French court. If our chronology of the correspondence between Huygens and Rembrandt is correct, it was also in that month that Rembrandt was squeezing his 1244 guilders out of the prince through Huygens.

This is reflected in his courtly new image. Eddy de Jongh has interpreted fig. 231 as 'Rembrandt emulating Titian.' If so, he must have been doing it mainly for the eyes of Lopez and through him Richelieu. 'The Titian of the north' – even Rubens would have been proud of the title.

The guise that Rembrandt assumed for himself, out of those he apparently had for the choosing in Lopez's collection, was that of the poet Ludovico Ariosto, as the portrait was then identified. Ariosto (1474-1533) was in the diplomatic and military service of the house of Este, to whose glory he wrote his epic *Orlando furioso*. While Rembrandt was at

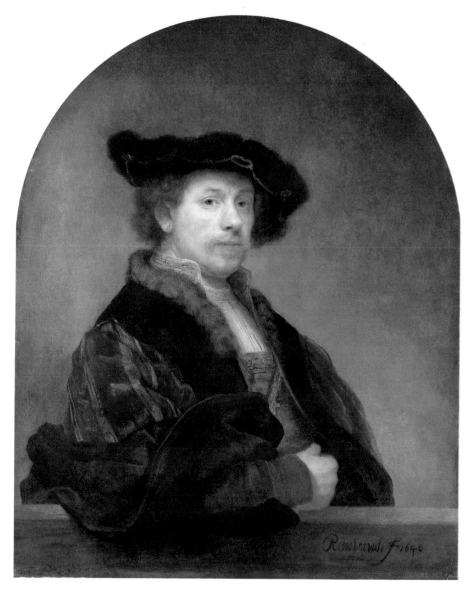

231 *Self-portrait.* Signed *Rembrandt f. 1640.* Inscribed, not by Rembrandt, *Conterfeycel.* Canvas, 102 x 80 cm. Bredius 34. London, National Gallery.

In this painting, not much smaller than the three-quarter length *Self portrait with bittern* of the year before, the artist presents himself at his grandest. The portrait is half as large again as the Titian on which it is modelled.

One of the most striking aspects of Rembrandt's emulation of the masters of the Italian Renaissance is the way he uses his name. The practice among Dutch painters was to sign with their last names, preceded sometimes by the first name (with or without patronymic) in initial or in full.

In Leiden, Rembrandt departed from this, probably in imitation of Lievens, by adopting the Latinized RHL, for Rembrandus Harmenni Leidensis. In his first year in Amsterdam he experimented with the bastard form RHL van Rijn, but from 1633 on signed himself with his full first name only, the way Italian masters like Tiziano Veccelli often did.

it, he also picked a persona for Saskia from another Titian in the Lopez collection – a courtesan, which was also copied by Sandrart. The original (Florence, Uffizi), which was known at the time as *Flora*, shows a woman in a loose white blouse falling off the left shoulder to show her breast, with flowers in her extended right hand. Rembrandt buttons Saskia up and makes her look less available than Titian's model, but there can be no question that once more he has cast her in the role of the purchasable woman (fig. 233).

THE DAUGHTER AND SON-IN-LAW OF A BURGOMASTER | Rembrandt was not so jealous of his 'Ariosticity' that he was unwilling to share it with his associates (Bol used it for several portraits and possibly even self-portraits) and his sitters, bourgeois and patrician alike. Thanks again to the golden touch of Isabella van Eeghen, the identity of the patrician sitters is now pinned down: they were

232 Reinier Persijn (1615-1668) after Joachim von Sandrart (1606-1688) after Titian (ca. 1480-1576), *Portrait of a man,* formerly called *Ludovico Ariosto.* Inscribed *Ioachimus Sandrart del: et excud. Amsterd: E Titiani Prototypo in aedibus Alph: Lopez* (Joachim Sandrart, draftsman and publisher, in Amsterdam, after a Titian model in the house of Alphonso Lopez). Engraving, 26.1 x 19.7 cm. Amsterdam, Rijksprentenkabinet.

Sandrart was extraordinarily successful in Amsterdam in the late 1630s and early '40s, until he left for the court of Bavaria in 1644.

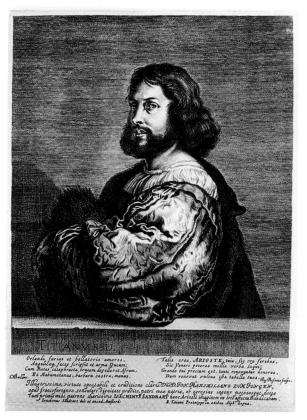

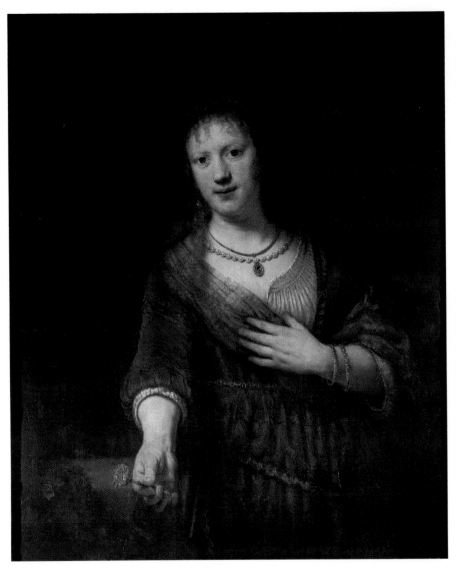

233 *Saskia with a flower*. Signed indistinctly and dated 1641. Panel, 98.5 x 82.5 cm. Bredius 108. Dresden, Gemäldegalerie.

Modelled on a courtesan portrait by Titian entitled *Flora* in the Lopez collection, with the lewdness removed. It was to be Rembrandt's last portrait of his wife during her lifetime.

Nicolaes van Bambeeck (fig. 234) and Agatha Bas (fig. 235). Their presence in the roster of Rembrandt's patrons confirms something that the *Nightwatch* had already given us reason to suspect: after a gap of several years, Rembrandt was once again being helped to patronage by Hendrick Uylenburgh. As we know, van Bambeeck was one of the main investors in the Uylenburgh shop, carrying him and his son with a loan that remained on the books through good times and bad. We can also trace his ties to Uylenburgh from the fact that he had portraits of himself and his wife painted not only by Rembrandt but also by Govert Flinck. To cap it all, one of the civic guard portraits flanking the *Nightwatch* was the *Company of Albert Bas* – Agatha's brother – painted by Flinck.

Van Bambeeck came from a wealthy Leiden family of traders in Spanish wool. Until his move to the Kloveniersburgwal, he lived further down the Breestraat, closer to the new city walls.

The Amsterdam background in the marriage was provided by Agatha. She was the daughter of Dirck Bas (1569-1637), thirteen times burgomaster between 1610 and 1637, one of the founders of the Dutch East India Company and trader with Russia. Bas had had himself painted with his family in 1634 by Dirck Santvoort, whose father was a guild official.

Unfortunately lost is a double portrait painted by Rembrandt in 1642 of one of the directors of the Dutch West India Company, Abraham Wilmerdonx and his wife, also near-neighbours of the artist. According to a statement he made in 1659, he paid Rembrandt 500 guilders for the painting and 60 guilders for canvas and frame. The van Bambeeck-Bas pendants will not have cost less than that. For the moment, Rembrandt was back on top.

THE FRAMEMAKER AND HIS WIFE | The bourgeois sitter whom Rembrandt dignified with the

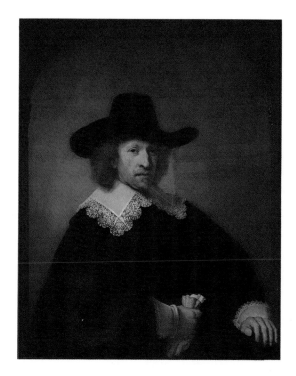

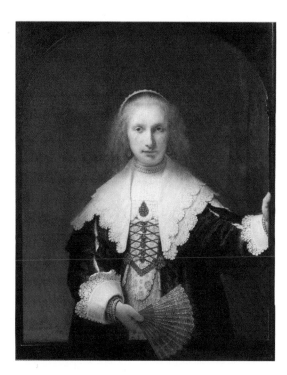

234 *Nicolaes van Bambeeck (1596-1661)*. Signed *Rembrandt f. 1641*. Inscribed *AE*[tatis] 44. Companion to fig. 235. Canvas, 105.5 x 84 cm. Bredius 218. Brussels, Musée Royal des Beaux-Arts.

235 *Agatha Bas (1611-1658)*. Signed *Rembrandt f. 1641*. Inscribed *AE*[tatis] 29. Canvas, 105.2 x 83.9 cm. Bredius 409. Companion to fig. 234. London, Buckingham Palace, collection of Her Majesty Queen Elizabeth II.

The male portrait owes its dignified form to Rembrandt's new acquaintance with a type coined by Titian in the early sixteenth century. Even the painted frame, with the sitter resting his elbow on it, is derived from that model.

If we take the ages and dates on the paintings literally, that of Agatha must have been done between January 1 and February 6, 1641, and that of Nicolaes between January 1 and May 14. The commission for the pendants is most likely to have been given in late 1640, around the same time as that for the *Nightwatch*.

The companion portraits were together until they were auctioned separately at Christie's on June 29, 1814. The differences in their colouring today reflect the influence of one hundred and seventy years of care by different owners.

Titianesque pose was Herman Doomer, an Amsterdam maker of ebony frames and, in a process which he patented in 1641 with his son Mattheus, of printed whalebone. Doomer and his wife Baertjen Martens were among the simpler of Rembrandt's sitters, although they were not poor, and they were terribly proud of their portraits by the great master (figs. 236-237). In Baertjen's will of 1662, she left the originals to her painter son Lambert on the condition 'that he provide each of his brothers and sisters with a copy, at his own expense,' and that upon their deaths the copies be returned in order to be presented to the grandchildren.

Lambert Doomer (1624-1700) began working under Rembrandt around this time, and we may guess that the painting of these portraits was part of the agreement between his father and Rembrandt. Herman Doomer, although he was not a Mennonite, was connected to that small world. His son Mattheus was married to the daughter of the painter and art dealer Lucas Luce (1575-1661), who worked with Hendrick Uylenburgh as an appraiser from 1639. The first such document concerns their joint appraisal of the collection of the Mennonite Cornelis Rutgers, which included two Rembrandts, including 'an oval portrait of a girl, in an ebony frame... 50 guilders.' There are paintings from the Uylenburgh shop made in the first half of the 1630s that have whalebone frames that were presumably delivered by Doomer. Not that Doomer invented the whalebone technique, which was considered a cheaper alternative to ebony. He learned it from an Englishman named John Osborn, who in 1626 collaborated with the goldsmith Johannes Lutma in making carved whalebone portraits of Frederik Hendrik and Amalia van Solms.

In the Doomer family, Rembrandt found not only a talented assistant, portrait sitters and probably a framemaker, but probably also customers for his paintings: the estate of Lambert Doomer contained four face paintings, two histories and a drawing by Rembrandt in addition to the portraits of his parents.

CORNELIS' VOICE | The final sitters of 1641 are from the dead centre of Uylenburgh's world: the preacher of his own church and his wife, Cornelis Claesz. Anslo and Aeltje Gerritsdr. Schouten (fig. 238). In 1641 the tie between Uylenburgh and his church became particularly close: on April 22 he took out a loan of a thousand guilders from the Waterland Congregation, secured by 125 etching plates. That year Rembrandt also made an etched portrait of Anslo alone. Both works were prepared by drawings of 1640. It is hard not to see these works in some connection with Uylenburgh's loan, and we are drawn towards the view that Rembrandt was once again employed by Uylenburgh. Rembrandt had not painted a Mennonite sitter since the early thirties, and Anslo was the last for a long time to come.

The Mennonites did not have ordained preachers. The most gifted interpreters of the Word led the congregation and delivered sermons at services. For the Waterlanders, this function was filled in Leeuwarden by Lambert Jacobsz. and in Amsterdam by Anslo. As Jan Emmens has shown, both the print and the painting give expression to

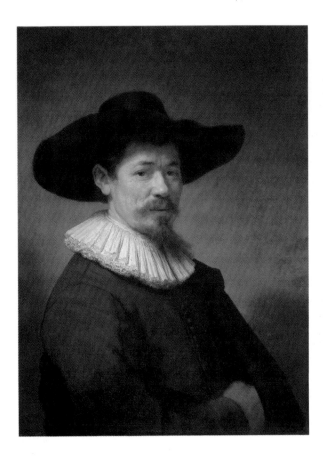

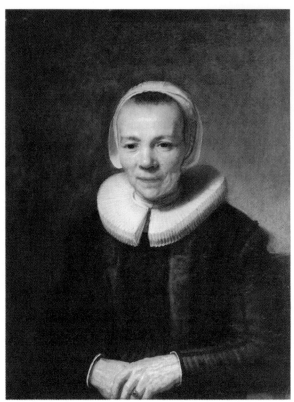

236 *Herman Doomer (1595-1650)*. Signed *Rembrandt f. 1640*. Companion to fig. 237. Panel, 75.2 x 55.2 cm. Bredius 217. New York, The Metropolitan Museum of Art.

237 *Baertjen Martens (1596-1678)*. Signed *Rebrandt* [not Rembrandt] *f*. Companion to fig. 236. Panel, 76 x 56 cm. Bredius 357. Leningrad, Hermitage.

Herman Doomer is one of Rembrandt's first known portraits of a professional associate – a framemaker and the father of a young man who worked with Rembrandt. For years, Rembrandt had been doing business of various kinds with the parents and other relatives of apprentices and assistants, and we can regard that as a normal part of the relationship between a master and his junior associates. He also painted the portrait of Bol's father, who died in 1641.

the Mennonite faith in the primacy of the spoken word as the medium of the divine message. In the print, a painting that hung behind Anslo's chair has been taken off the wall and turned around. Theoretically, this attitude is half way to iconoclasm, but in practice the Mennonites tended to be enthusiastic collectors of religious art.

Joost van den Vondel, who had been a member of the same church as his in-law Anslo earlier in his life, put the thought into a poem – the only one of his entire and large oeuvre, containing well over a hundred poems on works of art, devoted to a Rembrandt painting.

That's right, Rembrandt, paint Cornelis' voice!
His visible self is second choice.
The invisible can only be known through the word.
For Anslo to be seen, he must be heard.

Rembrandt indeed shows Anslo speaking, with his hand extended. The gesture worked so well that Rembrandt used it for other speaking figures as well: Frans Banning Cock and Abraham sending Hagar and Ishmael into the desert (fig. 239).

BIBLICAL HISTORIES OF 1640-1642 | Rembrandt's work on the *Nightwatch* did not stimulate a fresh

creative outburst in his production of history paintings. Only three or four smallish paintings from this period are generally accepted, the largest of which is only about a fifth of the size of *Samson's wedding* of 1638. The three paintings from 1640 are the *Dismissal of Hagar* (fig. 239), the *Visitation* (fig. 241) and the *Holy family* (fig. 242). Coming after the large, unprecedented works of the later 1630s, they look somewhat conventional. One of the subjects, Hagar, recurs in an inventory of 1671 which makes us pause for thought. Among the possessions of Nicolaes van Bambeeck Junior, there is 'an Abraham and Hagar by a disciple of Rembrandt.' One wonders whether it could not be identical to fig. 239, which cannot be traced further back than 1749. On the other hand, Flinck also painted the subject in 1640.

The *Meeting of Mary and Elizabeth*, a subject usually called the Visitation, found its way by 1662 into the collection of the burgomaster of Goes, Hieronymus van der Straten, who valued it (at cost price?) at 800 guilders. The document revealing this was first discovered in 1978, and its consequences have not yet been investigated but they promise to be very interesting. I look forward in particular to information concerning possible family connections between Hieronymus and Maria van der Straten,

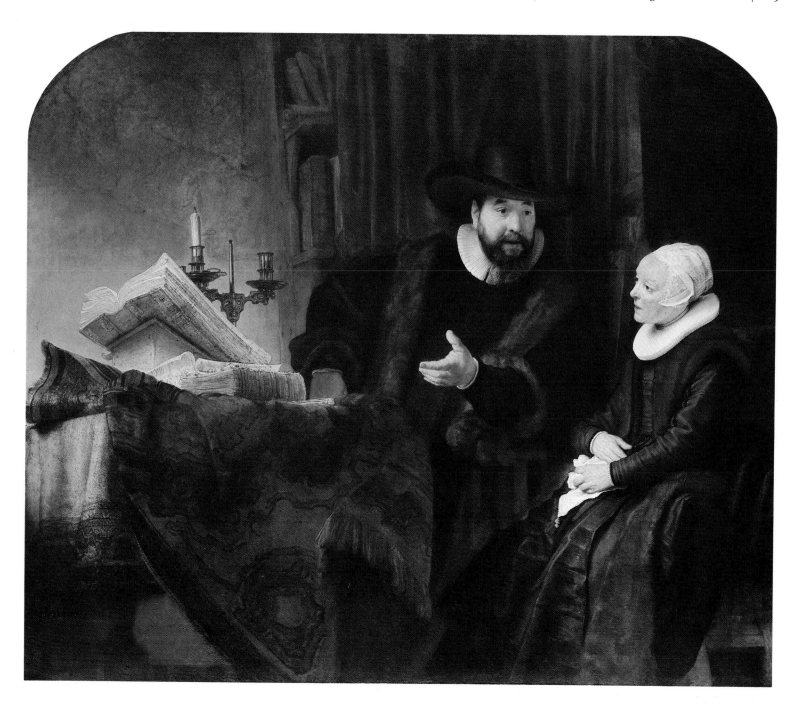

238 *Cornelis Claesz. Anslo (1592-1646) and his wife Aeltje Gerritsdr. Schouten (1598-1657).* Signed *Rembrandt f. 1641.* Canvas, 176 x 210 cm. Bredius 409. Berlin-Dahlem, Gemäldegalerie.

The painting remained in the sitter's family for a hundred and fifty years. The great-grandson of Cornelis and Aeltje, Cornelis van de Vliet, wrote these touching words on the sitters and the painting in 1767:

'Cornelis Claesz. Anslo… was well-known for his vocation as preacher, and was universally renowned through his portrait, skilfully etched by Rembrandt, of which I own an impression. I also own the portrait of him and his wife Aeltje Gerritsdr. Schouten, whom Rembrandt depicted inimitably well in a single painting… He was a well-to-do man, dealing… in cloth and other products. He also engaged in overseas trade, especially with Sweden and the Baltic, and in the shipping business. Although the sails of his ship of mortal life billowed with the winds of prosperity, he nonetheless remained very humble and pious, and at the same time respectable and respected. He practiced his religion as a churchman, not only for himself, his wife, children and the rest of his household, but even, despite his many temporal occupations, preaching the gospel in public… He filled the office of teacher or minister of the Mennonites out of love and with dependability. For this he earned neither a salary nor any other material advantage. He was so dedicated to this work, that the fruits of his faith and religion not only nourished, and were relished by, his listeners, but he deposited the seed within his wife and children as well. And this is how he is portrayed so amazingly well in the above-mentioned painting, speaking to his wife about the Bible lying open before him on a table. She, depicted with incomparable art, listens to him attentively and with visible concentration.'

whose son Willem married Theodora van Bambeeck, the daughter of Nicolaes. The next known owner of the painting was the king of Sardinia, a part of the world where the clan of the van Bambeecks and van der Stratens did a lot of trade.

The *Holy family* (fig. 242) was sold at the Isaac van Thye sale in Amsterdam in 1711 for 900 guilders, an indication that the handful of paintings from the early forties remained highly appreciated. Although there is no proof in the matter, I would identify the painting as one of the five Rembrandts traded in 1647 by Martin van den Broeck under the title the 'Wetnurse.' Van den Broeck, we recall, was the brother-in-law of Oopjen Coppit and Maerten Soolmans, whom we have tentatively identified as the first owners of the *Holy family* in Munich (fig. 175). These are the only paintings by Rembrandt showing a nursing woman, and it seems to make sense to think of them as having been painted upon special request. If fig. 242 is van den Broeck's 'Wetnurse,' it may have been the only history painting Rembrandt sold to an Amsterdam collector for six years, until his presumed sale in 1646 of *Abraham with the angels* – again to van den Broeck. The other histories of this time either stayed in his possession or went to dealers. However, all such conclusions have to be qualified emphatically, since the evidence on which they are based is incomplete and inconclusive. On the other hand, these uncertainties apply equally to all the periods of Rembrandt's life, so the picture we are left with, defective as it is, is probably accurate as a relative indication of how and to whom Rembrandt was selling his works at the various stages of his career.

THE CONCORD OF THE STATE | Surely the most remarkable of the paintings Rembrandt failed to sell was the grisaille he called '*De eendragt van 't lant*' (The concord of the state), a pure political allegory that can only have been designed for some specific function and was apparently never used (fig. 243). As the reader can imagine, the problems presented by this work have given rise to endless discussion. With some trepidation, I will take the risk of bypassing the old interpretations and presenting a new one – not of the meaning of the allegory, but of the function of the grisaille.

On May 12, 1641, Frederik Hendrik married his only son Willem to Mary, the oldest daughter of Charles I of England. This development was not greeted happily in Amsterdam, where most of the regents were fearful of the royal pretensions of the house of Orange. However, the gentlemen decided to applaud what they could not prevent, especially

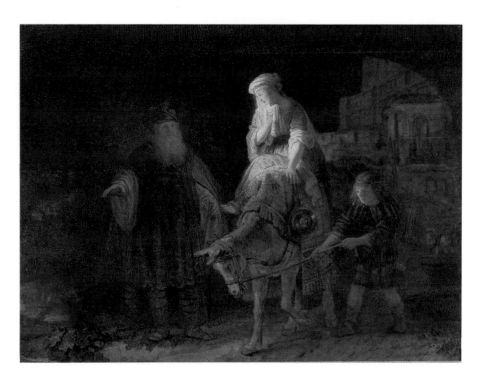

239 *Abraham sending off Hagar and Ishmael* (Genesis 21:9-14). Signed *Rembrandt f. 1640*. Panel, 39 x 53 cm. Bredius 508. London, Victoria and Albert Museum.

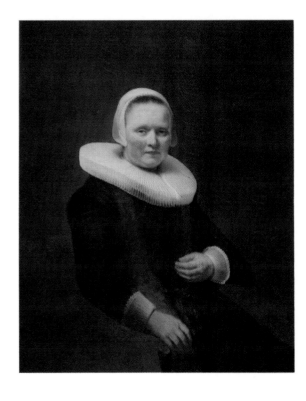

240 *Anna Wijmer (1584-1654)*. Signed *Rembrandt f. 1641*. Panel, 96 x 80 cm. Bredius 358. Amsterdam, Six collection.

Because of its presence in the Six collection, the painting is identified as a portrait of Jan Six's mother, Anna Wijmer, who was fifty-seven years old in 1641. The Six family is convinced that the traditional title is accurate. Miss van Eeghen's research into the history of the painting has however led her to conclude that the identity of the sitter is mistaken. See also fig. 303.

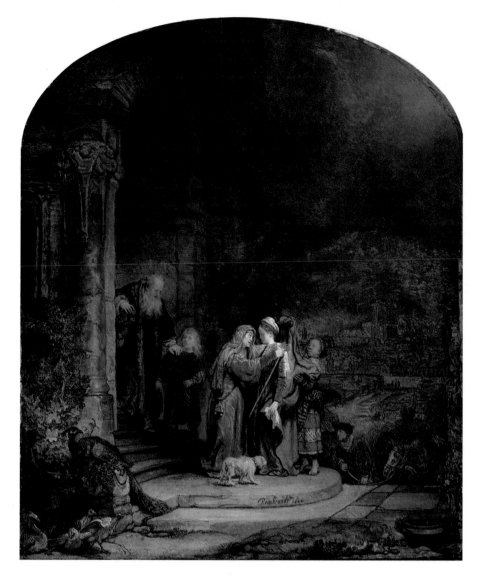

241 *The meeting of Mary and Elizabeth (The visitation)* (Luke 1:39-55). Signed *Rembrandt 1640*. Panel, 56.5 x 47.9 cm. Bredius 562. Detroit, Institute of Arts.

Stories of the nativity and infancy of Christ were to account for nine of the ten New Testament paintings from 1640-1647. The first owner of this work was the burgomaster of Goes, whose relationship with the artist remains to be demonstrated, but which may have been through Nicolaes van Bambeeck.

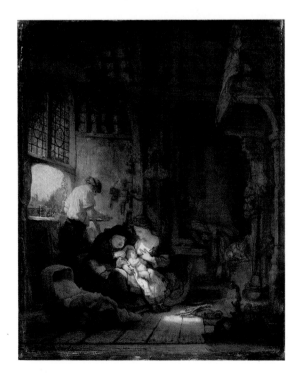

242 *The holy family*. Signed *Rembrandt f. 1640*. Panel, 41 x 34 cm. Originally rounded at the top and measuring 37.5 x 34 cm. Bredius 563. Paris, Musée du Louvre.

Known since the eighteenth century as 'Le ménage de menuisier,' the household of the furniture maker. The frequently noted absence of overt references to divinity strengthens my supposition that this is the painting called the 'Nursemaid' owned in 1647 by the silk merchant Martin van den Broeck, the brother-in-law of Maerten Soolmans and Oopjen Coppit, the owners of Rembrandt's only earlier painting of the scene.

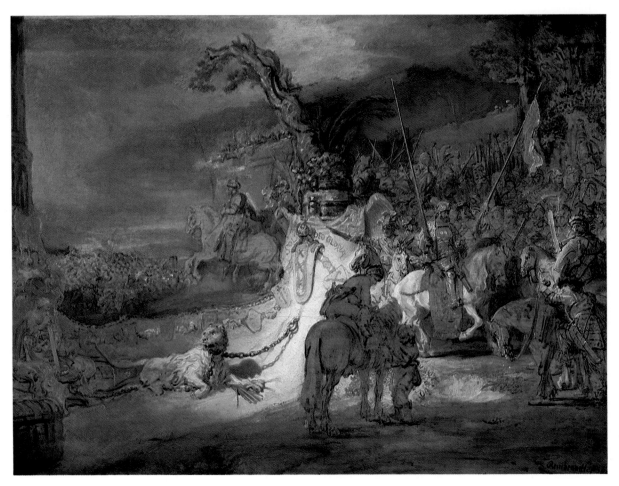

243 *The concord of the state (De eendragt van 't lant).* Signed *Rembrandt f. 164[.].* Ca. 1642. Panel, 74.6 x 101 cm. Bredius 476. Rotterdam, Museum Boymans-van Beuningen.

Sketchlike paintings of this kind were often made as models either for etchings or for larger decorative works. The *Concord of the state* is too large to have been made for an etching, but it fits well into the most conspicuous pageant being mounted in Amsterdam in the period when it originated: the joyful entry of Henrietta Maria, Frederik Hendrik and their children, the royal couple Willem and Mary.

Historically, joyful entries were demonstrations by the people and government of a city of their attachment to their liege lord, from whom they in turn expected a confirmation or extension of his obligations towards them. In the Republic, the entry was less specific in meaning, but just as fraught with overtones of ancient privileges and their present-day implications. A reconstruction of the preliminaries to the entry of 1642 may prove or disprove my theory that Rembrandt's *Concord of the state* is from a discarded early stage in the plans.

when it turned out that the marriage was to give them more of a hold over their trade competitors in England, when the king turned for financial aid to the merchants of Amsterdam. Early in 1642, his queen Henrietta Maria, the daughter of Maria de Medici, fled to Holland with the young couple and the royal jewels, as civil war broke out in England. Amsterdam arranged another joyous entry, for Henrietta, Willem, Mary and this time Frederik Hendrik as well. It was the prince's first and last ceremonial visit to the greatest city in his country, and even then he came not on his own but as the father of his son, with his royal mother-in-law.

The entry, which took place on May 20, 1642, and the coming days, was essentially a repetition of that of Maria de Medici: in the illustrated publications of events by Pieter Nolpe (plates) and Samuel Coster (text; Coster also designed the allegories), we read of the same troop of young cavaliers riding out to greet the party on the road, the same reception by the same Andries Bicker at the Haarlemmerpoort, and so on. The allegorical tableaux were devoted to themes from the history of the Republic in divine or legendary form. One was the redemption of the nation (as Andromeda), another the salvation of the nation (by William the Silent as Arion).

The designs were painted, in a loose imitation of

Moyaert's work for the entry of Maria de Medici, by a monogrammist who signed himself I.W. He is usually identified as Jacob de Wet, although it has surprised some that such a commission would have been given to an artist from Haarlem. What is perhaps more important than the artist's home town is the fact that de Wet, like Moyaert, was one of the shareholders in the shop of Hendrick Uylenburgh. In the early 1640s, there was hardly a lucrative commission to be had from Amsterdam by an artist who had not paid his dues to Uylenburgh. (What was the real purpose of all those loans Uylenburgh was always taking from artists?)

The one oil sketch for the entry that has been preserved, an *Andromeda* in the Rijksmuseum, is smaller than the *Concord of the state* but has the same proportions. The subject of Rembrandt's work, which we can interpret broadly as a glorification of the role of Amsterdam and its civic guard in sustaining the armed might of the Republic, is somewhat less bland than the ones that were eventually chosen, but it certainly fits into Coster's general scheme.

If the *Concord of the state* did come into the world as a design for an allegorical tableau, as I am suggesting, then it never filled its intended function. Some time before May 1642, the painting and

Rembrandt with it, were eliminated from the proceedings. In fact, we do know from other evidence that Rembrandt's relationship with Uylenburgh entered its terminal phase in those very months. The break was undoubtedly due partly to the death of Saskia in June, but that is not the entire explanation, as we shall see.

SASKIA'S DEATH | On June 14, 1642, Saskia died, leaving Rembrandt and the nine-month-old Titus behind. She left them with a bond of more than normal strength because the provisions of her will, made ten days before her death, tied the father to the son.

When she and Rembrandt drew up a joint will in 1635, shortly before the birth of Saskia's first child, each left to the other all their possessions except for two thousand guilders for Rembrandt's mother, if he died first, or Saskia's sisters Hiskia and Titia, if she did. In 1642, by contrast, Saskia left everything she owned to Titus and not a penny to Rembrandt. Since everything the couple owned belonged to them jointly, this meant that Rembrandt could never again claim sole possession of anything he owned at the time of Saskia's death. She made Rembrandt executor of the will and appointed him guardian of Titus, but after Rembrandt's bankruptcy in 1656, the Orphans' Court took over these tasks. The final settlement of Rembrandt's debt to Titus did not take place until November 6, 1665.

The stipulation concerning what would happen should Titus die without issue before his father tied Rembrandt down in a different way. In that case, upon Rembrandt's death or remarriage, Titus's share was to go to Hiskia and other of her relatives in Leeuwarden. At first Hendrick Uylenburgh was entrusted by the family to look after their interests, and when Rembrandt filed Saskia's will six months after her death, he declared himself in agreement with its provisions. He even waived the right of the heirs to demand that an inventory be taken of the goods of the deceased. By 1647 he had reason to regret this decision, and obliged Rembrandt to compile one at that point. (The document is unfortunately lost.) The Uylenburghs continued looking over Rembrandt's shoulder, and in 1656 Hiskia took Rembrandt to court in an abortive lawsuit. This new twist in the relationship between Hendrick and Rembrandt from 1642 on can only have led to increased tension.

THE BREAK-UP | In the year of Saskia's death, something drastic went wrong with Rembrandt's career, and probably his business relationship with Uylenburgh as well. The legend that the *Nightwatch*

FROM A LETTER BY CLAUDE VIGNON IN PARIS TO FRANÇOIS LANGLOIS, TRAVELLING TO ENGLAND AND HOLLAND IN 1641

Testimony to Rembrandt's international stature around the time of the *Nightwatch* is provided by this letter from one French painter and art dealer to another.

'You would do me a great favour, when in London, to greet Mr. Cornelis Poelenburgh, the celebrated painter, and other friends on my behalf. And if, by chance, the illustrious Mr. van Dyck has arrived there, send him my humble greetings and tell him that yesterday I was called upon to appraise the paintings belonging to Mr. Lopez, including some of Titian. Among them was the most exquisite portrait of Ariosto which will be sold this coming mid-December with many other splendid and curious objects. You will be notified of all this, and a catalogue, printed in England, will be dispatched. Sir, if you happen to think of it, when you pass through Holland, please greet Mr.

Moses van Wtenbroeck at The Hague, and take along some of his small landscapes. Also [try to] obtain paintings by Mr. Cornelio [Poelenburgh], which you can easily find in London and Utrecht. In the latter city greet Gerrit Honthorst and in Amsterdam give my greetings to Mr. Rembrandt and bring back something by him. Tell him also that yesterday I appraised his painting 'The prophet Balaam' which Mr. Lopez bought from him. This piece will be sold together with the ones mentioned above.'

The artists mentioned were all court painters to the stadholder. It would seem that in 1641 Rembrandt was still benefiting from his contact with Frederik Hendrik, although he had not received any new commissions from him in some eight years.

1641 also saw the first appearances of Rembrandt's

name in print: by Orlers (who makes no mention of Rembrandt's work for the court) and by Thomas Garzoni, who in his *Piazza universale* (Frankfurt), praises Rembrandt with Jacques Callot and Abraham Bosse as a practitioner of the 'amazing' art of etching.

was poorly received may have no support in the records, but there is proof of a serious disagreement between Rembrandt and Banning Cock's brother-in-law Andries de Graeff at the very time the painting was delivered. It concerns not the *Nightwatch* but the portrait of de Graeff (fig. 223). The sitter refused to pay for it. Now five hundred guilders was a lot of money, and Andries de Graeff was a notorious tightwad, but the price must have been agreed upon beforehand, so de Graeff had to have had some other reason to refuse payment.

My guess, and it is no more than that, is that during the preparations for Frederik Hendrik's visit it became apparent that Rembrandt was no longer favoured at court, which took away the whole point of hanging one's portrait by him on the wall.

The document concerning the de Graeff affair is a statement by Hendrick Uylenburgh from 1659, when the Orphans' Court was trying to reconstruct Rembrandt's financial position at the time of Saskia's death. Uylenburgh testified 'that he was one of the arbitrators in the dispute between Mr. de Graeff on the one hand and van Rijn on the other concerning a painting or portrait that the aforementioned van Rijn painted for the aforesaid gentleman, and that he and the other arbitrators decided that the aforesaid van Rijn should be paid

five hundred guilders by the above-mentioned Mr. de Graeff, which affair the attestant remembers to have occurred in the year 1642.'

Uylenburgh had nothing to gain from a break with the de Graeffs over Rembrandt. Apparently he did not have to, since his protegés Flinck and Backer continued to work for the de Graeffs and he himself benefited from their patronage during the magnificat of Cornelis de Graeff. But after 1642 there is no evidence that Rembrandt ever again worked for anyone who belonged to the clan in 1642, or for Uylenburgh.

The *Nightwatch* – and this could not have had less to do with what the common guardsmen thought of it as a painting – was Rembrandt's last group portrait until 1656 and his last portrait of anyone in Amsterdam politics until 1654, when he painted an ensign in the civic guard. That he was let back at all into the small circle of artists with municipal patronage I would attribute to a single new development: in 1645 Cornelis and Andries de Graeff got a new brother-in-law, who in 1653 became a captain in the guards and in 1656 a member of the council. That was Willem Schrijver, Rembrandt's old schoolmate and the son of Petrus Scriverius.

244 *The reconciliation of David and Mephiboseth* (2 Samuel 21:7 and Flavius Josephus, *Jewish antiquities*, book 7, chapter 10). Signed *Rembrandt f. 1642*. Panel, 73 x 61.5 cm. Bredius 511. Leningrad, Hermitage.

The previous identifications of the subjects as David and Absalom or David and Jonathan have always left art historians with an unsatisfied feeling. Perhaps this new suggestion will stand the test of criticism better. In any case, it is anchored in Rembrandt's immediate surroundings, and fits the details of the painting better than the others.

In 1641 Joost van den Vondel's play *Gebroeders* (The brothers), dedicated to Professor Gerard Vossius, was put on in the new Amsterdam theatre. Vossius' son Isaac had helped Vondel with a translation of Sophocles' *Electra* in 1638, an exercise in Greek theatre that Vondel found very inspiring. Until then, the highest forms of European drama followed the conventions established by the Roman tragedian Seneca. Vondel now took the important step of returning to the Greeks. In the classical Greek drama, the action is confined to one day and the number of characters is limited to the barest minimum. Vondel now applied its principles to a Biblical theme. *Brothers* was the first such play ever written.

The playwright 'combed through Scripture' searching for a Biblical equivalent of the story of Electra. He found it in the episode of David and the Gibeonites. David's predecessor Saul had once perpetrated a murder on members of this Canaanite people, who were protected by an old pact with Joshua. As a result, years later, God punished Israel with a drought. When David found out what was causing the scourge, he asked the Gibeonites if there was anything he could do to atone for Saul's crime. They demanded the blood of Saul's descendants, and David had no choice but to comply. The only one he spared was the son of his bosom friend Jonathan, the lame

Mephiboseth. There are no stage instructions in the printed play, but David's last speech certainly seems to call for an embrace: 'Stand up, cousin, stand up: you've already said enough... Now dry and wipe your eyes... Follow me to court. I'll be your support.'

Apart from the pictorial language of the painting, which fits this story better than that of David and Jonathan, there is one otherwise inexplicable detail which lends strength to the new identification: the younger figure in the foreground of Rembrandt's painting is wearing spurs, and there is a noticeable difference between his two legs. Almost all we know about Mephiboseth is that he was lame and rode on a donkey.

Brothers, written in 1639, was published in 1640 and not put on the stage until April 8, 1641. It played eleven more times in the course of the year, on one occasion in the presence of the burgomasters. The play served Vondel as an instrument on behalf of the Academie, one of the literary chambers to which he belonged. The roles of David and Mephiboseth were filled by two men who were themselves playwrights: Jan Lemmers and Isaac Vos.

In the Rembrandt documents there occurs only one painting that seems to match up with the panel in Leningrad. In 1659 Rembrandt promised his creditor Lodewijk van Ludick to finish for him within a year 'a painting depicting the story of Jonathan and David, which he has already started.' The next reference is in the inventory of Harmen Becker, who we know bought several paintings by Rembrandt from van Ludick. Thereafter we find it in the collections of Laurens van der Hem and Jan van Beuningen before it was bought in 1716 for eighty guilders by Osip Solovyov for Tsar Peter the Great.

I would reconstruct the sequence of events thus: in 1642 Rembrandt painted the closing scene of *Gebroeders* for an unknown patron. When it was completed, the patron refused to accept it, and Rembrandt was stuck with it.

Some time before the sale of his goods in 1656, he sold the painting to van Ludick, on the condition that it be repaired and touched up. (The upper edge shows signs of bad damage, and has been repaired with three inserted pieces of wood.) Rembrandt's memory of the exact subject had become blurred by then, and he described it to van Ludick as David and Jonathan.

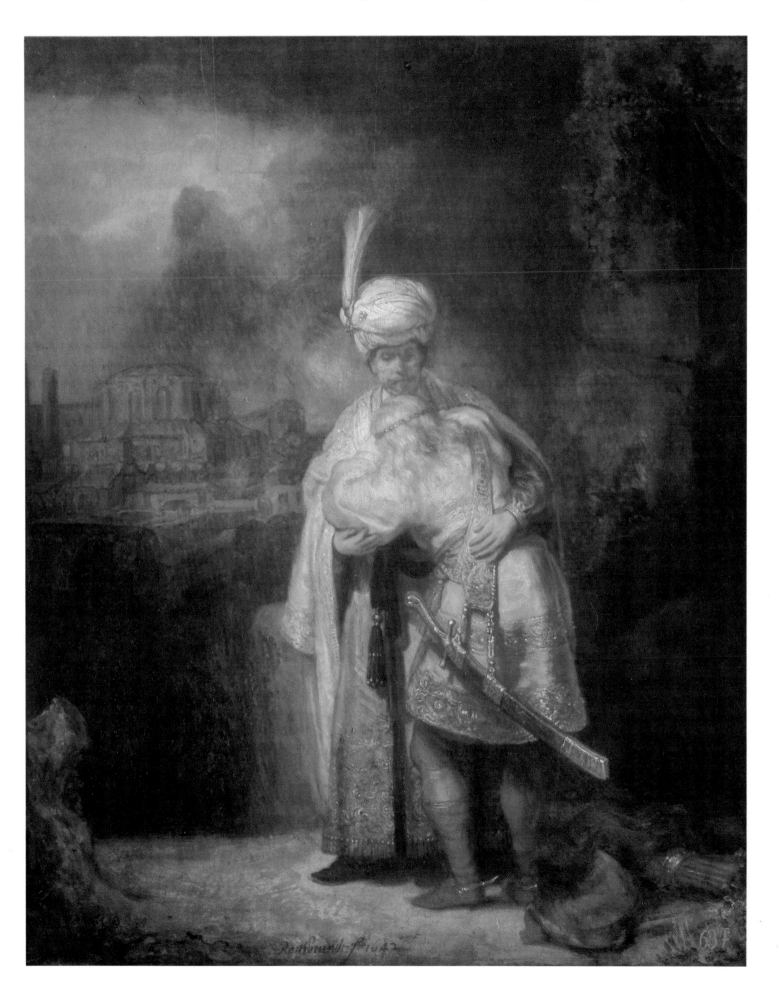

After the Nightwatch

Until now, we have been able to follow Rembrandt's life through his paintings. The succession of sitters, purchasers and protectors has shown so many points of contact with the rest of his life that we have not had to distinguish between our biography of Rembrandt and our account of his career as a painter. For about eleven years after 1642, that is not the case. With a few exceptions, the faces in Rembrandt's paintings of those years are nameless, the histories ownerless. In that entire decade, there are fewer paintings that look like commissioned portraits than in the single year of 1641. Two depict artist colleagues, one with a companion portrait of his wife, and one is a preparatory sketch for an etched portrait of a Jewish doctor.

Of the old sources of patronage, only one is in evidence in the 1640s: in 1646 Rembrandt painted two biblical histories for Frederik Hendrik. Otherwise, there are few known or suspected commissions, and no sign of spontaneous interest in Rembrandt on the part of old or new patrons. Not even Joannes Wtenbogaert (who married three days before Saskia's death) is on the scene. The provenances of the paintings seldom can be traced back to the seventeenth century, and the eighteenth-century records contain hardly any hints of the kind that have allowed us to place other paintings in a certain milieu.

The only first owners we are able to identify, apart from Frederik Hendrik, are two Amsterdam art dealers: Johannes de Renialme and Lodewijk van Ludick. Other new acquaintances of his were the art dealer Pieter de la Tombe and the broker Adriaen Hendricksz. van Wees. It looks like most of Rembrandt's paintings from 1642 to 1654 were done at his own risk for the market. With one exception (fig. 275), the subjects are of a uniformity and simplicity that would lend themselves to this: about half the histories depict the infancy of Christ, and the rest Christ and the woman in adultery, Christ and the Magdalene, Bathsheba bathing and Susanna

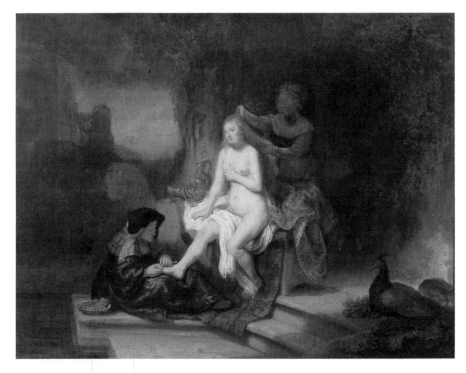

245 *Bathsheba bathing.* Signed *Rembrandt f. 1643.* Panel, 57.2 x 76.2 cm. Bredius 513. New York, The Metropolitan Museum of Art.

Derived from a Pieter Lastman painting of 1619 and composed of elements that do not fit together convincingly. The painting has been doubted by Gerson, and does not inspire great enthusiasm for its qualities as a work of art. However, its authorship by Rembrandt is supported by outside evidence, such as the

fact that it was copied by Gijsbert Sibilla, who around 1645 copied other works by Rembrandt. For the painting of this subject made by Salomon Koninck for Lodewijk van Ludick, see caption to fig. 248.

bathing. The figures are all either old men with fur coats and berets or young girls with brooms, at windows or half-doors or in bed. A preponderance, in other words, of sentiment and sex. The only documented sale of the period was of the *Susanna*, to a merchant named Adriaen Banck, for five hundred guilders in 1647.

Rembrandt's life during this period is poorly documented, and we are able to follow only a few of its strands: his activity as a teacher; his tragic love affair with Geertge Dircx; his legal problems with the Uylenburghs; the commission for two last paintings for Frederik Hendrik; the gradual recovery of his reputation after 1645.

REMBRANDT'S PUPILS | Ben Broos was I believe the first, in 1983, to take strenuous objection to the term 'Rembrandt school' for the fifty-five or so artists whose work shows 'Rembrandtesque' features or whose paths in life followed (or led) his. I need only sum up Rembrandt's relationship to those of his 'school' we have met so far to demonstrate how right he is.

Jan Lievens, who was an independent master even before Rembrandt entered the studio of Jacob van Swanenburg, probably extended to Rembrandt the hospitality of his studio and the services of his father as a picture-seller.

Gerard Dou became Rembrandt's apprentice only after being trained as a stained glass artist and was soon collaborating with Rembrandt. At least one work by Dou (and several by Lievens) was brought out as a composition by Rembrandt.

Isaac Jouderville probably served his first apprenticeship with Rembrandt, and stayed on with him as an assistant for several years after it ended.

Jan Jorisz. van Vliet was an independent etcher from Leiden who collaborated with Rembrandt in transferring compositions to the printing plate, in Leiden and Amsterdam.

Dirk Santvoort was a master painter when Rembrandt met him in the early 1630s. He made several copies and adaptations of Rembrandt compositions in the 1630s. He and his father were officials of the Amsterdam guild of St. Luke.

Salomon Koninck was a mature master, a pupil of Pieter Lastman's Remonstrant brother-in-law François Venant, when he subordinated himself to Rembrandt's artistic direction, starting in the early 1630s. His relatives traded in copies after Rembrandt paintings.

Jacob Adriaensz. Backer, a Mennonite, later Remonstrant pupil of Lambert Jacobsz. whose arrival in Amsterdam coincided roughly with Rembrandt's. Worked under Uylenburgh.

Govert Flinck, another Mennonite, later Remonstrant pupil of Lambert Jacobsz. who probably succeeded Rembrandt as the artistic director of the Uylenburgh academy, appropriating Rembrandt's style, compositions and patrons in the process.

Jacob de Wet, a Haarlemer who invested in Uylenburgh's business, which apparently bought him the right to borrow and copy works by Rembrandt on his own (the difference between such adaptations and those done under Rembrandt's supervision is unmistakeable).

Jacob van Spreeuwen, a Leidener in the same position as de Wet.

Ferdinand Bol had been fully trained as a painter in Dordrecht by Jacob Cuyp before joining up with Rembrandt as an assistant, after the latter had left Uylenburgh.

Lambert Doomer, the son of a framemaker who probably had business connections with Uylenburgh and Rembrandt and whose own relationship with the master is vague.

Few of these artists received their initial training from Rembrandt or were dependent on him, while many of them traded in his works or in copies after them, thereby making him to some extent dependent on them. Rembrandt's relationship with

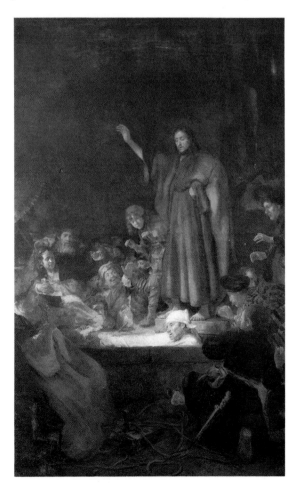

246 Carel Fabritius (1622-1654), *The raising of Lazarus* (John 11:1-45). Signed *Car. Fabr.* Ca. 1642. Canvas, 210 x 140 cm. Warsaw, Museum Narodowe.

This combination of motifs from paintings and etchings by Rembrandt from several periods is more a demonstration of virtuosity by Fabritius than a typical product of Rembrandt's studio. Yet it shows how motifs and stylistic features could be transferred from master to pupil.

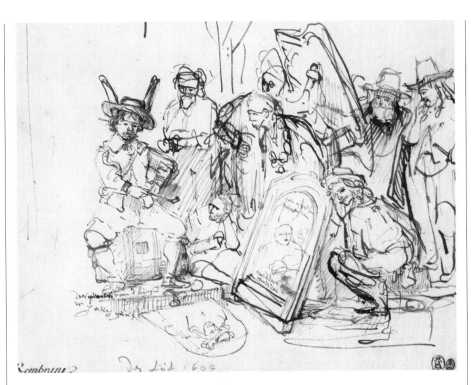

Rembrandt. den tijt 1644

CRITICISM AND RESPONSE

247 *The asinine art buyer.*
Inscribed with as yet
undeciphered text in the
picture, and below *den tijt
1644.* Pen and bistre, 15.6 x 20
cm. Benesch A 35a. New
York, The Metropolitan
Museum of Art (The Robert
Lehman Collection).

From 1642 Rembrandt faced a
new kind of criticism of his
work, far more serious than
the scattered complaints of
the preceding decades. In
1642, Andries de Graeff
refused to pay for his portrait.
(Even if his ulterior motives
were political, he must have
based his case on a rejection
of the painting as such.) A
biblical painting that was
apparently made to order was
rejected by the patron (fig.
244). And the *Nightwatch* was
also not received with
universal approval. The first
two writers to mention the
painting, Hoogstraten (1678),
and Baldinucci (1686), make
it plain that the painting was
the subject of controversy.
Hoogstraten says that 'in the
judgment of many,...
Rembrandt paid too much
attention to the grand design
he had invented and too little
to the particular portraits he
was commissioned to make.
And yet that work, to my
mind, will outlast all its
competitors, being so

picturesque in conception, so
graceful in the placing of the
figures, and so powerful, that
to some viewers the other
pieces look like playing cards.
Although I did wish that he
had illuminated it more.'
 Baldinucci, basing himself
on the report of Bernhardt
Keil, a Dane who, like
Hoogstraten, was in
Rembrandt's studio when the
Nightwatch was delivered,
says that the painting was
widely admired and brought
Rembrandt more fame than
almost any other painter,
thanks to the successful effect
of the figure marching out of
the painting, 'holding a lance
which, although no larger
than half a foot on the canvas,
looks to the eye as if it had its
full extent.' Yet, he adds, 'the
painting was so jumbled and
confused that it was hard to
see where one figure stopped
and the next one began,
although all were made most
diligently from life.'
 These remarks, it seems to
me, reproduce in capsule
form the initial reactions of
admirers and detractors of the
Nightwatch, rather than later,
revised views. They have the
ring of clichés that get
attached to works of art the
first time they are exposed to
critical view.
 All of this insult and injury,
coming on top of

Rembrandt's loss of Saskia,
must have hit hard at a man
who two years before had
seen himself as the rival of the
immortal Titian.
 There are two works from
1644 that I would interpret as
reactions to the criticism,
once Rembrandt had a chance
to digest it. The drawing in the
Lehman Collection, whose
secret is waiting to be
unlocked by the paleographer
who succeeds in reading its
text, looks to me like a
counter-attack on the
ignorant art buyers by whom
Rembrandt was now
confronted. On the other
hand, a painting like *Christ
and the woman taken in
adultery* can be seen as a
triumph for the maligned
style.

248 *Christ and the woman
taken in adultery* (John
8:2-11). Signed *Rembrandt f.
1644.* Panel, 83.8 x 65.4 cm.
Bredius 566. London,
National Gallery.

This work was valued higher
than any other single history
painting of Rembrandt. In
1657 it was in the estate of
Johannes de Renialme at an
appraised value of fifteen
hundred guilders. The next
known owner was Jacob
Jacobsz. Hinlopen, upon
whose death in 1705 the
painting was appraised at two
thousand guilders. From
there it went into the
collection of Willem Six,
whose family kept it, after it
failed to sell at auction in
1736, until 1803. Throughout
this period, and into the
nineteenth century, it was
considered a landmark.
Several of the individual
motifs in the painting were
copied and exploited
independently, and the
composition as a whole was
used by Gerbrant van den
Eeckhout and others.
 The role of the art dealers
de Renialme and van Ludick
in Rembrandt's work of the
1640s has never been
explained, but it was probably
profound, influencing not just
subjects but also style. A most
valuable clue concerning their

interests is found in the
biography of Salomon
Koninck, who had never been
far from Rembrandt's side
since 1632, in the *Gulden
Cabinet* by Cornelis de Bie
(1660): 'The well-known
art-lover Lodewijk van
Ludick owns, among others, a
David and Bathsheba [by
Koninck]. In 1646, for the
art-lover Johannes de
Renialme, he executed a
painting with small figures
and quite a lot of details,
depicting Christ calling
St. Matthew from the tax
office. For the same person he
also made a painting of Mary
with Joseph and St. Anne,
life-size.'
 The subjects and treatment
remind us of such
Rembrandts of the 1640s as
Bathsheba bathing (fig. 245),
*Christ and the woman taken in
adultery* (fig. 248) and the
several Mary and Joseph
depictions (figs. 250, 252,
253). Two paintings of Mary
and Joseph are known to have
been owned by de Renialme.
From what de Bie tells of the
relationship between de
Renialme and Koninck, the
assumption that these
paintings were commissioned
is a likely one. On the other
hand, Rembrandt kept at
least one painting of the
subject himself, as we know
from his inventory.

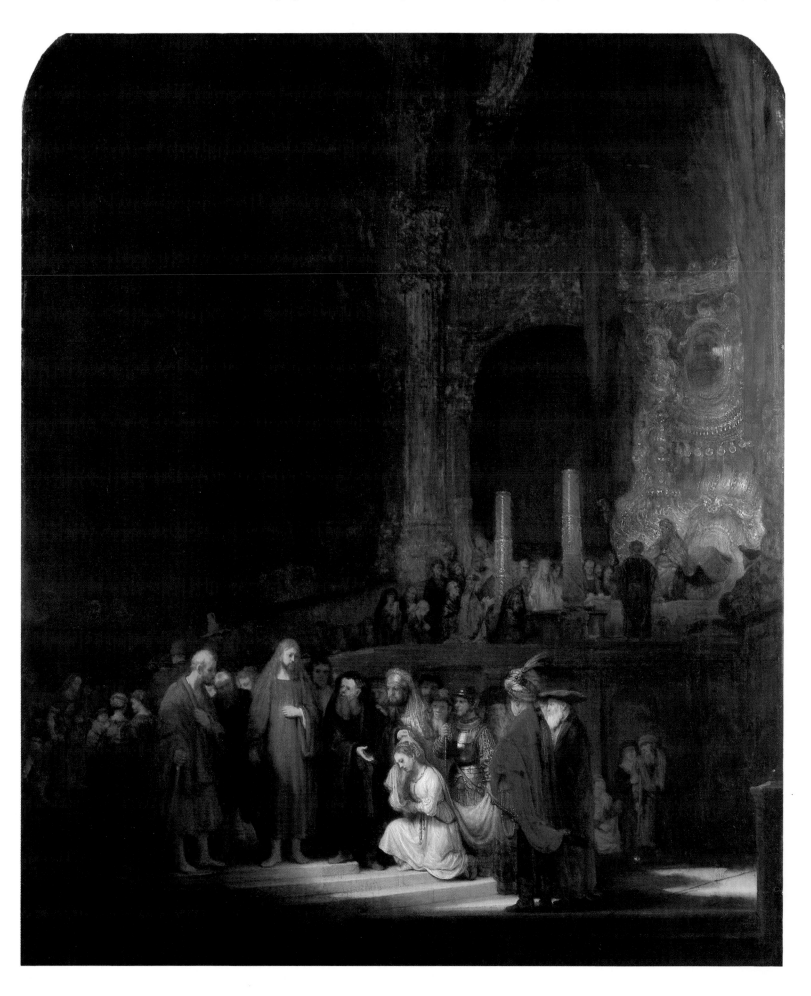

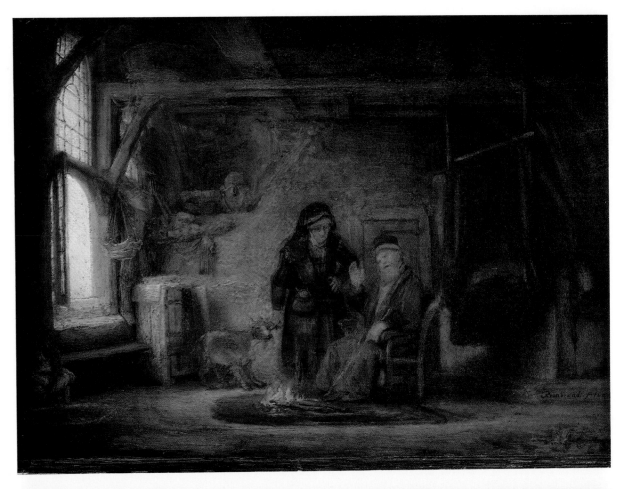

249 *Anna accused by Tobit of stealing the kid* (Tobit 2:20-23). Signed *Rembrandt f. 1645*. Panel, 20 x 27 cm. Bredius 514. Berlin-Dahlem, Gemäldegalerie.

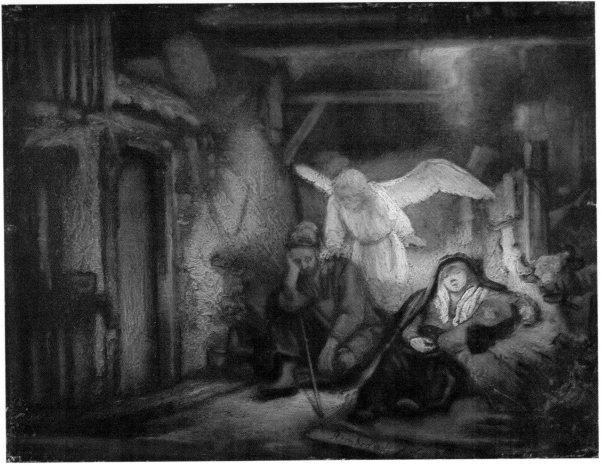

250 *Joseph's dream in the stable at Bethlehem* (Matthew 2:13). Signed *Rembrandt f. 1645*. Panel, 20 x 27 cm. Bredius 569. Berlin-Dahlem, Gemäldegalerie.

These two small works, which I would call oil sketches, are painted on identical mahogany panels and have been in Berlin together at least since 1786. The themes are unknown as a pair or part of a series, and I wonder whether they were not painted as alternative proposals for a prospective patron. The most likely one to come to mind is Johannes de Renialme, who was buying expensive works from Rembrandt at the time. He may well have wanted to approve before ordering. In the 1650s, de Renialme was selling – or at least offering – paintings to the Great Elector in Berlin, which may be how these panels got there.

each was different, and it can only confuse matters to speak of them as pupils in a school of Rembrandt.

The term 'Pre-Rembrandtist' for such artists as Venant, Pynas, Tengnagel and Moyaert is not only confusing but, to my mind, reprehensible, suggesting that their lives derive their significance from He who followed them. Insofar as they form a group, the common tie between them is certainly not Rembrandt.

Shortly before this point in Rembrandt's life, there is a noticeable change in the background of these associates. Bol was the first of a whole crew from Dordrecht, including Samuel van Hoogstraten, Nicolaes Maes and Aert de Gelder. Bol emerged later as a protégé of the Trips, who also moved from Dordrecht to Amsterdam. Since Rembrandt first worked for the Trips two or three years after Bol joined him, it is not impossible that Rembrandt was introduced to those important patrons by the younger man.

The milieu of each of these artists would have to be analyzed as thoroughly as we are attempting to chart those of Rembrandt before we can arrive at conclusions concerning their relationships with him. Should it turn out, for example, that the co-operation between Rembrandt and Bol in 1639 represented part of an approach on all fronts between the de Graeffs and their dependents to the Trips and theirs, there would be little point in discussing the phenomenon as a matter that mainly concerned the two artists. In any case, the ties between Rembrandt and these masters were far richer than that of a modern art teacher and his pupils, and we cannot do justice to them here.

Among the younger masters who worked with Rembrandt around 1640 were Carel Fabritius (1622-1654), Gerbrand van den Eeckhout (1621-1674) and Jurriaen Ovens (1623-1678). Fabritius was born in the Beemster, a newly reclaimed area of West Frisia that was administered for the city of Amsterdam by a succession of 'chief landowners,' among them Pieter Cloeck, the son of Allard Cloeck and the lawyer in the conflict between Uylenburgh and Rembrandt. Cloeck's successor in the Beemster was Karel Looten, a Calvinist brother of Marten's (fig. 125), and he was later succeeded by Dirk van Os (fig. 394). Fabritius is today considered Rembrandt's most original follower. Van den Eeckhout, the nephew of one of the musketeers in the *Nightwatch*, is one of Rembrandt's rare associates who is referred to as a friend by the eighteenth-century biographers. Van den Eeckhout's father was re-married in 1633 to Cornelia Dedel, the daughter of Willem Joosten Dedel, director of the West India Company in Delft.

This brought van den Eeckhout a certain social status, from which Rembrandt was able to profit to a limited degree. Cornelia Dedel seems to have been a niece of Jacob Isaacsz. van Swanenburg, so that the ties between Rembrandt and van den Eeckhout were anchored in solid old foundations. Whether or not as a result of his association with Rembrandt, van den Eeckhout shared with his master the humiliating experience of being denied commissions for the new town hall. He continued longer than any of the other artists of his generation to adapt and copy work by the master. Ovens was another German who was a close associate of Flinck and Uylenburgh (Ameldonck Leeuw owned 'a painting by Uylenburgh's son, in which my face was painted by Ovens.') In the 1640s and '50s he held positions at various courts in his native land, to return in 1656 and upstage Rembrandt in the most conspicuous way imaginable, a sad story for a later chapter.

We can anticipate it by pointing out what the reader may have already noticed: while Amsterdam patronage was virtually closed to artists from Leiden, Haarlem and The Hague, let alone England and France, some of the most successful portraitists in the city came from Germany. In addition to Sandrart and Ovens (Flinck is literally a borderline case), there was also Johann Spilberg (1619-1690), who painted a civic guard banquet piece in 1650 in honour of burgomaster Jan van de Poll. Houbraken says of Spilberg that in 1640 he was on his way from Düsseldorf to Antwerp with a letter of introduction from Duke Wolfgang Wilhelm to Rubens when he learned of the latter's death. 'Thereupon he took a detour to Amsterdam, to the famous Govert Flinck, under whom he practiced the art of painting for seven years.' Amsterdam had a new Rubens in its midst.

For several years after 1642 we hear of no new Rembrandt pupils or associates. Then, about 1646, he took on an apprentice from a source that had been out of his life for fifteen years: his own Leiden family. It was Karel van der Pluym (1625-1672), from the Zwaerdecroon side. Rembrandt was about to begin all over again from scratch, with the same help that got him off the ground the first time round.

It would be nice at this point to have a heart-warming anecdote about Rembrandt as a teacher. But the few stories that found their way into the sources are not heart-warming at all. They nearly all illustrate his love of money, his ill-humour with his apprentices and his bad manners. The most moving record of life in Rembrandt's studio that I know is a parenthesis in Samuel van Hoogstraten's book on painting. Hoogstraten became Rembrandt's

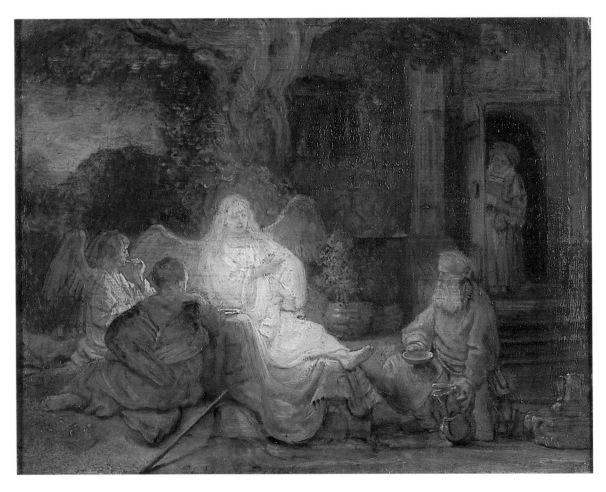

251 *Abraham serving the three angels* (Genesis 18:1-15). Signed *Rembrandt f. 1646*. Panel, 16 x 21 cm. Aurora Trust.

In all likelihood, the *'Abraham with the three angels'* that Martin van den Broeck traded with four other Rembrandts and other paintings the following year for ship's provisions.

There are two composition drawings for the painting (Benesch 576 and 577), which itself seems to be an oil sketch. For many of the histories of the forties we have such drawings, in contrast to those of the 1630s. Only one compositional drawing from that decade, for the *Ganymede*, is now accepted.

apprentice at the age of fourteen, after the death of his father, who was his first teacher. In advising the apprentices among his readers how to shape their attitude towards work, Hoogstraten cites imaginary and real examples, telling how 'sometimes, depressed by my master's teaching, I would go without eating or drinking, and, shedding copious tears, would not leave my work until conquering the fault in which my nose had been rubbed' (p. 12).

THE KLOVENIERS PUTSCH | On February 6, 1643, Andries Bicker missed a council meeting. In his absence the quorum was asked to decide who to send to The Hague for a three-year term as the Amsterdam delegate to the States General. In a move that was undoubtedly planned in advance, burgomasters Gerbrand Claesz. Pancras, Jan Cornelisz. Geelvinck, Albert Coenratsz. Burgh and Cornelis de Graeff announced that their candidate was Andries Bicker, and of course their candidate was chosen. Bicker had been running Amsterdam since 1627 – first with Geurt Dircksz. van Beuningen, then with Jacob de Graeff, but since the latter's death in 1638 all alone, and he liked to do it on the spot. He had tried to keep Cornelis de Graeff at bay after Jacob's death, but in 1643 he had to allow the son to serve a term as burgomaster. The

vote took place four days after his installation. Bicker saw it quite rightly as a deliberate attempt to get him out of the way.

He stormed into the town hall the next day and was told coolly that his brother Cornelis Bicker and his nephew Roelof had let it be known that he would be pleased with the appointment. Bicker called that a lie (which it probably was), but was unable to revoke the appointment. He accepted it for one year, but was forced to stay on for two.

It would not have escaped Bicker's notice that except for Geelvinck, all the men in the plot, and even his brother and nephew, were attached to the Kloveniersdoelen, as governor, captain or, in the case of Pancras, former lieutenant. Their administrative coup d'état had a threat of violence behind it.

For the rest of the decade, Bicker was able to hold on to the magnificat, though under constant pressure from de Graeff. Cornelis himself served one more term as burgomaster, but his clan was kept out of the office by the Bickers. In the words of a pamphleteer of 1650: 'Do you ask, who is director of the East *and* West India Companies? Who the delegate in The Hague to the States General? Who burgomaster? Who alderman? Who colonel of the civic guard? Who dikegrave of water rights? Who

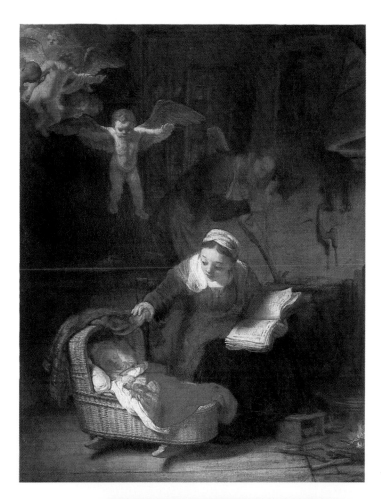

252 *The holy family with angels.* Signed *Rembrandt f. 1645.* Canvas, 117 x 91 cm. Bredius 570. Leningrad, Hermitage.

The inventory of Johannes de Renialme included two paintings of 'Mary and Joseph by Rembrandt van Rijn,' one appraised at 120 guilders and one at 36. The first recorded prices of figs. 252 and 253, in the early eighteenth century, were 150 and 125 guilders respectively, putting them in the same range as the first of de Renialme's paintings of the subject.

If either of these works is identical with de Renialme's more expensive Mary and Joseph, it is probably the painting in Leningrad. There are early copies after it without the angels, and at least one partial copy of the head of Mary alone. This reminds one of the way *Christ and the woman taken in adultery* was used while it was in de Renialme's possession.

The *Holy family with painted frame and curtain* is a sophisticated piece of *trompe l'oeil* whose closest parallel in Rembrandt's work is his design for the frame of *John the Baptist preaching* made for Jan Six in the 1650s. Rembrandt met Six by 1645, and fig. 253, of 1646, may well have been made for him or someone near to him.

Another *Holy family* from the mid-1640s attributed to Rembrandt by many scholars but rejected by others, among them Gerson, was acquired by the Rijksmuseum in 1965.

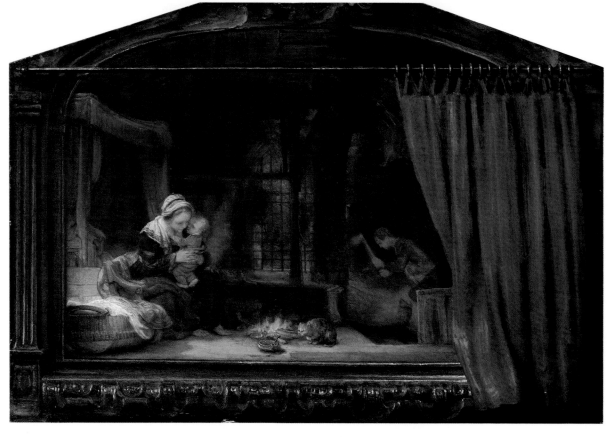

253 *The holy family with painted frame and curtain.* Signed *Rembrandt fc. 1646.* Panel, 46.5 x 68.8 cm. Bredius 572. Kassel, Gemäldegalerie.

the holders of a dozen other offices? I will never lie if I always answer Bicker. For the Bickers are all and everything.'

To which the art historian can add: ask me who painted the Bickers, and I can tell you. First Sandrart, then van der Helst.

As for Rembrandt, not only did he never work for the Bickers – even the party that was *out* of power ostracized him for long periods. Astonishingly, in nearly forty years as one of the leading portraitists of Amsterdam, Rembrandt never once painted a sitting or former burgomaster, and only two or three sitting members of the council: Nicolaes Tulp, Frans Banning Cock and, if my interpretation of *Jacob blessing the sons of Joseph* is correct, Willem Schrijver. All of them were political dependents of the de Graeffs.

RE-ENTER SCRIVERIUS | At the age of seventy, Petrus Scriverius was still fit and well. He had been working without great haste but without interruption mainly on Dutch medieval history since we left him two decades earlier. He had been keeping an eye on current events as well, waiting for the right chance to settle his sons in life. He married Hendrick to the daughter of a burgomaster of Oudewater, a post later held by Hendrick and his son after him. Willem, unmarried and unambitious at thirty-eight, must have been more of a problem, until a splendid match came his way. In 1645, he married Wendela de Graeff, a daughter of Jacob's and a sister of Cornelis and Andries.

Of the six brothers and sisters de Graeff, three had already married Bickers, a fourth was to do so in 1646, and the fifth was married to a Hooft. Why Wendela, with her fortune of more half a million, married a Remonstrant Leidener with no position, no fortune to speak of and outdated connections, we do not know. Religious politics almost certainly played a role. At the age of twenty-eight, Wendela had borne a daughter, out of wedlock, to the Catholic Willem Nooms, and two years later had married the wealthy but Catholic Pieter van Papenbroeck, who died in 1641. The succession of men in Wendela's life suggests that she was reserved for de Graeff alliances with non-Calvinists.

Status-seeking was another motive for the match. The Schrijvers may have been political nobodies, but they were recognized as the founders of a venerable medieval foundation in the village of Graft, while the prominent de Graeffs found it increasingly painful that they were unable to trace their ancestors further back than the fifteenth century. The Graft documents were found in Wendela's papers.

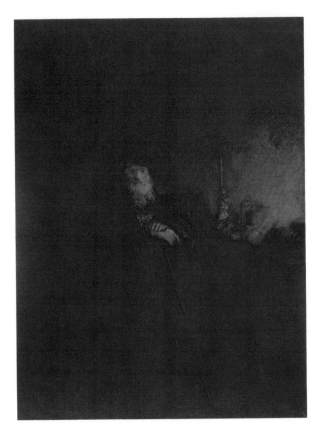

254 *Biblical figure.* Signed *Rembrandt f. 1643.* Panel, 70.5 x 53.5 cm. Bredius 435. Budapest, Museum of Fine Arts.

If this work is indeed by Rembrandt, it shares the same disappointing quality as the *Bathsheba* dated the same year (fig. 245).

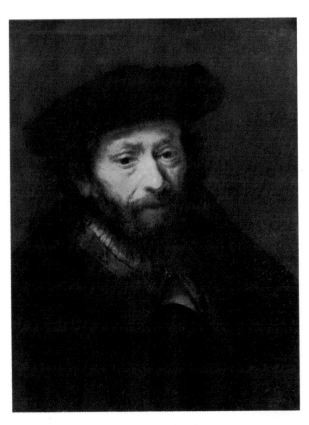

255 *Old man with beret.* Signed (falsely) *R.F.* Ca. 1643. Enlarged on all sides from 47 x 37 cm. Bredius 229. Leningrad, Hermitage.

None of the heads, busts, half-lengths and full-lengths of old men that Rembrandt painted between 1643 and 1652 can be traced back to early collections. One head is documented as being in his own possession in 1656, another was appraised at forty-two guilders in the estate of one Paulus Ramers in 1649. Most of those works are in the borderland of what is usually considered genuine Rembrandt.

The marriage of his son to one of the leading ladies of the city gave Scriverius an authority in Amsterdam he had never had before. The de Graeffs may have been playing second fiddle to the Bickers in 1645, but joining them was better than sitting in the balcony.

The miraculous appearance of his childhood acquaintance so near the centre of power in Amsterdam seems to have made Rembrandt acceptable again to a small section of Amsterdam society. In 1646, he brought out a portrait etching – his first since the Anslo of 1641, and his most formal one ever. The print has all the marks of having been inspired by the marriage. It portrays, and this is remarkable in itself, a man who had been dead for eight years, Johannes Cornelisz. Sylvius (fig. 194). Sylvius, we recall, had been the protégé of Wendela's father Jacob and the minister of the church where the de Graeffs were baptized, wed and buried. Rembrandt took as his model the portrait of Scriverius by Frans Hals (fig. 5) and he got Scriverius and Barlaeus to contribute poems in praise of the late relative of his late wife.

The lengthy tribute to Sylvius by Caspar Barlaeus gives food for thought. Barlaeus had moved from Leiden to Amsterdam about the same time as Rembrandt, and was in close contact with several of Rembrandt's important patrons of that period, mainly Constantijn Huygens.

In 1920, the German art historian Hans Kauffmann, searching for a figure who could have introduced Rembrandt into the Amsterdam literary world, claimed to have found him in Barlaeus. In a stimulating article entitled 'Rembrandt und die Humanisten vom Muiderkring' (Rembrandt and the Humanists of the Muiden Circle), Kauffmann analyzed Rembrandt's contacts with the Amsterdam poets and scholars of the presumed 'salon' of Pieter Cornelisz. Hooft, of which Barlaeus was a member.

Among the other writers associated with that circle we indeed find many of Rembrandt's patrons and portrait sitters. However, the status of the Muiden Circle as an institution has been called into question since 1920, and Kauffmann's article has been unjustly ignored by latterday scholars. William Heckscher, in his immensely rich monograph on the *Anatomy lecture of Dr. Nicolaes Tulp*, is the great exception.

One could say that Kauffmann and Heckscher assigned to Barlaeus roughly the role given here to Petrus Scriverius: a Leiden humanist operating behind the scenes to smoothe Rembrandt's path in Amsterdam. If I have given Scriverius all the credit for this honourable historical function, and Barlaeus next to none, it is only because of the absence of

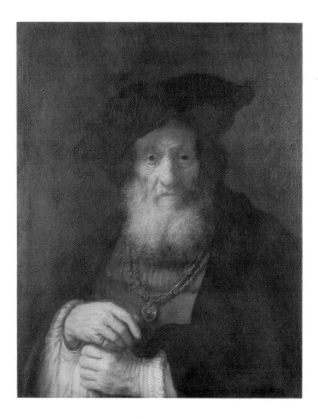

256 *Old man in rich costume.* Signed *Rembrandt f. 1643.* Panel, 73.7 x 59.7 cm. Bredius 185. Woburn Abbey, England.

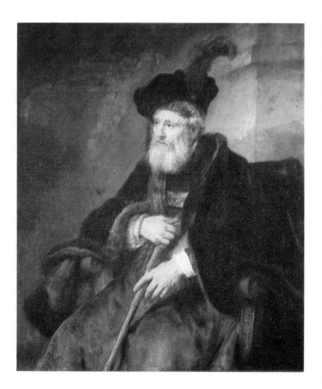

257 *Old man with a stick.* Signature removed when the canvas was cut down. Dated 1645. Canvas, 128.2 x 112.1 cm. Bredius 239. Oeiras, Portugal, Calouste Gulbenkian Collection.

documented links between Rembrandt and Barlaeus. There remains a strong case to be made for an important connection between Barlaeus and Rembrandt. Poems by both Barlaeus and Scriverius on Rembrandt's portrait of his in-law Sylvius give us the welcome opportunity of suggesting that both men were personal friends and patrons of Rembrandt.

This assumption adds interest to the recent discovery by Bert van Selm that two paintings by Rembrandt were owned by the husband of van Baerle's daughter Suzanne, Gerard Brandt (1626-1685). One of them depicted an old man, and could have been painted at any time in Rembrandt's career. The other, however, described as 'a student with an open jerkin,' sounds like an early painting from a period when Brandt was a mere child. This leads us to surmise that the painting was bought by Barlaeus and inherited by Suzanne.

Brandt himself, who became a Remonstrant minister in 1652, was acquainted with Rembrandt's Remonstrant relative Hendrick Zwaerdecroon early in life. When Zwaerdecroon's wife gave birth to a daughter in Rotterdam in January 1638, he was congratulated from Amsterdam by two twelve-year-old poets. Caspar Kinschot wrote the parents a Latin poem which Brandt translated into Dutch. In later years, as we shall see, Brandt was the friend and collaborator of other protectors and patrons of Rembrandt in theatrical and literary circles.

The information on Barlaeus and Brandt, disjointed as it is, nonetheless adds up to a picture of a long-standing mutual sympathy between Rembrandt and two generations of Barlaeuses. It closely resembles what we know about Rembrandt's relationship with father and son Schrijver.

These are some of the reflections prompted by Rembrandt's portrait of Sylvius, with its poems by Barlaeus and Scriverius. To us, they are distant and uncertain clues to the form of a part of Rembrandt's world. The informed observer in 1646, I believe, would have interpreted them as vivid signs of the social forces at play between the sitter, his admirers and their dependents, their common political protectors – the de Graeffs – and the artist who had various relationships with them all.

REMBRANDT AND THE TAKING OF ANTWERP

There was another very good reason for Rembrandt to advertise his relationship with Saskia's family in 1646. One of his old in-laws was in action that year with a plan that, if it had succeeded, would have gone down in history as a masterstroke of espionage and would have assured Rembrandt of instant

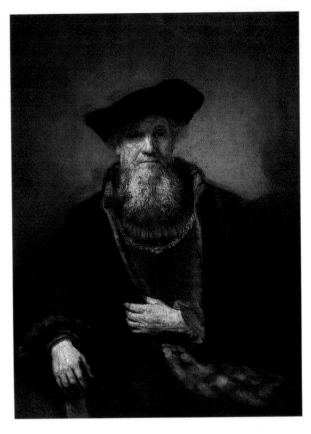

258 *Old man in a fur-lined coat.* Signed and dated *Rembrandt f. 1645.* According to Gerson, the signature is false, 'covering a possibly good one.' Canvas, 110 x 82 cm. Cut down on all sides. Bredius 236. Berlin-Dahlem, Gemäldegalerie.

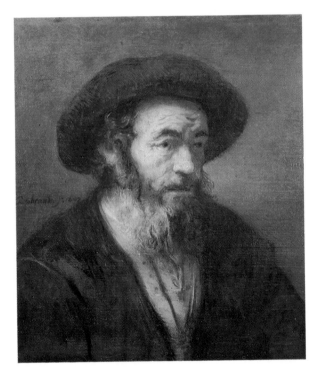

259 *Old man in a fur cap.* Signed *Rembrandt f. 1647.* According to Gerson redrawn. Panel, 25.1 x 22.5 cm. Bredius 249. The Hague, Gallery of Stadholder Willem V (Netherlands Office for Fine Arts).

opulence and universal fame. In 1646 Anthonis Coopal attempted single-handedly to capture Antwerp for Frederik Hendrik.

More than any other military ambition, the taking of his birthplace Antwerp had always been Frederik Hendrik's greatest dream. Sentimental and strategic considerations apart, holding Antwerp and opening its harbour would have brought about a vast change in the internal balance of power in the Republic. The might of Amsterdam was an unremovable thorn in Frederik Hendrik's side. We have already mentioned that in February 1639 he attempted to replace its burgomasters with men of his own choosing. The background to that desperate move will help us to understand the events of 1646.

In 1638 the French had found out that an Amsterdam merchant had sold the Antwerpers vast stores of gunpowder for their defence, and had asked Frederik Hendrik to do something about it. The Amsterdamer who came to the court to explain things told the prince 'that the burghers of Amsterdam were free to trade anywhere,… and that if he had to pass through hell to make a profit, he would take the risk of scorching his sails.' This was of course bombast of a merchant whose first move, if trading in hell, would be to divide the market with the devil to avoid competition, but Frederik Hendrik couldn't know that. Wringing his empty hands, he told the French ambassador d'Estrades 'I have no greater enemy than the city of Amsterdam. But if I ever get Antwerp, I will bring her down so hard that she'll never get up again.'

That chance was offered to him – almost – in the summer of 1646 by the brother of Rembrandt's brother-in-law. The States army was camped not far from Antwerp, under the command of a stadholder declining into premature senility. He did not have the vigour to lay siege to Antwerp, as he had to so many fortified places in the past twenty years. Needless to say, he also lacked the financial backing

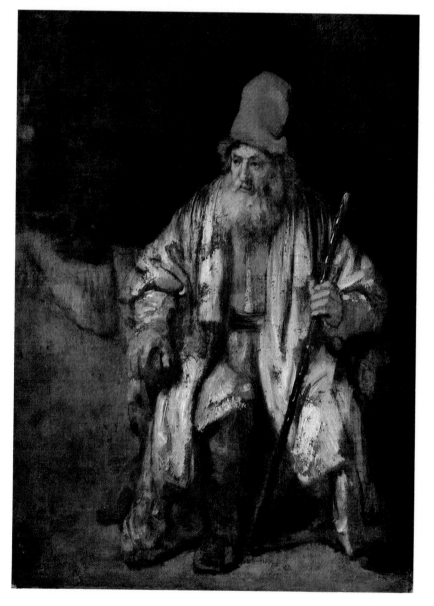

260 *Old man in an armchair.* Ca. 1652. Canvas, 51 x 37 cm. Bredius 269. Berlin-Dahlem, Gemäldegalerie.

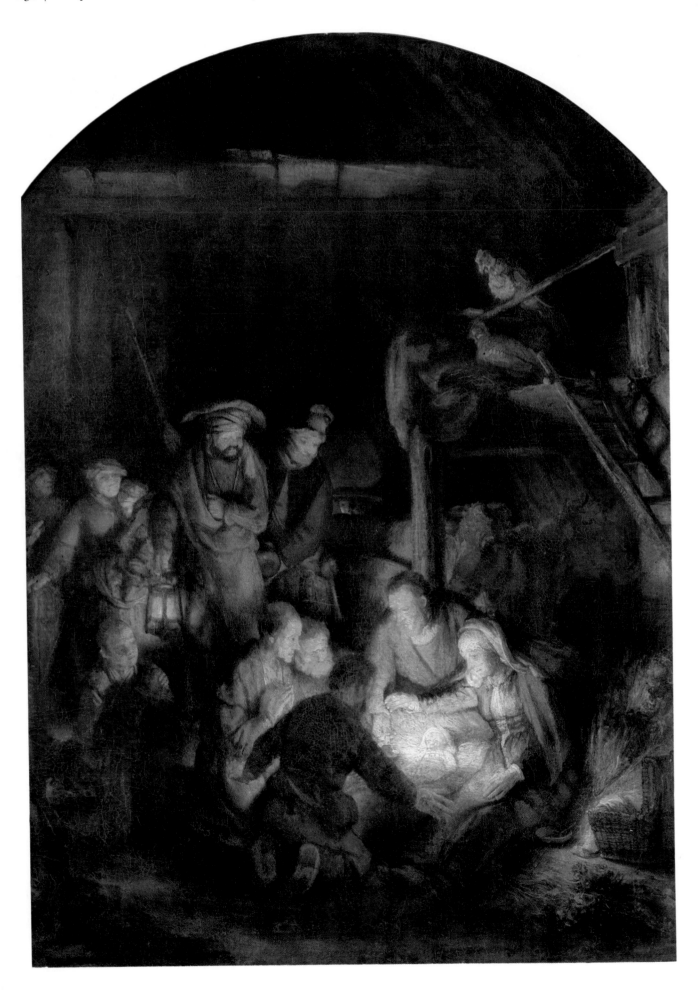

261 *The adoration of the shepherds* (Luke 2:15-17). Signed indistinctly and dated 1646. Canvas, 97 x 71.3 cm. Bredius 574. Munich, Alte Pinakothek.

262 Copy after Rembrandt, *The circumcision of Christ* (Luke 2:21). Ca. 1646. Canvas, 98 x 73 cm. Braunschweig, Herzog Anton Ulrich-Museum.

Seven years after the delivery of the *Entombment* and the *Resurrection* (figs. 106, 108), thirteen years after receiving his last commission from Frederik Hendrik, out of a clear blue sky Rembrandt delivered and was paid for these two additional pieces. The subjects fit in with his other paintings of the 1640s, so many of which are devoted to the infancy of Christ, and are unrelated to those of the Passion series.

The *Circumcision* was lost between 1719 and 1750, and is known only in this copy the same size as the original. The scale of the figures in the *Adoration* matches that of the last two paintings of the Passion series, but for the *Circumcision* Rembrandt reduced the size of the figures by about a third, and placed them in a deep space very different to the shallow stage of the *Adoration*. This is probably the kind of inconsistency that Huygens objected to ten years earlier, and one can imagine his reaction to these works. When in 1647 Huygens began organizing the painted decoration for a new palace in The Hague, Huis ten Bosch, he did not invite Rembrandt to participate. The two artists from Amsterdam he did call on were both related to the Uylenburgh studio and through it to Rembrandt: Jacob Backer and Jacob van Loo.

263 *The adoration of the shepherds* (Luke 2:15-17). Signed *Rembrandt f. 1646*. Canvas, 65.5 x 55 cm. Bredius 575. London, National Gallery.

A loose copy, in reverse and on a smaller scale, of the *Adoration* for Frederik Hendrik. The construction of the space and the forms of the figures are considerably clearer than in the painting for the stadholder.

264 Jean-Etienne Liotard (1702-1790), *François Tronchin (1704-1798)*. Dated 1757. Pastel on vellum, 38.1 x 46.3 cm. Cleveland, The Cleveland Museum of Art.

Artist and sitter were both Swiss with close ties to Holland. Liotard lived there from 1755 to 1772, while Tronchin had one relative who was a professor of medicine in Amsterdam and another who published the *Gazette Français* there. The sitter built up two important art collections, the first of which he sold to Empress Catherine of Russia.

of Amsterdam for the costly enterprise. At this point Coopal came up with a plan to take Antwerp from inside by bribing the garrison. He was in touch with the commander and 'certain well-disposed persons' who could be bought for three hundred thousand guilders. He himself would have to have four hundred thousand, 'to be paid promptly, after the above-mentioned affair shall have succeeded. And moreover he, Coopal, shall have and possess for himself and his heirs both male and female the hereditary marquisate of the city of Antwerp' plus other lucrative offices plus the guarantee that certain third parties would be 'favoured and provided with good jobs.' The position of the Bickers in Amsterdam, in short, and hereditary to boot.

This document was drawn up by Huygens and signed by the prince. It was not limited by time, and although Frederik Hendrik was obviously hoping for quick results, he remained bound by his offer even after Coopal's initial attempt failed.

The value of performing such services for Frederik Hendrik cannot be underestimated. The man who had saved Orange for him in 1629, Johan de Knuyt, boasted to Lopez in 1639 that he was worth two million guilders and stood in relation to Frederik Hendrik as Richelieu to Louis XIII. Even a failed attempt obligated Frederik Hendrik. And Coopal apparently felt he had done enough to merit at least some reward. As we know from the inscription on the back of Rembrandt's portrait of him (fig. 130), he actually used the title Marquis of Antwerp. In 1682, Coopal's son was still using the document to try to squeeze money out of Frederik Hendrik's grandson!

How else, except against this background, are we to explain the sudden new order from Frederik Hendrik for two more paintings from Rembrandt, at double the old price he was always quibbling about? In the ordinance book of Frederik Hendrik for November 29, 1646, we read: 'His Highness hereby orders his treasurer to pay to N. Rembrandt, painter in Amsterdam, the sum of two thousand four hundred guilders, for two paintings that he made and delivered to His Highness, one of them the birth of Christ, and the other the circumcision of Christ.'

The paintings (figs. 261, 262) were uniform with the Passion series and in the same frames, and, although stylistically and iconographically they do not add up, they were hung with the five earlier works. For once in his life, Rembrandt was able to benefit from sheer favouritism. He might have gone on to receive more commissions of the kind if Frederik Hendrik had not died on March 14, 1647. From then until his own death twenty-three years later, there are no known contacts between him and the court.

For one magic moment, Rembrandt was a breath away from becoming court painter to the marquis of Antwerp, out in front once and for all. If Coopal had succeeded, he could have packed his bags. If Coopal had succeeded, he… But Coopal did not succeed, and Rembrandt had to stay on in a city where he was as popular as a rainy day in June.

FIRST SKIRMISH OVER TITUS'S INHERITANCE
Rembrandt's tribute to old Sylvius did not cut ice with all of his in-laws. In 1647 the Uylenburghs

265 *Young woman in bed.* Signed *Rembra*[…]*f. 164*[7]. Canvas, 81.3 x 68 cm. Bredius 110. Edinburgh, National Gallery of Scotland.

Derived from the figure of Sarah waiting for her bridegroom Tobias in a painting by Lastman (Boston). Close in conception to the main figure in Rembrandt's *Aegina* (fig. 123), which he revised some time in the mid-1640s.

The date 1647 can be read on Liotard's charming evocation of the painting, being admired by its eighteenth-century owner. If that is when it was made, then the model was probably Geertge.

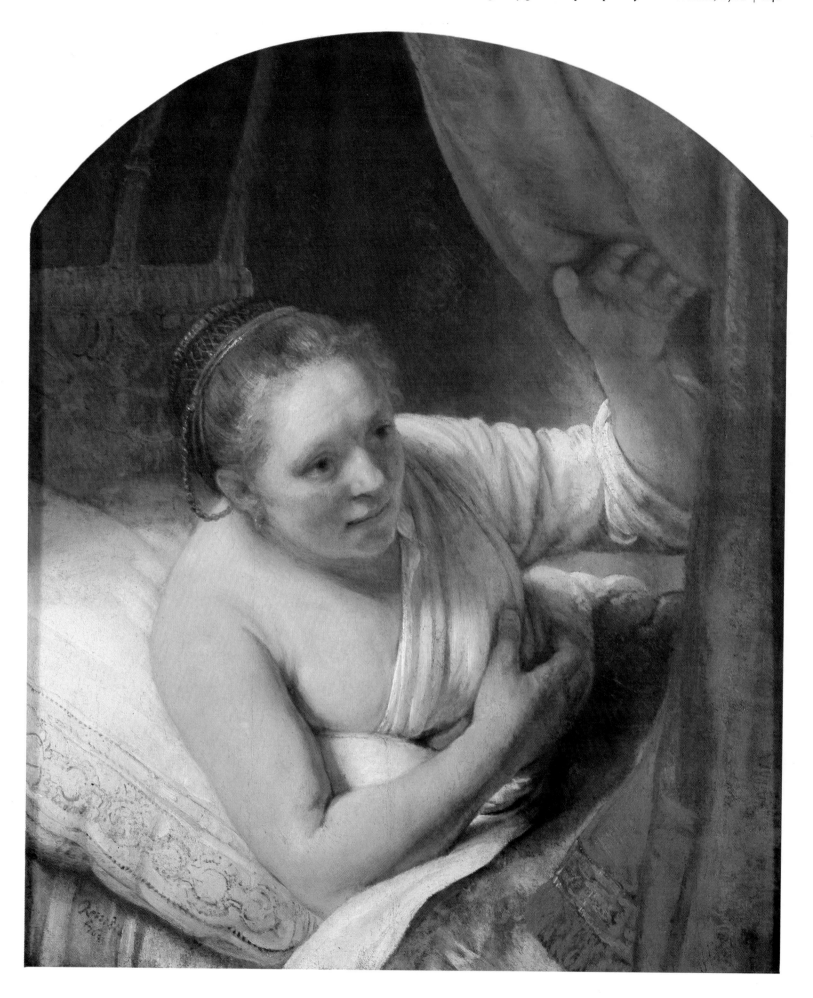

asked him to account for Saskia's estate. The lawyer
to whom he turned (or was sent) had the largest
practice in the city: Pieter Cloeck (1589-1667). He
was related by marriage to the branch of the Hooft
family where we identified Uylenburgh's protectors.
And he had been the next-door-neighbour of Frans
Banning Cock for sixteen years. In 1642 Cloeck
advised Rembrandt to draw up a retrospective
inventory, which took Rembrandt two months. The
document is lost, but we know from a later
deposition that the figure Rembrandt arrived at – a
'minimum estimate' – was 40,750 guilders.

GEERTGE DIRCX | The Uylenburghs had good
grounds for concern with regard to Rembrandt's
administration of Saskia's estate. Since her death he
had been having an affair with Titus's nursemaid,
Geertge Dircx, the widow of a ship's trumpeter
from Hoorn named Abraham Claesz. Rembrandt
had been making Geertge promises and giving her
presents of Saskia's jewelry. Legally there was
nothing wrong with this as long as Rembrandt was
able to cover half the value of the jewelry in cash or
other possessions, but one can understand that
Saskia's sisters were unhappy at more than just the
legal aspects of the matter.

The story of what followed, the most extensively
documented incident in Rembrandt's personal life,
puts his character in a bilious light. If I refrain from
criticism, it is not because I wish to reserve judgment
on the case, but because I feel that nothing could
add to the eloquence of the facts.

On January 24, 1648, the ailing Geertge made a
will in which she left all of her possessions except for
her clothing – and specifically including her jewelry
– to Titus, stipulating only that he give one hundred
guilders and her portrait to Trijntje Beets in Hoorn.
This document neutralized the worst consequences
of Rembrandt's rashness in giving the jewels to
Geertge. In drawing up the will, she was apparently
convinced that Rembrandt intended to marry her.
From her point of view the will is of course
meaningless in any other light. By June 15, 1649,
Geertge was disabused of this notion, and we find
her in negotiations with Rembrandt concerning a
separation settlement. Present at the discussion was
Hendrickje Stoffels, who must have been
Rembrandt's mistress by then.

Geertge was not satisfied with Rembrandt's offer,
and she had him summoned to appear before the
Commissioners of Marital Affairs and Damage
Claims on September 25th. He did not show up, but
on October 1st he had Hendrickje make a deposition
concerning Geertge. She declared 'by her veracity
as a woman,... at the request of the Hon.

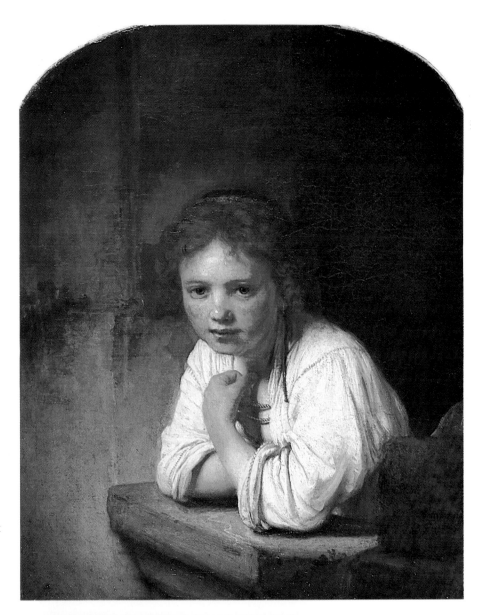

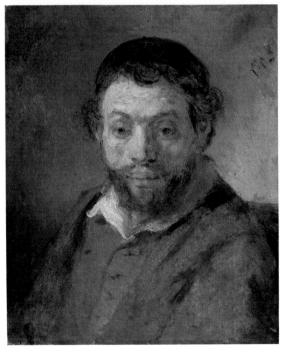

267 *Girl leaning on a
windowsill*. Signed
Rembrandt ft. 1645. Canvas,
81.6 x 66 cm. Bredius 368.
London, Dulwich College
Gallery.

In 1671 the broker Abraham
Fabritius owned a 'Young
lady looking out of a window
by Rembrandt van Rijn.'

266 *A young Jew*. Ca. 1648.
Panel, 25.1 x 21.5 cm. Bredius
250. Berlin-Dahlem,
Gemäldegalerie.

See also fig. 299.

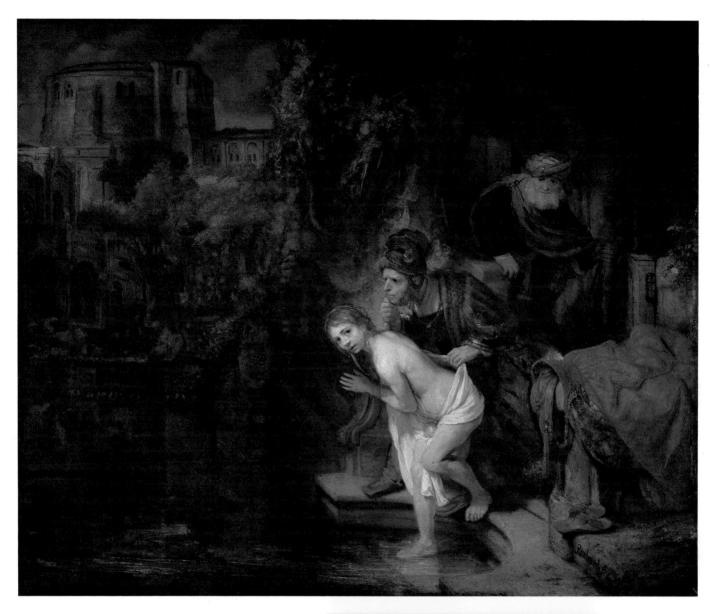

268 *Susanna surprised by the elders* (The apocryphal chapter 13 of Daniel, verses 15-23). Signed *Rembrandt f. 1647*. Panel, 76 x 91 cm. Bredius 516. Berlin-Dahlem, Gemäldegalerie.

This painting, derived fairly directly from a Lastman of 1614 (also in Berlin), was begun in the mid-1630s, when Rembrandt adapted several other works by his master. It remained unfinished until 1647, when Rembrandt re-worked it, signed and dated it and sold it for five hundred guilders to the Amsterdam merchant Adriaen Banck, of whom he also painted a portrait. In 1668 Banck sold both works and a 'sketch' by Rembrandt to the Schiedam merchant Adriaen Maen, getting five hundred and sixty guilders for the *Susanna*, fifty for the portrait and thirty for the sketch.

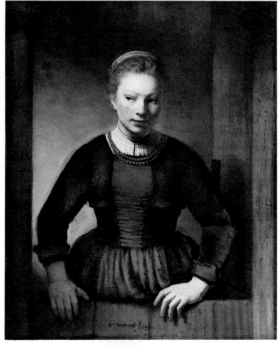

269 *Young woman at a half-door*. Signed [Rembrandt f. 16]45. Most of the signature in another hand. Canvas, 102 x 84 cm. Bredius 367. Chicago, Art Institute.

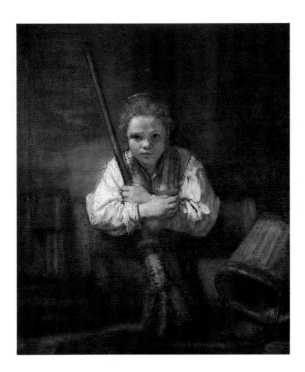

270 *Girl holding a broom.*
Signed *Rembrandt f. 1651.*
Canvas, 107 x 91 cm. Bredius
378. Washington, National
Gallery of Art.

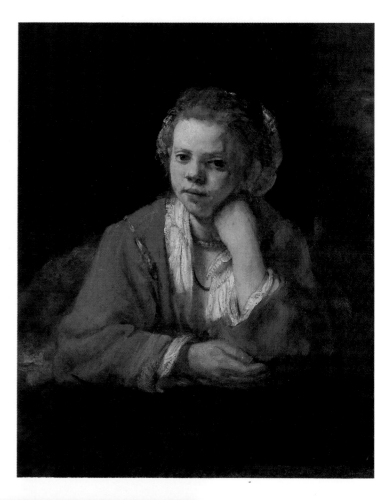

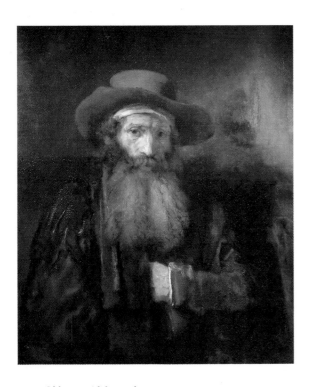

273 *Old man with hat and*
headband. Signed *Rembrandt*
f. 1651. Canvas, 77 x 66 cm.
Bredius 263. Wanås, Sweden,
private collection.

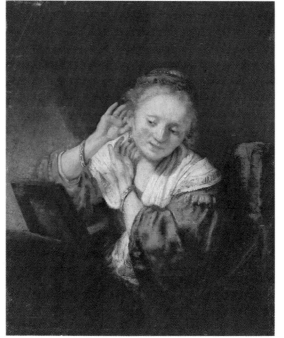

272 *A young woman at her*
mirror. Signed *Rembrandt f.*
165[4]. Panel, 39.5 x 32.5 cm.
Bredius 387. Leningrad,
Hermitage.

Rembrandt's inventory
includes 'A courtesan

grooming herself' by
Rembrandt that may be this
work. The painting probably
belonged to the amiable
eighteenth-century
eccentric Coenraad Baron
Droste, who wrote poems to
all his paintings. To his

271 *Girl at a window.* Signed
Rembrandt f. 1651. Canvas,
78 x 63 cm. Bredius 377.
Stockholm, National
Museum.

The brother of the painter
Esaias Boursse, Jan Boursse,
who lived in the Sint
Anthonisbreestraat, owned
many prints and drawings by
Rembrandt, and three
paintings by him, among them
a 'portrait of a maidservant.'

Rembrandt he rhymed:

'That woman getting dressed,
Needs no more than her finery
And her power to prove,
That she is by van Rijn.'

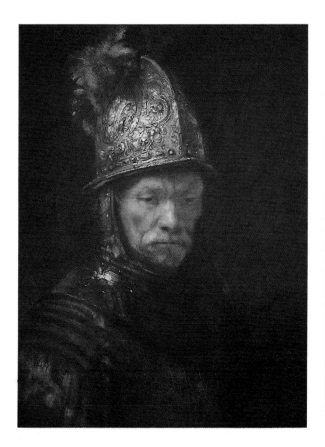

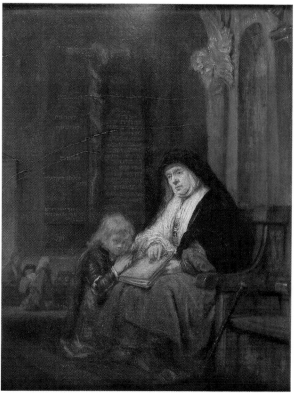

274 *'The man with the golden helmet.'* Ca. 1650. Canvas, 67 x 50 cm. Bredius 128. Berlin-Dahlem, Gemäldegalerie.

A popular favourite among visitors to the Berlin museum since its acquisition in 1897. Art historians have been casting about for some time, however, for a new name to attach to it.

275 *Hannah and Samuel in the Temple.* Signed *Rembrandt f. 16*[50]. Panel, 40.6 x 31.8 cm. Bredius 577. Edinburgh, National Gallery of Scotland.

The feeling of unease concerning Rembrandt's involvement in the histories of the late forties extends to this work of about 1650. Most recent scholarship has regarded it as a collaboration of some undefined kind between Rembrandt and a pupil.

The inventory of Lambert Doomer (1701) included a 'painting of Hannah the prophetess with her son Samuel, painted by the deceased,' which one might be inclined to identify with fig. 275 were it not for the fact that the painting in Edinburgh was in the Philips de Flines sale in Amsterdam in 1700, where it was sold as a Rembrandt for three hundred guilders.

Rembrandt van Rijn, painter,' that on June 15th Geertge had agreed to a settlement of 160 guilders at once, 60 guilders a year for the rest of her life and the vague promise of further support as needed, under the condition that she did not change her will.

Geertge, who was now living in a rented room, had meanwhile pawned some of her valuables, which was threatening for Rembrandt. On October 3, he presented her with a second offer: two hundred guilders in cash – to be used for the exclusive purpose of redeeming her gold and silver, which she was forbidden ever to pawn again – and 160 guilders a year for 'legitimate maintenance and alimony,' not to pay off debts. The will in Titus's favour, of course, 'is to remain unchanged.' One week later they met again to sign the document, at which time Geertge made a scene in Rembrandt's kitchen, refusing even to let the notary read the draft, let alone sign it, and screaming that she was sick and couldn't pay for the nursing she required out of 160 guilders a year. She had Rembrandt summoned once more, to appear on October 16th, and again he defaulted, incurring a larger fine than the first time.

The third summons, for the hearing on October 23rd, he did obey. The Commissioners' Book of Disputes reproduces the charges and replies, in a legal nutshell:

'The plaintiff declares that the defendant made an oral promise to marry her, in token of which he gave her a ring; she said moreover that he slept with her more than once; she requests that she may be married to the defendant, or otherwise be supported by him.

'The defendant denies having promised to marry the plaintiff, declares that he is under no obligation to admit that he slept with her, and adds that the plaintiff would have to come with proof.'

The commissioners believed Geertge, but gave Rembrandt what he wanted. They raised her annuity to two hundred guilders, but approved the unsigned document that Rembrandt's notary had drawn up.

On April 28, 1650, Geertge assigned power of attorney to collect her debts to her brother Pieter Dircksz. and her nephew Pieter Jacobsz., apparently because she could not face Rembrandt. This was a terrible mistake. Her first annual payment was due on June 28, 1650, and when her brother went to collect it he sold Geertge out by arriving at a malicious agreement with Rembrandt. He and his cousin hired a neighbour of Geertge's, Cornelia Jansdr., to gather testimony from other neighbours concerning her way of life. On the basis of these stories, Pieter got the burgomasters to commit

276 *The rest on the flight into Egypt*. Signed *Rembrandt f. 1647*. Panel, 34 x 48 cm. Bredius 576. Dublin, National Gallery of Ireland.

The holy family takes leave, in this *Flight into Egypt*, not to return to Rembrandt's work for ten years. The composition leans heavily on a famous Elsheimer that was brought to Holland by Hendrick Goudt in 1610 and was sold before 1628 to Elector Maximilian I of Bavaria. In 1625 Goudt showed the painting to Sandrart and others. A copy was owned by the Delft art dealer Herman de Neyt when he died in 1642. Moreover, Goudt etched the composition. The early history of Rembrandt's painting is unknown.

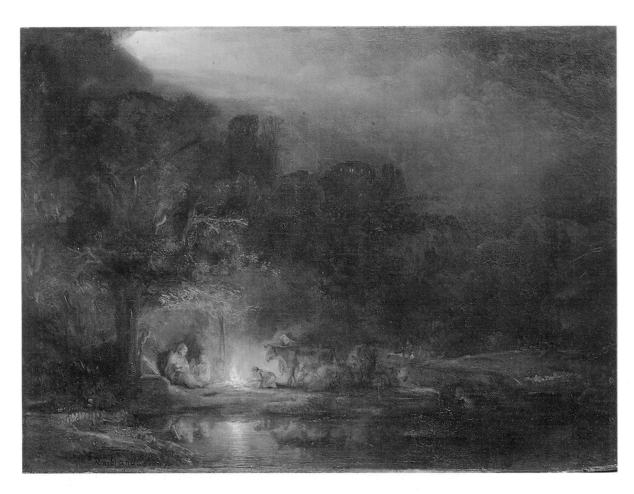

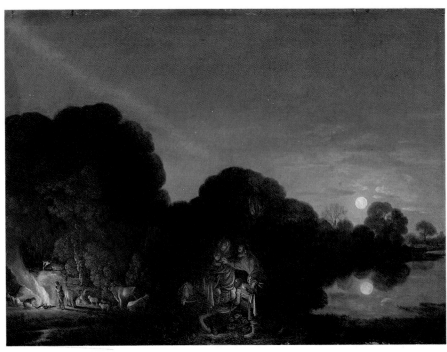

277 Adam Elsheimer, *The flight into Egypt*. Inscribed on the back *Adam Elsheimer fecit. Romae 1609*. Copper, 31 x 41 cm. Munich, Alte Pinakothek.

278 *The risen Christ at Emmaus* (Luke 24:13-31). Signed *Rembrandt f. 1648.* Panel, 68 x 65 cm. Bredius 578. Paris, Musée du Louvre.

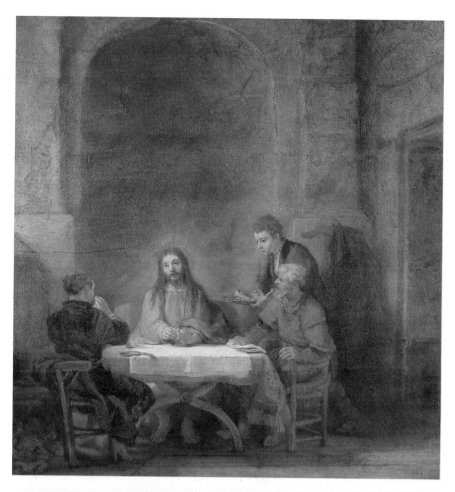

279 *The risen Christ at Emmaus* (Luke 24:13-31). Signed *Rembrandt f. 1648.* Canvas, 89.5 x 111.5 cm. Bredius 579. Copenhagen, Statens Museum for Kunst.

The version in Copenhagen was dismissed as not being Rembrandt's work by Kurt Bauch in 1965 and reallocated to him in 1968 by Horst Gerson. The debate over the authenticity of the painting highlights an ambiguity in Rembrandt's way of doing things in these years: using motifs from one painting for another, copying his own work, letting associates like Gerbrand van den Eeckhout make copies for him. This exploitation of his ideas, commercial though it was, could nonetheless lead to striking results, although I do not think of the Copenhagen painting in those terms.

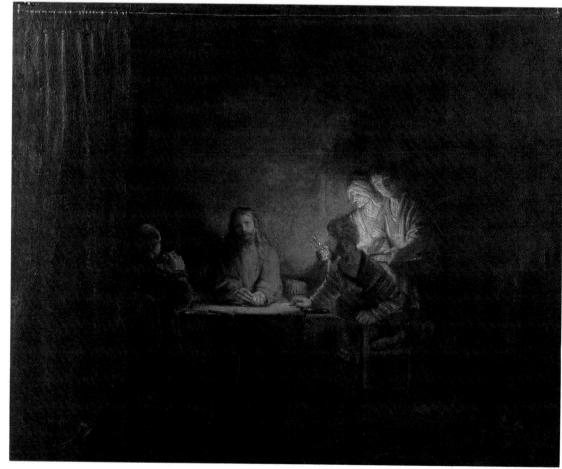

Geertge for twelve years to the house of correction in Gouda. The costs of the procedure, 140 guilders, were paid by Rembrandt.

With Geertge locked up and deprived of her legal rights, her brother and nephew went to the pawnshop where Geertge had, apparently in violation of the terms of the agreement, left 'a purse with three gold rings, silver and gold coins, sixteen pieces in all, including the above-mentioned rings and an unminted silver wedding medal.' Acting on her behalf, they redeemed the pledge.

The following year, for obscure reasons, Rembrandt sent Cornelia Jansdr. to Edam, Geertge's former home, to collect more evidence against her. There she approached four women, friends and relatives of Geertge's, who had no idea of what had happened to her. They refused adamantly to have anything to do with Cornelia, and went to work to try and help Geertge. It took them a long time. In May 1655, Trijn Jacobsdr., one of the four, came to Rembrandt to tell him that she was on her way to Gouda to get Geertge out (perhaps on grounds of sickness). Rembrandt fumed and threatened her, but she persevered, and on May 31, after nearly five years in the house of correction, Geertge was released.

On February 14, 1656, in Edam, she revoked the power of attorney, which had continued all that time, so that Pieter Dircksz. had probably been collecting the alimony from Rembrandt since 1650. In 1655, Rembrandt did not make his payment. In the spring of 1656, a new round of litigation began between Geertge and Rembrandt, which ended with her death in the second half of the year.

In the meantime, there had been a rift between Rembrandt and Pieter Dircksz., and Rembrandt gained an order forbidding Pieter from leaving Amsterdam to answer questions at a hearing of unspecified nature. Pieter was a ship's carpenter for the West India Company, and was under orders to sail on the Bever on March 3, 1656. On March 2nd, he sent a notary to Rembrandt to demand that he make his charges known then and there, so he could answer and leave. He also protested against harassment by Rembrandt and losses undergone as a result of the procedures against him. Rembrandt refused to enter into discussion with the notary.

Insofar as this story has been told at all by Rembrandt's biographers, it has been isolated as an unfortunate incident that had nothing to do with his career except to keep him from his work. (1649 is the one year between 1625 and 1669 with no dated paintings or etchings.) There is, however, reason to believe that the affair was connected with his professional life as well. When Pieter Dircksz.'s

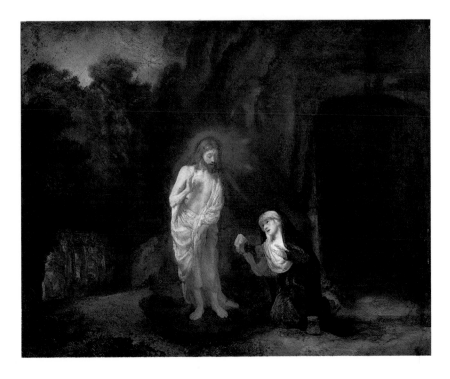

280 *The risen Christ appearing to Mary Magdalene* (John 20:16-17). Signed *Rembrandt 165*[1]. Canvas, 65 x 79 cm. Braunschweig, Herzog Anton Ulrich-Museum.

In 1651 several writers who admired Rembrandt edited an anthology of poems under the title *Verscheyde Nederduytsche gedichten* (Assorted Dutch poems). One of the most interesting new poems in it was *Goede Vrydag* (Good Friday) by

Jeremias de Decker, who in 1638 had seen Rembrandt paint *Christ appearing to Mary Magdalene* (fig. 190). It is probably more than coincidence that Rembrandt painted the subject again in 1651. The new painting would have been intended for a mutual acquaintance of the artist and the poet, a circle that included Rembrandt patrons such as Jan Six, Tobias van Domselaer and Gerard Brandt.

notary visited Rembrandt on March 2, 1656, he brought two witnesses: Nicolaes Ruts Jr. and Simon Ingels. They were both sons of Rembrandt patrons from the 1630s. Ingels belonged to a group of poets and playwrights which had taken up Rembrandt; in 1660 he published a poem on a portrait etching by Rembrandt. Whether or not this had anything to do with the matter I do not know, but it is curious that both their fathers went bankrupt, Ruts in 1637 and Johannes Ingels in 1654. While their confrontation with Rembrandt took place he was making preparations for his own bankruptcy. There is something suspicious in this, and something that leaves one with the uneasy feeling that Rembrandt's association with Pieter Dircksz. went back to the 1630s, which would put the affair with Geertge in a different light.

29 | Landscapes, still-lifes and animals

In the mid-1630s, as we have seen, Rembrandt changed the focus of his figure paintings and some of his histories. He moved in closer, enlarging the main subject and crowding out the background. Around the same time, he also did the opposite – stepping so far back from the motif that it becomes an incident in a landscape. The closest precedents in his work to the *Landscape with the baptism of the eunuch* of 1636 (fig. 282) are the mythologies in landscapes of 1632 and 1633. In this way, Rembrandt eased himself into becoming a painter of landscapes. One of his other early works in this category also has a biblical subject, but the rest, from the twenty-year period that Rembrandt practiced the genre, have no identifiable story.

Nor do they have an identifiable locale. In contrast to Rembrandt's landscape drawings and etchings, many of which can be situated in and around Amsterdam, or in the country homes of his patrons, the motifs in the paintings give the impression of being invented or derived from works by other artists. If one made the same distinction in landscapes as in paintings of people, the paintings would be heads of studio models and the drawings and etchings, portraits.

The first reference to a landscape in the documents is in the collection of the Delft tax collector Boudewijn de Man. Upon his death in 1644, a 'landscape by Rembrandt' was sold from his estate for one hundred and sixty-six guilders. De Man, whom we have already met as the owner of an early Rubens (fig. 4), was one of the most important collectors in Delft, and his relationship with Rembrandt deserves to be thoroughly investigated.

After Rembrandt's death a 'castle by Rembrandt' in the collection of the widow of the Delft alderman Johan van der Chijs was appraised at a mere ten guilders. Still, this points to a certain concentration of interest in Delft for Rembrandt's landscapes.

In Amsterdam, he had less success. Jan Pietersz. Bruyningh owned one, along with two by and one

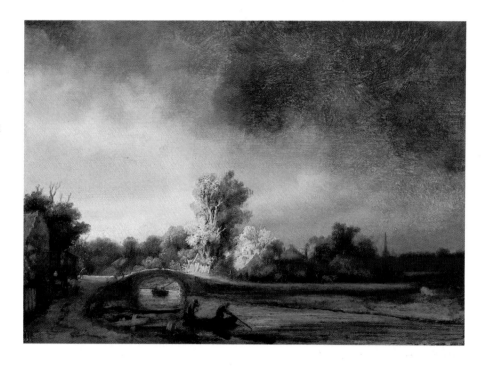

281 *Landscape with a stone bridge*. Ca. 1638. Panel, 29.5 x 42.5 cm. Bredius 440. Amsterdam, Rijksmuseum.

after Govert Flinck. (This brings up an interesting point that was raised by Dudok van Heel. Landscapes by Flinck are listed in the inventories of Bruyningh and Ameldonck Leeuw, but today no such works are recognized. Where are Flinck's landscapes? Is it possible that some are concealed among the works illustrated in this chapter?)

The faithful Martin van den Broeck owned a landscape by Rembrandt in 1647 (see fig. 289), but the next mention after that is in the 1656 inventory of Rembrandt's goods, which included no fewer than ten landscapes and two town views. From then until 1669 there is silence, followed only by sparing appearances in the collections of mainly dealers and fellow artists.

If Rembrandt turned to landscapes in the mid-thirties in an attempt to escape from his dependence on patrons, then the manoeuvre failed. He never found a decent market for his landscape paintings, and after 1654 he stopped doing them.

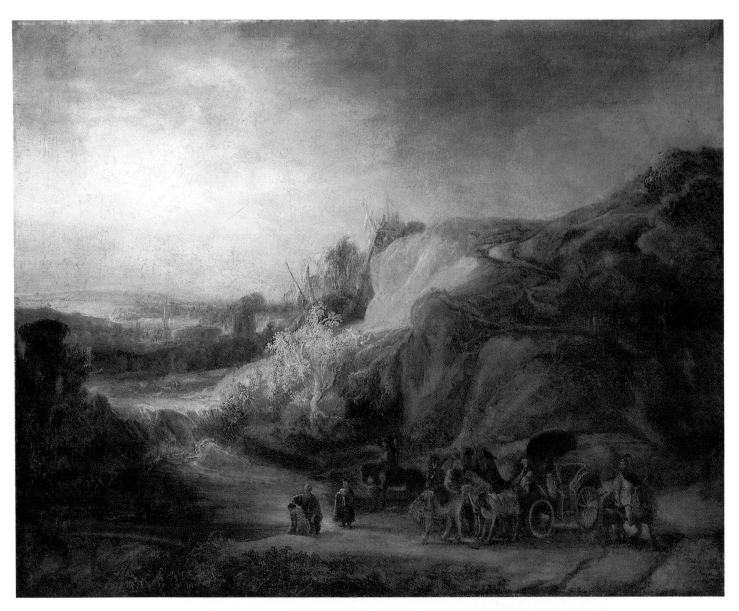

282 *Landscape with the baptism of the eunuch*. Signed *Rembrandt ft 1636*. Signature questioned by Gerson. Canvas, 85.5 x 108 cm. Bredius 439. Hannover, Niedersächsisches Landesmuseum (on loan).

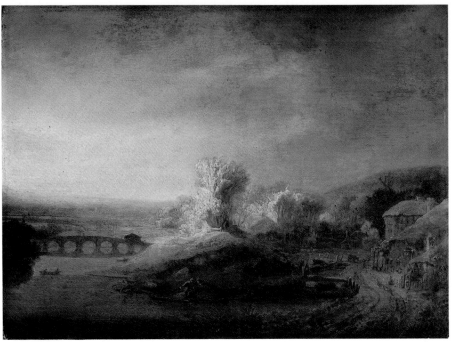

283 *Stormy landscape with an arched bridge*. Ca. 1638. Panel, 28 x 40 cm. Bredius 445. Berlin-Dahlem, Gemäldegalerie.

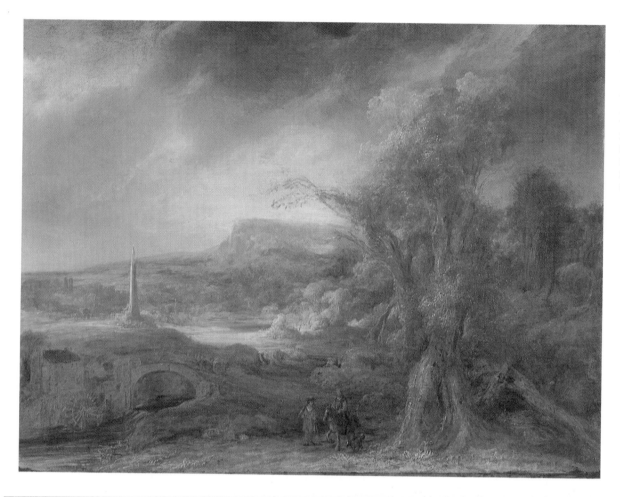

284 *Landscape with an obelisk*. Ca. 1638. Panel, 55 x 71 cm. Bredius 443. Boston, Isabella Stewart Gardner Museum.

After the completion of the text, I learned that the museum discovered the signature of Govert Flinck on this painting, and has re-assigned it to that master. (See p. 249.)

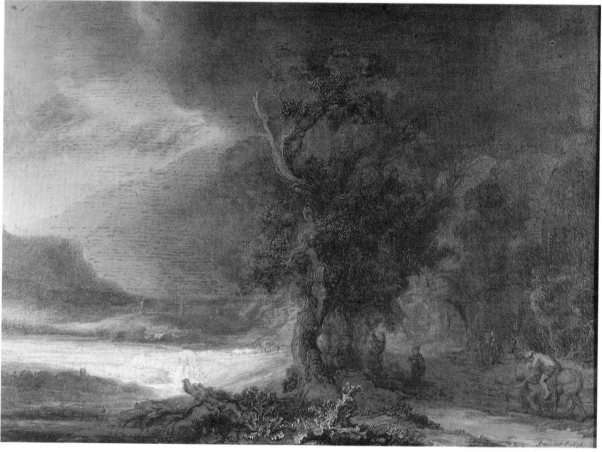

285 *Landscape with the good Samaritan*. Signed *Rembrandt f. 1638*. Panel, 46.5 x 66 cm. Bredius 442. Cracow, Czartoryski Museum.

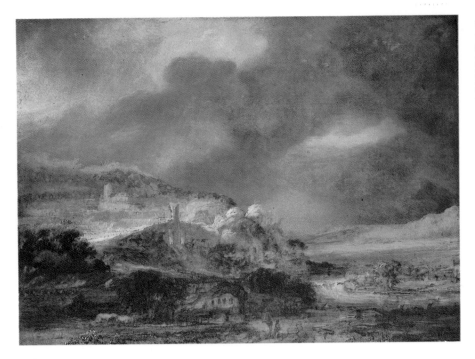

286 *Town on a hill in stormy weather.* Signed *Rembrandt f.* Ca. 1638. Panel, 52 x 72 cm. Bredius 441. Braunschweig, Herzog Anton Ulrich-Museum.

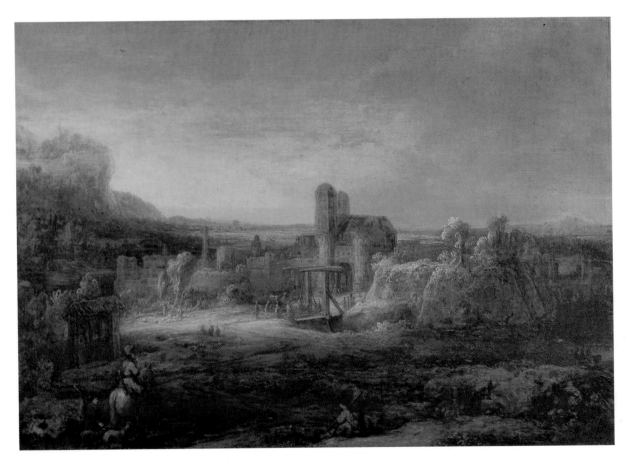

287 *Landscape with a church.* Ca. 1640. Panel, 42 x 60 cm. Bredius 446. Madrid, collection of the duke of Berwick and Alba.

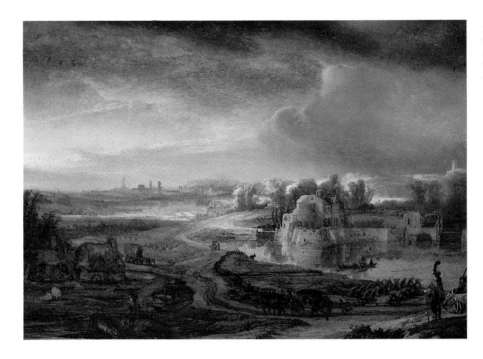

288 *Landscape with a coach.*
Ca. 1640. Panel, 45.7 x 63.8
cm. Bredius 451. London,
Wallace Collection.

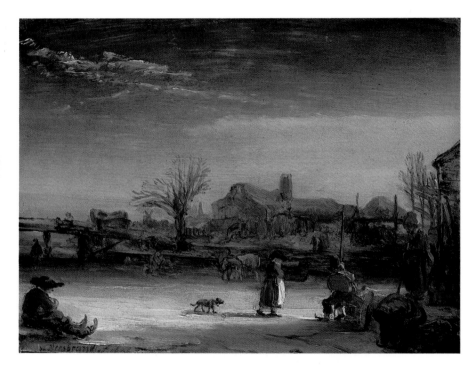

289 *Winter landscape.*
Signed *Rembrandt f. 1646.*
Panel, *17 x 23* cm. Bredius
452. Kassel, Gemäldegalerie.

With its close resemblance in
size and technique to
Abraham and the three angels
(fig. 251) of the same year,
this landscape is most likely to
be the work that belonged to
Martin van den Broeck in
1647, along with an 'Abraham
with the three angels.'

STILL-LIFE | The above applies even more to the still-lifes that we know Rembrandt to have painted, or at least to have touched up. Apart from the semi-still-life of the *Girl with dead peacocks* (fig. 229), the only paintings of this kind known from documents are those in Rembrandt's own inventory: 'still-life touched up by Rembrandt,' three different paintings of a 'Vanitas, touched up,' a 'Vanitas with sceptre, touched up,' and a painting that also merits the denomination Vanitas: 'Death's head, painted over.' (Vanitas paintings were symbolic representations of the transience and vanity of mortal life.) Finally, 'hares,' 'two greyhounds' and

'bittern,' which are either still-lifes or animal paintings. The works of this kind have disappeared without trace.

The suggestion of the Rembrandt Research Project that the paintings called 'Vanitas' were self-portraits is groundless. In 1678, Harmen Becker, who acquired most of his sixteen Rembrandts from the artist himself, owned a 'still-life being a Vanitas by Rembrandt van Rijn.' Here there is no talk of 'touching up,' although Rembrandt seems not to have originated any paintings of this kind himself.

Still-life was obviously a genre that Rembrandt

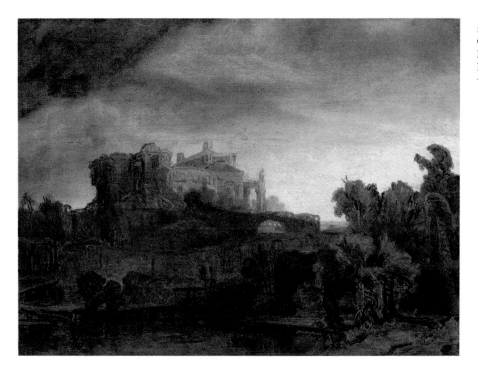

290 *Landscape with a castle*. Ca. 1640. Panel, 44.5 x 70 cm. Bredius 450. Paris, Musée du Louvre.

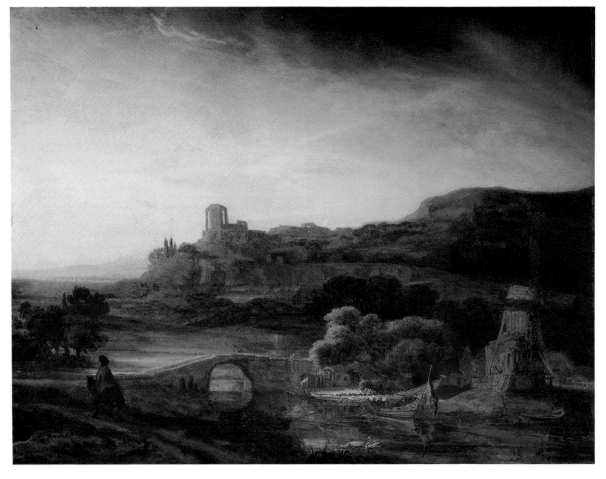

291 *River landscape with ruins*. Signed *Rembrandt. f.* Ca. 1654. Panel, 67 x 87.5 cm. Bredius 454. Kassel, Gemäldegalerie.

In the 1656 inventory, the subjects of a number of landscapes are characterized more precisely: 'mews,' 'mountainous landscape,' an exceptional 'several houses, from life,' 'twilight' and 'moonlight.' Except for the 'mountainous landscape,' which could apply to several of the works illustrated here, none of the other descriptions match any of the landscapes now put down to Rembrandt. There is an unfortunate discrepancy between the documents and the existing paintings that remains to be reconciled.

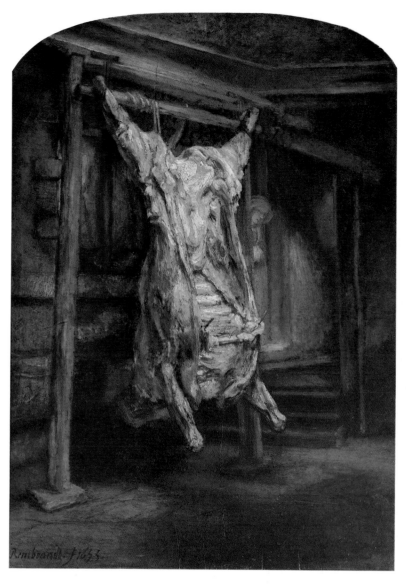

worked on only half-heartedly. All six of the true still-lifes in the inventory were touched up or painted over, evoking a picture of Rembrandt paying a junior associate to produce half-done works for the master to finish. He cannot have signed them, otherwise one or another would certainly have turned up in later collections, and none ever did. A more rewarding challenge for the connoisseur cannot be imagined than tracing one of these works.

The 1656 inventory places one of the still-lifes in the 'anteroom to the art gallery,' together with three paintings by Titus, one of which is described as 'a painted book.' Could it be that Titus was the one who began all those still-lifes that Rembrandt touched up?

292 *The slaughtered ox.*
Signed *Rembrandt f. 1655.*
Panel, 94 x 69 cm. Bredius
457. Paris, Musée du Louvre.

The surviving still-lifes (see also fig. 229) were done in the same period as the landscapes: around 1640 and around 1655. An 'ox' that may have been one of these paintings was in Rembrandt's inventory. In 1661 a 'painting depicting a slaughtered ox by Rembrandt' was in the ownership of a Nürnberger named Christoffel Hirschvogel. Two days before leaving Amsterdam on July 31, he told the man with whom he was leaving his belongings, the lawyer Theodore Ketjens, that the Rembrandt was worth seventy-five guilders. After his departure, Ketjens had it appraised by someone else, who did not value it higher than thirty guilders.

In 1681 'an ox by Rembrandt' was owned by Michiel van Coxie in Amsterdam. Coxie was an artist whose work was also traded by Gerrit Uylenburgh, and who was praised to the skies by Uylenburgh's Frisian relative Wybrand de Geest II.

The only other recorded animal paintings, apart from those in Rembrandt's inventory, were 'a bass' that the physician Johannes Dillemans sold in 1662 to Gabriël de Sale and 'a painting with a dog' that belonged in 1671 to Joris van Oorschot. Van Oorschot was married to Maria Coymans, a relative of Balthasar's.

293 *The slaughtered ox.*
Signed *Rembrandt f. 16[..].*
Signature questioned by
Gerson. Ca. 1643? Panel, 73.3
x 51.8 cm. Bredius 458.
Glasgow, Art Gallery and
Museum.

In the wings, 1647-1654

For several decades, and on several fronts, the theatre had been making itself more and more indispensable in the municipal and political life of Amsterdam. To begin with, the exploitation of the theatre by the chambers of rhetoric and public charities brought official recognition of, and meddling in, popular entertainment. This in itself caused complications and paradoxes. On the one hand, the authorities favoured plays that bolstered 'the high authority of God, rulers and regents, but also that of lower governing bodies.' On the other hand, since full houses meant more income for the widows and orphans under their care, the public charities also approved of the popular, though somewhat subversive, theatre of farce, pastoral themes and romantic comedies. We find modern stagings of classical tragedies by regents with a literary bent, cheek by jowl with glorified Punch-and-Judy shows brought in off the street. There is another way of putting it: literary exercises by well-meaning amateurs as against gripping spectacles by thorough professionals. In the middle ground, there were authors who were neither regents nor mountebanks, and whose work combined the serious with the spectacular. Men like Krul, Vondel and Jan Vos were the most important native playwrights, and their works and personalities the most controversial.

Not only did the town become involved in the theatre – it worked the other way as well. Pageantry became an increasingly important political instrument, and it was given to the city fathers partly by the intellectuals in their midst, men like Pieter Cornelisz. Hooft and Daniel Mostart, but also by outside theatrical producers, painters and musicians. The joyous entries of 1638 and 1642 were highpoints in this marriage of politics and art, and they were so successful that they made the rulers of Amsterdam dependent on artists overnight, to a degree that even van Mander could hardly have envisioned.

Because so many documents have been lost, we cannot reconstruct the exact course of this fascinating interaction. We know which branches of Amsterdam officialdom were most closely involved: the town theatre, of course, with its six-man board appointed annually by the burgomasters, and the heads of the home for the aged and the orphanage. But there was also the guild of St. Luke, in which the painters, sculptors, engravers, printers, booksellers and glaziers were organized, and the surgeons' guild, which shared premises with the guild of St. Luke and was full of playwrights and would-be producers. Finally, the civic guard and some of the city fathers took a keen interest in the theatre.

This aspect of Amsterdam politics put the Calvinists at an insurmountable disadvantage. Not only were they afraid of the moral dangers of the theatre, but they also had little control over the theatre groups which tended to be dominated by Remonstrants and Catholics. All the Calvinists could do was to take preventive action when things threatened to get out of hand, as they did on December 26, 1638. On that day the new town theatre was to be inaugurated with the première of Vondel's *Gijsbrecht van Aemstel*. The drama of medieval Amsterdam which has remained Vondel's best-known work was notorious even before it was put on stage. The opening night was called off at the last moment when Vondel's Calvinist enemy Simon Engelbrecht told the church council that he was planning to celebrate a mass on stage. The première was postponed for a week, until Burgomaster Jacob de Graeff intervened on Vondel's behalf. The growing acceptance of public displays of Catholicism could not be stemmed. In 1640 Vondel himself became a Catholic, which eased the way back to the mother church for many a repentant Protestant.

ARCHITECTS, PAINTERS, POETS, GLAZIERS | The architect of the new theatre in Amsterdam was

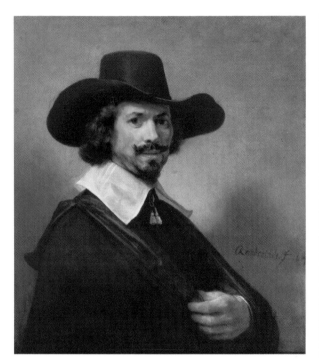

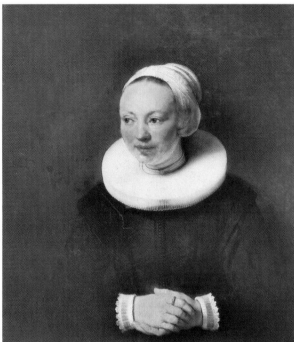

294 *Hendrick Martensz. Sorgh (1611-1670)*. Signed *Rembrandt f. 164*[7]. Companion to fig. 295. Panel, 74 x 67 cm. Bredius 251. London, Westminster Collection.

295 *Ariaentje Hollaer (born 1610)*. Signed *Rembrandt f. 1647*. Signature questioned by Gerson. Companion to fig. 294. Panel, 74 x 67 cm. Bredius 370. London, Westminster Collection.

Sorgh was a Rotterdam painter of genre subjects, histories, seascapes and portraits. He was well known in Mennonite and Remonstrant circles in Amsterdam, where he lived for a few years in the early 1630s. A painting by him of a 'waffle baker' was owned by Ameldonck Leeuw, whose collection was composed largely if not exclusively of work by masters who were associated with Hendrick Uylenburgh. Moreover, he painted portraits of the Remonstrant preachers Simon Episcopius (1643) and Theophilus Ryckwaert (1646), both of whom were active in Amsterdam during Sorgh's stay there.

Rembrandt's contact with the Remonstrants of Rotterdam came to life again in 1646 when Hendrick Zwaerdecroon's nephew Karel van der Pluym entered his studio as an apprentice.

Sorgh also maintained ties with Rembrandt's new circle of friends. Jan Vos wrote a poem on a painting by him in the collection of Tobias van Domselaer.

Jacob van Campen (1595-1657). He was a nephew of the grain merchant Cornelis van Campen (1564-1636), who as head of the Old Chamber in 1612 had introduced the system of turning over the theatre receipts to charity. One cousin of Jacob's, Nicolaes van Campen (1586-1638), was the patron of the new theatre building, and another, Willem Claesz. van Campen (1611-1661), was on the theatre board in 1638-1639, when it was opened. The choice of van Campen, ten years later, to build the new town hall, apart from all other considerations, underlines the continuity between the stage and the power of the town hall.

The same principle was demonstrated, in reverse, when Claes Moyaert, the painter who designed the setting for the state visit of Maria de Medici, was appointed to the board of the town theatre for 1640-1641, and in 1640 painted a group portrait of the governors of the home for the aged (Rijksmuseum). Both Moyaert and van Campen were Catholics who, if not for that, might have held high positions in the city government.

A new cause for celebration was provided by the end of the Eighty Years War with the signing of the Treaty of Münster on January 30, 1648. The peace was a triumph for Amsterdam, which since 1633 had been at odds with Frederik Hendrik (who died in 1647) over the issue, and now had its way. On June 5th, the treaty was marked with public festivities. Within six days, three stages were erected for eighteen tableaux vivants designed by Samuel Coster, Gerard Brandt and Jan Vos. Brandt was the son of one of the heads of the theatre that year, and was to fill the same office himself the next year. The

father of his bride-to-be, Caspar Barlaeus, had played a major role in the Medici pageants. Brandt's biography of Vondel and his *Historie der Reformatie* are our most important sources for information on the internal religious struggles in Amsterdam in the first half of the seventeenth century.

Jan Vos (1610-1667) was a glazier who had been writing successful plays since the 1630s, under the patronage of Barlaeus. He prided himself on his ignorance of all languages but Dutch, and was a constant butt because of the formlessness and violence of his plays. (Charges of the same kind were also levelled against Brandt, who made his debut as a playwright in 1647.) In 1647 Vos served the first of twenty terms as head of the theatre. In 1652 Cornelis de Graeff appointed him chief glazier of Amsterdam, in time to deliver all the glass for the town hall. He too was a Catholic from an old family of regents.

The Treaty of Münster was celebrated separately, with great splendour, by the civic guard. Two of the leading captains immortalized their role in the proceedings in paintings for the Crossbowmen's Doelen: Joan Huydecoper and Cornelis Witsen (figs. 296, 297). These paintings reveal the new alliance of regents, painters and poets: Huydecoper was painted by Govert Flinck, who stands behind him in the painting as a member of his company, and Witsen by Bartholomeus van der Helst, while both works contain painted poems by Jan Vos. The one on Huydecoper begins 'Van Maarsseveen takes the lead in the Everlasting Peace, /Just as his sire was first in battle for the state.' (Since he acquired the seignory of Maarsseveen in 1640, Joan Huydecoper

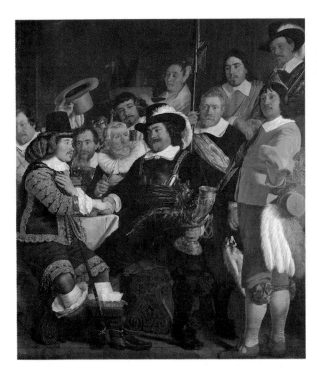

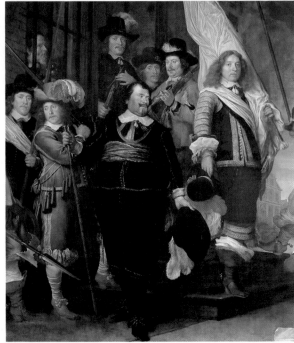

296 Bartholomeus van der Helst (1613-1670), *Detail of a civic guard banquet in celebration of the Treaty of Münster, 1648*. Canvas, 232 x 547 cm. Amsterdam, Amsterdams Historisch Museum.

Captain Cornelis Witsen is shaking the hand of Johan Oetgens van Waveren. This painting was commissioned for the Archers' Doelen at the same time as Flinck's (fig. 297), in which a prominent place is assigned to Johan Oetgen's two brothers, Frans and Nicolaes. The three were sons of the treacherous Antonie Oetgens van Waveren, the former leader of the third bloc in Amsterdam. In the wake of the Treaty of Münster, Andries Bicker was overthrown, and rival parties seized power. Only one of the Oetgens brothers, Joan, became burgomaster, for a single term in 1670, while Huydecoper and Witsen assumed control of parts of their father's former faction. The outward, ceremonial aspect of their struggle for power was reflected in grandiose paintings like these, and in their courting of Amsterdam artists and poets.

One of the sitters in this group was the poet Lambert van den Bos, who praised Rembrandt (for Maerten Kretzer) in 1650. Witsen lent Rembrandt his personal support in 1653, but later in the decade turned against him and helped bring about his financial downfall.

297 Govert Flinck (1615-1660), *Detail of a civic guard banquet in celebration of the Treaty of Münster, 1648*. Signed *Flinck f. 1648*. Canvas, 265 x 513 cm. Amsterdam, Amsterdams Historisch Museum.

The captain is Joan Huydecoper. The men above and behind him are Joris de Wijze, left, and the painter right. The scene is commemorated in a poem by Jan Vos painted into the composition in the lower centre. Flinck also worked for de Wijze, who was a playwright for the theatre of which Vos was a board member.

Huydecoper was the first known buyer of a painting by Rembrandt, in 1628. In later years he extended patronage to Flinck and ignored Rembrandt. This became particularly apparent in the 1650s, when Huydecoper controlled many of the commissions for the new town hall.

bore the title lord of Maarsseveen. For his father's role in the civic guard at the start of the Eighty Years War, see p. 209.) It may surprise the reader that a Mennonite – and therefore a pacifist – like Govert Flinck would bear arms in the guards. No problem. In 1645 he married a wealthy Remonstrant woman, and in September 1651, after her death, he joined their church himself.

In order not to hold up our story, I am including most of Houbraken's biography of Flinck separately, on p. 282. It shows clearly how successful Flinck was in conquering the position in Amsterdam that once seemed reserved for Rembrandt.

REMBRANDT AND THE THEATRE | The theatre's presence is there behind Rembrandt in the 1630s and '40s in several forms. One of the sitters for the *Anatomy lecture of Dr. Nicolaes Tulp*, Jacob Dielofsz. Block, served seven terms on the board of the theatre. Another, Jacob Jansz. Coolevelt, was a playwright. In 1633, Rembrandt painted the playwright Jan Harmensz. Krul, who stood in close contact with Block. Drawings by Rembrandt have been identified as sketches of actors and scenes in two plays by Vondel, *Sophompaneas* and *Gijsbrecht van Aemstel*, both first staged in 1638, after the collapse of Krul's Musyck-Kamer. Of the six board members of the theatre in 1638-1639, when the new building was inaugurated with *Gijsbrecht van Aemstel*, three are known to have had contact with Rembrandt: Tobias van Domselaer owned a painting of his from 1639 (fig. 229; inherited from his mother, whom I assume bought it new); Willem van Campen owned 'a crying woman' and 'a candlelight scene' which sound as though they come from the 1640s, and Floris Soop was painted by Rembrandt in 1654. Claes Moyaert was on the board in 1640-1641, and the Catholic draper Jacob Dircksz. de Roy, one of the guardsmen in the *Nightwatch*, in 1641-1642 and 1651-1652.

An etching of 1642, *The Spanish gypsy* (Bartsch 120) was probably made, but not used, for the printed edition of a play by Willem Gansneb Tengnagel.

None of these relationships measures up to that Rembrandt enjoyed with Jan Six from 1645 on. Six was from a different class to the men who served on the board of the theatre, a function that was never filled by anyone in the council. He was a future burgomaster, with connections which could make or break theatre board members, and in fact it was he to whom Jan Vos dedicated a poem after his first appointment in 1647. That was the year in which Rembrandt made a portrait print of Six (Bartsch 285); in the following year he etched an illustration for the edition of Six's new play *Medea* (Bartsch 112), which Jan Vos directed and which played to empty houses.

The tie between Rembrandt and Six endured for several years. In 1652, Rembrandt contributed two drawings to Six's art album (Benesch 913, 914). In the same year he agreed to sell to his friend three splendid paintings of the 1630s he still owned, a portrait of Saskia (fig. 205), *Simeon in the Temple* (probably fig. 97) and *John the Baptist preaching* (fig. 179). The trust between them was apparently not boundless, since they formed a contract

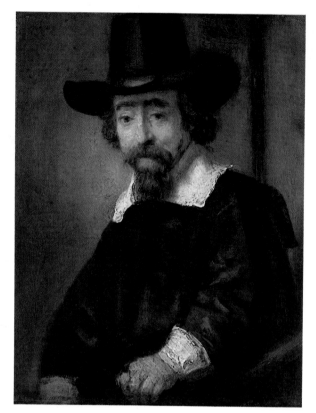

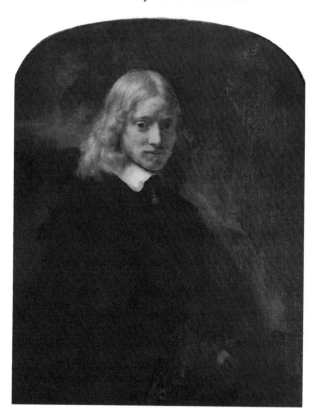

298 *Jan van de Cappelle (ca. 1625-1679)?* or *Pieter Six (1612-1680)?* Signed *Rembrandt f.* Ca. 1652. 94 x 75 cm. Bredius 265. Buscot Park, The Faringdon Collection.

When he died, Jan van de Cappelle left a large and outstanding collection of paintings and drawings. Among them were portraits of himself by Rembrandt, Frans Hals and Gerbrand van den Eeckhout, several paintings and hundreds of drawings by Rembrandt – 56 histories, 89 landscapes and 135 of 'the life of women with children.' He must have been one of the important buyers at the 1656 auction. Of the numerous indirect ties between Rembrandt and van de Cappelle, their common friendship with Gerbrand van den Eeckhout was probably the most significant. Van de Cappelle also lent large sums of money to Clement de Jonghe, Rembrandt's print dealer, for which at one time he accepted etching plates as security.

This portrait is usually said to depict Clement de Jonghe, though without good reason. By changing the proposed identification to Jan van de Cappelle, with a question-mark, at least we are attempting to explain a real problem rather than introduce an arbitrary new one.

The alternative proposal, Pieter Six, Jan's brother, was advanced in a note in the Dutch edition of the present book (1984) on no firmer grounds than the similarity between the sitter and this description of a portrait in *Verscheyde Nederduytsche gedichten:*

The painter is quite pleased;
 he's managed to express
The inner Pieter Six by means
 of outwardness.
His giving nature shows in
 golden-yellow hair
And purity of soul in features
 white and fair.

The poem was written in Latin by Jan Six and translated into Dutch by Gerard Brandt.

299 *Ephraim Bueno (1599-1665).* Preparatory sketch for an etched portrait dated 1647. Panel, 19 x 15 cm. Bredius 292. Amsterdam, Rijksmuseum.

This Jewish physician, whose father Jozef Bueno had administered a draught of gold to Prince Maurits on his deathbed, was one of the backers of Menasseh ben Israel's press. The commission for a portrait etching by Rembrandt was undoubtedly inspired by that of Jan Six of the same year. Six had wide contacts among the physicians of Amsterdam.

This is the only known oil sketch by Rembrandt for a portrait etching, although we know of several for history subjects. The first known collector of this type of work was Six, who bought *The preaching of St. John* (fig. 179) in the 1650s. Jan van de Cappelle (see fig. 298) owned the oil sketch for *Christ presented to the people* (fig. 104), for which the *St. John* was once intended to serve as a companion. The *Bueno* and three other grisailles, finally, were bought by Six's collector nephew Willem.

The appreciation of half-finished products such as oil sketches is characteristic of a more sophisticated collecting climate than Rembrandt had encountered before his meeting with Six. The head of a young Jew of this period can also be placed in the same category (fig. 266).

concerning the *Simeon* and *John the Baptist* including penalties for abusing the agreement. In 1658 that clause had to be annulled, since the contract was in Rembrandt's possession and he claimed to have lost it.

On March 7, 1653, Six lent Rembrandt a thousand guilders free of interest, and in 1654 Rembrandt painted Six's portrait (fig. 301). However, when in 1656 Six's bride was painted, the commission went not to Rembrandt but to Flinck.

Six's highly visible support of Rembrandt had an instantaneous effect. The publisher of *Medea*, Jacob Lescaille (1611-1679 – he printed many of the stage plays and posters for the theatre), wrote a poem on the portrait etching. H.F. Waterloos, Jeremias de Decker's friend (fig. 190), wrote a poem on the *Hundred-guilder print* (Bartsch 74) of about 1648, and in 1650, Lambert van den Bos (1610-1698), a poet who was also a member of Cornelis Witsen's guard company, wrote in his ode to the art collection of Maerten Kretzer (1598-1670) 'To sketch, O Rembrandt, your great fame / Is asking too much of my pen. / Your honour shines before all men / When I merely name your name.'

The most significant of these tributes, from the political point of view, came from the pen of a councilman, the only such praise of Rembrandt known. In 1648, Gerard Schaep, Pietersz. (1599-1655) published a farce that he translated out of the Spanish, *Zabynaja, of vermomde loosheid* (Cunning in disguise; Schaep's translation was put into rhyme by Jan Soet). At a given point, Zabynaja uses Rembrandt's name as a byword for superlative art in praising the embroidery of a lady.

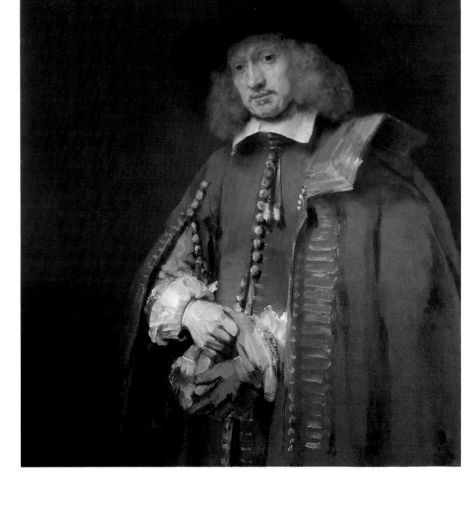

300 *'Six's bridge.'* Signed *Rembrandt f. 1645.* Etching, third state, 12.9 x 22.4 cm. Bartsch 208. Amsterdam, Rijksprentenkabinet.

301 *Jan Six (1618-1700).* Datable from a poem by Six on the painting, containing Roman numerals that add up to 1654: 'AonIDas tenerIs qVI sVM VeneratVs ab annIs/TaLIs ego JanVs SIXIVs ora tVLi' (This was my appearance, Jan Six, who worshipped the Muses from youth.) Canvas, 112 x 102 cm. Bredius 276. Amsterdam, Six collection.

The brilliant execution of this portrait, with its daringly broad stroke, has been related by Eddy de Jongh to the sitter's ideal of courtly dash.

Gerard Schaep, Pietersz. was second in command of the Calvinist faction in the council, under his burgomaster uncle Dr. Gerard Schaep, Simonsz. (1598-1666). For the first time in his career, Rembrandt enjoyed the support of a Calvinist office-holder, one of the few involved in the theatre. Rembrandt's portrait of Sylvius, which preceded these developments, now takes on additional meaning.

Many of those named in the paragraphs above played a role in that remarkable anthology of 1651, *Verscheyde Nederduytsche gedichten* (Assorted Dutch poems), edited by among others Vos, Six, Brandt and van Domselaer, the latter three all owners of paintings by Rembrandt. The volume was dedicated by the publisher to a painter, Gerard Pietersz. van Zijl (1607-1665). One of the aims of the book was to bring together Remonstrant, Calvinist and Catholic poets. Another was to bridge the gap between poetry and painting.

POETS AND PAINTERS | The poems cited formed part of a great round of mutual admiration between the painters and poets of Amsterdam, which as far as I know has never been described, let alone analyzed. There is even praise for the work of certain dead artists in the collections of certain living owners. In 1648 Vondel wrote a long poem on a Titian *Mary Magdalene* in Maerten Kretzer's collection. In the same year he dedicated to Jan Six a poem on Pieter Lastman's *Sacrifice at Lystra* of 1614, the companion to which, *The sacrifices of Orestes and Pylades*, was to be acquired by Six a few years later. In 1648 it was in the collection of Reynier van der Wolff, the son-in-law of Dirck Pesser (fig. 144). After decades of increasingly painful silence, from 1648 on we are bombarded with poetic references to Rembrandt and artists, collectors and patrons in his circle. It takes some restraint not to fill the following pages with quotations. Instead, I shall try to describe the broad view in which they existed.

PAINTERS AND POETS RAISED TO THE SKIES | The outburst of poetic tributes to painters reached its climax on St. Luke's Day, October 20, 1653. At the Archers' Doelen that day, and night, was celebrated 'The Union of Apelles and Apollo,... celebrated by painters, poets and lovers of their arts.' The union was also known as the Brotherhood of Painting. At the head of the table was a Father, who was expected to support the assembled Brothers. It was the city father Joan Huydecoper.

City patronage was at its height. The building of the town hall (1648-1655) brought unprecedented expenditure on sculpture, painting, architecture and

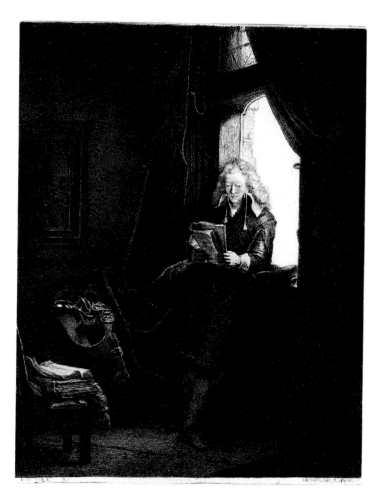

302 *Jan Six (1618-1700).* Signed *Rembrandt f. 1647.* Inscribed *Jan Six. AE[tatis] 29.* Etching, fourth state, 24.4 x 19.1 cm. Bartsch 285. Amsterdam, Rijksprentenkabinet.

Frits Lugt was able, in 1920, to weave some delicate strands of evidence into a convincing theory that the tiny figures in fig. 300 are Jan Six and Albert Coenratsz. Burgh, on Burgh's country estate Klein Kostverloren on the Amstel.

The two men, one a Remonstrant, the other a moderate Calvinist, had enough to talk about while Rembrandt was etching them – to win a bet, according to the old story, that he could finish the etching before a manservant returned to the bridge with a pot of mustard. Burgh lived on the Kloveniersburgwal with Six, two doors away from his brother-in-law Dirck Geurtsz. van Beuningen, Willem Schrijver's uncle. Burgh and Six were both in the dye business, and if Burgh had lived longer, they would have

become relatives: in 1650 Burgh's daughter Anna married Dirck Tulp, and in 1655 Six married Margaretha Tulp, both children of Nicolaes. But Burgh died, on a trade mission to Russia, in 1647, in Nishni Novgorod.

The etching brings the latest date of the meeting between Rembrandt and Six back to 1645, the year of Willem Schrijver's wedding.

The first sign that Six was to take over the (apparently abandoned) place of Joannes Wtenbogaert as Rembrandt's best friend among the patricians of Amsterdam was the portrait etching of 1647. After five years of working exclusively, it seems, for dealers, Rembrandt once more had a patron, and a wealthy and respected one. In 1648 the portrait was followed by an etching to illustrate a play that Six had written.

The painted portrait of Jan Six, which did not follow until 1654, was made in the same year, and the same style, as that of Floris Soop (fig. 306). These were Rembrandt's first paintings of Amsterdamers from the ruling class since the

Nightwatch, twelve years before. Apart from their having been neighbours for twenty-one years by the time Rembrandt painted them, their main common interest, as far as we know, was the theatre.

Jan Six and his brother Pieter, both serious art collectors, were good friends of Hendrick Uylenburgh's son, Gerrit. Jan's wife witnessed the birth of a child of Uylenburgh's in 1670, and Pieter witnessed that of another in 1671. Jan was among Uylenburgh's creditors when his business failed in 1675. At that time the younger Uylenburgh also owned a valuable painting by Rembrandt, 'A Jewess.' One wonders whether the Uylenburghs too might not have played a role of some kind in the relationship between Rembrandt and Jan Six.

iconographic designs, the commissions for which mostly went to Amsterdamers. There was no need for the moment for painters and poets to compete for the favour of regents. There was more than enough for everyone.

Huydecoper, who was keenly aware that art was a high road to glory, was eager to share (with Cornelis de Graeff) the main credit for the building and decoration of the town hall. Beside him at the table that day were the men behind the Brotherhood, Maerten Kretzer, Bartholomeus van der Helst, Nicolaes de Helt Stockade and publisher Jacob van Meurs. Master of ceremonies was the poet Thomas Asselijn (ca. 1630-1701), who wrote an allegorical play for the occasion. (Thomas's late brother, the painter Jan Asselijn (1610-1652), whose portrait was etched by Rembrandt about 1647, had been married to de Helt Stockade's sister.) The guest of honour was Joost van den Vondel, who was crowned with a laurel wreath that day. Across the table from him was Govert Flinck, who was soon to emerge as the main painter of the town hall decorations. The year before, Vondel and Flinck had joined forces for the first time, when Vondel wrote a poem on Flinck's portrait of the controversial town secretary Gerard Hulft. They remained friends and collaborators from then until Flinck's death.

Flinck's reputation had been growing steadily since the 1630s, but in 1652 it had reached unknown heights when he painted the portrait of Friedrich Wilhelm of Brandenburg, who since 1648 had been married to a daughter of Frederik Hendrik. The prestige attached to this commission was heightened even more by the place of the German Electors in Amsterdam history. All of the pageants we have mentioned included the seven Electors, as participants in the 'Granting of the imperial crown to the Maid of Amsterdam by Emperor Maximilian,' and they were regarded as guarantors of the city's freedom. The close ties between Amsterdam and German courts were no doubt an important factor in the careers of Sandrart, Flinck and many others.

As opposed to the guild of St. Luke, where artists were on the same level as house painters and other such, the Brotherhood brought them into association with the practitioners of the equally noble art of poetry, under the auspices of an art-loving burgomaster who was going to reward them on a princely scale for their contribution to the glory of Amsterdam. The triumph of painting as an instrument of 'pomp and propaganda,' in the phrase of D.P. Snoep, was so intoxicating that evening that the artists were able to forget the plague that was ravaging the city, the disastrous war with England,

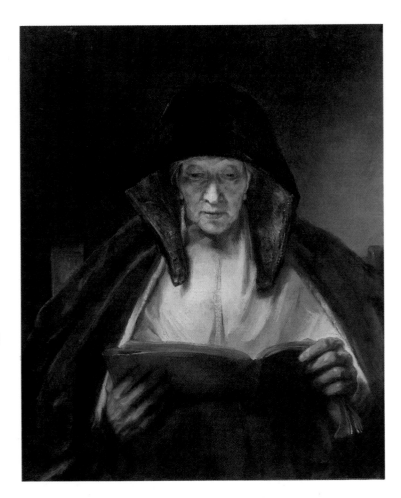

303 *An old woman reading.* Signed *Rembrandt f. 1655.* Canvas, 80 x 66 cm. Bredius 385. Drumlanrig Castle, Scotland, collection of the Duke of Buccleuch.

There is evidence, albeit inconclusive, that Rembrandt painted the mother of Jan Six, Anna Wijmer (1584-1654). In *Hollantsche Parnas*, Vondel wrote poems on painted portraits of the mother and son that are taken to refer to paintings by Rembrandt, although the artist is not named. In the Six collection is a painting dated 1641 that is usually identified as that work, but both the identity of the sitter and the authorship of the painting are questionable.

As an alternative, I would suggest that the painting in the Buccleuch collection is a posthumous portrait of Anna Wijmer. Rembrandt's second drawing in Six's art album is probably an allegorical depiction of Anna as Athena, reading a book. Vondel's poem, which is otherwise obscure, becomes a bit clearer if we assume that the portrait

it describes shows a literary mother reading a book by her son:

Anna Wijmer, who did give
Life to Six, here seems to live.
She hides the breasts he
 sucked upon
The mother's eye reveals the
 son.

As Christopher Brown has pointed out, the device of illuminating the sitter's face with light reflected from an open book was first used by Rembrandt in the etched portrait of Jan Six (fig. 302).

in its second year, the ruinous state of the economy, which led Burgomaster Huydecoper to issue sumptuary laws in 1654, and even that the same Huydecoper was busy paring the budget for the new town hall, which put their presence at his table in something of a questionable light. At the height of the celebration, the sixty-six year old Vondel left, after pushing a sheet of paper across the table to Flinck with the lines:

Govert, what a terrible fright!
See them drink and feud and fight,
Scream and roar and kick and bite.
Stuffing bowel and belly tight
By the lamp or candlelight.
This will cause a fearful plight:
Headache, loss of appetite,
Vapours, nervous tics and blight.
Want to stay? I'll say good-night.

The two former Mennonites had come a long way.

REMBRANDT IMMORTAL AT LAST | Rembrandt does not seem to have been present that evening, or at the one-and-only repetition of what was to have been an annual event on October 21, 1654. Yet, between July and September 1654, he was fêted by Jan Vos in a blunt piece of artistic politics, a long poem, dedicated to Cornelis de Graeff, entitled *Battle between Death and Nature, or the triumph of Painting*. In hundreds of verses of allegory, Vos sketches a pitiful picture of mankind seeking an antidote to the all-devouring punishment of the gods, death. After being let down by Nature, then by Poetry, man finds salvation in Painting – not just any kind of painting, but that of the Amsterdam school. Until then, the highest flattery that could possibly be given to the art of painting was to call it the equal of poetry. And here is the poet Vos placing painting above his own art.

The verses in which he finally names names begin like this, with Nature talking to Painting:

I see, my child, I see the day draw near
When in the north, awash with salty waves,
A city will grow from a fisher's hut
(Although her ground be buried still in peat),
And she shall serve you as a strong support,
For Amsterdam (and that shall be her name)
Will ply the trident over all the seas
And she will swarm with painters and with bards
Who, in this capital of harbour towns,
Will found a Brotherhood, on Kretzer's wise advice,
To serve you on your anniversary.
…

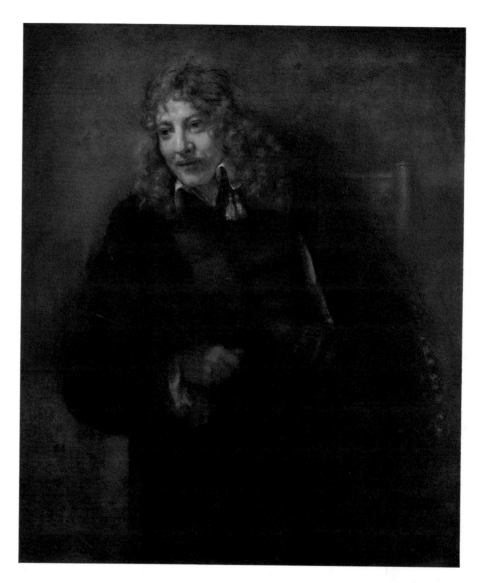

304 *Nicolaes Bruyningh* (1629/30-1680). Signed *Rembrandt f. 1652*. Canvas, 107.5 x 91.5 cm. Bredius 268. Kassel, Gemäldegalerie.

Nicolaes Bruyningh was related not only to the Trips, but also to several of Rembrandt's Mennonite sitters of the 1630s and '40s – Jan Pietersz. Bruyningh, the Moutmakers, the Anslos – and to Joost van den Vondel. In 1652, however, when he was baptized, it was in the Remonstrant church. Among the other Mennonites who went over to Remonstrantism around this time were Jacob Backer and Govert Flinck. One reason, as far as Bruyningh was concerned, was undoubtedly that Remonstrants could have more fun with their money than Mennonites. In 1652 he inherited a sizeable fortune from his grandfather, which he lost before he died.

His portrait ended up in the collection of his sister's grandson Jan Graswinckel. After the latter's death, his widow gave it to his cousin, the collector Valerius Röver, whose widow sold it to the landgrave of Hesse-Cassel.

305 *Man in a fur-lined coat.* Signed *Rembrandt f.* Ca. 1654. Canvas, 114.3 x 87 cm. Bredius 278. Toledo, Museum of Art.

The portraits of Jan Six became a standard of quality for Rembrandt's other sitters. On Christmas Day 1655, Rembrandt contracted to buy a house, for which he was to pay in part with 'a portrait of Otto van Cattenburgh [the brother of the seller] to be etched from life by the aforesaid van Rijn, of the same quality as the portrait of Mr. Six, for the sum of 400 guilders.' The painted portrait of Six provided a model for portraits like this, which is about the same size.

Apollo and Apelles will be joined,
And poetry with her daughter song.
Here is Rembrandt, Flinck, de Wit, Stockade,
There van der Helst, the Konings and Quellijn.

Rembrandt at the head of the painters to achieve immortality on earth – at last the role in which we know him still.

TWIN TOWERS ON THE DAM | Did I say there was enough to go around for everyone? How foolish. Is there ever? Over the heads of the celebrating artists and poets, a three-ring battle of the Titans was raging, which was going to break some great men. The main struggle was between church and state, brought down to the level of a primitive, but deadly game: of the two monumental buildings on the Dam, the Nieuwe Kerk and the town hall, which was to be taller? In 1645 there was a fire in the medieval Nieuwe Kerk, and when money was voted for its repair, the Calvinist party took advantage of the occasion to add a tower to the building that would make it higher than the projected dome of the town hall.

The plans for a new, relatively modest town hall had already been approved in 1642, but in 1646 the libertine party called in Jacob van Campen and asked him to revise his designs outward and upward, with a dome that would rise above the projected church tower. The first piles for the new building were driven in 1648. In 1652, a fire in the old town hall led to an acceleration in the pace of work. But in 1653, in the midst of the first Anglo-Dutch War and a severe economic crisis, the competition between the two parties centred on keeping the other's building low rather than one's own high. Work on the tower was discontinued, and the plans for the new town hall were downgraded from two storeys to one. Van Campen, who had also submitted a design for the church tower, became entangled in a strange and sinister struggle.

That year, the recently appointed town carpenter, Daniel Stalpaert, a relative of Huydecoper's, and the new town mason, Simon Bosboom, began to claim credit for the final plans of the town hall. This pretension was ridiculed in a pamphlet addressed to van Campen's two main supporters in the council, Cornelis Bicker and Gerard Schaep, Simonsz.

The ins and outs of this complex drama, which involved all the great and many small themes of Dutch politics, religion, city-building and artistic patronage, have never been reconstructed. We can only observe the upshot: the Calvinists lost, and so did van Campen. In September 1654, Cornelis

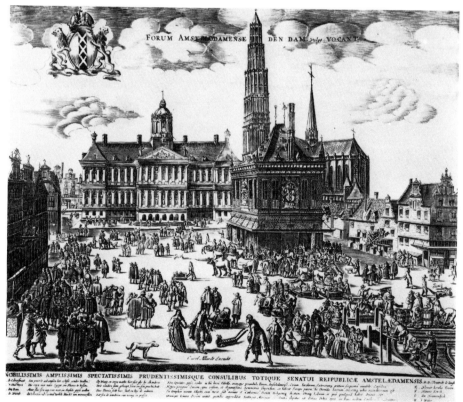

FORUM AMSTELRODAMENSE DEN DAM VOCANT.

NOBILISSIMIS AMPLISSIMIS SPECTATISSIMIS PRUDENTISSIMISQUE CONSULIBUS TOTIQUE SENATUI REIPUBLICÆ AMSTELÆDAMENSIS

HIGH AND LOW
305a Clement de Jonghe (1624-1677) after Jacob van der Ulft (ca. 1627-1680), *The Dam in Amsterdam*. Ca. 1655. Engraving.

The building in the middle of the square is the old weighing hall, long since demolished. In 1655 a battle was raging over the relative height of two structures in the background, neither of which was standing when the print was made: the dome of the town hall and the tower of the Nieuwe Kerk.

Clement de Jonghe, to judge by this print and another, of the church tower alone, was a supporter of the Calvinist party which was trying to make of the Nieuwe Kerk tower the tallest construction in the northern Netherlands. He was one of the foremost print dealers in Amsterdam, and was soon to become the main dealer in Rembrandt's prints.

In sharp contrast to this view, are the paintings of the Dam by Gerrit Adriaensz. Berckheyde (1638-1698) and Jan van der Heyden (1637-1712), who was probably a protégé of Huydecoper. They choose points of view at the southern foot of the town hall, its dome dominating the square.

Two small, amateurish prints showing the reality were published in 1664 in a broadsheet describing the disasters and natural wonders that had befallen the city in 1663: an outbreak of plague, the passage of a comet, and the breaking of many trees under the weight of ice that had formed on their branches and trunks. The first two scenes are shown on the Dam, with the Nieuwe Kerk as it was, without tower, and the dome of the town hall in scaffolding, under construction. The implication is that the city fathers brought down the wrath of God upon Amsterdam by setting the state above the church. The broadsheet has poems by one dead poet, Roemer Visscher. and three living ones: Jan Soet, Gerbrand van den Eeckhout and Jeremias de Decker. All three were backers of Rembrandt, close to the Calvinist camp in the council.

Bicker died, and the circumstances of his replacement took an unexpected turn. The logical candidate, the Calvinist Spiegel, was kept out of office by Huydecoper and Banning Cock, who induced their colleague Tulp into accepting a man of their own, Albert Pater. These manipulations were too much for the Calvinists. As the meeting where the predetermined election was to take place was being opened with the customary prayer, Gerard Schaep, Pietersz., stood up, shook his fist at the burgomasters and screamed 'And you dare to pray, with such corruption going on!' His fury was a sign of impotence. He and his party had been outmanoeuvred, and Jacob van Campen had lost his base of support. On December 1st he abandoned Amsterdam and when the town hall was inaugurated the following year, he was not present. In the 1379 lines of Vondel's 'Dedication to the town hall of Amsterdam,' he is mentioned only once in passing, together with Stalpaert, who in two other verses is cited on his own.

REMBRANDT AND HIS BROTHERS | The Brotherhood can be seen as the glorification of a development we have traced from the Pijlsteeg in the sixteenth century to the Breestraat in the early seventeenth. The painters and politicians who embraced each other under the loving gaze of playwrights and poets were either the same men or the successors of those who had been operating all along on the dividing line between art, politics and – think of Abraham de Koning and Theodore Rodenburgh – theatre. However, the unity and massiveness of the Brotherhood was artificial, and its hour of glory brief. After 1654, we hear nothing more about it.

Although Jan Vos puts Rembrandt at the head of this behemoth, one has the feeling that his position there was either shaky or actually non-existent. The portraits of Jan Six and Floris Soop point to a base of support closer to the theatre than to any other institution in Amsterdam, but at this stage of research we do not know what consequences were entailed in his position vis-à-vis the guild, the Brotherhood or the commissions for the town hall.

Rembrandt's man on the town council

WILLEM SCHRIJVER | The marriage of Willem Schrijver and Wendela de Graeff in 1645 was followed, we know, with a tribute by the bridegroom's father Scriverius to the Amsterdam clergyman Sylvius, in a portrait etching by Rembrandt (fig. 194). The closest relative in Amsterdam of father and son Scriverius was Floris Soop, the son of Scriverius's brother Jan Hendricksz. Soop. In 1654 Floris Soop had himself painted in a large portrait by Rembrandt (fig. 306). Soop lived all his life in the house where his father Jan Hendricksz. had a glass factory for the first quarter of the century. The huge triple house on the Kloveniersburgwal was still called Het Glashuys (The Glasshouse) even after the business was discontinued.

From 1631, the Soops' next-door neighbours were Anna Wijmer and her sons Jan and Pieter. Jan Six shared with Floris Soop an interest in the theatre, and it is not too much to assume that they knew each other well. The resemblance between Rembrandt's portraits of the two, both from 1654, has long led art historians to assume that there was a connection between the sitters. The Schrijver-Six-Soop triangle was completed in 1673 when Willem Schrijver's son married Pieter Six's daughter. In all likelihood, however, it existed from the moment of Willem's marriage in 1645. If so, Rembrandt's tie to Jan Six may be an extension of his much older connection to Willem Schrijver and Petrus Scriverius. The Remonstrantism of the Leideners did not prevent them from marrying Amsterdam Calvinists, a development which probably helped Rembrandt capture the Calvinist support we came across in the last chapter.

Unfortunately for Rembrandt, Willem Schrijver was not much of a go-getter. When his last kinsman in the Amsterdam council, Geurt Dircksz. van Beuningen, died, Vondel put into the mouth of the Maid of Amsterdam the words 'Councillors I have many, fathers few.' Another saying was more appropriate to Willem. The Amsterdamers spoke of their thirty-six councilmen as 'twelve who are all, twelve who are on call, and twelve who are crazy as a screwball,' and while I do not know whether Willem belonged in the second group or the third one, I'm sure he wasn't in the first.

What made it even worse is that his connections could not have been better. When he married Wendela de Graeff, he wedded the black sheep of a family that was itself mistrusted by the leading power in Amsterdam. But five years later the worm turned. Schrijver, to borrow the phrase of Billy Wilder and I.A.L. Diamond *(The front page)*, was in the brother-in-law business, and in 1650 business became good (fig. 307).

A PALACE COUP | In 1650 everything changed in Amsterdam. August brought with it a siege by the States army and the fall of the Bickers. The story is full of unexplained elements, but basically what happened is that the new stadholder, Willem II (1626-1650), who was not as judicious as his father, seized on one of Amsterdam's countless provocations to teach the city a lesson. He launched a surprise attack, and if he hadn't got lost with his entire army in a fog east of Amsterdam, he might have taken it. As it was, Amsterdam was able to keep him from entering its gates, and to reach a quick agreement on talks. A commission of four men was sent to The Hague under Cornelis de Graeff. The negotiations took place behind closed doors, and no one knows exactly what went on. In later years, a statesman in The Hague said that people there were surprised by the ease with which they had been able to outwit the sharp Amsterdamers. With a knife at their throats, the delegation was forced to sacrifice their own principals, Andries and Cornelis Bicker. What van Waveren had not been able to do in 1639, and he himself had failed at in 1643, Cornelis de Graeff was finally able, with the help of someone else's army, to

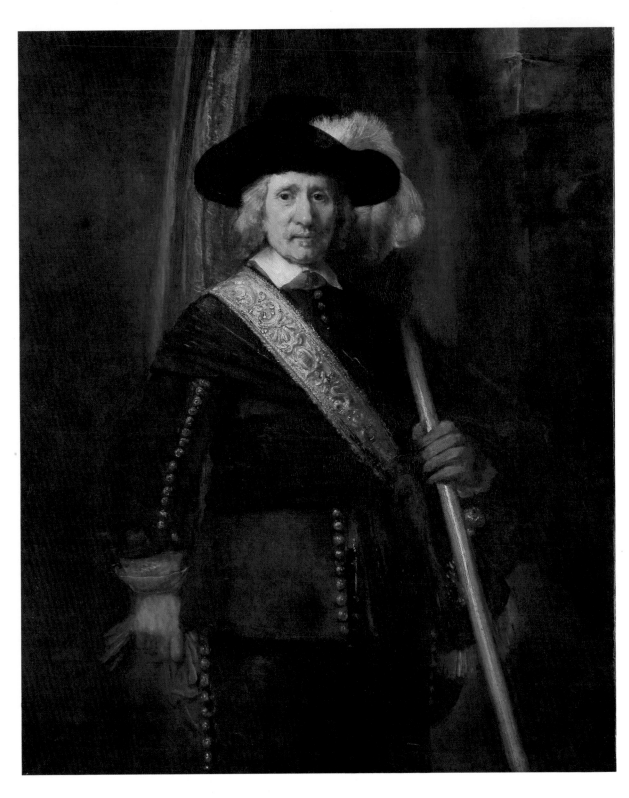

306 *Floris Soop (1604-1657).* Signed *Rembrandt f. 1654.* Canvas, 140.3 x 114.9 cm. Bredius 275. New York, Metropolitan Museum of Art.

The identity of the sitter is another of Isabella van Eeghen's countless contributions to Rembrandt studies.

Floris's elder brother Jan Soop de Jonge was the captain of one of the five Amsterdam companies of professional soldiers which were kept at arms in addition to the twenty companies of civilian guardsmen. Because Jan Soop was a Remonstrant, his appointment in 1628, like that of Jan Claesz. van Vlooswijck, led to a major incident. The paymaster of the mercenary companies was another Remonstrant, Augustijn Wtenbogaert.

Floris chose for the civic guard, in which he served as ensign of Precinct XV under his father's cousin Captain Dirck Geurtsz. van Beuningen. Even higher positions were held by Albert Coenratsz. Burgh and Pieter Reael, who were not only captains but also governors of the Kloveniersdoelen.

We begin to get an idea of the importance of armed might in the rise of the 'tolerant' Remonstrants in Amsterdam.

The position that Floris Soop occupied among Rembrandt's patrons can be demonstrated most effectively by one story. When he died without leaving a will, the heads of his father's and mother's families were Petrus Scriverius and Soop's near neighbour Willem Boreel. (The house was turned upside down in a search that lasted eight months. When no will was found, Scriverius became universal heir.)

307 Thomas de Keyser (1596/97-1667), figures, and Jacob van Ruisdael (1628/29-1682), landscape, *Cornelis de Graeff with his wife Catharina Hooft in the coach, their children Jacob and Pieter on horseback, with their brother and brothers-in-law Andries de Graeff, Pieter Trip and Willem Schrijver in the background.* Canvas, 170 x 117 cm. Dublin, National Gallery of Ireland.

The identification of the figures is due to S.A.C. Dudok van Heel. He places the scene in Soestdijk, which belonged to the de Graeffs until 1674, when it was bought from them by the man who ejected them from office, Stadholder Willem III.

Cornelis de Graeff, in control of the magnificat, was at the height of his power. The respectful distance between him and his brother and brothers-in-law reflects the gap between his status and theirs.

The portraitist Thomas de Keyser was the son of Hendrick de Keyser (1565-1621), town sculptor and architect. His brother Willem was town carpenter and stonemason from 1647 to 1653 as a close associate of Jacob van Campen in the construction of the new town hall. He was replaced in the latter year by Joan Huydecoper's protégé Simon Bosboom.

accomplish in 1650: when he came back from The Hague, the magnificat was his.

Willem II died in December 1650, and the Bickers were able to regain some ground, but not much. Cornelis, the old captain in the musketeers, was given more authority than Andries, who died in 1653.

OLD PATRONS IN POWER | The coming of the de Graeffs brought to power the people who had once been Rembrandt's most important patrons, men who had been kept out of the burgomaster's chamber by Andries Bicker for decades. The genie was out of the bottle. In 1650 Frans Banning Cock became burgomaster, in 1651 Joan Huydecoper, in 1654 Nicolaes Tulp, in 1657 Andries de Graeff. Willem Schrijver had to be content with a seat in the council in 1656, after he rose from the ranks of the civic guard to lieutenant in 1647 and captain in 1653. (The rank was effectively downgraded in 1650, when the number of companies was increased from twenty to fifty-four.)

If Willem was famous in Amsterdam for one thing, it was for being the father of a son who stood to inherit the fortune of his late wife's first husband. This operetta plot, which was inherent in Willem's marriage, became a *cause celèbre*, leading after Willem's death to something approaching a national incident.

JOSEPH AND JACOB, 1656 | The public mark of Willem's favour to Rembrandt was the 'large painting by Rembrandt hung over the fireplace' in the main room of his house on the Herengracht, a considerable recommendation coming from a councilman. In its way, it is equivalent to the approving line in *Zabynaja* by Gerard Schaep, Pietersz., and it fills the historian with a particular satisfaction when he discovers that the seat in the council that Willem Schrijver took over in 1656 was that of the same Gerard Schaep (see p. 273).

Several off-hand suggestions have been made as to which painting Willem owned. I believe it to have been the largest history Rembrandt did since the *Samson* and *Aegina* of the 1630s, a painting in the same 'eight-by-ten-foot' category that Rembrandt reserved for his special patrons: *Jacob blessing the sons of Joseph* (fig. 308).

The Schrijver mantelpiece painting was removed from the panelling after Willem's death, by the guardian of his son and stepdaughter, Andries de Graeff, who installed it above the mantel of his own new house. It might have been pure suppressed love for Rembrandt that made Andries take this trouble, but I believe there was another reason, contained in the painting itself.

The subject of *Jacob blessing the sons of Joseph* is rightful inheritance by a younger son over an older one. Blind Jacob insists on giving his blessing to Ephraim, the younger of Joseph's two boys, rather than Menasseh, the older one. And this was exactly Willem Schrijver's main problem in life, a problem that was to be inherited by Andries de Graeff. Wendela de Graeff had two children by her husband Pieter van Papenbroeck (1612-1641), a son who died young and a daughter, Alida, who in 1655 married Gerard Bicker van Swieten (1632-1716), the son of the late Cornelis Bicker and of Aertge

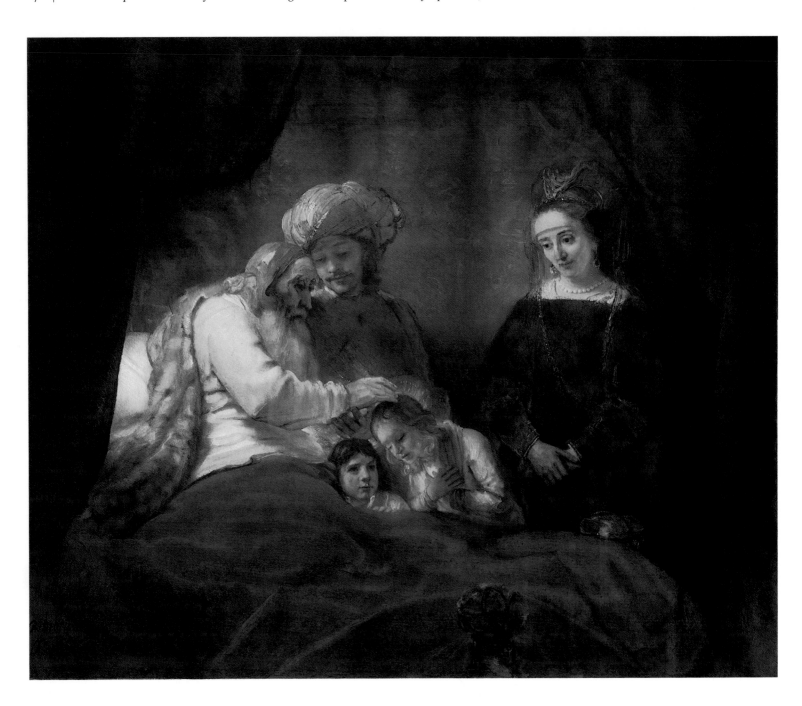

308 *Jacob blessing the sons of Joseph* (Genesis 48:8-20): *a portrait historié of Petrus Scriverius, Willem Schrijver, Wendela de Graeff and her two sons?* Signed *Rimbran*[dt] *f. 1656.* Gerson: 'false; copied from the good signature?' Canvas, 175.5 x 210.5 cm. Bredius 525. Kassel, Gemäldegalerie.

The story of how the blind old patriarch insisted on blessing the younger son Ephraim with his right hand and the elder Menasseh with his left was not unpopular in Dutch art. (The scene does not occur in any of Vondel's three plays on Joseph.) What sets Rembrandt's version apart, in terms of the subject, is the presence of Asenath, Joseph's wife.

Here the painting is explained not in terms of iconography but with reference to the personal life of the man for whom, I believe, it was painted, Willem Schrijver.

Witsen (1599-1652), the niece of Burgomaster Cornelis Witsen (1605-1669). Wendela had died in 1652, and when Alida too passed away, in August 1656, Willem found himself in an uneasy relationship with a vast fortune composed of money that a few years before had belonged to other families, and which under certain circumstances (which later came to pass) could still be inherited by the family of little Willem's deceased older half-brother and half-sister, the van Papenbroecks. Willem Schrijver and Andries de Graeff disputed the van Papenbroeck claim, but when the matter came to court, in what went into history as 'The Schrijver-van Papenbroeck case,' they lost. Andries de Graeff fought all the way to the high courts, and when in 1670 his last appeal was defeated, he broke with Pensionary Fagel over the issue.

Looking at the painting in Kassel against this background, one cannot help wondering whether it is not a *portrait historié* of Willem Schrijver I as Joseph, Willem Schrijver II as Ephraim, with the inclusion of the deceased Wendela de Graeff as Joseph's wife and her oldest son as Menasseh. Jacob would in that case be no one else but Petrus Scriverius, who in 1656 was eighty years old and blind. A depiction of Willem Schrijver as Joseph, the ideal regent, would be a great compliment to the sitter, who entered the council that year, while the incident is of unique pertinence to his position at that moment. Moreover, Andries de Graeff's interest in the painting would also be explained.

The Schrijver-de Graeff mantelpiece painting can be traced down to 1733 in inventories of the family possessions. By 1776 it was definitely gone. *Jacob and Joseph* appears for the first time in a Kassel inventory of 1749. In the 1730s and '40s Landgrave Wilhelm VIII of Hesse-Cassel (1682-1760) was busy buying paintings in Amsterdam for his collection. One of the other works that appears for the first time in that same inventory of 1749 is the portrait of Andries de Graeff (fig. 223). This is not yet absolute proof, but it takes us a long way in that direction.

If the implied interpretation of Rembrandt's great masterpiece brings it down to earth from the spiritual heights at which the subject is usually discussed, all I can say is: that was the earth on which Rembrandt's patrons were walking in 1656.

On stage, 1655-1660

JOSEPH AND POTIPHAR'S WIFE │ Rembrandt's relationships with the two artistic heroes of the Brotherhood, Flinck and Vondel, go back a long way. Flinck was his successor in Uylenburgh's academy, and they were collaborators of a kind from 1636 to 1642, but after that they seem to have had little more to do with each other. As for Vondel, despite the lack of direct contact between them, from 1625 to 1642 Rembrandt followed his career virtually from play to play. The climax of *Palamedes* (1625; fig. 17), drawings of *Gijsbrecht van Aemstel* and *Sophompaneas* (1638) and perhaps the final scene of *Brothers* (1642; fig. 244). The historian of the Amsterdam theatre Ben Albach has pointed out that the occurrences of Joseph in Rembrandt's work coincide with the productions of Vondel's Joseph play on the Amsterdam stage.

The Joseph trilogy was revived in December 1653 in a programme with all three plays being performed one after the other, 'a spectacular show with music, ballet and tableaux vivants. But in 1655,' Albach goes on, '*Joseph in Egypt* commanded attention because in it a woman appeared on the Amsterdam stage for the first time: the capable Ariane Noozeman-van den Bergh, who was about thirty years old at the time.' The play ends with the scene depicted in Rembrandt's two paintings of the subjects (figs. 309, 310), with Joseph, Potiphar and his wife all present, in contrast to the Bible story. Cautiously, Albach suggests that Rembrandt's paintings are re-creations of this scene. In view of Rembrandt's close contacts with the theatre in the preceding period, this seems perfectly likely. The contacts in the subsequent period, to be described below, make it even more certain that Albach was right.

HESTER, 1660 │ Several of Rembrandt's paintings of the late 1650s can be connected with the Amsterdam theatre. The argument for this can best be presented backwards, beginning with a brief sortie into the future.

In 1660 he painted *Haman and Ahasuerus at the feast of Esther* (fig. 311). Probably the next year, Jan Vos wrote a poem on the painting, the first in a series on 'Several paintings in the house of Mr. Jan Jacobsz. Hinlopen, alderman of Amsterdam.'

This Jan Jacobsz. Hinlopen (1626-1666), who lived on the Kloveniersburgwal, near Jan Six, was married to Leonora Huydecoper (1631-1663), Joan's daughter, and was a nephew of Rembrandt's old patron Tymen Jacobsz. Hinlopen.

Although considerable discussion has been devoted to the painting, it seems not to have been noticed until now that the scene it depicts can be found in a play whose première in the Amsterdam theatre took place in June 1659: *Hester, or the Salvation of the Jews*, dedicated to none other than Leonora Huydecoper.

In the fifth act, with the three main characters at the table, Esther exposes Haman to Ahasuerus as the man who wished to destroy her people. The men respond as follows:

AHASUERUS Fie Haman, curse the day when you
 were born.
HAMAN Where can I hide? I dare not face the prince
 again.
Woe is me! I brought this disaster on my own head.
My greatness, Gods, takes an unexpected turn.

The conclusion that Rembrandt's *Esther* for the Hinlopens was occasioned by the play, if it was not a portrayal of the actual moment on the stage, is inescapable.

Rembrandt's formal solution for the scene made a deep impression on at least one observer. The painter Gerard de Lairesse, who worked in Rembrandt's proximity in the 1660s (see caption to fig. 401), wrote this interesting remark forty years later: 'I have just thought of a story in which the three main emotions have to be depicted side by side in one painting, and that is Ahasuerus, Haman and Esther. [If I were to paint it, I would place]

Esther in the strongest light, in profile and to one side; the king [where] most of the light falls, ... but Haman I would put on the other side of the table in dim light.' De Lairesse apparently re-invented in his imagination a composition by Rembrandt he had seen long ago.

In quoting Jan Vos's poem in 1719, Arnold Houbraken, too, stresses the 'power of the individual emotions' in the painting (see caption to fig. 311). This is not how it strikes us today. A sensitive modern student of Rembrandt like H. van der Waal responded to the painting in exactly the opposite way: he was so impressed by what he saw as the suppression of emotions in the painting that he doubted the fairly incontrovertible evidence that it is the same work that was praised by Vos and Houbraken.

These contradictory reactions, it seems to me, may well derive from the original inspiration of the painting in the play. The author was Joannes Serwouters (1623-1677), who as a dramatist was known as the innovator of a new style of acting, in which the emotions were expressed with restraint, but spectacular staging was not eschewed. This could explain why the *Feast of Esther* was singled out, from all of Rembrandt's late histories, to be praised for a quality we no longer see in it.

The same philosophical mood pervades Rembrandt's only other painting of a story from the book of Esther, an undated work in Leningrad (fig. 312) which cannot be much later than that in Moscow. This scene too, which has been the subject of endless controversy, corresponds to a scene from *Hester*. In the third act, Ahasuerus, after talking to Mordechai in the garden, joins Haman and the old courtier Harbona in the palace. Haman tells the king that there is a people in his land who were conspiring against his 'turban and crown.' Ahasuerus gives him permission to kill them, and Haman addresses the audience with the words 'Now all of Jewry is in my hands.'

TAMERLANE, 1657 | *Hester* was not the beginning of Serwouters's career in the theatre. In 1655 he had served the first of eight consecutive terms on the board, all of them concurrently with Jan Vos. Two years later he made his debut as a playwright, with *Tamerlane the Great, with the death of Bayazet the First, Emperor of Turkey*. The play was dedicated to Jacob Jacobsz. Hinlopen (1621-1679), Jan's brother. Jacob was a governor of two orphanages, and in 1657 became a member of the council (see adjoining text). He had more influence on the theatre than Jan.

Tamerlane is a melodrama of the overthrow of the Turkish sultan Bayazet I (standing, in the words of the preface, for 'greatness') by the Mongol Tamerlane ('bravery'), which took place in 1402. In Act II, the epic battle of Ankara is reduced to a horseback chase outside the city. After being challenged by the Mongol, the sultan cries out 'Ye Turkish heroes, gird yourselves, saddle your mounts./ Our mutual dispute will be decided in the fray.'

The stage action that follows is not described, but the next speech finds Bayazet in solitary flight, blaming his horse for his undoing: 'Oh horse I trusted so unreasonably,/ I lose you, and hold the

THE ELECTION TO THE AMSTERDAM TOWN COUNCIL OF WILLEM SCHRIJVER AND JACOB JACOBSZ. HINLOPEN

From Hans Bontemantel, *The government of Amsterdam, civil as well as criminal and military (1653-1672)*

28 January 1655. – Present were Messrs. Tulp, Pater and Maarsseveen [Huydecoper], the lord of Purmerland [Banning Cock] having died on the first of January. The usual privileges having been read, Jacob Bas, Dircksz. and Jacob Bicker, Andriesz. were elected to the council. Candidate for the third vacant seat was Zacharias Roode, in opposition to whom was nominated Jacob Jacobsz. Hinlopen. The objection was raised that he was not a *poorter* [registered citizen], despite the fact that his father, who was also called Jacob Jacobsz. Hinlopen, was appointed councilman and alderman in 1617, served many terms as alderman and died a councilman. Thereupon Hendrik Hooft was elected with the most votes to the third seat.

July 30, 1655, being the first meeting in the burgomasters' chamber of the new town hall. [The resolution was passed] that all children whose parents have been known to have inhabited the city for a long time continuously shall be considered *poorters*, since in former times no records of this kind were kept. [Bontemantel then wrote, but crossed out the words:] This was for the benefit of Jacob Hinlopen, because his brother was about to marry the daughter of the lord of Maarsseveen.

January 28, 1656. – Present all the burgomasters [Huydecoper, Cornelis de Graeff, van de Poll, Spiegel] and all the councilmen except Hendrik Hudde. In the place of Gerrit Schaep, Pietersz., who died on June 21, 1655, Willem Schrijver was elected with unanimous votes except that of the lord of Polsbroek [Cornelis de Graeff], since the aforesaid Schrijver was married to Wendela de Graeff, Polsbroek's sister. This Schrijver was born in Leiden, and when he married his wife made him a citizen [of Amsterdam].

Sunday the 28th of January 1657. – Present were Polsbroek, Tulp and van Vlooswijk, burgomasters. The prayer and privileges being read, the vacant council seats of the deceased Roelof Bicker and Jacob Bas and the promoted Hendrik Hudde, Gerritsz., who became a councillor in the Council of State, were filled. Elected unanimously in their places where Frederik Alewijn, Cornelis de Vlaming van Outshoorn and Jacob Jacobsz. Hinlopen. On January 28, 1655 objection had been voiced against the latter, who even though his father had been alderman and councilman, was not a *poorter*, which objection was removed with the resolution of July 30, 1655, as we have seen.

The as yet unanalyzed meaning of these events in terms of the relationships between Cornelis de Graeff, Joan Huydecoper, Jacob Jacobsz. Hinlopen, Willem Schrijver and the late Gerrit Schaep, Pietersz., is of the greatest importance for understanding Rembrandt's position in Amsterdam in the years 1655-1662.

What strikes one is that Cornelis de Graeff and Joan Huydecoper were falling over themselves to advance the career of Jacob Jacobsz. Hinlopen. Ancient procedures were amended to open his way to the council. Willem Schrijver was treated differently. His powerful brother-in-law Cornelis de Graeff not only refused to vote for him, citing a rule that was honoured as often in the breach as the observance, but actually – and needlessly – voted against him, for Jacob Jacobsz. In the chapter on Rembrandt's insolvency we shall see that Cornelis indeed could not have cared less about Willem.

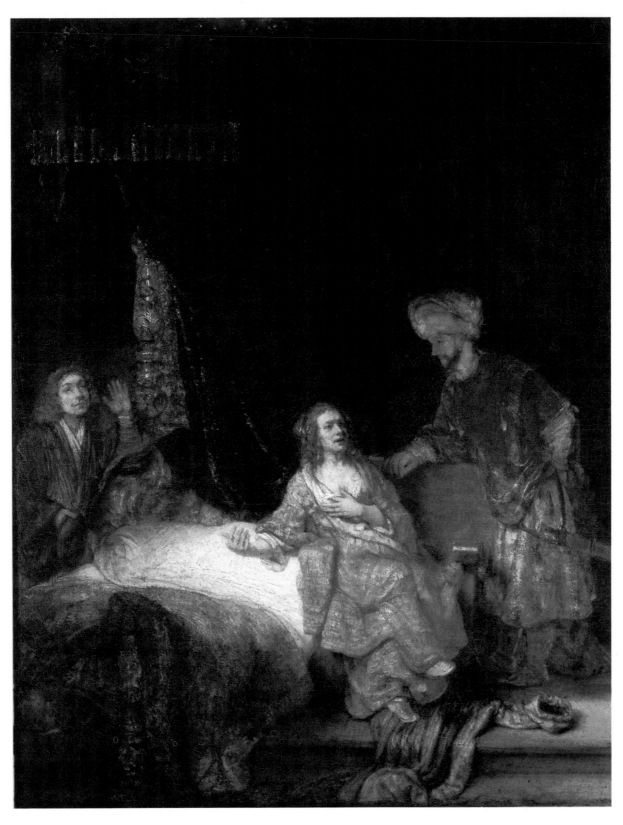

309 *Joseph accused by Potiphar's wife* (Genesis 39:17-18). Signed *Rembran*[dt] *f. 1655.* Signature questioned by Gerson. Canvas, 110 x 87 cm. Bredius 524. Berlin-Dahlem, Gemäldegalerie.

The original story is of course Biblical – the young household servant Joseph rejects the advances of his master's wife, who then accuses him of trying to rape her. But Rembrandt's paintings show the scene as it occurs at the end of Vondel's play *Joseph in Egypt*, as Potiphar asks: 'My darling, what's going on? Why is your head hung low? The tears roll down your scratched cheeks. Your locks are loose. Why are you sad? Why are your clothes in disarray?'

He drags the story out of his wife Iempsar and her maid. The proof of Joseph's guilt is his cloak. Potiphar orders him brought in, and as he approaches, Iempsar cries 'Ach, ach, ach, ach, ach, ach, there's the fine fellow now.' Joseph's only defence is 'I am accused of something I never dreamed of doing.'

The play was written in 1640, and dedicated to Johannes Victorinus. The production of 1655 was a particular success, with a woman in the role of Iempsar, Adriana van den Bergh. Potiphar was played by her husband Gillis Nooseman and Joseph by Cornelis Laurensz. Krook.

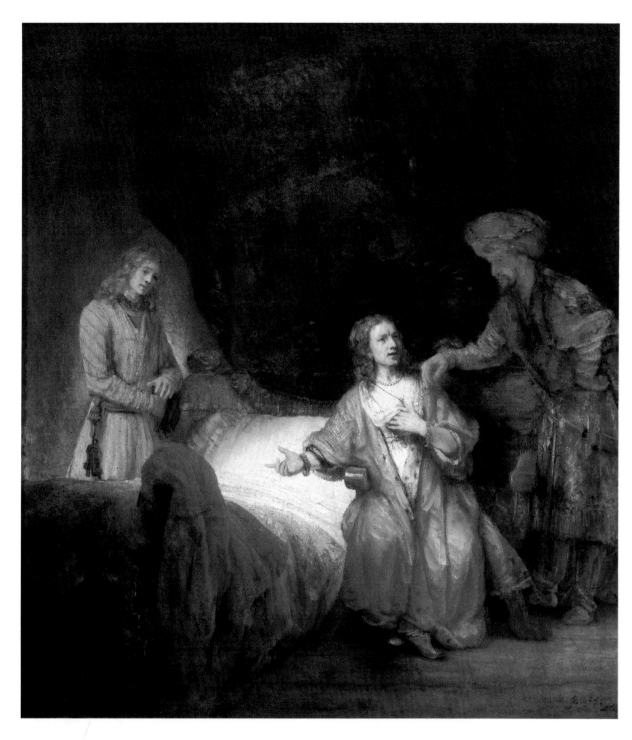

310 *Joseph accused by Potiphar's wife*. Signed *Rembrandt f. 165*[5]. Canvas, 106 x 98 cm. Bredius 523. Washington, National Gallery of Art.

One of the differences between Rembrandt's two versions of the subject, probably from the same year, is that the model for Joseph is another young man. A change in the cast of Vondel's *Joseph in Egypt* may be the reason for Rembrandt's repetition of the subject.

In 1655 Tobias van Domselaer was again appointed to the board of the theatre, for the first of eighteen consecutive terms, after an absence of fourteen years. Joannes Serwouters served the first of eight terms that year. Jan Vos was of course still in office as well. The new men represented a clique surrounding the Hinlopen brothers, van Domselaer's kinsmen and the patrons of Serwouters – and Rembrandt.

311 *Haman and Ahasuerus at the feast of Esther* (Esther 7:1-6). Signed *Rembrandt f. 1660.* Canvas, 73 x 94 cm. Bredius 530. Moscow, Pushkin Museum.

Houbraken: 'Jan Jacobsz. Hinlopen also owns a painting by Rembrandt where Haman is the host of Esther and Ahasuerus [sic]. The poet Jan Vos, as a knowledgable connoisseur, gave expression to its content and to the power of the particular emotions one can observe in the painting in these words:

Here Haman shares a meal
 with Esther and the king,
But all in nought; his breast is
 full of grief and pain.
He eats of Esther's food, but
 bites her heart in twain.
Ahasuerus is obsessed by
 wrath and rage's sting.
The fury of a prince is fearful
 at full blast.
The menace of all men by a
 woman is surpassed.
And so one can be thrown
 from the heights to the
 abyss.
The slowest-paced revenge is
 the cruellest nemesis.

Vos reads into the painting the kind of exaggerated emotions he sought in his own plays, while the painting reflects the more subdued acting favoured by Joannes Serwouters. When his *Hester* was produced in the Amsterdam theatre in 1659, the role of Esther was played by Susanna Eeckhout, Gillis Nooseman acting Ahasuerus and Heere Pietersz. de Boer Haman.

Another painting of Esther and Ahasuerus by Rembrandt was recorded as being in the possession of Johannes de Renialme in 1657, valued at 350 guilders. Another of his Rembrandts, *Christ and the woman taken in adultery*, was probably bought by Jan Jacobsz.'s brother in 1657.

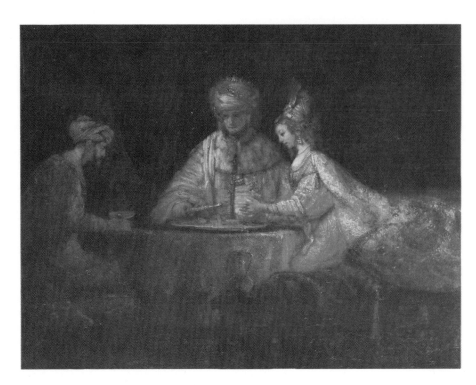

312 *Ahasuerus, Haman and Harbona.* Signed *Rembrandt f..* Signature questioned by Gerson. Ca. 1660. Canvas, 127 x 117 cm. Bredius 531. Leningrad, Hermitage.

The scene may be taken from Joannes Serwouters' play *Hester* rather than the Bible. At one point in the action Ahasuerus, Haman and the righteous old courtier Harbona are on stage alone together, and Haman is given permission by the king to murder all the Jews in his empire. It must be said, though, that the Haman in the painting does not look triumphant, nor does he hold the king's signet ring, as in the play.

In contrast to nearly all other literary and artistic treatments of Old Testament subjects in Holland in the seventeenth century, Serwouters's *Hester* was applied specifically by the author to the condition of the Jews of his own time. In 1648-1649 there had been a murderous pogrom in Poland, which drove many eastern European Jews to the west.

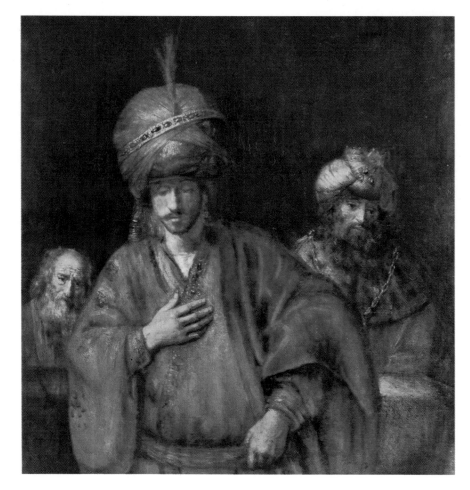

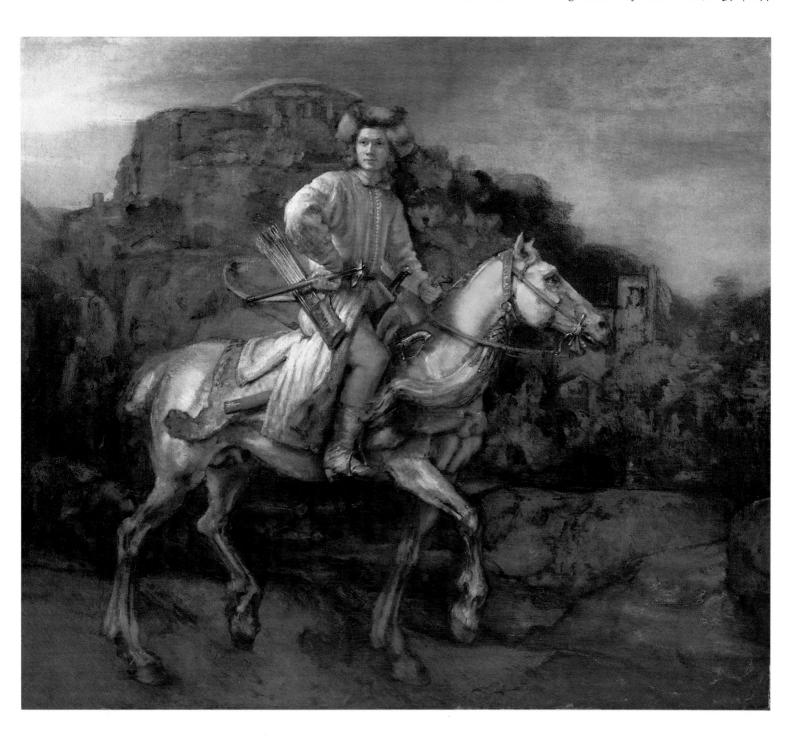

313 *'The Polish rider,'* here identified as *Tamerlane pursuing Bayazet outside Constantinople*. The part of the canvas bearing the signature has been cut off, leaving only the letters *Re*. Ca. 1657. Canvas, 116.8 x 134.9 cm. Bredius 279. New York, The Frick Collection.

The great event of the 1657 season at the Amsterdam theatre was the debut as a playwright of the recently appointed head of the theatre Joannes Serwouters, protégé of the up-and-coming young councilman Jacob Jacobsz. Hinlopen. Serwouters favoured a more classical, restrained type of play than Jan Vos, but he did make use of spectacular stage effects, such as the riding of a live horse on to the stage during performances. The main roles were acted by Heere Pietersz. de Boer (1629/30-1703) as Bayazet and Gillis Nooseman (1627-1682) as Tamerlane.

The theatre stood in particularly high regard in 1657. The presiding burgomaster, Cornelis van Vlooswijck, allowed his son to appear in Latin and Greek plays put on by his school. The burgomasters and other members of the town government attended the performance of *Tamerlane* on September 5, 1657.

The new identification of the subject is not completely irreconcilable with the traditional title, *The Polish rider*. Although no satisfactory explanation of that subject has ever been given, Polish art historians have shown that the figure is wearing some Polish weapons and articles of clothing. After the death of Gillis Nooseman, an inventory of the props he had acquired for his theatre (then in The Hague) specifies 'Polish, modern, Spanish and Roman' costumes – no Turkish or oriental ones. One of the plays in the repertoire of the Amsterdam theatre since 1647 was *Sigismund, prince of Poland, or Life is a dream*. Apparently, Nooseman used Polish props for his *Tamerlane*, which in later years caused confusion over the identity of the rider in the painting. This no doubt made it easier to sell the painting to the Polish nobleman Michal Kazimierz Oginski in the late eighteenth century.

reins alone./ You were the foreboding of lamentable disaster./ You threw me from the saddle…'

He is then captured by Tamerlane's men, and Tamerlane himself arrives on the scene, commanding them not to kill Bayazet until he could be properly disgraced.

Before being executed, Bayazet was humiliated by Tamerlane in a particular way: he was kept in a cage, and when the new ruler wished to mount his horse, Bayazet was brought out to serve as a footstool. From another source we know that a live horse was brought on to the stage during the performance. This is the scene that is illustrated on the title page of the printed edition of the play.

The production of *Tamerlane* was an event of no small importance for the Amsterdam theatre. One performance was attended by the burgomasters – Cornelis van Vlooswijck, presiding burgomaster, Gerard Schaep, Simonsz., Joan Huydecoper and Andries de Graeff – who were addressed by Serwouters in a poem pointing out the moral of the play (despotism doesn't pay) and another requesting their continued support for the theatre. ('Poetry solicits your support, your protection, your favour.') It was also a great moment for the new councilman, Jacob Jacobsz. Hinlopen, who formed the link between the playwright and the burgomasters.

And the link with Rembrandt? In any case, there is evidence that he too was in the good graces of the Hinlopens at the time. The day before the command performance of *Tamerlane*, September 4, 1657, Johannes de Renialme's estate was auctioned, and *Christ and the woman taken in adultery*, in what was probably the highest price ever paid for a Rembrandt in the seventeenth century, was knocked down to Jacob Jacobsz. Hinlopen. We assume this from the fact that his non-collecting son was the next known owner of the painting and that he appraised it at two thousand guilders.

Not to delay the conclusion any longer: Rembrandt's painting known as *The Polish rider* (fig. 313) fits so perfectly into the niche provided by the theme of *Tamerlane* and the circumstances surrounding its genesis that I have no hesitation in inserting it there, with the title *Tamerlane in pursuit of Bayazet*.

ATTRIBUTION AND INTERPRETATION | The above argument illustrates a truth about art history that can at times be extremely inconvenient. Much as one would like to rely on tradition, documentation and the existing consensus among scholars as a firm basis for the attribution of paintings, these seldom provide us with complete certainty. The links I have demonstrated between Vos, Rembrandt, Serwouters and the Hinlopens can be significant for the interpretation of figs. 311-313 *if* those paintings are by Rembrandt. And whereas his authorship has seldom been called into doubt until now, J. Bruyn of the Rembrandt Research Project has recently suggested that fig. 313 is by Rembrandt's pupil Willem Drost.

Although this opinion was first circulated by the Rembrandt Research Project about fifteen years ago, no arguments in its favour have been published. At the present rate of progress of the *Corpus*, we may well have to wait another fifteen years before being able to judge the new attribution. Meanwhile, a generation of art historians has to live with a 'Polish rider' or 'Tamerlane' of indeterminate status. Although I have always resisted the re-attribution, I must admit that its very existence forces me to look at the painting more critically. One then discovers that features of the painting which were always considered marks of its greatness as long as it was a Rembrandt – a certain vagueness, a poetic suggestiveness, an ambiguity of meaning – turn into signs of inferior artistry when they are attributed to Drost.

Whether the new identification of the subject proposed here will also lose its merit if the re-attribution is accepted remains to be seen.

The great chain of patronage

In the preceding chapter we caught a glimpse of the workings of the machine of patronage in mid-century Amsterdam. At the controls were the holder of the magnificat and the presiding burgomasters. From 1651 to 1662 this function was fulfilled by Cornelis de Graeff four times, Banning Cock, Huydecoper and van Vlooswijk twice each, and Nicolaes Corver once. Under them were the burgomasters who were exluded from the presidency, including Cornelis Bicker, Tulp, Witsen, van Hoorn, Andries de Graeff and a few others. It was at this level that Jan Six, through his father-in-law Tulp, could exert a certain influence. Below them were the aldermen and top councilmen who were shut out of the burgomastership but filled important administrative posts. That was the level of the Hinlopens in the 1650s. At a more subordinate level, and too low to dispense civic patronage, were the minor councilmen, like Willem Schrijver.

Branching off into the theatre, we find board members recruited from families who could not enter the council, either for reasons of religion or lack of political weight. Here we find Jan Vos, Floris Soop, Maerten Kretzer, Tobias van Domselaer and Claes Moyaert. The theatre board gave Catholics, in particular, a chance to participate in politics at a low but conspicuous level which gave them a direct line to the burghers.

The status of an artist, poet or playwright who worked within this system depended largely, it would seem, on the position of his main patron. In more openly hierarchic societies like those of England and France, the dependence of such suppliers of art on highly-placed protectors was public knowledge, and was part of the biography of an artist. In the Dutch Republic, writers on art either avoided the subject, or cast it in the mold of friendship, admiration or the just reward for excellence. This deception worked on future generations, but contemporaries certainly knew better.

FLINCK'S NICHE | In Amsterdam, there was no question who was at the top: the artist who painted not only Cornelis de Graeff and his wife Catharina Hooft, but also Joan Huydecoper, and who received the main commissions for the painted decorations of the town hall, was Govert Flinck. He owed his position at least in part to the fact that he could reciprocate the patronage of his protectors in Amsterdam with the prestige of his connections to the Brandenburg court and to the new stadholder of his native Kleve, Johan Maurits van Nassau.

Flinck, together with Huydecoper and Vos, rose to his ultimate height in 1659 when they associated their names demonstratively to the houses of Orange and Brandenburg in the streets of Amsterdam. Since the death of Willem II in 1650, the country had been without a stadholder, and many, especially in Amsterdam, liked it that way. Willem's son, who was not to become Willem III until 1672, was under the guardianship of his mother Mary and grandmother Amalia, who hated each other. The lustre that had adorned the house of Orange with the marriage of Frederik Hendrik's son to the Stuart daughter of Charles I had been tarnished when the latter was beheaded in 1649. This added to the importance of the marriage of one of Frederik Hendrik's daughters to the Elector of Brandenburg, an alliance that was popular even in Amsterdam.

When the couple had a child in 1655, Amsterdam sent Huydecoper to Berlin to accept the godfatherhood for the city, and upon his return, he was greeted with a triumphal entry of his own, put together by Vos.

In 1659 and 1660, Amsterdam held its last displays of pageantry for many years, with the visits of Orange and Brandenburg in 1659, and Orange and Stuart in 1660. The Brandenburg visit was presided over by Huydecoper and the Stuart one by Cornelis de Graeff. The floats and tableaux vivants for Orange and Brandenburg were designed by Flinck,

of course, and staged by Vos, with his famous theatrical flair. That entry was probably the most perfect expression of all of the synergy of art and theatre with the politics of Amsterdam, the Republic and Europe. The bare, transparent interests of all the parties involved were advanced by their celebration of each other, with the people cheering and the world watching. This, one has the feeling, is what it was really all about.

The mood in 1660 was more defensive. De Graeff let Vos use second-hand designs for the most part, and Vos overplayed his hand. He rode out on horseback at the head of the parade, and he included a dramatic float showing the beheading of Charles I. Before the pageants were over, he was subjected to an outburst of criticism he never overcame.

WHERE REMBRANDT STOOD | The highest slot in which we can place a primary patron of Rembrandt's is that of alderman, a dignity acquired by Jacob Jacobsz. Hinlopen in 1658 and by Jan Jacobsz. in 1661. However, the Hinlopens derived their political power mainly from Huydecoper, and he was not inclined to elevate Rembrandt to anything approaching the height of Flinck. Of more direct help to Rembrandt was Jan Six, who however was not a political principal in the 1650s, and was dependent on Nicolaes Tulp. In 1655 he married Tulp's daughter and in 1656 Rembrandt received renewed orders from the medical world. In that year he painted the portrait of the physician Arnout Tholincx (fig. 314) and the *Anatomy lecture of Dr. Jan Deyman* (fig. 315). Tholincx, whose cousin Anna was married to Jacob Jacobsz. Hinlopen, had been married since 1648 to another daughter of Tulp's, and when Deyman's daughter Ammerentia married in 1683, it was to Six's nephew Pieter.

The *Deyman* was the first anatomy lecture to be painted for the surgeons' guild since that of Tulp in 1632, as with Tulp himself in the burgomasters' chamber the choice of Rembrandt as a painter must have been subject to his approval. In short, we can chalk up the two medical portraits of 1656 to the good offices of Jan Six.

Rembrandt's ties to the Hinlopens were certainly strengthened by Six. Since 1629 his cousin Willem had been married to Catalina Hinlopen, the cousin of Jacob and Jan Jacobsz.

The man who arranged for the sale of *Aristotle and the bust of Homer* to Antonio Ruffo, Cornelis Gijsbertsz. van Goor, aslo belonged to this segment of Amsterdam society. He was to marry his son Cornelis to a Schrijver, and a granddaughter was to wed a Hinlopen.

In 1656 the personal allegiance of Jan Six to

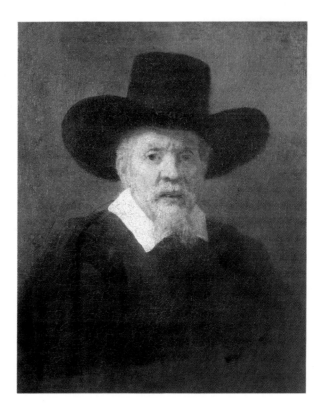

314 *Arnout Tholincx (1607-1679).* Signed *Rembrandt f. 1656.* Canvas, 76 x 63 cm. Bredius 281. Paris, Musée Jacquemart-André.

Tholincx was married to Catharina Tulp, the daughter of Nicolaes and therefore became Six's brother-in-law in 1655. His uncle Dierik was the one who had assigned to Tulp the cadaver on which he performed the dissection that Rembrandt had painted in 1632. The inbreeding and nepotism in this corner of the Amsterdam medical world are particularly noticeable, although the phenomena themselves were universal.

In the same year, 1656, Rembrandt also made an etched portrait of Tholincx (Bartsch 284).

Rembrandt apparently came to an end. Some time before July, he turned over Rembrandt's debt to him to a third party, precipitating Rembrandt's insolvency, and when his wife Margaretha Tulp was painted that year, it was by Govert Flinck.

THE DUTCH PARNASSUS | The literary tributes to Rembrandt quoted in the previous chapter were included in a weighty anthology assembled by Tobias van Domselaer, whom we have met as a board member of the theatre, the owner of several paintings by Rembrandt and one of the compilers of *Verscheyde Nederduytsche gedichten*. In the pages of *Hollantsche Parnas*, published by Jacob Lescaille and dedicated to Joan Huydecoper, we find an almost eerie reunion of many of the figures we have encountered throughout Rembrandt's career. Not only does it contain nearly every poem that had been written until then on Rembrandt or works by him, and poems by Vondel, Vos and others on many of Rembrandt's sitters and patrons, but also includes reminiscences of the Leiden period. Scriverius's poem on Rombout Hogerbeets, a poem by Lescaille on a portrait of Pieter Lastman, one by Gerard Brandt to Willem van Heemskerck, the nephew of Jacob Isaacsz. van Swanenburg.

(In 1652, Willem's younger brother had married a

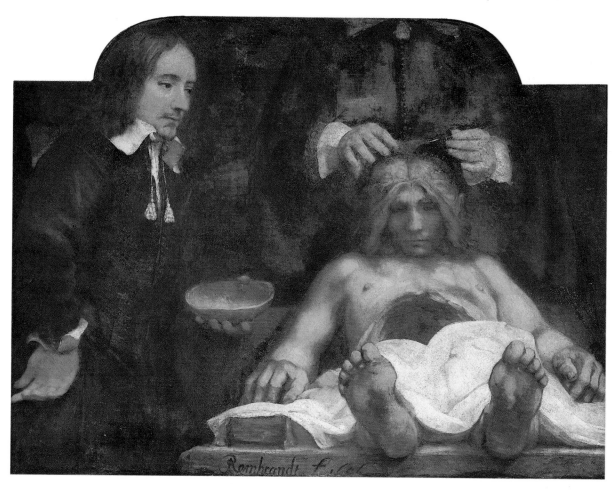

315 *The anatomy lecture of Dr. Jan Deyman (1620-1666).* Signed *Rembrandt f. 1656.* Canvas, 100 x 134 cm. Originally about 275 x 200 cm. Cut down after being damaged by fire in 1723. Bredius 414. Amsterdam, Rijksmuseum (on loan from the city of Amsterdam).

Rembrandt's first commission from a civic body after the *Nightwatch*. Deyman had succeeded Tulp as prelector of the surgeons' guild in 1653. The painting in which Rembrandt immortalized him followed on another of those pre-Candlemas dissections, like the one Tulp performed on Aris 't Kint on January 30, 1632. This criminal, the Fleming Johan Fonteyn, condemned for breaking into a draper's shop and pulling a knife on his apprehender, was executed on January 28, 1656, and dissected on the 29th, 30th, and 31st. On January 28th, a new councilman was sworn in: Willem Schrijver.

The original composition is known only from a sketch for the handsome frame (Amsterdam, Rijksprentenkabinet). It was symmetrical in structure, with the surgeon and cadaver on the central axis.

Remonstrant niece of Joan Huydecoper's first wife.)

The contributor who stood closest to Rembrandt was Gerbrand van den Eeckhout, who could hold his own as an occasional poet. Gerbrand's birthday happened to be February 2nd, as was that of two friends, the poet-painter Willem Schellinks and the poet-publisher Hieronymus Zweerts. On their common birthday in 1657, the three friends wove a wreath of poems to each other.

We could go on and on marvelling at the many strands of Rembrandt's career that were picked up by van Domselaer in *Hollantsche Parnas*, but I am afraid the reader might find it less fascinating than the writer. To move, then, to what I think is the heart of the matter: the anthology, dated 1660, contains a poem by Vondel referring to a sad event of February 2nd of that year: 'In memory of the late gifted painter Govert Flinck: an epitaph.' Flinck died at the height of his powers, in the middle of his work on the town hall. Vondel commemorated in the same publication what must have been one of his last works: 'On G. Flinck's drawing of the perennial feud between Electoral Brandenburg and the States of Kleve and Mark, settled by Prince [Johan] Maurits.' The events concerned took place in January 1660.

Who was going to succeed Flinck on the Dam and

in the affections of Vondel? To go by *Hollantsche Parnas*, with nearly as many references to Rembrandt as to Flinck, and only a scattered handful to five other painters, one member of the theatre board was betting on Rembrandt. So was Lescaille, the printer to the theatre. If we add to *Hollantsche Parnas* the evidence of Jan Vos's poem to Jan Jacobsz. Hinlopen on the *Esther* (1661), on a theme from a play by Serwouters, we can tally up two more. Van Domselaer, Vos and Serwouters – three of the six board members of the theatre – gave their public support to Rembrandt after the death of Flinck. That of Vos and Serwouters was addressed to Jan Jacobsz. Hinlopen, who could be counted on to be helpful. That of van Domselaer – remember the dedication of *Hollantsche Parnas* – to Joan Huydecoper, who was going to make the final decision. There was a groundswell of support for Rembrandt from below, and the big question was: would Huydecoper be swayed by it? It seems he wasn't. As we shall see in the chapter on the town hall, Rembrandt's one big chance at taking over the town hall decorations, after a number of failed smaller ones, was given to him a year and a half after the death of Flinck, in the last week of October 1661, the week when Joan Huydecoper died.

Govert Flinck, born in Kleve in December 1616, found himself inclined from youth towards drawing.... His father, who lived a moral and well-mannered life, and was tax-collector of that city, would say: 'May God spare me the fate of having to raise my son to be a painter. Most of them are bohemians and live wanton lives.' He therefore admonished his son repeatedly and earnestly to stop drawing altogether, promising that he would soon place him with an Amsterdam merchant...

But what happened at a given moment, to his joy? One Lambert Jacobsz., Mennonite or Anabaptist teacher from Leeuwarden in Friesland, came to Kleve to preach and visit his co-religionists. He was famous for his eloquence and his sober life, and Govert Flinck's parents went to hear him. They derived great spiritual benefit from his sermon, and when they heard that he was a well-known painter, changed their minds completely and decided on the spot to consult the aforesaid Lambert Jacobsz.; they agreed with him that he would take their son to Leeuwarden to study art in his house and under his supervision....

Arriving in Leeuwarden, he became the room-mate and companion in art of Jacob Backer, a fit and industrious young man who went with him to Amsterdam, where Flinck had some very prosperous relatives....

But since Rembrandt's style was praised by all at the time, and one's art had to be fashioned after his to find favour in the eyes of the world, Flinck deemed it advisable to study under Rembrandt for one year, in order to learn his way of handling oils and his style of painting. In a short time he was able to imitate it so well that various of his works were thought to be original Rembrandts and were sold as such. Later on, however, with considerable effort, he managed to unlearn that style. He did this before Rembrandt's death, when thanks to the importing of Italian paintings the eyes of the true connoisseurs were opened, and transparent painting once again came into its own.

When his fame as an artist was widespread, he was taken with the urge to marry; he therefore let his eye fall on a young lady of an old and respected family whose father had been a director of the East India Company in Rotterdam, and who lived with her widowed mother in Amsterdam... Shortly after his wedding he built a large studio with a high skylight, on the upper shelf of which stood busts of the emperors as well as many handsome casts of the most famous antique marbles, between which were hung many exotic articles of dress, coats of armour, guns and knives; in addition to precious old velvet and other gold-embroidered hangings from the old court of the duke

of Kleve. For he stood high in the favour of [Friedrich] Wilhelm, elector of Brandenburg and duke of Kleve, the grandfather of the present king of Prussia. He painted various works for him, including his portrait, done with unusual freedom and wit... These works pleased the prince so well that he presented Flinck with his portrait set with diamonds.

From that time on he also enjoyed the friendship of Prince Johan Maurits of Nassau, stadholder of Kleve, later field marshal of the Republic. When he was in Amsterdam he often visited Flinck, and also entertained him as a guest. Flinck, moreover, had the honour to be favoured by many distinguished gentlemen of Amsterdam. Among them were the burgomasters Cornelis and Andries de Graeff. The latter often came to his house, and he was on such familiar terms with the former that in the evening, when he was too tired to go on painting, he would often call on him unannounced...

After church on Sunday, he spent the rest of the day visiting artists and art-lovers, mainly tax-collector Wtenbogaert and aldermen Jan and Pieter Six, who subsequently bought many outstanding Italian paintings and also excellent prints and drawings, just as he himself collected a good number of paintings, drawings and prints by famous masters of Italy and elsewhere. He was able not only to distinguish

knowledgeably the individual styles of all of them, but also to pick and choose among their attractions and turn them to his own use. When the collection was sold after his death, it fetched about twelve thousand guilders.

As a widower he painted two more civic guard companies, one of which can still be seen next to the mantelpiece in the great hall of the Kloveniersdoelen in Amsterdam. But his spirit inclined towards greater enterprises, and spurred on by the art of Rubens and van Dyck, which he had gone to Antwerp to study closely, he later turned away those who asked him to paint portraits, referring them to Bartholomeus van der Helst, adding that his fluent brush was just as able to give them satisfaction.

Thereupon he made the mantelpiece painting for the burgomasters' chamber depicting Marcus Curtius rejecting the gifts of the Samnites and contenting himself with a meal of turnips. Following that he did a large painting of Solomon praying to God for wisdom. Afterwards he executed another of the same subject but smaller and with fewer accessories, which he presented to his home town Kleve, being thanked in writing by the burgomasters, aldermen and councilmen of said city on August 29, 1659...

Having won great fame through these works, his only ambition was to do large paintings such as those

commissioned from him in November 1659 by the burgomasters of Amsterdam – eight paintings for the eight corners of the town hall gallery, and four others, somewhat smaller, for the arches. He attacked the preparatory studies with a will. The eight large paintings were to depict the wars fought in the distant past by the Batavians under Claudius Civilis against the Romans. And in the four other pieces the two heroes who performed glorious deeds for the sake of their Fatherland, being David and Samson of the Hebrews and the Romans Marcus Curtius and Horatius Cocles.

While his spirit was preoccupied by the execution of these works, it pleased the Almighty to cut short his plans with a sudden fever followed by vomiting, which removed him from this world within five days, on December [should read February] 2, 1660, only forty-four years of age.

34 Insolvency

On January 8, 1653, the financial side of Rembrandt's life turned sour, bringing complications that were to plague him and others for the rest of his life. There are about one hundred-and-twenty-five documents dealing with the problems, and it would be foolish to try to give a complete account of the matter. Archivists and art historians are not sure what really happened. In particular, there is uncertainty concerning the background of the official insolvency, when Rembrandt sold his belongings for the benefit of his creditors. Was it voluntary on his part, or was he forced by his creditors?

I shall tell the main story as I see it, as briefly as possible, but my interpretation of people's motives is of course speculative.

FROM A PERSONAL TO A POLITICAL AFFAIR | The basic problem, as everyone knows, is that Rembrandt never paid for his house. On the terms of his agreement with Belten and Thijsz. in 1639, he was to pay it off at his convenience by 1646. In January 1653, he still owed Thijsz. and the heirs of Pieter Belten eight thousand guilders in principal, 1137 in interest and 333 in taxes. With the country at war and money scarce, they put pressure on Rembrandt by attaching the property of the guarantors of his debt.

At the end of the month, Rembrandt made his first move. On January 29th, he borrowed 4180 guilders, free of interest, from Cornelis Witsen (fig. 296). As it happens, we know a thing or two about Witsen's character, from the notes of Hans Bontemantel: 'A gentleman,' Bontemantel wrote by way of epitaph after Witsen's death, 'somewhat too fond of the grape; unpopular as sheriff because he bled the community, the deputies and the assistants a bit excessively, while claiming that he was not after the money at all, and that the office was forced on him.' From other evidence from Bontemantel we know that it certainly was for the money that Witsen put the screws on his underlings.

What led this gross man, with whom Rembrandt had no known previous contact, to lend the painter such a large sum free of interest? One possibility is that he was making a bid for protectorship of the Brotherhood, and was wooing Rembrandt in this way. The guard company of which Witsen was captain, which had itself painted in 1648 with a poem by Jan Vos, counted among its members the poet Lambert van den Bos. In 1650, he wrote a hundred-poem cycle on the art collection of Maerten Kretzer, in which he also praised Rembrandt.

Another circumstance leads us to believe that the loan had a political background of some kind. The reader has no doubt already noted that the loan was given on one of those late January days when Amsterdam regents put their cards on the table. As it happens, Witsen and Rembrandt reached their agreement in the presence of two aldermen, Gerrit van Hellemont and Cornelis van Vlooswijck, on the day after the two of them were installed as councilmen, and two days before he himself was to be elected to his first term as burgomaster. We remember with some amazement that it was after the installation of van Vlooswijck's father twenty-one years earlier that Rembrandt was commissioned to paint the *Tulp*.

On March 7th, Rembrandt borrowed one thousand guilders from Jan Six, also free of interest, and on March 14, 4200 at five per cent from Isaac van Hertsbeeck. He promised to pay all those loans back within one year. Some of the money was used to pay off the principal of the Thijsz. debt, but Rembrandt let the interest ride. This debt, 1168 guilders plus 52 guilders annual interest, was assigned by Thijsz. to the thirteen-year-old son of alderman Allard Cloeck, while Six transferred his to Gerbrand Ornia, the husband of Witsen's niece Maria Bicker van Swieten. Rembrandt's debt was no longer a personal matter only. It had become a political one as well.

CHRIST FROM LIFE

The common assumption that Rembrandt had a special affinity for the Jews is based in part on his presumed use of Jewish models for paintings of Christ. However, consider this poem by Jan Vos.

Christ painted for Joris de Wijze by Govert Flinck, after a Jew

...

All that lacks is speech, but
　Govert Flinck refused
To paint an open mouth,
　despite de Wijze's plea.
For this Christ would not
　speak of Christ except in
　blasphemy.
The heart is not reflected by
　the face that shines at you.
You ask how come? Because
　the model was a Jew.

Joris de Wijze was a notary and a playwright (see fig. 297). He was such a serious lover of painting that in 1658 he gave the cranky Emanuel de Witte a room in his house and 800 guilders a year in exchange for paintings.

Rembrandt's relationships with Jews have been the subject of much sentimental conjecture. The evidence is less romantic. Apart from the portraits of Menasseh ben Israel and Ephraim Bueno, the collaboration with Menasseh in 1635 and 1655, an etching of a synagogue and the likelihood that Rembrandt used Jewish

models, there are only three documented contacts between him and Jews: in 1637 Samuel d'Orta accused him of unfair dealing in the sale of an etching plate (see p. 194); in spring 1654 he was involved in a dispute with his neighbour Daniel Pinto concerning work on both their houses (Rembrandt tried to avoid paying his half of the expenses, and in a cellar of Pinto's house he had rented for half a year made so much noise that Pinto couldn't hear himself think) and in February of that year Diego d'Andrada refused to accept a portrait of a girl on the ground that 'the aforesaid painting or portrait bore not even the least resemblance to the person or face of the aforesaid girl.' The second and third affairs may have been related. One of Pinto's witnesses, a young man living in his house, signed himself Mordechay d'Andrada.

Rembrandt's inventory included two 'heads of Christ' by him and an anonymous 'Head of Christ from life.'

In 1662 a *Christ* by Rembrandt is listed in the estate of Johanna de Smit, Amsterdam. Jan van de Cappelle later owned a painting of the same description.

As a group, the paintings reproduced here lack stylistic and technical consistency.

Which, if any of them, was actually painted by Rembrandt seems to me a minor issue for the art historian, if not for the owners of the paintings. The evidence is strong that he produced works of this kind somewhere between the mid-1640s and the early 1660s.

What the painting do have in common is a fairly close adherence to the description of Christ in an apocryphal letter by Lentulus, which Hoogstraten quotes approvingly even though he appears to know it is fictional: 'His hair is the colour of a ripe hazelnut, parted on top in the manner of the Nazirites, and falling straight to the ears but curling further below, with blonde highlights and fanning off his shoulders. He has a fair forehead and no wrinkles or marks on his face, his cheeks are tinged with pink,... his beard is large and full but not long, and parted in the middle. His glance shows simplicity adorned with maturity, his eyes are clear and commanding, never apt to laugh, but sooner inclined to cry; he has straight hands and his arms are very pleasing. He speaks sparingly and is very polite to all. In sum, he is the most beautiful of all mortals.'

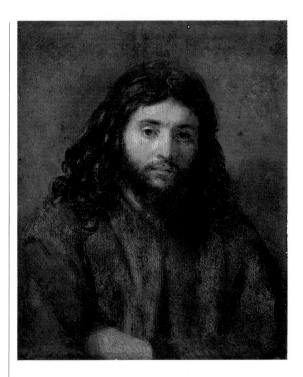

316　*Christ*. Panel, 25.5 x 21 cm. Ca. 1645-1655. Bredius 620. The Hague, Bredius Museum.

318　*Christ*. Ca. 1645-1655. Panel, 24.7 x 20 cm. Bredius 624. Philadelphia, The John G. Johnson Collection.

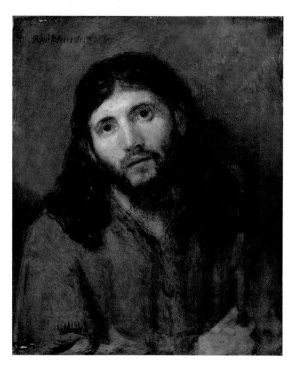

317　*Christ*. Signed *Rembrandt f.* The signature – the only one on any of the paintings of Christ in this group – was doubted by Gerson. Ca. 1645-1655. Panel, 25.4 x 21.3 cm. Bredius 621. Detroit, Institute of Arts.

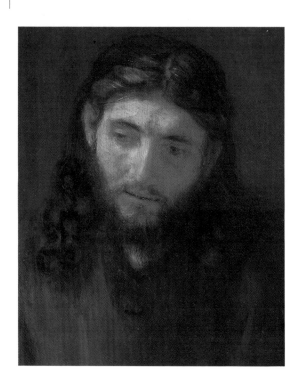

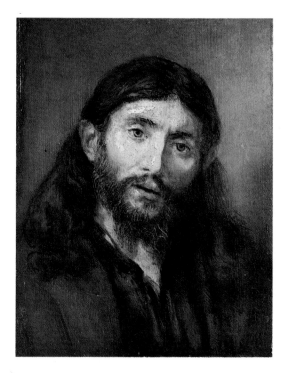

319 *Christ*. Ca. 1645-1655.
Panel, 25.2 x 19.9 cm.
Bredius-Gerson 624A.
Cambridge, Massachusetts,
Fogg Art Museum.

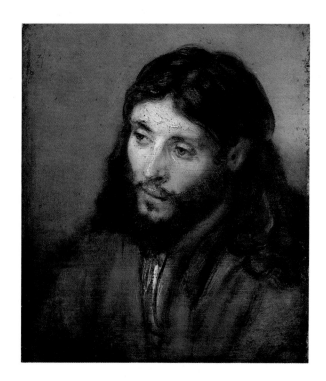

320 *Christ*. Ca. 1650. Panel,
25 x 20 cm. Bredius 622.
Berlin-Dahlem,
Gemäldegalerie.

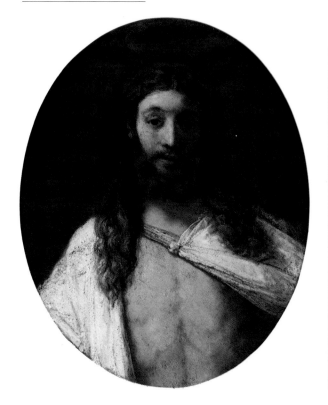

321 *The risen Christ*. Signed
Rembrandt f. 1661. Canvas,
78.5 x 63 cm. Bredius 630.
Munich, Alte Pinakothek.

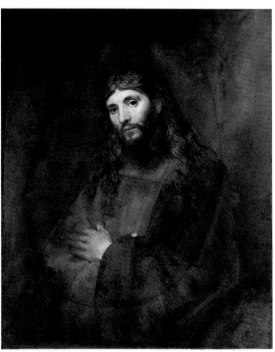

322 *Christ*. Ca. 1661.
Canvas, 108 x 89 cm. Bredius
368. Glens Falls, New York,
The Hyde Collection.

PLAYING FOR TIME | The year 1653 went by without Rembrandt repaying his new moneylenders. If he expected help from Cornelis Witsen in earning money to repay him, in the form of municipal commissions, he was disappointed. Witsen too was let down in his hopes. On October 20th the Brotherhood held its inaugural feast, as we know, with his rival Huydecoper at the head of the table, not him, and his new protégé Rembrandt conspicuous by his absence.

1654, 1655 and half of 1656, too, passed without Rembrandt repaying any of his debts, while he began to take measures to minimize the damage to himself in case of bad trouble. He transferred ownership of the house to Titus, had Titus make a will leaving everything to him (and nothing to Saskia's family!), and contracted to buy a new house to be paid for in part by subsequent paintings. In that way, he must have thought, not only was his house out of reach of his creditors, but even part of his future earnings. In December 1655 he held a voluntary sale, which went on for three whole weeks, pocketing the proceeds without paying his creditors a penny. He did not even pay the 130 guilders rental for the premises where the sale was held until 1660.

On July 10, 1656, with no noticeable fresh cause, Rembrandt applied for a form of insolvency known as *cessio bonorum*. Under this exceptional measure, which could only be granted by the States General, he would cede ownership of all he possessed – specified by inventory – for the benefit of his creditors. On the other hand, they would have no further claim on him after the liquidation of his property, regardless of whether they received all of what they were owed. Having sold much of what he owned in 1655, and having transferred the house to Titus, the value of his remaining goods was not very high. The first sale of the household goods, in August or September, realized 1322 guilders, 15 stuivers, while Rembrandt's debts totalled more than thirteen thousand, not counting the twenty thousand he owed Titus.

This sale would probably not have upset Rembrandt much more than the one he held half a year earlier. Apparently he had things well in hand, and was able to keep his trustees from proceeding to a total sale of his house, his collections and his own work. One gets the impression that Rembrandt was orchestrating all these moves, in a bid for time.

TIME RUNS OUT | The first creditor to take action was Ornia. Shortage of cash was not his motive – he was one of the richest men in Amsterdam. On August 1st, 1657, he demanded and soon received his thousand guilders plus interest – not from Rembrandt but from Lodewijk van Ludick, who had guaranteed Rembrandt's loan from Jan Six, the one Ornia was now holding. On November 21st, a new sale was held – this time of Rembrandt's collection. It fetched 2516 guilders 10 stuivers. There were now some 3800 guilders in Rembrandt's account with the Insolvency Court, about 300 guilders less than the debt to Cornelis Witsen, whose loan, because it was registered by the aldermen, took precedence over other loans. (Some of the other creditors also had preferential loans, but they never received complete payment, although Witsen did.)

At this point, the Uylenburghs and the Orphans' Court began to grow seriously alarmed about Titus's interests, the way things were going. Hendrick Uylenburgh was on outstanding terms with the burgomasters that year. He himself owed the town 1400 guilders in back rent, and on January 18, 1658, 'after conferring with the burgomasters in private,' the township dropped 400 guilders from its claim and let him pay the rest with services rendered. Four days later, Titus's guardian produced for the Orphans' Court the document through which Rembrandt had assigned ownership of the house in the Breestraat to Titus.

But there was a new Candlemas rolling on, which was to see the departure of three of the burgomasters who were so nice to Uylenburgh, van Vlooswijck, Huydecoper and Andries de Graeff. On February 2nd new elections were held, at which Cornelis Witsen was elected to his second term, together with Gerard Schaep, president, Cornelis de Graeff and Joan van der Poll. The new men were less concerned about Rembrandt's son than about his most important creditor, who happened to be one of themselves. On that very day, the Insolvency Court overrode the Orphans' Court, and the house in the Breestraat was sold at auction. On February 22nd, Rembrandt and Witsen both appeared at the cashier's window of the Insolvency Court, where the painter received and immediately handed over to the burgomaster, the sum of 4180 guilders.

OTHER PEOPLE'S FRIENDS, OTHER PEOPLE'S ENEMIES | The question raised by this story leaves one big question: what happened between Candlemas 1653 and Candlemas 1658 to turn Cornelis Witsen from a protector of Rembrandt into the man who forced the sale of his house for a mere three hundred guilders?

What happened, I believe, is the outbreak of the Schrijver-van Papenbroeck affair. In 1655, Willem Schrijver's stepdaughter Alida van Papenbroeck

married Gerard Bicker van Swieten, Cornelis Witsen's nephew, and Gerbrand Ornia's brother-in-law. Both Alida and her daughter Wendela died within two years, and at that juncture 'dispute arose concerning Willem Schrijver the Younger, as the son of Wendela de Graeff and her second husband Willem Schrijver, and the sister and brothers of Pieter van Papenbroeck, whose goods, inherited from his parents, were encumbered with debt to quite a large sum. The guardians of this child, Willem Schrijver the Younger, were Willem Schrijver the Elder, Cornelis and Andries de Graeff and Jan Duyts.'

Of the two brothers de Graeff, one took his guardianship more seriously than the other. Andries, as we have seen, went under defending Willem Schrijver junior's claim. Cornelis, on the other hand, struck a deal with the van Papenbroecks. Bontemantel tells us that Cornelis was on conspicuously good terms with the van Papenbroecks, and even assigned a lucrative office to the member of the family who was leading the legal battle against his own ward. Also on the van Papenbroeck side, of course, were Gerbrand Ornia and Cornelis Witsen, whose kinsman Gerard Bicker van Swieten was the widower of Alida van Papenbroeck.

On the eve of Candlemas 1658, then, it was not so much Rembrandt the debtor, let alone Rembrandt the painter, it was, if I am right, Rembrandt the protégé of Willem Schrijver who was tripped up by Witsen and Cornelis de Graeff.

A THOUSAND GUILDER LOAN

1653 March 7 Rembrandt borrows a thousand guilders from Jan Six, guaranteed by Lodewijk van Ludick.

1656 before July 14 Jan Six transfers the debt, whether or not at a discount we do not know, to Gerbrand Ornia.

1657 August 1 Ornia demands payment from van Ludick of 1000 guilders and 200 guilders interest, now that he has given up hope of recovering the money from Rembrandt, who has declared himself insolvent.

1659 March Rembrandt acknowledges his debt to van Ludick of 1200 guilders. Agrees to pay in three annual instalments, in the form of paintings.

1662 August 28 Rembrandt acknowledges his indebtedness once more. Of the 1200 guilders nothing has been paid, but 118 guilders have been deducted as the result of another transaction between the two parties. Rembrandt now cedes to van Ludick a quarter of what he is to receive for the painting he made for the town hall and whatever he may earn from re-touching it, as well as one half of what he earns from sales of other work after January 1, 1663.

1664 June 4 Van Ludick sells his claim on Rembrandt to Harmen Becker for a quantity of cloth he did not really want, which the seller says is worth 500 guilders.

1665 June Becker duns Rembrandt for payment. Rembrandt agrees to pay in full on condition that Becker returns the nine paintings and two albums of prints and drawings he is holding as collateral against two other loans. Becker demands in return that Rembrandt 'first finish the Juno' which Becker apparently had bought from the artist.

(21 July Lodewijk van Ludick sells the house in which he has been living since 1635 to pay his debts.)

1665 September 12 Becker appoints the lawyer Jan Keijser of The Hague to collect from Rembrandt.

1665 October 6 Rembrandt repays his two other loans to Becker, 1090 guilders, 15 stuivers, but not the Six-Ornia-van Ludick loan.

1667 September 2 A committee of arbitration summons Rembrandt to produce the records pertaining to the loan, which he has so far failed to do.

1668 July 24 Rembrandt agrees to the decision of the arbitrators to pay two-thirds of the 1082 guilders in cash, with no time limit, and one-third in paintings, to be delivered in six months. The new commitment is guaranteed unconditionally by Titus.

1668 September 7 Titus is buried.

1669 October 4 Rembrandt dies, without having paid back any part of the sixteen-year-old loan.

1678 November 23 When the inventory of the estate of the late Harmen Becker was completed, a job of five weeks, it was found to include not only the Juno that he bought from Rembrandt and the *'David and Jonathan'* he must have bought from van Ludick, but also eleven other paintings by and one after Rembrandt that he seems to have acquired from the executors of Rembrandt's estate in settlement of a loan that had caused so many people so much annoyance for so many years.

Of all Rembrandt's creditors, the only ones to recover their money in full were Cornelis Witsen and Gerbrand Ornia. The others took losses that ran from 20 guilders and 5 stuivers for Isaack Vrancx, for the recuperation of which he pestered his nephew, alderman Dirck Spiegel, for years, up to 4200 guilders in the case of Isaac van Hertsbeeck, and about thirteen thousand guilders in that of Titus. As Miss van Eeghen remarked, the only one of Rembrandt's final creditors to die rich was Harmen Becker.

INVENTORY

drawn up by the secretary of the Insolvency Court, with Rembrandt's help, on July 25-26, 1656. The document was an appendix to Rembrandt's petition to the States General for *cessio bonorum*, a form of voluntary bankruptcy, which offered the petitioner a measure of protection from his creditors.

For the sake of easy reference, the items are here arranged by type. In the original document they are listed in the order in which the secretary encountered them in Rembrandt's house, room by room. In the nineteenth century the items were numbered in the sequence of the inventory. These numbers are here printed in parentheses after each item. The location of the items in the house is as follows:

1-32 In the entrance hall
33-76 In the anteroom
77-101 In the room behind the anteroom
102-137 In the back parlour or salon
138-191 In the art gallery (138-178: in the room itself) (179-191: on the ledge in the back)
192-287 The art books
288-311 In the anteroom to the art gallery
312-338 In the small studio, divided among five compartments
339-345 In the large studio
346-348 In the studio storage room
349-350 In the small office
351-356 In the small kitchen
357-358 In the corridor

PAINTINGS BY REMBRANDT

History paintings
A deposition from the Cross, large, by Rembrandt, with a beautiful gold frame [37]
A raising of Lazarus by the same [38]
A flagellation of Christ by the same [62]
A Mary with a Christ Child by Rembrandt [78]
A crucifixion of Christ, modelled by the same [79; perhaps not a painting]
The consecration of Solomon's Temple, in grisaille, by the same [91]
The concord of the state by the same [106]
The resurrection of Christ by Rembrandt [113]
An Ecco Homo in grisaille by Rembrandt [121]
The deposition from the Cross by Rembrandt [293]

Figures
A [painting] of a woman with a child by Rembrandt van Rijn [3]
A standing figure by the same [12]
A St. Jerome by Rembrandt [14]
A soldier in armour by the same [26]
A courtesan grooming herself [39]
A model by Rembrandt [59]
A herding scene by the same [60]
A naked woman by the same [80]
A model, from life, by Rembrandt [297]

Heads
A head by Rembrandt [23]
A head by the same [24]
Two heads by Rembrandt [45]
A head by Rembrandt [48]
A head, from life, by Rembrandt [66]
Two heads, from life, by Rembrandt [90]
A head of an old man by Rembrandt [103]

A woman's head by Rembrandt [105]
A head of Christ by Rembrandt [115]
Christ's head by Rembrandt [118]
Two blackamoors, in a piece by Rembrandt [344]

Landscapes
A small landscape by Rembrandt [10]
Another landscape by the same [11]
A landscape by Rembrandt [20]
A mews by Rembrandt [35]
A mountainous landscape by Rembrandt [43]
A landscape by Rembrandt [65]
A few houses, from life, by Rembrandt [68]
A landscape, from life, by the same [69]
A twilight scene by Rembrandt [125]
A landscape, from life, by Rembrandt [291]
An unfinished landscape, from life, by the same [304]

Animals and still-life paintings
A painting of hares by the same [15]
A painting of a pig by the same [16]
A lions' fight by the same [21]
Two greyhounds, from life, by the same [36]
An ox, from life, by Rembrandt [108]
A horse, from life, by the same [305]
A bittern, from life, by Rembrandt [348]

Various
Two paintings by Rembrandt [338]
Ten paintings, small and larger ones, by Rembrandt [349]

PAINTINGS AFTER REMBRANDT

A copy after a sketch by Rembrandt [89]
The circumcision of Christ, copy after Rembrandt [92]
A copy after the flagellation of Christ, after Rembrandt [302]

PAINTINGS TOUCHED UP BY REMBRANDT

History painting
A painting of a Samaritan, touched up by Rembrandt [33]

Landscape
A moonlight scene, overpainted by Rembrandt [301]

Still-life
A still-life, touched up by Rembrandt [25]
A Vanitas still-life by Rembrandt, touched up [27]
A ditto of the same with a sceptre, touched up [28]
A Vanitas by Rembrandt, touched up [120]
A Vanitas, touched up by Rembrandt [123]
A skull, overpainted by Rembrandt [295]

DRAWINGS AND PRINTS BY REMBRANDT

History subject
A sketch of the entombment of Christ, by Rembrandt [111]

Nudes
A book, filled with drawings by Rembrandt, consisting of men and women in the nude [239]
A nude woman, modelled from life, by Rembrandt [303; perhaps not a painting]

Figures
A ditto [book] full of figure sketches by Rembrandt [257]
A ditto as above [257A]

Landscapes
A ditto [book], full of landscapes drawn from life, by Rembrandt [244]
A parchment book full of landscapes from life, by Rembrandt [256]
A small book full of views drawn by Rembrandt [259]

Animals
A ditto [Chinese basket], full of drawings by Rembrandt, consisting of animals, from life [249]

Statues
A ditto [book], full of statues drawn by Rembrandt from life [261]
A ditto as above [262]

Various
A drawing by the same [Rembrandt] [61]
A sketch by Rembrandt [88]
A book full of sketches by Rembrandt [192]
An antique book with a number of sketches by Rembrandt [218]
A large book, full of sketches by Rembrandt [220]
A book bound in black leather with the best sketches by Rembrandt [236]
Another book with all Rembrandt's works [238]
A packet full of antique drawings by Rembrandt [251]
5 books in quarto, full of drawings by Rembrandt [252]
A ditto full of sketches by Rembrandt, drawn with the pen [265]
A ditto as above [266]
A ditto as above [267]
Another ditto by the same [268]
Another ditto by the same [269]
A ditto in quarto, full of sketches by Rembrandt [272]
Various packets of sketches, by Rembrandt as well as by others [275]
See also under Drawings and prints by other masters: Holbein

PAINTINGS BY OTHER MASTERS

Dutch and Flemish masters

[ANTHONISZ., HENDRICK, 1605-after 1656]

A seascape finished by Hendrick Anthonisz. [29]

[BROUWER, ADRIAEN, 1605-1638]

A painting by Adriaen Brouwer, being a confectioner [1]

A ditto of gamblers by the same Brouwer [2]

A painter's studio by ditto Brouwer [4]

A 'rich kitchen' piece by ditto Brouwer [5]

A ditto [head] by Brouwer [49]

A quack after Brouwer [55]

Two half-length figures by Brouwer [82]

[EYCK, JAN VAN, ca. 1390-1441]

An old head by van Eyck [85]

[HALS, DIRCK, 1591-1656]

A small painting by the young Hals [306]

[JANSZ., GOVERT, 1578- before 1619]

A landscape by Govert Jansz. [44]

A village by Govert Jansz. [107]

[GRIMMER, ABEL, 1570/77-before 1619]

A winterscape by Grimmer [116]

[LASTMAN, PIETER, 1571-1633]

A Tobias by Lastman [41]

An ox by Lastman [119]

[LEYDEN, AERTGE VAN, 1498-1564]

A resurrection of the dead by Aertge van Leyden [87]

A St. Peter's boat by Aertge van Leyden [112]

A Joseph by Aertge van Leyden [288]

[LEYDEN, LUCAS VAN, 1494-1533]

A perspective by Lucas van Leyden [57]

[LIEVENS, JAN, 1607-1674]

A Nativity by Jan Lievens [13]

A landscape by Jan Lievens [18]

Another ditto by the same [19]

A moonlight scene by Jan Lievens [22]

A resurrection of Lazarus by Jan Lievens [42]

A grisaille by Jan Lievens [46]

A hermit by Jan Lievens [52]

A priest after Jan Lievens [58]

An Abraham's sacrifice by Jan Lievens [122]

[PORCELLIS, JOHANNES, ca. 1584-1632]

Two grisailles by Porcellis [47]

A view in the dunes by Porcellis [50]

Another, smaller, by the same [51]

A grisaille by Porcellis [63]

A seascape by Porcellis [84]

[PYNAS, JAN, ca. 1580-1631]

Two heads by Jan Pynas [56]

A Juno by Pynas [71] [may be by Jacob Pynas]

[RIJN, TITUS VAN, 1641-1668]

Three small dogs, from life, by Titus van Rijn [298]

A painted book by the same [299]

A head of Mary by the same [300]

[SEGHERS, HERCULES, 1589/90-ca. 1638]

A small landscape by Hercules Seghers [17]

A wooded landscape by Hercules Seghers [40]

A few houses by Hercules Seghers [70]

Two small landscapes by Hercules Seghers [93]

A large landscape by Hercules Seghers [104]

A grisaille landscape by Hercules Seghers [124]

A landscape by Hercules Seghers [292]

[VALCKENBURGH, LUCAS VAN, 1540-1625]

Two small heads by Lucas van Valckenburgh [53]

[VINCK, ABRAHAM, ca. 1580-1621]

A portrait of a deceased person by Abraham Vinck [86]

[VLIEGER, SIMON DE, 1601-1653]

A grisaille by Simon de Vlieger [64]

Italian masters

[BASSANO, JACOPO, ca. 1510-1592]

An army scorching the earth, by the old Bassano [54]

[CARRACCI, ANNIBALE, 1560-1609]

A copy after Annibale Carracci [81]

Another copy after Annibale Carracci [83]

[GIORGIONE, ca. 1476/78-1510]

A large painting of the Samaritan woman, half the proceeds of which are due to Pieter de la Tombe [109]

[NOVELLA, LELIO ORSI DA, 1511-1586]

The crucifixion of Christ by Lelio da Novella [117]

[PALMA VECCHIO, 1480-1528]

A rich man by Palma Vecchio, half the proceeds of which are due to Pieter de la Tombe [34]

[RAPHAEL, 1483-1526]

A head by Raphael [67]

An image of Mary by Raphael [114]

DRAWINGS AND PRINTS BY OTHER MASTERS

Dutch and Flemish masters

[AELST, HENDRICK VAN: *see under Lorch*]

[BLOEMAERT, ABRAHAM, 1564-1651: *see under Floris*]

[BOL, FERDINAND, 1616-1680: *see under Lievens*]

[BRUEGHEL, PIETER, ca. 1515-1569]

A ditto [book] full of prints by the old Brueghel [204]

[BROUWER, ADRIAEN, 1605-1638]

A ditto with drawings by Adriaen Brouwer [215]

[BUYTEWECH, WILLEM, 1591-1624: *see under Floris*]

[COCK, HIERONYMUS, ca. 1510-1570?: *see under Hollar*]

[DYCK, ANTHONY VAN, 1599-1641]

A book full of portraits by van Dyck, Rubens as well as several other old masters [228]

[FLORIS, FRANS, 1516-1570]

A ditto [Chinese basket] full of prints by Frans Floris, Buytewech, Goltzius and Abraham Bloemaert [250]

[GOLTZIUS, HENDRICK, 1558-1617]

A ditto [book] full of copper engravings by Goltzius and Muller, consisting of portraits [213]

See also under Floris

[HEEMSKERCK, MAERTEN VAN, 1498-1574]

A ditto [book] of Heemskerck, being all the works by the same [227]

[JORDAENS, JACOB, 1593-1678: *see under Rubens*]

[LASTMAN, PIETER, 1571-1633]

A ditto [book] full of sketches by Pieter Lastman, drawn with the pen [263]

A ditto by Lastman, with red chalk [264]

[LEYDEN, LUCAS VAN, 1494-1533]

A book with woodcuts by Lucas van Leyden [193]

A ditto with copper prints by Lucas van Leyden, double as well as single [198]

[LIEVENS, JAN, 1607-1674]

Another engraved book with prints, being the works of Jan Lievens and Ferdinand Bol [274]

[MIEREVELT, MICHIEL VAN, 1567-1641]

A ditto [book] full of portraits by Mierevelt, Titian and some others [246]

[MULLER, JAN HARMENSZ., 1571-1620: *see under Goltzius*]

[RUBENS, PETER PAUL, 1577-1640]

A ditto [book] with trial proofs by Rubens and Jacob Jordaens [245]

See also under van Dyck

[SAVERY, ROELANT, 1576-1639]

A ditto [book], large, with drawings of the Tyrol, drawn from nature by Roelant Savery [270]

[VLIET, JAN JORISZ. VAN, active 1630-1640]

A box with prints by van Vliet after paintings by Rembrandt [277]

Italian and German masters

[BAROCCI, FEDERICO, 1526-1612: *see under Vanni*]

[BONASONI, GIULIO, 1531-1574: *see under Raphael*]

[BROESMER?: *see under Schongauer*]

[CARRACCI, ANNIBALE, 1560-1609; AGOSTINO, 1557-1602; LODOVICO, 1555-1619]

A ditto [book] of [work by] Annibale, Agostino and Lodovico Carracci, Guido Reni and Spagnoletto [209]

See also under Raphael

[CRANACH, LUCAS, 1472-1553]

A ditto [book] with copper prints as well as woodcuts by Lucas Cranach [208]

[HOLBEIN, HANS, 1497/98-1543: *see under Schongauer*]

[HOLLAR, WENZEL, 1607-1677]

An East Indian basket containing several prints by Rembrandt, Hollar, Cocq and several others [235]

[LORCH, MELCHIOR, 1527-ca. 1585]

A ditto [basket] full of Turkish buildings by Melchior Lorch, Hendrick van Aelst and several others, portraying Turkish life [234]

[MANTEGNA, ANDREA, 1431-1506]

The precious book of Andrea Mantegna [200]

[MECKENEM, ISRAHEL VAN, before 1450-1503: *see under Schongauer*]

[MICHELANGELO, 1475-1564]

A ditto [book] full of the works of Michelangelo [230]

[RAPHAEL, 1483-1526]

A ditto [book] with copper prints by Raphael [196]

A ditto [book] with prints by Raphael [205]

A ditto [book] with very precious prints by the same [206]

A ditto [book] by Raphael, very beautiful impressions [214]

A ditto [basket] with erotic prints by Raphael, Rosso, Annibale Carracci and Giulio Bonasoni [232]

[SCHONGAUER, MARTIN, ca. 1430-1491]

A paper box full of prints by Martin Schongauer, Holbein, Hans Broesmer and Israhel van Meckenem [237]

[SPAGNOLETTO: *see under Carracci*]

[TEMPESTA, ANTONIO, 1555-1630]

A ditto [book] full of prints by Antonio Tempesta [207]

A ditto [book] with engraved and etched figures by Antonio Tempesta [210]

A ditto large book by the same [211]

A ditto book as above [212]

[TITIAN, ca. 1487-1576]

A ditto very large [book] with most of Titian's works [216]

See also under Mierevelt

[VANNI, FRANCESCO, 1563-1610]

A ditto [book] with copper prints by Vanni and others, including Barocci [195]

ANONYMOUS PAINTINGS
History paintings
A painting of Jephthah [77]
An Annunciation [290]
A large painting, representing
 Danae [347]

Heads
A head, from life [294]
A head of Christ, from life
 [326]
A head of a satyr, with horns
 [327]
3 or 4 antique heads of women
 [333; possibly sculptures]
Another 4 heads [334]

Figures
Two completely naked figures
 [187]

Landscape
A forest by an unknown
 master [102]

Animals
A still-life with fish, from life
 [307]

ANONYMOUS PRINTS AND DRAWINGS
Landscapes
A ditto [book] full of
 landscapes by assorted
 masters [229]
A ditto [basket] full of
 landscapes by assorted
 famous masters [233]

Architecture
A ditto [book] full of drawings
 of all Roman buildings and
 views, by all the leading
 masters [240]
A ditto [Chinese basket] full
 of prints of architecture
 [248]
A ditto [book] full of prints of
 architecture [253]

Statues
A book full of statues in
 copper engravings [226]

Costume
A ditto [book] full of curious
 miniature drawings,
 together with assorted
 woodcuts and copper prints
 of all kinds of costume [203]

Calligraphy
A ditto [book] with
 outstanding examples of
 calligraphy [260]

Various
A ditto [book] of woodcuts by
 Wa.. [194]
A ditto [book] with drawings
 by the foremost masters of
 the whole world [199]
A large ditto [book] full of
 drawings and prints by
 many masters [201]
Another larger ditto [book]
 with drawings and prints by
 assorted masters [202]
A ditto [book] full of drawings
 by assorted important
 masters [271]
3 framed prints [289]

STATUES
By identified artists
A bath of Diana in plaster by
 Adam van Vianen [296]
A basin with naked figures in
 plaster by Adam van
 Vianen [308]
A child by Michelangelo [345;
 not necessarily a statue]

Roman emperors
A statue of the Emperor
 Augustus [147]
A statue of Tiberius [149]
A head of Caius [151]
A Caligula [152]
A Nero [156]
An Emperor Galba [168]
A ditto Otho [169]
A ditto Vitellius [170]
A ditto Vespasian [171]
A Titus Vespasian [172]
A ditto Domitian [173]
A ditto Silius Brutus [174]
The statue of the emperor
 Agrippa [324]
Ditto of the emperor Marcus
 Aurelius]325]
A Vitellius [331]
A Roman emperor [160]

Empresses
A statue of an empress [145]
A Faustina [166]

*Classical philosophers and
poets*
A Heraclitus [154]
A Socrates [162]
A Homer [163]
An Aristotle [164]
A Seneca [332]

Other statues from antiquity
Three antique statues [110]
A brown antique head [165]
A statue representing the
 antique Amor [180]
A plaster cast of an antique
 Greek statue [323]
An antique Sibyl [328]
An antique Laocoon [329]

Children
Two naked children in plaster
 [7]
A sleeping infant in plaster [8]
A pissing child [142]
See also under Michelangelo

Portrait busts
A plaster head [6]
2 modelled portraits of
 Bartholt Been and his wife
 [322]

*Masks and casts of arms and
legs*
A blackamoor, cast from life
 [161]
Eight works in plaster, cast
 from life, large [178]
The death-mask of Prince
 Maurits, cast from his very
 own countenance [188]
A Chinese basket full of casts
 of heads [241]
A plaster mould of Prince
 Maurits [287]
A large lot, consisting of
 hands and heads cast from
 life, with a harp and a
 Turkish bow [316]
17 arms and legs, cast from
 life [317]

Animals
A lion and a bull, modelled
 from life [189; possibly a
 sketch]

BOOKS
With contents
An antique book [219]
Jan Six's *Medea*, tragedy [254]
All Jerusalem by Jacques
 Callot [255]
A wooden booklet with round
 plates [?: *teljooren*; 258]
Albrecht Dürer's book on
 proportion, woodcut [273]
15 books in different formats
 [281]
A German book with military
 figures [282]
A ditto with woodcut figures
 [283]
A Flavius Josephus in

German, illustrated with
 figures by Tobias Stimmer
 [284]
An old Bible [285]

Empty books
Another antique book, empty
 [221]
An empty art book [242]
A ditto as above [243]

MUSICAL INSTRUMENTS
13 bamboo instruments as
 well as flutes [314]
7 string instruments [337]
A wooden trumpet [343]
See also under Masks

CURIOSITIES
Objets d'art
A small column [140]
A cabinet with medals [185]
A few curiosities, viz. pots
 and Venetian glasses [217]
A small tric-trac board [222]
A marble writing set [286]
See also under Orientalia

Naturalia
A box with minerals [139]
47 items of marine and
 terrestrial flora and the like
 [175]
23 items of marine as well as
 terrestrial fauna [176]
A large quantity of horns,
 marine plants, casts from
 life and many other
 curiosities [179]
A large piece of white coral
 [225]
A drawer containing a bird of
 paradise and six fans [280]
A lot consisting of antlers
 [318]
9 gourds and bottles [321]
A large marine plant [330]
The skins of a lion and a
 lioness, with two fur [or
 multicoloured] coats [346]

ORIENTALIA
Two East Indian dishes [143]
A ditto bowl with a Chinaman [144]
An East Indian powder-box [146]
An Indian cup [148]
An East Indian sewing box [150]
Two porcelain cassowary birds [153]
Two porcelain statuettes [155]
A Japanese helmet [158]
A hammock with two gourds, one of copper [177]
A Chinese dish with minerals [224]
A Chinese basket [247]
An article of male and female dress from India [340]

WEAPONS
Firearms and accessories
A handgun, a pistol [181]
An old-fashioned powder flask [183]
A Turkish powder flask [184]
33 antique handguns and wind instruments [or blow-pipes] [312]
60 Indian guns, as well as arrows, shafts, javelins and bows [313]
A small metal cannon [335]

Other weapons
A catapult [191]
13 items, arrows, bows, shields etc. [315]
4 catapults and longbows [319]

Helmets, cuirasses and shields
Two iron helmets [157]
A carboy helmet [159]
An iron cuirass with a helmet [167]
An iron shield by Quinten Matsys with unusual decoration [182]
An osier shield [186]
An iron gorget [279]
5 antique hats and shields [320]
20 halberds, broadswords and Indian fans [339]
A giant's casque [341]
5 cuirasses [342]

STUDIO MATERIAL
An ebony frame [73]
A gilded frame [94]
One lot of paper, very large format [276]

HOUSEHOLD EFFECTS
Tables and tablecloths
A walnut table with a Tournai tablecloth [75]
A small oak table [95]
An oak table [128]
An embroidered tablecloth [129]
A deal table [311]
A small table [353]

Chairs and cushions
Four Spanish chairs with Russia leather [30]
Two ditto chairs with black seats [31]
A deal platform [32]
Seven Spanish chairs with green velvet seats [76]
4 simple chairs [98]
4 green cushions for chairs [99]
6 chairs with blue seats [127]
A rush chair [136]
A very antique chair [223]
4 chairs with black leather seats [310]
Some old chairs [355]
2 chair cushions [356]

Beds and linen
A bed and bolster [132]
2 pillows [133]
2 blankets [134]
A blue hanging [135]
A small gilded bedstead, modelled by Verhulst [197; possibly a sketch or a design]
A bedstead [350]

Linen-presses
An oak press [97]
A press made of sacredan wood [130]

Various
'Een poviese schoen' [9; obscure]
A looking-glass in an ebony frame [72]
A marble [wine] cooler [74]
4 cardboard screens [96]
A brass kettle [100]
A coat-stand [101]
A large looking-glass [126]
A ditto [sacredan] chest for baby-diapers [131]
An andiron [137]
Two terrestrial globes [138]
A pewter pot [141]
Some canes [190]
Two osier baskets [231]
A baize childbed screen [278]
An old trunk [309]
A quantity of antique textiles of various colours [336]
A pewter waterjug [351]
A few pots and pans [352]
A cupboard [354]
9 white serving dishes [357]
2 earthenware plates [358]
Linen said to be at the laundry: 3 man's shirts, 6 handkerchiefs, 12 napkins, 3 tablecloths, some collars and cuffs [359-363]

A NOTE ON THE INVENTORY
In our ignorance of the items in the extensive auction held by Rembrandt half a year before this inventory was drawn up, we cannot judge its completeness as a record of his possessions.

The parts that seem intact to me are the prints and drawings, the sculptures, the objets d'art and weapons. The studio material and household goods are certainly incomplete, possibly because Rembrandt was allowed to keep much of what he owned of that kind.

We have discussed many of the entries referring to paintings by Rembrandt at various places in the book. Here it seems important only to note that all of the categories into which I have grouped the paintings include compositions that have been lost or are no longer recognized as Rembrandt's work.

The paintings by other masters form an interesting group. As opposed to the prints and drawings by others, which have the character of a collection, the paintings look like the stock in trade of a small dealer. Two of the Italian paintings were half-owned by the dealer Pieter de la Tombe. Of those by the seventeen Dutch and Flemish masters represented, half were by four artists: Adriaen Brouwer, Johannes Porcellis and Hercules Seghers, all of whom died in the 1630s, and Jan Lievens. The painting 'completed' by Hendrick Anthonisz. provides a tie with his fellow seascape painter Porcellis. Anthonisz. was married to the sister of Porcellis's wife. Both had lived in Leiden in the late 1620s, and in 1642 Anthonisz. had an address on the Sint Anthonisbreestraat in Amsterdam before moving, as Rembrandt was soon to do, to the Rozengracht.

About a year before December 25, 1655, Rembrandt had contracted to deliver to Otto van Cattenburgh three paintings by Brouwer and three by Porcellis for 750 guilders, so we may assume he was known as a dealer in their works.

We know that Rembrandt came into possession at one point of part of the estate of Hercules Seghers, since he changed an etching plate by the latter from a *Tobias and the angel* into a *Flight of the holy family into Egypt*.

Of the nine paintings by Lievens in the inventory, the histories and figures may be from the Leiden period, and could have belonged to Rembrandt since then. But the three landscapes must have been made in Antwerp. Apparently, then, Rembrandt and Lievens were in contact in Amsterdam, after Lievens moved there (see p. 318), and Rembrandt may have acted as his dealer. The seven or eight paintings by Brouwer in the inventory may also have come into Rembrandt's possession through Lievens, who worked closely with Brouwer in Antwerp.

Hendrick Anthonisz. and Lievens are the only living masters, apart from Titus and Rembrandt himself, represented in the inventory. They, like Porcellis and Seghers, were in chronic need and never far from the bankruptcy courts.

The great loss to scholarship in the sale was the dispersal of Rembrandt's own drawings. Had they been preserved as a group, the study of his art would have been a far more secure and structured branch of Dutch art history than it is.

For the image of Rembrandt's studio conjured up by the inventory, see fig. 37 and Houbraken's description of Flinck's house, p. 282.

35 Hendrickje and Titus

We have already met the two people with whom Rembrandt shared the last twenty years of his life, his mistress Hendrickje and his son Titus – she making a statement in 1649 backing up Rembrandt's version of his agreement with Geertge Dircx, he guaranteeing Rembrandt's renewed promises to Harmen Becker in 1668. I am afraid that none of the documents of the intervening years are much more pleasant. While it is true that notaries do not take statements concerning the day-to-day happiness of contented families, the provisions and parenthetical remarks in wills are often revealing of human tenderness. Feelings of this kind are conspicuously absent from the Rembrandt documents. The records of his household speak of constant tensions brought about by him and shunted off on to his family. Their life with him must have had its rewards, but they also suffered at his hands.

HENDRICKJE | Hendrickje Stoffels was born about 1615 in Bredevoort near Winterswijk, the daughter of the army sergeant Stoffel Jegers. Hendrickje's brothers Berent and Herman Jegers were soldiers in the company of Gerard Ploos van Amstel. This nobleman son of the Utrecht delegate to the States General became a captain in Frederik Hendrik's army in 1640, and was on close terms with the prince and with Huygens.

Rembrandt's milieu in Amsterdam was not prudish, and his affair with the new girl in his house, after the disastrous end of the one with her predecessor, should not have caused more trouble than a bit of gossip. For Rembrandt that may have been the case, but Hendrickje was made to pay for living in sin. On June 25, 1654, she was summoned before the church council to answer the charge that she 'practiced whoredom with Rembrandt the painter.' The language of the document leaves open the possibility that Rembrandt too was called, but that applies only to the first summons, which was ignored. Two more followed, addressed to

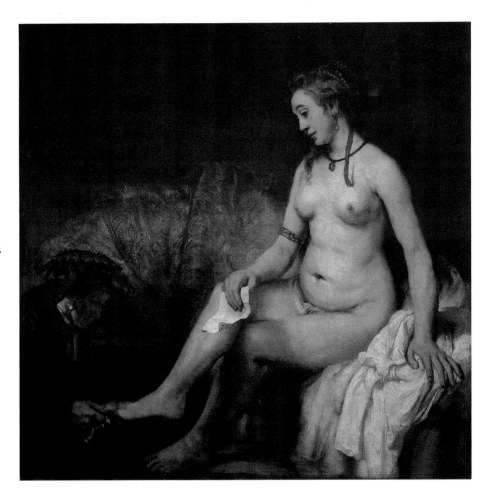

323 *Bathsheba with King David's letter*. Signed *Rembrandt ft. 1654*. Canvas, 142 x 142 cm. Bredius 521. Paris, Musée du Louvre.

The composition is unquestionably based on an engraving of 1645 by François Perrier after an antique relief of a young woman having her foot pumiced by an older one. The main figure in the engraving is dressed, however, so that Rembrandt based his *Bathsheba* on life drawings of Hendrickje.

The subject, which corresponds to that of fig. 173, fits into the row of sinful women of the 1640s. It is the largest history painting Rembrandt had made for over fifteen years. Coming in the year of the portraits of Six and Soop, it gives one the impression of having been ordered by one of Rembrandt's new patrons.

Hendrickje alone, which were also disobeyed. Not until July 23rd did Hendrickje appear before the council, after a visit from 'the brothers of the quarter,' one of whom was the son of Joannes Elison. She confessed to the charges, and was 'admonished severely, urged to repent and forbidden to attend the Lord's Supper.' This meant that until that day Hendrickje had been a member of the Reformed Church, a status she never regained.

Rembrandt's biographers have all speculated on his reasons for not marrying Hendrickje. Most of them connect it with the terms of Saskia's will, and there is probably some truth in this. A marriage in itself would not have changed his situation, but if he married and Titus then died, he would be required to turn over Saskia's inheritance to her family, which he was in no position to do. H.F. Wijnman believes that it would have compromised Rembrandt's standing as a gentleman to marry Geertge Dircx or Hendrickje.

Three months after Hendrickje was condemned by the church council she gave birth to a daughter, named Cornelia after Rembrandt's mother.

'POSING NAKED AS NAKED CAN BE' | It was also in that year that Rembrandt painted Hendrickje, in one of his rare nudes: *Bathsheba with King David's letter* (fig. 323). The beautiful wife of Uriah, having been seen naked by the king, is being groomed for his bed by an old woman skilled in the art of procurement (compare fig. 173).

In the 1650s, posing in the nude was not a neutral matter. Many models were prostitutes and to pose nude always cast suspicion on a woman. Govert Flinck had three models, the van Wullen sisters, who ran 'a notorious house' in his street, the Lauriergracht. One of them, Margarita, after bearing two children to Nicolaes Heinsius, sued him for matrimony in 1656 when he became town secretary. Among the evidence he gathered in 1657 to blacken her character was the fact that she and her sisters had posed some eight years earlier for Flinck, 'being painted as naked as anyone could possibly be painted.'

A model who worked for Dirck Bleeker in the early 1650s was brought into contact by the artist with the admiring men to whom he sold paintings of her (see also p. 32). One cannot help suspecting the same of the Rembrandt apprentice Willem Drost's *Bathsheba* of 1654 in the Louvre, in which the model looks directly out at us with an unmistakably enticing gaze. These paintings are not far removed from the portraits of courtesans which were displayed in the brothels of Amsterdam. Customers

made their choice from such portraits, and only after paying were they introduced to the model herself. As a visiting Frenchman commented in 1681: 'If she doesn't match up to the picture, it's your bad luck.'

Rembrandt's other paintings of Hendrickje from this period, splendid as they are, do nothing to correct possible misunderstandings (figs. 324, 326 and 328). Two show her in the poses of Venetian courtesans after Titian and Palma Vecchio, the other in an indelicate, irresistible guise (as Bathsheba? fig. 328) that would made King Davids of us all.

It is quite possible, I feel, that the church council, which did not take it upon itself to police the bedrooms of Amsterdam, and allowed Hendrickje to continue attending communion for five years after she began living with Rembrandt, saw the large *Bathsheba* as a provocation that could not be ignored. (Her pregnancy, of course, was another). Even so, I have the feeling that the punishment of this young woman with no other contacts in Amsterdam beside Rembrandt was actually a way of hurting him through her.

TITUS | Saskia's will of 1642 attached Rembrandt and Titus to each other with chains of gold. Half of

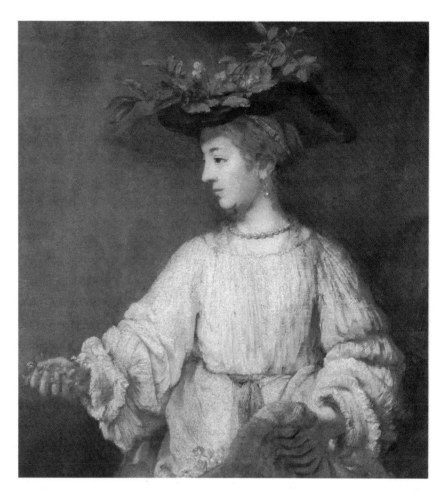

324 *Hendrickje as Flora*. Ca. 1654. Canvas, 100 x 91.8 cm. Bredius 114. New York, Metropolitan Museum of Art.

A re-creation, in a more relaxed mode, of the painting of Saskia (fig. 205) that Jan Six contracted to buy in 1652. It was exactly the same height, but wider, closer to the square format of the *Bathsheba*. The new version also contains elements of Titian's *Flora* from the Lopez collection (see fig. 233).

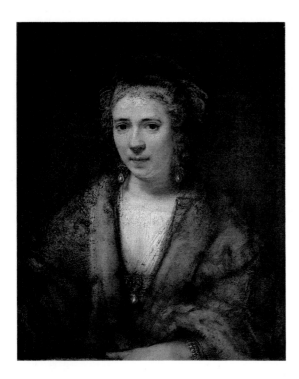

325 *Hendrickje*. Ca. 1655.
Canvas, 72 x 60 cm. Bredius
111. Paris, Musée du Louvre.

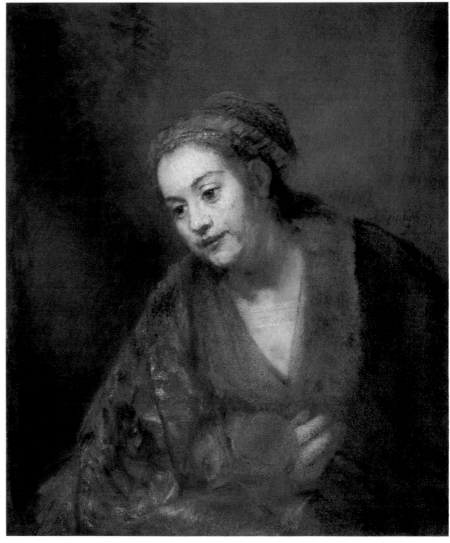

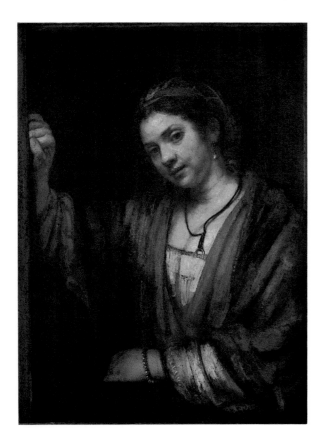

326 *Hendrickje at an open
door*. Ca. 1656. Canvas, 88.5
x 67 cm. Bredius 116.
Berlin-Dahlem,
Gemäldegalerie.

Adapted from a courtesan
painting by the Venetian
master Palma Vecchio (ca.
1480-1528) that was auctioned
in Amsterdam by Gerrit
Uylenburgh in the 1640s.

327 *Hendrickje*. Signed
Rembrandt f. 1660. Canvas,
78.4 x 68.9 cm. Bredius 118.
New York, Metropolitan
Museum of Art.

Figs. 325 and 327 are
sometimes said to be
companions to two
self-portraits, one in Kassel
no longer accepted as a
Rembrandt, and fig. 411. This
seems to lack sufficient
ground both in the histories of
the paintings and their form.
 The painting in the
Metropolitan Museum is very
badly damaged, and must
have been mistreated in its
early years. Could it have
been inherited by
Hendrickje's daughter
Cornelia and taken by her to
the Dutch East Indies when
she moved there in the 1670s?

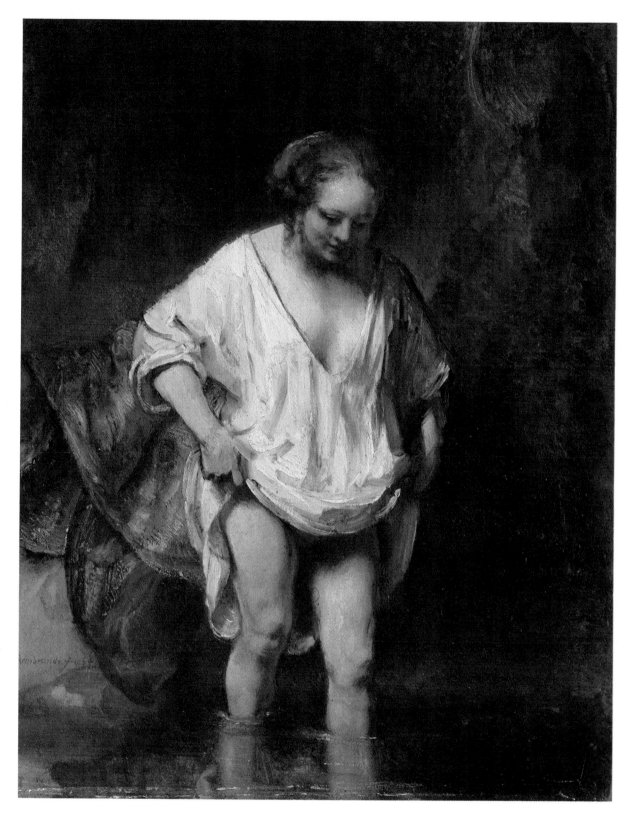

328 *Hendrickje bathing.* Signed *Rembrandt f. 1655.* Panel, 61.8 x 47 cm. Bredius 437. London, National Gallery.

This oil sketch enlarged to the dimensions of a full-scale painting is to my eye one of the freshest and most original of Rembrandt's works in oil. The eye can be deceived, however. Many such expressions of enthusiasm by art historians have turned out to apply to forgeries, copies, works by apprentices or adaptations by the master of someone else's idea.

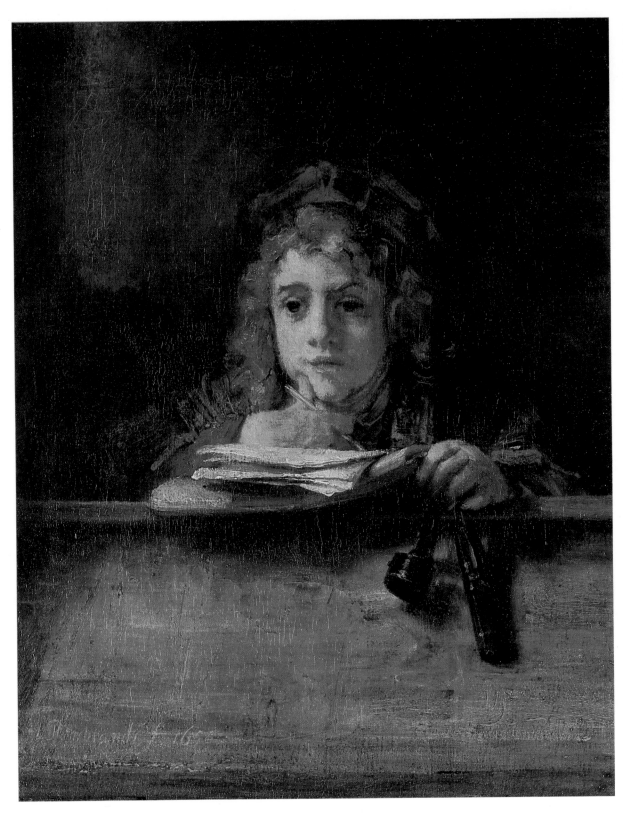

329 *Titus at his desk*. Signed *Rembrandt f. 1655*. Canvas, 77 x 63 cm. Bredius 120. Rotterdam, Museum Boymans-van Beuningen.

Whatever tenderness there was between Rembrandt and his son we have to guess from the paintings, an unreliable source. Since all we know Titus to have done in 1655 was write a will in Rembrandt's favour, we could, in a parody of documentary biography, call this painting *Titus writing his will*. It will not do, however, for the simple reason that Rembrandt wrote Titus's will.

Titus was trained by Rembrandt in drawing and painting, although he never emerged as an artist in his own right. The 1656 inventory suggests to me that Titus made Vanitas still-lifes that were then re-touched by Rembrandt. No such works have ever been identified.

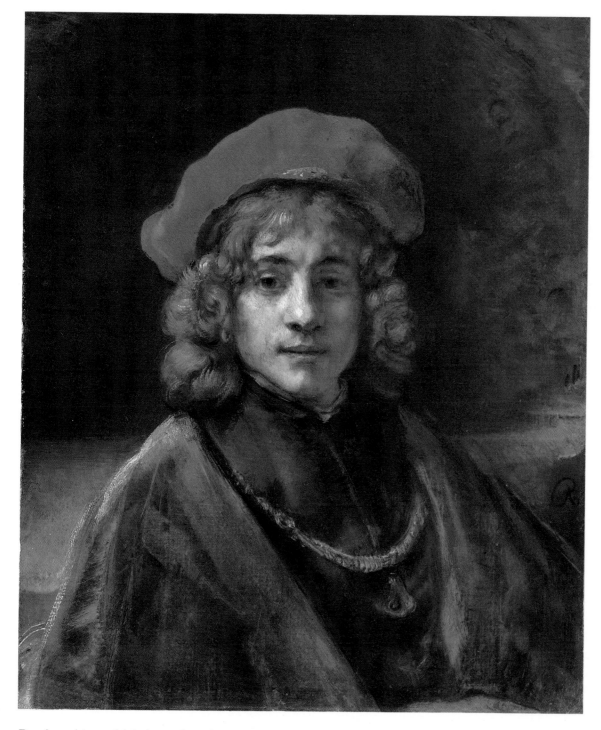

330 *Titus*. The part of the canvas with the signature has been cut off, leaving only the *R*. Ca. 1658. Canvas, 67.3 *x* 55.2 cm. London, The Wallace Collection.

Rembrandt's wealth belonged to Titus, but he could use it at his discretion until Titus married or came of age. As Rembrandt's fortunes declined in the 1650s, the value of Saskia's legacy came to exceed Rembrandt's total worth, so that, in effect, his son owned him. This was the situation by the time of his portrait of Titus (fig. 329), painted in the year the boy drew up his first will, making his father his universal heir.

THE FIRM | The strange knot through which father and son were tied was tightened even more in 1660 when Rembrandt had Hendrickje and Titus form

a company to take financial responsibility for his affairs, without having any real authority over him. This was done on the day when the Insolvency Court terminated its control over Rembrandt, and he became prey once more to creditors – even, because of special agreements, to some of the old ones. In effect, Rembrandt now shielded himself behind his eighteen-year-old son and his mistress, who by then was calling herself, in legal statements, his wife.

Rembrandt was to be their in-house adviser in an art dealership, and for this he was to receive free room and board from the partners, who were required to sink all they owned into the firm,

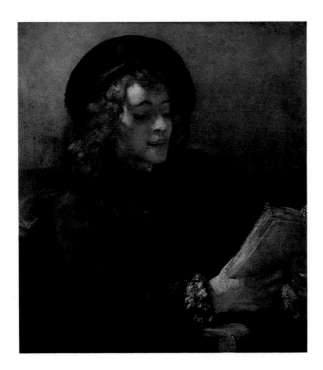

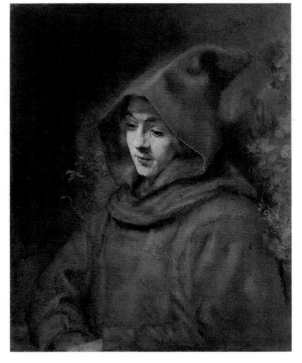

332 *Titus in a monk's habit.*
Signed *Rembrandt f. 1660.*
Canvas, 79.5 x 67.5 cm.
Bredius 306. Amsterdam,
Rijksmuseum.

The same habit was donned
by an old model in a painting
the following year.

331 *Titus reading.* Ca. 1656.
Canvas, 70.5 x 64 cm. Bredius
122. Vienna,
Kunsthistorisches Museum.

angle, with a different hat on.
Apparently Titus served as a
model for others as well while
Rembrandt was painting him.

A drawing by another hand
than Rembrandt's shows the
same figure from another

specifically including, in the case of Titus, 'all he had
still retained by way of baptism gifts, savings, his
own profits and all else.' Rembrandt received
spending money – he started off with fifteen hundred
guilders – but it was only for his personal use, and he
was forbidden to repay debts with it.

The document, like most of Titus's and
Hendrickje's wills, was dictated by Rembrandt and
tailored mainly, not to say exclusively, to his needs,
not theirs. The most painful passage in the contract,
which makes it clear not only that he was pulling the
strings but also playing the other two off against
each other, reads: 'The aforesaid parties [Titus and
Hendrickje], have also agreed and contracted that
neither shall be allowed without the other to sell,
steal or expropriate from the firm, and if this should
occur, the one who is found to have done it will
forfeit to the other the sum of fifty guilders, which
will be put aside and paid by Rembrandt van Rijn
out of the money due to them from him, so that the
offender will receive that much less and the other
that much more. This is to be repeated at every such
occurrence.'

There are no records of Hendrickje undertaking
any manner of business dealings. She died in July
1663, leaving all she owned to her and Rembrandt's
daughter Cornelia, under the guardianship of the
painter Christian Dusart (1618-after 1681).

TITUS AS A PARTNER IN THE FIRM | The vignettes
from the life of Titus shown by the documents reveal
a likeable boy and obedient son without much
strength of will.

In 1662 he was mentioned in the last will of Karel
van der Pluym, who had spent some time in
Rembrandt's studio when Titus was about four
years old, and who, in the meantime, had risen to
head of the guild of St. Luke in Leiden and had
become a member of the town council.

In 1665 Karel's father Willem Jansz. van der
Pluym, who lived in Amsterdam, underwrote Titus's
application for legal majority, which was granted to
him on June 19th. He was now able to take
possession of Saskia's estate – or at least its remains,
some thirteen thousand guilders less than she left
him. The concern of the van der Pluyms for Titus
shows that it was not only the Uylenburghs who
were looking after the boy's interests.

Earlier in 1665 we find Titus in Leiden negotiating
with the publishers Daniel and Abraham van
Gaesbeek to get a commission for Rembrandt to do
a book illustration, an engraving after the portrait of
the late Dr. Johannes Antonides van der Linden by
Abraham van den Tempel. (I assume that it was this
son of Lambert Jacobsz. who brought Titus to the
publisher, although one witness said he was simply

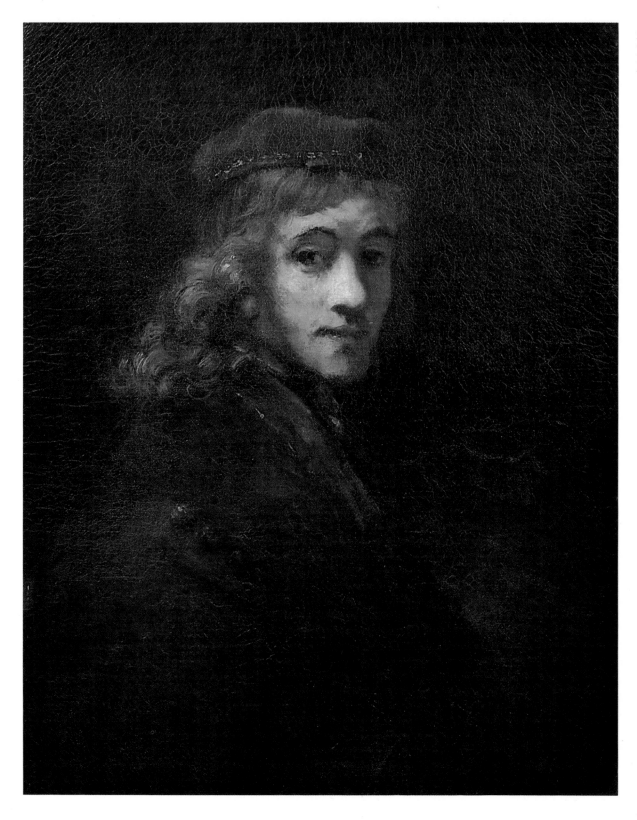

333 *Titus*. Ca. 1660. Canvas, 72 x 56 cm. Bredius 126. Paris, Musée du Louvre.

Rembrandt, born Leiden 15 July 1606, died Amsterdam 4 October 1669, buried 8 October 1669 in the Westerkerk,

× 22 June 1634 in St. Annaparochie Saskia (van) Uylenburgh, baptized Leeuwarden 2 August 1612, died Amsterdam 14 June 1642, buried 19 June 1642 in the Oude Kerk

lived with Hendrickje Stoffelsdr. Jaeger, born Bredevoort ca. 1626, buried 24 July 1663 in the Westerkerk, Amsterdam

Rombartus, born Amsterdam, baptized 15 December 1635 in the Oude Kerk, buried 15 February 1636 in the Zuiderkerk

Cornelia, born Amsterdam, baptized 22 July 1638 in the Oude Kerk, buried 13 August 1638 in the Zuiderkerk

Cornelya, born Amsterdam, baptized 29 July 1640 in the Oude Kerk, buried 12 August 1640 in the Zuiderkerk

Titus, born Amsterdam, baptized 22 September 1641 in the Zuiderkerk, buried 7 September 1668 in the Westerkerk, painter, merchant
× 28 February in the Nieuwe Kerk Magdalena van Loo, born Amsterdam, baptized 21 May 1642 in the Nieuwe Kerk, buried 21 October 1669 in the Westerkerk

Cornelia, born Amsterdam, baptized 30 October 1654 in the Oude Kerk, died Batavia, Dutch East Indies
× shortly after 3 May 1670
Cornelis Suythof, painter and jailkeeper, born Amsterdam ca. 1646, died Batavia after 1689

Titia, born Amsterdam, baptized 22 March 1669 in the Nieuwezijds Kapel, died Amsterdam 22 November 1715, buried 27 November 1715 in the Westerkerk
× 27 June 1686 in Sloten
François van Bijler, jeweller, born Amsterdam ca. 1668, died Amsterdam, buried 14 April 1728 in the Westerkerk

Rembrandt, born Batavia, baptized 5 December 1673

Hendric, born Batavia, baptized 14 July 1678

The family tree on this page was compiled for the present publication by P.J.M. de Baar of the Leiden municipal archives.

called in off the street.) The publisher was wary: 'I have indeed heard that your father makes etchings, but not engravings. This plate has to be engraved.' (For the purposes of a book publisher, an engraving is far more preferable to an etching, from which only a limited number of good impressions can be printed.) Titus: 'My father can engrave with the best of them.' The publisher showed him a rejected plate by another artist, 'adding that the new one would have to be better engraved. At this, van Rijn laughed and declared flatly that it came nowhere near to his father's work.'

This declaration by an eyewitness, and another like it, would not have had to be taken if the plate Rembrandt subsequently delivered was not only largely etched, but actually corrected in drypoint, a technique that produces no more than a handful of usable prints. It was not used for the book.

This is the only document referring to Titus as an active agent in the firm.

TITUS AS BRIDEGROOM | If Titus's choice of a bride was his own, then it was unspeakably touching, but if Rembrandt's, simply unspeakable. We know that Saskia's family still had a claim on Rembrandt, that Hiskia Uylenburgh, the wife of Gerrit van Loo, was named as a creditor in his application for insolvency, and that she took him to court around 1656. The girl Titus married in February 1668 was Magdalena van Loo, Hiskia's niece. This marriage, by returning Saskia's legacy to her family, as it were, removed the last cause that they might yet have to sue Rembrandt.

On September 7, 1668, Titus was buried in the Westerkerk. His posthumous daughter Titia was born six months later, in March 1669, and in October the baby lost her mother and grandfather.

The tip of the nose: half-lengths

DON ANTONIO | Messina is on the northernmost point of Sicily, across the straits from the toe of the Italian boot. In Rembrandt's lifetime it was ruled by Spain, like the southern Netherlands, and was therefore not as remote from Holland as it sounds. Certainly the man with whom Rembrandt did business there, Don Antonio Ruffo (born 1610) did not think of himself as isolated. He collected modern paintings from all over Europe. By 1648 he had 166, and in 1662 over two hundred. As nearly as I can reconstruct the beginning of his contact with Rembrandt, it was in 1652 when Ruffo decided that he would like a figure painting by a good Amsterdam master, and asked his friend Giacomo di Battista, who traded with Amsterdam, to help him out. Giacomo's correspondent there was the very wealthy merchant Cornelis Gijsbertsz. van Goor (1600-1675), a man from the circle of Willem Schrijver.

Thanks, perhaps, to this connection, Rembrandt was approached and commissioned to paint a work for the Sicilian. This was Rembrandt's first commission for a figure painting, by all accounts, since the 1630s, and he put his heart and soul into it. He was free to choose the subject, and came up with an idea of unusual wit and richness (fig. 334). While there is only one figure in the painting, Aristotle, he is shown wearing a medallion with the profile of his pupil and patron Alexander the Great, and fondling a bust of his adored Homer. The image opens wonderful perspectives for the dreamy observer, on the relation between the philosopher, the poet, the prince and their respective worlds.

That year Rembrandt enriched Jan Six's art album with two drawings, one of them Homer reciting his verses to an appreciative audience. As the author of a classical tragedy and a man Rembrandt associated with Homer, Six was undoubtedly consulted by the artist on the subject.

At first, the subtlety was lost on Ruffo. When he entered the new acquisition in his inventory on September 1, 1654, he called it a 'half-length of a philosopher made in Amsterdam by the painter called Rembrandt (it looks like an Aristotle or Albertus Magnus).'

The *Aristotle* grew on Ruffo, and in 1660 he decided he would like to have a pendant for it. Perhaps to economize (Rembrandt had charged him five hundred guilders for the painting), he commissioned a companion piece from the Bologna master Guercino (1591-1666). The latter responded warmly, in a letter full of praise for Rembrandt, agreeing to Ruffo's request that he paint the work in his early broad manner in order to match Rembrandt's. Guercino's works of the 1650s are generally in cooler colours and finer forms than Rembrandt's. Ruffo sent him a sketch that looked to him like a phrenologist examining the bumps on a head, and he felt that an appropriate companion would be a 'cosmographer' inspecting a map of the world. He asked 'sixty ducats, as a special price for you, a special patron.'

The results were not what Ruffo expected, and the next year the don asked Guercino's pupil Mattia Preti (1613-1699) to try his hand at the same commission.

Meanwhile, Ruffo had a new iron in the fire with Rembrandt. This time the Dutch agent was Isaac Just, whom Ruffo calls his friend. Just was the cousin of Gerrit Uylenburgh's wife Elizabeth. The ties between the agents for the first and second commissions can be divined from a later document, which identifies Cornelis Gijsbertz's son Gijsbert van Goor as one of Gerrit Uylenburgh's creditors.

The new commission was for an *Alexander the Great* (cf. fig. 336) – in other words, for a flesh-and-blood portrayal of the personage present in the *Aristotle* in the form of a medallion. Ruffo had finally caught on to the conceit, and wished to play along. The companion was apparently to be the same height as the *Aristotle*, but narrower.

When Rembrandt's delivery arrived, it caused

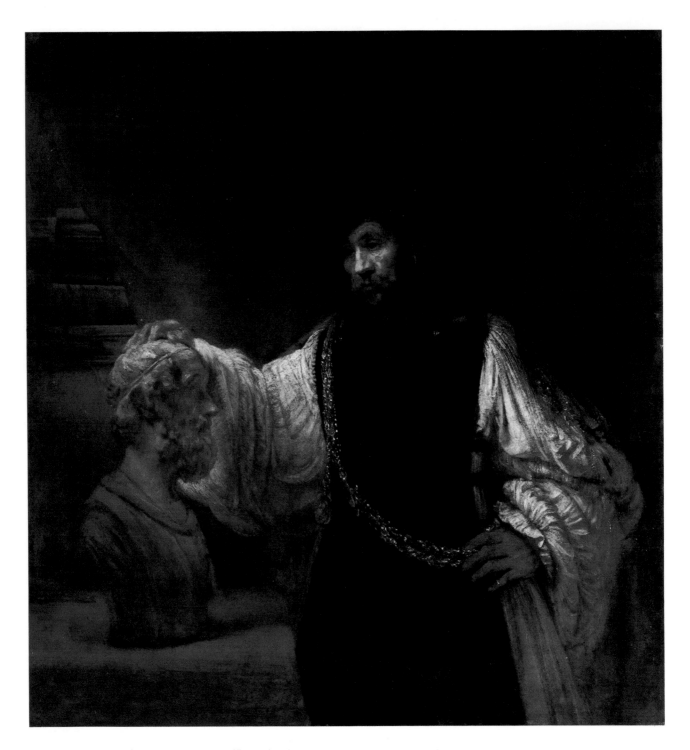

334 *Aristotle contemplating a bust of Homer*. Signed *Rembrandt f. 1653*. Canvas, 143.5 x 136.5 cm. Bredius 478. New York, Metropolitan Museum of Art.

J.A. Emmens has demonstrated some of the depths of meaning built into this highly wrought work: 'Aristotle is depicted here as the man who distilled the art of warfare from Homer's epics and passed it on with overwhelming success to the young Alexander.' The work also personifies 'Aristotle's division of human activity into the poetic, contemplative and active, [shown here] respectively by Homer, Aristotle and Alexander.'

Emmens also points out that Aristotle was the official philosopher of Dutch Calvinism.

All in all, the carefully thought-out invention betrays the hand of an author well-versed in the classics – why look further than Jan Six?

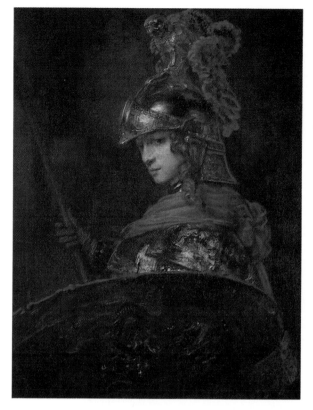

335 *Alexander the Great.* Ca. 1655. Canvas, 118 x 91.1 cm. Bredius 479. Oeiras, Portugal, Calouste Gulbenkian Foundation.

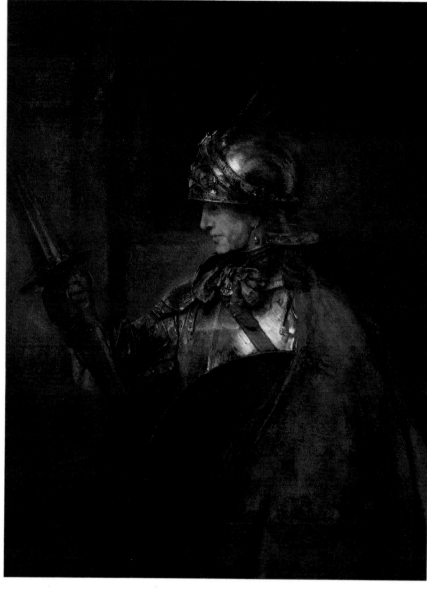

consternation in Messina. Ruffo had a letter of instruction drafted for the Italian consul in Amsterdam, Giovanni Battista Vallembrot, which paints a sad picture of Rembrandt's behaviour towards a patron who respected him. The *Alexander* was originally a mere head, Ruffo discovered, which Rembrandt had made a half-length by sewing on three extra pieces of canvas. Not one of the collector's two hundred paintings 'by the best artists of Europe' were pieced together in this way. The seams were not only unspeakably ugly, but there was every chance that the painting would eventually fall apart.

Included with the *Alexander* was a painting of *Homer* (fig. 366), half-finished, on approval, but painted on a single, sound piece of canvas. The subject rounded out the trio of ancient Greeks from the *Aristotle*. Ruffo interpreted this as a gesture on Rembrandt's part to make up for the deficiencies of the *Alexander*.

336 *Alexander the Great.* Signed *Rembrandt f. 1655.* Canvas, 137.5 x 104.4 cm., enlarged from about 115.5 x 87.5 cm. Bredius 480. Glasgow, Art Gallery and Museum.

The ambiguities surrounding the subject, date, form and function of these paintings have defeated the best efforts of generations of scholars. They combine features of the iconographies of Athena and Alexander the Great; they seem to be related to the second Ruffo commission of 1661, but one is dated 1655; the pieced-together canvas of fig. 333 suggests that it is the work Ruffo complained about, but the later pieces of canvas are from the eighteenth century. Moreover, the painting in

Glasgow seems to be the one that was in the Count Fraula auction in Brussels in 1738 as 'Rembrandt's son with helmet, shield and armour,' while Ruffo's *Alexander* remained in his family until 1743. (The Glasgow painting was later – as 'Achilles' – in the collection of Sir Joshua Reynolds, who seemed to keep getting stuck with patched-up Rembrandts; see fig. 109.) X-rays show that the Glasgow *Alexander* was painted over an oblong composition whose subject cannot be made out. Perhaps the best thing to do for the moment is to admit ignorance and await fresh evidence or inspiration.

Ruffo demanded that Rembrandt take the *Alexander* back and repair it properly or re-paint it, or else return his money. As for the *Homer*, he was willing to accept it, but wished the price to be adjusted accordingly. Instead of the five hundred guilders Rembrandt was asking, Ruffo was willing to pay two hundred and fifty, which was still four times as much, he said, as he would have to pay in Italy for a half-length.

Ruffo put his remarks into a letter for Giovanni Baptista van den Broeck, instructing him in how to negotiate on his behalf with Isaac Just on his next visit to Holland. He said that he expected no less of Just 'than what Mr. van Goor did,' which suggests that there had been difficulties with the *Aristotle* as well. Dangling a carrot in front of Rembrandt's nose, Ruffo ends by asking the artist for sketches of six more paintings for his collection.

Rembrandt's answer, written in Italian by one of the middlemen, was curt and unaccommodating. Ruffo's complaints proved, he wrote, only that Messina was lacking in people with a proper understanding of art. There was nothing wrong with the *Alexander* that proper lighting could not correct – the artist had merely noticed while painting it that it was too small. If Ruffo wanted Rembrandt to paint a new one for him, that was his business, but it would cost him six hundred guilders. And the price for *Homer* was five hundred and not a penny less. (These prices are in fact three to ten times as high as the amounts Rembrandt could command in Holland for a half-length.)

Ruffo apparently kept the *Alexander* as it was, and let Rembrandt finish the *Homer* for five hundred guilders.

Rembrandt did not pick up the hint concerning additional commissions, and abandoned Ruffo as a patron. The Sicilian remained attached to his three Rembrandts, and included them in his will among the one hundred paintings that were not to be sold by his descendants. He also ordered, in 1669, no fewer than 189 etchings by Rembrandt. They were underway from Holland when the artist died.

FROM ARISTOTLE TO PARACELSUS | Around 1650, meditating philosophers enjoyed a vogue in Rembrandt's circle. Examples are works by Salomon Koninck in Braunschweig (1649) and Ferdinand Bol in the National Gallery in London (1652). Rembrandt too made other figures like the *Aristotle*, and sold them to collectors as distinguished as Ruffo. In 1659 Archduke Leopold Wilhelm, who had been governor of the Spanish Netherlands from 1646 to 1656, owned a Rembrandt painting 'in which an astrologer sits at a table with a book in front of him; on the table are a

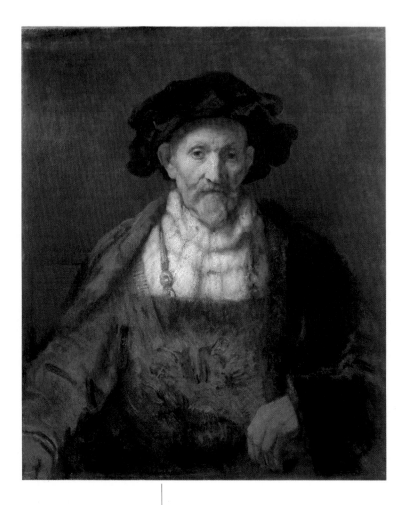

337 *An old man in fanciful costume*. Signed *Rembrandt f. 1651*. Canvas, 78.5 x 67.5 cm. Bredius 266. Chatsworth, Derbyshire, Devonshire Collection.

Could this have been Reinier van der Wolff's *Paracelsus*?

COLLECTORS OF HALF-LENGTHS

None of the paintings of old men and women from the mid-1650s have provenances going back to the seventeenth century. The fact that so many of them are in Russia merely reflects the taste of the buyers of the Hermitage collection in the late eighteenth and early nineteenth century – the works were purchased from French and German owners.

Documents between 1655 and 1700 that refer specifically to old heads (which however may be earlier paintings by Rembrandt or, of course, mistaken attributions) are, in Amsterdam: 'A portrait by Rembrandt, being an old woman' (Anna van Baserode, widow of Anthonie van Beaumont, 1670), 'An old man's head' appraised by Gerrit Uylenburgh at ten guilders (Jan de Beaumont, 1676), 'An old woman's head' and 'An old man's head' (Jan van de Cappelle, 1680), 'An old man by Rembrandt, in a gilt frame' (Gerard Brandt, 1686), 'An old man' appraised by Catharina Schaeck at two-and-a-half guilders (Hendrick Becker, Harmen's son, 1688); in Rotterdam, aside from Reinier van der Wolff's *Paracelsus*: 'An old man's head' and 'Another old man's head' (Jacob Lois, 1680); The Hague: 'A portrait of an old man' Cornelis van Werckhoven, 1656); Amersfoort: 'Portrait of an old man' (Lady Arundel, 1655); Dordrecht: 'Old woman' (Abraham Heyblom, 1685); Antwerp: 'An old woman' valued at an amazing 400 guilders (Hendrik Bartels, 1672).

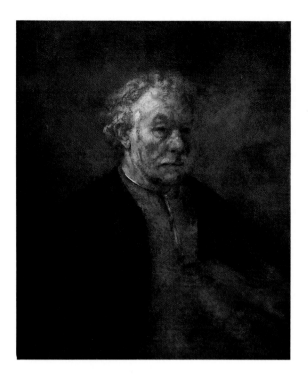

338 *An old man*. Signed *Rembrandt f. 1650*. Canvas, 80 *x* 67. 1 cm. Bredius 130. The Hague, Mauritshuis.

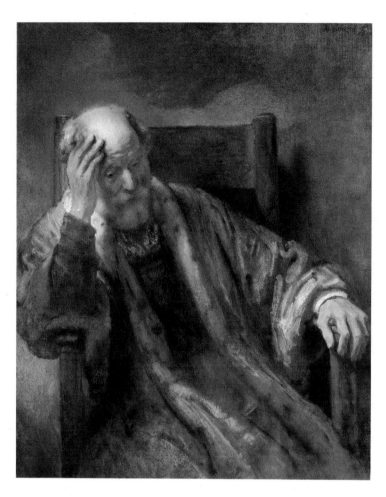

339 *An old man in an armchair*. Signed *Rembrandt f. 1652*. Signature and authorship by Rembrandt doubted by Gerson. Canvas, 111 *x* 88 cm. Bredius 267. London, National Gallery.

Despite the loose execution, there is something irresistible in picturing Rembrandt painting this old man with his hand on his head in the year he began working on *Aristotle and the bust of Homer*.

globe, a skull and other astrological instruments.'

There were half-lengths of everyday old people as well, in continuation of those from the 1640s. One such 'old man,' whose date we do not know, was in the collection of the exiled Lady Arundel in Amersfoort in 1654, along with several other paintings and a drawing by Rembrandt. This surprising connection, harking back to the days of Rembrandt the court painter, deserves to be investigated more deeply. Another English nobleman who ended his days in Holland after the fall of his king was Sir Robert Kerr, who had presented paintings by Rembrandt and Lievens to Charles I a quarter-century before. As an impoverished refugee in Amsterdam, he was painted by Lievens (see p. 318), but Rembrandt had no known contact with him.

When we discussed the works of 1625 and 1626 we observed that they were still light years away from the common conception of Rembrandtesque. Well, with the half-lengths of the 1650s we come to its hard core. Against an undefined, gloomy background we see a venerable man or woman in the garb of a past generation, gazing sadly into space, part of the face and sometimes the hands illuminated dimly.

If the *Aristotle* invites the spectator to share the thoughts of one great man about another, the nameless half-lengths draw us into the more approachable world of ordinary people, thinking, apparently, about themselves. The age of the models, their aloneness with their thoughts, and the gloom around them lends the figures a maximum of what Hoogstraten called 'soul.' Like so many Dutch *Mona Lisas*, Rembrandt's half-lengths combine the attractions of inscrutability and unassailable artistic reputation. They provide the viewer with a flatteringly fuzzy mirror for his own most profound reflections on the meaning of life, a function they have filled admirably for three centuries.

The choice of Aristotle as a subject for the Ruffo commission does not mean that Rembrandt was converted to rigorous rationalism in his middle age. In the same year as the *Aristotle*, he made, with as much loving attention, an etching of Aristotle's opposite in the world of philosophy, the medieval magician Faust, observing a genuine mystical vision (Bartsch 270). In 1655, he etched the illustrations for a cabalistic book by Menasseh ben Israel, an even further cry from Aristotle. Even the *Aristotle* itself did not succeed in projecting an image of the sharp thinker. An old fellow-professional of Rembrandt's like Guercino saw in it a practitioner of the demi-science of physiognomy.

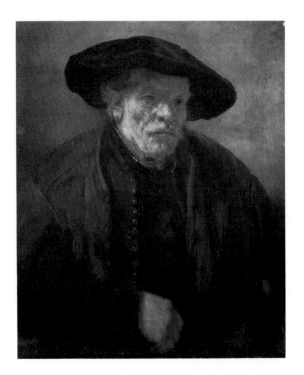

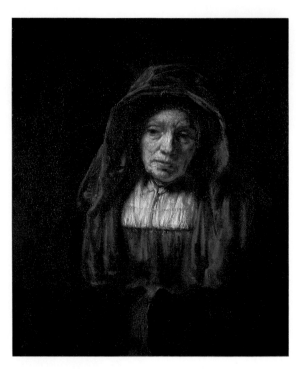

340 *An old man with a beret.* Signed *Rembrandt f. 1654.* Companion to fig. 341. Signature doubted by Gerson. Canvas, 74 x 65 cm. Bredius 131. Moscow, Pushkin Museum.

341 *An old woman with a hood.* Signed *Rembrandt f. 1654.* Companion to fig. 340. Canvas, 74 x 63 cm. Bredius 383. Moscow, Pushkin Museum.

At least one of the half-lengths conveyed a Faust-like feeling to its owner. The will of Reinier van der Wolff, the son-in-law of Dirck Pesser (fig. 144), included 'A Paracelsus, a half-length by Rembrandt,' valued at two hundred guilders. Theophrastus Bombasticus Paracelsus was a German alchemist, who, like Faust, gave his middle name to a word in many languages. In 1661, in van der Wolff's circle in Rotterdam, a translation came out of the anti-rationalist tract *On the uncertainty and vanity of the sciences and arts* by the German occult philosopher Cornelis Agrippa von Nettesheim.

Rembrandt's evocations of ancient wisdom in the half-lengths of the fifties found fertile ground in the imaginations of some.

BACKLASH | It was inevitable that this group of paintings, with its strong emotional appeal to collectors of a sentimental type, should have evoked hostile reactions from protagonists of clarity and transparency in art. J.A. Emmens has written a brilliant reconstruction of the development of classicist criticism in the arts, based on demands for clear outlines, good drawing, historical accuracy and intellectual consistency. He showed how the application of these standards formed the basis for a negative judgment of Rembrandt.

Rembrandt was certainly aware of the evolution of this approach to art, which began to make itself felt in Holland by 1628, when a young artist named Jacques de Ville, later the son-in-law of Daniel Mostart, published a small treatise in Amsterdam urging the artist to adopt the same principles of classical purity as the architect. The discussion cannot be followed closely in Holland on account of the lack of books on painting. In Italy, where writing on painting was a lively branch of literature, we see how this view took shape. The ancient poet Horace, in his writings on his own art, provided a model, it was felt, for the painter as well: the essential thing was to develop and exercise one's critical judgment and not follow nature slavishly. Learning, decorum and a proper balance between description and invention were called for. The *bête noire* of the classicists was Caravaggio, who excelled in lifelike paintings of single figures but sinned wilfully against decorum and seldom bothered to think out a composition in all its details.

In Holland, the Horatian attitude was formulated by Vondel in 1650 in his *Aenleidinge ter Nederduitsche dichtkunst* (Prolegomena to Dutch poetry), and around that time painters too began to make a conscious choice between two kinds of style. Roughly, there was naturalism with a heavy touch versus classicism with a light one. Whether he deserved it or not, Rembrandt became the symbol of naturalism.

Houbraken tells it very matter-of-factly in his biography of Jan de Baen (1633-1702). At the age of eighteen, in 1651, 'he had to form for himself a conception of a kind of painting which was praiseworthy to abide by. The painting of Anthony van Dyck stood in high regard, and that of Rembrandt too had many followers. At this parting of the ways he stood long undecided, but in the end chose as his object the style of the former, which he considered to be more enduring.'

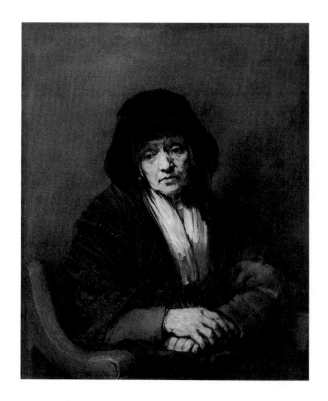

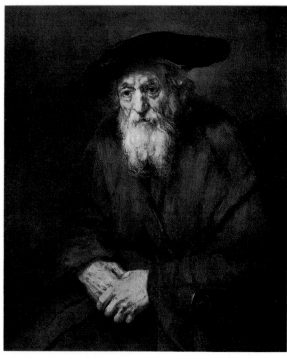

342 *An old woman in an armchair*. Signed *Rembrandt f. 1654*. Companion to fig. 343? Signature and authorship by Rembrandt doubted by Gerson. Canvas, 109 x 84.5 cm. Enlarged on sides and bottom from 89 x 76.5 cm. Bredius 381. Leningrad, Hermitage.

343 *An old man in an armchair*. Signed *Rembrandt f. 1654*. Companion to fig. 342? Canvas, 109 x 84.8 cm. Enlarged on sides and bottom from 89 x 76.5 cm. Bredius 270. Leningrad, Hermitage.

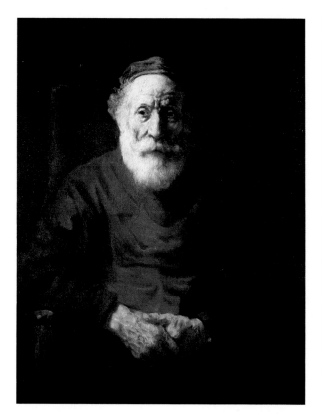

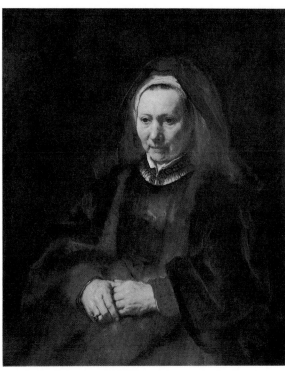

344 *An old man in an armchair*. Signed *Rembrandt f*. Ca. 1654. Canvas, 108 x 86 cm. Bredius 274. Leningrad, Hermitage.

345 *An old woman seated*. Signed *Rembrandt 165[.]*. Ca. 1655. Canvas, 82 x 72 cm. Bredius 371. Moscow, Pushkin Museum.

While it is true that Rembrandt had given occasion in the 1630s and '40s for complaints from classically minded colleagues – lack of decorum here, unclear outlines and too little light there – his work of those decades left open the possibility of a move towards the middle. In the half-lengths of the 1650s, however, he executed works that were practically tailored to the classicists' idea of misguided art.

The first frontal attack on record was directed against the first work in the new genre, the *Aristotle* itself. It was written, appropriately enough, in Rome, the world headquarters of classicism, by the Flemish painter and art dealer Abraham Brueghel in a letter of January 24, 1670 to Antonio Ruffo.

'From your letter of last December 24th I understand that you have ordered a number of half-lengths from the best painters of Italy and that none of them can stand up to that of Rembrandt. I quite agree with you, but one should also take into consideration the fact that great painters do not like to spend their time on such bagatelles as draped half-lengths with only the tip of the nose illuminated, the rest being left so dark that one cannot identify the source of light. What a great painter will attack seriously is a beautiful nude in which he can display his knowledge of drawing. This is in contrast to the inexpert painters who try to hide their models with obscure and cumbersome garments. Painters of this kind fudge their outlines. What I want to say is that it is not the business of great men to concern themselves with the kind of bagatelles that anyone can make. I beg you to forgive me for speaking so freely, but my love for the art of painting obliges me to do so.'

The independent Ruffo was not impressed by these clichés, from a man who may not ever have seen a painting by Rembrandt, but dozens of collectors all over Europe, who had been hearing the same tune from other dealers for a long time, undoubtedly were. It must be admitted that by adopting the dimly lit, heavily clothed half-lengths at just that moment, Rembrandt walked straight into the line of fire. For several decades, a new consensus had been finding support among larger and larger circles of patrons and artists. What's more, the consensus was taking form in new institutions – confreries, brotherhoods, academies – that were acquiring the support of governments and kings.

The movement received a mighty stimulus in 1648 with the foundation in France of the Académie, a royal institution for the arts. To many artists, dealers and collectors, it must have seemed that the art of painting stood on the threshhold of a new age.

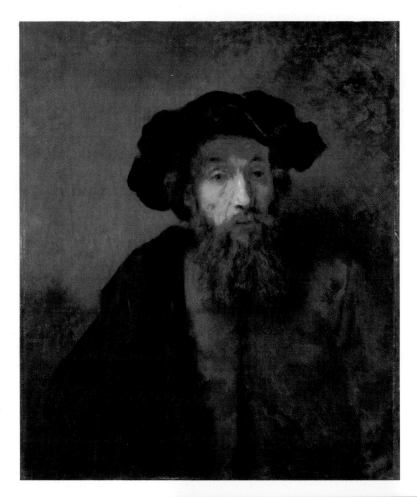

346 *A bearded man in a cap.* Signed *Rembrandt f. 165[.].* Ca. 1655. Canvas, 78 x 66.7 cm. Bredius 283. London, National Gallery.

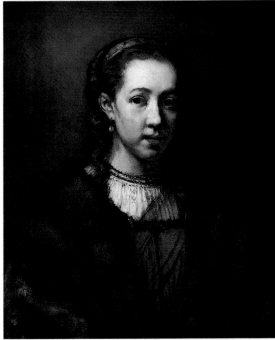

347 *A young woman.* Ca. 1655. Canvas , 65.5 x 54 cm. Bredius 112. Los Angeles, County Museum of Art (on loan from Lucille Ellis Simon).

Universally acknowledged standards of excellence in art suddenly seemed to be within reach, standards that would greatly simplify the evaluation of art, and raise painting and its criticism to the level of a science. The status and saleability of painting could only profit from such a development, while the system of patronage through connections could be replaced by reward for merit.

The Amsterdam Brotherhood of Painters was symptomatic of this development in that it distinguished itself from the old guild and laid claim for painting to have the intellectual status of poetry. The academic movement wished to sever the association of painting with the crafts and to establish the rule of science and order in art, rather than the uncontrollable qualities of inborn talent, dexterity and cleverness for which artists had formerly earned their highest praise.

REMBRANDT AT THE CROSSROADS | Whatever difficulties Rembrandt may have encountered in 1642, and despite the loss of his early patrons at court and among the Amsterdam regents, he was still one of the most prominent artists of Amsterdam, and the eyes of many must have been on him to see which way he would tilt.

One of those most interested in his behaviour

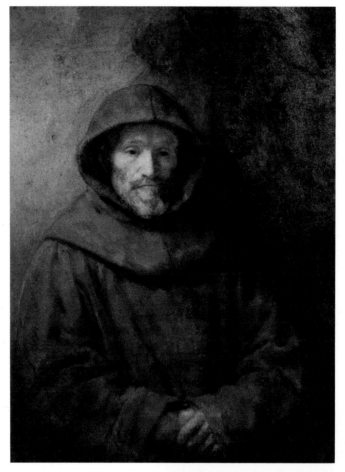

349 *A Franciscan monk.* Signed *Rembrandt f. 165*[.]. Ca. 1659. Canvas, 89 x 66.5 cm. Bredius 308. London, National Gallery.

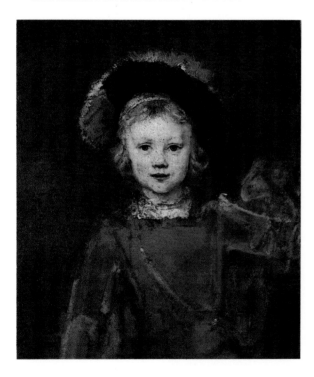

348 *Boy in fantasy costume.* Ca. 1660. Canvas, 64.8 x 55.9 cm. Bredius 119. Pasadena, California, The Norton Simon Foundation.

350 *Man with a beard.* Ca. 1657. Canvas, 70.5 x 58 cm. Bredius 284. Berlin-Dahlem, Gemäldegalerie.

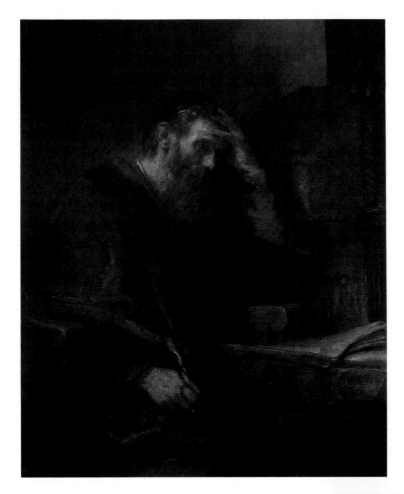

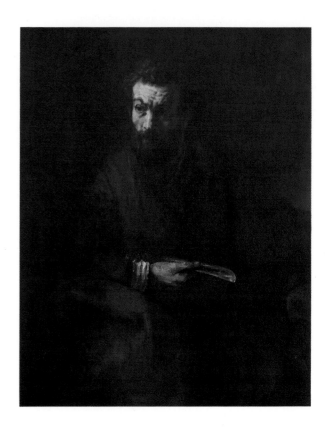

351 *The apostle Paul at his desk*. Signed *Rembrandt f.* Ca. 1657. Canvas, 129 x 102 cm. Bredius 612. Washington, D.C., National Gallery of Art.

352 *The apostle Bartholomeus*. Signed *Rembrandt f. 1657*. Canvas, 122.7 x 99.5 cm. Bredius 613. San Diego, California, Timken Art Gallery.

353 *The apostle Paul*. Signed *Rembrandt 165[9?]*. Canvas, 102 x 85.5 cm. Bredius 297. London, National Gallery.

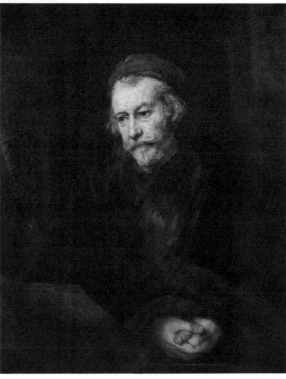

354 *The evangelist Matthew inspired by the angel*. Signed *Rembrandt f. 1661*. Canvas, 96 x 81 cm. Bredius 614. Paris, Musée du Louvre.

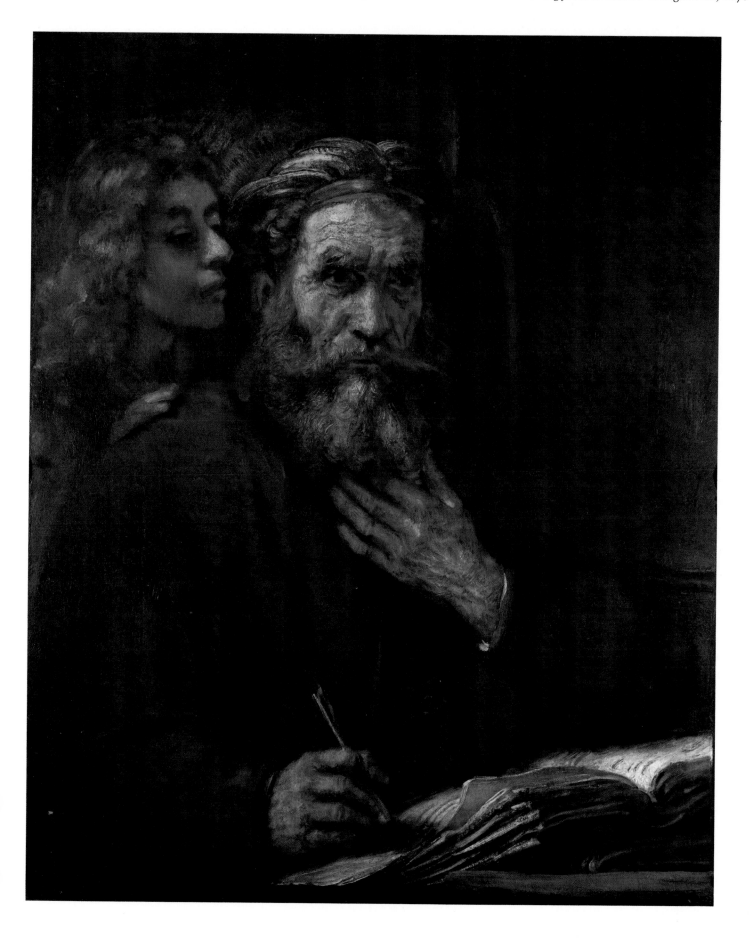

must have been Jan Six. Six was praised by Jan de Bisschop as the one who had inspired the principles of classicism in him, and he dedicated to him the first volume of his prints after antique statues, *Paradigmata* (1669; the other volumes, we remember, were dedicated to Constantijn Huygens the younger and Joannes Wtenbogaert). However, Six was not a dogmatic patron, and in 1652 he bought from Rembrandt the *St. John preaching*, defecating dog and all.

In the portrait of Six (fig. 301), as opposed to that of say Bruyningh (fig. 304), Rembrandt took account of the sitter's preference for clarity of structure and colour. We can say the same of the three first paintings of Hendrickje, of *Jacob blessing the sons of Joseph* and of several portraits of the 1650s. However balanced these works may be, though, their effect was overshadowed by the half-lengths, which are veritable anti-classicist slogans, and were seen that way. Viewed from another angle, which casts a fascinating light on style as an aspect of institutional history, the competition between Brotherhood and guild represented a clash between classicism and naturalism. Rembrandt showed himself, with his half-lengths, to be a man of the guild.

REMBRANDT THE HERETIC | Later developments give some support to this view. The Brotherhood, as we have seen, was too large and formless to serve its intended purpose, and it collapsed. The ideological core of the classicist movement did not take new institutional shape until 1669, with the foundation of a small society that called itself Nil Volentibus Arduum (Where There's A Will There's A Way). One of the pillars of this new group was Andries Pels (1631-1681), who translated Horace into Dutch in 1677 and in 1681 brought out a manifesto for the movement under the title *Gebruik en misbruik des toneels* (Use and abuse of the stage). Although writing a quarter-century after the mid-50s, Pels's polemic still reflected the events of that time, which must have left him with an indelibly bitter aftertaste. His main target was Jan Vos, whose 'chaotic plays' are a disgrace to the theatre, 'for the art of the stage has her rules and her foundations just as architecture does...' There follows:

'The great Rembrandt, who looked for inspiration
Not to Titian or van Dyck, Michelangelo or
 Raphael,
But chose instead the path of sovereign error,
To become the first heretic of painting
And catch many a beginner on his hook.'

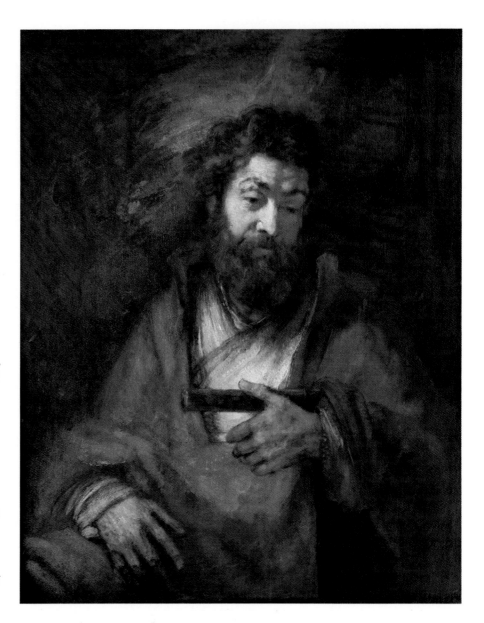

Rembrandt, in other words, was the Jan Vos of painting, seeking effect above all, resisting the application of Horatian principles to art and, we read between the lines, retarding the academic movement in Holland for decades by lending the authority of his reputation to outdated styles and institutions.

We wonder, more than ever, what happened in autumn of 1654, when Jan Vos put Rembrandt at the head of the Amsterdam immortals, and the Brotherhood held its last supper.

MARKETING THE HALF-LENGTHS | Rembrandt's production of half-lengths in the 1650s and '60s was not steady. The great majority were made in three years only, 1654, 1655 and 1661. The works of 1654 and 1655 seem to have found their way into collections all over the Netherlands. I assume most of them to have been sold at the auction that Rembrandt held in 1655, since there are few entries

355 *The apostle Simon.* Signed *Rembrandt f. 1661.* Canvas, 98.3 x 79 cm. Bredius-Gerson 616A. Zurich, Kunsthaus (Ruzicka Foundation).

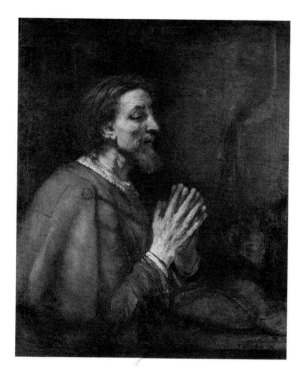

356 *The apostle James.*
Signed *Rembrandt f. 1661.*
Canvas, 90 x 78 cm. Bredius
617. Jerusalem, Israel
Museum (on loan).

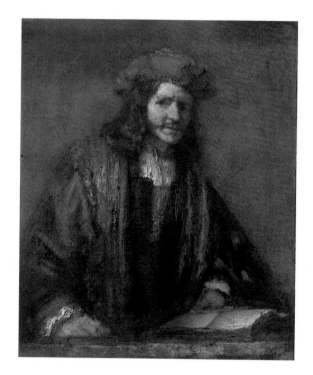

357 *An evangelist (?)*
writing. Ca. 1661. Canvas, 102
x 80 cm. Bredius 618.
Rotterdam, Museum
Boymans-van Beuningen.

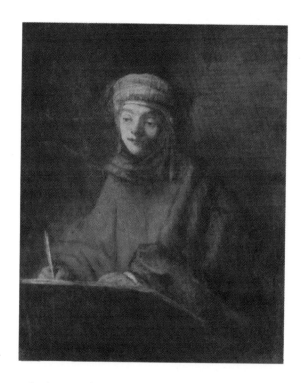

358 *An evangelist writing.*
Signed *Rembrandt f. 166*[.].
Ca. 1661. Canvas, 102.2 x 83.8
cm. Bredius 619. Boston,
Museum of Fine Arts.

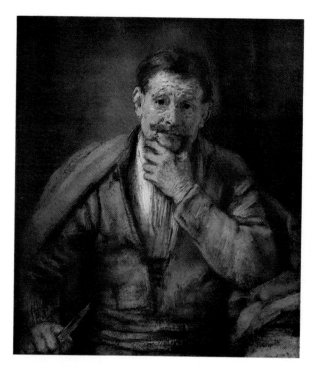

359 *The apostle*
Bartholomew. Signed
Rembrandt f. 1661. Canvas,
87.5 x 75 cm. Bredius 615.
Malibu, The J. Paul Getty
Museum.

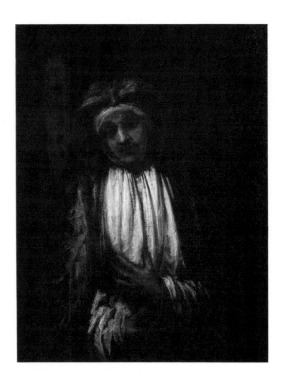

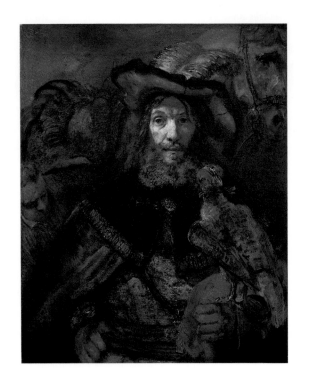

360 *The virgin Mary*. Signed
Rembrandt f. 1661. Canvas,
107 x 81 cm. Bredius 397.
Epinal, France, Musée des
Vosges.

361 *Man with a falcon*. Ca.
1661. Canvas, 98 x 79 cm.
Bredius 319. Gothenburg,
Sweden, Konstmuseum.

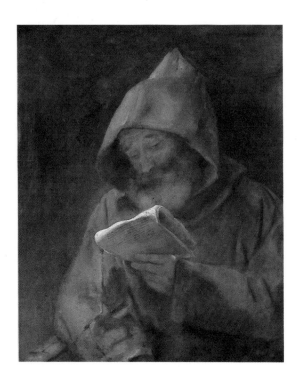

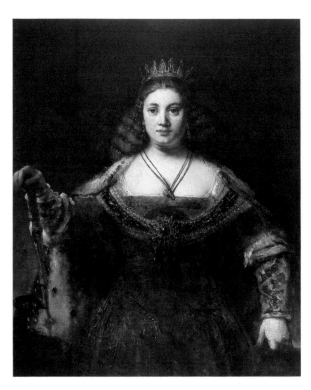

362 *A Capuchin monk
reading*. Signed *Rembrandt f.
1661*. Canvas, 82 x 66 cm.
Bredius 307. Helsinki,
Sinebrychoff Art Museum.

363 *Juno*. Begun about
1661, finished after summer
1665. Canvas, 127 x 107.5 cm.
Bredius-Gerson 639. Los
Angeles, The Armand
Hammer Foundation.

The painting about which
Harmen Becker complained
in 1665 that it was not yet
finished. Apparently it was
paid for by then, otherwise
Becker would not have been
able to make such an issue out
of it.
 The painting bears a closer
resemblance to a
sixteenth-century *St.
Catherine enthroned* after
Quentin Massys than to any of
the sources yet cited.
(Vienna, Kunsthistorisches
Museum. Friedländer 73.) I
suspect that Becker owned a
painting like the Massys and
commissioned Rembrandt to
do a modernized version of it.

in the 1656 inventory that could cover them.

The half-lengths of 1661 (to which we must add figs. 322 and 420) show a totally different pattern of distribution. Most have identifiable attributes, or give the appearance of being saints or apostles – and there are virtually no references to paintings of this type in Dutch inventories between 1661 and the end of the century. Exceptions are Harmen Becker's *Juno* and *Pallas* (1675), Volckwijn Momma's 'Philosopher' (1679 – although it sounds more like a painting of the early 1650s); Steffen Lindeman's 'Head of a man with a sabre … 20 guilders' (1682), Nicolaes Rosendael's 'half-length' (1687 – this could, however, be anything) and the Delft clergyman Gerrit van Heusden's 'painting of St. Paul' (1667).

The seventeenth-century histories of most of the paintings is unknown. There were the two half-lengths for Ruffo, one for the Medici and one whose first known owner was Prince Trivulzio. The others all showed up in French, German and English collections in the eighteenth and nineteenth centuries.

The only transaction of which we have the details was the sale in 1661 of the *Alexander* and *Homer* to Ruffo, who offered to buy a lot more. The agent was Isaac Just, a relative of Gerrit Uylenburgh's wife-to-be, Elizabeth Just. Can this be an important clue? When Uylenburgh went bankrupt in 1675 he owned three paintings by Rembrandt: 'A Jewess' (150 guilders), a 'small Danae' (48 guilders) and 'a woman's portrait, begun.' Quite a few of the names of his creditors also occur in the Rembrandt documents or are closely related to patrons of Rembrandt: Jan Six, Pieter Six, Gijsbert van Goor, Pieter Schaep, Simonsz., Willem Schellinks, Harmen Becker, Hendrick Scholten, Herman van Zwol. We do not even have to know that in the 1660s Rembrandt and Gerrit lived a block away from each other to realize that they moved in the same circles and did business with each other.

These facts allow us to sketch lightly the following picture of how Rembrandt sold his half-lengths. At the top of the range were the few 'philosophers' of the early 1650s, which found aristocratic buyers in Sicily and Brussels and distinguished collectors in Holland. In 1654 and 1655, Rembrandt made his 'everyman's philosophers' for the open market, dispersing most of those which had not yet found a buyer at his auction in December 1655. From July 1656 through December 1660, while he was under the jurisdiction of the Insolvency Court, he did little except on commission, but in 1661, as soon as the 'firm' was established, his production rose dramatically, to the highest level since 1634. As

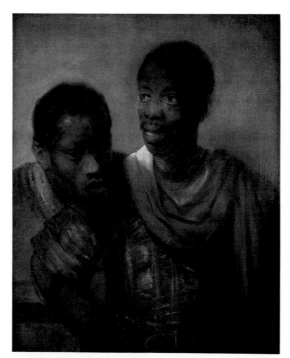

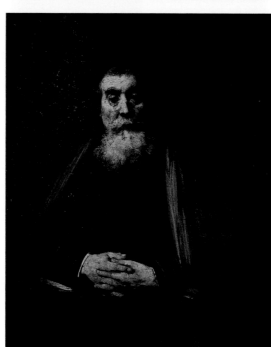

364 *An old man in an armchair.* Signed *Rembrandt f. 166[.].* Ca. 1661. Canvas, 104.7 x 86 cm. Bredius 285. Florence, Uffizi.

The painting was in the Medici collection in Florence by the reign of Great Prince Ferdinando di Cosimo, who died in 1713. The interest of the Medicis in Rembrandt dates back to at least as early as 1669, when Cosimo de Medici visited the artist in Amsterdam.

365 *Two black Africans.* Signed *Rembrandt f. 1661.* The reliability of the signature is questioned by Tóth-Ubbens. Canvas, 77.8 x 64.5 cm. Bredius 310. The Hague, Mauritshuis.

The Dutch ethnologist W.C. Dusée has identified the figure on the right as a north-west African, from an area of Morocco whose inhabitants were kidnapped by the Dutch, not for the slave trade, but to be exchanged for Dutchmen who had been taken prisoner by Africans.

However, the story was going around Amsterdam that Rembrandt painted at least one of the heads not from life but from the cast head he owned. In 1711 the German art-lover Zacharias Conrad von Uffenbach wrote of a sculptor he visited in Amsterdam: 'He owned a Moor's head that Rembrandt is said to have depicted from life.'

If we dismiss the date on the painting, which Magda Tóth-Ubbens, in *Rembrandt in the Mauritshuis*, says was added later, we can identify the painting as the 'Two Moors, in a painting by Rembrandt' in the artist's inventory. There is in any case firm evidence that Rembrandt painted 'A Moor' by 1657, when a painting of that description was appraised in the de Renialme estate at twelve guilders.

The Mauritshuis paintings may well be 'The Moors by Rembrandt' that was sold at an anonymous auction in Amsterdam on May 16, 1695 for 46 guilders.

Tóth-Ubbens connects the costume with stage dress, and points out that blacks appeared in plays on the Amsterdam stage in the 1650s.

THE NEGLECTED ARTIST

In 1661, when Rembrandt sent his *Alexander* to Antonio Ruffo, he included in the shipment this *Homer*, half-finished, on approval. The painting was in the same format as the *Alexander* and the earlier *Aristotle*. Ruffo sent it back to be completed, offering two hundred and fifty guilders for it, half of what Rembrandt was asking. The artist stuck to his price, and got it. In 1662 the canvas was returned to him. He completed it in 1663 and it arrived in Messina for the second time on May 20, 1664.

The painting probably remained in the hands of Ruffo's descendants until the second half of the eighteenth century. At one point, perhaps during the earthquake in Messina in 1783, it was damaged by fire, and subsequently cut down to its present form. A drawing in Stockholm gives us an idea of the original shape and composition of the work, which included a scribe in an architectural setting at the right and a monumental pilaster at the left (fig. 366a).

The background suggests that the scene depicted is Homer before the town council of Cumae. The story is re-told by Hoogstraten in his chapter 'How an artist should conduct himself when overpowered by fortune.' The chapter begins with an anecdote concerning a painter who, after producing good work for a certain township, was allowed to die in the poorhouse – a pure tale of the neglected artist, a type of character often thought wrongly to be a nineteenth-century creation. Hoogstraten goes on: 'But arrogance of this kind has shamed many a whole city. For when the great poet Melesigenes, who has since been known to all the world as Homer, came to sing his divine poems in Cumae, and noticed that they pleased several amateurs among the inhabitants, he made them the following proposition. If they would support him, he would make the city of Cumae famous. All those who heard this were quite enthusiastic about it. They praised his initiative and promised to speak on his behalf and help him all they could if he would

put his request to the town council.' His champions almost had their way, until 'one of the [councilmen,] to the undying shame of Cumae, opposed them, saying that if they began supporting Homers, i.e. the blind, they would get a lot more of them, without deriving any advantage in the least.' Applying the moral to present-day painters, Hoogstraten lays a bit of the blame at the feet of the artists themselves: 'Excellent painters when they associate with bestial people sometimes receive the same kind of treatment.'

The arguments of the Dutch artists fighting in the 1980s for continued government support would not have seemed strange to Hoogstraten, Rembrandt or Homer, nor the arguments of the politicians of today to those of the seventeenth century or ancient Greece. The welfare-state rhetoric of the present debate is only a contemporary version of the perennial tug-of-war between artists and their governmental patrons.

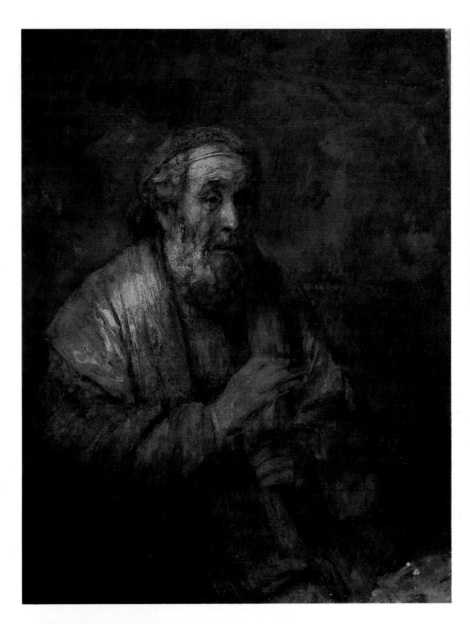

366 *Homer dictating to a scribe*. Signed [Rembr]*andt f. 1663*. Canvas, 108 x 82.4 cm. Fragment of a painting that may have been as large as 200 x 150 cm. Bredius 483. The Hague, Mauritshuis.

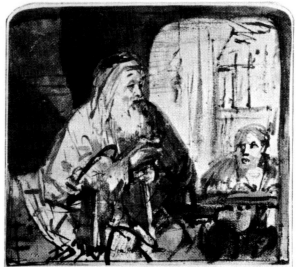

366a *Homer in the town hall of Cumae?* Ca. 1661. Pen and bistre in Indian ink, washed, 14.5 x 16.7 cm. Benesch 1066. Stockholm, Nationalmuseum.

367 *A bearded man.* Signed *Rembrandt f. 1661.* Canvas, 71 x 61 cm. Bredius 309. Leningrad, Hermitage.

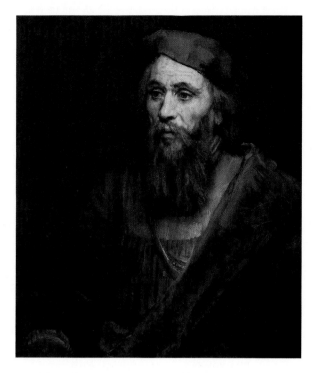

there were still claims against him, he avoided selling these works in Holland. In March 1659, he had promised to deliver to Lodewijk van Ludick 1200 guilders worth of paintings within three years. He still had not sent him a single work by 1661, nor did any of the new half-lengths go to him. Those that can be traced went to Italy through Isaac Just. In view of the fact that Gerrit Uylenburgh was developing into an important dealer with Italy, Germany, England and France, it seems not unlikely that he dealt in the sales of many of these works to buyers abroad, keeping Lodewijk van Ludick in ignorance of the transactions. (For the sale of a self-portrait from 1660 to France, see p. 347.)

Gerrit remained with his father for as long as old Hendrick lived. They had moved from the Breestraat to the Dam in 1647, in 1654 from there to the Leliegracht (this is a hitherto unpublished discovery by Dudok van Heel), and from 1658 to 1660 they lived in a house at the corner of the Prinsengracht and the Westermarkt. In 1660 they moved to the Lauriergracht, one canal down from the Rozengracht, where Rembrandt moved that year to a house 'across from the Maze,' an amusement park. Hendrick died in March 1661.

It was as if the old Breestraat was reconstituting itself on the other side of town. Govert Flinck had been living in a grand house on the Lauriergracht, with a splendid show-room for his art, since 1644. With him from 1657 to 1660 lived Rembrandt's old pupil Jurriaen Ovens, who was able to pick up some of Flinck's unfinished commissions after his death. (In 1651 Ovens had the honour of painting the portraits of Jacques Specx and his wife.)

After Flinck's death, Gerrit Uylenburgh moved into his house. (Flinck's career in Amsterdam was sandwiched between his residence in Hendrick Uylenburgh's house, and Gerrit Uylenburgh's residence in his.) Other painters who lived on the Lauriergracht were Isaac Luttichuys (1615-1673), Isaac Isaacksz. (next door to Samuel Pits van der Straaten; see caption to fig. 122), Bartholomeus Breenbergh (1598-1657), Lucas Luce (see p. 217) and Melchior Hondecoeter (1625-1695). It was also the home of the Bohemian Elias Noski (d. 1668), an engraver of calligraphic texts in stone who worked for the town hall and for Johan Maurits van Nassau. The most prominent inhabitant of the Lauriergracht, however, who made the street famous throughout the city, was Joan Huydecoper II (1625-1704), the equally grasping but less capable son of Joan I.

We know of no other contact between Rembrandt and Hendrick Uylenburgh from 1642 to 1661 except for documents related to Titus's inheritance. Gerrit seems not to have concerned himself with those ancient issues, and to have had no difficulty in working with Rembrandt after, and perhaps even before, he took over his father's business. One thing Gerrit did not take over was Hendrick's dour religion. By 1666, when he married, he had joined the Reformed Church.

The first payments for paintings in the new town hall were a tribute to Rembrandt the teacher and a slap in the face for the working artist:

In the chamber of the burgomasters, above the mantelpiece, by Jan Lievens, cost 1500 guilders.
In the burgomasters' room, above the mantelpiece, towards their chamber, done by Ferdinand Bol, 1500 guilders.
In the burgomasters' room, above the mantelpiece, on the side of treasury, by Govert Flinck, 1500 guilders.
In the treasury, above the mantelpiece, by Stockade, 600 guilders.

Flinck's position we understand, but Bol? In 1655, the year the commissions were probably given, Bol was not only foreman of the guild of St. Luke, but the influence of his protectors, the Trips, reached new heights with the marriage, on February 15, of Jacob Trip's sister-in-law Wendela Bicker with the grand pensionary Jan de Witt, then the most powerful man in the country.

Flinck and Bol, then. But *Lievens*? What in the world was he doing in Amsterdam, upstaging Rembrandt? He had been living there, in fact, since 1644, after going broke in Antwerp the year before. Once he made the move to Amsterdam, he quickly succeeded in acquiring the patronage of the Trips, Joannes Wtenbogaert, Vondel, the Great Elector of Brandenburg, Joan Huydecoper, Andries de Graeff – in short, a compound of the patronage of Rembrandt, Flinck and Bol all together. When Cornelis Witsen's son Jonas wanted drawing lessons, it was to Lievens that he went. Moreover, as the widower of the daughter of an Antwerp sculptor, he must have had special ties to the very highly regarded artist who had been brought from Antwerp to do the sculptural decoration of the new town hall, Artus Quellinus. Nicolaes de Helt Stockade too owed his commission to an old tie with Quellinus,

whose brother Erasmus Quellinus II contributed frescoed ceilings to the decoration. Lievens had not lost any of his old self-confidence. In 1652, after being painted by him, Robert Kerr wrote to his son that the artist 'is the better because he has so high a conceit of himself that he thinks there is none to be compared with him in all Germany, Holland nor the rest of the seventeen Provinces.'

The commissions for the other paintings to be hung in the various rooms went to Jan van Bronkhorst, Thomas de Keyser, Willem Strijker, Cornelis Holsteyn and Jacques Jordaens. The subjects were taken from the Old Testament and Roman history, and had a heavy bearing on municipal finances, politics, and administration of justice. The story of these commissions has never been re-constructed, and behind the documents we sense a 'swarming of painters and poets' on a scale worthy of the high stakes.

The real plum, the commission for the vast canvases to be placed in the galleries, was awarded on November 28, 1659 to 'Govert Flinck, who contracted to paint twelve paintings for the gallery of the town hall, two per year, for one thousand guilders apiece.' The subjects for the large works, in a part of the building open to visitors, were more national than municipal. They were derived from the very cycle of paintings of the Batavian revolt by Otto van Veen that Pieter van Veen had sold in 1612 to the States General in 1612 (p. 23).

Flinck had designed most of the decorations for the state visits to Amsterdam of the Brandenburgs and Oranges a few months earlier. That year, his protectors Cornelis de Graeff and Joan Huydecoper were both burgomaster together, and his position seemed unassailable. Less than two months after November 1659, however, there was another 'Battle between Death and Nature,' and this one ended not with a Triumph of Painting but with the death of the painter.

At first Jan Vos and the Hinlopen clique, if our

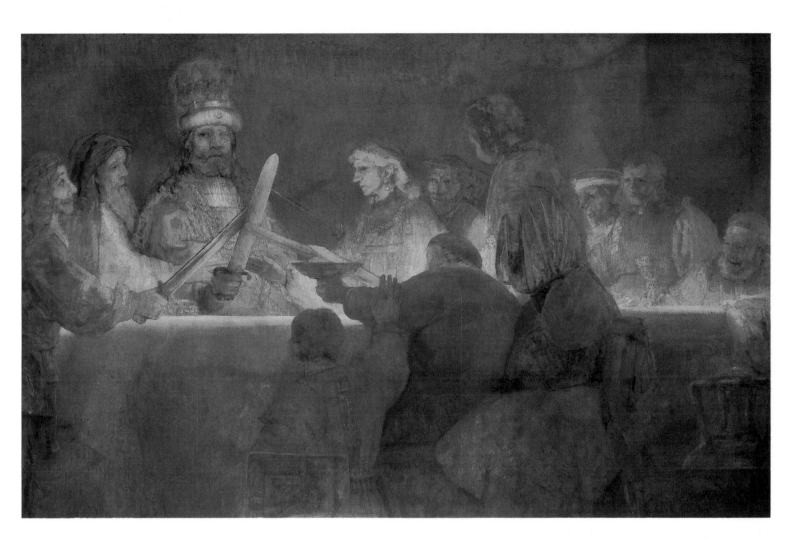

368 *The conspiracy of Claudius Civilis: the oath*. Ca. 1661-1662. Canvas, 196 *x* 309 cm. Cut down from about 600 *x* 550 cm., rounded at the top. Bredius 482. Stockholm, Nationalmuseum.

The paintings for the gallery of the town hall depicted scenes from the uprising of the early inhabitants of Holland, the Batavians, against the Romans in the first century. The scene that Rembrandt was asked to paint was described in 1662, in the *Beschrijvinge der wijdt vermaarde koop-stadt Amstelredam* (Description of the widely celebrated merchant city Amsterdam) by Melchior Fokkens, as the first scene in the cycle.

'Here [the story] begins [with] the exhortation of the leader, Claudius Civilis, who convoked all the great and noble [men] from the cream of the aristocracy, and those most outstanding in the community at the Schakerbos, where a large banquet was tendered.' The chieftain let the men get drunk, and then spoke to them in ringing words, appealing to their manhood, bravery and love of freedom, calling on them to rise against the Romans. For good measure, he added that the Roman camps were full of rich booty and were guarded just then only by a handful of old men. 'After he had thus spoken, all those attending the banquet, who were the bravest, heard his proposal with great satisfaction and approval. Civilis made them all swear an oath, scorning those who displayed weakness. Then a large golden goblet filled with wine was passed around, and all of them promised to follow him wherever he would lead them... And this is shown in the first painting, painted by Rembrandt.'

The painting was however removed by the end of that year, and Rembrandt was never paid for it.

368a Drawing for fig. 368. Late 1661. Pen and wash drawing, 19.6 *x* 18 cm. Benesch 1061. Munich, Graphische Sammlung.

Sketched on the back of an invitation to a funeral that took place on October 25, 1661. I take it to be Rembrandt's first sketch for the majestic Claudius Civilis, the largest work he ever painted.

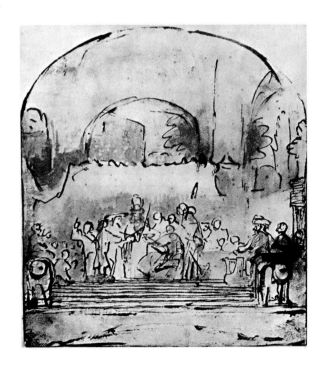

reading of the evidence is correct, hoped that the entire commission could go to Rembrandt. Flinck had died on Candlemas 1660, and a new foursome was to decide on the recipient of the commission. One of the new men, Cornelis van Vlooswijk, had helped Rembrandt before, and could probably be counted on to do so again. Andries de Graeff was up to his neck in the van Papenbroeck affair on the side of Willem Schrijver, and could probably be brought to forget his old grudge against Rembrandt for once. The third man, Cornelis de Vlaming van Oudtshoorn, was a neutral. But the presiding burgomaster was Joan Huydecoper, and it was his vote that counted. Dividing in order to rule, he allowed Andries de Graeff to dispense two commissions, to Lievens and Jordaens, and held back for the moment on the rest.

The crew for 1661 looked a lot better for Rembrandt. Presiding burgomaster was Cornelis van Vlooswijck, and he was backed up by Gerard Schaep, Simonsz. It was the first year that a Trip had been nominated for alderman, and although he did not make it, Jan Jacobsz. Hinlopen did. The third burgomaster, however, was Jan van de Poll, the protector of Johannes Spilbergen and probably of Jurriaen Ovens, and the fourth Cornelis de Graeff, who could be counted on to block any favours to a protégé of Willem Schrijver. Nothing happened until October, when the air cleared and Rembrandt finally got his one commission. His sketch for *The conspiracy of Claudius Civilis* (fig. 368) is drawn on the back of an invitation to a funeral (that of Rebecca Vos), on October 25. In the same week two other deaths occurred which opened Rembrandt's path to the town hall: on October 17th Willem Schrijver died, and on October 26th, Joan Huydecoper. The one freed Rembrandt of the embarrassing protection of a political nonentity, the other of an enemy who had been blocking his way for a long time. Van Vlooswijck was free to give Rembrandt at least one commission.

By August 1662 the painting was delivered, and Rembrandt assigned in advance a quarter of what he was to receive for it to Lodewijk van Ludick. It was van Ludick's bad luck, though, that Rembrandt never received anything at all for the *Claudius Civilis* except the canvas it was painted on. Sometime before the end of the year it was taken off the wall and returned to him.

While the preceding incidents have fitted well into the chronology of political events in Amsterdam, I can find no change in the second half of 1662 to account for this dramatic turn of events. The terms in which the matter is usually discussed – the bourgeois, lightly classical taste of the burgomasters versus the timeless talent of Rembrandt – do not get us very far in a situation where all the participants, painters as well as patrons, were concerned with power and glory, and the word style never crossed anyone's lips. No one in Amsterdam really thought that Rembrandt was a less suitable candidate than Willem Strijker (whose brother was town secretary) or Jurriaen Ovens.

What I suspect is that the burgomasters of 1662, rather than insulting their predecessors by rescinding Rembrandt's commission as soon as they were elected, allowed him to finish the painting first, install it, and then rejected it on some pretext or other – perhaps even a stylistic one. The two burgomasters that year with an interest in the affair were Cornelis de Graeff and, for his third term, Cornelis Witsen. Since de Graeff had acquiesced the year before in giving the commission to Rembrandt, the one who must have pulled the rug from under him was Witsen, the same man who had forced the sale of Rembrandt's house the previous time he was elected burgomaster.

To add insult to injury, the spot vacated by Rembrandt's canvas was filled by an old design begun by Flinck before his death, and which was now finished, in four days, by Jurriaen Ovens, for a fee of forty-eight guilders.

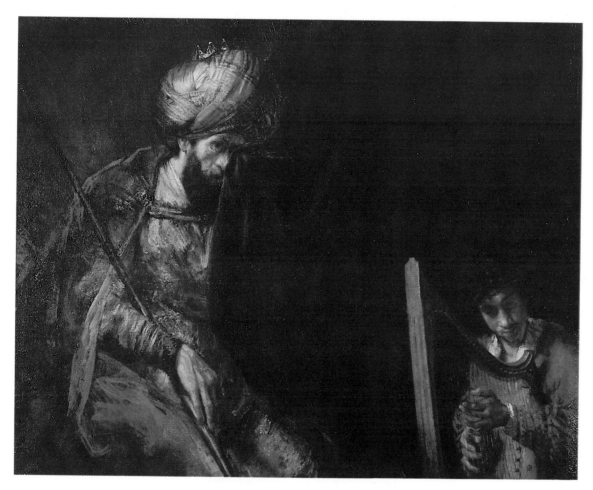

369 *David playing the harp before Saul* (1 Samuel 18:9-11). Ca. 1655. Canvas, 130 x 164.3 cm. The canvas consists of three pieces, two of the original material – that with the figure of Saul and the other, narrower one, with David – and a third piece, above David, in different material. Bredius 526. The Hague, Mauritshuis.

The emotion in the scene has appealed strongly to many, but there was no general agreement as to its meaning. Most viewers thought Saul was being consoled by David's music and was drying his tears. However, it has now been established by Tümpel and others that the subject is Saul contemplating revenge on David.

The red cloak, which has disturbed many critics on account of its slapdash technique, was added at a later stage, perhaps when the two parts of the canvas were reunited.

For information suggesting that the painting may originally have been used as covers for the wings of an organ, see the text.

The great shock of Horst Gerson's *Rembrandt paintings* when it came out in 1968 was the omission of *Saul and David* in the Mauritshuis (fig. 369) from the list of accepted works. For generations the painting had been one of the favourites of visitors to the museum, as well as an inspiration to other artists, like Jozef Israëls, and writers – even to Jan Emmens, who was a distinguished poet as well as an art historian.

In the catalogue *Rembrandt in the Mauritshuis* of 1978, the authors admit that 'since 1947 doubts as to whether this is Rembrandt's own work have been expressed now and then, but, as far as we know,

only by word of mouth.' This sentence is followed immediately by the statement: 'The history of this painting shows that even in the 19th century it had been doubted whether this was the work of Rembrandt's own hand.' In 1984 Henry Adams tentatively attributed it to Karel van der Pluym.

The tendency to dismiss the painting is strong, yet I feel uncomfortable at doing so. Gerson's main objection to it is its theatricality, a quality which to my mind argues in its favour. The lachrymose gesture of Saul, which Henry Adams finds in works by van der Pluym, was used by Rembrandt before his nephew came on the scene in *Christ and the*

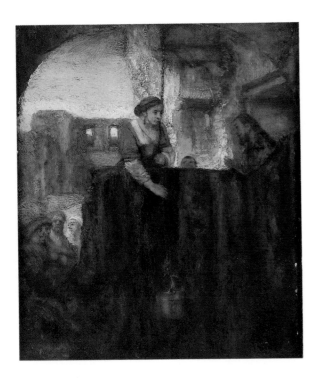

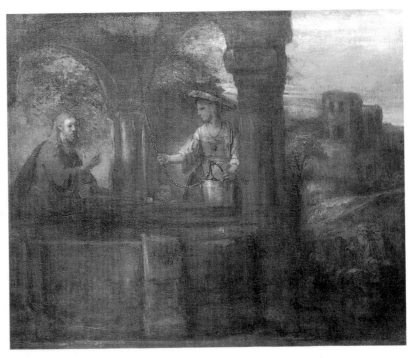

370 *Christ and the woman of Samaria* (John 4:4-26). Signed *Rembrandt f. 1659.* Panel, 48 x 40.5 cm. Bredius 588. Berlin-Dahlem, Gemäldegalerie.

As Jesus was passing through Samaria on his way from Judea to Galilee, he stopped to rest at Jacob's well, near the field that Jacob had given to his son Joseph. 'There came a woman of Samaria to draw water. Joseph said to her, "Give me a drink."'… The Samaritan woman said to him, "How is it that you, a Jew, ask a drink from me, a woman of Samaria?" For the Jews have no dealings with Samaritans.' In the discussion that follows, Jesus reveals himself to her as the Messiah, and she asks him for water from the spring of eternal life, that she may never thirst again.

371 *Christ and the woman of Samaria.* Signed *Rembrandt f. 1659.* Canvas, 60 x 75 cm. Bredius 592A. Leningrad, Hermitage.

In 1658 Rembrandt made an etching of the subject (Bartsch 70). The relevance of the theme in these years is unknown to me.

Rembrandt's inventory included 'a large painting of the Samaritan woman by Giorgione, half of which belongs to Pieter de la Tombe.' The co-owner of this and another Venetian painting, by Palma Vecchio, was an art dealer who also dealt in Rembrandt's etchings. After the sale his brother Jacob collected his share of the proceeds – 32 guilders and five stuivers. The Venetian atmosphere of Rembrandt's treatments of the subject has long been noticed, and may be due to his adapting motifs from the 'Giorgione' in his possession.

woman taken in adultery (fig. 248). The figure of Saul is so close to the contemporaneous *Apostle Paul* (fig. 351) that the two must have come out of the same workshop.

If only because that apostle and perhaps another twenty or so paintings in this book would logically have to be excised from Rembrandt's oeuvre if the *Saul and David* goes (a consequence that was not accepted by Gerson), it is perhaps worth the effort, even if it is a quixotic one, to see whether the large and famous work can be fitted into Rembrandt's career.

One property of the painting, noticed by many writers but never interpreted convincingly, may help us to understand it better, and perhaps find peace with it as a Rembrandt. The canvas is cut through its entire height between the two figures, and a square of material above David's head is a replacement for the original canvas.

In her discussion of the painting in the catalogue referred to above, Magda Tóth-Ubbens points to the existence of a painting by Salomon Koninck in Schwerin of the same subject, with a comparable composition, dated 1655. This has long been the supposed date of the Mauritshuis painting as well, although art historians have felt that it was re-worked about a decade later. In view of Koninck's

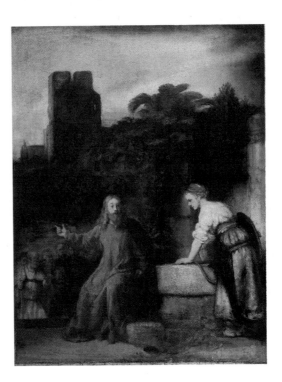

372 *Christ and the woman of Samaria.* Signed *Rembrandt f. 1655.* Panel, 63.5 x 48.9 cm. Bredius 589. New York, Metropolitan Museum of Art.

leech-like attachment to Rembrandt, the existence of his painting may be regarded as an argument in favour of the Mauritshuis *Saul and David*. Tóth also refers to a painting of the *Wrath of Saul* in the Rijksmuseum Het Catharijneconvent, Utrecht, painted by David Colijns around 1635-1640. Colijns was Salomon Koninck's first master, so his work may be presumed to be known to Koninck, and Rembrandt. An interesting peculiarity concerning the Colijns is that at some time between 1640 and 1665, it was converted for use as an organ shutter, together with another painting of David with the head of Goliath. The two canvases were attached to the wings of the organ on the Nieuwe Zijds Kapel in Amsterdam. The appropriateness of the subject for this purpose is self-evident – David was the great musician of the Bible.

What better explanation is there for the vertical seam in the *Saul and David* than that it was cut down the middle to be attached, like Colijns's paintings, to the wings of an organ? The work as we see it today would then be the reconstituted whole, put together again, with less space between the figures and with large laps of canvas removed, especially on David's side. The lack of balance in the painting, its disjointedness, would then be accounted for: it was not made to be seen as it is. Even the broad execution, another of the grounds for doubting Rembrandt's authorship, can be explained away if we assume that the painting was intended to be seen from a distance.

Scientific examination of the painting, as I understand it, does not rule out this possibility. In the reconstruction of the painting's history, the

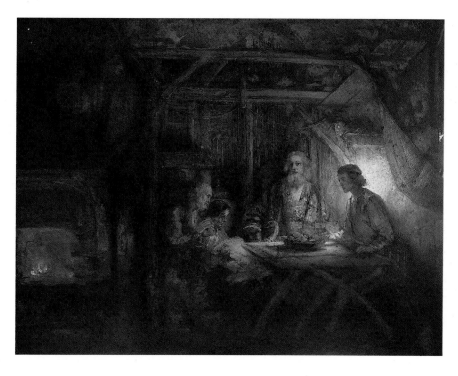

373 *Jupiter and Mercury visiting Philemon and Baucis* (Ovid, *Metamorphoses*, 8.61ff.) Signed *Rembrandt f. 1658*. Panel, 54.5 x 68.5 cm. Bredius 481. Washington, D.C., National Gallery of Art.

For the source of the composition in Hendrick Goudt's print after Adam Elsheimer, and for the subject, see fig. 33. Elsheimer was no less admired in Amsterdam in the 1650s than in Utrecht and The Hague in the 1620s. Jan van de

Cappelle was the owner of the original painting by Elsheimer upon which Goudt's engraving was based.

Jan Vos's poems on paintings (published in 1662) include one on a work of this subject by 'van Zorg' – whom I take to be Hendrick Martensz. Sorgh – in the collection of Tobias van Domselaer. With the unusual subject, the artist, the owner and poet all so close to Rembrandt, this work too must have been done for someone in the theatrical

world of Vos and van Domselaer.

374 *Tobit and Anna waiting for their son* (Tobit 10:1-4). Signed *Rembrandt f. 1659*. Panel, 40.3 x 54 cm. Bredius 520. Rotterdam, Museum Boymans-van Beuningen.

'The rays of daylight in a closed space,… with normal weather, somewhat resemble the light of a fire or torch… Our Rembrandt distinguished himself splendidly in reflections. Indeed, it would seem that the option of bouncing light [off a surface] was his proper element. If only he had paid closer attention to the basic rules of this art: for he who depends solely on his eye and supposed experience often commits errors deserving derision even from apprentices, let alone masters.'

Unfortunately we do not

know for whom Rembrandt did this painting, in which he indeed seems to be in his element. Could it be the same protector who helped him with his first *Tobit and Anna* (fig. 26)? Scriverius, old and blind like Tobit, was still alive in 1659. Moreover, the paintings that Rembrandt did for him in Leiden in 1625 and 1626 were probably now in Amsterdam, in Willem Schrijver's house on the Herengracht.

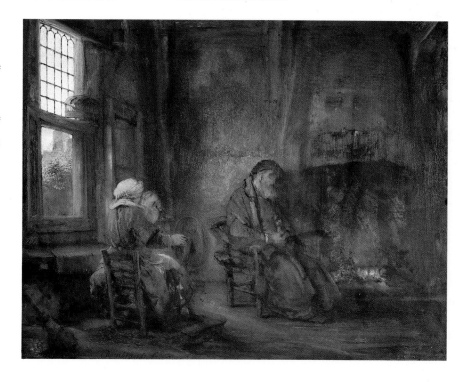

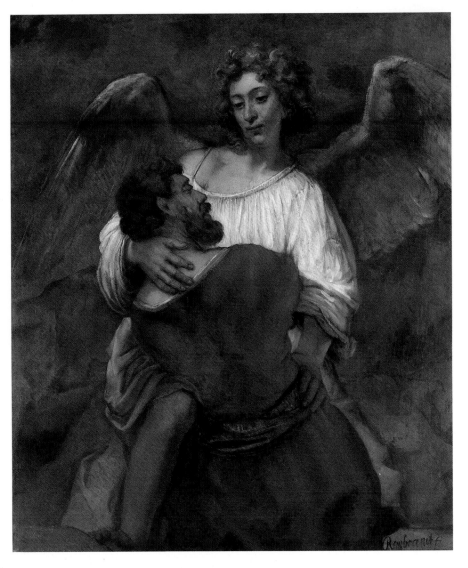

375 *Jacob wrestling with the angel* (Genesis 32:22-32). Signed *Rembrandt f.* on a patch of added canvas. Ca. 1659. Canvas, 137 x 116 cm. Probably cut down from 172.5 x 165 cm. Bredius 528. Berlin-Dahlem. Gemäldegalerie.

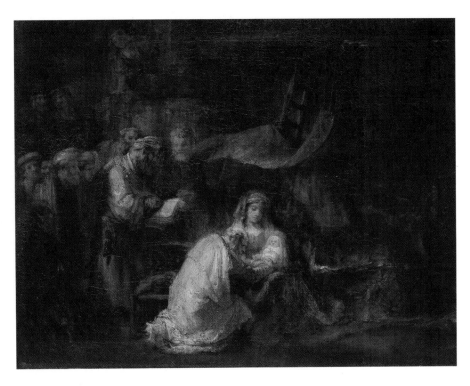

376 *The circumcision of Christ* (Luke 2:15-22). Signed *Rembrandt f. 1661*. Canvas, 56.5 x 75 cm. Bredius 596. Washington, D.C., National Gallery of Art.

On August 28, 1662, Rembrandt and Lodewijk van Ludick were back at the notary's again to go over their finances. One of the points they covered was the recent sale to van Ludick 'of two paintings, one of them the *Nativity* and the other the *Circumcision*, sold by van Rijn to van Ludick for 600 guilders,' which was paid for mostly in the form of prints and plates that Rembrandt bought from van Ludick at auction.

There seems little doubt that this is the painting Rembrandt sold to his old benefactor and dealer, although doubts have been expressed as to whether it is a work by the master's own hand, or by his assistant at that time, Aert de Gelder.

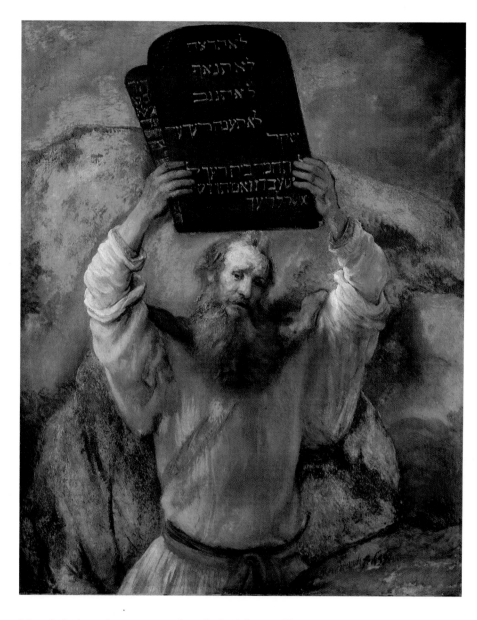

377 *Moses with the tablets of the law* (Exodus 32:19 or 34:29). Signed *Rembrandt f. 1659*. Canvas, 168.5 x 136.5 cm. There is additional canvas folded around the stretcher. Bredius 527. Berlin-Dahlem, Gemäldegalerie.

These two paintings – a kind of super half-length – seem to have some kind of connection with each other, but they remain a puzzle to scholars. A suggestion made by A. Heppner in 1935 that they are fragments of monumental paintings for the town hall has been disproved by scientific examination: the *Moses* was never much larger than it is now.

The theme of Moses showing the tablets to the people was in any case one of those chosen for the town hall, although the vast painting of the subject by Bol was not made, according to Blankert, until after 1662. This I find hard to believe, in view of the fact that in 1659 Vondel published a broadsheet with this poem:

ON RECEIVING MOSES' LAW, IN THE ALDERMEN'S CHAMBER
The Hebrew Moses has
 received the Lord's own law
And brought it to his people,
 descending from the mount.
They yearned for his return,
 and greeted him with awe.
Free nations thrive the best
 with law-abiding folk.

A similar poem was written by Jan Vos, we know not when. In the endless contests of strength on the Dam, Vos duplicated many of Vondel's verses on the paintings for the town hall. Those by Vondel, at least most of them, were calligraphed or painted for the rooms where the paintings hung.

It seems to me unlikely, in view of the coincidence of dates, that Rembrandt's *Moses* was totally unrelated to the painting in the aldermen's chamber. In 1658, Jacob Jacobsz. Hinlopen became alderman. Could he have ordered the *Moses* from Rembrandt for his own mantelpiece as a symbol of that position? As Heppner showed, Rembrandt's *Moses* is painted in the same scale as the figure on the painting in the aldermen's chamber, but

covers only the main figure. It was common practice for regents to order for their houses duplicates or different versions of paintings which played a role in their public lives.

The law of Moses, symbolized by the Sabbath commandment, was in 1659 the subject of 'the beginning of what is commonly called the Eighty Years War of the [Dutch Reformed] Church. The battle grew so fierce that the States of Holland had to intervene; in 1659 they forbade preaching on the subject of the Sabbath… The basis of the dispute concerning the Sabbath lay far deeper: at bottom it touched the authority of the confession and more or less of the Bible. In another form, the old struggle between Arminius and Gomarus had resurfaced.'

The son of an old Remonstrant, Jacob Jacobsz. Hinlopen will have known on which side to stand: that of the Bible, as a counter-balance to the official church. One detects here the influence not only of Arminius, but even of the Mennonites, with their doctrine of direct inspiration by the word.

Rembrandt's Moses, interestingly, holds the second tablet in front of the first, so that the commandment ordaining the Sabbath is invisible. (Bol's shows both tablets.)

These clues concerning the *Moses* leave us in the dark concerning the *Jacob*, a theme with no place in the town hall decorations. Not that it wouldn't have made a fine adornment to the house of a man named Jacob Jacobsz.

Mauritshuis authors suggest that the incision and its repair took place between 1830 and 1869, but the only evidence they cite is the measurements in catalogues of those years. This evidence is more likely, however, to refer to a cutting down of the painting on its outer edges, since the height as well as the width were reduced between those years. In any case, the painting as we see it today is a mockery of the artist's intentions.

The spirit of our exercise – rescuing *Saul and David* from becoming an ex-Rembrandt, a category in which it would find itself in the company of some of the ugliest Dutch paintings of the seventeenth century – demands that we find a niche for it in Rembrandt's career.

There is only one church that Rembrandt ever drew with an eye to precise topographical detail – the Petruskerk in Sloten, outside Amsterdam. The drawing concerned, in Copenhagen, was first published by E. Haverkamp Begemann in 1974 and

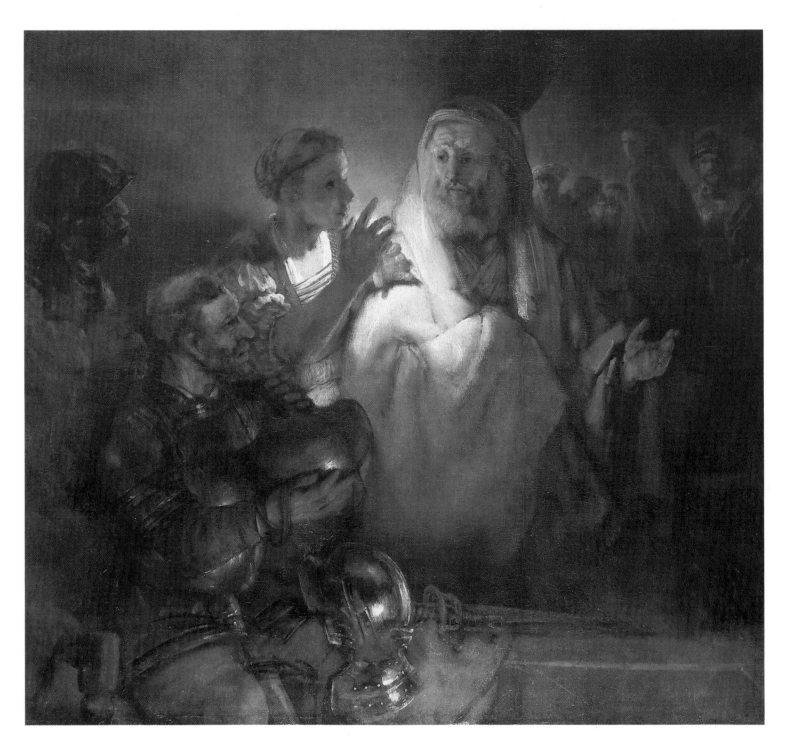

378 *The apostle Peter denying Christ* (Luke 22:54-57). Signed *Rembrandt 1660*. Canvas, 154 x 169 cm. Bredius 594. Amsterdam, Rijksmuseum.

The early history of this important painting is not known. In it, Rembrandt goes further than ever before in the cultivation of a 'broad style' in history painting. This, combined with the concealed lighting, and the heavily clothed half-length figures, make the painting another of those works that offended the canons of classicism. Not everyone subscribed to those canons, however, and the patron who ordered this work would have chosen deliberately for Rembrandt's broadest manner.

Portrait sitters who made that choice around this time were the Trips (figs. 386-388), whose new house on the Kloveniersburgwal was finished in 1660. Could there be a connection?

The subject of the painting was later taken as the theme of a long poem by a Rembrandt apprentice of the 1650s, Heijmen Dullaert. In it, Dullaert establishes a three-way link between the maidservant, Peter and Christ which comes remarkably close to the visual metaphor of the painting: if you remind me of my sin, says Peter, I will teach you faith in him whom I denied.

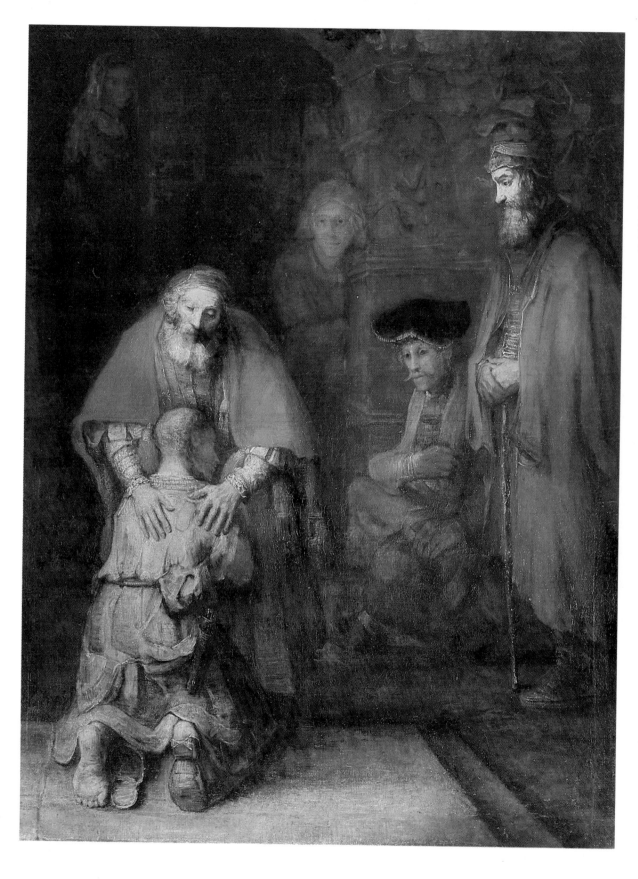

379 *The return of the prodigal son* (Luke 15:11-32). Signed *R v Rijn f.* The signature is undoubtedly false. Ca. 1662. Canvas, 262 x 206 cm. Leningrad, Hermitage.

The origins of this major work are completely unknown. For once, there can be no debate as to the subject and its emotional content. The wastrel son embraced by his father was the symbol of the heavenly reward that awaits the sincere Christian penitent.

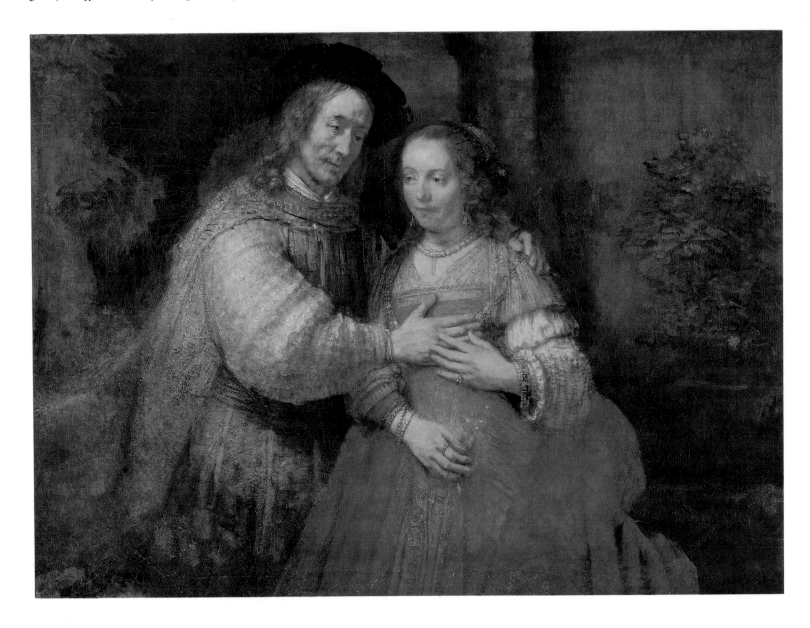

380 *'The Jewish bride'
(Cyrus and Aspasia?)*. Ca.
1662. Canvas, 121.5 x 166.5
cm. Signed *Rembrandt f.
16[..]*. Bredius 416.
Amsterdam, Rijksmuseum.

TRIJN JANS: Jeeps! Ain't that a
 neat picture!
Do you have any idea if it has
 a story, or is it just made
 up?
PIET: For all I know it could
 just as well be from the
 Bible as from the soaps.
Painters just paint any old
 thing that pops into their
 head.
(Bredero, *The miller's farce*,
 1613).

Bredero, who started life as a
painter's apprentice, knew
what he was talking about. I
appeal to his authority, now
that art historians have run

out of biblical lovers for the
pair in *'The Jewish bride,'* in
trying out the characters from
a 'soap opera' (Bredero's
word is *schelmerij*, a rogue's
play).
 One of the perennial
favourites in the Amsterdam
theatre was *Koninglyke
harderin Aspasia, blyende spel*
(The royal shepherdess
Aspasia, a play with a happy
ending; 1656) by none other
than Jacob Cats. The leading
roles, of King Cyrus of
Babylon and the beautiful
shepherdess Aspasia, were
first played by the husband-
and-wife team Gillis
Nooseman and Adriana van
den Bergh, but after
Adriana's death in December
1661 four new actresses
replaced her.
 The play was a dry piece of
fare with little action, but to

make up for that Cats
introduced some soft sex on
stage. When the Persian king
first lays eyes on Aspasia in
her shepherdess costume, he
treats her in the way he was
used to with his court ladies:

Your honest ways and lovely
 face, and these orbs of ivory
Enflame my mind and set my
 soul on fire.

In a footnote to 'orbs of
ivory,' Cats specifies: 'Cyrus
having said this, begins to feel
her breasts and to fondle
Aspasia, who parries him with
dignity.'
 In the print illustrating the
printed edition of *Aspasia*, we
see the king with his hand in
the décolletage of one of the
easier-going ladies at court.
 Cyrus is brought up short by
Aspasia's refusal, but he

quickly realizes that he is in
love.

I've now completely
 quenched my concupiscent
 fire.
Unto my deepest core, all is
 pure desire.
Believe me that your limbs
 will never feel my hand
Until we have been joined by
 matrimonial band.

The king is as good as his word
in marrying her (after dressing
her in gorgeous clothes), and
although Cats does not
annotate the loving curtain
scene, we may assume that
Cyrus repeated his gesture
more respectfully, as he said
he would.
 The key motif of *Aspasia*, in
other words, is also that of
The Jewish bride, which is
more than one can say for any

of the biblical titles proposed
for it. As for the traditional
name: when I visited the
Rijksmuseum several years
ago with the old Jewish
mother of a friend, who also
knew what she was talking
about, she commented, after
scrutinizing the couple's
behaviour, 'They're not
Jewish.'

381 *Simeon with the Christ Child in the Temple* (Luke 2:25-35). Begun ca. 1661, unfinished at the time of Rembrandt's death. Canvas, 98 x 79 cm. Bredius 600. Stockholm, Nationalmuseum.

The main figures are found in a drawing Rembrandt made in the *album amicorum* of Jacobus Heijblocq (1623-1690), the master of the Latin school on the Nieuwe Zijde. He had close ties to many Amsterdam painters, including Gerbrand van den Eeckhout. (Van den Eeckhout, by the way, painted this subject for Jan Jacobsz. Hinlopen.)

The painting of *Simeon* was commissioned by Dirck van Cattenburgh, with whom Rembrandt had business dealings of the usual litigious kind since the early 1650s. The relationships with Rembrandt of Dirck and his brother Otto van Cattenburgh, secretary to the count of Brederode, are of more than usual interest because of the connections of the brothers at court, but they have never been investigated.

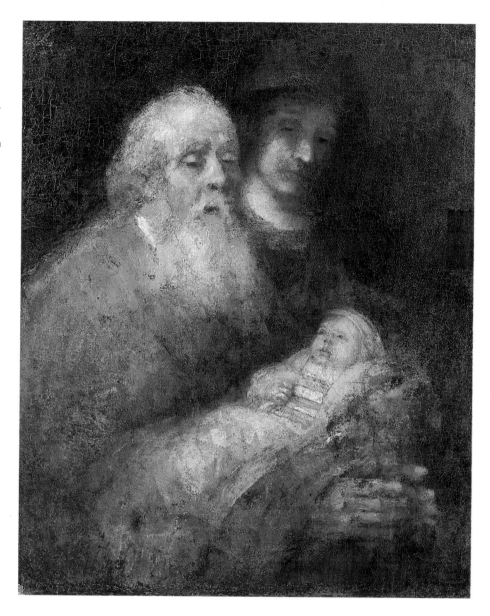

dated by him 1650-1655. Frits Lugt had already observed on the basis of other drawings that in this period Rembrandt paid his only visits, with sketching paper, to Sloten, which was on the other side of Amsterdam to where he lived.

The Petruskerk was Johannes Cornelisz. Sylvius's pulpit from 1604 to 1610, and Dirck Pietersz. Tulp's in 1617. As we have had occasion to note, the villages of Sloten and Sloterdijk fell under the jurisdiction of a lord of the manor appointed by Amsterdam. (They are now altogether part of the city.) From 1604 to 1624 that office was held by Jacob de Graeff, from 1624 to 1652 by Andries Bicker and from 1652 until his death in 1664, by Cornelis de Graeff. The inhabitants of the village were beside themselves with joy when after thirty years of Bicker's neglect they experienced the return of a de Graeff. Churchmaster Engelbertus Sloot inscribed in the church registry: 'I the undersigned [attest] that the lord of the manor of Sloten and

Sloterdijk, Burgomaster Cornelis de Graeff, lord of Zuidpolsbroeck, showed exceptional favour to the village of Sloten in the years 1652 to 1653 to 1654 and 1655, for example by buying a plot of land for the minister to put up a splendid house,... all of this from the means and income of the city of Amsterdam.'

The years 1652 to 1655 were the years between the death of Wendela de Graeff and the marriage of Alida van Papenbroeck, when Willem Schrijver and Cornelis de Graeff were not yet adversaries, and Willem could still hope for support from Cornelis for political advancement. The possibility I wish to suggest is that Willem presented the church in Sloten with a set of Rembrandt organ wings depicting *Saul and David*, and that they were removed and returned to the painter in 1663, after Willem's death. In 1663-1664 the church was completely re-built, once more with the help of de Graeff.

This theory provides a function for a painting

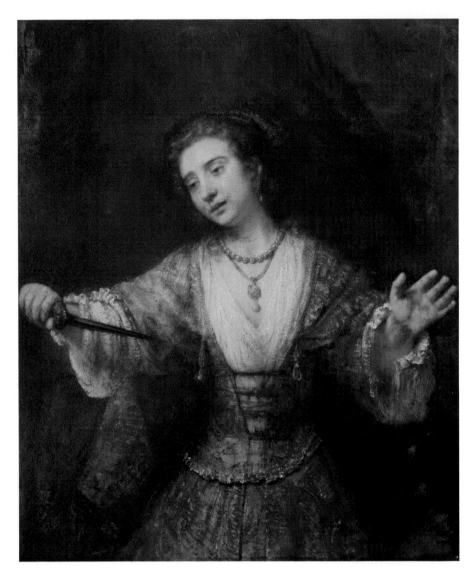

382 *The suicide of Lucretia.* Signed *Rembrandt f. 1664.* Canvas, *120 x 101* cm. Bredius 484. Washington, D.C., National Gallery of Art.

The story of Lucretia, appearances aside, was pure political allegory in the circles of Rembrandt's patrons. Lucretia killed herself after the tyrant of Rome, Tarquinius, raped her. Her death was avenged by her brother Brutus and her husband Collatinus. They murdered Tarquinius and while they were at it overthrew the monarchy and instituted the Republic in Rome.

Jan Vos's poem on a *Lucretia* by Govert Flinck in the collection of Joan Huydecoper gives the painting exactly that meaning: 'In the red ink [of her blood] she writes a definition of freedom.' As often in such cases, the twist of meaning intended – pro-Orange or anti-, in this case – depends on knowing who commissioned the paintings. Once more, however – or rather, twice more – we are without a clue.

There was 'a large painting of Lucretia by R: van Rijn' in the collection of the bankrupt Abraham Wijs and his wife Sara de Potter in 1656. This may be the same man as the Abraham de Wijs who in 1653 was appointed guardian over the children of the late Maria Lefebvre, the widow of Isaac Jouderville.

whose authorship by Rembrandt is itself hypothetical. Nonetheless, it adds an element of concreteness to a discussion that until now has been distinguished by reliance on little more than personal taste.

HISTORIES OF 1659-1662 | Our good fortune in finding clues to help us reconstruct the circumstances under which the late histories were made has nearly run out. The virtual certainty that the *Banquet of Esther* of 1660 (fig. 311) was painted for Jan Jacobsz. Hinlopen led us to a discovery of the theatrical connections of that painting and perhaps the *Haman, Ahasuerus and Harbona* (fig. 312) and the *Tamerlane* (fig. 313) as well. In the captions, I present snatches of inconclusive evidence bringing *Philemon and Baucis* (fig. 373), *Moses and the tablets of the law* (fig. 372), *Jacob wrestling with the angel* (fig. 375) and *Simeon in the Temple* (fig. 381) into links of several kinds with the Hinlopen

clique. The *Circumcision* (fig. 376) was almost certainly painted for Lodewijk van Ludick.

There is one other circle – not in the area of patronage but of spiritual kinship – with which we can associate Rembrandt and some of his late history paintings. Around 1658 some of the Calvinists of *Hollantsche Parnas* joined to form a cell for Christian meditation and poetry. Societies of this kind were tolerated by the church as long as they met under proper theological guidance and honoured the dictates of dogma in their reading and writing. This particular circle published the fruits of its meditations in 1658 in a volume entitled *'t Gebedt onzes Heeren* (The Lord's Prayer). It consists of an introduction in rhyme by the minister L. Sanderus from De Bilt, the monitor of the group, and eight poems, each on one sentence of the Lord's Prayer, and each by a different member of the cell: Joan Boogaart, Heijmen Dullaert, H.F. Waterloos, Willem Schellinks, Hieronymus Zweerts, Jeremias

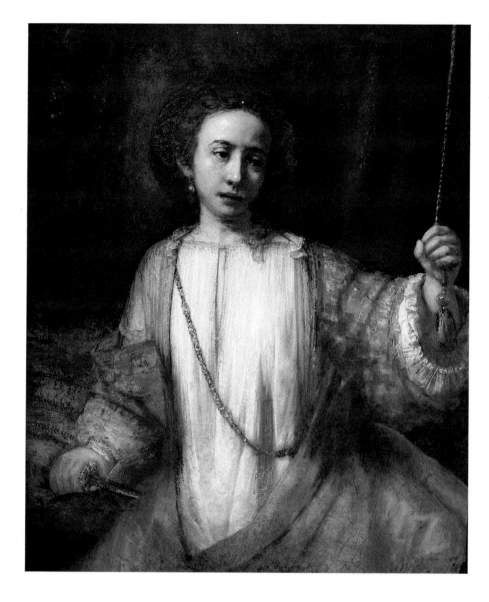

383 *The suicide of Lucretia.*
Signed *Rembrandt f. 1666.*
Canvas, 105.1 *x* 92.3 cm.
Bredius 485. Minneapolis,
Institute of Arts.

de Decker, Thomas Asselijn and Jan van Petersom.
Three are known to us as owners of Rembrandt
paintings, and nearly all of them as the authors of
poems on him or his work.

The member of this pious company with the
closest tie to Rembrandt was Heijmen Dullaert
(1636-1684), who was his apprentice for three or
four years in the early 1650s. In contrast to Gerbrand
van den Eeckhout, Dullaert became more a poet
than a painter. His religious verse sometimes comes
extremely close to the atmosphere of Rembrandt's
late biblical histories. This is most striking in the
case of his 'Edifying plaint of the Holy Apostle
Peter, on his inconstancy,' compared with
Rembrandt's painting of St. Peter in the
Rijksmuseum (fig. 378).

The climax of the poem is Peter's speech to the
maidservant. He asks her 'always to point out his
crime' and promises her in turn to convert her to
belief in the God he denied. Although the poem was

not written until the 1670s, the similarities between
it and the painting of 1660 are so striking that,
coming from a master and pupil, they must derive
from the same spiritual source.

That inspiration, I feel, also lies behind the *Return
of the prodigal son* (fig. 379), another of the classic
New Testament penitents. We recall that a painting
of a third penitent, Mary Magdalene (fig. 190),
provided the theme for a poem by de Decker.

The theme of penitence was as meaningful to the
Calvinist circle of Dullaert and de Decker as to the
Remonstrant Scriverius, who so many years earlier
wrote comments on van Swanenburg's prints of
penitents and, I believe, helped Rembrandt invent
the theme of the penitent Tobit (fig. 26). The motif
led Rembrandt to a new peak in his development.

This one, however, was to be his last, as a painter
of Biblical histories. After 1662 Rembrandt stopped
painting them altogether. *Simeon in the Temple* (fig.
381), begun in the early 1660s, remained unfinished.

39 The last portraits

THE TRIPPENHUIS | On May 24, 1660, the seven-year-old Louis Trip picked up an engraved silver trowel and laid the first stone of the largest and grandest house of all on the Kloveniersburgwal, the Trippenhuis. His father Hendrick and uncle Louys, the nephews of Elias Trip and Alijdt Adriaensdr., had bought a large plot of land between the houses of Michiel and Tymen Hinlopen on the south and those of Guillelmo Bartolotti, Abel Burgh and Dirck Geurtsz. van Beuningen on the north, and were building two identical houses, one for each brother, behind a single imposing façade. On June 6, there was a get-together in the country house of the Hinlopens, Oud Bussum, at which they gave the Trips permission to build on a four-inch-wide strip of their ground, and on June 12 the Trips reciprocated with similar permission for the Hinlopens.

For nearly a hundred years, the descendants of the captains of the Alteration had been engaged in a tug of war for power and status, giving each other as little rope as possible. Amsterdam life at the highest levels was full of taboos against conspicuous consumption. One's house could only be so broad, so high and have so many windows. An Amsterdam gentleman got around town by foot: for years Tulp was the only regent with a carriage, which he said he needed for emergency house calls, and even then people talked.

Between clans there were battles of precedence that took the form of whittling down the opponent's privileges; church and city counted the inches on each other's towers on the Dam; within a clan, one family would have a dormant claim on the capital of the other, so that, wealthy as they all were, everyone was constantly begrudging his neighbour his money.

The Trips, 'having come to this city from Dordrecht and conquering all before them,' as Bontemantel wrote with the taste of sour grapes in his mouth, were different. Even after half a century in Amsterdam, they could keep their distance from

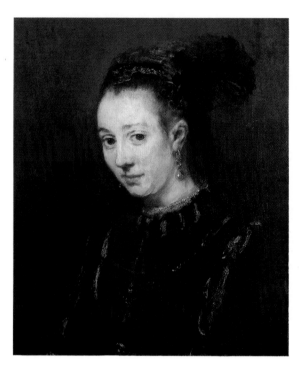

384 *A young woman.* Ca. 1655. Canvas, 56.3 x 47.5 cm. Bredius 400. Montreal, Museum of Fine Arts.

the petty bickering of the Amsterdamers. Moreover, their fortune, even by Amsterdam standards, was vast enough for them to be able to permit themselves considerable liberties.

They had earned it in a few brief decades of mining, manufacturing and trading on a grand scale, thanks mainly to certain monopolies they held in Sweden, such as the export of armaments, iron and tar. The most profitable branch of their commercial empire was the arms trade. At the outbreak of the Thirty Years War, they were already capable of outfitting an entire army of over five thousand men in four weeks flat. What more need be said of their wealth when the war ended?

THE DECORATION OF THE HOUSE | The Trips had little to contribute towards the design of their house by way of individual taste. The most original feature of their house was the theme of its sculptural and architectural elements, which were carved in the

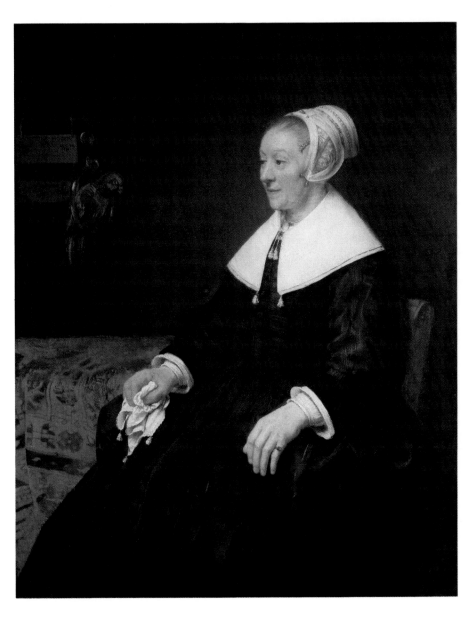

shape of weapons: cannons pointing north and south from the pediment up and down the Kloveniersburgwal, chimneys in the form of mortars. On the façade were the palms and fruits of peace, because the Trips were no warmongers, only believers in the principles of deterrence.

The architect was Justus Vingboons (1621-1698), whose family had been builders to the Coymanses and Huydecopers, in the same classicist style, for half a century, and to the Swedish relations of the Trips for some time too. The painters were already at work on the town hall, and had that much extra prestige to bring: Ferdinand Bol, Nicolaes de Helt Stockade, Jan Lievens, joined by the Trip family painter Allaert van Everdingen, who depicted their iron ore and copper mines and weapon factories in Sweden, and decorated their house with Scandinavian scenery. (Van Everdingen owned several paintings by Rembrandt.)

Bol too meant more to the Trips than just a name

385 *Catrina Hooghsaet (1607-1685)*. Signed *Rembrandt f. 1657*. Inscribed *Catrina Hoogsaet, out 50 jaer*. Canvas, 123.5 x 95 cm. Bredius 391. England, private collection.

The sitter is a relation of Rembrandt's from the Mennonite community of the 1630s. In 1637 she married the brother of Lambert Jacobsz., Hendrick Jacobsz. Rooleeuw, who was living in the same street as Rembrandt that year, the Binnen Amstel. The marriage was not a success, and the couple seem to have lived apart from 1647. In 1657 Trijn Jans, as she was mostly called, was thinking about death. On June 7th, she drew up a will, to which she added a codicil in December leaving 'the portraits of herself and her deceased brother' to a

three-year-old nephew. She also made provision for her parrot.

The commission to paint Catrina Hoogsaet must have been related in some way to the two etched portraits Rembrandt did in 1657 or 1658 of her aunt's sister's husband Lieven Willemsz. Coppenol (1599-after 1677). Coppenol, a schoolmaster and calligrapher, was a remarkable character whose biographer H.F. Wijnman has called him a lunatic and a sex maniac, but granted that in 1657-1658 he displayed an extraordinary outburst of concentrated energy. Most notably, he calligraphed a poem by Constantijn Huygens and one by Vondel for the burgomasters' chamber of the new town hall, and solicited poems by more than a dozen poets in praise of

himself and his calligraphy and his portraits by Rembrandt and Cornelis Visscher. Several of the poets he approached were those who had already written tributes to Rembrandt – Vos, de Decker and Waterloos – and many of the poems to Coppenol, even those that do not name Rembrandt, were published in *Hollantsche Parnas*. This leads one to believe that Coppenol, and perhaps his church, played a hitherto unrecognized role in the artistic-political struggle on the Dam in the late 1650s. If so, he was definitely on the same side as Rembrandt. Whether the alliance of a notorious crank like Coppenol was any help is another matter.

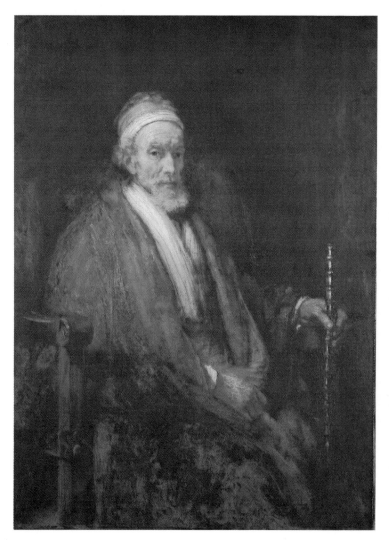

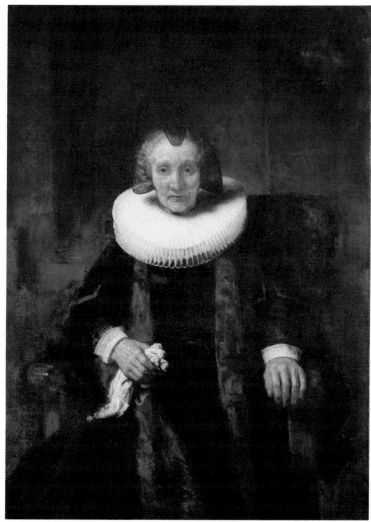

386 *Jacob Trip* (*1575-1661*).
Signed *Rembr*[*andt*]. Ca.
1661. Companion to fig. 387.
Canvas, 130.5 x 97 cm.
Bredius 314. London,
National Gallery.

387 *Marguerite de Geer*
(*1583-1672*). Signed
Rembrandt f. 1661.
Companion to fig. 386.
Canvas, 130.5 x 97.5 cm.
Bredius 394. London,
National Gallery.

to be bought and flaunted. He was a fellow
Dordrechter who had made it in Amsterdam, and
their contact with him was an old one. His master
Jacob Gerritsz. Cuyp (1594-1651) and Jacob's son
Aelbert (1620-1691) had painted family portraits in
the preceding years, as had Ferdinand himself.

In addition to the painted decorations, the
brothers also ordered portraits for their new house.
Four works by Nicolaes Maes (1634-1693) were
probably made for this purpose, four or more by
Bol, and three, for Hendrick Trip, by Rembrandt
(figs. 386-388).

Rembrandt's tie to the Trips was also an old one,

dating back at least to 1639 (figs. 226, 227), shortly
after Bol began to work with him. In the following
decades a stream of young men from their home city
came to Amsterdam to take Rembrandt as their
second master, among them Maes himself. Around
1661 the last and most impressionable of the bunch
arrived, Aert de Gelder (1645-1727). Several if not
all of them were patronized by the Trips after they
left Rembrandt's studio.

The Trips may have been the most important
people from Dordrecht that Rembrandt knew, but
he was not the most important painter in
Amsterdam of their acquaintance. Their own Bol

RUSSIAN GRAIN AND REMBRANDT

One of the abortive sidelines of the Trips throws an interesting light on mutual relations between Rembrandt's patrons we have not been able to deal with in this book – their business interests. In 1628 Elias Trip took the initiative in setting up the Noordsche Compagnie (Northern Company), a barely disguised attempt to get a monopoly on Russian grain. Two of the other partners were Guillelmo Bartolotti and Tymen Jacobsz. Hinlopen. (The location of the Trippenhuis between plots owned and inhabited by Hinlopens and Bartolottis, thirty years later, did not come completely out of the blue.) One of the competitors which the new venture was trying to displace was the firm of the Witsen family. In 1614, Cornelis Witsen's father and two uncles had begun a large-scale trading operation with Russia, mainly in grain, under letters from Prince Maurits to the Tsar.

In 1633, Elias Trip participated in a separate purchase of Russian rye, taking one quarter of a particular shipment to the two quarters bought by Jan and Pieter Gerritsz. Hooft, the Mennonite investors in Uylenburgh's academy. Twelve years earlier, he had joined another cartel, to monopolize trade with Guinea for six months, working with Hendrick Pietersz. Schrijver, Scriverius's father, and Marten van Papenbroeck, Pieter's father: a Remonstrant and a Catholic, respectively. In the East India Company as well, where Elias played an important role, he encountered several people we have met: Jacques Specx, Joan Huydecoper, Jan Rijksen and Geurt Dircksz. van Beuningen.

Should these early ties between the Trips and so many of Rembrandt's supporters ever be laid bare, we might add yet another dimension to our understanding of his career.

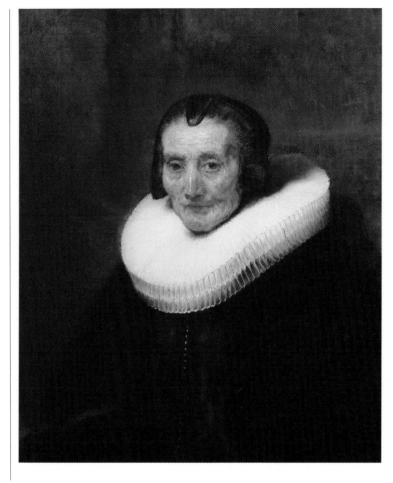

388 *Marguerite de Geer* (*1583-1672*). Signed *Rembrandt f. 1661*. Canvas, 75.3 x 63.8 cm. Bredius 395. London, National Gallery.

The marriage of Jacob Trip and Marguerite de Geer in 1603 was ten years after the equally dynastic betrothal of their brother and half-sister Elias Trip and Maria de Geer. After the death of Maria in 1609, Elias was married for the second time to Alijdt Adriaensdr. (fig. 227).

Jacob began his career as a shipper on the Maas, participating later in a salt monopoly with a group of other Dordrecht merchants, and later still working with the de Geers in the manufacture of arms in Sweden. The business enterprises of the two families, which were sometimes co-operative and sometimes competitive, covered a large range of activities and vast stretches of the globe. It must have been unimaginably thrilling for the children of a modest businessman in the backwaters of Holland to wake up one morning and find themselves exclusive masters of all the iron mines and arms plants in Sweden, the saltpetre production of Poland, the entire export trade of Guinea, the financiers of whole nations and their kings. Nonetheless, the Trips continued to live relatively modestly, leaving it to their children to build large houses. Even the second generation, though, never developed habits of the art lover.

Jacob Trip died on May 8, 1661, and although it is assumed that his portrait was, therefore, begun before his death, Miss van Eeghen points out that Rembrandt probably did not paint him from life, but from an existing portrait. Marguerite, who outlived him to reach the age of 89, could have been painted in the flesh. We recognize her sharp chin and keen gaze in an informal portrait sketch by Rembrandt of about the time he painted her sister-in-law Alijdt in the late 1630s (Benesch 757).

Rembrandt was the first non-Dordrecht artist to paint a portrait of Jacob and Marguerite. His canvases, made to match portraits of other family members made in 1660 by Bol, were probably ordered by Hendrick Trip, who lived in the northern, left wing of the Trippenhuis.

was foreman of the guild, painter of the town hall, etc., etc. When commissions for family portraits were distributed, it was he who painted new likenesses of Hendrick Trip and his wife Johanna de Geer, while Rembrandt was commissioned to paint Hendrick's aged parents Jacob Trip and Margaretha de Geer, probably after existing portraits, at that.

THE SYNDICS | Rembrandt's final group portrait of a civic body came in the same year as his work for the Trips. In 1661-1662 he painted the sampling officials of the drapers' guild (fig. 389), in a group portrait of far greater spatial clarity than any of his preceding works of that kind, let alone such contemporaneous work as the Trip portraits. The painting was made for the Staalhof, the sampling hall, which was across the canal from the Kloveniersdoelen. The last of Rembrandt's four portraits of civic groups was, therefore, hung in the same small district as the other three.

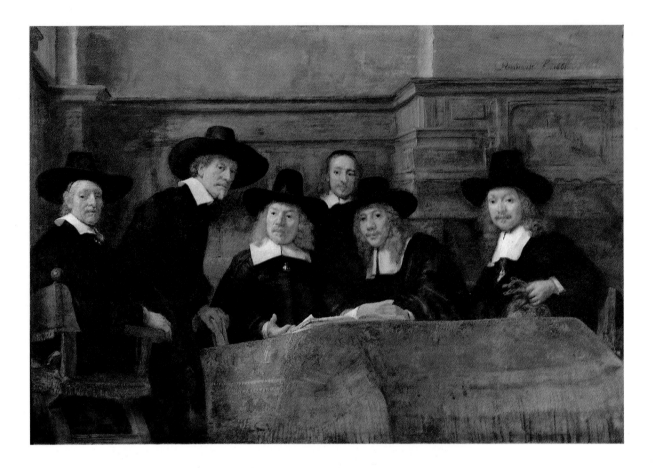

In 1763, the Amsterdam historian Jan Wagenaar described the institution for which the painting was made, and the tradition of portraiture into which it was expected to fit: 'Downstairs in the Staalhof, apart from the steward's dwelling, is a large room where the cloth is sampled or leaded [with a seal], and a courtyard where it is first hung up for inspection; a room where the five cloth wardens, also called syndics [*staalmeesters*; sample-masters], appear in turn, one at a time, three times a week, on Tuesday, Thursday and Saturday, to judge the materials and put their seal on the blue and black cloths that are the only kind brought to the Staalhof. In this room hang six paintings of syndics from the sixteenth and seventeenth centuries. The oldest is marked with the year 1559. In each of these paintings are portrayed five wardens seated and the Staalhof steward, standing.'

Rembrandt did not accommodate himself with this hundred-year-old tradition with perfect grace. The X-rays show that he first painted the foremost figure standing up straight. It was no doubt only after the shocked protests of the syndics – of four of them anyway – that he bent the man into a position that with a little good-will could be called half-seated. That figure has been identified by Miss van Eeghen as Volckert Jansz. (1605/10-1681), a

389 *The sampling officials of the drapers' guild (The syndics)*. Signed *Rembrandt f. 1662* and, in the eighteenth century, *Rembrandt f. 1661*. If, as Miss van Eeghen assumes, the painting depicts the syndics who held office from Good Friday 1661 to Good Friday 1662, then the sitters, from left to right, must be: Jacob van Loon (1595-1674), Volckert Jansz. (1605/10-1681), Willem van Doeyenburg (ca. 1616-1687), the steward Frans Hendricksz. Bel (1629-1701), Aernout van der Mye (ca. 1625-1681) and Jochem de Neve (1629-1681). Canvas, 191.5 x 279 cm. Bredius 415. Amsterdam, Rijksmuseum.

This body, which was two hundred and fifty years old at the time Rembrandt painted it, should not be confused with the governors of the guild, an office created in 1652 to take over some of the functions of the syndics. They did their work – one for one and not in plenary sessions – in a room decorated with five group portraits from 1559 to this work of 1661. The other

four all seem to have been works of the sixteenth century. The portraits were done to an unvarying formula – all showed the five syndics seated and the steward, who lived in the house where they met, standing.

Were there other binding conditions? It would not surprise me to learn that the sampling officials of 1661-1662, in their revival of an old tradition, insisted on being shown looking the viewer straight in the eye, in the manner of sixteenth-century group portraits.

Mennonite draper like Anslo, though of the Frisian community rather than the Waterlanders. With his large collection of art and curiosities, begun by his father, he fitted into the category of art-loving drapers which was so conspicuous among Rembrandt's patrons. Most recently the Hinlopens, who, we neglected to say above, were also drapers.

Because of his prominence in the painting, despite his low rank in the company (he had become a warden for the first time in 1660, while the chairman that year, Willem van Doeyenburg, had first served in 1649), I would guess that he was the prime mover behind the portrait, and that he was the one who chose Rembrandt to paint it.

The sampling officials were appointed to one-year terms from Good Friday to Good Friday, by the burgomasters and aldermen. The group portrayed by Rembrandt, which served in 1661-1662, was, therefore named by the same men who in October 1661 gave Rembrandt the commission for the *Claudius Civilis*. This was probably the first commission given by the burgomasters to a painter after the installation of these particular wardens, so the choice of Rembrandt to paint their portrait made good plain sense.

THE STRASBOURG RIDER | In 1663 Rembrandt delivered the painting, begun in 1660, of one man and his horse, larger than that of all five syndics and their servant put together. Larger, in fact, than any other portrait by Rembrandt except for the *Nightwatch*. The sitter was Frederick Rihel, a trader who was the business partner of the Bartolottis (fig. 391). Rihel had come to their firm as a young man,

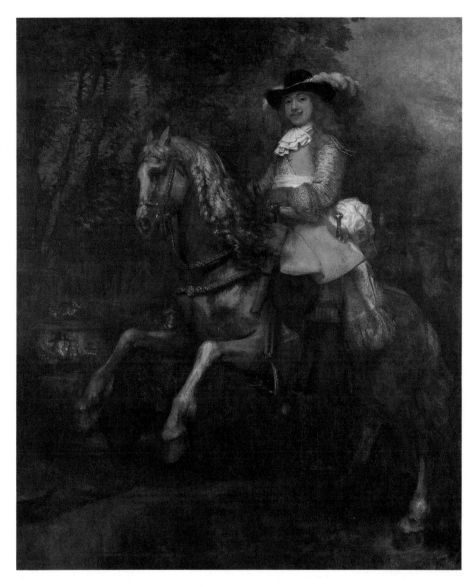

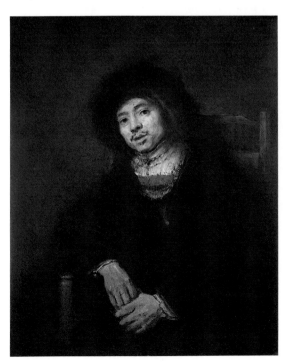

390 *Young man seated.* Signed *Rembrandt f. 1660.* Canvas, 93 x 87.5 cm. Bredius 299. Rochester, New York, Memorial Art Gallery of the University of Rochester.

391 *Frederick Rihel (1625/26-1681).* Signed *R[em]brandt f. 1663.* 'Faint, though visible in infra-red photographs': museum. Canvas, 194.5 x 241 cm. Bredius 255. London, National Gallery.

Rihel was a wealthy Lutheran merchant who moved as a youth from Strasbourg to Amsterdam to work for the Bartolottis. The painting shows him as he rode out to greet the Orange and Stuart party on their state visit to Amsterdam in July 1660. In May of that year, ground had been broken for the Trippenhuis, and Rembrandt may already have been working for these new neighbours (though old associates) of the Bartolottis. The painter also made his

Esther for the Hinlopens that year (fig. 311), the neighbours on the other side of the Trippenhuis. This commission fits in, therefore, with Rembrandt's enhanced status after the death of Flinck in the corner of Amsterdam society represented by the Trips, the Hinlopens and by extension Jan Vos, Tobias van Domselaer and the poets of *Hollantsche Parnas.*

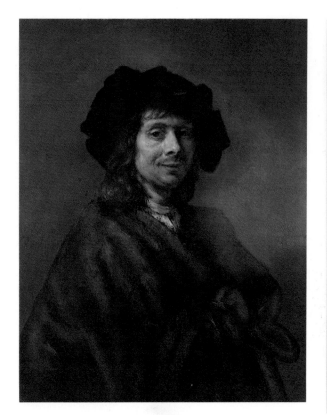

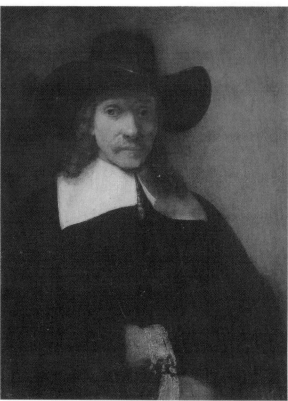

392 *Portrait of a young man.* Signed *Rembrandt f. 1662.* Signature rejected by Gerson. Canvas, 89.9 x 70.8 cm. Bredius 311. St. Louis, Missouri, St. Louis Art Museum.

393 *Portrait of a man.* Ca. 1660. Canvas, 83.5 x 64.5 cm. Bredius 277. New York, Metropolitan Museum of Art.

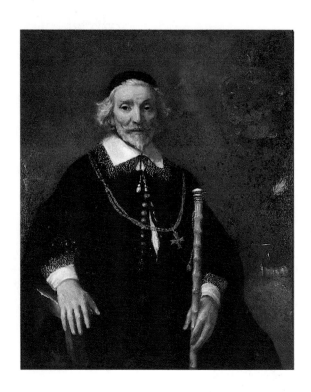

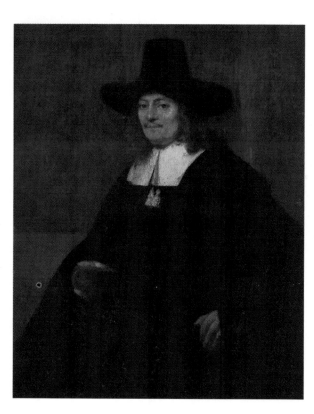

394 *Dirck van Os.* Ca. 1660-1665. Inscribed *D van Os* [Dijckgra]*ef van d*[e Beemster]. Canvas, 103.5 x 86.4 cm. Bredius 315. Omaha, Nebraska, Joslyn Art Museum.

For the Beemster, see above, p. 231. In 1668, Caspar Pellicorne, who Rembrandt had painted as a five-year-old, served a term there as a public official. The painting of Dirck van Os is doubted by Gerson.

395 *Man in a tall hat.* Ca. 1660-1665. Canvas, 121 x 94 cm. Bredius 313. Washington, D.C., National Gallery of Art.

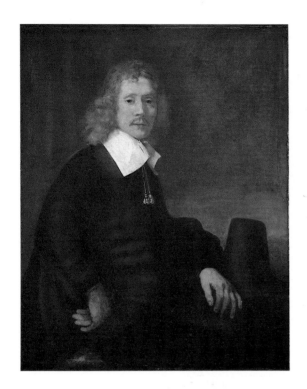

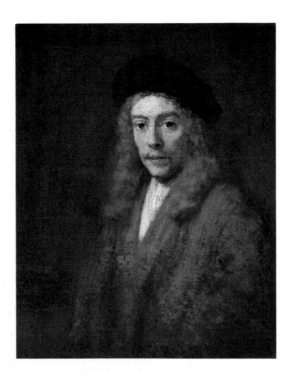

396 *A young man.* Ca. 1660. Canvas, 110 x 90 cm. Bredius 312. Washington, D.C., National Gallery of Art.

The painting was previously said to be signed and dated 1662 or 1663, but the museum denies that it is.

397 *A young man.* *Re*[mbrandt]*f.* [16]*63.* Canvas, 78.6 x 64.2 cm. Bredius 289. London, Dulwich College Gallery.

There do not seem to be sufficient grounds for Valentiner's identification of the sitter as Titus.

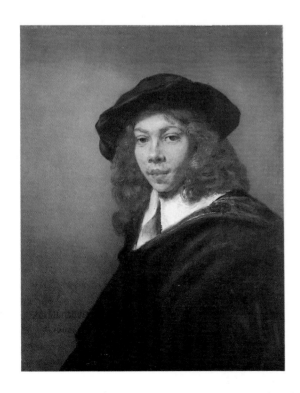

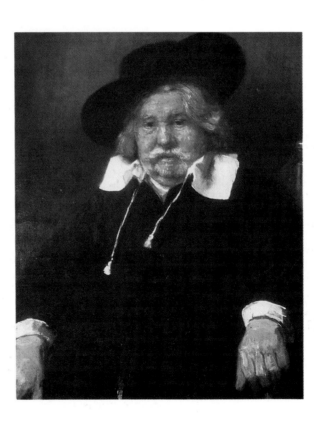

398 *A young man.* Signed *Rembrandt f. 1666.* Signature re-touched, according to Gerson. Canvas, 80.6 x 64.8 cm. Bredius 322. Kansas City, Missouri, Nelson-Atkins Museum of Art.

399 *An old man.* Signed *Rembrandt f. 1667.* Canvas, 78.7 x 66 cm. Bredius 323A. England, collection of the Viscount Cowdray.

from Strasbourg, in December 1642. He stayed on after his five-year apprenticeship, and when the old Bartolotti died in 1658, Rihel became director of the firm, along with two other companies that he ran, one of his own and one in partnership with Bartolotti's son. Rihel had important connections in Sweden, in connivance with his partners' neighbours the Trips. When they were forced to end their monopoly on the export of arms from Sweden, it was Rihel, after an interval, who picked it up in 1669. He was not the only one of Trip's successors to patronize Rembrandt. Joseph Deutz, who in July 1662 took over their tar monopoly, owned a Rembrandt self-portrait and a painting by him of the *Tribute money*, appraised in 1685 at 80 and 75 guilders respectively.

The grand equestrian portrait – certainly the most aristocratic Rembrandt ever painted – was ordered by Rihel to commemorate his role as the leading horseman of the third of the three companies who rode out of Amsterdam to greet the Stuarts and Oranges on June 15, 1660. Rihel was a high-living bachelor with his own stable and horses, and his clothing in the painting was certainly no stage or studio costume – it is described in his last will. Horses were not his only hobby. When Cosimo de' Medici visited him in 1668, it was to admire his 'gallerietta' of natural and man-made curiosities.

THE PORTRAITS OF JEREMIAS DE DECKER

Rembrandt's last identified portrait introduces into this all-too-cold life a note of unusual warmth. In the year of the sitter's death, Rembrandt painted the portrait of someone we can truly call an old friend of his, the poet Jeremias de Decker (fig. 400). De Decker was the author of a poem on Rembrandt's *Christ and the Magdalene* of 1638 (fig. 190), in which he addresses the painter, much more personally than is usual in this kind of verse: 'Friend Rembrandt, I once saw this panel undergo your deft and expert touch.' No matter what the date of the poem, then, which is disputed, de Decker says that he watched Rembrandt at work on his panel of 1638.

De Decker was born, about 1608, in Dordrecht, and he could have owed his acquaintance with Rembrandt to the Trips or to Bol. Or it may have been de Decker who introduced him to them: he was apparently related to the painter Abraham de Decker, who lived in the Sint Anthonisbreestraat in 1625, and who had dealings with Lastman's brother-in-law François Venant. In this case, though, the friendship between Rembrandt and another man transcended the interests that brought them together. His words to Rembrandt and Rembrandt's gift to him of a portrait bear the marks of mutual

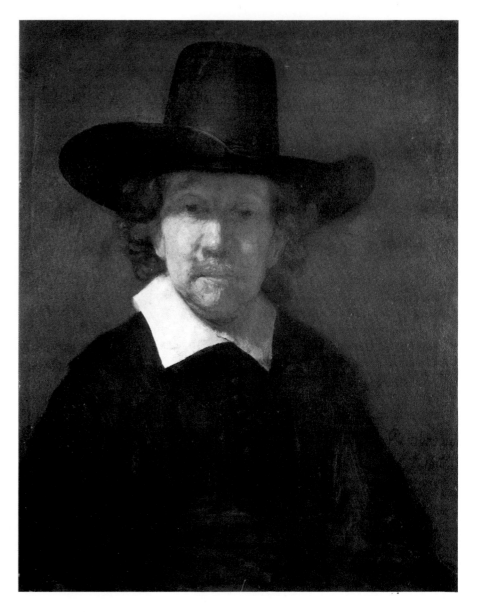

400 *Jeremias de Decker (1609-1666)*. Signed *Rembrandt f. 1666*. Panel, 71 x 56 cm. Bredius 320. Leningrad, Hermitage.

———

In a poem of thanks to 'Heer Rembrandt' for the portrait, de Decker wrote,

And still it pleases me (I will not tell a lie) and takes my breath away
To see myself portrayed on a panel by the Apelles of our day.
And what is more, he did not even ask a fee.
He did it from the heart,
From pure attraction to the muse of poetry,
Inspired by love of art.

Among the others who wrote poems on the portrait was the poet's brother, David de Decker, who edited his collected works in the year after his death: 'If by chance you never saw de Decker in his life,/Regard him here, portrayed by master hand.' This portrait and that of Lieven Coppenol were the only works by Rembrandt to which numerous tributes were dedicated in his lifetime.

In 1667 there appeared in The Hague a Dutch edition of Scriverius's history of Holland in the Middle Ages. The captions to the illustrations were written by de Decker, and were thus published after his death as well as that of Scriverius. The posthumous link between two of Rembrandt's truest admirers is moving, and if it points to a tie between them in their lives may be significant as well.

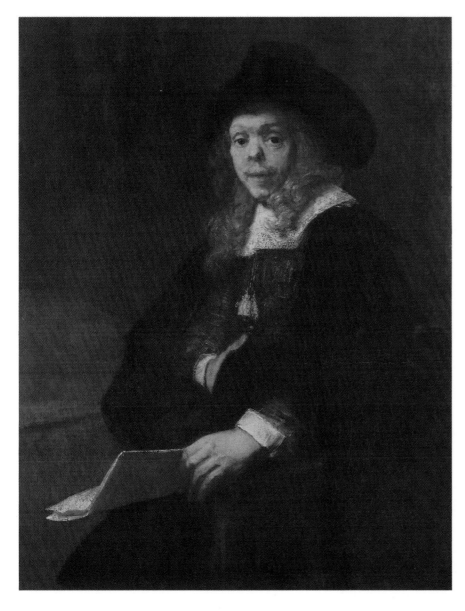

401 *Gerard de Lairesse (1640-1711).* Signed *Rembrandt f. 1665.* Canvas, 112.4 x 87.6 cm. Bredius 321. New York, Metropolitan Museum of Art (Robert Lehman Collection).

Gerard de Lairesse was so disfigured, Houbraken relates, that when he showed up around 1665 at the studio of his new employer, Gerrit Uylenburgh, the other assistants 'gazed in horror at his sickening appearance.' His engraved portrait in Houbraken's *Groote schouburgh der Nederlantsche konstschilders en schilderessen* (Great theatre of Netherlandish painters and paintresses; 1721-1723), shows him without the bridge of his nose, like the sitter in this portrait. If the identification is correct, we can only say that Rembrandt did a good job of glamourizing his sitter.

De Lairesse came from a family of Liège businessmen who had had dealings with the Trips for half a century. In 1652-1656 two of his relatives, Matthijs and Daniël de Lairesse, took part in a disastrous expedition to Brazil for Jacob Trip the Younger (1604-1681), the black sheep of the family. They came back destitute, with nothing to show for their efforts except 'four items, being negroes,' whom they deposited in Tobago and in 1656 sold to a slave trader in Vlissingen.

The artist became one of the main champions of classicism in Dutch painting, and was a co-founder of Nil Volentibus Arduum (see p. 311). During his years with Uylenburgh, however, his ideas were not yet clearly formed. In his own tract, the *Groot schilderboek* (Great painter's book; 1707), de Lairesse attacks Rembrandt with the weapons of the classicist, but then admits 'that I have very mixed feelings in the matter. While I do not wish to deny that I used to have a particular weakness for his style, it did not take long after I had begun to recognize the infallible rules of the art [of painting] before I found myself obliged to repent of *my* heresy and reject *his* for being founded on nothing but unconnected, imaginary wills-o'-the-wisp.'

respect and affection. This is confirmed by the sheer duration of their tie, which was unique for Rembrandt. De Decker was part of the group of poets around Six and Vos in the *Verscheyde Nederduytsche gedichten* of 1651 and the *Hollantsche Parnas* of 1660. In the latter, not only do we find his poem on the *Magdalene*, dedicated to his friend H.F. Waterloos, but also a poem by Waterloos on a Rembrandt portrait of de Decker.

The work in Leningrad, however, is dated 1666, and if the date is correct we can only assume that there was an earlier painting which was lost. Poems on the portrait in Leningrad were written by de Decker himself and, after his brother, by his brother David and Jan van Petersom, a poet from de Decker's Calvinist circle (see p. 330). After de Decker's death, a portrait of him by Rembrandt became the property of yet another of the Lord's Prayer poets, Hieronymus Zweerts. If anything in Rembrandt's biography attests to a meeting with

kindred souls, this is it. One prefers not to speculate on the possible implications of de Decker's choice of words in 1666, when, in contrast to the earlier poem, he addressed Rembrandt not as 'Friend' but as 'Sir.,

THE QUALITY OF EARNESTNESS | De Decker's reputation as a poet, after a brief peak in 1651, when he was singled out by the editors of *Verscheyde Nederduytsche gedichten* as the heir to Huygens and Vondel, soon fell back to that of the gifted minor master, where it has remained since.

He was a melancholy bachelor who found his calling, when he was not tending his father's shop or the old man himself, with whom he lived, in poems of resignation and bitterness. His masterpiece was *Goede Vrydag ofte Het lijden onses Heeren Jesu Christi* (Good Friday, or the Passion of our Lord Jesus Christ), first published in *Verscheyde Nederduytsche gedichten.* De Decker admits of himself 'full of fun I'm not... I'd rather see you learn

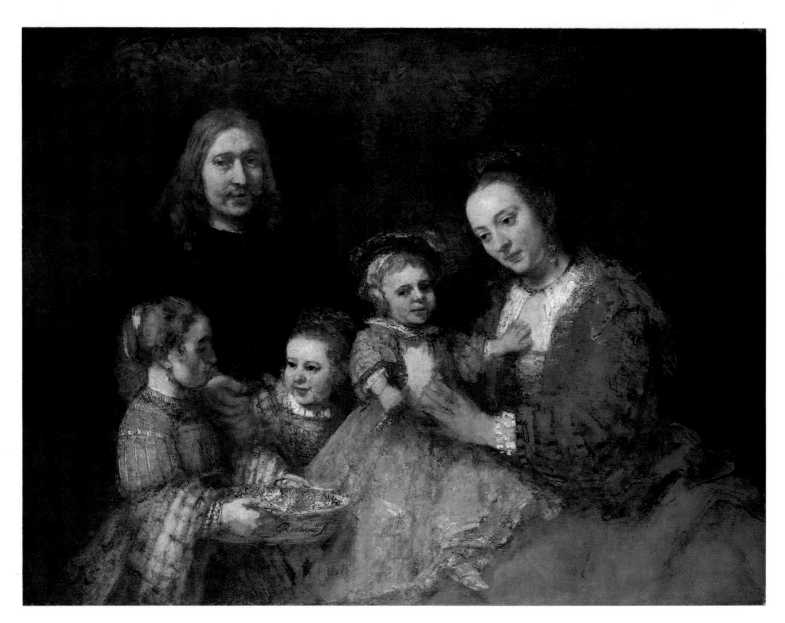

than laugh.' He associated himself gladly with his Old Testament namesake, whose Lamentations he put into psalm form.

His longest work was *Lof der geldsucht* (Praise of avarice), a satire in the spirit of the seventeenth-century followers of Erasmus. His moralism and his satire he shared with Rembrandt's earlier poet friend Krul, but de Decker not only lacked, but hated, the third leg of Krul's poetic creed, eroticism.

He also lacked Krul's daring in thrusting himself into the business side of literature and on to the political stage. He lived a withdrawn life, full of sickness and need, distinguished only by a marked ambivalence to religious politics. If he experienced opposition from his colleagues – respectful opposition, not the bar-room brawls we are used to – it was on account of this. For all his strictness in his personal faith, he was not a member of the Calvinist church, and he gave his Remonstrant colleagues at a given moment cause to believe that he was one of

them. When they began to claim him in public, however, he retreated behind dogmatic Calvinism (which he then mitigated by saying that he did not feel the issues involved were worth a schism), and exacerbated things by suggesting that the most reasonable solution he could think of would be for the Remonstrants to return to the bosom of the Reformed Church. For three years he corresponded with J. Westerbaen on the matter, with the Remonstrant Westerbaen on the attack, and de Decker shifting ground constantly until neither side would have him as their own. The key issue was predetermination: did de Decker believe in it or not? His answer: yes and no. In the last analysis, though, de Decker was willing only to criticize the church, not dissent from it.

If there were any works by Rembrandt that show the influence of de Decker, it would be his etchings of 1653-1655, *Christ shown to the people* (Bartsch 76), the *Three crosses* (Bartsch 78), the *Descent*

402 *A family group*. Signed *Rembrandt*. Signature questioned by Gerson. Ca. 1663-1668. Canvas, 126 x 167 cm. Bredius 417. Braunschweig, Herzog Anton Ulrich-Museum.

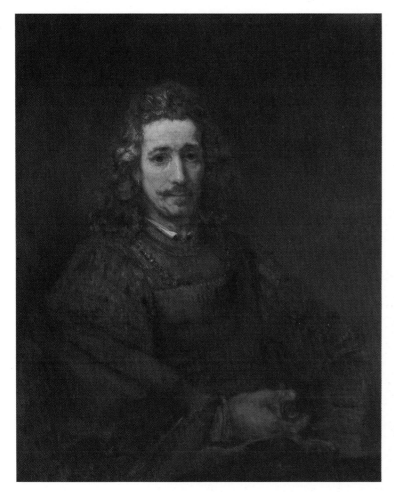

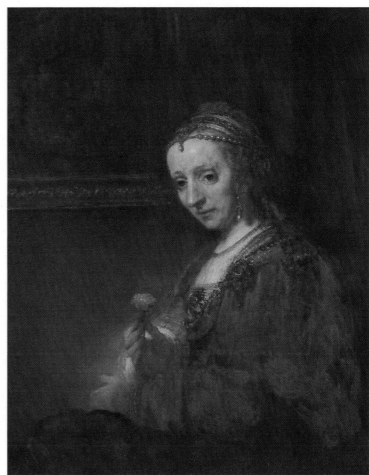

from the Cross (Bartsch 83) and the *Entombment* (Bartsch 86), which all depict Good Friday themes that were certainly compared by their mutual friends with de Decker's poem.

The relationship between Rembrandt and de Decker shows at least one clear parallel between them: both devoted a large part of their lives to the artistic interpretation of the Bible without being able to take a clear stance within an existing church, and both were made to suffer for it. They were inept players of the game of religious-artistic politics, and for that they were made to suffer even more.

Because de Decker was a writer and his ideas were the subject of open discussion, we are able to capture his character in words, wondering as we do to what extent they can be applied to Rembrandt as well: respected, but indecisive and therefore mistrusted; in his tone towards God, sometimes resigned and sometimes plaintive; to his fellow man, inspiring but in the end incomprehensible.

403 *A man with a magnifying glass*. Ca. 1662. Companion to fig. 404. Canvas, 91.4 x 74.3 cm. Bredius 326. New York, Metropolitan Museum of Art.

404 *Woman with a pink*. Ca. 1662. Companion to fig. 403. Canvas, 92.1 x 74.6 cm. Bredius 401. New York, Metropolitan Museum of Art.

The autoradiographs of the male portrait reveal a perfect preparatory drawing in boneblack, resembling the drawings for the sitters in the *Syndics*. Those of the woman show that the head of a child in the lower left, which had already been picked up in the X-rays, was painted over in an early stage of the work. The painting on the back wall is only slightly more legible in the autoradiographs – it seems to be a landscape.

With so many clues to go on, the identification of these intriguing sitters can only be a matter of time.

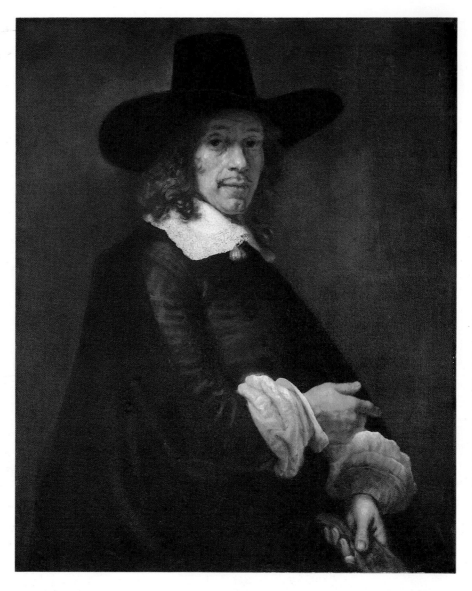

405 *A man holding gloves.* Ca. 1660. Companion to fig. 407. Canvas, 99.5 x 82.5 cm. Bredius 327. Washington, D.C., National Gallery of Art.

407 *A woman with an ostrich-feather fan.* Ca. 1660. Companion to fig. 405. Canvas, 99.5 x 83 cm. Bredius 402. Washington, D.C., National Gallery of Art.

On pure instinct, Miss van Eeghen has suggested that his pair of portraits depicts Jacob Trip Louysz. (1636-1664) and Margarita Trip Hendricksdr. (1637-1711), both grandchildren of the old Jacob and Marguerite. Her instinct has been more often right than wrong. From 1658 on, Jacob was captain of the district including the Maze, across the Rozengracht where Rembrandt lived from 1660.

406 *A fair-haired man.* Signed *Rembrandt f. 1667.* Canvas, 109.2 x 93.3 cm. Bredius 323. Melbourne, Australia, National Gallery of Victoria.

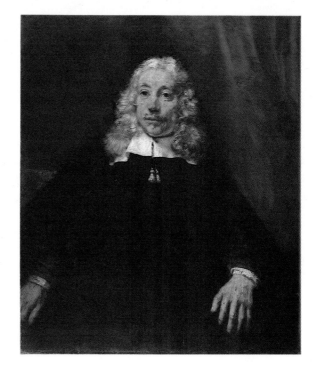

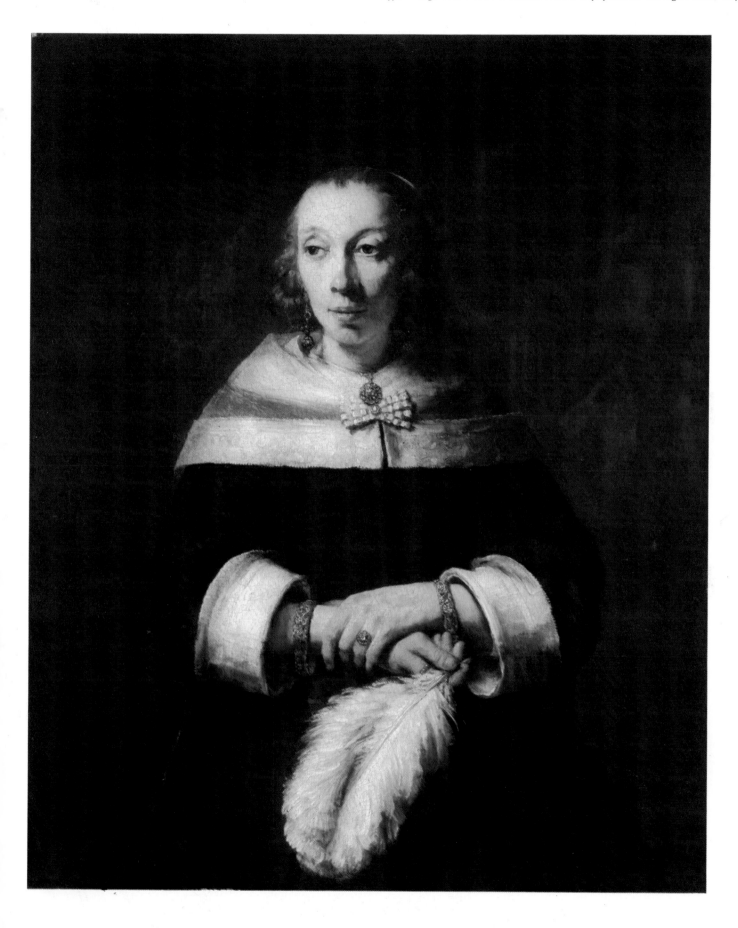

The paintings of Rembrandt can be compared loosely to the writings of poets like Huygens and Vondel. The portraits are like occasional poems, the face paintings like epigrams; the genre pictures and figure paintings have already been compared with morality and character poems. The history paintings of course are the dramas and religious poetry, and an allegory like the *Concord of the state* an heroic epic. In many cases, the same occasion that gave rise to a work of one kind also engendered the other – marriage portraits, say, and a wedding poem, or historical allusions to a contemporary event in paint and in print.

For the self-portraits, however, there is no equivalent in Dutch literature. Most of the poets Rembrandt knew avoided the first person altogether, and those who did not, like Huygens, used themselves as objects to point out a moral or win an argument. He did this within the confines of a variety of existing genres, such as the 'daily round' poem or the religious psalm. Perhaps if one analyzed Rembrandt's self-portraits in this light, they too would fall into categories comparable to literary forms. For the moment, they appear to us as a group on their own, not only unrelated to the varieties of poem, but unprecedented, even within the realm of art. Self-portraiture as a specialty was Rembrandt's most fundamental contribution to the profession of painting as such.

As a measure of prestige, self-portraiture was also his most successful type of work: the first paintings by Rembrandt to enter the royal collections of England and France and that of the German emperor, the summit of status in Rembrandt's world, were all self-portraits. Even in terms of everyday commerce, the self-portraits provided a thankful return on the artist's efforts. None at all is found in the inventory of 1656, meaning that he found buyers for all of the earlier ones by then.

To come back to the question of royal collections: we do not know whose idea it was to give a self-

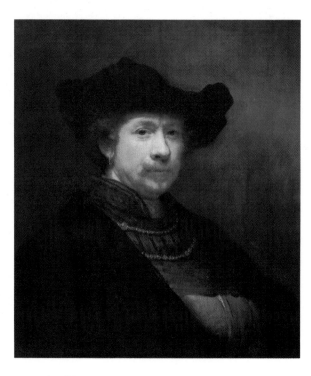

408 *Self-portrait*. Signed *Rembrandt f. 164[.]*. Ca. 1642. Panel, 67.5 x 57.5 cm. Bredius 37. Windsor Castle, collection of Her Majesty Queen Elizabeth II.

portrait of Rembrandt to an English legate, but looking back, one wonders whether there was not an element of calculation in the move – to make Rembrandt better known at the English court than he would have been if represented there with a normal subject painting or portrait. To establish him as a personality linking the courts of Orange and Stuart. If so, then the initiative was not pursued. But others were undertaken in later years, not on behalf of third parties, but for the artist himself.

The *Self-portrait as Ariosto* was made under the gaze of an agent of the king of France, Alphonso Lopez. This time, however, the transfer was not effected, let alone that the painting helped Rembrandt become a French court favourite. I suspect that it was bought by Johannes de Renialme.

One of the next self-portraits Rembrandt painted after that, however, now in Karlsruhe (fig. 409), had as its first known owner Hyacinthe Rigaud (1649-1743), court painter to Louis XIV and XV. The

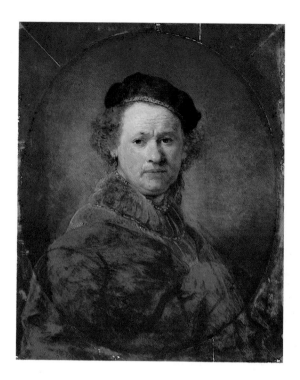

409 *Self-portrait.* Ca. 1643-1645. Panel, 69 x 56 cm. Originally oval, enlarged in the eighteenth century to a rectangle. Bredius 38. Karlsruhe, Staatliche Kunsthalle.

It seems strange that Rembrandt would paint an oval self-portrait so long after he had stopped painting portraits in that shape. The painting was one of Hyacinthe Rigaud's seven Rembrandts or so-called Rembrandts (one was a *Head of John the*

Baptist, a subject that Rembrandt never painted). If the date and attribution are nonetheless correct, this is the only self-portrait painted during the decline of the 1640s.

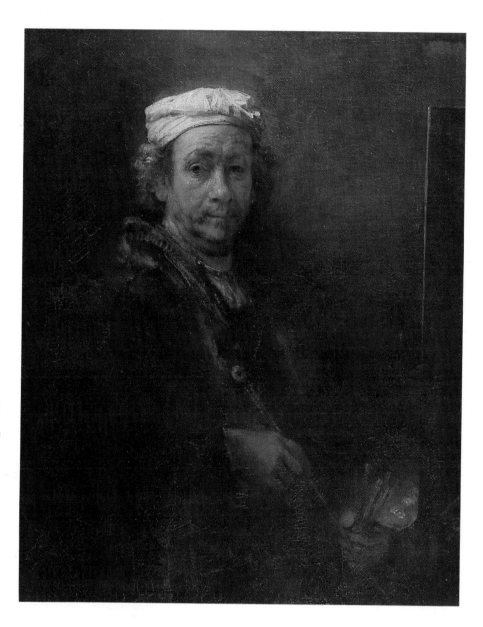

410 *Self-portrait.* Signed *Rem*[brandt] *f. 1660.* Canvas, 111 x 85 cm. Bredius 53. Paris, Musée du Louvre.

painting that finally was bought by Louis XIV (fig. 410), probably by 1671 but in any case by 1683, came to him via a route that has been demonstrated by Jacques Vilain and Jacques Foucart. Noticing that in 1695 there was a copy of the painting in the collection of the Paris banker Everard Jabach, and that Jabach owned copies only of paintings that had once been in his possession, they concluded that fig. 410 belonged to him before it was sold (through Sieur de la Feuille) to the king.

As it happens, we know with whom Jabach dealt in Holland. When Gerrit Uylenburgh went bankrupt, his largest creditor was 'Everard Jabach in Paris, 5142 guilders.' Uylenburgh undoubtedly sold to Jabach as well as buying from him, and this painting was very likely one of his sales. It is dated 1660, and since Rembrandt's insolvency was not lifted until December 15th of that year, a fiscal investigator working for the Insolvency Court would certainly have tried to find out, if he knew about the

SELF-PORTRAITS IN DUTCH COLLECTIONS

1685
Joseph Deutz, an associate of the Trips, who had his own house built by the same architect and builders as theirs, owned a self-portrait appraised at 80 guilders.

1689
Willem Spieringh, Delft.

1687
Anonymous auction, Amsterdam: a painting called a Rembrandt self-portrait is sold for six guilders.

1700
Mme. van Sonsbeeck, The Hague. A family from the circle of the Trips, later to marry into the Trip clan.

1706
Jan de Walé, Amsterdam, a relative of Jacob Jacobsz. Hinlopen's wife. At the auction of his goods a self-portrait is sold for thirty guilders.

1709
Valerius Röver, Delft, Related through the Graswinckel family to the Trips.

1711
Sibert van der Schelling, Amsterdam, owned, according to Uffenbach, 'an incomparable portrait of Rembrandt made by himself, quite large.'

(See also pp. 192-193).

painting, whether the sale took place before that date, unreported and illegal. It is not for us to judge the merits of the case, but we cannot deny that Rembrandt and Gerrit Uylenburgh have once more incurred the suspicion of the historian that they were selling Rembrandt's work out of the country behind the backs of creditors and courts.

FROM COURTIER TO PRINCE | Until now, I think I have been successful in avoiding the art historian's sin of trying to interpret my artist's character on the basis of his work. The notion that seventeenth-century artists chose their subjects in order to express their inner convictions has been shown by others to be utterly without ground, and our findings in this book are certainly consistent with theirs. When it comes to Rembrandt's late self-portraits, though, it is hard not to psychologize, and I am not sure that it is a virtue to try. As lightly as I can, I shall attempt to fit the self-image of the artist into the historical picture we have worked up.

When we left Rembrandt the self-portraitist in 1640, it was in the guise of the court poet Ariosto, a role that fitted in with the exalted expectations of those years. From around the time of Saskia's death are one or two other works (figs. 408, 409) of a far more uncertain character. None of the works of the ensuing decade that answer to the description 'Rembrandt self-portrait' is accepted by present-day scholars as authentic, leaving us no way for the moment of placing them. Rembrandt's re-emergence as a self-portraitist occurred in the same year he began to receive major commissions after the blight of the forties – 1652, the year of the *Nicolaes Bruyningh* (fig. 304) and the commission for the *Aristotle* (fig. 334). Dated 1652 is the great three-quarter-length self-portrait in Vienna (fig. 412), a work of the same type as the portraits of Six and Soop (figs. 301, 306). That the association with Six inspired Rembrandt with fresh self-confidence is suggested by his etched self-portrait of 1648, the

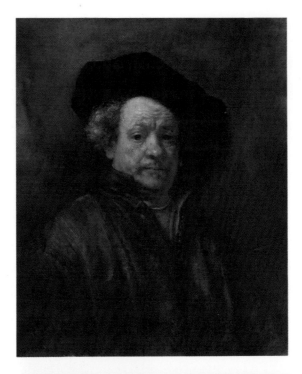

411 *Self-portrait*. Signed *Rembrandt f. 1660*. Canvas, 80.3 x 67.3 cm. Bredius 54. New York, Metropolitan Museum of Art.

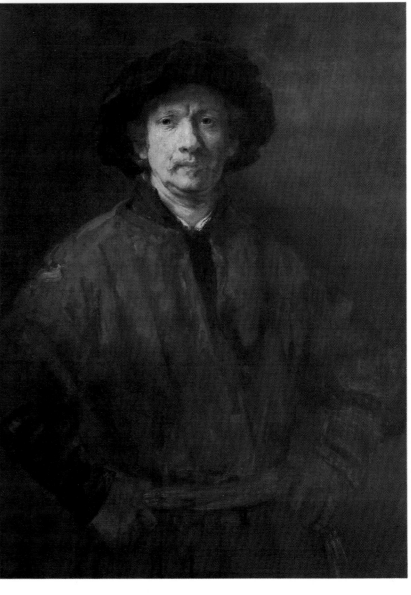

412 *Self-portrait*. Signed [Rembran]*dt f. 1652*. Canvas, 112 x 81.5 cm. Bredius 42. Vienna, Kunsthistorisches Museum.

With the portrait of *Nicolaes Bruyningh* of the same year (fig. 304), this work represents Rembrandt's recovery from years of decline and indecision.

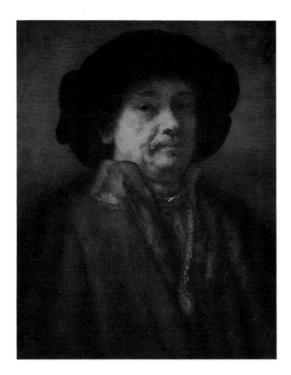

413 *Self-portrait*. Signed
Rembrandt f. 1655. Panel, 66
x 53 cm. Bredius 44. Vienna,
Kunsthistorisches Museum.

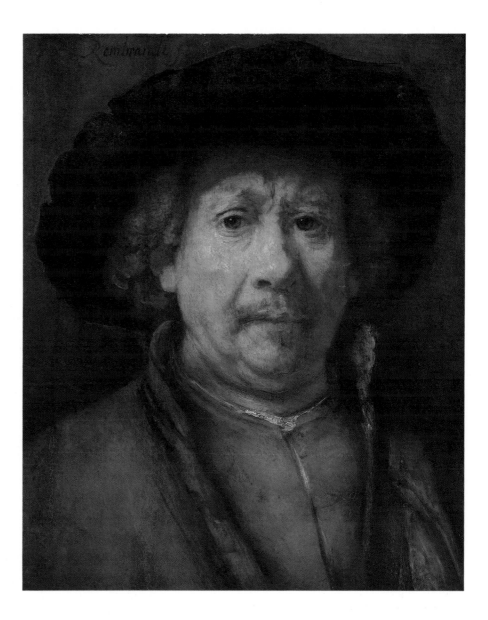

414 *Self-portrait*. Signed
Rembrandt f. Ca. 1655. Panel,
49.2 *x* 41 cm. Bredius 49.
Vienna, Kunsthistorisches
Museum.

year after that of Six. In it, he shows himself at the window, sketching, just as he had shown Six at the window reading. This is the first self-portrait in which Rembrandt appears in working clothes, at work, an image that is to become increasingly important to him.

The three-quarter-length of 1652 is the painting that is first recorded in Vienna, in the collection of Emperor Karl VI, and as such it may have something to tell us about the way the self-portraits were sold in the 1650s. By 1659, we know, Karl's great-uncle Leopold Wilhelm owned a lost 'astrologer' whose subject suggests that it was made around the same time as the *Aristotle* in the early 1650s. One suspects that the combination of van Goor, Just and Gerrit Uylenburgh, which was behind the sale of the *Aristotle, Homer* and *Alexander* to Ruffo and probably that of the 1660 *Self-portrait* to Jabach, may also have been instrumental in placing the *Astrologer* with Leopold Wilhelm and perhaps the 1652 self-portrait with someone else high up in the imperial court. The existence of a large number of copies of the work suggests that it remained in the hands of dealers for some time before disappearing into a palace, but the two things do not have to contradict each other.

Other self-portraits of the 1650s and '60s, which

however present problems of identification or authenticity, were documented in two important collections lower down the pyramid than those imperial and royal ones: by 1675 Cardinal Leopoldo de Medici had one in his Pitti Palace, and by 1719 Elector Johann Wilhelm of Düsseldorf. It would appear that the self-portraits of the last decades were being thrust into the world of European royalty and nobility as a kind of superior calling card.

In the short run, these early sales did not lead to an explosion of interest in Rembrandt. (Although we do not know whether these other patrons also tried to order more paintings from the artist, only to be brushed off as arrogantly as Ruffo.) Seen as an investment in depth, however, the efforts made by van Goor, Just and Uylenburgh or whoever else it was who got these paintings sold, brought more lasting gains for the Netherlands than that other classic Dutch investment of the seventeenth century, the purchase of Manhattan Island. (For twenty-one

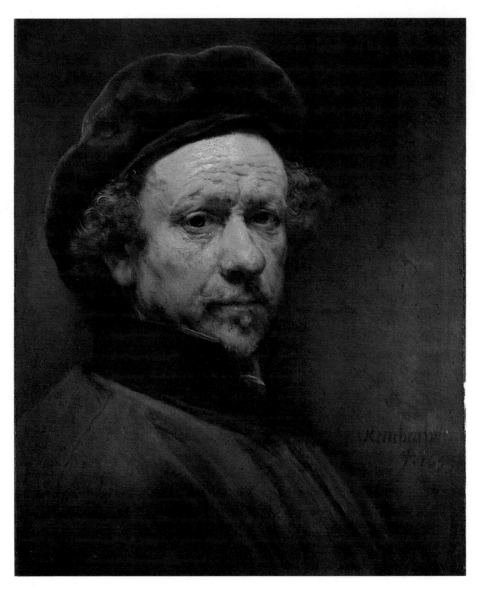

415 *Self-portrait.* Signed *Rembrandt f. 1657.* Canvas, 53.5 x 44 cm. Bredius 48. Edinburgh, National Gallery of Scotland.

The general feeling, expressed by Gerson, is that the painting must have been larger originally. During a restoration in 1933, added pieces of canvas were removed from all sides which, even if they were not original, may well have replaced additions to the central canvas made by Rembrandt, as he did to Ruffo's *Alexander.*

dollars worth of beads that were probably manufactured by Floris Soop's father.)

Even if there were no outside evidence that the intended market for the late self-portraits were the crowned heads of Europe, the thought enters one's mind willy-nilly regarding the painting in the Frick Collection (fig. 416). Rembrandt's painting three years later of the richest man he ever painted, Jacob Trip, was an inch shorter than this portrait and distinctly less regal in appearance. I cannot imagine this, the largest and most overwhelming of the self-portraits, hanging anywhere but in the collection of someone whose own portraits were commensurately larger and whose dignity could bear comparison, at least in his own eyes, with that of this awe-inspiring figure.

REMBRANDT AS APELLES | It was such a cliché to call a painter the Apelles of his age that the compliment cannot have meant very much. On the other hand, because of the very ease with which the exaggerated praise was uttered, it may have hurt a painter not to be compared with the court artist of Alexander the Great. In print, no one in Holland did that for Rembrandt until 1667, when de Decker's collected works were published posthumously.

Before then, Rembrandt himself seems to have applied the simile to himself in his self-portrait in Kenwood House (fig. 419). The interpretation of the arcs behind the painter in the work have given rise to several theories, of which the most likely is that the artist is showing himself as the prince of painters.

Apelles came to Rhodes, in a story told many times, and at length by van Mander, to make the acquaintance of a master he respected but had never met, Protogenes. When he arrived at his home, Protogenes was out, and instead of telling the old servant woman his name, he drew on a primed canvas, with the brush, a fine line. Protogenes,

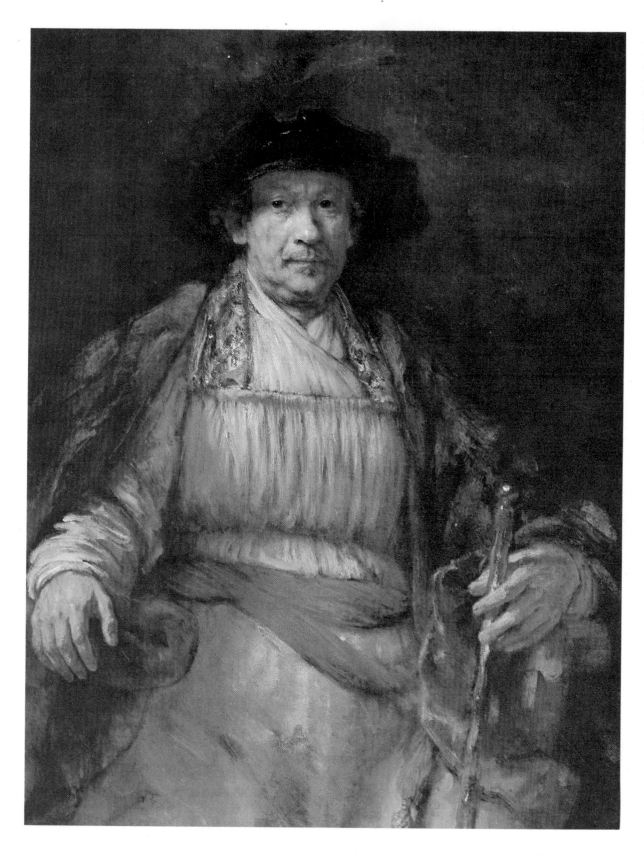

416 *Self-portrait*. Signed *Rembrandt f. 1658*. The signature was re-painted, according to Gerson, and he says it may read 1655. Canvas, 133.7 x 103.8 cm. Bredius 50. New York, The Frick Collection.

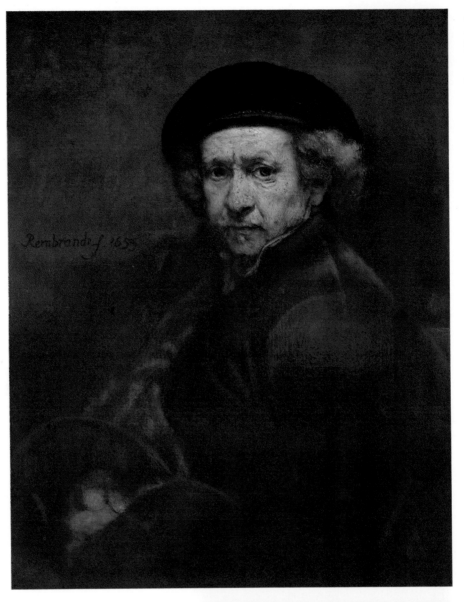

417 *Self-portrait*. Signed
Rembrandt f. 1659. Canvas,
84 x 66 cm. Bredius 51.
Washington, D.C., National
Gallery of Art.

418 *Self-portrait*. Ca. 1660.
Canvas, 85 x 61 cm. Bredius
60. Florence, Uffizi.

seeing it, realized that it must be the work of
Apelles, and, entering into the spirit of things, drew
another line on the same canvas, equally fine.
Apelles was only nonplussed for a moment on his
second visit. Seeing a way of outplaying his rival, he
picked up a brush and drew a third line cleaving the
first two perfectly.

The story, from Pliny, leaves the reader guessing
what kind of line the two masters drew. A similar
legend concerning the Italian master Giotto speaks
of a circle drawn with the free hand, and this seems
to be the interpretation here depicted by
Rembrandt. The artist as Apelles is standing before
a large canvas with his own first circle and his rival's
answer, in the form of an arc, and he is about to
draw an equally fine third circle cutting across the
other two. As Rembrandt evokes the scene, we
expect the third circle to have the same diameter as
the others, and for its centre to lie exactly between
theirs.

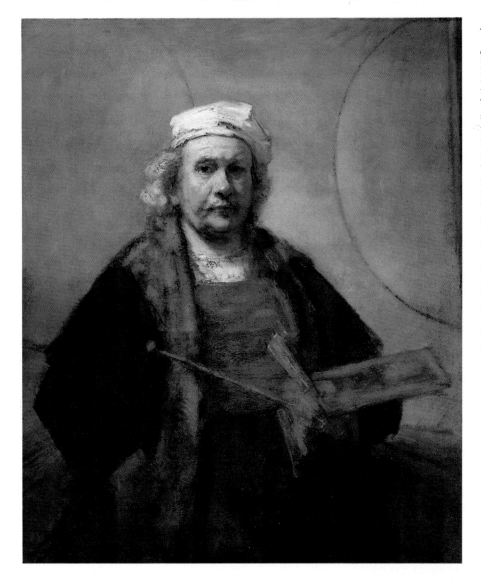

419 *Self-portrait.* Ca. 1661-1662. Canvas, 114.3 *x* 95.2 cm. Bredius 52. London, Kenwood House, The Iveagh Bequest.

This is only Rembrandt's second painted self-portrait with a palette. One can interpret it as a sign of modesty and reconciliation with reality, after the Persian princes, soldiers, Renaissance poets and patricians of past works, but if the meaning suggested in the text is accurate, there is little reason to think the artist is being modest. The arcs behind Rembrandt have been a scholarly conversation piece for a hundred and fifty years, and continue to add interest to a work that shows the artist the way one wishes he really was.

Rembrandt had good reason to identify himself with Apelles, not just for the ancient artist's supremacy, but for one of his presumed shortcomings: 'Plutarch chides Apelles,' tells Hoogstraten (p. 301). 'When he painted Alexander with lightning in his hand he failed to capture the sitter's natural complexion, making him browner and darker than he was… But it is possible to excuse Apelles for this on the grounds that he had put all the light he could into the lightning and the extended hand holding it, so he had no choice but to diminish the brightness of the face in order to establish a proper balance between brighter and darker passages, in accordance with the laws of art.'

In effect, Hoogstraten describes Apelles as a master of chiaroscuro, making him a much-needed ally for Rembrandt, the turn things were taking. His image was beginning to crystallize into the caricatural form that Houbraken would put into words sixty years later: 'In order to bring out the

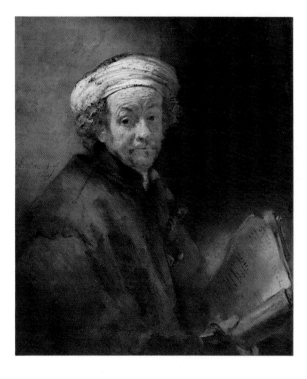

420 *Self portrait as the apostle Paul.* Signed *Rembrandt f. 1661.* Canvas, 91 *x* 77 cm. Bredius 59. Amsterdam, Rijksmuseum.

A potent compound of the half-length self-portraits with the apostles and saints of the same period.

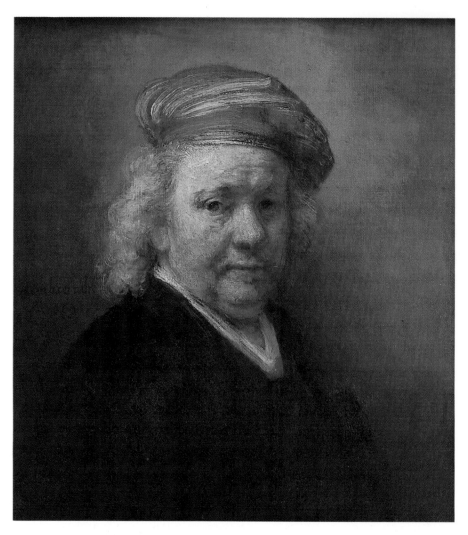

421 *Self-portrait*. Signed *Rembrandt f. 1669*. Signature redrawn but correct, according to Gerson. Canvas, 63.5 x 57.8 cm. Bredius 632. The Hague, Mauritshuis.

strength of a single pearl, [Rembrandt would have] covered a beautiful Cleopatra completely under *taan*.'

Taan was a transparent, yellow-brown shellac that darkened with age, as the owners of so many Rembrandt paintings know. We notice that in the self-portrait itself Rembrandt answers his critics differently, by painting so brightly and clearly that no one could find fault with the work.

If that is the metaphor of the self-portrait, it has even more to tell us. Apelles was the artist who painted a one-eyed king, just as Rembrandt at this time was painting his one-eyed Claudius Civilis. And the painting on the easel is unfinished, as Rembrandt's customers were always complaining about his works. Even when the third line was added, van Mander tells us, the painting looked like nothing so much as a raw canvas. Yet the painting later became a cherished possession of the emperors of Rome, visitors to whose palace were delighted to

discover that an apparently unfinished work could display to the eye of the connoisseur such unimpeachable perfection.

This interpretation, though, is putting words into Rembrandt's mouth, and we would do better to await further confirmation of the main subject before giving our full credence to it.

REMBRANDT AS ZEUXIS | Whether or not the Rembrandt of the town hall years painted himself as Apelles triumphant, it is certain that in his final decline he painted himself as another Greek painter, Zeuxis, not in triumph but caught in the jaws of death. Thanks to Albert Blankert's brilliant demonstration, we know the laughing self-portrait in Cologne to be Rembrandt as Zeuxis in his final moments. The same subject was painted by Aert de Gelder, and is told by van Mander in the appendix to the *Lives*: 'Zeuxis is said to have departed this life while laughing immoderately, choking while

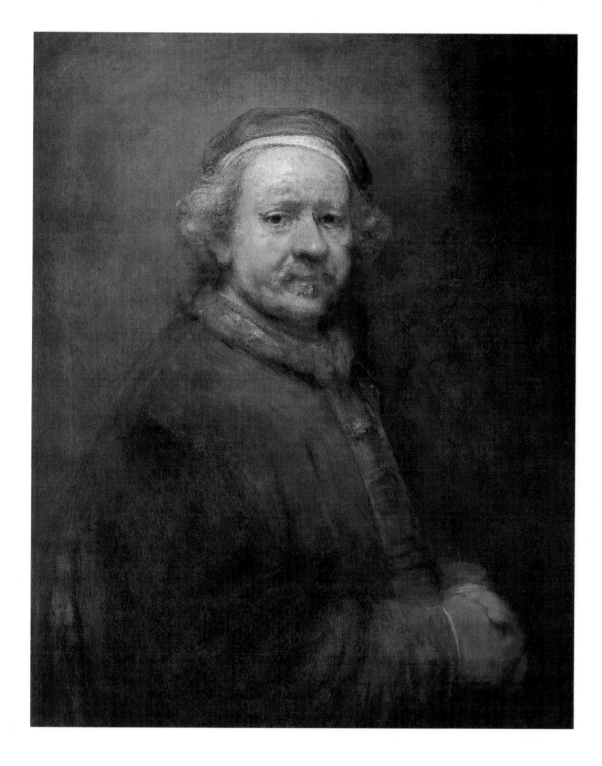

422 *Self-portrait*. Signed *Rembrandt f. 1669*. Canvas, 86 x 70.5 cm. Bredius 55. London, National Gallery.

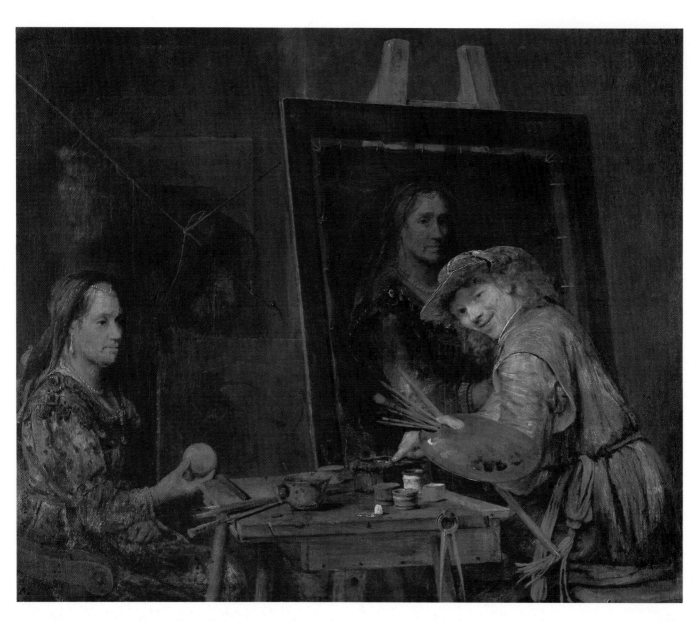

painting a wrinkled, funny old woman in the flesh…
On this motif a certain poet coined these lines: 'Are
you laughing to excess? Or trying to imitate the
painter who laughed himself to death?''

A laughing self-portrait, a return to his first
exercises in art in order to paint a satirical subject
like those of his own prehistory: old men flawed by
blindness, dullness, gullibility, lasciviousness,
cupidity. This old man, an old painter, is flawed,
and destroyed, through his disdain for the ugliness
of a fellow human being. This is how Rembrandt let
himself be remembered.

423 Aert de Gelder
(1645-1727), *The artist as
Zeuxis*. Signed and dated
1685. Frankfurt, Städelsches
Kunstinstitut.

Albert Blankert has shown
that Rembrandt's painting,
like de Gelder's, must depict
the artist as the Greek painter
Zeuxis who died laughing
while painting a funny-
looking old woman.

De Gelder continued in
Amsterdam and Dordrecht to
paint in Rembrandt's late

style for the rest of his life.
The broad manner that
brought such opprobrium on
Rembrandt apparently
remained popular in some
circles. The identification of
such late commissions as the
Family group (fig. 402) would
give us the name of at least
one such patron. In view of
the Dordrecht connection,
and the style of the portraits
the Trips ordered from
Rembrandt, it would seem
like a good idea to look first in
their direction.

424 *Self-portrait as Zeuxis*.
Ca. 1669. Canvas, 82.5 x 65
cm. The upper corners have
been replaced, and the
painting may originally have
been somewhat larger.
Bredius 61. Cologne,
Wallraf-Richartz-Museum.

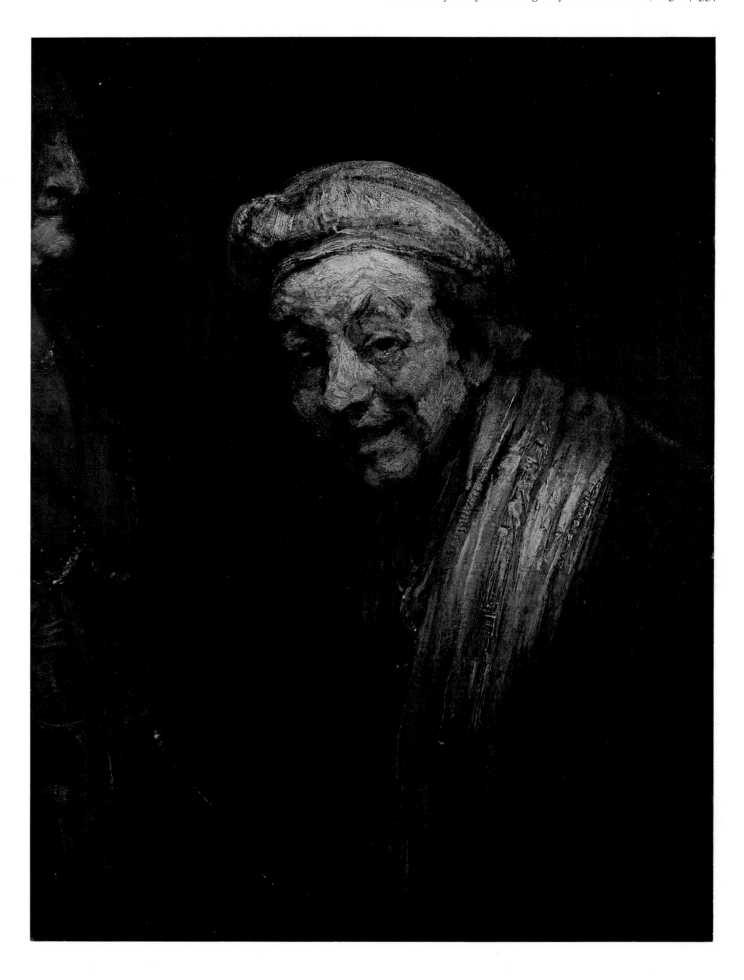

Afterword

The motto opening this book (p. 8) was spoken by J.G. van Gelder at a Rembrandt symposium in Berlin in 1970, commemorating the 300th anniversary of the master's death. His plea for a reconstruction of Rembrandt's circle of patrons did not go unchallenged. In the discussion that followed, Julius Held expressed 'doubt concerning van Gelder's opinion that all efforts to improve our grasp of the essence of Rembrandt's art will not be of much use without intensified study of the documents. What is the point of documents or sources that tell us that paintings by Rembrandt were in this or that collection for a period of time? Even if we find out who the *Shipbuilder and his wife* were, it may be historically interesting, but it is not essential for the interpretation of the painting.'

To judge by developments in the intervening years, I am afraid that Held's opinion has held more sway than van Gelder's. The unremitting efforts of I.H. van Eeghen and S.A.C. Dudok van Heel to provide art historians with the basic material for a new understanding of Rembrandt – even the invaluable compilations of Rembrandt documents published by C. Hofstede de Groot in 1906 and W. Strauss and M. van der Meulen in 1979 – have been treated as 'historically interesting' and nothing more. Art historians have continued their search for 'the essence of Rembrandt's art' in two directions: probing the 'corpus' of paintings to determine the authenticity of individual works, and analyzing their iconography with reference to artistic tradition. In neither approach is an attempt made to fit the paintings into their immediate social and intellectual niche.

Now it must be admitted that van Gelder's reply to Held was not very exciting. 'I do not wish to exaggerate its importance, but it does improve our understanding of the circle of collectors, patrons and buyers of Rembrandt's works, and therefore of the milieu in which Rembrandt lived and worked.'

After what we have uncovered in this book concerning the ties and tensions between Rembrandt and his patrons, I think we can formulate a much stronger reply to Held's criticism: without a proper understanding of the milieu for which a work was made, the respective position in it of the artist and the patron, as well as the circumstances defining the commission or purchase, we have very little chance of understanding a painting by Rembrandt at all. The perils of ignoring this evidence cannot be illustrated better than in the work of Held himself on Rembrandt. One of his contributions is a small book entitled *Rembrandt and the Book of Tobit*, in which no mention is made of the fact that Tobit was struck out of the Calvinist Bible during Rembrandt's early life, while it was cherished by Mennonites and Catholics. This leaves the rest of the author's reflections on his subject indeed up in the clouds.

Even with the patchy evidence at our disposal, the reconstruction of Rembrandt's milieu can bring us much closer than even van Gelder thought possible to an understanding of the original meaning of his work. Not just the meaning of the paintings in terms of Rembrandt's career and his patrons' material interests – although I consider these far more important than they have been given credit for – but even in terms of their iconographic, stylistic and aesthetic meanings.

THE CONTRIBUTIONS OF THE PATRONS | Perhaps the most significant conclusion we can attach to the evidence in the foregoing chapters is that Rembrandt's paintings were not solely the product of one man's mind. The Rembrandt who painted superior genre paintings for Jacques de Gheyn was the same artist who made Holy Families for Johannes de Renialme and theatre paintings for Jan Jacobsz. Hinlopen. Some of the vast differences between the iconographical and even stylistic approaches in those paintings are unquestionably due to the character and interests of those for

whom they were made. If we study the paintings exclusively in terms of Rembrandt's development as an artist, we are bound to miss not just 'interesting' but essential aspects of their meaning as works of art.

A rough recapitulation of Rembrandt's patronage, in the graph on pp. 360-361, can serve to remind us of the various circles for which he worked, of the kinds of work he made for each, and when. It is revealing that the resulting curve – peaking in 1631-1634, then declining to a low level from which it shot up briefly a few times thereafter – is paralleled by the curve of Rembrandt's productivity as a whole. Lest the reader be inclined to think that this is a result of the large number of portraits, which are always attached to a patron, I have also included the curve for the etchings. Although these were seldom commissioned, as far as we know, they display the same ups and downs as the paintings. The stimulus of patronage was apparently indispensible for Rembrandt's productivity.

The role of the patrons forms a kind of mold for the shape of Rembrandt's oeuvre. Both forms are worn by time, but there can be no question that they fit.

CONSTANTS IN REMBRANDT'S PATRONAGE | The most striking constant in Rembrandt's patronage is that so much of it came from the de Graeffs and their circle. Andries de Graeff, Frans Banning Cock and Willem Schrijver were in the family itself, the Trips were allied to it by marriage, Wtenbogaert and his master Frederik Hendrik were dependent on their favour, Joan Huydecoper, Nicolaes Tulp and Jan Jacobsz. Hinlopen owed their council seats or burgomasterships to them. Hendrick Uylenburgh's shop was financed in part by cousins of Cornelis de Graeff's wife. This phenomenon could be chalked up to chance if not for the equally striking absence of patronage from any other source in Amsterdam politics. The Oetgens van Waveren and Bicker families, who were conspicuous in the careers of Flinck and van der Helst, are completely missing in Rembrandt's.

Wherever we locate the ultimate source of the tie between Rembrandt and the de Graeffs – my own feeling is that it was brought about by Scriverius – it is clear that it is a larger and more significant constant in Rembrandt's career than any other. It cuts neatly across even the lines of religion we have traced. The Remonstrants, Mennonites and Calvinists alike in Rembrandt's life were, nearly without exception, the Remonstrants, Mennonites and Calvinists in the camp of the de Graeffs.

If this is the most enduring feature in Rembrandt's career, then it stands to reason – and reason is for once backed up by the facts – that the other changes in his life had a minor influence on his fortunes, by comparison. This includes the features which are usually singled out as the backbone of his career: the development of his style and the evolution of his conception of art. These are matters which may be of infinitely more concern to us than the clan politics of seventeenth-century Amsterdam, but to see them as active factors in Rembrandt's career can only be misleading.

Another extremely striking constant in Rembrandt's career in Amsterdam was a topographical one: the majority of his connections there lived in two streets, the Sint Anthonisbreestraat and the Kloveniersburgwal, in a part of town that was a Remonstrant stronghold. In the two hundred metres from his house to the Nieuwmarkt and the eight hundred from there to the Kloveniersdoelen we find the houses of nearly all his important protectors, dealers and customers, from Pieter Lastman to Joannes Wtenbogaert to Hendrick Uylenburgh, Jan Six, the Hinlopens and the Trips. The same is true of the group portraits, all four of which were made for institutions in that single small section. This is the part of town where the de Graeffs had their family home until, in the 1610s, they moved to a new home on the Herengracht.

Then there are the business ties between his patrons. We find the Amsterdamers among them concentrated in a few lines of trade: the interrelated enterprises of textile, dye manufacturing and cloth dyeing. Trade with Russia plays an important role in their business lives, as does the arms business. The medical world is represented in portraits and group portraits of physicians and surgeons and in the abiding interest shown in Rembrandt by two men whom we have unfortunately not been able to deal with in this book, the surgeon Daniel Francen and more especially his apothecary brother Abraham. Of the Rembrandt patrons in government, three were tax-collectors: Wtenbogaert, Martens and de Man. Others were town secretaries in Leiden and Amsterdam.

The most unchanging feature of Rembrandt's professional contacts was his association with the world of letters. Petrus Scriverius, Constantijn Huygens, Joost van den Vondel, Gisbertus Plempius, Jan Hermansz. Krul, Menasseh ben Israel, Caspar Barlaeus, Jan Vos, Tobias van Domselaer, Jeremias de Decker, Jan Six, Gerard Schaep, Pietersz., Jacob Lescaille and Joannes Serwouters were some of the scholars, poets and playwrights with whom he had significant ties, but

	1625	26	27	28	29	30	31	32	33	34	35	36	37	38	39	40	41	42

Leiden civil servants, notaries, burghers
Genre, portraits (?), faces

Scriverius-Schrijver-Soop
Bible, ancient history, portrait, portrait historié (?)

Wtenbogaert-de Gheyn
Moralized genre, portraits, allegorical portrait

Frederik Hendrik
Bible, mythology, portraits, allegorical portrait, self-portrait, faces

Specx
Bible, mythology, saint, portraits

Hendrick Uylenburgh
Bible, portraits, figures, faces

Surgeons' guild, Kloveniersdoelen, town hall, drapers' guild
Group portraits, national history

Amsterdam Remonstrants
Portraits

Amsterdam Mennonites
Bible, portraits, faces

Amsterdam Catholics
Bible, portraits

Soolmans-Coppit-van den Broeck
Bible, portraits, self-portrait, landscape

Hinlopen-de Varlaer-van Domselaer
Bible, mythology, theatre, genre, portraits

Bol
Bible, portrait

Doomer
Bible, portraits

Trip
Portraits

De Renialme
Bible, portraits, self-portrait, faces

Van Ludick
Bible, faces

Six
Bible, mythology, portraits

Van de Cappelle
Bible, portraits, faces, landscape

Van Goor-Ruffo-Just-Gerrit Uylenburgh
Half-lengths, self-portraits, faces

Becker
Bible, mythology, half-lengths, portrait, still-life, faces

REMBRANDT'S FOREMOST PATRONS
AND COLLECTORS
These twenty-one persons,
groups and institutions are
known to have commissioned
or purchased paintings by
Rembrandt over a period of
years. The blue dots mark the
years in which we can date
with certainty commissions,
purchases or other signs of
close contact. The yellow dots
indicate years when undated
commissions probably took
place.
 The green graph gives the
sum of these groups of
patrons, year by year, with the
blue dots counting for two
yellow ones.
 The bars below the line give
an indication of Rembrandt's
overall production of
paintings and etchings. The
sample counted consisted of
248 dated paintings (light red)
and 165 dated etchings (grey).

there are quite a few others as well. In their turn, Rembrandt's literary associates permeated all the other circles of patronage we have discussed.

This phenomenon has never, as far as I know, been singled out for study. Although the general feeling prevails that Rembrandt was a poetic artist, there has always been a great reluctance to link his name with other, less desirable literary qualities. Anything smacking of the anecdotal, the illustrative or the theatrical, for example, has always been regarded as antithetical to Rembrandt's mature art. If Rembrandt illustrated a scene from a play, art historians would see it as their first task to demonstrate how far he rises above the literary aspects of his subject, let alone the topical ones. One of the dogmas of the Rembrandt creed is that the master penetrated to essences, while his colleagues clung to surfaces.

Moreover, historians of art and literature seem to agree that Rembrandt was so much greater an artist than any of his literary contemporaries in Holland that any influence they had on him could only have been trivial.

VARIABLES | Within the constellation of the de Graeff clan, there were few individuals who had a strong personal affinity with Rembrandt. This was typical of his relationships in general. Of his primary working associations, none lasted very long. Judging by the dates we know with some certainty, we can say that he worked with Scriverius from 1625 to 1627, with Lievens from 1627 to 1631, with Huygens from 1627 to 1633, with Hendrick Uylenburgh from 1631 to 1636 and 1640 to 1642, De Renialme from 1640 to 1646, Jan Six from 1647 to 1654 and Gerrit Uylenburgh from 1660 to 1669. Certain figures behind the scenes remained in Rembrandt's life for longer periods: Joannes Wtenbogaert from 1626 to 1642, Lodewijk van Ludick from 1642 to 1664, Abraham Francen from 1653 to the painter's death. With Uylenburgh, Six and van Ludick, Rembrandt ended up in the courts or in front of the notary, while his associations with Lievens, Huygens, Wtenbogaert and de Renialme all terminated with suspicious abruptness. Few of Rembrandt's pupils showed any inclination to keep in touch with him after leaving his studio.

WHY DID REMBRANDT HAVE SUCH A HARD TIME OF IT? | At every stage of his life Rembrandt did have people around him – a dealer, a patron, a good customer, a friend at court. Moreover, from the time he was twenty he was always regarded as one of the most gifted artists in the country. What prevented him from building a career like Flinck's

upon this base, full of honour and wealth? While it would be untrue to call Rembrandt a failure in his time, neither was he an unqualified success, at least not after 1635.

If our analysis of Rembrandt's dependence on the de Graeffs is correct, we are guided to a simple answer to our question; Rembrandt's career faltered because he failed to acquire the indispensible protection of the clan leaders, Jacob and Cornelis. There are indeed no known direct ties between him and either of them. Another indirect proof of Rembrandt's failure to break through to the top is that he never, in nearly forty years in Amsterdam, painted a sitting or former burgomaster.

This answer, however, raises the next question: why was Rembrandt not accepted at the top?

That Rembrandt, the protégé of Remonstrant patrons, lacked support in Leiden, can be attributed directly to politics; in The Hague to a combination of political and personal factors; but in Amsterdam, I am afraid, almost entirely to personal ones. The clashes with Uylenburgh, Andries de Graeff, even Cornelis Witsen, could have been averted, I am sure, by someone with even a grain of the tact that was altogether absent from Rembrandt's character. That quality would also undoubtedly have made it possible for Rembrandt to win the trust of Cornelis de Graeff, as Flinck did.

He was, however, far from being tactful. The Geertge Dircx tragedy shows him as a bitter, vindictive person who reacted to setbacks by attacking the adversary with all means, fair and foul. His dealings with Lodewijk van Ludick and Jan Six show him to be underhanded and untrustworthy even to his friends, and those with Antonio Ruffo as arrogant to those who admired him. He would go to great lengths to avoid paying debts, especially the interest-free ones extended by well-wishers. We know this from his behaviour towards the sellers of his house, his creditors of 1655-1656, van Ludick, Saskia's family and his own son.

It would hurt me if the reader thought that I was painting too black a picture of Rembrandt's character by leaving out evidence of his humanity. Believe me, this is not so. If anything, I have spared him of even worse, such as the testimony that he stole some of the savings of his daughter, Cornelia, half of which belonged to Titus's widow.

Additional evidence concerning his character is provided by documents that do not exist: no one ever asked Rembrandt to be the godfather of their child, or even to witness a document for them. The only legacy he ever received, apart from those of his parents, was a share in the estate of a Leiden relative who had left the country when Rembrandt was nine

years old and was presumed dead after fifty years. Both his wife and his sister Elisabeth re-wrote their wills to cut him out completely. He was never even called in as an expert to testify to the authenticity or value of paintings, except in one unusual instance.

To sum it up bluntly: Rembrandt had a nasty disposition and an untrustworthy character. To compound the damage, those who were inclined to overlook his faults out of respect for his great qualities as an artist were as likely as not to be treated to insults and lawsuits for their trouble. He himself sabotaged his own career.

Several people with whom I have discussed this have refused to allow it to upset them. Even if they did not share the misguided feeling that genius is an excuse for any kind of unsocial behaviour, they would say things like: 'If Rembrandt had had a more amiable nature, he would have been a court artist or a decorative painter, and who would have wanted him to become that?' Well, I would have, for one. Had he been able to collaborate with Jacob van Campen, decorating the stadholder's palaces and the town hall of Amsterdam, the Netherlands may have been blessed with the greatest seventeenth-century artistic creations in northern Europe.

CRITICISM OF REMBRANDT | In the course of this book we have followed the attitudes towards Rembrandt by those whom the American art historian Seymour Slive has called 'his critics.' The term, I feel, is misleading. If one takes account of where the men who wrote about Rembrandt, from Constantijn Huygens to Andries Pels, stood in Dutch life, one discovers that they were not the disinterested observers one expects an 'art critic' to be. With Rembrandt, they were participants in a contest for favour in which art and criticism alike were among the weapons.

If the reader was unprepared for the harshness of my judgment of Rembrandt, it is because the artist's former biographers have bent over backwards not only to give him the benefit of the doubt, but to explain away or even reverse the meaning of negative criticism of him and his art. Slive, for example, quotes one of Huygens's sarcastic poems on Rembrandt and his portrait of Jacques de Gheyn III, and then comments 'These lines should not be interpreted too literally, for they can be explained as a rhetorical compliment of the sitter instead of adverse criticism of the painter.'

Modern art history is full of such wilful misreadings of the sources and documents. In Jakob Rosenberg's book on Rembrandt, the entire discussion of Geertge Dircx is contained in these two sentences: 'The sad situation at home was not improved by the presence of Geertghe Dircx, a trumpeter's widow whom Rembrandt engaged as a nurse for Titus, after Saskia's death. The outcome of this unfortunate relationship was a breach-of-promise suit which dragged on until 1650, and ended only with Geertghe's confinement in a mental hospital.'

Such distortions of the truth are no doubt guided by a reverence for Rembrandt so great that negative evidence either does not penetrate or is unconsciously twisted in the telling. While no historian would openly admit that he is out to whitewash the object of his study, none of Rembrandt's biographers so far has succeeded in breaking with the powerful tradition that sees him as a sensitive human being with great spiritual depths. No matter what the documents say, writers on Rembrandt have begun and ended their books without ever doubting that the creator of such profoundly human art as his had to be a gem of humanity – a coarse one, perhap, but still a gem.

This understandable reaction has not only distorted our picture of Rembrandt, it has also blinded us to the merits of many of his contemporaries, not least the critics of whom Slive wrote. What Pels, Hoogstraten and de Lairesse are all saying is really not the result of a misunderstanding or an incapacity to understand greatness. They admire his greatness, but regret his boorish recalcitrance. Nature had endowed him richly as an artist, but to the exasperation of all those who care about art, they say, he refused to discipline himself. He was unsurpassed in capturing emotions in facial expressions and gestures, but his figures and compositions lacked articulation. The form and content of his work lacked clarity and sometimes dignity. What made these lapses all the worse is that they would have been so easy to correct with a little application and common sense. But the artist was cursed, said his pupil Hoogstraten, with an 'onnoozel verstand,' a lack of intellectual sophistication or perhaps a perverse simplicity.

At least in one particular, the modern art historian has to grant the justice of this complaint. Rembrandt was often so nonchalant in defining his subjects that many of them remain unknown to this day. Even that does not deter the adulatory art historian. All seventeenth-century writers on art agreed that the history painter who expected to receive independent commissions should show that he understood the subjects he was depicting. But modern scholars have discovered a virtue in Rembrandt's vagueness, praising him for having elevated his subjects from the merely literal level to the universal plane. Praise of this kind tends to be linked to the attribution of

disputed works. However, once a painting is degraded from the status of a genuine Rembrandt, the visual, aesthetic and spiritual qualities observed in it until then cease to exist. The obvious fact that Rembrandt's mature style has much of a manner about it, as de Lairesse complained, is not acknowledged.

Seventeenth-century criticism of the portraits and half-lengths, especially with regard to their lighting, has also been dismissed as the product of mere prejudice. I cannot agree. Many of Rembrandt's paintings evoke in me the same kind of irritation I feel in museums which spotlight their masterpieces from interesting angles, throwing romantic shadows over half the work. Personally, I admire the *Syndics*, with its bright, even light, more than the *Nightwatch*. This is not exclusively an aesthetic preference. Because Rembrandt used light and shadow in the *Nightwatch* to impose a hierarchy of his own making on the composition, suppressing insubordinate details to add relief to the main subject, there is a greater contrast between the officers and the men than in any other Dutch civic guard portrait. To the extent – and it is a considerable one – that a Dutch group portrait reflects a power structure, Rembrandt has here accentuated the autocratic side of life in the Republic at the expense of the democratic one. To some degree he was following orders, but there can be little doubt that his stylistic approach greatly enhanced the effect. When Hoogstraten therefore says that many people felt that Rembrandt 'paid more attention to the grand design of his own choice than to the individual likenesses he was commissioned to paint,' I feel no urge to contradict him. In general, I believe the study of Rembrandt has much to gain from the serious consideration of the negative criticism voiced by his contemporaries.

CHIAROSCURO IN THE WRITING OF ART HISTORY
Rembrandt's style seems to have communicated itself to those who write about him. In the literature on Rembrandt, the artist soaks up all the light, like Banning Cock and Ruytenburgh combined, while all the other people in his life are shadows in the background of whom we are told nothing more than their name and function.

The contrast has an understandable appeal for Rembrandt's modern worshippers. F. Schmidt-Degener wrote in 1919 in his article 'Rembrandt en Vondel,' 'Rembrandt was appreciated, and his etchings and early paintings were admired intermittently, but his age lacked an organ of perception for his deep thoughts.' Art historians like Schmidt-Degner (and in this category I would also place the Svetlana Alpers of *The art of describing*) write as if they share secrets with Rembrandt above the heads of the spiritually underdeveloped mortals of the master's age and all the intervening generations.

By keeping the image of the profound Rembrandt alive, and demonstrating their understanding of his depths, art historians lay claim to a share in his superior spiritual status. This Faustian temptation has proved irresistable to those working on other masters as well, and in some ways it applies to the whole field. By feeding the notion that the objects artists create are not only beautiful and interesting but also filled with wisdom, art historians elevate their own importance as well.

There are several factors that make the temptation that much more seductive for those working on Rembrandt. One we have already discussed in the chapter on the half-lengths, which provide the viewer with a flattering mirror of his own thoughts on the meaning of life. This sometimes led to scholarship of extreme perniciousness, especially in Germany, even decades before the Nazi period. The reaction itself has nothing to do with politics, nor with nastiness. Even the gentlest of scholars can be seduced into feeling pleased that his deepest insights into art and life were shared by the greatest painter of all. Another contributing factor is the uncertainty concerning the authenticity of so many hundreds of paintings that are now or once were attributed to Rembrandt. In order to praise such paintings in terms appropriate to Rembrandt's reputation, one is quickly forced to move into the higher rhetorical realms. One has to shout down one's own doubts as well as those of others. 'Who else but Rembrandt could have created an image of such immense profundity,' goes the circular argument. 'Certainly not those mediocrities of the Rembrandt school.' In the past half-century, hundreds of such profound images have been removed from the accepted corpus, leaving their profundity behind them, to be attached that much more passionately to the remaining works and to the master himself.

Finally, there is the mystique coined by Rembrandt himself, which has clung to his name and works. Two arrogant sayings of his, quoted by Houbraken, illustrate this. When visitors tried to get a close look at his canvases, he would hold them back, saying 'The smell of paint would annoy you.' And he was in the habit of saying – no doubt when customers complained that his work was unfinished – 'a painting is finished when the artist has achieved his aim in it.' These may be clichés, but coming from the author of more than fifty self-portraits, and the

only Dutch painter of his time to sign his works majestically with his first name, they strike me as the ploys of someone who worked at his own glorification. It is neither an accident of fate nor a triumph of historical hindsight that Rembrandt, of all Dutch artists, has become the object of hero worship. It is, at least in part, a natural result of the pose he struck while he was among us.

And so the chiaroscuro of Rembrandt's image, laid down by the painter himself, has gained steadily in contrast, like that of his paintings, as time darkens their backgrounds.

RESTORING OUR PICTURE OF REMBRANDT | Of course there are those who have tried to clear away the cant. Too often, however, their efforts have taken the form of 'debunking the Rembrandt legend,' in which the old stories – especially those that the *Nightwatch* was rejected and that Rembrandt died in poverty – were cast aside as later inventions or typical artists' legends. Rather than weighing the evidence for its value, such critics reject the sources as pieces of conventional writing, with no measurable relationship to their subject. Houbraken wrote that Rembrandt's pupils painted coins on the studio floor to tease him, knowing how much he loved money. The art historians who have demonstrated this story to be an old saw then go on to conclude that it never happened to Rembrandt, and that there is therefore no evidence that his students thought he was a mercenary person. But Houbraken was the pupil of Rembrandt's pupil Hoogstraten, and if he applied this particular story to Rembrandt, it surely should be tested against other evidence before being dismissed altogether. As it happens, there is abundant evidence that Rembrandt was overly attached to his money, so that we may take Houbraken's story as an accurate reflection of what his pupils thought of him. And who says it never happened? Cliché or not, it would

not surprise me if art students were still pulling the same trick today.

The art historians of Holland have been more successful than those abroad in redressing the balance between Rembrandt and his fellows. The specialist studies of J.A. Emmens and R.W. Scheller, and the general books of B. Haak and H. Gerson – but also those of Christopher White – take an analytical and level-headed approach, achieving results that can be built on. In general, however, they leave Rembrandt exclusively in the world of art and art theory, a creature of the studio and the bookshelf. The same flaw attaches to the valuable work on the iconography of Rembrandt's art by Christian Tümpel. The writings of these scholars leave one with a picture of Rembrandt as an independent agent making his own free choices among the possibilities opened to him by his age and by artistic tradition.

It has been my aim in this book to look at Rembrandt as an artist in a world where art did not represent the independent value it does today. I have attempted to identify the forces that helped him and those that stood in his way. In doing so, my attention has been drawn to the political, religious and personal drawbacks that blocked his career after its meteoric start, and made his later life so difficult.

In the 1950s, I.Q. van Regteren Altena wrote a series of articles under the title 'Retouching our picture of Rembrandt.' Here I have attempted to subject the picture to a treatment that comes closer to a restoration. I have tried to bring back the minor details that have been covered by time, placing them in relation to the brightly illuminated central features. The seductive chiaroscuro of the Rembrandt image will survive, but I hope that a knowledge of the action in the background will help us achieve a new balance in our view of the man and his work.

Notes

Numbering of notes

Note numbers correspond to page numbers in the text, with letters to indicate running heads, paragraphs of text, figure captions and inserts. To link a note to the passage annotated, imagine the text is lettered by paragraph. Note 8A, for example, is the note to the first paragraph on p. 8. The sources of quotations in the running heads (RH) are under page number on which they end. These are sometimes shortened without elision marks.

Basic literature

The most useful single publication was *The Rembrandt documents* by Walter L. Strauss and Marjon van der Meulen, with the assistance of S.A.C. Dudok van Heel and P.J.M. de Baar, New York 1979. It contains all published, and several unpublished, documents. Until his death, *The Rembrandt documents* serves as a revised and improved edition of *Die Urkunden über Rembrandt, 1575-1721*, by C. Hofstede de Groot, The Hague 1906. In the notes, I refer to Rembrandt documents by their numbers in these compilations, abbreviated Doc. and Urk.

For the Leiden period I have used vol. 1, covering the years 1625-1631, of *A corpus of Rembrandt paintings* by the Rembrandt Research Project, J. Bruyn, B. Haak, S.H. Levie, P.J.J. van Thiel and E. van de Wetering, with the collaboration of L. Peese Binkhorst-Hoffscholte, The Hague etc. 1982.

Although I had not always realized it during work on the book, I am now very aware of the influence of the late Jan Emmens. In *Rembrandt en de regels van de kunst* (Rembrandt and the rules of art; 1964), he was the first to succeed in levelling the barriers between Rembrandt and the world of ideas around him. I have tried to do the same for Rembrandt and his political and social surroundings. My conviction that these forces were more important in Rembrandt's life than intellectual ones does not diminish my respect for Emmens's work. Had I thought of it early enough, and had I had the nerve, I would have given my book the title *Rembrandt and the rules of the game*. In any case, I warmly recommend, to the reader with a knowledge of Dutch, Emmens's collected works, both scholarly and literary. As David Freedberg showed in his outstanding review, in *Simiolus* 13 (1983), pp. 142-146, the two aspects of Emmens's creativity complement each other.

The paintings

For basic references to Rembrandt's paintings, I have chosen the numbers in A. Bredius, *Rembrandt: the complete edition of the paintings*, revised by H. Gerson, London 1969. The Bredius numbering, first established in 1935, covers nearly all but four of the paintings in this book, and is referred to in nearly all important literature. The revision of Bredius's list by Horst Gerson was a major step towards clarifying our cloudy picture of Rembrandt's oeuvre. See, too, Gerson's *Rembrandt paintings*, published in English and Dutch in 1968 and in French and German in 1969.

Still at the root of every modern corpus of Rembrandt's paintings is C. Hofstede de Groot, *A catalogue raisonné of the works of the most eminent Dutch painters of the seventeenth century, based on the work of John Smith*, vol. 6, London 1916 (first published in German in 1915; I have used the photomechanical reprint published in Teaneck and Cambridge in 1976). For the section on Rembrandt, Hofstede de Groot was helped by Karl Lilienfeld and Heinrich Wichmann. This remains the only publication with systematic information on the provenances of the paintings and on lost paintings. In the notes, I refer to it by the accepted abbreviation HdG, followed by catalogue number.

The drawings

Rembrandt's drawings are identified here by their number in O. Benesch, *The drawings of Rembrandt: complete edition*, enlarged and edited by E. Benesch, 6 vols., Oxford 1973. In general, I have made little use of the drawings, mainly because of uncertainty in my understanding of them. Despite the work of Benesch, I feel strongly that the real job of sifting and ordering the drawings still remains.

The etchings

The etchings are referred to by Bartsch number, following the 1797 catalogue of Adam Bartsch. The same numbering is used in the most recent scholarly edition, Christopher White and Karel G. Boon, *Rembrandt's etchings: an illustrated critical catalogue*, Amsterdam 1969, and in the most recent popular edition, [G. Schwartz], *Rembrandt: all the etchings reproduced in true size*, London 1977.

Museum catalogues

The catalogues of museums with large Rembrandt holdings are an important secondary source. The summary catalogues of the museums in Kassel, Vienna, London (National Gallery and Wallace Collection), New York (Metropolitan Museum of Art), Amsterdam, The Hague and Paris (Louvre) have illustrations, technical information and literature. The museums of Berlin, Braunschweig, Munich and the National Gallery in London have published excellent scholarly catalogues of their complete holdings or their Dutch paintings. Complete books have been devoted to the Rembrandts in the Mauritshuis, the National Gallery of Art in Washington, the Hermitage and Pushkin Museum, and the Louvre. Most Rembrandts in the Louvre and other French museums were covered outstandingly in the exhibition catalogue *Le siècle de Rembrandt: tableaux hollandais des collections publiques françaises*, Paris (Musée du Petit Palais) 1970-1971.

Sources

Van Mander: Carel van Mander, *Het schilder-boek, waerin voor eerst de leerlustighe iueght den grondt des edel vry schilderconst in verscheyden deelen wort voorghedraghen*, Haarlem 1604. Three of the four sections are quoted.

Grondt: Den grondt der edel vry schilder-const.
Levens: Het leven der doorluchtighe Nederlandtsche en Hoog-duytsche schilders.
Wtlegginghi: Wtlegginghi op de Metamorphosis Pub. Ovidij, Basonis. Alles streckende tot voordering des vromen eerlijcken borgherlijcken wandels.

I have used the reprint published by Davaco, Utrecht 1969.

Of great use to the reader of van Mander are the publications of H. Miedema, especially *Karel van Mander: Den grondt der edel vry schilder-const*, 2 vols., Utrecht 1973, and *Kunst, kunstenaar en kunstwerk bij Karel van Mander: een analyse van zijn levensbeschrijvingen*, Alphen aan den Rijn 1981.

Orlers: Jan Jansz. Orlers, *Beschrijvinge der stadt Leyden*, second ed., Leiden 1641.

Hoogstraten: Samuel van Hoogstraten, *Inleyding tot de hooge schoole der schilderkonst, anders de zichtbaere werelt*, Rotterdam 1678. Reprint Davaco [Utrecht] 1969.

De Lairesse: Gerard de Lairesse, *Groot schilderboek*, 2 vols., Amsterdam 1707. I consulted the edition published in Amsterdam in 1712. A Davaco reprint of de Lairesse is also in print.

Houbraken: Arn. Houbraken, *De groot schouburgh der Nederlantsche konstschilders en schilderessen*, 3 vols., Amsterdam 1718, 1719 and 1721. References are to the edition edited by P.T.A. Swillens, Maastricht 1943, 1944, 1953.

Documents

Apart from the documents published by Strauss and van der Meulen and Hofstede de Groot, for the period after Rembrandt's death, I have consulted A. Bredius, *Künstler-Inventare: Urkunden zur Geschichte der holländische Kunst des XVIten und XVIIten Jahrhunderts*, 7 vols. and index vol., The Hague 1915-1922. Many of the Rembrandt documents in the *Documents* and *Urkunden* were first discovered by Bredius.

Documents from the years after Rembrandt's death, and discovered after 1906, the year of Hofstede de Groot's *Urkunden*, have not yet been compiled. Most were published in *Oud-Holland* or, in much greater number, the monthly and annual organs of the Genootschap Amstelodamum, which I cite, in accordance with general usage, at variance with the actual title pages of the journals, as *Maandblad Amstelodamum* and *Jaarboek Amstelodamum*, respectively. I have not conducted a systematic search for the posthumous documents,

and I hope that Strauss and van der Meulen will realize their plan to publish them, in a sequel to *The Rembrandt documents*.

Scriverius

A.H. Westerhovius, *Petri Scriverii V. Cl. opera anecdota et poetica*, Utrecht 1737, and [S. Doekes], *Gedichten van Petrus Scriverius, benevens een uitvoerige beschryving van het leeven des dichters*, Amsterdam 1738. Of particular interest are Scriverius's contributions to Ampzing 1628. For the rest of Scriverius's published work, see Tuynman 1977.

Huygens

The letters are quoted from J.A. Worp, *De briefwisseling van Constantijn Huygens (1608-1687)*, 6 vols., The Hague 1911-1917, the poems from J.A. Worp, *De gedichten van Constantijn Huygens*, 9 vols., Groningen 1892-1899. The translations from Latin in the letters, poems and autobiography are based on the Dutch translations made for the first edition of this book by Loekie Schwartz. For a complete Dutch text of the autobiography, see A.H. Kan, *De jeugd van Constantijn Huygens, door hemzelf beschreven*, uit het Latijn vertaald, toegelicht en met aanteekeningen voorzien, Rotterdam and Antwerp 1946, and for the Latin, Worp 1897.

Vondel

J.F.M. Sterck et al., *De werken van Vondel: volledige en geïllustreerde tekstuitgave in tien delen*, 10 vols., Amsterdam 1927-1937, with an index published in 1940. The introductions, excursuses and annotations throughout this edition are of incalculable value for the study of Vondel and his times, but are impossible to use systematically because they are not indexed.

Amsterdam history
Bontemantel

G.W. Kernkamp, *De regeeringe van Amsterdam soo in 't civiel als crimineel en militaire (1653-1672), ontworpen door Hans Bontemantel*, 2 vols., The Hague 1897.

Wagenaar

Jan Wagenaar, *Amsterdam in zijn opkomst, aanwas, geschiedenissen, voorregten, koophandel, gebouwen, kerkenstaat, schoolen, schutterije, gilden en regeeringe*, 3 vols., Amsterdam 1760, 1765 and 1767. I have used the photomechanical reprint published in Alphen aan den Rijn and Amsterdam in 1971-1972.

Elias

Johan E. Elias, *De vroedschap van Amsterdam 1578-1795*, 2 vols., Haarlem 1903-1905. *The* book without which this book could never have been written. The introduction, republished in expanded form in 1921, is the only synthetic history I know of Amsterdam patrician politics. Even that contribution, however, fades beside the stunning wealth of genealogical and personal information on the rulers of Amsterdam. A book of dry scholarship that can bring tears to the eyes of the grateful user.

Quotations from Dutch are translated in the notes into English. For the original quotations, see the Dutch edition of this book.

Preface

8 A Van Gelder 1973, p. 204.
G Scheller 1961, p. 115.

Chapter 1
The Netherlands in the early seventeenth century
14 C Huizinga 1924, p. 278.
15 RH Brandt 1704, p. 607.

Chapter 2
Leiden
16 A Huizinga 1942.

Chapter 3
Rembrandt's family
18 A Doc. 1484/1.
B Doc. 1589/4.
C Wijnman, in White 1964, pp. 140-141, notes 5,6. Wijnman may have gone too far in saying that Rembrandt's relatives on his mother's side were shut out of the Leiden government. The van Tethrodes seem to have maintained considerable

influence. Rembrandt may even have been related to a Burgomaster van Tethrode who was an amateur painter. *Künstler-Inventare*, vol. 3, p. 774.

Chapter 4
Learning in Leiden
20 A Orlers 1641, p. 375. Doc. 1641/8.
F Doc. 1620/1.
21 A Doc. 1622/1.
C Docs. 1611/1, 1617/1, 1621/1.
D Ekkart 1978 and 1979.
22 C For the relationships between the various denominations, see van Deursen 1970 and 1980.
D C. de Waard, in NNBW, vol. 5, Leiden 1921, cols. 1182-1183. Proof of Zwaerdecroon's connections with the world of art is provided by the fact that his daughter Wilhelmina married a painter – her cousin Bernard Zwaerdecroon (ca. 1617-1654). See Haverkorn van Rijsewijk 1895.
INSERT Ekkart 1978, pp. 46-49, 60.
23 RH Hoogstraten, p. 89.
A Van Mander, *Levens*, fol. Ppv verso: 'Until he was fourteen, Octavio van Veen applied himself to the study of painting under Isaac Claesz. in Leiden, devoting several hours a day to literature as well.'
B Van de Waal 1952, vol. 1, pp. 210-211.
C De Maeyer 1955, pp. 92-130. Van Gelder 1950-1951.
D Magurn 1955, pp. 68-69, 73-74.
E Ekkart 1979, and oral communication of the author. Huygens, *Briefwisseling*, vol. 1, p. 4. *De jeugd van Constantijn Huygens*, p. 33. Johan Dedel lived from 1589 to 1665. Had he lived longer, his friendship with Huygens would have been put to a severe test. In 1667 Constantijn's son Constantijn Jr., engaged to Dedel's daughter Isabella, got her with child and then left her for another. Leonhardt 1979, p. 184. For the paintings by 'Swanenberch' and 'Swanenburgh' at court, see Drossaers and Lunsingh Scheurleer 1974.
G Wolleswinkel 1977.
24 B Tuynman 1977.
D There is no secondary literature on these captions, many of which were published in Scriverius 1737 and 1738. Captions on prints belong to a no-man's land between art history and the history of literature. Scholars in both fields neglect them, to the detriment of both disciplines.
E Published in Scriverius 1738, pp. 120-121, but also in Orlers 1641, pp. 274-275.
25 INSERT Tuynman 1977, Wolleswinkel 1977, Scriverius 1738.
26 B Elias, vol. 1, pp. LXX, 255-258.
C Scriverius 1738, pp. 18-27. About 1625 Vondel wrote a poem 'On the fine paid by Mr. Peter Schrijver for the caption on the portrayal of Mr. Rombout Hoogerbeets, pensionary of Leiden.' A manuscript copy of the poem is inserted in Scriverius's *album amicorum*. The poem was published for the first time in 1659, reviving the memory of Scriverius's heroic support for the Remonstrants. Vondel, vol. 2, pp. 759-760, and Sterck 1934, pp. 15-16.
27 A Elias 1903, pp. 340-346. De Roever Az. 1878, pp. 72-74.
B, C Van Eeghen 1969g, pp. 65-102, esp. pp. 78-80. 'The prohibition against auctioneers bidding was apparently never enforced' (p. 80). Dudok van Heel 1975.

Chapter 5
Pieter Lastman
28 B The only monograph on Lastman is still Freise 1911, which was outstanding in its time but has long been obsolete. Eagerly awaited is the promised new monograph by Astrid Tümpel, the author of so many important articles on the Amsterdam history painters. See also the interesting facts in Dudok van Heel 1975.
C Lastman's personal ties to the Amsterdam literary world come dramatically to the fore in the suit brought against him in 1615 by Bredero's sister Hillegont, apparently for breach of promise. Van Eeghen 1968.
D Freise 1911, pp. 11-12. For the houses of Pieter Isaacksz., Lastman and van Nieulandt, see fig. 125. That van den Valckert lived in the neighbourhood is known from a note scribbled by Buchelius in 1620 (Buchelius 1928, p. 47).
E Dudok van Heel 1982, p. 89, note 40. See below, note 139A. For Dutch artists at the Danish court, see Gerson 1942, pp. 453-474.
29 B Wijnman 1937, cols. 407-410. For the paintings, see Blankert 1975/1979, nrs. 194, 195,

and *Künstler-Inventare*, vol. 7, pp. 129-136.
C Wijnman 1971, vol. 1, pp. 124-125. Pieter Seegers lost his job, Dudok van Heel has assured me in conversation, not on account of his religion but because of his radical religious politics. See also Dudok van Heel 1975.
D Van Eeghen 1969b. The less than sterling reputation enjoyed by the dealers in old clothes among whom Pieter Lastman grew up may be surmised from the *dramatis personae* of Bredero's *Spaansche Brabander* of 1617, where Byateris is described as 'a dealer in old clothes and a procuress.' (Or is this an outright insult aimed at his near mother-in-law of two years before?)
FIG. 7 Broos 1975-1976.
31 RH Pontanus 1614, p. 286.
A Kernkamp 1902.
B Unger 1885. Dudok van Heel 1976. For the Pijlsteeg background of the painters, see there, pp. 30-31. On p. 28 Dudok van Heel coined the phrase 'the Sint Anthonisbreestraat painters' world.'
INSERT Vondel, vol. 1, pp. 447-458. On p. 446 is a translation of the captions to the print, and on pp. 819-821 an analysis of the relationship between the print and the poem. For a discussion of the print from another point of view, see Slatkes 1983, pp. 80-84. In the New Testament, Jephthah and David are cited together for the strength of their faith (Hebrews 11:32).
32 A For Moyaert, see p. 257. Tengnagel was related to Andries Bicker through the latter's marriage to Elisabeth van Hoogeveen, as well as to Rubens (Dudok van Heel 1976, p. 18). He was married to the sister of the painters Jan and Jacob Pynas. We also know that he was a member of the civic guard company of Geurt Dircksz. van Beuningen (see fig. 6). After his appointment in 1625 to the lucrative office of assistant sheriff, his production as a painter declined drastically.
B In 1632 Frederik Hendrik owned 'A painting in which Moses is discovered, made by Lastman.' For Pieter Isaacksz.'s family troubles, see *Künstler-Inventare*, vol. 5, p. 1478. His son's use of the father's patronymic as a last name is very exceptional.

Chapter 6
The Leiden period
33 B For Barlaeus, see Blok 1976 and literature cited there. The tribulations Barlaeus endured in the religious struggles led in 1623 to the first of his recurrent depressions. Blok is inclined to believe that the 'melancholic' Barlaeus committed suicide during one of these attacks, twenty-five years later.
D Sijbout Symonsz. van Caerdecamp, from a family of Leiden notaries, was the owner in 1644 of 'an old man's head', being the portrait of Master Rembrandt's father (Doc. 1644/1). Elisabeth Wiggertsdr. owned 'a square [painting] by Rembrandt [valued at] six guilders' in 1649 (Doc. 1649/2); the Mennonite Pieter Gerritsz. van Hogemade a 'small head by Rembrandt' (Doc. 1652/3); in 1648 the painter Abraham van den Tempel married into his family. The widow of Dirck Segersz. van Campen, next-door-neighbour of the Jouderville family, had a 'candlelight scene by Rembrandt' (Doc. 1662/8); Gerard van Hoogeveen, Aelbert's son, had a 'painting by Rembrandt van Rijn' and two heads by him (Doc. 1665/1); Henrick Bugge van Ring, the owner of a 'painting by Rembrandt', being a scholar with his books' (Doc. 1667/1), was a close friend of the van Campen family and an associate of the Amsterdam Catholic artist Jan Jansz. Uyl, with whom Rembrandt also had dealings (see p. 194). The art appraiser (and thus probably art dealer and painter) Jan Jansz. van Rhijn owned 'a head' and 'a singer' by Rembrandt (Doc. 1668/3). Apart from several repeated references, this is the entire harvest of paintings by Rembrandt mentioned in known Leiden documents during the artist's life.
E Dudok van Heel 1978b.
34 A Elias, vol. 1, p. 265, note 1.

Chapter 7
Rembrandt's beginnings as a master
35 A The Scriverius auction catalogue (Doc. 1663/7) was published in Frederiks 1894, pp. 62-63. What Dudok van Heel found was the inventory of Willem Schrijver, which included most of the paintings that ended up in the Scriverius sale, but not those by Rembrandt. Wurfbain formulated his hypothesis in an unsigned entry in the exhibition catalogue *Geschildert tot Leyden*, pp. 66-68.

C For Saftleven's letter, see fig. 18, and for Matham's, p. 43. The Lievens portrait of Scriverius is known only from its occurrence in Willem Schrijver's inventory. See Wolleswinkel 1977, p. 119.
E Gerson 1962-1966, published in 1962. For Elsheimer's *St. Stephen*, in the National Gallery of Scotland, Edinburgh, see Andrews 1977, cat. nr. 15, fig. 46.
36 B The painting is currently exhibited under this title at the Stedelijk Museum De Lakenhal, Leiden, of which Wurfbain is director. For his interpretation, see the reference in note 35A. Another fascinating new interpretation, taken from David's life before he became king of Israel, has been proposed with verve by the American art historian Mary Lewis, in her doctoral dissertation in progress.
37 RH Vondel 1707, fol. *6 verso. In the seventeenth-century editions of the play, of which there were seven in 1626-1627 alone, the explanatory key to the significance of the personages is not included.
FIG. 17 For the story of the reading of *Palamedes* in Noordeinde Palace, see Brandt 1683, p. 25. The only wall hangings in the 1632 inventory which could include a representation of Palamedes were 'in the furniture attic above the new hall.' They are described under nr. 718 as 'ten pieces of tapestry, the story of Ulysses, which used to be employed regularly in the new hall in Noordeinde.' Drossaers and Lunsingh Scheurleer 1974.
38 RH Quoted by Leendertz. 1910, p. 96.
C The painting was sold by the Wallraf-Richartz-Museum in the 1940s and its location has been unknown since. The only earlier publication known to me is Nicolson 1979.
G Scriverius 1738, p. 23: 'Scriverius replied... that as far as publishing the plate went, that was the work of the bookseller, and not at all that of the accused.'
H Wagenaar, vol. 1, p. 482.
I Schulz 1978, p. 45, does not know what to make of the letter and drawing. He acknowledges the authenticity of the handwriting and signature, but nonetheless refuses to accept the drawing as a work by the young Saftleven, six years earlier than any other known sheet. For our purposes the contents of the letter are more important than the authenticity of the drawing, although I fail to see how one can accept the letter but not the drawing.
39 RH Words uttered by Alderman Jan Gijsbertsz. de Vries; see Vondel, vol. 3, p. 371.
D Defoer 1977.
40 A I wonder whether the Dutch regents did not feel a sense of affinity with the deacons of the early church. One of the burning issues of the day was whether or not the church should have a voice in affairs of state. The distinction between ordained and lay servants of the Lord, apostles and deacons, could have provided an argument for the regents who felt that the clergy should keep to sacred matters and leave secular affairs to the laity. I have not yet come across any evidence that this was so.
FIG. 20 Visscher's print is illustrated by J. Bruyn in 'The documentary evidence of early graphic reproductions [of Rembrandt compositions],' *Corpus*, vol. 1, p. 38.
41 RH Van Mander, *Grondt*, fol. 5 recto.
FIG. 21 Heinsius 1965, pp. 274-275.
42 C Moes 1894, Hofstede de Groot 1909.
FIG. 22 Kurt Bauch was the first, in 1933, to observe the borrowing from Stradanus. His writings, especially his magnum opus of 1960, have been of great importance for the study of the early Rembrandt. Cf. there, pp. 110-111.
43 RH As the reader can see in fig. 24, the quotation is from Cats 1632, pp. 19-20. The same message is, I believe, depicted in a painting of about 1625 by Honthorst (Rome, Galleria Borghese). See *Von Frans Hals bis Vermeer* 1984, nr. 49. Rembrandt may thus have been *au courant* with the newest developments in Utrecht by 1625.
D Matham's letter is in the Royal Library, The Hague, nr. 131 B 33, fol. 125 verso, among Scriverius's autograph notes for his *Laure-crans voor Laurens Coster van Haerlem, eerste vinder vande boeck-druckery*, which was published in the back of Ampzing 1628.
45 RH Scriverius 1738, p. 110. The poem is entitled 'Dialogue concerning a certain poet and a painter.' The subject of the painting is an allegory on the glorification of Laurens Jansz. Coster as inventor of movable type. It was published first in the *Laure-crans* (see previous note), pp. 78-79, with the date August 15, 1628. The words 'I have it from those

who know' allude to Dante's famous characterization of Aristotle and his followers. The poem, in which the poet charmingly flatters the intellectual attainments of the painter, reads like an idealized rendition of the kind of working talks Scriverius held with young artists.
B For the origins of the iconography, see caption to fig. 65. The source of the motif was discovered by Campbell 1971.
C Bruyn 1970, esp. pp. 30-31. Scriverius's interest in the theme of the penitent also found expression in his poem 'Op de boetveerdigheyd des leevens door Jan Taffin,' a eulogy on an evergreen of Reformed pietism. Scriverius 1738, pp. 46-47.

Chapter 8
The compositions in light and shade: Rembrandt and Utrecht
49 RH Hoogstraten, p. 234. That author's hostile curtness on the subject of Honthorst requires further explanation, just as van Mander's on Isaac Claesz. van Swanenburg.
B Swillens 1945-1946.
C *Resolutiën* 1981, pp. 129 (nr. 803), 150 (nr. 492) and 387 (nr. 2637). His first petition was rejected on May 17, 1619. The second, submitted by Carleton, was dealt with by the States General on June 8 of the same year. It was decided to ask the artist for an impression of each print before taking the final decision. Approval was finally given, for a weak form of protection, on February 24, 1620. On March 11, 1620, Rubens wrote a letter to van Veen thanking him for his efforts, which apparently continued even after Carleton went into action. See Magurn 1955, pp. 73-74. Rubens dedicated prints to both men in recognition of their help. One of the prints in the group was fig. 47, which was devoured by the young Rembrandt and Lievens.
F Dudok van Heel 1978b, p. 169, afterword. Van Eeghen 1977a.
51 RH Peltzer 1925, p. 160.
52 A Doc. 1628/1. Buchelius 1928, pp. 66-67.

Chapter 9
The Leiden studio
53 A Orlers 1641, p. 377.
B Pelinck 1953, pp. 51-56. Van Tatenhove 1984. The reputations of glass painters have proved as fragile as the material in which they work. A survey of Dutch stained glass could be of importance for the study of civic patronage in the seventeenth century.
F Gaskell 1982.
G Van de Wetering 1983, with references to the documents on Jouderville published by Bredius.
54 B Montias 1982.
55 RH *Cabinet des singularités d'architecture, peinture, sculpture et gravure*, Paris 1699. Urk. 373.

Chapter 10
Familiar faces
57 C For Huygens's appreciation of the art of portraiture, see p. 76.
58 D Buchelius 1928, pp. 46-47: 'At Schellinger's I saw a *Marriage at Cana* painted by Isaac Claesz., where he portrayed himself from life in the guise of a musician, and Albert Martens with his first wife and several children, who commissioned the painting; he was a wineseller in the Campertoorn.'
59 A *Corpus*, vol. 1, pp. 223-224.
60 RH Doc. 1639/11.
FIG. 46 Froentjes 1969, pp. 233-237.
61 RH and FIG. 48 *Levens*, fol. 218 verso. Pieter Coecke van Aelst (1502-1550) had lived in Constantinople for a year. In 1656 Rembrandt owned prints by 'Hendrick van Aelst and others, depicting life in Turkey' (p. 239). Could this have been the 'Moeurs et fachons de Turcz...' described at length by van Mander in his life of van Aelst? The self-portrait à la Turque was included in the final print in the series.
B *Corpus*, vol. 1, pp. 289, 291.
63 RH *Levens*, fol. 298 verso.
A Doc. 1644/1.
B *Urk.* 346, print 10.
64 B Doc. 1645/3, letter of June 29, 1645.

Chapter 11
Paintings for The Hague
67 D Israel 1983.

Chapter 12
Frederik Hendrik
68 FIG. 61 Sluyters-Seijffert 1983.
69 RH FIG. 62 The medal is described in van Loon, *De Nederlandsche historiepenning*.

70 FIG. 63 Tiethoff-Spliethoff 1978.
71 RH Drossaers and Lunsingh Scheurleer 1974.
FIG. 64 Gerson 1969. The painting is obviously cut around the edges, and may originally have had the same dimensions as fig. 63.

Chapter 13
Constantijn Huygens
72 A See Basic literature under Huygens. Two recent biographies dealing with different aspects of the many-sided Huygens are Smit 1980 and Hofman 1983.
73 Huygens's autobiography remained unpublished until 1897, when Worp brought out the Latin text and a Dutch translation in the *Bijdragen en Mededeelingen van het Historisch Genootschap* 18 (1897), pp. 1-121. The ms. is in the Royal Library, The Hague.
77 RH Van Mander writes these candid wordt in the dedication of the *Schilder-boeck* to 'Mr. Melchior Wijntgis, formerly councilor, and general supervisor of the mints of the United Netherlands; presently director of the national mint and that of the county of Zeeland, my special master and good friend,' fol. *iii verso.
NEXT TO LAST PARAGRAPH Bloemaert's model book was not published until 1740. The fists are on plate 54.

Chapter 14
Rembrandt and Lievens
78 A Schneider/Ekkart 1973. The exhibition, organized by R. Klessmann, was held in the Herzog Anton Ulrich-Museum in Braunschweig in 1979, with an extensive catalogue.
F The inventory of Orlers's paintings, drawn up by the Leiden Orphans' Court in 1640, is published in *Geschildert tot Leyden*, pp. 17-18.
79 B Doc. 1630/3.
80 A Van Schooten's *Tabula cebetis* is in the Lakenhal Museum, Leiden. Hoogstraten (p. 89) regards the subject as an achievement that raises painting to the level of scholarship.
FIG. 67 Bialostocki 1966.
81 RH Scriverius 1738, p. 11, from the *Dialogue* (see p. 45, RH).
A In Schneider/Ekkart 1973, Ekkart suggests that the meeting took place in November 1628 (pp. 310-311). Constantijn was indeed in Leiden that month, but not, as far as we know, with his brother Maurits.
B Docs. 1649/2, 1653/18. For the Orlers inventory, see note 78F, and for Delft, Montias 1982. The rate per head for van Schooten's civic guard portraits is from a document of 1626, quoted in the 1949 catalogue of the Lakenhal, p. 247.
C In 1646 Rembrandt earned twice as much for each of two not very large paintings (p. 238).
D The following painting is described as 'a piece done with the pen, being a Venus looking in the mirror.' A painting described in this way is virtually certain to be a monochrome of the sort usually called a *penschilderij* in Dutch. Drossaers and Lunsingh Scheurleer 1974, p. 185, nr. 88. For the predating of the *Samson*, see the *Corpus*, vol. 1, p. 252.
82 B Doc. 1639/11, with literature.
FIG. 68 Lievens's inventory of July 3, 1674 is published in *Künstler-Inventare*, vol. 1, pp. 187-189.
C The reconstruction of the genesis of Rembrandt's and Lievens's paintings is from the *Corpus*, vol. 1, pp. 293-308.
83 FIG. 70 *Beschrijving*, p. 6: 'The painting was bought in 1632 by the city to decorate the great hall of the town hall: 'Paid for a portrait [sic] of Samson, bought for the township, *f* 75.17.' For the painter, see van Gelder 1948-1949.
FIG. 71 The painting on which the print is based was acquired in 1983 by the National Gallery in London.
84 B Lastman's *Lazarus* is on loan from the Mauritshuis, The Hague, to the Lakenhal, Leiden.
85 RH De Lairesse, vol. 1, pp. 41-42.
86 A See Vey and Kestsieg 1978, pp. 42-43.
87 RH Hoogstraten, p. 195.
88 A Poelhekke 1978, pp. 315-319. Dohna 1878.
FIG. 77 Magurn 1955, pp. 50-61.
89 RH *Gedichten*, vol. 1, p. 144, from Huygens's *Verclaringh van de XII artijckelen des Christelicken geloofs*.

Chapter 15
Jacques de Gheyn III etc.
91 A *Briefwisseling*, vol. 2, pp. 132, 468.
C Idem, vol. 3, p. 40.
D *De jeugd*, pp. 66-71. Huygens's attitude towards the old as well as the young de Gheyn displays a

mixture of admiration and annoyance. Jealousy of their well-paid positions at court plays an unmistakable role in his reactions.

92 B *Gedichten*, vol. 1, p. 139.

C Magurn 1955, pp. 59-68.

G For the testament of Jacques de Gheyn III, see van Regteren Altena 1936, pp. 128-132.

H Hollstein, vol. 7, p. 200, nr. 24, 'Le sommeil.' See also Burchard 1917, p. 175, nr. 9.

93 FIG. 83 The prints of Paul and Peter are Burchard nrs. 5 and 6, and Hollstein nr. 20. For the theological background, see Posthumus Meyjes 1967. The author refers to the stories of St. Stephen and the baptism of the eunuch as evidence of the importance of the deacons for St. Paul's thought.

94 D Doc. 1639/11.

F Van Gelder 1972, p. 19.

95 RH *Gedichten*, vol. 2, p. 20. The guaranteed half-success of the 'print-writer' is also the inevitable lot of painters of genre scenes with intellectual ambitions.

B *Gedichten*, vol. 2, p. 252.

C Idem, vol., 1, pp. 312-313. The poem is signed 'F.C.' but is attributed to Cats.

E *Briefwisseling*, vol. 2, p. 302: 'Monsr. vostre frere luy est grandement familier.'

FIG. 86 Martin 1925. See also *Von Frans Hals bis Vermeer*, pp. 136-137.

96 FIG. 88 *Briefwisseling*, vol. 1, p. 311.

97 RH *Briefwisseling*, vol. 1, p. 210. For another reading of the letter, written in Schmelzing's private patois, see Hellinga 1957, pp. 50-51. In April 1627 Constantijn married Susanna van Baerle, who had turned down a proposal from Maurits five years earlier.

A *Gedichten*, vol. 2, pp. 245-246. Written on February 18, 1633. This translation is based on the sparkling Dutch translations of Loekie Schwartz. With thanks to Dr. P. Tuynman for his kind help.

Chapter 16
Prophets and apostles

98 D *Briefwisseling*, vol. 1, p. 347. The letter is in French.

E *Gedichten*, vol. 2, p. 235.

99 C Doc. 1655/5.

D Coolhaas 1973, pp. 29-64.

100 C A close look at Specx's collection shows a remarkable number of painters from the Uylenburgh circle: Jacob Adriaensz. Backer, Jurriaen Ovens, Jan Adriaensz. van Staveren, Govert Flinck (with two evangelists), Pieter de Neyn, Simon de Vlieger and Jan Moyaert (see esp. p. 141). Gerrit Dou and Gerbrand van den Eeckhout were also represented. In later years Specx and his wife were painted by Flinck and Ovens. This raises the possibility that the connection between Rembrandt and Govert Specx was brought about not by Huygens but by Uylenburgh.

FIG. 92 'If he chose to depict Jerusalem burning and the treasures from the Temple (which were carried off to Babylon) as lying next to Jeremiah,... the artist did not intend to interpret any particular moment... but to illustrate Jeremiah's lament by adding to his figure various motifs indicating the downfall of Jerusalem' (*Corpus*, vol. 1, p. 282). This flight into the unknown is a manoeuvre of a kind frequently encountered in Rembrandt studies. R. van Luttervelt had this sensible judgment on the phenomenon: 'When elements of Rembrandt's work strike us as fantastic, that is usually due to our lack of pertinent information. All too often, ... the notion of 'imagination' provides an easy excuse for us, [in explaining] things that are unclear to us for the moment.' From Luttervelt 1958, p. 149. In the present case, there may be a source outside the artist's imagination. According to the second book of Maccabees 2:4, Jeremiah took at least some of the Temple furnishings with him: 'It was also in the writing that the prophet, having received an oracle, ordered that the tent and the ark should follow with him.' Jeremiah was enjoying a bit of a vogue at the time. In 1629 Scriverius's friend Ampzing brought out an edition of the prophet's Lamentations. Some day the 'relevant information' allowing us to interpret this painting properly will turn up.

102 RH Doc. 1634/3.

103 RH Vondel, vol. 2, p. 397.

fig. 95 Lambert Jacobsz.'s testament was published in Straat 1925, p. 83.

105 RH From an address on tolerance delivered by Grotius to the Amsterdam town council. See Wagenaar, vol. 1, p. 455. The distinction he draws is of central importance. In the seventeenth century

the Mennonites were no longer a threat to the state, while the Remonstrants were.

C For Abraham van den Tempel, see Wijnman 1959, pp. 39-93.

D Doc. 1628/2.

Chapter 17
The Passion

106 D The story of Rubens's quick retreat is told with a touch of glee by Grotius 1964, pp. 463-464.

107 A Gerson 1961. Mrs. Ovink's translation is printed here with permission from the Rijksbureau voor Kunsthistorische Documentatie, under whose aegis the *Seven letters* were published. In Strauss and van der Meulen, the letters are Docs. 1636/1-2, 1639/2-7.

109 RH *The poems of John Donne*, ed. H. Grierson, London n.d., p. 306-308 *Gedichten*, vol. 2, p. 256.

111 RH Houbraken, vol. 1, p. 56.

FIG. 102 For the copy by van der Linde see Gerson 1942, p. 305. Doc. 1647/7. Sibilla's version is in the Gemeentemuseum, Arnhem. See *Impact of a genius*, nr. 68.

112 FIG. 104 Docs. 1647/7, 1662/16.

115 RH See note 109 RH.

116 FIG. 109 MacLaren 1960, pp. 3-5.

117 RH Vondel, vol. 3, p. 415. According to Vondel, Donne was devoured with relish, in Huygens's translations, by Hooft, Maria Tesselschade and Daniel Mostart, 'who can't get enough of that kind of salad./ Well, gentlemen, eat till you're sick./ Vinegar and salt will help do the trick./ These delicacies are not for my palette.' The scholars who edited Vondel's poem in 1929 agreed with him. In a note, they characterize Donne's work as 'recherché, obscure and... fashionable.'

118 A Hoogstraten, pp. 110-111. Neercassel 1675. The Dutch edition also appeared in that year.

B Rivet thanks Huygens for his 'good advice in writing my *Apologia pro beata virgine*' in a letter of March 30, 1639. *Briefwisseling*, vol. 2, p. 443.

INSERT *Resolutiën* 1981, p. 347, nr. 2347.

Chapter 18
Mythological paintings

119 D *Leidse universiteit 400*, pp. 155-158.

F Heinsius 1965, p. 320, under the heading 'Explanation of certain worldly stories, words and turns of speech which are used in this Hymn.' The issue was sensitive. Aratus is also cited by Junius 1637: 'Plutarch praises the great and good Aratus for his profoundly learned judgment concerning painting.'

120 FIG. 111 Evers 1943, pp. 265-274.

121 RH See note 119 F.

C Drossaers and Lunsingh Scheurleer 1974, vol. 1, p. 185, nr. 89.

D Ibid., p. 193, nr. 248.

E Marlet 1895. For Charlotte's visit to The Hague, 'grande ville déjà, mais ville républicaine, dans laquelle l'étiquette était ignorée' (p. 35), see pp. 48-52.

122 B Poelhekke 1978, pp. 350-351.

E Drossaers and Lunsingh Scheurleer 1974, vol. 1, p. 184, nr. 82.

123 RH *Briefwisseling*, vol. 1, p. 339.

B *Corpus*, vol. 1, p. 371.

C With thanks to K. van der Horst for his help with the translation. In 1641, Vondel compared Barlaeus to Claudianus. Vol. 4, p. 211.

D Van Mander, *Wtleggingh*, fol. 46 recto.

124 A Ibid., fol. 21 recto.

B Doc. 1653/4.

FIG. 115 Vliegenhart 1972. The Rotterdam artist-art-dealer-architect Jacob Lois, who also owned paintings by Rembrandt, brought out an etching in 1643 under the title *De History van Diana en Antiona*, which however depicts Callisto. Hollstein, vol. 11, p. 92, nr. 1.

125 RH Bacon 1619. Huygens met Bacon in England in 1618 or 1621-1623. He wrote of him that he 'always worshipped him with a kind of holy awe' (*De jeugd*, p. 114). Whether or not Rembrandt's painting has anything to do with Bacon's saying I do not know. I was merely struck by the comparison of Actaeon with a courtier.

A Israel 1983.

126 FIG. 119 Brown 1983.

127 RH Cats 1637, pp. 168-169.

C Kettering 1983.

D Louttit 1973.

E Van Gelder 1950-1951, pp. 113-115. In this connection, van Gelder refers to a print of Diana

sleeping, after a painting by Rubens in Frederik Hendrik's collection. The print, dedicated to Jacob van Campen as architect of Honselaarsdijk Palace, was cut by Jacob Lois and published by Peter Soutman. Rembrandt's relationships with both those artists, uninvestigated until now, undoubtedly have something to do with the court.

F Worp 1907, vol. 2, p. 108.

128 A Clark 1966, pp. 12-13.

B Russell 1977.

E Van Campen 1940, pp. 71, 99. The book concerned is by Giovanni della Casa (1503-1556), archbishop of Benevento. For van Werckhoven, see Doc. 1656/3 and *Künstler-Inventare*, vol. 3, pp. 786-787. Offering a *Rape of Ganymede* to Frederik Hendrik was not a far-fetched idea. According to the English traveller John Evelyn, who visited Honselaarsdijk on September 1, 1641, 'the ceiling of the staircase is painted with the 'Rape of Ganymede' and... was the work of F. Covenberg.' Quoted by van Gelder 1948-1949, p. 143. Was Rembrandt's painting intended for Frederik Hendrik after all? If so, it would be another example of the curious parallels between the careers of Rembrandt and van Couwenbergh.

FIG. 121 Bruyn 1983, pp. 52-60, where the reader will also find interesting speculations concerning the crying child in this painting and in fig. 123.

129 RH Hoogstraten, p. 94.

B The idea that the painting may represent *Aegina* was suggested to me by the title of a classical nude by J.-B. Greuze in the Metropolitan Museum of Art, New York. Greuze knew Rembrandt's painting, and may even have drawn upon it for his own work. Since I saw it there, in January 1984, I am told that the museum has changed the identification of the subject. My own main objections to calling Rembrandt's painting *Danaë* are the absence of Danaë's main attribute, the shower of gold, and the attitude of the nude woman, which is anything but that of a virgin being taken by surprise.

C Van Mander, *Wtleggingh*, fol. 68 recto.

D Junius 1637, in ed. Rotterdam 1694, second section, 'Catalogus...,' p. 3: 'Aegineticum atque Deliacum aes diu obtinuere principatum. Antiquissima aeris gloria Deliaco fuit, mercatus in Delo concelebrante toto orbe, et ideo cura officinis triclineorum pedibus fulcrisque.' That the 1637 edition was being circulated by 1636 is proved by van Dyck's letter of recommendation in the front matter, dated August 14, 1636.

FIG. 122 Isaac Isaacksz.'s testimony is published in *Künstler-Inventare*, vol. 5, p. 1483. The letters of van der Straaten and his crony de Cocq are in Huygens's *Briefwisseling*, vol. 4. The presence of brothels on the Lauriergracht can be surmised from evidence presented below, p. 293.

130 FIG. 123 Docs. 1644/4, 1656/12, 1660/15.

C Huygens, *De jeugd*, pp. 74-75.

131 RH *Wtleggingh*, fol. 68 recto.

A Van de Wetering 1984 has shown that the Leningrad painting was originally larger, with a format that 'agreed with the format of Rembrandt's *Blinding of Samson* in Frankfurt (203.5 x 270.5 cm.).'

B The works that Rembrandt presented to Huygens in 1636 were probably etchings, which Huygens then gave to Frederik Hendrik. In any case, the stadholder's collections did contain a volume of Rembrandt etchings, conserved by Huygens. See Slive 1953, p. 19, note 2.

D Doc. 1646/3.

Chapter 19
Rembrandt and the regents of Amsterdam

132 C See p. 134.

D In Leiden the malaise was not quickly dispelled. On September 4, 1648, 'the supervisors of painting sales in Leiden declared ... that the painters of this city have little business and moreover do not know what they must do to sell their work in order to support themselves.' *Künstler-Inventare*, vol. 7, p. 263.

133 B Barbour 1950, p. 13.

E Taverne 1978, pp. 143-144. See too, always, Elias.

134 D Utrecht, Rijksarchief, Huydecoper-archief, nr. 30. Hopefully the complete cashbook, with its wealth of information for historians and art historians, will soon be published in its entirety. For Huydecoper, see Schwartz 1983.

135 RH Vondel, vol. 3, p. 352.

136-137 Most of the material for this chart is from Elias. Many of the local connections have already

been demonstrated in articles, mainly by H.F. Wijnman, I.H. van Eeghen and S.A.C. Dudok van Heel. If I had to characterize this large group in a single word, I would call them the principals and dependents of the Amsterdam faction whose successive leaders were Geurt Dircksz. van Beuningen, Jacob de Graeff and Cornelis de Graeff. The absence of clients of Andries Bicker and Anthony Oetgens van Waveren is striking. One also misses the names of a number of prominent Amsterdam collectors one would expect to encounter in this company, mainly the Reynsts, the Marcelisses, the van Loons and the Hasselaars.

138 D Israel 1983, pp. 9-10.

E Coymans's connections with the secret council of the prince can be deduced from a letter of his to Johan de Knuyt of August 28, 1623 in the Algemeen Rijksarchief, The Hague, Nassause Domeinraad, Orange na 1581 (*Vervolg-archieven, afd. 184, map* 213/1). The letter concerns carriage charges for several shipments from Paris. Another letter, with similar contents, is dated June 30, 1627 (*map* 213/19).

INSERT For Huydecoper's list, see note 134 B. What could the 'large painting' by Moyaert have been, predating all the master's known works? The reference to 'Willem' Tengnagel is puzzling. For the auction of de Man's collection, see Montias 1982, p. 262.

Chapter 20
Hendrick Uylenburgh

139 A Dudok van Heel 1982, pp. 78 and 79, note 89. In the meantime, Dudok van Heel has revised the version of events in that note. Uylenburgh lived in Pieter Isaacksz.'s old house not before, but after his period in the former premises of Cornelis van der Voort.

C Wijnman 1959, pp. 1-18, 'Rembrandt als huisgenoot van Hendrick Uylenburgh te Amsterdam (1631-1635): was Rembrandt doopsgezind of libertijn?' Could Uylenburgh's sudden appearance in Amsterdam in 1625 be connected to the visit of the king of Poland to the Netherlands in September 1624? At least one painter from Rembrandt's world, Pieter Soutman, did have connections to the Polish court. Ampzing 1628, p. 373, calls him court painter to the king of Poland.

F Van Deursen 1980, pp. 101-120.

141 RH Doc. 1640/2.

B Wagenaar, vol. 1, p. 410.

E The 1639 loan is published in the *Künstler-Inventare*, vol. 5, p. 1687. The eighteen creditors were 'Jan and Pieter Hooft, Pieter Beltens, Jan Carels on behalf of Jasper Tongerlo, Claes Moyaert, Symen de Vlieger, Johannes Staveren, Jacob de Wet, Johan Colenbier, Wijbrandt Claesen, Jacob Hero, Rembrandt van Rijn, Nicolaes van Bambeeck, Claes Arentsz. van Neerden, Lambert Jacobsz's heirs, Jan Jansz Treck, the widow of Jacob Liewen, and the widow of Pieter de Neyn.' Van Staveren was not only a painter but also an alderman and burgomaster of Leiden. Wijbrandt Claesz. was an ebony craftsman, and probably a framemaker (Zantkuyl 1959, p. 159). For Lambert Jacobsz.'s estate, see Doc. 1637/4, and for Uylenburgh's loan of 1641, Wijnman 1959, p. 15.

142 B Wijnman 1959, p. 16. One of Uylenburgh's more interesting relations was Willem Kerckrinck (1616-1668), whose portrait he painted for the sitter's sister, Anna Kerckrinck (1626-1689); *Künstler-Inventare*, vol. 5, p. 1689. Kerckrinck's brother Dirck (born 1604) was the brother-in-law of Burgomaster Dirck Bas (see p. 216), while Anna was the mother-in-law of the Rembrandt collector Valerius Röver (1654-1693).

C Docs. 1630/1, 1631/8. For van Vliet, see Fraenger 1920, a study which is in need of replacement. See too Bruyn, work referred to in note 40 RH. 20.

Rembrandt's loan to Uylenburgh is Doc. 1631/4. The often repeated assertion that the loan consisted of paintings rather than cash is unfounded. The document speaks of 'lent money.'

D The lack of a monograph on Salomon Koninck is a great handicap to Rembrandt studies.

E Baldinucci 1686, cited by Six 1926. Baldinucci's claim that Rembrandt was a Mennonite is not supported by any other evidence, but is interesting to keep in the back of one's mind.

F The listing of activities in the Uylenburgh studio is based largely on documents in *Künstler-Inventare*, vol. 5, pp. 1684-1690, and Wijnman 1959.

Chapter 21
Portraits, 1631-1635
143 D Heckscher 1958. Van Eeghen 1948 and 1969a.
F Reznicek 1977.
144 B Vondel, vol. 3, pp. 406-407. This interesting poem seems to have escaped the attention both of Heckscher and of Schupbach 1982, which contains a long bibliographical appendix on 'cognitio sui, cognitio dei, as the rationale of anatomy.'
FIG. 126 Schouten 1970. Van Eeghen 1971c.
145 RH Wagenaar, vol. 1, p. 524.
B Diederik Tholincx was a favourite of Amalia van Solms. When he went bankrupt in 1644, she appointed him *drost* of Zevenbergen (Elias, vol. 1, p. 367, note c).
FIG. 127 Doc. 1669/3.
146 F Dudok van Heel 1980b. Wijnman 1959. Van Eeghen 1977e.
147 RH Wagenaar, vol. 1, p. 499.
A For Ruts, see van Eeghen 1977, for Marten Looten, van Dillen 1939. An amusing story about J. Paul Getty as researcher of his own collection is told by P. van Eeghen 1957.
C Dudok van Heel 1980b.
148 A *Briefwisseling*, vol. 6, p. 298, paraphrased by Worp as follows: 'My nephew Anthonis Copal, councillor and pensionary of Vlissingen, has passed away; is that not a suitable position for your son Louis? If you wish to consider it, ask the prince for letters of recommendation to the Vlissingen government and Councillor Ingels. It is important for His Highness to have a person he can trust in that post. In 1649 my nephew was recommended in the same way.' Letter of Justus de Huybert (1610-1682) of February 21, 1672.
149 RH *De jeugd*, p. 59.
A Doc. 1633/2. Dudok van Heel 1978a.
150 C Tideman 1903.
INSERT Knoest and Graafhuis 1970. The Rembrandt documents are on pp. 184 and 198. These are the only published Rembrandt documents I have come across that were missed by Strauss and van der Meulen.
151 RH Vondel, vol. 3, p. 425. 'On the *Zendbriefschryver* [Secretary] by Daniel Mostart, secretary of Amsterdam.'
152 FIG. 139 MacLaren 1960, pp. 322-324.
153 RH Hoogstraten, pp. 44, 45, Z22.
154 B J. Bruyn was kind enough to show me the copy for part of the entry on these paintings in the forthcoming part 2 of the *Corpus*. The new identification was previously published by Strauss and van der Meulen 1979, p. 105.
D Van Eeghen 1956b. Pronck 1956.
E Wijngaards 1964.
155 RH Wagenaar, vol. 2, p. 209.
FIGS. 146-147 *Art and autoradiography* 1982.
156 B Tóth-Ubbens 1975-1976. An exceptionally important article that has not had the impact it merits, perhaps on account of its uninformative title.
157 RH Vondel, vol. 2, pp. 814-815.
158 C Van Eeghen 1969c and 1970. The name on the letter is read by all paleographers as Jan Heykens. In a way, it is too bad that the real Jan Heykens, whose son Hendrik was married to the sister of Oopjen Coppit (fig. 156), is not the sitter. See Citroen 1978.
E Wijnman 1934 and 1957.
FIG. 154 Van Eeghen 1956c.
159 FIGS. 155-156 Van Eeghen 1956a. Leiden, Gemeente-archief, records of notary Caerl Outerman, NA 524, doc. 31.
161 RH Van Deursen 1980, p. 118.
FIG. 158 Hart 1969.
162 B Wijnman 1959, pp. 110-136, 'De Amsterdamse literator Mr. Joannes Victorinus, een Remonstrants Vondelvriend.'
F Docs. 1653/4, 1655/5. Van Eeghen 1956d, Coolhaas 1973.
163 RH *Briefwisseling*, vol. 2, p. 158, letter of March 28, 1636.
FIGS. 159-160 *Art and autoradiography* 1982.
165 RH Van Mander, *Grondt*, fol. 49 verso. The differences in colour between the illustrations of companion portraits on these pages are not due to the painter's adherence to van Mander's advice, but to the unfortunate fact that they are all in different collections, and are therefore conserved (and photographed) differently.

Chapter 22
Biblical histories of the 1630s
167 B Dudok van Heel 1969a.

C Dudok van Heel 1978b, p. 164.
D Doc. 1653/4.
168 FIG. 173 Angel 1642, pp. 49-50. See also Slatkes 1983, pp. 49-51.
169 RH Angel 1642, p. 50.
B Houbraken, vol. 2, p. 205.
D That Croon was Catholic I learned from Dudok van Heel, whose forthcoming book on the Catholic families of Amsterdam promises to equal in importance Elias's work on the Protestant patricians. For de Leeuw, see Bruyn, *Corpus*, vol. 1, pp. 47-49. The assertion there, note 22, that 'Plemp wrote no epigrams on pictures other than those' for the prints of *Saul and David, Old Tobit* and *St. Paul* is incorrect. To those we can add our fig. 28 and a Latin caption on a 1608 print of the new exchange in Amsterdam, mentioned in the *Nieuw Nederlandsch Biografisch Woordenboek* in the article on Rodenburgh, vol. 7, col. 1054. This proves that the manuscript of Plemp's poems in the Amsterdam University Library, on which Bruyn relied, is incomplete.
170 B Scheltema 1872, p. 4.
C Doc. 1660/8.
D Doc. 1653/8. Dudok van Heel 1980b and Moltke 1965, a book badly in need of replacement. Houbraken's life of Flinck is quoted at length in this book on p. 282.
171 RH Houbraken, vol. 2, pp. 16, 17.
B Bauch 1926. The subtitle of the book, identifying Backer as '*Ein Rembrandtschüler aus Friesland,*' is inaccurate, as has often been stated since.
FIG. 177 Broos 1972.
173 RH Van Mander, *Grondt*, fol. 298 recto.
FIG. 181 Vondel, vol. 3, pp. 431-482.
174 C The drawing for the frame is Benesch 969.
175 RH Blok 1976-1977-1978.
A Docs. 1656/12, nr. 121; *Urk.* 350.
B Hoet 1752, p. 419.
C Hoogstraten, p. 183.
G Hausherr 1963.
176 C On November 7, 1645, Ameldonck Leeuw and Arent Dircksz. Bos contracted to buy from Menasseh a complete edition of the Mishnah, in four thousand copies, a print run that would be considered respectable even today. Kleerkoper and van Stockum 1914-1916. The size of the transaction leads me to believe that this was not the first time that Leeuw did business with Menasseh.
E Was T. Fulwood related to the royalist judge Christopher Fulwood (ca. 1590-1643), who lost all his possessions in the Civil War?
For the etchings, see van der Waal 1954-1955.
FIG. 183 The copy of Josephus I consulted, complete with a foreword 'to the Christian reader' that speaks plain anti-Jewish language, was published by Frans Pels in Amsterdam in 1642, but has a title print dated 1636.
177 RH Wagenaar, vol. 1, p. 531.
POINT 9 Elias, vol. 2, pp. 1002, 1006. The loan was probably seen by lender and borrower as an inducement for the Elector to extend protection to the Mennonites in Brandenburg.
POINT 10 The copy was published in Gerson 1957.
178 C The information on the Schönborn holdings is from Hofstede de Groot 1915.
D Angel 1642, pp. 47-48.
FIG. 185 There is a photograph of the Ebenrod *Capture of Samson* in the Rijksbureau voor Kunsthistorische Documentatie in The Hague. The lost copy after Rembrandt is illustrated in Eich 1981.
179 RH Angel 1642, p. 48.
FIG. 186 Slatkes 1983, pp. 37-46.
181 RH States version, 1637 edition, fol. 43 recto.
A Information from Hofstede de Groot 1915.
182 FIG. 190 Doc. 1660/25.

Chapter 23
Rembrandt's marriage
183 A The state of the literature on the Uylenburghs is terrible. The interested reader undoubtedly knows the nineteenth-century books by Scheltema and Eekhoff which are still the standard sources.
C Doc. 1634/5.
185 RH Doc. 1634/2.
C Docs. 1635/6, 1638/8, 1640/5, 1641/4.
E The only particulars I have been able to uncover concerning Sylvius are that he was the subject of a scandal for 'going with a young woman' as a student in Franeker in 1591 (Vos 1903, p. 42) and that in 1598 he turned down an offer to serve as chaplain on Jacob van Neck's expedition to the East Indies (Evenhuis 1967, vol. 2, p. 318). The latter proves

that Sylvius's studies were financed by the township of Amsterdam – all three candidates for the chaplaincy were in that position.
186 C Bontemantel, vol. 2, pp. 118-119. The conversation took place on February 2, 1656.
187 RH Krul, bridal poem from *Eerlycke tytkorting*, Amsterdam 1634.
A Doc. 1634/6. Should have been placed before 1634/5. Mentz and Jauernig 1944, p. 130. On fol. 322v of the album is an inscription dated August 5, 1634, by Hendrick van Bilderbeeck. He was the agent of the States General in Cologne and, I believe, the father of Margaretha van Bilderbeeck (fig. 138).
G *Vermakelijke uyren*, in which the 'A.B.C. der Minnen' was included, was published in 1628 by J. A. Colom, from whom Uylenburgh later rented space for his art gallery (Dudok van Heel 1982, pp. 78, 89, note 42). The poem is on p. 171. Heckscher's compliment to Rembrandt ('It seems significant that Rembrandt managed to escape the emblematic fashion [in inscribing Grossmann's album] where few others among his colleagues would have done so'; Heckscher 1958, p. 178) was not quite deserved.
FIG. 196 Snoep 1975, p. 79. Heckscher 1958, p. 19, says that Uylenburgh's motto derives from Ovid's 'You will go with the greatest safety in a middle path.'
188 D Docs. 1634/7, 1638/7.
189 RH Van Mander, *Levens*, fol. 259 verso.
C Doc. 1636/1.
D For the steady stream of communications between Huygens and Boreel, see the former's *Briefwisseling*. Rembrandt's address is analyzed – too sharply, I believe – by van Eeghen 1959. For Boreel's 'gross and tactless behaviour,' see Elias, vol. 1, p. 541. Boreel's wife was judged by the Dutch diplomat Soete de Laecke de Villiers to be 'une bonne et grosse femme et une vraye Amsterdamsche-Moer; elle n'est past de grand entretien, et pour entretenir a quantité de petits chiens avec elle ioué' (diary entry of March 5, 1657, cited by Elias). The present-day reader may suspect the diplomat of sheer snobbish prejudice when he reads the following remark: 'Il la faut entretenir en flamand, car elle ne parle ny entend le français, ce qui nous estoit desia une assez grande peine, nous estant desaccoustumés de nostre langue.'
190 FIGS. 202-205 See Louttit 1973.
191 RH Krul 1627, cited by Louttit.
192 B Doc. 1647/2.
C Doc. 1648/7.
D *Urk.* 336.
193 A Doc. 1652/7.
D Doc. 1657/2.
E Leonhardt 1979.
H Rembrandt made purchases at the sales of B. van Someren (1635/1), Jan Basse (1637/2), Nicolaes Bas (1637/3) and G. Spranger (1638/2). See van Eeghen 1969g, p. 86, note 1.
194 A Docs. 1637/6, 1659/20.
B Van Eeghen 1977d.
C Doc. 1637/7.
F White 1969, vol. 1, p. 118.

Chapter 24
Figures and faces
195 B Docs. 1637/4, 1638/5, 1639/9.
196 FIG. 208 Wijnman 1959, pp. 12-13.
197 FIG. 211 The mother-in-law of the first known owner was the same Anna Kerckrinck who commissioned Hendrick Uylenburgh to paint a portrait of her brother (see note 141d). If this painting was made for her, then the germ of the famous Rembrandt collection of Valerius Röver (1686-1739) was formed by the purchase of this painting by his grandmother, as early as 1632, from Uylenburgh!
198 FIG. 216 Doc. 1640/4.
199 RH See p. 76.
FIG. 217 HdG 272e. In addition to the documents cited above, see also Docs. 1646/7 and 1665/23.
200 FIG. 219 Walker, p. 32.
201 RH Houbraken, vol. 1, pp. 205-206.

Chapter 25
1639
202 A Docs. 1639/1, 1639/2, 1639/4.
B Meischke 1956.
D For Belten's date of death, see Buchelius in van Campen 1940, p. 102. Because he died in Utrecht and was buried in Maarssen, Belten's date of death was not registered in Amsterdam, and has evaded

the attention of researchers. Buchelius remarks that Belten's body was transported under a coat of arms, which the diarist found ridiculous.
F *Künstler-Inventare*, vol. 1, p. 274.
G Van Eeghen 1977b.
INSERT For Huydecoper's cashbook, see note 134 B.
203 F Dudok van Heel 1978b, p. 64 and map on p. 161.
G Elias, vol. 1, pp. LXXXIII-LXXXVIII.
204 A *Briefwisseling*, vol. 4, p. 115. Hooft calls de Graeff and Banning Cock his 'nephews' on the basis of the various marriages between the Hoofts, the Overlanders and the de Graeffs. An eloquent testimony to the Orangist sentiment in the de Graeff family is their pious preservation, throughout the generations, of the chair in which William of Orange sat when he visited Burgomaster Dirck Jansz. de Graeff (Elias, vol. 1, p. LXXXIV).
B Illustrated in Martin 1935, vol. 1, p. 313.
C Elias, vol. 1, pp. LXXXI-LXXXIII.
205 F Vondel, vol. 4, p. 602.
FIG. 224 A photograph of van Couwenbergh's painting, formerly in the art trade in Monaco, is preserved in the Rijksbureau voor Kunsthistorische Documentatie, The Hague. For the shared commission with de Vlieger, see van Ysselsteyn 1936, vol. 1, p. 136.
206 A The discovery in 1964 that the sitter of fig. 64 is Amalia van Solms was 'of fundamental importance for the biography of Rembrandt, since his relations with the stadholder's court at such a young age made him 'in' among certain Amsterdam circles.' Wijnman 1966.
B Sullivan 1980.
C Van Eeghen 1956f. For the joyous entry, see Snoep 1975, pp. 39-76.
FIG. 225 Blankert 1982. The portrait of Maria Trip is not named there. For its attribution to Flinck, see Moltke 1965, p. 138, nr. 350; p. 149, nr. 397.
207 RH Houbraken, vol. 2, p. 16.
C Prins 1933, p. 212.
208 B Moltke 1965, pp. 156-157, nrs. 432, 433.
FIG. 228 Docs. 1640/13, 1647/3.
FIG. 229 Docs. 1660/15, 1660/22-26. Dudok van Heel 1978b, pp. 161-162; Dudok van Heel 1980a.

Chapter 26
The Nightwatch
209 A See note 134 D.
D Bontemantel, vol. 1, p. 190: 'The gentlemen of the government and the war council [the colonels, captains and lieutenants] consist of the identical individuals, with so few exceptions as to be negligible.'
G Kok 1967.
H Bontemantel, vol. 1, pp. 170-175.
210 D Nieuwenhuys 1834. Six 1909. Haverkamp Begemann 1982.
F Kok 1967, p. 118.
FIG. 230 The survey of civic guard portraits is based on the holdings of the Amsterdams Historisch Museum and the Rijksmuseum, checked against older sources like Bontemantel and Schaep, as quoted in Kernkamp's annotations to Bontemantel. A systematic study of the Amsterdam civic guard portraits, in their relation to institutional and political history, could give form to future research into Dutch art, culture and history. For the borrowing from de Gheyn, see Martin 1947.
211 RH Cited by Kok 1967, p. 120, as proof that the painting does not depict a specific event.
212 B Wagenaar, vol. 1, p. 534.
E That the commissions for the *Nightwatch* had to have been given before December 1640 was demonstrated by Dudok van Heel in 1979. See Haverkamp Begemann 1982, p. 14, note 16. One of the sitters, Jan Claesz. Leijdeckers, died in the last week of that month. Leijdeckers was the uncle of Rembrandt's future pupil Gerbrand van den Eeckhout.
F The size of the fee is known from a declaration by one of the sitters (Doc. 1659/16).
213 RH Manuscript owned by the author. Other manuscripts with roughly the same contents, copied by various town secretaries, are in the Amsterdam archives.

Chapter 27
During the Nightwatch
214 C For Lopez, see Docs. 1639/8 and 1641/6, with literature; Huygens, *Briefwisseling*, vols. 2 and 3; Tallement des Réaux 1834, pp. 226-229. According to Buchelius, in van Campen 1940, p. 71,

there were rumours that most of the paintings Lopez bought at the van Uffelen auction were captured in transport by Dunkerque pirates.
E De Jongh 1969.
215 B Van Eeghen 1958a. *Künstler-Inventare*, vol. 5, p. 1689.
FIG. 232 Persijn was undoubtedly related to the Reinier van Persijn who held a high post in the financial service of the States General.
217 RH Doc. 1659/18.
A Docs. 1654/13, 1662/3, 1668/7. *Künstler-Inventare*, vol. 1, pp. 74ff. Van Eeghen 1956e.
B Doc. 1639/10. An earlier instance of collaboration between Uylenburgh and Luce was their appraisal, on December 11, 1637, of the collection of Jan Arentsz. van Naerden, undoubtedly the brother of Uylenburgh's creditor Claes Arentsz. van Naerden (*Künstler-Inventare*, vol. 4, p. 1230). On December 7, 1644, he carried out an appraisal jointly with Gerrit Uylenburgh, (ibid, p. 1233).
D Emmens 1956, in Emmens 1981, vol. 3, pp. 61-97, 206. Frederichs 1969.
218 A The painting turned to the wall was noticed by Busch 1971. For the imagery of the painting, see also Klamt 1975.
E *Künstler-Inventare*, vol. 3, p. 1022.
F Doc. 1662/21.
219 RH Van Deursen 1980, p. 108.
FIG. 238 Frederichs 1969.
220 B Doc. 1647/1.
D Snoep 1975, pp. 64-76.
221 RH Cats, 'Klaegh-liedt van Hagar, Abrahams maeght,' in Cats 1712, vol. 1, p. 449.
222 D During the next joyous entry of a prince of Orange into Amsterdam, in 1659, the train of sixteen floats was led by 'De Eendracht' (Concord). See Snoep 1975, p. 84.
223 RH Van Mander, *Grondt*, fol. 19 recto.
E Doc. 1659/21.
INSERT Doc. 1641/6.
224 FIG. 244 Vondel, vol. 3, pp. 797-878. In Vondel's dedication of *Gebroeders* is a famous passage in which the painter invents the program of a painting he would have liked to see Rubens paint. Doc. 1659/15. HdG 36D. Schwartz 1985.

Chapter 28
After the Nightwatch
226 C In Doc. 1659/14, van Ludick and de Wees testify that from 1640 to 1650 they enjoyed 'very great familiarity' with Rembrandt. Van Ludick was a landscape painter as well as a dealer. One of his signed works is a copy after a landscape by Jan Asselijn, who was portrayed by Rembrandt in an etching (von Wurzbach 1906-1911, vol. 2, p. 71).
FIG. 245 Golahny 1983 demonstrates that the painting is based in part on a sixteenth-century engraving after a Raphael drawing of Alexander the Great and his bride Roxanne.
227 C Broos 1983.
H Rembrandt's quick admittance to the guild of St. Luke, by 1634, may have been due to Uylenburgh's presumed good relationship with Santvoort's father Dirck Pietersz. Santpoort. In 1641 Santvoort married a cousin of Rembrandt's partner in crime, Jan Jansz. Uyl (see p. 194). The extensive study of Santvoort being prepared by R.E.O. Ekkart will unquestionably turn up interesting new points of view for the Rembrandt student.
228 FIG. 247 Hoogstraten, p. 176. *Urk.* 360. Emmens 1964, in Emmens 1979, vol. 2, pp. 200-208, 'Rembrandt en de 'pictor doctus': de 'Satire op de kunstkritiek'. Emmens interprets the drawing as a 'modern adaptation and application of the '*Calumny of Apelles*' – the painter's traditional means of defense against criticism.' I agree with Emmens, but am more inclined to see the figure on the barrel as an art dealer or collector rather than a scholar like Junius.
FIG. 248 See p. 278.
229 RH Houbraken, vol. 1, p. 205.
230 FIG. 250 For de Renialme's contacts with the Brandenburg court, see Seidel 1890. The masters of whose work de Renialme offered the Elector more than one example were Lievens, Salomon Koninck and Porcellis. Rembrandt too dealt in works by Lievens and Porcellis, and there may even be a connection between his art dealing and de Renialme's. See 'Note on the inventory,' p. 291.
231 RH Houbraken, vol. 1, p. 214.
E For van den Eeckhout's family, see Anonymous 1883-1884.

F Houbraken's story about Spilberg is in vol. 3, p. 33.
G In 1648 van der Pluym was back in Leiden, where he was one of the founders of the guild of St. Luke. His apprenticeship with Rembrandt must have begun in 1645 or 1646.
232 B Elias, vol. 1, pp. XCII-XCIII.
233 RH From the dedication to Vondel's 'Letters of the holy virgins, martyrs,' written in 1642 after his conversion to Catholicism. Vol. 4, p. 431.
234 A Elias, vol. 1, p. XCII. Elias also quotes a friend of the Bickers, who says, with equal justice, 'that the city underwent miraculous growth under the rule of Mr. Bicker' (p. LXXXIX).
C Sandrart's *Company of Cornelis Bicker* (1638) and van der Helst's *Company of Roelof Bicker* (1639) were followed by more family portrait commissions for both painters.
F Amsterdam, Gemeente-archief, familie-archief de Graeff, nr. 639 (printed inventory, p. 57).
235 RH Quoted by Elias, vol. 1, p. LXXXII.
D Kauffmann 1920.
236 B Van Selm 1984-1985, p. 118.
C The Latin and Dutch versions were published on facing pages in the *Bloemkrans van verscheiden gedichten*, pp. 48-49.
F Rammelman Elsevier 1849.
237 RH See note 226 F.
C Wagenaar, vol. 1, pp. 535-539.
239 RH From Huygens's poem 'Euphrasia. Ooghen-troost aen Parthenine, bejaerde maeghd, over de verduijstering van haer een ooghe,' a poem of consolation to an old woman friend who lost the sight of one eye. *Gedichten*, vol. 4, p. 100. The thousand-line poem is dated January 5, 1647. It consists largely of a 'parade of blindmen,' which neatly covers all of mankind. A place of honour is assigned to the painters.
FIG. 262 Huygens listed the painters he wanted by city: 'Haghe: Van Tulden, Honthorst, Hanneman, Willeboirts, Couwenbergh wapentuigh [arms], Gonzales, Soutman, Grebber. Haarlem: de Breij, Albert de Valck pilaren, Pieter Claesz. silver en gout. Amsterdam: Van Loo, Backer. Alkmaar: Cesar Everdingen.' Slothouwer 1945, p. 315.
240 C Poelhekke 1978, p. 135.
D Doc. 1646/6.
G Doc. 1647/6.
241 RH Houbraken, vol. 1, p. 214.
242 B Although the essential documents have been known since 1890, the story of Geertge Dircx was not told in a coherent fashion until 1964, by Wijnman in White 1964, pp. 147-152, and in the following year by Vis 1965. Both authors are rightly critical of the indifferent attitude towards Geertge of Rembrandt's earlier biographers.
FIG. 267 *Urk.* 321.
243 RH Doc. 1656/4.
244 FIG. 271 *Urk.* 322.
FIG. 272 *Urk.* 404.
245 FIG. 275 *Künstler-Inventare*, vol 1, p. 75; *Urk.* 383.
246 FIGS. 276, 277 Andrews 1977, pp. 154-155.
247 RH Doc. 1656/5.
248 F For Ruts, see van Eeghen 1977c, and for Ingels, Doc. 1654/1.

Chapter 29
Landscape, still-lifes and animals
249 B Lugt 1920.
C A possible tie between Rembrandt and de Man was via Joannes Wtenbogaert, his fellow tax-collector. For the connection with Scriverius, see fig. 4.
D *Urk.* 368.
E Dudok van Heel 1980b.
251 RH *De jeugd*, p. 73.
253 RH Hoogstraten, p. 232.
B *Corpus*, vol. 1, pp. 223-224. Bredius 1910, p. 196.
255 RH Doc. 1656/4. Quoted in order to suggest that Willem Jansz. was the butcher in whose shop Rembrandt was able to work, and that the woman in the background of fig. 292 was Cornelis Jansdr.
FIG. 292 Doc. 1661/10. *Urk.* 353. Slive 1953, p. 166, note 1. Doc. 1662/5. *Künstler-Inventare*, vol. 3, p. 973.
FIG. 293 In the dating, I respect the general tendency to date the Glasgow painting earlier than that in the Louvre, although I do not really understand why this is done. It is true that there is a difference in mode between the two *Slaughtered oxen*, the Paris version being painted more broadly. However, the same difference can be observed in

the two versions of *Joseph and the wife of Potiphar* (figs. 309-310) of the same year as the Paris *Ox*, the Berlin version corresponding to the latter, and the Washington one to the *Ox* in Glasgow. If all four paintings date from 1655 (and if all four survive the ordeal of the Rembrandt Research Project as well as they have survived the judgment of posterity until now), this would indicate that Rembrandt was in control of alternative styles, which should oblige us to rethink our notions of the role of style in his declining fortunes. Curiously, there is yet another pair of matched paintings from 1655, figs. 335 and 336.

Chapter 30
In the wings, 1647-1654
256 A Albach 1977. Worp 1920.
257 D Dudok van Heel 1980a.
FIGS. 294, 295 Dudok van Heel 1980b, p. 120. Vos 1662, p. 556. The wealth of information on Amsterdam patronage in the collected poems of Jan Vos has never been studied.
258 C Tóth-Ubbens 1975-1976. The board members of the theatre from 1637 to 1688 are listed by Dudok van Heel 1980a, pp. 41-43. For Willem van Campen's painting, see Doc. 1661/11. The suggestion that Rembrandt made an etching for Tengnagel's play (Bartsch 120) is from Six 1909a. The plates that were used in the printed edition were engraved by Nolpe after designs by de Vlieger, Quast and Isaac Isaacksz. All of them except Quast also worked on the joyous entry of 1642 and the peace celebrations of 1648. Rembrandt's print may have had another function. Tengnagel was not the only Amsterdam playwright to use the theme of the Spanish gypsy. Preceding his was a play by Catharina Verwers, who in 1642 married Christian Dusart, later one of Rembrandt's close friends. Worp 1904-1908, vol. 1, p. 385.
259 RH This is from the poem painted on fig. 296.
FIG. 298 See Bredius 1892, for van de Cappelle. The identification of the sitter as Pieter Six was arrived at independently by J.P. Voûte, in correspondence with K.G. Boon of September 1984.
261 RH *Verscheyde Nederduytsche gedichten* is signed with six sets of initials, standing for Jan Vos, Jan Six, Tobias van Domselaer, Gerard Brandt, Gerrit Pietersz. van Zijl and an unknown CLB. See Penon 1880. My own suggestion for the identity of the final editor is Nicolaes Borreman, calling himself Cl[aes] for the occasion. The dedication is addressed to the painter van Zijl (1607-1665), himself one of the editors. Poems of this kind are nearly always dismissed by art historians with an obligatory reference to Horace's law 'ut pictura poesis' – 'poezy moet wezen als schildery' (Vondel, vol. 7, p. 367), poetry should be like painting. Progressive practitioners of both arts were expected to do what they could to validate the saying. Ancient wisdom no doubt played a role in Amsterdam, but to my mind contemporary developments were more important, with the Union of Apelles and Apollo in the offing (pp. 262-266). In this regard, it is unusually interesting that both Brandt and Vos wrote poems in the 1640s, on paintings by van Zijl, in which they used the metaphor of 'eye and ear' – painting and poetry or painting and music. According to Emmens, the poets were borrowing the imagery of Vondel's poem on Rembrandt's *Anslo*. 'As amazing as it may seem, the caption to the portrait of Anslo is the first place [in Dutch literature] where the hierarchy of hearing and seeing is combined with the more usual hierarchies of word and image, body and soul' (Emmens 1964, in Emmens 1981, p. 94).
Re-translated into terms of Amsterdam patronage, where 'word and image' meant as much as 'glorifying the civic government in poetry and painting,' this suggests that Rembrandt was an early candidate for the civic commissions which later went to Flinck. Van Zijl, as far as I know, had no contact with Rembrandt. He did have ties with Flinck: two portraits of Flinck by van Zijl were published in print form, one with a caption by Vondel (vol. 7, p. 944).
FIG. 302 Lugt 1920, pp. 118-119.
262 C Vondel, vol. 5, pp. 451-453, 454-455. Freise 1911, pp. 73ff., 274-275.
D I have not been able to find any books or articles devoted to the Brotherhood. The subject comes up often in the Vondel literature. The sources I used are a mixed bag of references, and cannot possibly have provided me with anything resembling a complete picture.

FIG. 303 Vondel, vol. 4, p. 295. The dating of the poem to 1641 is based purely on the presumption that it was written on the painting in fig. 240. In fact it was not published until 1660, in *Hollantsche Parnas*, and for that reason alone almost certainly dates from the 1650s.
263 RH Hoogewerf 1947, p. 159. The editors of the collected works of Vondel are less sure that the poem was written to Flinck on that occasion, but I see no reason to doubt the traditional view.
FIG. 304 Hendrik Trip's sister-in-law, Maria Godin, married Pieter Graswinckel in 1644 (van Eeghen 1983, p. 36). In 1648, Bruyningh's sister Hillegond married Pieter's relative Jan Graswinckel (van Eeghen, 1977e, p. 59).
265 RH Jan Vos, 'Strydt tusschen de Doodt en Natuur, of zeege der Schilderkunst' (Struggle between Death and Nature, or the Triumph of Painting), quoted from *Klioos Kraam*, vol. 1, Leeuwarden 1656, pp. 30-31. The poem is dedicated to Cornelis de Graeff, who in 1652 appointed Vos city glazier.
C Brugmans and Weissman 1914, pp. 58ff.
E Stalpaert's relationship to Huydecoper is surmised from the frequent references in the diary of Joan Huydecoper II to 'cousin Stalpaert' (Rijksarchief Utrecht, Huydecoper-archief).
INSERT De Jongh 1973. Blankert 1975. Schwartz 1983. The broadsheet is in the Royal Library, The Hague, catalogued under de Decker.
266 A Elias, vol. 1, p. CXI. Vondel, vol. 5, pp. 857-904.

Chapter 31
Rembrandt's man on the town council
267 A Van Eeghen 1971a and b.
C Bontemantel, vol. 1, p. 167. Schaep's commentary on the saying was: 'As I have often observed that most power was in the hands of a much smaller number [than twelve], I am in no doubt that this was also the case in the past.'
269 RH Wagenaar, vol. 1, p. 568.
E Doc. 1661/14.
F Dudok van Heel 1969b.
271 A Bontemantel, vol. 2, pp. 481-483.

Chapter 32
On stage, 1655-1660
272 A Albach 1972, p. 121.
B Vondel, vol. 4, pp. 148-208, p. 204.
D Doc. 1662/19.
F Van de Waal 1969, mentions the play on p. 221, note 5, entirely for the record, and in another connection.
273 A De Lairesse, vol. 1, p. 335.
274 FIG. 309 For the cast of the 1655 production, see Albach 1977, p. 74, and Worp 1920, p. 115.
276 FIG. 311 Houbraken, vol. 1, p. 205. For the cast of *Hester*, see Albach 1977, p. 75.
277 RH Poem published at the end of the printed edition of *Tamerlan*.
FIG. 313 For the cast, see again Albach 1977, p. 77. The literature on the painting is very extensive. The most recent contribution is Slatkes 1983, pp. 61-92. His theory that the rider is not a Pole but a Middle Easterner I agree with gladly, but not with his identification of the subject as the biblical David. By a curious coincidence, Slatkes cites in support of his argument the print of the *Christian knight* by Serwouters's father (fig. 11).
For a spirited interpretation of the traditional identification of the horseman as a Pole, see Broos 1974. He argues that the painting is a portrait. If it is, then the most likely Pole for the role is Mathias Przijpskouski, to whom Joachim Oudaen and Willem van Heemskerk wrote poems on the eve of his departure to Poland. (*Bloemkrans van verscheide gedichten*, Amsterdam 1659, pp. 324-326.) Both of them describe him explicitly as a Christian knight, though not on horseback. In fact, their imagery is rather close to that of fig. 11.
What I mainly object to in the existing interpretation is exemplified by Slatkes's remark 'This extraordinary work may have to be read on two or even more levels to be fully understood.' This gives *carte blanche* to the art historian wishing to read into the painting those elevated spiritual values with which the Rembrandt literature is already overloaded. With Rembrandt's paintings, we should be happy if we can extract an unequivocal meaning on one level.
278 C For the horse on stage, see Albach 1977, pp. 101, 108.

Chapter 33
The great chain of patronage
279 D Moltke 1965, pp. 154-155, 166-167.
F De Balbian Verster 1918.
G Snoep 1975, pp. 83-90.
280 H Needless to say, *Hollantsche Parnas* was not published just to help Rembrandt get city commissions. There are a number of other recurrent themes in the anthology: verses on the Brotherhood, the relief of Copenhagen from the Swedish siege, and the praise of the cities of Leiden and Dordrecht. It stands to reason that there is a relationship of some kind between *Hollantsche Parnas* and the earlier anthologies of the kind, *Verscheyde Nederduytsche gedichten* (1651 and 1653), *Klioos Kraam* (1656 and 1657) and *Bloemkrans van verscheide gedichten* (1659). (The second volume of *Verscheyde Nederduytsche gedichten*, by the way, was dedicated to Jan Six.) Three of the anthologies are liberally provided with poetic captions to paintings. Only in the *Bloemkrans* are they signally scarce.

Without discussing the nature of the anthologies, or looking for the institutional and political history behind them, Jan Emmens made a first step towards their study in his unfinished paper 'Apelles en Apollo: Nederlandse gedichten op schilderijen in de 17de eeuw' (Dutch poems on paintings in the seventeenth century; 1955), which was first published in 1981, in vol. 3 of the collected works.
281 RH Vondel, vol. 8, p. 943: 'In memory of the late gifted Govert Flinck, painter.'
282 INSERT Houbraken, vol. 2, pp. 15-20.

Chapter 34
Insolvency
283 A The documents regarding Rembrandt's finances are easy to find in Strauss and van der Meulen, and are not noted separately here.
D Bontemantel, vol. 2, p. 495.
F The role of the van Vlooswijks in Rembrandt's career deserves close study. The family was actually involved in the arts: Cornelis van Vlooswijk's cousin Jan Gijsbertsz. van Vlooswijk (1610-1667) was a painter and art dealer. He was probably the illegitimate son of Gijsbert Claesz. van Vlooswijk, which however did not keep Cornelis from witnessing his marriage vows in 1638. His father's rightful wife, after his death, married Joan Huydecoper. Elias, vol. 1, p. 84, note f.
284 INSERT Vos's poem is in Vos 1662, p. 531. The documents relating to Rembrandt and Jews are 1637/7, 1653/9, 1654/3, 1654/4 and 1654/8. The fond wish of many to link Rembrandt to Spinoza has no historical basis. Whatever indications there are point in another direction. Spinoza's great friend in the Amsterdam art world was Lodewijk Meyer, one of the founders of Nil Volentibus Arduum and ally of Andries Pels. Their antagonism towards Rembrandt will certainly have communicated itself to Spinoza, if they ever talked about him.

For the owners of paintings of Christ, see Doc. 1662/1a and Urk. 350. The quotation from Hoogstraten is on p. 105, as is the running head.
286 D That Rembrandt was behaving on his own volition, and not under pressure from creditors, is also suggested by Ornia's declaration in Doc. 1657/3.
F For Uylenburgh and the burgomasters, see Wijnman 1959, p. 16.
287 RH Doc. 1657/3.
A Bontemantel, vol. 2, pp. 481-483.
INSERT Harmen Becker's entry into Rembrandt's life was not unannounced. When Johannes de Renialme died in 1657, his jewelry and nine of the paintings he owned were in the hands of Becker, as security for loans, including four by Lievens (*Künstler-Inventare*, vol. 1, pp. 238-239). Since Becker was also a creditor of Gerrit Uylenburgh, we could call him Rembrandt's indirect financier for a period of at least twenty years.
289 RH Houbraken, vol. 1, p. 203.
291 RH Urk. 352. Pels 1681, p. 42.
INSERT For the documents pertaining to Porcellis and Hendrick Anthonisz., see *Künstler-Inventare*, vol. 2, pp. 614-633.

Chapter 35
Hendrickje and Titus
292 FIG. 323 That Rembrandt once more took a classical model for a nude, after *Andromeda* (fig. 111) and the *Bathsheba* of 1643 (fig. 245), is characteristic of his attitude towards the motif. Yet this did not prevent Pels from branding Rembrandt's

nudes as crimes against the laws of art, drawn purely from observation.
293 RH Urk 352.
B Wijnman, in White 1964, p. 152, note 41.
F Dudok van Heel 1981 and 1982.
298 F Van Eeghen 1977.
299 RH Doc. 1660/20.

Chapter 36
The tip of the nose: half-lengths
301 A In addition to the documents, see the reconstruction of events by Tóth-Ubbens in *Rembrandt in the Mauritshuis*, pp. 222-223.
C Doc. 1652/11.
F Dudok van Heel 1982, pp. 86-87.
302 FIG. 334 Emmens 1964, p. 250.
303 RH Hoogstraten, pp. 107-108.
FIG. 336 The information concerning the X-rays is from a communication by the museum, dated January 1984. The date 1655 was observed by the museum staff at that time.
304 F Archduke Leopold Wilhelm was the patron, in 1647, of a group of itinerant players who later came to Amsterdam, where several members of the troupe were painted in later years by Rembrandt, I believe. See Albach 1977.
INSERT Amsterdam: *Urk.* 313, 334, 350, HdG 475. Rotterdam: *Urk.* 351. The Hague: Doc. 1656/3. Amersfoort: Doc. 1655/1a. Dordrecht: HdG 81d. Antwerp: Denucé 1932, p. 262. Bartels also owned 'a portrait by Rembrandt van Ryn' appraised at fifty guilders.
305 RH From the preface to Cats 1632.
B Schneider/Ekkart 1973, nr. 244.
306 A *Urk.* 333. The translator of Agrippa von Nettesheim was Joachim Oudaen (1628-1692), a church deacon with close ties to several of the poets in Rembrandt's milieu. In 1657 he wrote a poem on Lastman's *Pylades y Orestes* in the collection of van der Wolff, the companion to another Lastman that was shortly to be purchased by Jan Six. Oudaen's poem was first published in the *Bloemkrans*.
C Emmens 1964.
D A good article on the various Amsterdamers named Jacques de Ville, one of whom was a prominent actor, would be more than welcome.
F Houbraken, vol. 2, p. 239.
307 RH Vondel, vol. 5, pp. 484-491, lines 98-101.
C Based on the Dutch translation in Emmens 1964 (Emmens 1979, p. 77). With thanks to M. Emmens-Vijlbrief for her kind permission to quote from Emmens's work.
311 RH Hoogstraten, p. 256.
312 A Rembrandt was visited in the 1660s by Constantijn Huygens Jr., who looked at a drawing by Carracci Rembrandt was offering for sale. See Doc. 1663/9.
D *Urk.* 352.
315 RH Hoogstraten, p. 106.
B Momma: *Urk.* 349; see also here, p. 337. Lindeman: *Künstler-Inventare*, vol. 2, p. 610. Rosendael: *Urk.* 361. Van Heusden: Doc. 1667/5. Medici: HdG 380. Trivulzio: HdG 168.
D Dudok van Heel 1982, pp. 86-87. Six, van Goor, Becker and Schaep are already known to the reader. Hendrick Scholten (1617-1679) was probably the next owner of the *Old man sleeping* (fig. 84), following Joannes Wtenbogaert. Because he died before Wtenbogaert, the latter must have sold his Rembrandt heirloom at some point. *Corpus*, vol. 1, p. 207. In 1670 Scholten was appointed director of the Dutch East India Company, as Becker's son Hendrick was in 1671. They were two of the three 'merchants not in the government' who managed to capture this valuable post. Bontemantel, vol. 1, pp. 145-147. Herman van Zwol was the owner in 1707 of 'A Muscovite envoy' by Rembrandt (HdG 272c).
FIG. 365 *Urk.* 371, 391.
316 INSERT Hoogstraten, pp. 309-310.
317 A In this light, it is ironic that the organization which takes it upon itself to preserve art treasures for the Netherlands calls itself the Vereniging Rembrandt.
B The house on the Westermarkt was rented by the Uylenburghs from the prominent Mennonite publisher Jacob Aertsz. Colom (1599-1673), a man who played a role of importance in the lives of many of the people named in this book, beginning with his publication of Vondel's *Palamedes* in 1625. For Rembrandt's last dwelling, see van Eeghen 1969c.
C Dudok van Heel 1982, p. 70.
317 RH Dudok van Heel 1982, p. 78. The testament was that of a young woman living in Uylenburgh's house.

Chapter 37
Town hall
318 B Bontemantel, vol. 2, p. 520.
C Blankert 1982, p. 73. Perhaps equally painful for Rembrandt was the commission Bol received from the township of Leiden in 1664, to replace a mantelpiece painting by Claes Isaacsz. Swanenburg.
D For Lord Ancrum's comment, see *The Orange and the Rose*, p. 37, nr. 41.
E Van de Waal 1952, vol. 1, pp. 215-219.
F Ibid., pp. 220-230.
319 FIG. 368 Doc. 1662/15. Translation of Strauss and van der Meulen.
320 C Van Eeghen 1969d.

Chapter 38
Histories, 1655-1662
321 B Adams 1984.
322 FIG. 371 Docs. 1658/26-28.
323 FIG. 374. Hoogstraten, p. 273. For Eeckhout's painting, see *God en de goden*, nr. 41.
325 RH Hoogstraten, p. 121.
C Haverkamp Begemann 1974, p. 155.
FIG. 377 Heppner 1935. The latter's conclusions are disproved by Kelch 1975, pp. 340-341, 345. For the poem, see Vondel, vol. 8, p. 757. Blankert 1982, pp. 109-110. Evenhuis 1967, vol. 3, pp. 115-127.
327 RH Dullaert 1719, p. 59.
328 FIG. 380 Bredero 1613, lines 330-333. Albach 1977, p. 77, fig. 19. Cats 1712, vol. 2, pp. 423-450, p. 438.
329 RH *Urk.* 352. Pels's line provides evidence that Rembrandt probably painted a Cyrus other than the early one (fig. 174).
B Den Herder 1958. Van de Hoek Ostende 1967.
FIG. 381 Doc. 1661/3. HdG 81d.
330 C Visser 't Hooft 1956, pp. 52-77: 'The spiritual milieu of the final period.' Van Putte 1978. Wille 1926. The admirable reconstruction of Rembrandt's surroundings in his later years in these books has received far too little attention from art historians.
FIG. 382 Vos 1662, p. 550. Doc. 1658/8. *Künstler-Inventare*, vol. 5, p. 1965.
331 RH De Lairesse, vol. 2, p. 31.

Chapter 39
The final portraits
332 A Van Eeghen 1983. Klein 1965.
D Bontemantel, vol. 2, p. 171.
F Snoep 1983.
333 B Allaert van Everdingen's Rembrandts are HdG 272d, 475 and 966.
FIG. 385 Wijnman 1959, pp. 19-38: 'Rembrandts portret van Catrina Hoogsaet (1657).' Wijnman's research does not tell us how Coppenol came to play such a prominent role in those years.
334 B Dudok van Heel 1979. Hofstede de Groot 1928.
335 RH From the dedication of Fokkens 1662. Fokkens is the author who devoted so much space to the *Claudius Civilis*. The fact that both he and Rembrandt were clients of the Trips at the time may have contributed to this.
B Van Eeghen 1957.
INSERT Klein 1965, pp. 149, 153-157.
336 A Wagenaar, vol. 2, p. 42.
B For reproductions of the X-rays, see Haak 1969, p. 309.
337 RH Vondel, 'The knighthood of Amsterdam, under his royal Majesty William of Orange,' vol. 9, p. 257. The poem was written on the occasion of the same event Rembrandt commemorated for Rihel in fig. 391.
D Van Eeghen 1958b. Klein 1965, pp. 455, 456. For Deutz, see Klein, p. 471 and van Eeghen 1969f, for Momma, Klein, p. 430 and *Urk.* 349.
340 B Hoogewerff 1919, p. 78.
FIG. 400 Doc. 1667/11.
341 RH De Lairesse, vol. 2, p. 18. These words of high praise, mixed with so much negative criticism, prove that de Lairesse was neither prejudiced against Rembrandt nor afraid to print favourable things about him.
B For Zweerts, see J.W. Enschedé in NNBW, vol. 3, cols. 1223-1225. In 1689 Zweerts published, and possibly compiled, a book called *Den Berg Parnas* 'in which Nil Volentibus Arduum is given a sound thrashing' (col. 1224). Apparently there was an unorganized opposition to Nil and to classicism which rallied around the cry 'Parnassus,' and of which Zweerts was a lifelong adherent.
D De Decker's preface to his *Puntdichten*, in the 1726 edition of the *Rym-oeffeningen*, ed. M. Brouërius van Nidek, vol. 2, fol. A3 recto-verso.

FIG. 401 In the fourth *stelling* appended to Snoep 1975, the *promovendus* asserts 'Rembrandt never painted the hideous mug of Gerard de Lairesse.' I do not agree. For the tie between the de Lairesses and the Trips, see Klein 1965, p. 101. The quotation is from de Lairesse, vol. 1, p. 325.
342 C Buytendijk, in the introduction to de Decker 1958, pp. 34-49.
345 RH Hoogstraten, p. 74. The easy recognizability of Rembrandt's style was certainly one of the factors that assured it of a prominent place in the flower-beds of Dutch art, a recognizability which was only enhanced by the exaggerations and misunderstandings of hundreds of associates, followers, copyists and forgers through the centuries. Rembrandt's image, in the process, grew more and more hackneyed, and his truly individual characteristics more and more difficult to distinguish.
FIG. 407 Van Eeghen 1983, p. 73.

Chapter 40
The last quarter-century of self-portraits
347 A *Urk.* 387. Lauts 1966. *Le siècle de Rembrandt*, pp. 186, 189. Everard Jabach represented the Dutch East India Company in Paris.
B Dudok van Heel 1982, p. 81.
INSERT Deutz: van Eeghen 1969f. Anonymous sale: *Urk.* 362. Spieringh: *Urk.* 364. Van Sonsbeeck and Jan de Walé: HdG 590. I assume that he is a descendant of Jacob Jacobsz. Hinlopen's grandfather Jan de Wale. I do not know whether there is any relationship between him and the Jan Walé for whom Isaac Isaacsz. made his statement regarding the *Ganymede* in 1647 (above, p. 129; *Künstler-Inventare*, vol. 5, p. 1483). Sibert van der Schelling: *Urk.* 393; was he related to the Pieter van der Schelling who owned the Scriverius papers? (Scriverius 1738, p. 41). Jan van Bueningen (1667-1720), the grandson of Geurt Dircksz.' cousin Hendrick, also owned a self portrait (Houbraken, vol. 1, p. 212).
351 RH Houbraken, vol. 1, p. 212. The painting that comes closest to his description is fig. 415, which cannot be traced further back than 1802, when it appeared in the auction of the Countess of Holderness (HdG 553).
352 B Broos 1971, pp. 150-184.
353 RH Elizabeth Hardwick, referring to the twentieth-century author of *Advertisements for myself*, Norman Mailer, in her review of Peter Manso, *Mailer: his life and times*, New York 1985, in *The New York Review of Books*, May 30, 1985, p. 4.
354 A Houbraken, vol. 1, p. 204.
354 E Blankert 1973, pp. 32-39.
355 RH Lugt 1920, p. 118, found in the register of deeds of Nieuwer-Amstel, penned by a tired researcher who had read Roemer Visscher's *Sinnepoppen, Het tweede schock, Boslach*.
356 RH Baldinucci, in *Urk.* 360.
357 RH De Decker 1958, p. 110, line 580.

Afterword
358 D Held 1964.
362 J *Urk.* 315.
363 D Docs. 1665/3, 1642/2, 1652/6.
E Slive 1953, pp. 19-20.
F Rosenberg 1964, pp. 24-25.
364 D Published in *De Gids*, February 1919, pp. 222-275, republished in the author's collected essays on Rembrandt, Amsterdam 1950, p. 30.
E Miedema 1975, an article of fundamental importance.
365 D See especially Tümpel's articles in the *Jahrbuch der Hamburger Kunstsammlungen* 1968 and 1971, and the *Netherlands Kunsthistorisch Jaarboek* 1969. At the Berlin conference, Tümpel very sensibly attempted to find a compromise between the positions of van Gelder and Held.
365 F Published between 1950 and 1954 in *Oud-Holland*.

Literature

Literature abbreviated in the notes

Adams 1984
H. Adams, 'If not Rembrandt, then his cousin?,' *Art Bulletin* 66 (1984), pp. 427-441
Albach 1972
B. Albach, 'Een tekening van het Amsterdamse toneel in 1638,' *Kroniek van het Rembrandthuis* 26 (1972), pp. 111-125
Albach 1977
B. Albach, *Langs kermissen en hoven: ontstaan en kroniek van een Nederlands toneelgezelschap in de zeventiende eeuw*, Zutphen 1977
Ampzing 1628
Samuel Ampzing, *Beschryvinghe ende lof der stad Haerlem*, Haarlem 1628
Andrews 1977
Keith Andrews, *Adam Elsheimer: paintings, drawings, prints*, Oxford 1977
Angel 1642
P. Angel, *Lof der schilder-konst*, Leiden 1642
Anonymous 1883-1884
'Eenige bijzonderheden betrekkelijk de familie van den beroemden Nederlandsche schilder Gerbrand van den Eeckhout,' *Algemeene Nederlandsche Familieblad* 1 (1883-1884), nrs. 104-105
Art and autoradiography 1982
Art and autoradiography: insights into the genesis of paintings by Rembrandt, Van Dyck and Vermeer, New York 1982
Bacon 1619
Francis Bacon, *The wisdome of the ancients*, London 1619 (first Latin ed. 1609)
de Balbian Verster 1918
J.F.L. de Balbian Verster, 'Amsterdam en de groote keurvorst,' *Jaarboek Amstelodamum* 16 (1918), pp. 115-168
Baldinucci 1686
Filippo Baldinucci, *Cominciamento e progresso dell' arte dell' intagliare in rame, colle vite di molti de' piu eccellenti maestri della stessa professione*, Florence 1686
Barbour 1950
V. Barbour, *Capitalism in Amsterdam in the seventeenth century*, University of Michigan 1963 (first ed. Johns Hopkins Press 1950)
Bartsch
See Basic literature
Bauch 1926
K. Bauch, *Jakob Adriaensz. Backer, ein Rembrandtschüler aus Friesland*, Berlin 1926
Bauch 1960
Kurt Bauch, *Der frühe Rembrandt und seine Zeit: Studien zur geschichtlichten Bedeutung seines Frühstils*, Berlin 1960
Benesch 1973
See Basic literature
Beschrijving
Beschrijving van en notities over de schilderijen in de Raadzaal te Dordrecht, n.p., n.d.
Bialostocki 1966
J. Bialostocki, 'Puer sufflans ignes,' *Arte in Europa: scritti di storia dell' arte in onore di Edoardo Arslan*, Milan 1966, pp. 591-595
Blankert 1973
A. Blankert, 'Rembrandt, Zeuxis and ideal beauty,' *Album amicorum J.G. van Gelder*, The Hague 1973, pp. 32-39
Blankert 1975
A. Blankert, *Kunst als regeringszaak in de 17de eeuw: rondom schilderijen van Ferdinand Bol*, Lochem 1975
Blankert 1975/1979
A. Blankert, met bijdragen van R. Ruurs, *Amsterdams Historisch Museum, schilderijen daterend van voor 1800: voorlopige catalogus*, Amsterdam 1975/1979
Blankert 1982
A. Blankert, *Ferdinand Bol (1616-1680), Rembrandt's pupil*, Doornspijk 1982
Bloemkrans 1659
Bloemkrans van verscheiden gedichten, Amsterdam 1659
Blok 1976
F.F. Blok, *Caspar Barlaeus: from the correspondence of a melancholic*, Assen 1976
Blok 1976-1977-1978
F.F. Blok, 'Caspar Barlaeus en de Joden,' series 57 (1976-1977), pp. 179-209 and new series 58 (1977-1978), pp. 85-108
Bontemantel 1897
See Basic literature
Brandt 1671-1704
G. Brandt, *Historie der Reformatie*, four vols., Amsterdam 1671-1704
Brandt 1682
G. Brandt, *Leven van Joost van den Vondel*, Amsterdam 1682
Bredero 1613
G.A. Bredero, *De klucht van de meulenaar*, Amsterdam 1613
Bredius 1892
A. Bredius, 'De schilder Johannes van de Cappelle,' *Oud-Holland* 10 (1892), pp. 25-40
Bredius 1910
A. Bredius, 'Rembrandtiana, II: De nalatenschap van Harmen Becker,' *Oud-Holland* 28 (1910), pp. 195-201
Broos 1971
B.P.J. Broos, 'The 'O' of Rembrandt,' *Simiolus: Kunsthistorisch Tijdschrift* 4 (1971), pp. 150-184
Broos 1972
B.P.J. Broos, 'Rembrandt Verandert. En overgeschildert,' *Kroniek van het Rembrandthuis* 26 (1972), pp. 137-152
Broos 1974
B.P.J. Broos, 'Rembrandt's portrait of a Pole and his horse,' *Simiolus: Netherlands Quarterly for the History of Art* 7 (1974), pp. 192-218
Broos 1975-1976
B.P.J. Broos, 'Rembrandt and Lastman's *Coriolanus*: the history-piece in seventeenth-century theory and practice,' *Simiolus: Netherlands Quarterly for the History of Art* 8 (1975-1976), pp. 199-228
Broos 1977
B.P.J. Broos, *Index to the formal sources of Rembrandt's art*, Maarssen 1977
Broos 1983
B.P.J. Broos, 'Fame shared is fame doubled,' in *Impact of a genius*, pp. 35-58
Brown 1983
C. Brown, 'Rembrandt's 'Saskia as Flora' X-rayed,' *Essays in Northern European art presented to Egbert Haverkamp Begemann on his sixtieth birthday*, [Doornspijk] 1983, pp. 49-51
Brugmans and Weissman 1914
H. Brugmans and A.W. Weissman, *Het stadhuis van Amsterdam*, Amsterdam 1914
Bruyn 1970
J. Bruyn, 'Rembrandt and the Italian Baroque,' *Simiolus: Kunsthistorisch Tijdschrift* 4 (1970), pp. 28-48
Bruyn 1983
J. Bruyn, 'On Rembrandt's use of studio-props and model drawings during the 1630s,' *Essays in Northern European art presented to Egbert Haverkamp Begemann on his sixtieth birthday*, [Doornspijk] 1983, pp. 52-60
Buchelius 1928
Arnoldus Buchelius, '*Res picturae*': aantekeningen over kunstenaars en kunstwerken, 1583-1639, ed. G.J. Hoogewerff and J.Q. van Regteren Altena, The Hague 1928
Burchard 1917
L. Burchard, *Die holländische Radierer vor Rembrandt*, Berlin 1917
Busch 1971
W. Busch, 'Zu Rembrandts Anslo-Radierung,' *Oud-Holland* 86 (1971), pp. 196-198
Campbell 1971
C. Campbell, *Studies in the formal sources of Rembrandt's figure compositions*, thesis University of London 1971
van Campen 1940
J.W.C. van Campen, *Notae quotidianae van Aernout van Buchell*, Utrecht 1940
Cats 1632
J. Cats, *Spiegel van den ouden ende nieuwen tydt*, The Hague 1632
Cats 1637
J. Cats, 'Kort verhaal van het droevig trouw-geval tusschen twee vorstelicke persoonen, te weten, den koning Masanissa, en de koninginne Sophonisba,' (in *Trouw-ringh*, ready for the press in 1635, published in 1637), quoted from *Alle de werken*, Amsterdam 1712, vol.2, pp. 168-169
Citroen 1978
K.A. Citroen, 'De huwelijksbeker van Trijntje Coppit,' *Jaarboek Amstelodamum* 70 (1978), pp. 212-213
Clark 1966
K. Clark, *Rembrandt and the Italian Renaissance*, London 1966
Coolhaas 1973

W.Ph. Coolhaas, *Het huis 'De Dubbele Arend': het huis Keizersgracht 141, thans 'Van Riebeeckhuis' genaamd, nu daar een halve eeuw gearbeid is voor de culturele en economische betrekkingen met Zuid-Afrika*, Amsterdam 1973
Corpus
See Basic literature
de Decker 1726
J. de Decker, *Rym-oeffeningen*, 2 vols., ed. M. Brouërius van Nidek, Amsterdam 1726
de Decker 1958
J. de Decker, *Goede Vrydag*, ed. W.J.C. Buitendijk, Zwolle 1958
Defoer 1977
H.L.M. Defoer, 'Rembrandt van Rijn, De doop van de kamerling,' *Oud-Holland* 91 (1977), pp. 3-26
Denucé 1932
J. Denucé, *De Antwerpsche 'Kunstkamers': inventarissen van kunstverzamelingen te Antwerpen in de 16e en 17e eeuwen*, Amsterdam 1932
van Deursen 1970
A.Th. van Deursen, *Bavianen en slijkgeuzen: kerk en kerkvolk in Holland ten tijde van Maurits en Oldenbarnevelt*, Assen 1970
van Deursen 1980
A.Th. van Deursen, *Het kopergeld van de Gouden Eeuw*, vol. 4: *Hel en hemel*, Assen 1980
van Dillen 1939
J.G. van Dillen, 'Marten Looten en zijn portret,' *Tijdschrift voor Geschiedenis* 54 (1939), pp. 181-190
Dohna 1878
Siegmar, comte Dohna, *Les comtes Dona à Orange de 1630 à 1660*, Berlin 1878
Drossaers and Lunsingh Scheurleer 1974
S.W.H. Drossaers and Th.H. Lunsingh Scheurleer, *Inventarissen van de inboedels in de verblijven van de Oranjes en daarmee gelijk te stellen stukken, 1567-1795*, vol. 1, The Hague 1974
Dudok van Heel 1969a
S.A.C. Dudok van Heel, 'De Rembrandts in de verzamelingen 'Hinloopen',' *Maandblad Amstelodamum* 56 (1969), pp. 233-237
Dudok van Heel 1969b
S.A.C. Dudok van Heel, 'Het maecenaat De Graeff en Rembrandt, II,' *Maandblad Amstelodamum* 56 (1969), pp. 249-253
Dudok van Heel 1975
S.A.C. Dudok van Heel, 'Waar woonde en werkte Pieter Lastman (1583-1633)?,' *Maandblad Amstelodamum* 62 (1975), pp. 31-36
Dudok van Heel 1976
S.A.C. Dudok van Heel, 'De schilder Claes Moyaert en zijn familie,' *Jaarboek Amstelodamum* 68 (1976), pp. 13-48
Dudok van Heel 1978a
S.A.C. Dudok van Heel, 'Abraham Anthonisz. Recht (1588-1664), een Remonstrants opdrachtgever van Rembrandt,' *Maandblad Amstelodamum* 65 (1978), pp. 81-88
Dudok van Heel 1978b
S.A.C. Dudok van Heel, 'Mr. Joannes Wtenbogaert (1608-1680): een man uit Remonstrants milieu en Rembrandt van Rijn,' *Jaarboek Amstelodamum* 70 (1978), pp. 146-169
Dudok van Heel 1979
S.A.C. Dudok van Heel, 'Het maecenaat Trip: opdrachten aan Ferdinand Bol en Rembrandt van Rijn,' *Kroniek van het Rembrandthuis* 31 (1979), pp. 14-26
Dudok van Heel 1980a
S.A.C. Dudok van Heel, 'Jan Vos (1610-1667),' *Jaarboek Amstelodamum* 72 (1980), pp. 23-43
Dudok van Heel 1980b
S.A.C. Dudok van Heel, 'Doopsgezinden en schilderkunst in de 17e eeuw: leerlingen, opdrachtgevers en verzamelaars van Rembrandt,' *Doopsgezinde Bijdragen* new series 6 (1980), pp. 105-123
Dudok van Heel 1981
S.A.C. Dudok van Heel, 'Het 'gewoonlijck model' van de schilder Dirck Bleker,' *Bulletin van het Rijksmuseum* 29 (1981), pp. 214-228
Dudok van Heel 1982
S.A.C. Dudok van Heel, 'Het 'Schilderhuis' van Govert Flinck en de kunsthandel van Uylenburgh te Amsterdam,' *Jaarboek Amstelodamum* 74 (1982), pp. 70-90
Dullaert 1719
H. Dullaert, *Gedichten*, Amsterdam 1719
van Eeghen 1948
I.H. van Eeghen, 'De anatomische lessen van Rembrandt,' *Maandblad Amstelodamum* 35 (1948), pp. 34-36
van Eeghen 1956a

I.H. van Eeghen, 'Maerten Soolmans en Oopjen Coppit,' *Maandblad Amstelodamum* 43 (1956), pp. 85-90
van Eeghen 1956b
I.H. van Eeghen, 'De echtgenoot van Cornelia Pronck,' *Maandblad Amstelodamum* 43 (1956), pp. 111-112
van Eeghen 1956c
I.H. van Eeghen, 'Rembrandts portret van Salomon Walens,' *Maandblad Amstelodamum* 43 (1956), p. 113
van Eeghen 1956d
I.H. van Eeghen, 'De portretten van Philips Lucas en Petronella Buys,' *Maandblad Amstelodamum* 43 (1956), p. 116
van Eeghen 1956e
I.H. van Eeghen, 'Baertjen Martens en Herman Doomer,' *Maandblad Amstelodamum* 43 (1956), pp. 133-137
van Eeghen 1956f
I.H. van Eeghen, 'Maria Trip of een anoniem vrouwsportret van Rembrandt,' *Maandblad Amstelodamum* 43 (1956), pp. 166-169
van Eeghen 1957
I.H. van Eeghen, 'De Staalmeesters,' *Jaarboek Amstelodamum* 59 (1957), pp. 65-80
van Eeghen 1958a
I.H. van Eeghen, *Een Amsterdamse burgemeestersdochter in Buckingham Palace*, Amsterdam 1958
van Eeghen 1958b
I.H. van Eeghen, 'Frederick Rihel, een 17de eeuwse zakenman en paardenliefhebber,' *Maandblad Amstelodamum* 45 (1958), pp. 73-81
van Eeghen 1959
I.H. van Eeghen, 'Waar woonde Rembrandt in zijn eerste Amsterdamse jaren,' *Maandblad Amstelodamum* 46 (1959), pp. 151-153
van Eeghen 1968
I.H. van Eeghen, 'De familie van Garbrant Adriaensz. Bredero: 't kan verkeeren,' *Maandblad Amstelodamum* 55 (1968), pp. 148-163
van Eeghen 1969a
I.H. van Eeghen, 'Rembrandt en de mensenvilders,' *Maandblad Amstelodamum* 56 (1969), pp. 1-11
van Eeghen 1969b
I.H. van Eeghen, 'Uitdraagsters 't zij man of vrouw,' *Maandblad Amstelodamum* 56 (1969), pp. 102-110
van Eeghen 1969c
I.H. van Eeghen, 'Een brief aan Jan Heykens,' *Maandblad Amstelodamum* 56 (1969), pp. 196-198
van Eeghen 1969d
I.H. van Eeghen, 'Wat veroverde Rembrandt met zijn Claudius Civilis?,' *Maandblad Amstelodamum* 56 (1969), pp. 145-149
van Eeghen 1969e
I.H. van Eeghen, 'Het huis op de Rozengracht,' *Maandblad Amstelodamum* 56 (1969), pp. 180-183
van Eeghen 1969f
I.H. van Eeghen, 'De Rembrandts van Joseph Deutz,' *Maandblad Amstelodamum* 56 (1969), p. 211
van Eeghen 1969g
I.H. van Eeghen, 'Het Amsterdamse Sint Lucasgilde in de 17de eeuw,' *Jaarboek Amstelodamum* 60 (1969), pp. 65-102
van Eeghen 1970
I.H. van Eeghen, 'Jan Rijksen en Griet Jans,' *Maandblad Amstelodamum* 57 (1970), pp. 121-127
van Eeghen 1971a
I.H. van Eeghen, 'De vaandeldrager van Rembrandt,' *Maandblad Amstelodamum* 58 (1971), pp. 173-181
van Eeghen 1971b
I.H. van Eeghen, 'De buurhuizen van het Glashuys,' *Maandblad Amstelodamum* 58 (1971), pp. 182-186
van Eeghen 1971c
I.H. van Eeghen, 'De anatomische les van Christiaen Coeurshof of Op zoek naar een notoir misdadiger,' *Jaarboek van het Centraal Bureau voor Genealogie en het Iconografisch Bureau* 25 (1971), pp. 181-197
van Eeghen 1977a
I.H. van Eeghen, 'Willem Jansz. van der Pluym en Rembrandt,' *Maandblad Amstelodamum* 64 (1977), pp. 6-13
van Eeghen 1977b
I.H. van Eeghen, 'Rubens en Rembrandt kopen van de familie Thijs,' *Maandblad Amstelodamum* 64 (1977), pp. 59-62
van Eeghen 1977c
I.H. van Eeghen, 'Voor wie schilderde Rembrandt het portret van Nicolaes Ruts?' *Maandblad*

Amstelodamum 64 (1977), pp. 97-101
van Eeghen 1977d
I.H. van Eeghen, 'Jan Jansz. Uyl en Rembrandt als 'tamme eend',' *Maandblad Amstelodamum* 64 (1977), pp. 123-126
van Eeghen 1977e
I.H. van Eeghen, 'Drie portretten van Rembrandt (Bruyningh, Cater, Moutmaker),' *Jaarboek Amstelodamum* 69 (1977), pp. 55-72
van Eeghen 1983
I.H. van Eeghen, 'De familie Trip en het Trippenhuis,' in *Het Trippenhuis te Amsterdam*, Amsterdam 1983
P. van Eeghen 1957
P. van Eeghen, 'Eensaem was my Amsterdam,' *Maandblad Amstelodamum* 44 (1957), pp. 150-154
Eich 1981
P. Eich, 'Rembrandts 'Blendung Simsons',' *Städeljahrbuch* 8 (1981)
Ekkart 1978
R.E.O. Ekkart, 'De familiekroniek van Heemskerck en van Swanenburg,' part 1, *Jaarboek voor het Centraal Bureau voor Genealogie en het Iconografisch Bureau* 32 (1978), pp. 41-70
Ekkart 1979
R.E.O. Ekkart, 'De familiekroniek van Heemskerck en van Swanenburg,' part 2, *Jaarboek voor het Centraal Bureau voor Genealogie en het Iconografisch Bureau* 33 (1979), pp. 44-74
Elias 1903-1905
See Basic literature
Emmens 1955
J.A. Emmens, 'Apelles en Apollo: Nederlandse gedichten op schilderijen in de 17de eeuw' (1955), in *Verzameld werk*, vol. 3, Amsterdam 1981, pp. 5-60
Emmens 1956
J.A. Emmens, 'Ay Rembrandt, maal Cornelis stem' (1956), in *Verzameld werk*, vol. 3, Amsterdam 1981, pp. 61-97
Emmens 1964
Rembrandt en de regels van de kunst (1964), in *Verzameld werk*, vol. 2, Amsterdam 1979, pp. 200-208
Emmens, *Verzameld werk*
See Basic literature
Evenhuis 1967
R.B. Evenhuis, *Ook dat was Amsterdam*, 4 vols., Amsterdam 1965-1971
Evers 1943
H.G. Evers, *Rubens und sein Werk: neue Forschungen*, Brussels 1943
Fokkens 1662
M. Fokkens, *Beschrijvinge der wijdt-vermaarde koopstadt Amstelredam*, Amsterdam 1662
Fraenger 1920
W. Fraenger, *Der junge Rembrandt*, part 1: *Johann Georg van Vliet und Rembrandt*, Heidelberg 1920
Von Frans Hals bis Vermeer 1984
Von Frans Hals bis Vermeer: Meisterwerke holländischer Genre-malerei, exhibition catalogue Berlin-Dahlem (Gemäldegalerie) 1984
Frederichs 1969
L.C.J. Frederichs, 'De schetsbladen van Rembrandt voor het schilderij van het echtpaar Anslo,' *Maandblad Amstelodamum* 56 (1969), pp. 206-211
Frederiks 1894
J.G. Frederiks, 'Het kabinet schilderijen van Petrus Scriverius,' *Oud-Holland* 12 (1894), pp. 62-63
Freise 1911
Kurt Freise, *Pieter Lastman, sein Leben und seine Kunst*, Leipzig 1911
Froentjes 1969
W. Froentjes, 'Schilderde Rembrandt op goud?,' *Oud-Holland* 84 (1969), pp. 233-237
Gaskell 1982
Ivan Gaskell, 'Gerrit Dou, his patrons and the art of painting,' *Oxford Art Journal* 5 (1982), pp. 15-23
van Gelder 1948-1949
J.G. van Gelder, 'De schilders van de Oranjezaal,' *Nederlands Kunsthistorisch Jaarboek* 1948-1949, pp. 119-164
van Gelder 1950-1951
J.G. van Gelder, 'Rubens in Holland in de zeventiende eeuw,' *Nederlands Kunsthistorisch Jaarboek* 1950-1951, pp. 103-150
van Gelder 1972
J.G. van Gelder, *Jan de Bisschop, 1628-1671*, The Hague 1972
van Gelder 1973
J.G. van Gelder, 'Frühe Rembrandt-Sammlungen,' *Neue Beiträge zur Rembrandt-Forschung*, Berlin 1973
Gerson 1942

H. Gerson, *Ausbreitung und Nachwirkung der holländischen Malerei des 17. Jahrhunderts*, Haarlem 1942, Amsterdam 1983
Gerson 1957
H. Gerson, *Kunstchronik* 10 (1957), p. 122
Gerson 1961
H. Gerson, *Seven letters by Rembrandt*, transcription Isabella H. van Eeghen, translation Yda O. Ovink, The Hague 1961
Gerson 1962
H. Gerson, 'La lapidation de Saint Etienne peinte par Rembrandt en 1625 au Musée des Beaux-Arts de Lyon,' *Bulletin des Musées et Monuments Lyonnais* 3 (1962-1966), nr. 4, pp. 57-62
Gerson 1968
See Basic literature
Gerson 1969
H. Gerson, 'Rembrandts portret van Amalia van Solms,' *Oud-Holland* 84 (1969), pp. 244-249
Geschildert tot Leyden 1976-1977
Geschildert tot Leyden anno 1626, exhibition catalogue Leiden (Stedelijk Museum De Lakenhal), 1976-1977
God en de goden 1981
God en de goden: verhalen uit de bijbelse en klassieke oudheid door Rembrandt en zijn tijdgenoten, exhibition catalogue Amsterdam (Rijksmuseum), 1981 (English edition under the title *Gods, saints and heroes*)
Golahny 1983
A. Golahny, 'Rembrandt's early *Bathsheba*: the Raphael connection,' *Art Bulletin* 65 (1983), pp. 671-675
Grotius
Briefwisseling van Hugo Grotius, vol. 4: *1629-1630-1631*, ed. B.C. Meulenbroek, The Hague 1964
Haak 1968
B. Haak, *Rembrandt, zijn leven, zijn werk, zijn tijd*, The Hague 1968 (also published in English)
Hart 1969
S. Hart, 'De Pellicorne portretten van Rembrandt geveild: bravo!,' *Maandblad Amstelodamum* 56 (1969), p. 189
Hausherr 1963
R. Hausherr, 'Zur Menetekel-Inschrift auf Rembrandts Belsazarbild,' *Oud-Holland* 78 (1963), pp. 142-149
Haverkamp Begemann 1974
E. Haverkamp Begemann, 'The old and the new church at Sloten by Rembrandt,' *Master Drawings* 12 (1974), pp. 123-127
Haverkamp Begemann 1982
E. Haverkamp Begemann, *Rembrandt: The Nightwatch*, Princeton 1982
Haverkorn van Rijsewijk 1895
C. Haverkorn van Rijsewijk, 'Bernard Zwaerdecroon,' *Oud-Holland* 13 (1895), pp. 57-64
Heckscher 1958
W. Heckscher, *Rembrandt's anatomy of Dr. Nicolaes Tulp: an iconological study*, New York 1958
Heinsius 1965
D. Heinsius, *Bacchus en Christus: twee lofzangen van Daniël Heinsius*, ed. L.Ph. Rank, J.D.P. Warners and F.L. Zwaan, Zwolle 1965
Held 1964
J. Held, *Rembrandt and the book of Tobit*, Northhampton, Mass. 1964
Hellinga 1957
W.Gs. Hellinga, *Het hart op de tong in negentig brieven, 1571-1 april 1957*, The Hague 1957
Heppner 1935
A. Heppner, 'Moses zeigt die Gesetzestafeln bei Rembrandt und bei Bol,' *Oud-Holland* 52 (1935), pp. 241-251
den Herder 1958
T. den Herder, 'Sloterdijk: eertijds een 'sierlyk' dorp, nu een deel van onze stad,' *Ons Amsterdam* 10 (1958), pp. 130-138
van den Hoek Ostende 1967
I.H. van den Hoek Ostende, 'De Petruskerk te Sloterdijk,' *Maandblad Amstelodamum* 54 (1967), pp. 121-122
Hoet 1752
G. Hoet, *Catalogus of naamlijst van schilderijen, met derzelven prijzen (…)*, vol. 1, n.p. 1752
Hofman 1983
H.A. Hofman, *Constantijn Huygens (1596-1687): een christelijk-humanistisch bourgeois-gentilhomme in dienst van het Oranjehuis*, Utrecht 1983
Hofstede de Groot 1909
C. Hofstede de Groot, 'Nieuw-ontdekte Rembrandts,' *Onze Kunst* 16 (1909), pp. 173-183
Hofstede de Groot 1915
See Basic literature

Hofstede de Groot 1928
C. Hofstede de Groot, 'De portretten van het echtpaar Jacob Trip en Margaretha de Geer door de Cuyp's, N. Maes en Rembrandt,' *Oud-Holland* 45 (1928), pp. 255-264
Hollantsche Parnas 1660
Hollantsche Parnas of verscheiden gedichten gerijmt door J. Westerbaen, J. v. Vondel, J. Vos, G. Brandt, R. Anslo, … . Verzamelt door T. v. Domselaar, Amsterdam 1660
Hollstein 1949-
F.W.H. Hollstein, *Dutch and Flemish etchings, engravings and woodcuts, ca. 1450-1700*, vol. 1-, Amsterdam 1949-
Hoogewerff 1919
G.J. Hoogewerff, *De twee reizen van Cosimo de' Medici, prins van Toscane, door de Nederlanden (1667-1669)*, Amsterdam 1919
Hoogewerff 1947
G.J. Hoogewerff, *De geschiedenis van de Sint Lucasgilden in Nederland*, Amsterdam 1947
Hoogstraten 1678
See Basic literature
Houbraken 1719-1721
See Basic literature
Huizinga 1924
J. Huizinga, 'How Holland became a nation' (1924), in *Verzameld werk*, vol. 2, Haarlem 1948, pp. 266-283
Huizinga 1942
J. Huizinga, 'Leiden's ontzet' (1942), In *Verzameld werk*, vol. 2, Haarlem 1948, pp. 50-59
Huygens
See Basic literature
Impact of a genius
The impact of a genius: Rembrandt, his pupils and followers in the seventeenth century, Amsterdam (K. & V. Waterman) 1983
Israel 1983
J. Israel, 'Frederick Henry and the Dutch political factions, 1625-1642,' *English Historical Review* nr. 336 (January 1983), pp. 1-27
de Jongh 1969
E. de Jongh, 'The spur of wit: Rembrandt's response to an Italian challenge,' *Delta: A Review of Arts, Life and Thoughts in the Netherlands* 12, (1969), nr. 2, pp. 49-66
de Jongh 1973
E. de Jongh, ''t Gotsche krulligh mall': de houding tegenover de gotiek in het zeventiende-eeuwse Holland,' *Nederlands Kunsthistorisch Jaarboek* 24 (1973), pp. 85-145
Junius 1637
F. Junius, *De pictura veterum libri tres*, Amsterdam 1637 (quoted from the edition Rotterdam 1694 in the reprint, Soest 1970, where the indexes to parts 1 and 2 are switched)
Kauffmann 1920
H. Kauffmann, 'Rembrandt und die Humanisten vom Muiderkring,' *Jahrbuch der Preussischen Kunstsammlungen* 41 (1920), pp. 46-81
Kelch 1975
J. Kelch, *Katalog der ausgestellten Gemälde des 13.-18. Jahrhunderts*, Berlin-Dahlem (Gemäldegalerie) 1975
Kernkamp 1902
G.W. Kernkamp, 'Memorien van Ridder Theodorus Rodenburg betreffende het verplaatsen van verschillende industrieën uit Nederland naar Denemarken, met genomen resolutieën van koning Christiaan IV (1621),' *Bijdragen en Mededeelingen van het Historisch Genootschap* 23 (1902), p. 216
Kettering 1983
A.M. Kettering, *The Dutch Arcadia: pastoral art and its audience in the Golden Age*, Montclair, New Jersey 1983
Klamt 1975
J.C. Klamt, 'Ut magis lucent: eine Miszelle zu Rembrandts 'Anslo',' *Jahrbuch der Berliner Museen*, new series 17 (1975), pp. 155-165
Kleerkooper and van Stockum 1914-1916
M.M. Kleerkoper and W.P. van Stockum, *De boekhandel te Amsterdam, voornamelijk in de zeventiende eeuw*, The Hague 1914-1916
Klein 1965
P.W. Klein, *De Trippen in de 17e eeuw: een studie over het ondernemersgedrag op de Hollandse stapelmarkt*, Assen 1965
Klioos Kraam 1656
Klioos Kraam vol verscheiden gedichten, Leeuwarden 1656
Knoester and Graafhuis 1970
H. Knoester and A. Graafhuis, 'Het kasboek van Mr. Carel Martens, 1602-1649,' *Jaarboek Oud-Utrecht* 1970, pp. 154-223

Kok 1967
M. Kok, 'Rembrandts Nachtwacht: van feeststoet tot schuttersstuk,' *Bulletin van het Rijksmuseum* 15 (1967), pp. 116-121
Krul 1627
J.H. Krul, *Amstelsche Linde*, Amsterdam 1627
Krul 1628
J.H. Krul, *Vermakelijke uyren*, Amsterdam 1628
Krul 1634
J.H. Krul, *Eerlycke tytkorting*, Amsterdam 1634
Künstler-Inventare
See Basic literature
de Lairesse
See Basic literature
Lauts 1966
J. Lauts, *Katalog. Alte Meister bis 1800*, Karlsruhe 1966
Leendertz 1910
I. Leendertz, Jr., *Het leven van Vondel*, Amsterdam 1910
Leidse Universiteit 400 1975
Leidse Universiteit 400: stichting en eerste bloei, 1575-ca. 1650, exhibition catalogue Amsterdam (Rijksmuseum), 1975
Leonhardt 1979
G. Leonhardt, *Het huis Bartolotti en zijn bewoners*, Amsterdam 1979
Lievens 1979
Jan Lievens, ein Maler im Schatten Rembrandts, exhibition catalogue Braunschweig (Herzog Anton Ulrich-Museum) 1979
Louttit 1973
M. Louttit, 'The romantic dress of Saskia van Ulenborch: its pastoral and theatrical associations,' *Burlington Magazine* 115 (1973), pp. 317-326
Lugt 1920
F. Lugt, *Mit Rembrandt in Amsterdam*, Berlin 1920
Luttervelt 1958
R. van Luttervelt, 'Frederick Rihel of Jacob de Graeff?,' *Maandblad Amstelodamum* 45 (1958), pp. 147-150
MacLaren 1960
Neil MacLaren, *The Dutch school* (National Gallery catalogues), London 1960
De Maeyer 1955
Marcel De Maeyer, *Albrecht en Isabella en de schilderkunst*, Brussels 1955
Magurn 1955
Ruth Saunders Magurn, *The letters of Peter Paul Rubens*, Cambridge, Mass. 1955
van Mander 1604
See Basic literature
Marlet 1895
Léon Marlet, *Charlotte de la Trémoille, comtesse de Derby (1599-1664)*, Paris 1895
Martin 1925
W. Martin, 'Figuurstukken van Jan Janszoon de Heem,' *Oud-Holland* 24 (1925), pp. 42-45
Martin 1935
W. Martin, *De hollandsche schilderkunst in de zeventiende eeuw*, 2 vols., Amsterdam 1935 (second ed. 1942)
Martin 1947
W. Martin, *Van Nachtwacht tot feeststoet: lotgevallen, inhoud en betekenis van Rembrandt's schuttersstuk in het Rijksmuseum te Amsterdam*, Amsterdam-Antwerp 1947
Meischke 1956
R. Meischke, 'Het Rembrandthuis,' *Jaarboek Amstelodamum* 48 (1956), pp. 1-27
Mentz and Jauernig 1944
G. Mentz and R. Jauernig, *Die Matrikel der Universität Jena*, vol. 1: *1548-1652*, Jena 1944
Miedema 1973
See Basic literature, under van Mander
Miedema 1975
H. Miedema, 'Kunst is shit: een schets voor een herziene geschiedenis van het kunstbegrip,' *De Gids* 138 (1975), pp. 103-122
Miedema 1981
See Basic literature, under van Mander
Moes 1894
E.W. Moes, 'Een brief van kunsthistorische beteekenis,' *Oud-Holland* 12 (1894), pp. 238-240
Möller 1984
George J. Möller, 'Het album Pandora van Jan Six (1618-1700),' *Jaarboek Amstelodamum* 76 (1984), pp. 69-101
von Moltke 1965
J.W. von Moltke, *Govaert Flinck, 1615-1660*, Amsterdam 1965
Montias 1982
John Michael Montias, *Artists and artisans in Delft: a social-economic study of the seventeenth century*, Princeton 1982
Neercassel 1675

J. Neercassel, *Tractatus sanctorum et praecipue sanctissimae Virginis Mariae cultu*, Emmerik 1675

Nicolson 1979
B. Nicolson, *The international Caravaggist movement: lists of pictures by Caravaggio and his followers throughout Europe from 1590-1650*, Oxford 1979

Nieuwenhuys 1834
C.J. Nieuwenhuys, *A review of the lives and works of some of the most eminent painters*, Amsterdam 1834

NNBW
Nieuw Nederlands Biografisch Woordenboek, ed. P.C. Molhuysen and P.J. Blok, 10 vols., Leiden 1911-1937

The Orange and the Rose 1964
The Orange and the Rose, exhibition catalogue London (Victoria and Albert Museum) 1964

Orlers 1641
See Basic literature

Pelinck 1953
E. Pelinck, 'Pieter Couwenhorn, glasschrijver te Leiden,' *Oud-Holland*, pp. 51-56

Peltzer 1925
A.R. Peltzer, *Joachim von Sandrarts Akademie der Bau-, Bild- und Malerey-Künste von 1675: Leben der berühmten Maler*, Munich 1925

Penon 1880
Georg Penon, *Bijdragen tot de geschiedenis der Nederlandsche letterkunde*, Groningen 1880

Poelhekke 1978
J.J. Poelhekke, *Frederik Hendrik, prins van Oranje: een biografisch drieluik*, Zutphen 1978

Pontanus 1614
Johannes Isaaksz. Pontanus, *Historische beschrijvinghe der seer wijt beroemde Coop-stadt Amsterdam*, Amsterdam 1614

Prins 1933
I. Prins, 'Amsterdamse schimpdichters vervolgd,' *Jaarboek Amstelodamum* 30 (1933), pp. 189-227

Pronck 1957
S.E. Pronck, 'Cornelia Pronck,' *Maandblad Amstelodamum* 44 (1957), p. 29

van Putte 1978
P.C.A. van Putte, *Heijmen Dullaert: een biografische studie over de Rotterdamse dichter-schilder; commentaar en taalkundige verklaringen bij zijn gedichten, gevolgd door een fotomechanische heruitgave van zijn dichtwerk*, Groningen 1978

Rammelman Elsevier 1849
Jhr. Rammelman Elsevier, 'Prins Frederik Hendrik en het kasteel van Antwerpen,' *Kronijk van het Historisch Gezelschap te Utrecht* 5 (1849), pp. 111-113

van Regteren Altena 1936
J.Q. van Regteren Altena, *The drawings of Jacques de Gheyn*, Amsterdam 1936

Rembrandt documents 1979
See Basic literature

Rembrandt in the Mauritshuis 1978
A.B. de Vries, Magdi Tóth-Ubbens, W. Froentjes, with an introduction by H.R. Hoetink, *Rembrandt in the Mauritshuis: an interdisciplinary study*, Alphen aan den Rijn 1978

Resolutiën der Staten-Generaal
Resolutiën der Staten-Generaal, new series, vol. 4: *1619-1620*, ed. J.G. Smit, The Hague 1981

Reznicek 1977
E.K.J. Reznicek, 'Opmerkingen bij Rembrandt,' *Oud-Holland* 91 (1977), pp. 80-88

de Roever 1878
N. de Roever Az., *De Amsterdamse weeskamer*, Amsterdam 1878

Rosenberg 1964
J. Rosenberg, *Rembrandt: life and work*, revised edition, London 1964

Russell 1977
M. Russell, 'The iconography of Rembrandt's *Rape of Ganymede*,' *Simiolus: Netherlands Quarterly for the History of Art* 9 (1977), pp. 5-18

Sandrart 1675
See Peltzer 1925

Scheller 1961
R.W. Scheller, 'Rembrandt's reputatie van Houbraken tot Scheltema,' *Nederlands Kunsthistorisch Jaarboek* 12 (1961), pp. 81-118

Scheltema 1872
P. Scheltema, 'Dr. Cornelis Gysbertszoon Plemp en zijn beschrijving van Amsterdam,' in *Aemstel's oudheid, of Gedenkwaardigheden van Amsterdam*, vol. 6, Amsterdam 1882, pp. 1-15

Schneider/Ekkart 1973
H. Schneider, *Jan Lievens, sein Leben und seine Werke*, Amsterdam 1973 (reprint of ed. Haarlem 1932, with new introduction and supplements by R.E.O. Ekkart)

Schouten 1970
J. Schouten, 'Een onbekende Anatomische les van Dr. Nicolaes Tulp door Christiaen Coevershoff,' *Opstellen voor H. van de Waal aangeboden door leerlingen en medewerkers, 3 maart 1970*, Amsterdam and Leiden 1970, pp. 174-184 (see however also van van Eeghen 1971c)

Schulz 1978
Wolfgang Schulz, *Cornelis Saftleven, 1607-1681: Leben und Werke*, Berlin 1978

Schupbach 1982
W. Schupbach, *The paradox of Rembrandt's anatomy of Dr. Tulp*, London 1982

Schwartz 1983
G. Schwartz, 'Jan van der Heyden and the Huydecopers of Maarsseveen,' *J. Paul Getty Museum Journal* 11 (1983), pp. 197-220

Schwartz 1985
G. Schwartz, 'Rembrandt's *David and Mephiboseth*: a forgotten subject from Vondel,' *A tribute to Lotte Brandt Philip*, New York 1985 (in press)

Scriverius
See Basic literature

Seidel 1890
Paul Seidel, 'Die Beziehungen des grossen Kurfürsten und König Friedrichs I zur niederländischen Kunst,' *Jahrbuch der königlich Preussischer Kunstsammlungen* 11 (1890), pp. 119-149

van Selm 1984-1985
B. van Selm, 'Hooftiana in veilingcatalogi.' *Spektator* 14 (1984-1985), pp. 115-124

Le siècle de Rembrandt
See Basic literature

Six 1909a
J. Six, 'Gersaints lijst van Rembrandts prenten,' *Oud-Holland* 27 (1909), pp. 65-110

Six 1909b
J. Six, 'Een tekening van Bartholomeus van der Helst,' *Oud-Holland* 27 (1909), pp. 142-148

Six 1925-1926
J. Six, 'La famosa Academia di Eulemborg,' *Jaarboek der Koninklijke Akademie der Wetenschappen te Amsterdam* 1925-1926, pp. 229-241

Slatkes 1983
L.J. Slatkes, *Rembrandt and Persia*, New York 1983

Slive 1953
S. Slive, *Rembrandt and his critics, 1630-1730*, The Hague 1953

Slothouwer 1945
D.F. Slothouwer, *De paleizen van Frederik Hendrik*, Leiden [1945]

Sluyters-Seijffert 1983
N. Sluyters-Seijffert, 'De Nassause cavalcade: een opmerkelijk doek in het Mauritshuis,' *Ons Koningshuis* 13, nr. 25 (April 1983), pp. 36-37

Smit 1980
J. Smit, *De grootmeester van woord- en snarenspel: het leven van Constantijn Huygens*, The Hague 1980

Snoep 1975
D.P. Snoep, *Praal en propaganda: triumfalia in de noordelijke Nederlanden in de 16de en 17de eeuw*, Alphen aan den Rijn 1975

Snoep 1983
D.P. Snoep, 'Het Trippenhuis, zijn decoraties en inrichting,' in *Het Trippenhuis te Amsterdam*, Amsterdam 1983, pp. 187-211

Sterck 1934
J.F.M. Sterck, *Vondelkroniek* 5 (1934), pp. 15-16

Straat 1925
H.L. Straat, 'Lambert Jacobsz.,' *De vrije Fries* 28 (1925), pp. 53-76, 241-255

Strauss and van der Meulen 1979
See Basic literature

Sullivan 1980
Scott A. Sullivan, 'Rembrandt's *Selfportrait with a dead bittern*,' *Art Bulletin* 62 (1980), pp. 236-243

Swillens 1945-1946
P.T.A. Swillens, 'Rubens' bezoek aan Utrecht,' *Jaarboekje van 'Oud-Utrecht'* 1945-1946, pp. 105-125

Tallement 1834
Les historiettes de Tallement des Réaux: mémoires pour servir à l'histoire du XVIIe siècle, vol. 3, The Hague 1834 (late edition of seventeenth-century memoirs)

Tatenhove 1984
J. van Tatenhove, 'Een tekening van Pieter Kouwenhorn (1599?-1656),' *Oud-Holland* 98 (1984), p. 56

Taverne 1978
E. Taverne, *In 't land van belofte: in de nieuwe stadt. Ideaal en werkelijkheid van de stadsuitleg in de Republiek, 1580-1680*, Maarssen 1978

Tideman 1903
B. Tideman Jzn., 'Portretten van Johannes Wtenbogaert,' *Oud-Holland* 21 (1903), pp. 125-128

Tiethoff-Spliethoff 1978
M.E. Tiethoff-Spliethoff, 'De portretten van stadhouder Frederik Hendrik,' *Jaarboek van het Centraal Bureau voor Genealogie en het Iconografisch Bureau* 32 (1978), pp. 91-120

Tóth-Ubbens 1975-1976
M.M. Tóth-Ubbens, 'De barbier van Amsterdam,' *Antiek* 10 (1975-1976), pp. 381-411

Tuynman 1977
P. Tuynman, 'Petrus Scriverius, 12 January 1576-30 April 1660,' *Quaerendo: Quarterly Journal from the Low Countries devoted to Manuscripts and Printed Books* 7 (1977), pp. 5-45

Unger 1885
J.H.W. Unger, 'Theod. Rodenburg,' *Oud-Holland* 5 (1885), pp. 85 ff.

Urkunden 1906
See Basic literature

Verscheyde Nederduytsche gedichten 1651
Verscheyde Nederduytsche gedichten van Grotius, Hooft, Barlaeus, Huygens, Vondel en anderen. Versamelt door J.V. J.S. TVD. B. GP. CLB., Amsterdam (Lodewyck Spillebout) 1651.

Vey and Kestsieg 1967
H. Vey and A. Kestsieg, *Katalog der Niederländischen Gemälde von 1550 bis 1880 im Wallraf-Richartz Museum und im öffentlichen Besitz der Stadt Köln*, Cologne 1967

Vis 1965
D. Vis, *Rembrandt en Geertge Dircx: de identiteit van Frans Hals' portret van een schilder en de vrouw van de kunstenaar*, Haarlem 1965

Visser 't Hooft 1956
W.A. Visser 't Hooft, *Rembrandts weg tot het Evangelie*, Amsterdam 1956

Vliegenthart 1972
A.W. Vliegenthart, 'Einige Bemerkungen zu Rembrandts Aktäon und Kallisto,' *Nederlands Kunsthistorisch Jaarboek* 23 (1972), pp. 85-94

Vondel
See Basic literature

Vondel 1707
J. v. Vondels Palamedes of vermoorde onnozeleit. Treurspel met aantekeningen uit 's Digters mondt opgeschreven. Den tweeden druk merkelijk vermeerdert, Amersfoort 1707

Vos 1662
Alle de gedichten van den Poëet Jan Vos, Amsterdam (Jacob Lescaille) 1662

Vos 1903
G.J. Vos Az., *Amstels kerkelijk leven van de eerste zestig jaren der vrijheid*, Amsterdam 1903

van de Waal 1952
H. van de Waal, *Drie eeuwen vaderlandsche geschied-uitbeelding, 1500-1800*, 2 vols., The Hague 1952

van de Waal 1969
H. van de Waal, 'Rembrandt and the feast of Purim' (1969), in *Steps towards Rembrandt*, Amsterdam-London 1974

van de Waal 1974
H. van de Waal, 'Rembrandt's etchings for Menasseh ben Israël's *Piedra gloriosa* (1654-1655),' in *Steps towards Rembrandt*, Amsterdam-London 1974, pp. 113-132

Wagenaar
See Basic literature

Walker
J. Walker, *National Gallery of Art, Washington*, New York n.d.

van de Wetering 1983
E. van de Wetering, 'Isaac Jouderville, a pupil of Rembrandt,' in exhibition catalogue *The impact of a genius* 1983, pp. 59-69

van de Wetering 1984
E. van de Wetering, 'Het formaat van Rembrandts 'Danaë',' *Met eigen ogen: opstellen aangeboden door leerlingen en medewerkers aan Hans L.C. Jaffé*, Amsterdam 1984

White 1964
C. White, *Rembrandt*, met een voorwoord van Drs. K.G. Boon en aantekeningen van Mr. H.F. Wijnman, Nederlandse vertaling M. Komter, The Hague 1964 (originally published in English, without Wijnman's notes)

White 1969
C. White, *Rembrandt as an etcher*, 2 vols., London 1969

Wijngaards 1964
N. Wijngaards, *Jan Harmens Krul: zijn leven, zijn werk zijn betekenis*, Zwolle 1964

Wijnman 1933
H.F. Wijnman, 'Mr. Lieven van Coppenol,' *Jaarboek Amstelodamum* 30 (1933), pp. 93-187

Wijnman 1934
H.F. Wijnman, 'Een drietal portretten van Rembrandt (Joannes Elison, Maria Bockenolle en Catrina Hoogsaet),' *Jaarboek Amstelodamum* 31 (1934), pp. 81-96

Wijnman 1957
H.F. Wijnman, 'Rembrandts portretten van Joannes Elison en zijn vrouw Maria Bockenolle naar Amerika verkocht,' *Maandblad Amstelodamum* 44 (1957), pp. 65-72

Wijnman 1959
H.F. Wijnman, *Uit de kring van Rembrandt en Vondel: verzamelde studies over hun leven en omgeving*, Amsterdam 1959

Wijnman 1966
H.F. Wijnman, 'Een nieuwe oeuvrecatalogus van Rembrandt,' *Maandblad Amstelodamum* 53 (1966), pp. 121-124

Wijnman 1971
H.F. Wijnman, *Historische gids van Amsterdam*, Amsterdam 1971

Wille 1926
J. Wille, *Heiman Dullaert: leven, omgeving en werk*, Zeist 1926

Wolleswinkel 1977
E.J. Wolleswinkel, 'De portretten van Petrus Scriverius en zijn familie,' *Jaarboek van het Centraal Bureau voor Genealogie en het Iconografisch Bureau* 31 (1977), pp. 105-119

Worp 1897
J.A. Worp, 'Fragment eener autobiographie van Constantijn Huygens,' *Bijdragen en Mededeelingen van het Historisch Genootschap* 18 (1897), pp. 1-121

Worp 1904-1908
J.A. Worp, *Geschiedenis van het drama en van het tooneel in Nederland*, 2 vols., Rotterdam 1904-1908

Worp 1920
J.A. Worp, *Geschiedenis van den Amsterdamschen Schouwburgh, 1496-1772*, Amsterdam 1920

von Wurzbach 1906-1911
A. von Wurzbach, *Niederländisches Künstler-Lexikon, auf Grund archivalische Forschungen bearbeitet*, 2 vols., Vienna 1906-1911 (reprinted Amsterdam 1963 and 1968)

van Ysselsteyn
G.T. van Ysselsteyn, *Geschiedenis der tapijt-weverijen in de noordelijke Nederlanden*, 2 vols., Leiden n.d. (1936)?

Zantkuyl 1959
H. Zantkuyl, 'De reconstructie van de schuilkerk aan de Grimnessersluis,' *Maandblad Amstelodamum* 46 (1959), pp. 157-162

Index

This index is complete for all names of persons from the sixteenth and seventeenth centuries on pp. 8-357, except for those which occur only in the lists on pp. 18-19, 136-137, 140, 145, 146, 210, 288-291, 300 and 389.

Index of Rembrandt paintings, by collection

Sources of photographs

The illustrations in this book were made from photographs or transparencies supplied by the owners of the works reproduced, with the following exceptions:

Photo Agraci, Paris 155, 156
Art Promotions Amsterdam b.v. 240, 301
Joachim Blauel Artothek, Planegg 34, 41, 98, 99, 105, 106, 108, 175, 185, 220, 261, 277, 321, 423
BPK, West Berlin 30, 69, 113, 114, 179, 184, 197, 200, 238, 249, 250, 258, 260, 266, 268, 274, 309, 320, 326, 350, 370, 375, 377
The Bridgeman Art Library 385
Bulloz, Paris 21, 32, 48, 64
Courtauld Institute of Art, London 399
Devon Commercial Photos, Plymouth 174
A. Dingjan, The Hague 17
A.E. Dolinski Photographic, San Gabriel, California 207
Anne Gold, Aachen 225
Wim de Groot, Amsterdam 6, 296, 297
Tom Haartsen, Ouderkerk 126
Kurt Haase, Frankfurt am Main 138
A. Held, Ecublens, Switzerland 22, 176, 252, 244, 314, 379
Colorphoto Hinz, Allschwil-Basel 19
Graham Jackson 12
Jaroslav Jerabek 215
Meyer, Vienna 142, 143, 228, 331, 412-414
Museumsfoto B.P. Keiser 135, 203, 280, 286, 402
Jan Lindens, Rotterdam 243
Linster, Telfs 53
Studio Louton, La Tour de Salvagny 15
Edeltraut Mandl, Vienna 151
Gilbert Mangin, Nancy 79
Jeremy Marks, Woodmansterne Limited 88, 267, 397
Marco de Nood, Dordrecht 70
Photo Pernot, Epinal 360
Hans Petersen, Hornbaek 82, 279
Photographic Records Limited, London 295, 296
RMN, Paris 80, 148, 149, 189, 192, 214, 242, 290, 292, 323, 325, 333, 354
Rheinisches Bildarchiv, Cologne 77
Gerhard Reinhold, Leipzig-Mölkau 121, 206, 186, 198, 224, 233
Sixten Sandell, Göteborg 361
Scala, Florence 84, 210, 364, 418
Tass/Jürgens 103, 123, 168, 177, 237, 272, 341, 344, 367
Thomas Photos, Oxford 298
Lukasz Szuster, Cracow 285
Karoly Szelényi 254
T. Zolkowska, Warsaw 67, 246

Concordance and account of omitted paintings

Listed are the Bredius numbers of all paintings included in H. Gerson, *Rembrandt paintings,* New York 1968, and the *Corpus* numbers of four paintings not in Gerson or Bredius.

G Doubted by Gerson in his notes.
RRP Rejected by the Rembrandt Research Project.
M No longer regarded as a Rembrandt by the museum which owns it.
U Location unknown, or painting inaccessible.
S The present author is not convinced that Rembrandt had a hand in the painting.
S? Included despite such doubts.

(1) Rejected by the RRP, but probably painted under Rembrandt's supervision.
(2) Although dated 1631, not included in volume 1 of the *Corpus*. (Also missing, without explanation, are Bredius 142, 144, 145 and 146.) Omitted here because of my own doubts.
(3) Might have been given the benefit of the doubt.
(4) Old copy, as demonstrated by the RRP.
(5) Now given by the museum to Flinck.
(6) Stolen in 1973 and not recovered.
(7) The owner refuses to allow it to be reproduced in colour.

Br. nr.	Fig. nr.	
1	–	RRP
2	41	
5	–	(1)
6	44	
7	–	G
8	43	
9	–	RRP
11	46	
12	45	
16	48	
17	191	
18	192	
19	193	
20	–	G
21	200	
22	199	
23	197	
24	201	S?
25	–	G
26	–	G
30	206	
31	224	
32	207	
34	231	
36	–	G
37	408	
38	409	
41	–	G
42	412	
43	–	G
44	413	S?
48	415	
49	414	
50	416	
51	417	
52	419	
53	410	
54	411	
55	422	
59	420	
60	418	
61	424	
62	421	
63	60	
64	–	RRP
68	–	RRP
69	93	
70	58	
71	228	
73	–	RRP
76	53	
77	56	
78	–	RRP
79	55	
80	–	(1)
81	54	
82	–	(2)
84	212	
85	208	
86	–	M
87	210	
89	209	
94	195	
95	–	G
96	204	S?
97	198	
99	64	
101	205	
102	118	
103	119	
104	–	U
108	233	
109	–	(3)
110	265	
111	325	
112	347	S?
113	–	S
114	324	
116	326	
118	327	
119	348	
120	329	
122	331	
123	330	
126	333	
128	274	S?
130	338	
131	340	S?
132	50	
134	49	
141	–	RRP
142	–	(1)
143	52	S?
144	51	S?
145	128	
146	133	
148	–	RRP
152	211	
154	–	G
155	136	
156	–	S
159	135	
160	146	
161	87	
162	88	
163	142	
164	134	S?
165	148	S?
166	129	
167	159	
169	217	
170	62	
171	150	
172	166	
173	132	
175	137	
176	–	U
177	140	
178	220	
179	183	
180	219	
181	–	G
183	–	U
185	256	
186	213	
190	–	G
194	144	
196	168	
197	170	
199	155	
200	153	
201	164	
202	162	
203	130	
205	–	S
206	221	
207	–	G
211	218	
214	–	G
216	223	
217	236	
218	234	
219	–	U
221	–	S
222	–	U
229	255	
235	–	G
236	258	
239	257	
249	259	S?
250	266	
251	294	
252	299	
255	391	
256	–	G
259A	–	G
263	273	
265	298	
266	337	
267	339	S?
268	304	
269	260	
270	343	
274	344	
275	306	
276	301	
277	393	S?
278	305	
279	313	
281	314	
282	–	U
283	346	
284	350	
285	364	
289	397	
290	–	U
293	–	S
294	–	M
295	–	U
295A	–	U
297	353	
298	–	G
299	390	S?
300	–	U
304	–	U
306	332	
307	362	
308	349	
309	367	
310	365	
311	392	S?
312	396	
313	395	
314	386	
315	394	
319	361	
320	400	
321	401	
322	398	
323	406	
323A	399	
326	403	
327	405	
330	151	
331	160	
332	143	
333	–	U
335	147	
336	149	S?
337	–	(2)
339	138	
340	–	U
341	167	
342	156	
343	139	
344	141	
345	169	
346	171	
347	154	
348	–	G
349	163	
350	165	S?
354	145	
355	227	
356	226	
357	237	S?
358	240	S?
359	–	U
360	235	
362	–	S
367	269	
368	267	
369	–	(3)
370	295	
371	345	S?
377	271	
378	270	S?
380	–	G
381	342	
383	341	
385	303	
387	272	
389	–	S
391	385	
394	388	
395	387	
396	–	(3)
397	360	
398	–	S
400	384	S?
401	404	
402	407	
403	127	
405	131	
406	157	
407	158	
408	152	
409	238	
410	230	
414	315	
415	389	
416	380	
417	402	
419	36	
420	30	
421	13	
421A	14	
423	83	
427	–	RRP
428	84	
430	96	(4)
431	214	
432	215	
433	–	U
435	254	S?
437	328	
439	282	
440	281	
441	286	
442	285	S?
443	284	(5)
444	–	U
445	283	
446	287	S?
450	290	
451	288	S?
452	289	
453	–	(6)
454	291	
456	229	
457	292	
458	293	
460	17	
462	111	
463	114	
464	116	
466	113	
467	117	
468	120	
469	–	U
471	121	
472	115	
474	123	
476	243	
478	334	
479	335	
480	336	
481	373	
482	368	
483	366	
484	382	
485	383	
486	26	
487	21	
488	19	
489	69	
490	34	
491	174	
494	173	
497	182	
498	177	
499	184	
501	185	
502	188	
503	189	
504	181	
505	180	
507	186	
508	239	S?
509	–	G
511	244	
513	245	S?
514	249	
515	251	
516	268	
520	374	
521	323	
523	310	
524	309	
525	308	
526	369	S?
527	377	
528	375	
530	311	
531	312	
531A	15	
532	22	
532A	–	(1)
533	–	(1)
535	29	
536	–	(1)
538	73	
539	32	
539A	65	
543	97	
543A	80	
544	175	
546	104	
547	172	
548	98	
550	99	
551	103	
552	176	
552A	178	U
554	110	
555	179	
557	105	
558	187	
559	190	
560	106	
561	108	
562	241	
563	242	
565	109	
566	248	
569	250	
570	252	
572	253	
574	261	
575	263	
576	276	
577	275	
578	278	
579	279	S?
583	280	
586	–	U
588	370	S?
589	372	S?
592A	371	S?
594	378	
596	376	
597	–	S
598	379	
600	381	
601	90	
602	91	
604	92	
607	89	(7)
608	–	(5)
610	216	S?
611	–	S
612	351	
613	352	
614	354	
615	359	
616	–	G
616A	355	
617	356	
618	357	
619	358	
620	316	S?
621	317	S?
622	320	S?
624	318	S?
624A	319	S?
625	–	S
626	–	S
627	–	S
628	322	S?
629	–	S
630	321	
632	23	
633	–	(1)
639	363	

RRP nr.	Fig. nr.	
B3	12	
A5	20	
A14	40	
A22	42	S?